# The Future of Journalism: Risks, Threats and Opportunities

This volume draws together research originally presented at the 2015 Future of Journalism Conference at Cardiff University, UK. The conference theme, 'Risks, Threats and Opportunities', highlighted five areas of particular concern for discussion and debate.

The first of these areas, 'Journalism and Social Media', explores how journalism and the role of the journalist are being redefined in the digital age of social networking, crowdsourcing and 'big data', and how the influence of media like Twitter, Facebook, YouTube, Instagram and Reddit affects the gathering, reporting or consumption of news. 'Journalists at Risk' assesses the key issues surrounding journalists' safety and their right to report, as news organizations and their sources are increasingly targeted in war, conflict or crisis situations. The third area, 'Journalism Under Surveillance', asks what freedom of the press means in a post-Snowden climate. What are the new forms of censorship confronting journalism today, and what emergent tactics will help it to speak truth to power?

'Journalism and the Fifth Estate' examines the traditional ideals of the fourth estate, which risk looking outdated, if not obsolete, in the modern world. How much can we rely on citizen media to produce alternative forms of news reporting, and how can we reform mainstream media institutions to make them more open, transparent and accountable to the public? The final area, 'Journalism's Values', asks how journalism's ethical principles and moral standards are evolving in relation to the democratic cultures of communities locally, regionally, nationally or internationally. What are the implications of changing priorities for the education, training and employment of tomorrow's journalists?

Every chapter in this volume engages with a pressing issue for the future of journalism, offering an original, thought-provoking perspective intended to help facilitate further dialogue and debate.

The chapters in this book were originally published in special issues of *Digital Journalism*, *Journalism Practice* and *Journalism Studies*.

The editors of this book are based in the School of Journalism, Media and Culture at Cardiff University, UK.

## Journalism Studies: Theory and Practice

*Series editor: Bob Franklin, Cardiff School of Journalism,*
*Media and Culture, Cardiff University, UK*

The journal *Journalism Studies* was established at the turn of the new millennium by Bob Franklin. It was launched in the context of a burgeoning interest in the scholarly study of journalism and an expansive global community of journalism scholars and researchers. The ambition was to provide a forum for the critical discussion and study of journalism as a subject of intellectual enquiry but also an arena of professional practice. Previously, the study of journalism in the UK and much of Europe was a fairly marginal branch of the larger disciplines of media, communication and cultural studies; only a handful of universities offered degree programmes in the subject. *Journalism Studies* has flourished and succeeded in providing the intended public space for discussion of research on key issues within the field, to the point where in 2007 a sister journal, *Journalism Practice,* was launched to enable an enhanced focus on practice-based issues, as well as foregrounding studies of journalism education, training and professional concerns. Both journals are among the leading-ranked journals within the field and publish six issues annually, in electronic and print formats. More recently, 2013 witnessed the launch of a further companion journal, *Digital Journalism*, to provide a site for scholarly discussion, analysis and responses to the wide-ranging implications of digital technologies for the practice and study of journalism. From the outset, the publication of themed issues has been a commitment for all journals. Their purpose is first, to focus on highly significant or neglected areas of the field; second, to facilitate discussion and analysis of important and topical policy issues; and third, to offer readers an especially high quality and closely focused set of essays, analyses and discussions.

The *Journalism Studies: Theory and Practice* book series draws on a wide range of these themed issues from all journals and thereby extends the critical and public forum provided by them. The editor of the journals works closely with guest editors to ensure that the books achieve relevance for readers and the highest standards of research rigour and academic excellence. The series makes a significant contribution to the field of journalism studies by inviting distinguished scholars, academics and journalism practitioners to discuss and debate the central concerns within the field. It also reaches a wider readership of scholars, students and practitioners across the social sciences, humanities and communication arts, encouraging them to engage critically with, but also to interrogate, the specialist scholarly studies of journalism which this series provides.

**Recent titles in the series:**

**The Future of Journalism: Risks, Threats and Opportunities**
*Edited by Stuart Allan, Cynthia Carter, Stephen Cushion, Lina Dencik, Iñaki Garcia-Blanco, Janet Harris, Richard Sambrook, Karin Wahl-Jorgensen and Andrew Williams*

(for full list, see: https://www.routledge.com/Journalism-Studies/book-series/JOURNALISM)

# The Future of Journalism: Risks, Threats and Opportunities

*Edited by*
**Stuart Allan, Cynthia Carter, Stephen Cushion, Lina Dencik, Iñaki Garcia-Blanco, Janet Harris, Richard Sambrook, Karin Wahl-Jorgensen and Andrew Williams**

Routledge
Taylor & Francis Group

LONDON AND NEW YORK

First published 2019
by Routledge
2 Park Square, Milton Park, Abingdon, Oxon, OX14 4RN, UK

and by Routledge
52 Vanderbilt Avenue, New York, NY 10017, USA

First issued in paperback 2020

*Routledge is an imprint of the Taylor & Francis Group, an informa business*

Foreword, Introduction, Chapters 1–15, 17–36 © 2019 Taylor & Francis
Chapter 16 © 2016 Dan Gillmor

*British Library Cataloguing-in-Publication Data*
A catalogue record for this book is available from the British Library

ISBN 13: 978-0-367-58593-8 (pbk)
ISBN 13: 978-1-138-61649-3 (hbk)

Typeset in Myriad Pro
by codeMantra

**Publisher's Note**
The publisher accepts responsibility for any inconsistencies that may have arisen during the conversion of this book from journal articles to book chapters, namely the possible inclusion of journal terminology.

**Disclaimer**
Every effort has been made to contact copyright holders for their permission to reprint material in this book. The publishers would be grateful to hear from any copyright holder who is not here acknowledged and will undertake to rectify any errors or omissions in future editions of this book.

# Contents

CONTENTS

CONTENTS

CONTENTS

# Citation Information

The following chapters were originally published in *Digital Journalism*, volume 4, issue 7 (October 2016). When citing this material, please use the original page numbering for each article, as follows:

## Chapter 5

*Sourcing the BBC's Live Online Coverage of Terror Attacks*
Daniel Bennett
*Digital Journalism*, volume 4, issue 7 (October 2016) pp. 861–874

## Chapter 6

*Twitter as a Flexible Tool: How the job role of the journalist influences tweeting habits*
Lily Canter and Daniel Brookes
*Digital Journalism*, volume 4, issue 7 (October 2016) pp. 875–885

## Chapter 7

*The Anatomy of Leaking in the Age of Megaleaks: New triggers, old news practices*
Zvi Reich and Aviv Barnoy
*Digital Journalism*, volume 4, issue 7 (October 2016) pp. 886–898

## Chapter 8

*Social News = Journalism Evolution? How the integration of UGC into newswork helps and hinders the role of the journalist*
Lisette Johnston
*Digital Journalism*, volume 4, issue 7 (October 2016) pp. 899–909

## Chapter 9

*"Twitter Just Exploded": Social media as alternative vox pop*
Kathleen Beckers and Raymond A. Harder
*Digital Journalism*, volume 4, issue 7 (October 2016) pp. 910–920

## Chapter 10

*Who Shares What with Whom and Why? News sharing profiles amongst Flemish news users*
Ike Picone, Ralf De Wolf and Sarie Robijt
*Digital Journalism*, volume 4, issue 7 (October 2016) pp. 921–932

## Chapter 11

*Making Sense of Twitter Buzz: The cross-media construction of news stories in election time*
Raymond A. Harder, Steve Paulussen and Peter Van Aelst
*Digital Journalism*, volume 4, issue 7 (October 2016) pp. 933–943

## Chapter 12

*Letting the Data Speak: Role perceptions of data journalists in fostering democratic conversation*
Jan Lauren Boyles and Eric Meyer
*Digital Journalism*, volume 4, issue 7 (October 2016) pp. 944–954

The following chapters were originally published in *Journalism Practice*, volume 10, issue 7 (October 2016). When citing this material, please use the original page numbering for each article, as follows:

## Chapter 13
*Keynote Address – Towards a New Model for Journalism Education*
Dan Gillmor
*Journalism Practice*, volume 10, issue 7 (October 2016) pp. 815–819

## Chapter 14
*The Future of Professional Photojournalism: Perceptions of risk*
Adrian Hadland, Paul Lambert and David Campbell
*Journalism Practice*, volume 10, issue 7 (October 2016) pp. 820–832

## Chapter 15
*Unravelling Data Journalism: A study of data journalism practice in British newsrooms*
Eddy Borges-Rey
*Journalism Practice*, volume 10, issue 7 (October 2016) pp. 833–843

## Chapter 16
*Changes in U.S. Journalism: How do journalists think about social media?*
David H. Weaver and Lars Willnat
*Journalism Practice*, volume 10, issue 7 (October 2016) pp. 844–855

## Chapter 17
*Are You Talking to Me? An analysis of journalism conversation on social media*
Martin Chorley and Glyn Mottershead
*Journalism Practice*, volume 10, issue 7 (October 2016) pp. 856–867

## Chapter 18
*Political Journalists' Interaction Networks: The German Federal Press Conference on Twitter*
Christian Nuernbergk
*Journalism Practice*, volume 10, issue 7 (October 2016) pp. 868–879

## Chapter 19
*Journalism Under Threat: Intimidation and harassment of Swedish journalists*
Monica Löfgren Nilsson and Henrik Örnebring
*Journalism Practice*, volume 10, issue 7 (October 2016) pp. 880–890

## Chapter 20
*Fake News: The narrative battle over the Ukrainian conflict*
Irina Khaldarova and Mervi Pantti
*Journalism Practice*, volume 10, issue 7 (October 2016) pp. 891–901

## Chapter 21
*Gender, Risk and Journalism*
Janet Harris, Nick Mosdell and James Griffiths
*Journalism Practice*, volume 10, issue 7 (October 2016) pp. 902–916

## Chapter 22

*Intrapreneurial Informants: An emergent role of freelance journalists*
Avery E. Holton
*Journalism Practice*, volume 10, issue 7 (October 2016) pp. 917–927

## Chapter 23

*Mapping Changes in Local News*
Julie Firmstone
*Journalism Practice*, volume 10, issue 7 (October 2016) pp. 928–938

## Chapter 24

*Mixed Messages: An investigation into the discursive construction of journalism as a practice*
Sally Reardon
*Journalism Practice*, volume 10, issue 7 (October 2016) pp. 939–949

The following chapters were originally published in *Journalism Studies*, volume 17, issue 7 (October 2016). When citing this material, please use the original page numbering for each article, as follows:

## Chapter 25

*Keynote Address – The New Architecture of Communications*
Jean Seaton
*Journalism Studies*, volume 17, issue 7 (October 2016) pp. 808–816

## Chapter 26

*Normative Expectations: Employing "communities of practice" models for assessing journalism's normative claims*
Scott Eldridge II and John Steel
*Journalism Studies*, volume 17, issue 7 (October 2016) pp. 817–826

## Chapter 27

*Valuable Journalism: Measuring news quality from a user's perspective*
Irene Costera Meijer and Hildebrand P. Bijleveld
*Journalism Studies*, volume 17, issue 7 (October 2016) pp. 827–839

## Chapter 28

*Folk Theories of Journalism: The many faces of a local newspaper*
Rasmus Kleis Nielsen
*Journalism Studies*, volume 17, issue 7 (October 2016) pp. 840–848

## Chapter 29

*Interacting with Audiences: Journalistic role conceptions, reciprocity, and perceptions about participation*
Avery E. Holton, Seth C. Lewis and Mark Coddington
*Journalism Studies*, volume 17, issue 7 (October 2016) pp. 849–859

## Chapter 30
*Cosmopolitan Journalists? Global journalism in the work and visions of journalists*
Johan Lindell and Michael Karlsson
*Journalism Studies*, volume 17, issue 7 (October 2016) pp. 860–870

## Chapter 31
*Participation and the Blurring Values of Journalism*
Jaana Hujanen
*Journalism Studies*, volume 17, issue 7 (October 2016) pp. 871–880

## Chapter 32
*Core Blighty? How Journalists Define Themselves through Metaphor:* British Journalism
Review *2011–2014*
Martin Conboy and Minyao Tang
*Journalism Studies*, volume 17, issue 7 (October 2016) pp. 881–892

## Chapter 33
*What Makes a Good Journalist? Empathy as a central resource in journalistic work practice*
Antje Glück
*Journalism Studies*, volume 17, issue 7 (October 2016) pp. 893–903

## Chapter 34
*Camouflaging Church as State: An exploratory study of journalism's native advertising*
Raul Ferrer Conill
*Journalism Studies*, volume 17, issue 7 (October 2016) pp. 904–914

## Chapter 35
*Embedded Links, Embedded Meanings: Social media commentary and news sharing as mundane media criticism*
Matt Carlson
*Journalism Studies*, volume 17, issue 7 (October 2016) pp. 915–924

## Chapter 36
*Power to the Virtuous? Civic culture in the changing digital terrain*
Kristy Hess
*Journalism Studies*, volume 17, issue 7 (October 2016) pp. 925–934

For any permission-related enquiries please visit:
http://www.tandfonline.com/page/help/permissions

# Notes on Contributors

**Stuart Allan** is Professor and Head of the School of Journalism, Media and Culture at Cardiff University, UK.

**Aviv Barnoy** is Adjunct Lecturer in the Department of Communication at Ben-Gurion University of the Negev, Beersheba, Israel.

**Kathleen Beckers** is Postdoctoral Researcher in the Department of Communication at the University of Antwerp, Belgium.

**Daniel Bennett** is a graduate of the Department of Media, Film and Music at the University of Sussex, Brighton, UK.

**Hildebrand P. Bijleveld** is a marketer at Vlint as well as a Researcher associated with VU University Amsterdam, the Netherlands.

**Eddy Borges-Rey** is Associate Dean of Research in the Faculty of Arts and Humanities and Senior Lecturer in Journalism Studies at the Division of Communications, Media and Culture at Stirling University, UK.

**Daniel Brookes** is a journalism graduate from Sheffield Hallam University, UK.

**Jan Lauren Boyles** is Assistant Professor of Journalism/Big Data at Iowa State University, Ames, USA.

**David Campbell** is a writer, professor and producer, affiliated with the World Press Photo Foundation.

**Lily Canter** is Principal Lecturer in Journalism at Sheffield Hallam University, UK.

**Matt Carlson** is Associate Professor in the Hubbard School of Journalism and Mass Communication at the University of Minnesota, USA.

**Cynthia Carter** is Reader in the School of Journalism, Media and Culture at Cardiff University, UK.

**Martin Chorley** is Lecturer in the School of Computer Science & Informatics at Cardiff University, UK.

**Mark Coddington** is an Assistant Professor in the Department of Journalism and Mass Communications at Washington and Lee University, USA.

**Martin Conboy** is Professor of Journalism History at the University of Sheffield, UK.

**Irene Costera Meijer** is Professor and Head of Journalism Studies at VU University Amsterdam, the Netherlands and Professor II, Research Group for Media Use and Audience Studies at the University of Bergen, Norway.

**Stephen Cushion** is Reader in the School of Journalism, Media and Culture at Cardiff University, UK.

**Ralf De Wolf** is Doctoral Assistant in the Department of Communication at the Vrije Universiteit Brussel, Brussels, Belgium.

**Lina Dencik** is Reader in the School of Journalism, Media and Culture at Cardiff University, UK.

**Monika Djerf-Pierre** is Professor of Journalism, Media and Communication at the University of Gothenburg, Sweden, and Adjunct Professor of Journalism at Monash University, Australia.

**Scott Eldridge II** is Assistant Professor with the Centre for Media and Journalism Studies at the University of Groningen, the Netherlands.

**Raul Ferrer Conill** is a PhD Student in Media and Communication Studies at Karlstad University, Sweden.

**Julie Firmstone** is Associate Professor in Media and Communication at the University of Leeds, UK.

**Richard Fletcher** is Research Fellow in the Reuters Institute for the Study of Journalism at the University of Oxford, UK.

**Bob Franklin** is Founding Editor of *Digital Journalism*, *Journalism Practice* and *Journalism Studies*.

**Iñaki Garcia-Blanco** is Senior Lecturer (Teaching and Research) in the School of Journalism, Media and Culture at Cardiff University, UK.

**Marina Ghersetti** is Senior Lecturer in the Department of Journalism, Media and Communication at the University of Gothenburg, Sweden.

**Dan Gillmor** is Professor of Practice in the School of Journalism and Mass Communication at Arizona State University, Tempe, USA.

**Antje Glück** is Lecturer in Journalism and Digital Communication at Teesside University, UK.

**James Griffiths** is based in the School of Journalism, Media and Culture at Cardiff University, UK.

**Adrian Hadland** is Senior Lecturer in Communications, Media and Culture at the University of Stirling, UK.

**Raymond A. Harder** is Postdoctoral Researcher in the Department of Communication at the University of Antwerp, Belgium.

**Janet Harris** is Senior Lecturer in the School of Journalism, Media and Culture at Cardiff University, UK.

**Ulrika Hedman** is a PhD Student in the Department of Journalism, Media and Communication at the University of Gothenburg, Sweden.

**Kristy Hess** is Senior Lecturer in Communication at Deakin University, Geelong, Australia.

**Avery E. Holton** is Assistant Professor of Communication at the University of Utah, Salt Lake City, USA.

**Jaana Hujanen** is Professor of Journalism in the Swedish School of Social Science at the University of Helsinki, Finland.

**Stephen Hunt** is Research Associate in the Institute of Education at University College London, UK.

**Lisette Johnston** is Head of School at ScreenSpace UK, based in London.

**Michael Karlsson** is Professor in Media and Communication Studies at Karlstad University, Sweden.

**Irina Khaldarova** is a Ph.D. student in the Department of Social Research, Media and Communication Studies at the University of Helsinki, Finland.

**Paul Lambert** is a Professor in Sociology, Social Policy and Criminology at the University of Stirling, UK.

**Seth C. Lewis** is Chair of Emerging Media at the University of Oregon, USA.

**Johan Lindell** is Lecturer in Media and Communication Studies at Karlstad University, Sweden.

**Rasmus Kleis Nielsen** is Director of Research at the Reuters Institute for the Study of Journalism at the University of Oxford, UK.

**Monica Löfgren Nilsson** is a Lecturer in the Department of Journalism, Media and Communication at the University of Gothenburg, Sweden.

**Eric Meyer** is a graduate of the School of Journalism at Iowa State University, USA.

**Nick Mosdell** is Deputy Director of the MA in International Public Relations and Global Communications Management in the School of Journalism, Media and Culture at Cardiff University, UK.

**Glyn Mottershead** is Senior Lecturer in the School of Journalism, Media and Culture at Cardiff University, UK.

**Christian Nuernbergk** is a Researcher in Communication at LMU München, Germany.

**Nic Newman** is Visiting Fellow at the Reuters Institute for the Study of Journalism at the University of Oxford, UK.

**Henrik Örnebring** is Professor of Media and Communication at Karlstad University, Sweden.

**Mervi Pantti** is Professor of Media and Communication Studies at the University of Helsinki, Finland.

**Steve Paulussen** is Assistant Professor in Media and Journalism Studies at the University of Antwerp, Belgium.

**Ike Picone** is Assistant Professor of Journalism and Media Studies at the Vrije Universiteit Brussel, Belgium.

**Sally Reardon** is Senior Lecturer in Journalism at the University of the West of England, UK.

**Stephen D. Reese** is Professor of Journalism at the University of Texas, USA.

**Zvi Reich** is Associate Professor in the Department of Communication Studies at Ben-Gurion University of the Negev, Israel.

**Sarie Robijt** is a Ph.D. student in the Department of Communication Sciences at the Vrije Universiteit Brussel, Belgium.

**Inka Salovaara** is Professor of Media Studies at the University of Southern Denmark.

**Richard Sambrook** is Deputy Head of the School of Journalism, Media and Culture at Cardiff University, UK.

**Aljosha Karim Schapals** is a Research Associate in the School of Communication at Queensland University of Technology, Australia.

**Steve Schifferes** is Professor of Financial Journalism at City University, London, UK.

**Jean Seaton** is Professor of Media History at the University of Westminster, UK.

**John Steel** is Lecturer in Journalism Studies at the University of Sheffield, UK.

**Minyao Tang** is a researcher in the Centre for the Study of Journalism and History at the University of Sheffield, UK.

**Neil Thurman** is Professor of Communication at LMU München, Germany.

**Peter Van Aelst** is a Research Professor in the Department of Political Science at the University of Antwerp, Belgium.

**Karin Wahl-Jorgensen** is Director of Research Development and Environment in the School of Journalism, Media and Culture at Cardiff University, UK.

**David H. Weaver** is Professor Emeritus in the School of Journalism at Indiana University, USA.

**Andrew Williams** is a Senior Lecturer (Teaching and Research) in the School of Journalism, Media and Culture at Cardiff University, UK.

**Lars Willnat** is the John Ben Snow Research Professor at the S.I. Newhouse School of Public Communications at Syracuse University, USA.

# THE FUTURE OF JOURNALISM
## Risk, threats and opportunities

### Bob Franklin

The "mood music" of the Future of Journalism conference is distinctive and unique; especially the atmosphere of the opening plenary. The crowded conference hall, publishers setting up their book stalls, the hum of delegates' conversation, excited shouts as people recognise well-known and friendly faces not seen since the last conference, people distributing leaflets about additional sessions and the unmistakably loud buzz of energy, anticipation and excitement as the conference proceedings begin to unravel. Unlike the larger annual conferences of the professional bodies, with their fragmenting sub-groups which generate a plethora of "Conferences within the Conference", the Future of Journalism is a specialist, international meeting place for scholars of journalism studies. I remember one recidivist attender saying, "this feels like *our* conference—a conference for journalism scholars; a conference where we've all come to discuss the same thing—the future of journalism".

But for me, 2015 was bound to feel different; or so I thought. I had convened and helped to organise the previous four conferences, decided the key themes and chaired the opening plenaries. This time my role was simply to make a few brief introductory remarks to provide a little context about the conference in 2015 focused on *The Future of Journalism; Risks, Threats and Opportunities*.

The new organisational group of colleagues at Cardiff (Stuart Allan, Cindy Carter, Stephen Cushion, Lina Dencik, Iñaki Garcia-Blanco, Janet Harris, Richard Sambrook, Karin Wahl-Jorgensen and Andrew Williams) kindly invited me to contribute to the opening session by talking briefly about the history of the Conference and its links with the journals—*Digital Journalism, Journalism Practice* and *Journalism Studies*. They also asked me to be brief: I'll try.

The journals have always been closely connected to the Conference in two ways. From the outset, the journals' publisher, Routledge, Taylor & Francis, has provided financial sponsorship for the Future of Journalism, while the journals have always published a selection of conference papers in co-ordinated special issues in each of the three journals. So there—in essence—are the key links. I should also mention that the original idea for a Conference came from the publisher: why so?

*Journalism Studies* was launched in 2000 and enjoyed early success, so when I suggested a second journal to Routledge in 2005, they warmed to the idea and proposed a conference to kick-start the project. I agreed, but always viewed the conference as a "one off"—simply a launch pad for *Journalism Practice*. The Conference needed a theme and I decided on *The Future of Newspapers* which reflected my long-standing research interests in the local and regional press, as well as research on journalist–source relations at a time when news seemed increasingly packaged for

public consumption by public relations professionals working in government, corporations and the community.

But the Conference focus was also influenced by a meeting with some members of the National Committee of the National Union of Journalists in 2006. The mood of the meeting was an amalgam of near panic and deep despondency. Their members saw only *risks* and *threats*, but few *opportunities*, accompanying the introduction of new media into news gathering and reporting. They identified a perfect storm brewing with a cluster of factors suggesting a catastrophic and rapid collapse in the viability of local, regional and, to a lesser extent, national newspapers: sales and readerships were falling dramatically; revenues from copy sales, as well as advertising revenues, were disappearing and with them the business model which previously delivered revenues to fund regional news; journalists were being laid off; job vacancies were not being advertised; print journalists with 30 years' experience were being retrained across a weekend to file videos online; while some jobs—like photojournalism and sub-editing—were being redefined, sometimes out of existence. There were many new skills and working practices to learn and to re-learn but no sufficiently resourced scheme of staff development was in place. There was clearly a significant agenda to interrogate and contest here. It was a passionate meeting; we all left feeling certain that we would never forget what had been said there; in many ways it proved prescient of later developments.

The *Future of Newspapers* conference turned out to be a success, feedback was very favourable, the journal special issues were published and everyone asked about the date of the next Conference. The School of Journalism, Media and Cultural Studies agreed to host a conference at Cardiff every two years, but broadened the focus to consider The Future of *Journalism* in 2009. The specific focus of subsequent conferences was signalled by the sub-title following the heading, Future of Journalism: Developments and Debates (2011); In an Age of Digital Media and Economic Uncertainty (2013); and Risks, Threats and Opportunities in 2015.

This development of theme seemed appropriate and relevant. What was becoming clear in 2007, but is in sharp focus with a decade's hindsight, is that journalism has been experiencing a sustained period of far-reaching and rapid change in all aspects of day-to-day journalism practice; the organisation and resourcing of the journalism industry; and scholarly research in the field of journalism studies. The consequences for the academic study of journalism have involved: changes to the dominant research agenda, the need to reconsider basic concepts and theoretical frameworks, but also to rethink and develop new methods for conducting journalism research. In short, the emergence of digital journalism studies as a new field of inquiry rather than journalism studies conducted in an age of digital media.

Let me mention briefly how these changes impact on some aspects of the work of the academic journal editor; some evident *risks*, rather than *threats*, seem clear. Web metrics provide editors with a clear sense of "what works" editorially. Like newspaper editors, academic journal editors know in (perhaps too close) detail precisely what interests readers, measured by page views and downloads. Editors know that articles with a focus on "social media" or "mobile devices" will most likely trigger more downloads than almost any other theme. The significant question here is whether this knowledge necessarily helps to shape editorial choices? Certainly not when an editor is drowning in submissions and subscriptions are bullish.

But the *opportunities* for scholarly research are equally clear and significant. I am very struck by the scale and pace of change which new media have created, not only for the content and foci of academic research but for the methods to explore research issues. A study published in *Journalism Studies* (2001), for example, explored the reporting of Islam in the UK quality papers, based on a sample of 2500 articles across five papers; by contemporary standards this was a substantial research effort (Richardson 2001). By 2013, however, the first issue of *Digital Journalism* reported a study involving an automated content analysis of 2,490,429 articles from 498 online English-language news sources, from 99 countries, stretching longitudinally across a year (Flaunos et al. 2013). Only three years later, in February 2016, a paper published in *Digital Journalism* presented findings based on a sample of 1.8 billion tweets relating to 6103 hashtags for journalists and news organisations—one fascinating finding from the study is that less than 1 per cent of these tweets related to news (Momin and Pfeffer 2016).

The potential for research in our field—given the development of automated text analyses—where newsbots write the news, while other actants read and analyse its content (both quantitatively and qualitatively), based on these staggeringly large and barely conceivable samples, is just incredibly exciting. Automatic text generation makes the robots which merely drafted newspaper headlines in Michael Frayn's novel the *Tin Men*, look like uneducated illiterates.

By the close of Future of Journalism 2015, I was delighted to discover that despite all the changes in the convening and organisation of the Conference, the mood of anticipation and excitement at the opening plenary was still unmistakable. Many congratulations to the School of Journalism, Media and Cultural Studies at Cardiff for organising the fifth Future of Journalism Conference. Bigger and better than ever, fresher for having a new group of people organising the event, as well as three distinguished plenary speakers to launch us into our conversations about the future of journalism. And of course, that unmistakable buzz of this quite unique conference, was evident everywhere.

## REFERENCES

Flaunos, Ilias, Omar Ali, Thomas Lansdall-Welfare, Tijl De Bie, Nick Mosdell, Justin Lewis, and Nello Cristianini. 2013. "Research Methods in the Age of Digital Journalism: Massive-Scale Automated Analysis of News Content—Topics, Style and Gender." *Digital Journalism* 1 (1): 102–116.

Momin, Malik M., and Jürgen Pfeffer. 2016. "A Macroscopic Analysis of News Content in Twitter." *Digital Journalism*. doi:10.1080/21670811.2015.1133249.

Richardson, John E. 2001. "British Muslims in the Broadsheet Press: A Challenge to Cultural Hegemony." *Journalism Studies* 2 (2): 221–242.

INTRODUCTION

# THE FUTURE OF JOURNALISM
## Risks, threats and opportunities

**Karin Wahl-Jorgensen, Andrew Williams, Richard Sambrook, Janet Harris, Iñaki Garcia-Blanco, Lina Dencik, Stephen Cushion, Cynthia Carter** and **Stuart Allan**

Today journalism, as an industry and a profession, is characterised by ever-increasing turbulence and change, for better and for worse. Profound transformations affect every aspect of the institution, including the economic health of journalism, the conditions and self-understandings of its practitioners, its ability to serve as a watchdog on concentrations of power, its engagement with and relationship to its audience, and its future prospects. This emerging and dynamic ecology can be viewed as a unique constellation of challenges and opportunities. For these reasons, the fifth Future of Journalism conference, held in Cardiff on 10–11 September 2015, focused on the theme of Risks, Threats and Opportunities. The conference saw over 120 papers from around the world presented across 34 sessions, with keynote speeches from Dan Gillmor, Stephen Reese and Jean Seaton. This introduction briefly outlines some of these key risks, threats and opportunities, drawing on work presented at the conference, as well as insights from the field of journalism studies.

## Risks and Threats

The current disruption to journalism raises threats to journalists themselves, but also for the public, as well as to business models, and established journalistic roles and practices. Risks and threats to journalists themselves come in many forms. For journalists around the world, their profession can be a dangerous one (Cottle, Sambrook, and Mosdell 2016). The risks and threats stem from geopolitical changes as well as a perceived loss of neutrality for journalists. Where once they were trusted intermediaries now they are seen as either "with us or against us". There are direct and often physical threats to reporting—particularly in conflict zones. According to figures from the International News Safety Institute, more than 1000 journalists have died on the job in the past decade—often local journalists reporting on the news in volatile conflicts (http://www.newssafety.org/about-insi/, accessed May 16, 2016). However, threats are not limited to conflict zones—as papers presented at the conference showed, even in European countries with protections for the media journalists face harassment and intimidation. As journalist casualties continue to rise there are further dimensions to physical risk, such as gender (where we have seen some high-profile sexual assaults on women journalists in the Middle East) and technology, where new developments enable journalists

to get closer—often secretly—to conflict or crime at increased personal risk or make journalists vulnerable to surveillance by hostile governments or groups.

In addition, there are the well-documented and long-standing institutional threats to journalism. While the crisis in the business model of journalism has been ongoing for decades, it has sharpened since the global recession of 2007, and led to the demise of some of long-established and well-regarded institutions, includes most recently the *Independent* in the United Kingdom and the *Tampa Tribune* in the United States. Commercial newspapers and broadcasters have been losing audiences and advertising revenues and making cutbacks across the board, often leaving journalists at both national, regional and local publications stretched thin. The challenge to the economic model of journalism has resulted in the growing casualisation of the workforce, which means that employment is less secure, and freelancers are taking on more responsibility for reporting, with the rise of "low-pay, no pay" journalism (Bakker 2012). Technology has facilitated a de-professionalisation of journalism with many economic, quality-related and ethical questions raised as a consequence—alongside opportunities for greater participation. Sometimes these changes impact in surprising ways. For example, although the greater use of freelancers is a result of resource cuts and undermines job security, freelancers and other "entrepreneurial journalists" may also contribute to introducing innovation into newsrooms (Gynnild 2014).

The emergence of the so-called "fifth estate" (Dutton 2009) of networked bloggers contributing through alternative media was supposed to herald a wider role for the audience in journalism, articulating important news, generating public debate and facilitating new forms of accountability. However, it is increasingly clear that audience inclusion has not been as participatory as expected. Research into news organisations' use of social media reveals that it does not always provide the heralded opportunities for the audience to become more active in the news-creation process, with limited user participation on websites and users rarely allowed to set the agenda. As a consequence, social media users can be sceptical about user contribution to the news, and far from social media being a means of widening the representation of sources, journalists' approach to sources remains largely unchanged. Research has demonstrated time and again that mainstream media news is dominated by elite sources—predominantly politicians and their spokespersons—and this has not changed despite the emergence of social media and other technologies that facilitate and broaden participation.

There are other institutional threats. As barriers to entry to media fall, the once clear lines between independent journalism, public relations and advertising, and activism or propaganda have blurred with new corporate and government players entering what once would have been deemed the journalism arena—but not always with the same public-interest intent. The "fake news" controversy in Ukraine is one high-profile case in point. Here, it is also important to note the emergence of "native advertising" which, as Carlson (2015) has noted, complicates the long-standing division between editorial and advertising. These factors contribute to a perception that independent journalism, and the traditional accountability roles of the fourth estate, are under significant threat. Certainly at a local level, the economic viability of professional journalism is under serious pressure with the traditional democratic role of local news being undermined as costs are cut and newsrooms hollowed out (Franklin 2011).

Journalism plays a key role in democracies around the world, acting as a watchdog on the state and informing citizens about the decisions that affect their

everyday life. But journalists face a number of new threats that limit their ability to fulfil their watchdog role. In an increasingly market-driven media landscape, the resources journalists have to scrutinise political elites and expose wrongdoing are increasingly diminished in local, national and international contexts. With cuts to public service broadcasting and a concentration of media ownership, for example, the information supply of local politics and public affairs is threatened.

Similarly, coverage of international affairs is expensive to produce and does not always appeal to audiences. As a consequence, a lack of public knowledge about war-torn countries and humanitarian crises—as much as about social, political or economic events—can leave democratic decisions at national levels under-informed.

In the light of these threats, while the future of journalism is often associated with online and social media platforms, how far they can help enhance democratic citizenship remains open to question. The disruption of traditional journalism models by digital technology and new players raises clear risks for professional journalists and institutions. However, the longer-term threat may be to our civic and public life.

## Opportunities

Despite the continued attention to the risks and threats facing the profession, research in the field demonstrates that the journalistic landscape offers a range of opportunities based on technological, social and economic developments, and forms of innovation. First of all, the blurring of the line between producers and audiences has generated new forms of audience participation, as demonstrated in research presented at the conference on practices as diverse as the use of participatory mapping to advance protection of the Amazon rainforest, to the emergence of news gaming. At the same time, there is evidence of the maturation of more established forms of participation, including user-generated content, social media and citizen journalism.

For both citizen journalists and professionals, the increasing sophistication of smartphones for news production and sharing might offer new possibilities which are particularly significant in enabling reporting in distant locations, and often empowering disenfranchised groups, as demonstrated in research on smartphone-facilitated citizen journalism from the Australian outback. This feeds into an emerging trend whereby citizen journalism plays a key role in covering distant communities, for example, rural areas of Eastern Taiwan. Further, smartphones are transforming the field of photojournalism as non-professionals are now able to contribute content, frequently facilitated through platforms such as Instagram and Flickr.

Social media are now well-established tools facilitating audience participation and journalistic practice. The widely documented normalisation of Twitter (e.g. Lasorsa, Lewis, and Holton 2012) has taken place alongside the cementation of Facebook and YouTube, and the growing importance of Instagram. These platforms allow audience members to share news and information and participate meaningfully in local and global debates. Such participation may range from that of "accidental journalists" providing user-generated content, to the social sharing practices that shape engagement with news events small and large. Research presented at the conference shows that journalists increasingly draw on these same social media platforms for crowd-sourcing, to find vox pops, and to enhance their professional profiles and virtual identities.

The normalisation of social media is challenging conventional hierarchies of news. While the presentation of news in legacy media, including print and broadcast, is characterised by (1) distinctive hierarchies of news value, and (2) the explicit separation between contributions from professionals and members of the public, the order in which news is presented to its audiences on newer platforms is no longer based primarily on news values, but rather determined by immediacy.

At the same time, cultural and economic trends towards quantification in journalism are changing the nature, production and reception of news storytelling. "Big data" enables new forms of news-gathering, storytelling, visualisation and access to information by journalists and the public. The emergence of the "data journalist" as a professional category signals a new direction for professional practice at a time when others may be shrinking. Data journalism has been particularly important in reviving investigative journalism, with areas such as financial data and geodata frequently being used to provide evidence for major stories. It has offered new ways of detecting patterns in large-scale investigations, presenting stories to audiences, and crowd-sourcing the reporting of major stories (Coddington 2015). Similarly, while the increasing role of analytics, and audience quantification (Anderson 2011), has raised alarms around the rise of "clickbait", and journalism driven by algorithms rather than professional judgement, it is also the case that it has enabled more audience-centred journalistic practices.

Amidst justified alarm over the business models of legacy journalism, there is also reason to be hopeful about the potential of new business models, including crowd-funding projects on platforms such as Kickstarter, which although short term in nature allow news to be produced from a more diversified income than most legacy models (e.g. Carvajal, García-Avilés, and Gonzalez 2012). Alongside attention to emerging business practices, research also demonstrates attention to those digital native news organisations that have successfully bucked the trend of economic decline and manage to survive within an altered journalistic landscape. These include what are by now established players such as Vice, Huffington Post and BuzzFeed. The online and non-profit investigative organisation ProPublica has won three Pulitzer Prizes since its establishment in 2008, while the investigative radio spin-off *Serial* gained funding from donations and sponsors to continue its ground-breaking podcast series, winning a Peabody Award in 2015. Such players, however, remain relatively under-researched, and further understanding their commercial and editorial practices might lead the way to identifying sustainable models for the future of journalism. A few established news organisations have managed to attract audiences to their online offerings, with *The New York Times* now topping 1 million digital subscribers.

It has been common in recent decades to consider local news as an area defined more by serious risks and continued existential threats than promising opportunities. "Good news stories" have been rare in this sector. But changing forms of audience participation have inspired a new wave of research about hyperlocal community news which has unearthed a growing group of hobbyists, entrepreneurs, civic activists, out-of-work journalists, and others using blogs and social media to enliven often moribund local information systems (Williams, Harte, and Turner 2015). This has led to an upsurge in activity in the realm of the local digital commons as well as (albeit limited) experimentation with business models by an emergent generation of digital community news startups.

Opportunities in the field of local journalism itself are matched by new chances to re-invigorate our study of local news. Numerous conference interventions employed

tried and tested methods to illuminate both hyperlocal and established local news (focusing mainly on the production and content of local news; audience studies continue to be rare, with some notably excellent exceptions). But we were encouraged to view traditional (and even new) local news providers as only partly responsible for the proliferating information flows in local communities. In our attention to the local we were reminded to consider not only shifting audience patterns of production and consumption, but also changes in the traditional roles of local officials, politicians and others routinely cited in news. We no longer interview or observe only local journalists in our research, not least because "the people formerly known as news sources" are now often communicating, unmediated, to local publics using various new media platforms and playing ever-greater roles in framing local life.

As this brief survey demonstrates, the risks, threats and opportunities facing journalism are varied and swiftly evolving. While many of the preoccupations of scholars presenting their work at the conference reflect continuities in the increasingly maturing discipline of journalism studies, and build on themes that have been present since the very first Future of Journalism conference in 2007, we have also seen a growing sophistication of both methodological and theoretical approaches to the study of journalism. We have selected papers that approach these risks, threats and opportunities in innovative and engaging ways from a variety of methodological and conceptual angles, as well as across countries and regions. Together, these papers offer an extraordinary snapshot of the cutting edge of research in journalism studies, demonstrating the vibrancy of a field of research which is as dynamic and diverse as the object of its study.

## Digital Journalism

In his keynote paper, "The New Geography of Journalism Research: Levels and Spaces", Stephen D. Reese urges journalism scholars to consider the challenges of doing research in a shifting domain, where technology has made the concept of journalism itself problematic. A "spatial turn" has made concepts of fields, spheres and networks more relevant than in the past. Understanding these spaces requires thinking in less media-centric terms as we identify newly coupled *assemblages* put together in producing digital journalism, beyond its traditional institutional containers.

Reese's paper provides a useful conceptual starting point for thinking about journalism studies in a digital era, broadly represented by the papers in this issue. We have grouped them into three distinctive yet overlapping areas of research, beginning with those investigating digital knowledge production (technologies), followed by journalistic roles and practices (production), and finally the analysis of public opinion and democracy (audiences/users.

The first section of Part I considers the role of technology in knowledge production. It opens with Inka Salovaara s árticle which examines InfoAmazonia, a data-journalism platform on Amazon rainforests, a geo-visualisation within information mapping. She concludes that the platform represents a digitally created map-space within which journalistic practice can be seen as dynamic, performative interactions between journalists, ecosystems, space and species. This is followed by an article by Neil Thurman, Steve Schifferes, Richard Fletcher, Nic Newman, Stephen Hunt and

Aljosha Karim Schapals who assess how algorithms help journalists identify trending stories, search social media, and verify contributors and content, whilst raising questions about journalistic accountability.

The second section begins with an article by Monika Djerf-Pierre, Marina Ghersetti and Ulrika Hedman, where they challenge the hype surrounding journalists' use of social media. Web surveys with Swedish journalists show that while the use of social media has been increasing, there has also been a decline in journalists' valuations of the platform. Next up is Daniel Bennett's paper in which he assesses whether the adoption of live online coverage has facilitated a more "multiperspectival" journalism. Journalists increasingly use "non-official" sources, he suggests, whilst continuing to depend on traditional news values and practices. This is followed by Lily Canter and Daniel Brookes' paper examining the tweeting habits of journalists at a UK city newspaper. Tweeting types, they conclude, are germane to specific journalistic job roles, challenging redefinitions of the journalist as a universal role. Attention then turns to Zvi Reich and Aviv Barnoy's paper, which presented findings from interviews with 108 Israeli reporters, where the authors found that news leaks are a largely oral practice, the prerogative of senior reporters in print and television, and subject to more editorial cross-checking than regular items. The section is rounded out by Lisette Johnston's study based on interviews with BBC journalists through which she seeks to understand how social media and "citizen journalism" have changed traditional news-gathering.

Turning to the third group of papers, we begin with Kathleen Beckers and Raymond A. Harder's qualitative and quantitative content analysis of Dutch and Flemish news websites which shows that journalists use vox pops regularly and as a representation of public opinion. Next is Ike Picone, Ralf De Wolf and Sarie Robijt's article, which considers what makes news content worth sharing online. Drawing on a survey amongst Dutch-speaking Belgian users, the piece demonstrates how motivations to share and internet skills are important predictors of sharing behaviour. This is followed by Raymond A. Harder, Steve Paulussen and Peter Van Aelst's article reporting on a content analysis of the 2014 Belgian election campaign coverage. The authors conclude that whilst Twitter was important in launching and shaping stories, established journalists and politicians dominated election news whilst citizens played a modest role. The final paper is by Jan Lauren Boyles and Eric Meyer and examines journalists' role perceptions as the guardian of public trust in an era of data journalism. In-depth interviews with data journalists in the United States illuminate how they perceive their social responsibility to foster democratic conversation with the audience.

## Journalism Practice

Part II addresses some of the risks, threats and opportunities facing journalists and journalism, with 12 articles covering a wide range of topics and issues.

Dan Gillmor suggests that journalism education needs to adopt some fundamental changes in approach if it is to remain relevant to the media realities of the twenty-first century. The focus then turns to how journalists are adapting to a fast-changing media environment. Hadland, Lambert and Campbell consider the use of new technologies and new methods of visual storytelling which require photojournalists to modify their

working practices. They examine the risks now faced by photojournalists, and the ethical and professional pressures these changes have placed upon them. Meanwhile, Eddy Borges-Ray examines how current practices of data journalism sit within UK newsrooms and working practices, and the extent to which they are able to hold data-led organisations to account in a world where data brokers are increasingly powerful.

The role and use of Twitter is examined in greater detail in subsequent articles. Drawing on a survey of US journalists, Willnat and Weaver find that while many see the benefits of social media, fewer are convinced that these new forms of digital communication will benefit journalistic professionalism. Chorley and Mottershead consider how social media has become a key platform for the discussion and dissemination of news by analysing large data-sets to investigate which stories are spread through social media and how the discussion around them is shaped by journalists and news organisations. Examining the use of Twitter by German political journalists, Nuernbergk's content analysis discovered that journalists mostly tweet publicly relevant communication in an information-oriented style and engage more with political elites than members of the public.

The focus then turns to the environment in which journalists operate. Nilsson and Örnebring's survey of Swedish journalists reveals that many routinely face intimidation and harassment. This has led to fear and self-censorship, and a threat to journalistic autonomy. At a time of increasing mediatised war, Khaldarova and Pantti's focus on Russia's dissemination of images of the Ukraine on Twitter identified by StopFake.com, analysing their ideological and mythical understandings and how Russians perceive them. Harris, Mosdell and Griffiths then examine the realities of war, asking whether it is more dangerous to be a woman journalist when reporting conflict. They conclude in many situations being a woman actually helps female journalists in conflict zones.

Attention then turns to more localised issues and the training of journalists. Holton examines freelance journalists in the United States who are now filling the gap left by cuts to the science and health sections, creating new and entrepreneurial roles in the traditional press and having to manage social media, digital audiences and increased workloads. Firmstone explores the production and value of local news in recent years, drawing on 14 interviews with journalists and political communicators to explore the threats to and opportunities for democracy in a major UK city. Finally, Reardon investigates competing public discourses around the requirements for the education of the next generation of journalists, asking what values, knowledge and skills should be taught.

## Journalism Studies

Part III engages with some of the central debates in the field of study. These articles confirm the strong normative component of our scholarly debates, permeating throughout all articles. They also indicate a growing academic interest in the study of audiences and their understanding of journalism and the role it plays (or should play) in our societies.

Jean Seaton's keynote paper, "The New Architecture of Communication", sets the discussion in motion by pinpointing paradoxical tensions in our new media ecology. At times, she points out, we are faced with what may feel like an overwhelming abundance of communicative resources, yet in struggling to cope we may become overly reliant upon narrow "silos" of information and opinion. Hence the vital import of public service institutions such

as the BBC, she contends, which perform the difficult work of breaking down such barriers, and in so doing forge bridging civic linkages consistent with the public interest.

Eldridge II and Steel's article considers citizen expectations of journalism and journalists, and facilitates an approach that allows for communities to reflect on their own conceptions of the role of journalism. This, they argue, allows for a more reflexive approach to the journalist–public relationship. Using survey data, in turn, Costera Meijer and Bijleveld attempt an audience-driven definition of what "valuable" journalism is. This notion aims at complexifying the traditional division between traditional news values and market-driven journalism. Combining interviews and focus groups, Kleis Nielsen explores "folk theories of journalism" emergent in differing views of the role played by a local newspaper in Denmark. He shows how the significance of the "same" newspaper can be interpreted differently by members of the community.

Holton, Lewis and Coddington use a large survey of US journalists to re-conceptualise interactions between journalists and audiences. In outlining four new role conceptions, they help inform our understanding of how and to what extent journalists might engage with audiences. Lindell and Karlsson discuss the tension between journalists' cosmopolitan professional aspirations and the more mundane issues that they engage with in their journalistic practice. The authors contend that the principles of global journalism may be difficult to embrace when working for news organisations which do not operate at a global scale. Hujanen examines the evolution of journalists' normative ideas about journalistic practice, with a particular focus on the notion of "participation". Her article documents how the normative tenets that used to drive journalistic practice are being adapted to fit the evolving societal, professional and technological contexts in which journalists operate. Studying the *British Journalism Review* in recent years, Conboy and Tang examine the metaphors journalists use to define journalism and its responsibilities. They highlight how the metaphors chosen by the prominent journalists contributing to the publication influence the articulation of concerns over journalism's current role and image, changes to traditional values, as well as future aspirations.

In thinking about journalistic skills and resources, Glück's article engages with the cultural politics of empathy, as distinct from emotion, in journalistic practices. Taking a cross-cultural approach, looking at the United Kingdom and India, the article identifies different roles that empathy plays in journalistic work and argues for empathy as a "core" skill for journalists in certain contexts. Engaging with normative ideas about the independence of journalism, Raul Ferrer Conill explores to which extent (and how) traditional newspapers in four western countries have embraced native advertising in their digital editions. Once a touchstone of good journalism, the separation between commercial and editorial content may be under question now that newspapers' traditional funding sources are drying up.

Part III closes with two conceptual interventions. Carlson develops the concept of "mundane media criticism" in order to assess the textual features of personal commentary typically accompanying the sharing of news stories across social media platforms. In this environment, he argues, to consume a news story is to simultaneously consume criticism about it. This experiential convergence raises important interpretive implications. Finally, Hess engages with notions of civic virtue, arguing that news media have a privileged position in shaping and legitimating civic virtue under certain social conditions. Drawing on local media in regions of Australia, this intervention provides a novel way of thinking about media power in relation to social capital.

## DISCLOSURE STATEMENT

No potential conflict of interest was reported by the authors.

## REFERENCES

Anderson, C. W. 2011. "Between Creative and Quantified Audiences: Web Metrics and Changing Patterns of Newswork in Local US Newsrooms." *Journalism* 12 (5): 550–566.

Bakker, Piet. 2012. "Aggregation, Content Farms and Huffinization: The Rise of Low-Pay and No-Pay Journalism." *Journalism Practice* 6 (5–6): 627–637.

Carlson, Matt. 2015. "When News Sites Go Native: Redefining the Advertising-Editorial Divide in Response to Native Advertising." *Journalism* 16 (7): 849–865.

Carvajal, Miguel, Jose A. García-Avilés, and Jose Luis Gonzalez. 2012. "Crowdfunding and Non-Profit Media: The Emergence of New Models for Public Interest Journalism." *Journalism Practice* 6 (5–6): 638–647.

Coddington, Mark. 2015. "Clarifying Journalism's Quantitative Turn: A Typology for Evaluating Data Journalism, Computational Journalism, and Computer-Assisted Reporting." *Digital Journalism* 3 (3): 331–348.

Cottle, Simon, Richard J. Sambrook, and Nick A. Mosdell. 2016. *Reporting Dangerously: Journalist Killings*. Palgrave: Intimidation and Security.

Dutton, William H. 2009. "The Fifth Estate Emerging through the Network of Networks." *Prometheus* 27 (1): 1–15.

Franklin, Bob. 2011. "Sources, Credibility and the Continuing Crisis of UK Journalism." In *Journalists, Sources and Credibility: New Perspectives*, edited by B. Franklin and M. Carlson, 90–107. London and New York: Routledge.

Gynnild, Astrid. 2014. "Journalism Innovation Leads to Innovation Journalism: The Impact of Computational Exploration on Changing Mindsets." *Journalism* 15 (6): 713–730.

Lasorsa, Dominic.L., Seth C. Lewis, and Avery E. Holton. 2012. "Normalizing Twitter: Journalism Practice in an Emerging Communication Space." *Journalism Studies* 13 (1): 19–36.

Williams, Andy, David Harte, and Jerome Turner. 2015. "The Value of UK Hyperlocal Community News: Findings from a Content Analysis, an Online Survey and Interviews with Producers." *Digital Journalism* 3 (5): 680–703.

# THE NEW GEOGRAPHY OF JOURNALISM RESEARCH
## Levels and spaces

**Stephen D. Reese**

*In this essay, I consider the challenges of doing research in a shifting domain, where technology has made the concept of journalism itself problematic. For many years, I have used (in my own work with Shoemaker on media sociology) a levels-of-analysis hierarchy of influences perspective to sort out the factors impinging on the symbolic reality produced by journalism, but a "spatial turn" has made concepts of fields, spheres, and networks much more relevant. Understanding these spaces requires thinking in less media-centric terms as we identify the newly coupled assemblages put together in producing digital journalism, beyond its traditional institutional containers. These include algorithmically restructured atomic units of news in content and different configurations of global journalism. A new wave of ethnographies has begun to tackle these challenges, using the kind of thick description that characterized the field in the pre-digital era.*

The future of journalism requires new thinking, as we try to accommodate the emerging, unsettled, and shifting digital-enabled configurations of newswork with the kind of predictive, generalizable stability sought by social science. In considering this challenge, I would like to explore in this essay some concepts that I have worked with over the years and consider how to adapt them in this new period of our field, what I will call the "new geography" of journalism research. And I find myself approaching this new geography with analytical preferences that have become steadily less linear and more spatial. Although much of the research I am familiar with in journalism studies (what I will also refer to as *media sociology*) has a decidedly American focus, I observe that many new studies I draw on, particularly in the area of digital journalism, come with a British perspective. With *Journalism Studies* and newer publications such as *Journalism Practice* and *Digital Journalism*, Cardiff University has provided an important platform for an increasingly international community of scholars—which has included strong participation from students and colleagues at my own institution.[1] Consequently, I was particularly pleased to be asked to provide a keynote at the 2015 Future of Journalism conference, from which this essay is adapted.

I am accustomed to thinking of media sociology from a levels-of-analysis perspective, as an organizing framework. Of course, I have noticed the "spatial turn" in the metaphors we use to describe media and journalism: whether networks, fields, or

spheres, so in recent years I have tried to address those ideas as best I can, and want to think here about how I might reconcile them within the levels framework. I realize what a difficult field we have to theorize, when the master concept of *journalism* itself is so problematic and unstable. When Pam Shoemaker and I revisited not long ago our book, *Mediating the Message: Theories of Influences on Mass Media Content*, I realized how much had changed since the last revision effort we made in 1996—the industry, profession, and the technology (Shoemaker and Reese 1996, 2014). As a result, we made the case to the publisher for a new title, signifying more than just a third edition. A *hierarchy of influences* model had worked well to disentangle the relationships among professionals and their routines—and the news organizations that housed them. But both the units and levels of analysis in journalism theorizing have been destabilized and restructured. The public sphere is constituted with new configurations: of news-work, institutional arrangements, and global connections, which have produced new emerging deliberative spaces (Reese 2009). We are all faced with the need to adapt our research thinking to this changing master concept.

## A Sociology of News Historiography

Some historical background gives context to this challenge. The early twentieth-century perspectives on journalism were at home in the University of Chicago School of Sociology, which emphasized community-based, multi-method participant observation. Communities existed *in* communication rather than affected *by* it. That changed when the communication field migrated east to the world of Paul Lazarsfeld and Robert Merton at Columbia with a more narrow media effects focus (Gitlin 1978; Reese and Ballinger 2001). There were a couple of prominent American studies in the 1950s regarding the news gatekeeper and social control in the newsroom, but these did not catch on at the time with the larger field. But several years later social protest and upheaval in the 1960s brought greater concern about how journalism was implicated in a discredited power structure, leading to a broader interest in the inner workings of institutional journalism—as represented most visibly by a number of newsroom ethnographies.

In her recent *Journalism Studies* essay, Sarah Stonbely (2013) locates a group of such studies in the later 1960s and 1970s that she argues represent a "cornerstone" of American media sociology, covering that "legacy" period of media development centered around a handful of major broadcast and print media. Among these she identifies Edward Jay Epstein's (1974) *News from Nowhere* (about network television news), Mark Fishman's (1980) *Manufacturing the News*, Gaye Tuchman's (1978) *Making News* (about local newspapers), and Herbert Gans' (1979) *Deciding What's News* (about national newsmagazines and television). I would certainly also include Philip Schlesinger's *Putting "Reality" Together* about the BBC (Schlesinger 1978). The Glasgow Media Group would put a critical edge on this work somewhat later in their analyses of "bad news" (Glasgow Media Group 1976, 1980, 1982). All of these texts broke with the prevailing communication research tradition by emphasizing news as an organizational product that had to be socially constructed, not simply transmitted to the audience. These became classic examples of newsroom sociology, time consuming but rich in detail, and served to anchor until recently our understanding of how newswork happens. (In

our work on *Mediating the Message*, Shoemaker and I embraced both a variable-analytic and ethnographic tradition, although in my own work and in this essay, as she has pointed out to me, I have gravitated more toward the latter.)

A new wave of news ethnographies was precipitated by the migration of news online. Prominent examples include the work of Pablo Boczkowski (2004, 2010), especially in showing how technology has affected the newsroom. David Ryfe's (2012) more recent analysis of three American newsrooms showed that journalists have not adapted very well to change, using the tensions embedded in their profession to reconfirm and justify the same procedures they have used since before the industry upheaval. Within the Gans tradition, Nikki Usher (2014) provides the most recent single-newsroom ethnography of the *New York Times*. This may, in fact, be the last of its kind, in choosing an elite news organization as the embodiment of the profession. Her participant observation shows that despite the major technological shifts, "many of the routines and practices of news production observed in the golden era of news ethnography remain constant" (228). Chris Paterson and David Domingo have collected several international studies, leading to the conclusion that the routines surrounding key values of immediacy, interactivity, and participation show remarkable similarities across a diverse host of other online settings (Domingo and Paterson 2011; Paterson and Domingo 2008). Thus, the newsroom tradition of research has been updated, but analytical challenges remain and begin with the definition of the newsroom itself.

## New Spatial Geography

The conceptual boundaries of journalism have shifted with global connectivity, so we have various terms to describe the new journalistic system. But they all suggest a more networked quality. This extends to the broader deliberative arena to which journalism contributes, a space now often loosely deemed a *networked public sphere*, or even a *global networked sphere*. Benkler (2011), for example, uses *networked fourth estate* to refer, along with professional journalists, to those citizen and other social movements that combine to form a more decentralized and redistributed democratic discourse.

Jeff Jarvis (2006) uses *networked journalism* to refer to the new collaborative relationships between professional and citizen in creating new information; and journalists have become nodes in this larger structure (Haak, Parks, and Castells 2012). Others use the *networked institution* concept to capture the need for news organizations themselves to become more collaborative (e.g., Anderson, Bell, and Shirky 2012). Journalism can no longer be easily understood within organizational containers but extends across traditional, more well-defined boundaries in unpredictable ways. These spatial metaphors—whether networks, fields, or spheres—point to the blurring of lines between professional and citizen, and between one organization and another. This is a different way of thinking about media than studies of production within institutions.

Adding a more organic quality to the picture leads to yet other terms like news *ecology* and *eco-system* (Anderson 2013), still suggesting interconnected but diverse units, all participating in a similar space with a differentiation of roles. Traditional legacy media provide an anchor for smaller publications, bloggers, and citizens, who react to and supplement what happens in the larger press. Thus, this new organic metaphor

captures the practice, product, and institutional dimensions of networked journalism. This eco-system shift is revealed in new forms of newswork. For example, the relentless flow of abundant information has led to a new breed of *news aggregators* who add value through digesting and repackaging information—stripping it down to its core components. Mark Coddington (2015), for example, has done innovative recent ethnography on these professionals and their news narratives, traditionally housed within article story structures but which now get broken down into smaller "atomic units." They can then be restructured, reordered, annotated, aggregated, and widely shared— ordering them back up into different narrative structures.

Of course, this flow of dis- and re-aggregated information would not be possible without the computational power now available. Journalism, like other forms of knowledge-production, has encountered its big data moment, which has led to theoretical shifts to better understand the restructuring of news and potential for interactivity. Access to new tools brings greater analytical power to journalists but also changes the way they can structure stories to allow greater utility for the audience and enhance what Jay Hamilton calls "accountability journalism" (Hamilton and Turner 2009).

Technology has reshaped the journalistic field in a more general way by importing new values. As news organizations rely on those outside the professional field for digital expertise, the values of the technology culture have become linked with journalistic practice. The open source concept, for example, is both a practical approach to coding but also a philosophy of sharing, including the DNA of its design. Lewis and Usher (2013) argue that the ethos of open source—embedded in hacker culture and emphasizing iteration, tinkering, transparency, and participation—opens journalism, drawing it out from its closed professional boundaries into greater transparency.

## Hierarchy of Influences

So, how does a traditional levels-of-analysis perspective fit into this new eco-system? A *hierarchy of influences* model considers factors at multiple levels that shape media content—the journalistic message system—from the micro to the macro: individual characteristics of specific newsworkers, their routines of work, organizational-level concerns, institutional issues, and larger social-systems. In our description, we say it "takes into account the multiple forces that simultaneously impinge on the media and suggest how influence at one level may interact with that at another" (Shoemaker and Reese 2014, 1). At each level, one can identify the main factors that shape the symbolic reality and how these factors interact across levels and compare across different contexts. I think that approach still has value. For example, as key concepts developed within journalism research, it has become helpful to unpack them across this kind of levels-of-analysis perspective. I have done something like that for the concept of *professionalism* across the five levels in the context of the *global journalist* (Reese 2001). Vos and Heinderycks (2015) examine another key concept, *news gatekeeping*, across these levels.

In addition, evaluating the *simultaneous* contribution of multiple levels gives greater explanatory power. Surveys of journalists, for example, by David Weaver et al. (2007) examined the contribution of different nested contextual factors on journalistic work (organization, medium, etc.). This has been extended by Thomas Hanitzsch's

cross-national team to include the social-system level in a hierarchical approach to factors shaping international journalism (Hanitzsch et al. 2011).

But this new geography of journalism has problematized and destabilized both the units and levels of analysis in journalism, so much of the most important theoretical effort in recent years has been directed at exploring the very definition of journalism and its boundaries (Carlson and Lewis 2015). In this respect, journalism becomes a jurisdictional project, policing those boundaries and defending its prerogatives. But this boundary work can still be organized at different levels. Institutionally, for example, this happens when the *New York Times* attempts to differentiate itself from WikiLeaks (Coddington 2012).

For a number of reasons, then, a levels-of-analysis perspective has been a valuable guide to theorizing journalism, but to what extent must it be reconsidered? The journalism of the twentieth century was synonymous with the prevailing industrial forms: news was what news organizations produced, and journalists were the professionals who worked for them. A *hierarchy of influences* approach worked well with this model to disentangle the relationships among professionals and their routines, and the news organizations that housed them. How does this framework adapt to the new media world where the lines are not as tidy? We do have to recognize that the work of journalism and our questions about it are not so easily nested now within a set of hierarchical levels. The aggregates traditionally signaled by levels—whether community, organization, or nation—are containers that do not have the same meaning they once did, as new structures are woven outside of and through institutional frameworks.

## Research Challenges

Capturing the workings of these new eco-systems brings new methodological challenges. The ethnographer must decide the appropriate *site*, identify the *social actors*, and describe their practices. But when news production becomes more diffused, with journalists working and communicating remotely, or in small organizations loosely aligned with a larger parent company, or dispersed across platforms, the single site becomes more difficult to select—as Simon Cottle (2007) has pointed out. How can ethnography be done on decentralized, deterritorialized communities? What is there to observe? Newer efforts fittingly have shifted away from a location-based "factory floor" ethnography. Phillip Howard (2002, 561) has demonstrated the utility of a *network ethnography*: "The process of using ethnographic field methods on cases and field sites selected using social network analysis." In his case demonstration, he identifies a distributed "e-politics" community—a loosely configured professional group of digital tool developers for political communication. He locates the critical actors through their strategically located position in the network that links them together—and targets interviews accordingly.

Beyond these methodological challenges, the new eco-system requires new concepts. In social network analysis, connections typically are found among homogeneous nodes (whether people or news hyperlinks), but related to the network is the richer concept of *assemblage*, which can include human and non-human, material and non-material. This concept is useful in many areas of social science to capture dynamic phenomena spilling out of existing categories, becoming recombined in new ways, and

not as easily identified within a single level of analysis. The idea of assemblage is appealing in reflecting the new reality, suggesting elements that cut across those levels. But that means the boundaries between levels are not always as clear. For example, the routines of newswork level and individual professional level become merged when considering a combination of individual workers and their technological affordances that form integrated actor-networks.

*Technology* has become a multi-scalar phenomenon, not easily located at any one level. An assemblage can be a contingent set of relationships to accomplish shifting social objectives not otherwise defined by formal institutions. In that respect, journalism is not some naturally existing and enduring category, but a complex and contingent assemblage—less product than process. This has led to new ways of theorizing socio-technical systems and examining their interconnections, such as Latour's Actor Network Theory (ANT), borrowed from science studies (reviewed in Turner 2005). This radically descriptive "ontologically flat" approach blurs the human–technological lines, rendering both *actants*. But the assemblage concept has richer utility than its association with ANT. C. W. Anderson (2013, 172) argues more broadly that newswork itself is one of "assemblage" and "can be envisioned and described as the continuous process of net-working the news" across "news products, institutions, and networks … drawing together a variety of objects, big and small, social and technological, human and non-human" (4). He maps online hyperlinks in the Philadelphia community to show a form of assemblage within a news ecosystem (Anderson 2010).

Assemblages also direct attention outside of journalism organizations to those places where journalism plays an integral part, especially in political communication. Chadwick (2011) does this with political information cycles as a complex assemblage of modular units, a "hybrid media system." Recent studies of political campaigns, for example, use the concept to capture the relational aspects of mobilization, where elements are assembled in ways that have an identity, outside of a more formally constituted organization (Kreiss 2012; Nielsen 2012). Networked assemblages encourage reordering relationships and rethinking a linear process of influence in favor of constantly changing interest clusters driven by information entrepreneurs. Traditional political communication studies, for example, have treated news production as responding to state actors as it relays information to citizens, either in a *cascading activation* process (Entman 2003) or through the *indexing* of news construction to the boundaries of the political system (Bennett 1990). Elite circuits of information exchange among institutional players, however, do not map onto this relationship so easily. As Aeron Davis (2007) has argued, policy-making networks—a form of assemblage of elite actors —constitute micro-spheres of power that do not correspond to representative politics. Journalists are integral, often captive, parts of these networks, not just the recipients of political newsworthy information.

The idea of *global journalism* brings other kinds of assemblage, beyond Peter Berglez's (2008) content-based idea of the "global outlook." The growing use of cross-national research helps untangle institutional-level variables, but emphasizing the national container for these fields may overestimate the degree of homogeneity in national media. Certain components of a journalistic field are more likely to converge toward a more global standard—as I argued previously (Reese 2001)—while the printed press, more firmly rooted in historical styles, may be less likely to change. Corcoran and Fahy (2009) take a more pan-national approach to global journalism, examining how

power flows within and across national contexts through elite-oriented media, whether the *International New York Times*, *Wall St. Journal*, or in their case the *Financial Times*. The *Financial Times* is global in the sense that it has a privileged place in European Union discourse, with a core audience among globalized elites. Journalists' critical systemic role is to become part of networks of information flow that support elite structures.

Globalization adds a different dimension that works beyond these nested levels-of-analysis hierarchies to produce subnational spaces. Global phenomena operate at multiple scales and are not neatly located on a continuum ranging from local to international. Saskia Sassen (2006) points to not only the disassembling of the state, but reconstituted arrangements: new global assemblages of, in her case, territory, authority, and rights. Ethnographic analysis of newswork need not be abandoned in the search for new globalized forms of journalism, and may be especially helpful. Research may take the form of case studies with thick description of new sites for investigation. For example, Firdhaus (2012) has studied Al Jazeera journalists working in Malaysia, signifying a subnational, *glocal* journalistic space embedded within the global media-hub city of Kuala Lumpur.[2]

## Mediated Spaces

As I hope to have shown, the future of journalism's networked public sphere is constituted from new assemblages: newswork, institutional arrangements, and global connections, which give rise to new emerging deliberative spaces. So, finally, I would ask: what shape do they take on and with what implications for healthy democratic discourse? Journalism research has a long tradition of equating these spaces to a mapping of media content, and content-based studies are growing in number with vast amounts of media material available for analysis. This is particularly true in research on online content that takes the hyperlink as the fundamental connecting feature and allows the mapping of the networked space, including blogo- and Twitter-spheres. These analyses often provide striking visualizations of the patterns, but which still must be related to larger structures. In explicating the idea of these *mediated* spaces, the challenge, perhaps counter-intuitive, is to conceive of them from a less media-centric perspective. Journalism is itself an assemblage but also a part of others that lie both inside and outside institutionalized structures. Also the assemblage concept alerts us to these wider combinations of media and non-media elements that must be identified.

In some of my own recent work, I have looked at what I call *mediated spaces*, which become globalized—in my example, for Chinese environmentalism. I think of assemblage in this case as involving not just media but international non-governmental organizations (NGOs), grassroots groups, and government policy makers—and, in many cases, online citizens (Reese 2015). These assemblages can be more difficult to define as they give rise to mediated spaces that emerge and contract in less predictable ways, and in places one might not expect them. In our recent edited collection, *Networked China*, my Texas colleague Wenhong Chen and I use the related concept of *glocalized media spaces* to capture these networks of civic engagement (Chen and Reese 2015).

I would argue nevertheless that a *hierarchy of influences* framework is still relevant to the world of journalistic assemblages. Even in a dramatically restructured news

environment, hierarchical power is still with us, reasserting itself in many areas, not the least of which through the State; and much of the work of journalism continues to occur in organized, institutionalized settings. As recent studies show, journalistic structures and routines are, perhaps surprisingly, robust. This is true even for non-news organizations that practice journalism as a part of their social mission—including advocacy NGOs, such as Human Rights Watch, which investigate, report, and disseminate information, not only to provide to traditional media organizations but to share directly with their stakeholders (as shown in recent work by Matt Powers [2014]).

Tracing new forms of assemblage helps illustrate the new journalistic eco-system, but they need to put in a larger structured context. The idea of a proliferating number of contingent and ever-shifting assemblages is to some degree at odds with the drive in social science for explanation (as Rodney Benson [2014] recently has pointed out for the more radically descriptive versions). We seek predictable aggregates of social material, congealing into institutions that have a history and life of their own. However shifting they may be, assemblages are still located within a framework of power, even if not so clearly. Indeed, the challenge is to determine which ones are really significant and worth examination. There are potentially too many to imagine trying to describe them all, even if they persist from one time to the next. A levels-of-analysis framework reminds scholars to identify in which larger macro structures their phenomena of interest are located. This recalls the value of hybrid methods, such as network ethnography, which find some systematic, agreed-upon way to identify significant sites for analysis. We need deeper ethnographic work in some of these emerging spaces guided, where possible, by digital mapping. Also we need other creative guideposts for finding the most interesting and significant assemblages, locating them within larger social structures, and investigating them using the kind of thick and multi-method description for which the field was known in earlier decades.

## DISCLOSURE STATEMENT

No potential conflict of interest was reported by the author.

## NOTES

1. A related but more professionally oriented conference pulls some overlap of scholars, hosted annually at the University of Texas by my School of Journalism colleague, Rosental Alves: the International Symposium for Online Journalism. I have been privileged to work with many outstanding doctoral students at Texas, but in this area of research I would particularly acknowledge Seth Lewis (now at Minnesota) and Mark Coddington (Washington & Lee) for helping keep me current with emerging issues of digital journalism. In their publications they also have contributed to the Texas–Cardiff connection.

2. I was on the dissertation committee for this research with a particularly global amalgamation of Malaysian student, working with a German adviser (Ingrid Volkmer), at an Australian university (Melbourne), including UK (Brian McNair) and American (me) committee members.

## REFERENCES

Anderson, C. W. 2010. "Journalistic Networks and the Diffusion of Local News: The Brief, Happy News Life of the 'Francisville Four.'" *Political Communication* 27 (3) (August 4): 289–309. doi:10.1080/10584609.2010.496710.

Anderson, C. W. 2013. *Rebuilding the News*. Philadelphia, PA: Temple University Press.

Anderson, C. W., Emily Bell, and Clay Shirky. 2012. *Post Industrial Journalism: Adapting to the Present*. New York: Tow Center for Digital Journalism, Columbia University School of Journalism.

Benkler, Yochai. 2011. "A Free Irresponsible Press: Wikileaks and the Battle over the Soul of the Networked Fourth Estate." *Harvard Civil Rights-Civil Liberties Law Review* 46: 311.

Bennett, W. Lance. 1990. "Toward a Theory of Press-State Relations in the United States." *Journal of Communicationof* 40 (2): 103–125.

Benson, Rodney. 2014. "Challenging the 'New Descriptivism': Restoring Explanation, Evaluation, and Theoretical Dialogue to Communication Research." In *Remarks at Qualitative Political Communication Pre-Conference, International Communication Association*. Seattle.

Berglez, Peter. 2008. "What is Global Journalism." *Journalism Studies* 9 (6): 845–858.

Boczkowski, Pablo J. 2004. *Digitizing the News: Innovation in Online Newspapers*. Cambridge: MIT Press.

Boczkowski, Pablo J. 2010. *News at Work: Imitation in an Age of Information Abundance*. Chicago, IL: University of Chicago.

Carlson, Matt, and Seth Lewis. 2015. *Boundaries of Journalism: Professionalism, Practices and Participation*. New York: Routledge.

Chadwick, Andrew. 2011. "The Political Information Cycle in a Hybrid News System: The British Prime Minister and the 'Bullygate' Affair'." *International Journal of Press/Politics* 16 (1): 3–29.

Chen, Wenhong, and Stephen Reese. 2015. *Networked China: Global Dynamics of Digital Networks and Civic Engagement*. New York: Routledge.

Coddington, Mark. 2012. "Defending a Paradigm by Patrolling a Boundary: Two Global Newspapers' Approach to WikiLeaks." *Journalism & Mass Communication Quarterly* 89 (3): 377–396.

Coddington, Mark. 2015. "Telling Secondhand Stories: News Aggregation and the Production of Journalistic Knowledge." Unpublished dissertation, University of Texas at Austin.

Corcoran, Farrel, and Declan Fahy. 2009. "Exploring the European Elite Sphere." *Journalism Studies* 10 (1): 100–113.

Cottle, Simon. 2007. "Ethnography and News Production: New (S) Developments in the Field." *Sociology Compass* 1 (1): 1–16.

Davis, Aeron. 2007. *The Mediation of Power: A Critical Introduction*. New York: Routledge.

Domingo, David, and Chris Paterson. 2011. *Making Online News—Volume 2: Newsroom Ethnographies in the Second Decade of Internet Journalism*. New York: Peter Lang.

Entman, Robert. 2003. "Cascading Activation: Contesting the White House's Frame after 9/ 11." *Political Communication* 20 (4) (October 1): 415–432.

Epstein, Edward. 1974. *News from Nowhere*. New York: Vintage.

Firdhaus, Amira. 2012. "Network Newswork across Glocal Spaces." Unpublished dissertation, University of Melbourne, Australia.

Fishman, Mark. 1980. *Manufacturing the News*. Austin: University of Texas Press.

Gans, Herbert J. 1979. *Deciding What's News: A Study of CBS Evening News, NBC Nightly News, Newsweek and Time*. New York: Vintage.

Gitlin, Todd. 1978. "Meda Sociology: The Dominant Paradigm." In *Mass Communication Review Yearbook*, edited by G. Cleveland Wilhoit and Harold De Bock, 2: 73–122. Beverly Hills, CA: Sage.

Glasgow Media Group. 1976. *Bad News*. London: Routledge and Kegan Paul.

Glasgow Media Group. 1980. *More Bad News*. London: Routledge and Kegan Paul.

Glasgow Media Group. 1982. *Really Bad News*. London: Writers and Readers Co-operative.

Haak, B Van der, Michael Parks, and Manuel Castells. 2012. "The Future of Journalism: Networked Journalism." *International Journal of Communication* 6: 2923–2938.

Hamilton, Jay, and Fred Turner. 2009. "Accountability through Algorithm: Developing the Field of Computational Journalism." Report from Developing the Field of Computational Journalism. Center for Advanced Study in the Behavioral Sciences Summer Workshop, Stanford CA, July 27–31.

Hanitzsch, Thomas, Folker Hanusch, Claudia Mellado, Maria Anikina, Rosa Berganza, Incilay Cangoz, Mihai Coman, et al. 2011. "Mapping Journalism Cultures across Nations." *Journalism Studies* 12 (3) (June): 273–293. doi:10.1080/1461670X.2010.512502.

Howard, Philip N. 2002. "Network Ethnography and the Hypermedia Organization: New Media, New Organizations, New Methods." *New Media & Society* 4 (4) (December 1): 550–574. doi:10.1177/146144402321466813.

Jarvis, Jeff. 2006. "Networked Journalism." *BuzzMachine*. http://buzzmachine.com/2006/07/05/networked-journalism/

Kreiss, Daniel. 2012. *Taking Our Country Back: The Crafting of Networked Politics from Howard Dean to Barack Obama*. New York: Oxford University Press.

Lewis, Seth, and Nikki Usher. 2013. "Open Source and Journalism: Toward New Frameworks for Imagining News Innovation." *Media, Culture & Society* 35 (5) (June 28): 602–619. doi:10.1177/0163443713485494.

Nielsen, Rasmus K. 2012. *Ground Wars: Personalized Communication in Political Campaigns*. Princeton, N.J.: Princeton University Press.

Paterson, Chris, and David Domingo. 2008. *Making Online News: The Ethnography of New Media Production*. New York: Peter Lang.

Powers, Matthew. 2014. "The Structural Organization of NGO Publicity Work: Explaining Divergent Publicity Strategies at Humanitarian and Human Rights Organizations." *International Journal of Communication* 8: 90–107.

Reese, Stephen D. 2001. "Understanding the Global Journalist: A Hierarchy-of-Influences Approach." *Journalism Studies* 2 (2): 173–187. doi:10.1080/14616700120042060.

Reese, Stephen D. 2009. "The Future of Journalism in Emerging Deliberative Space." *Journalism: Theory, Practice, Criticism* 10 (3): 362–364.

Reese, Stephen D. 2015. "Globalization of Mediated Spaces: The Case of Transnational Environmentalism in China." *International Journal of Communication* 9: 2263–2281.

Reese, Stephen D., and Jane Ballinger. 2001. "The Roots of a Sociology of News: Remembering Mr. Gates and Social Control in the Newsroom." *Journalism & Mass Communication Quarterly* 78 (4): 641–658.

Ryfe, David. 2012. *Can Journalism Survive?: an inside Look at American Newsrooms*. New York: Polity.

Sassen, Saskia. 2006. *Territory, Authority, Rights: From Medieval to Global Assemblages*. Princeton: Princeton University Press.

Schlesinger, Philip. 1978. *Puttting "Reality" Together: BBC News*. London: Constable.

Shoemaker, Pamela, and S. D. Reese. 1996. *Mediating the Message: Theories of Influences on Mass Media Content*. 2nd ed. New York: Longman.

Shoemaker, Pamela, and Stephen D. Reese. 2014. *Mediating the Message in the 21st Century: A Media Sociology Perspective*. New York: Routledge.

Stonbely, Sarah. 2013. "The Social and Intellectual Contexts of the U.S. 'Newsroom Studies', and the Media Sociology of Today." *Journalism Studies* 16 (2): 259–274. doi:10.1080/1461670X.2013.859865.

Tuchman, Gaye. 1978. *Making News: A Study in the Construction of Reality*. New York: Free Press.

Turner, Fred. 2005. "Actor-Networking the News." *Social Epistemology* 19 (4): 321–324.

Usher, Nikki. 2014. *Making News at the New York times*. Ann Arbor: Univ. of Michigan Press.

Vos, Tim, and Francois Heinderycks. 2015. *Gatekeeping in Transition*. New York: Routledge.

Weaver, David H., Randal Beam, Bonnie Brownlee, Paul Voakes, and G. Cleveland Wilhoit. 2007. *The American Journalist in the 21st Century: U.S. News People at the Dawn of a New Millennium*. Mahwah, N.J.: Erlbaum.

# PARTICIPATORY MAPS
## Digital cartographies and the new ecology of journalism

**Inka Salovaara**

*There has recently been considerable attention paid to spatial visualizations in data journalism; less as a product and more as practice. This refers to the notion that rather than reading maps as fixed representations, digital mapping is by nature a dynamic, performative, and participatory practice. In particular, mapping environmental damage, endangered species, and human-made disasters has become one focal point for environmental knowledge production. This type of digital map has been highlighted as a processual turn in critical cartography, whereas in related computational journalism, it can be seen as an interactive and iterative process of mapping complex and fragile ecological developments. This article looks at computer-assisted cartography as part of environmental knowledge production. It uses InfoAmazonia, the data-journalism platform on Amazon rainforests, as an example of a geo-visualization within information mapping that enhances embodiment in the experience of the information. InfoAmazonia is defined as a digitally created map-space within which journalistic practice can be seen as dynamic, performative interactions between journalists, ecosystems, space, and species.*

## Introduction

Digital cartographies are playing an increasingly critical role in today's environmental data-based knowledge delivery. Pervasive computerization and compelling visual imaginations with rhetorical power have changed our depiction of space, environment, and biodiversity. Recently, in human geography and visual studies there has been considerable attention paid to re-theorizing maps, "less as a product and more as a practice" (Dodge, Kitchin, and Perkins 2009, 12; Del Casino and Hanna 2005). This refers to the notion that rather than reading maps as fixed representations, digital cartography is by nature a dynamic, performative, and participatory practice.

In particular, mapping environmental damage, human-made disasters, and endangered species have become main areas of environmental communication. These more-than-human geographies include notions of species, space, and territory that mark the move towards a new political ecology. In this view, nature and society are not exclusive categories, but create hybrid assemblages of mutually constituting environments. These

spatialities emphasize the closeness between human and non-human actors by forging the widening consciousness of mutual dependencies. The InfoAmazonia data journalism platform exemplifies a networked and bottom-up mapping practice that has been adopted by environmental movements, as well as disaster maps where local knowledge produces a deeper depiction of the environment (Williamson and Connolly 2009). This type of participatory cartography involves interactive and iterative processes of mapping complex data on ecosystems.

This article explores how the iterative, participatory mapping of InfoAmazonia is re-assembled through journalist and local networks as part of environmental journalism. Theoretically, the article asks how epistemological modes of environmental communication have changed through participatory mapping and becomes grounded through local communities. Drawing from assemblage theory (Deleuze and Guattari 1987; DeLanda 2006), the article explores the InfoAmazonia platform as a social *assemblage* that gains political agency through practices of participatory journalism.

Empirically, the article analyses InfoAmazonia, the data-journalism platform on Amazon rainforests, as an example of geo-visualization that enhances embodiment of the environmental information. Methodologically, the article applies Latour's (2005) analytical method of re-assembling map-space by analysing the actor-network features of the platform and its role in socio-technological assemblage while constructing digitalized nature.

The article begins by addressing the different understandings of map-making as part of environmental communication and digital journalism. Focusing on the digitization of nature, the article further explores how human and non-human knowledge contributes to the production of networks and social assemblages. Finally, as digitized nature is a product of globalization produced through computerization, the article argues that more-than-human assemblages are productive of their forms, gaining distributed, post-human agency and, as such, exhibit emergent features of digital globalism in environmental communication.

## Maps and Environmental Communication

Cartography in digital journalism can be defined as a communication of data, geospatial information, and human–nature relations in the form of digital maps. From the advent of digital computing, mapping as a visual display has expanded from geographical information systems and military intelligence to everyday visualizations of journalism. While earlier cartography consisted of map projections, digital mapping provides the user interactivity with mash-ups including different types of data attached to certain points of map projection (Harley and Woodward 1987).

As Rob Kitchin, Martin, and Perkins (2009, 11) argue, the wider interdisciplinary focus within mapping during the twentieth century examined maps as *textual representations*. Maps were understood as constructed semantic spaces, which interpreted and presented data by defined communication objectives, political ideologies, and publics Harley 1989, 2001). Maps as representations were historical documents that depicted the worldviews and cultural values of the time. Hence, maps as part of written text have always contributed to creating, rather than simply revealing spatial knowledge.

In particular, environmental cartographies have been modified by a culturally specific historical understanding emphasizing the distinction between nature and society as part of their representational texture. Following Foucault (1969, 62), mapping has "never been neutral but always power-laden". Pickles (2004, 14) argues that maps are inscriptions of our surroundings that have the "power to act, work and code" our environment to modify our environmental understanding (Kitchin, Martin, and Perkins 2009, 12).

Specifically, the Digital Earth concept, introduced by Al Gore in 1987, opened a new way of conceiving maps as ever-expanding, data-based constructions that modified the epistemological perspective to map-making. Digital Earth referred to a 3D virtual representation of the geo-referenced Earth that connects to the world's digital knowledge archives. Digital Earth, with its vast information archives, not only constructed the world, it also produced the world.

This perspective evoked a new sense of global environmentalism addressing such challenges as natural resource depletion, energy scarcity, environmental deterioration, disaster response, population explosion, and, in particular, global climate change. As Harris and Hazen (2009, 51) argue, the emerging global conscience also stretched spatial understanding to cover human and non-human relations through the *more-than-human* concept. It brought in environmental justice and lifted biodiversity to the forefront of environmental communication and journalism.

However, until Web 2.0 digital affordances in cartography, environmental mapping was conceived as a top-down cartographic production of space. This top-down projection was not solely due to a lack of participatory mapping applications but was also based on a rigid epistemological distinction between nature and society that has been the key classificatory principle of modern thinking (Latour 1993, 41; Murdoch 2006).

According to Kitchin, Martin, and Perkins (2009, 16), theoretical thinking stemming chiefly from actor-network theory (ANT) and the theory of assemblages (Bennett 2010; Latour 2005) revised the theoretical understanding of cartography. It emphasized the complex political ecology of heterogeneous practices through which nature and culture continuously and mutually reconstitute one another. The actor-network theorists (Latour 2004, 2005; Serres and Latour 1995) argued for a politics of articulation by focusing on the blurring boundary between nature and culture, and by extending agency to the non-human, both natural and artificial. As Haraway (1992, 297) contended, "the world being co-construction among many actors, not all of them human, not all of them organic, not all of them technological".

According to this view (Latour 2004, 2005; Kitchin, Martin, and Perkins 2009), environmental maps gain meaning or action only if they are part of an assemblage of people, technologies, discursive processes, such as journalism, and other material things. Latour (1987) argues that maps are deployed in an actor-network of practices rather than existing solely as knowledge objects. Here, the particular actor-networks use the map as actants within various networks and the circulation of ideas between multiple actors (people, texts, species, animals, political discourses, digital objects and resources) (Kitchin, Martin, and Perkins 2009, 30–34).

Applying this to participatory, mapping platforms, the cartographic practices themselves reassemble spatio-political relations that are constantly changing, depicting, and processing nature. As such, participatory cartographic networks are forming social assemblages (Salovaara 2014, 2015). These assemblages represent complex ecologies of

subjectivity in which political agencies emerge as a consequence within a digital ecosystem. Social assemblages, such as participatory platforms, are not organic and hence do not always form a seamless whole. However, following DeLanda (2006, 12), non-organic cultural and social systems can also be seen as "assemblages", because participatory cartographies can be defined as "being wholes whose properties emerge from the interaction between parts".

In assemblage theory, such social assemblages have four specific roles  within their immediate, (digital) ecosystem (DeLanda 2006, 10–15). They have (1) a material role that refers to material elements, such as computers, human actors, buildings, etc.; (2) an expressive role referring to different semantic systems, such as used languages, forms, colours, and other expressive forms of communicating; (3) a territorializing role that refers to their physical, social, and political environment; and (4) a linguistic/coding role that is played in discourses such as environmentalism.

## InfoAmazonia as Actor-network and Assemblage: Data and Methods

InfoAmazonia was launched in June 2012 as an environmental journalism network reporting on the Amazon. As environmental journalism often focuses on hotspots of environmental urgency, rich biomes such as Amazonia are highly topical for global environmental engagement. The Amazon rainforest, or Amazonia, is globally one of the most precious natural resources and spans nine countries in the Amazon delta. Its flora continuously recycles carbon dioxide into oxygen, and has been described as the "Lungs of our Planet". Approximately 20 per cent of the Earth's oxygen is produced by the Amazon rainforest. Wet tropical forests are the most species-rich biomes and the Amazonian rainforests enjoy unparalleled biodiversity (Vieira et al. 2008).

During the last decades, the vast Amazon lost almost one-fifth of its forests, its ecosystem has been disturbed, and numerous species are subject to resource exploitation. The economic transformation of the Amazon is grounded in the conversion of its biosphere, which causes the systemic degradation of the region (Foley et al. 2007).

Hence, it is not surprising that the Amazon rainforest is a sensitive territory both politically and environmentally. Ecologically, it focuses public attention on habitat conservation, ecosystems, and the global importance of all plants and animals. Politically, biodiversity is controversial because it is concentrated in so-called developing countries. However, corporations, environmental movements, and science laboratories are predominantly located in industrial countries.

The rationale behind the InfoAmazonia data journalism platform was to contribute specifically to this debate for more sustainable development in a region of global importance. It provides news, reports, and data-based maps from a network of journalists that cover the nine countries that share the Amazon delta. The platform also provides open access to geo-referenced data on environmental changes within the region, in addition to tools to use and visualize these data for environmental reporting.

As the founder Gustavo Faleiros, the Knight Foundation Fellow, defined its function on the platform: "InfoAmazonia wants to be the instrument of citizenship" (InfoAmazonia 2015). This aim is supported by information distribution and delivery in the form of environmental data journalism. Due to InfoAmazonia's geographical coverage, various

linguistic groups are encompassed and data are provided in English, Spanish, and Portuguese.

In the following, the InfoAmazonia platform is analysed as (1) an open access, data journalism platform, (2) as a participatory actor-network, and (3) as a socio-techno-logical assemblage, especially analysing its material, expressive territorializing, and lin-guistic/coding roles. The data consist of the data architecture of the platform, the visual and semantic, and the background information related to launching and main-taining the platform. The methodological approach is inspired by Bruno Latour's (2005) analytical method of re-assembling the map-space by analysing (1) the technological Web 2.0 affordances of the platform, (2) the features of the digital participatory net-works, and (3) the roles of InfoAmazonia as a social and technological assemblage.

## Web 2.0 Affordances of Digital Networked Cartographies

InfoAmazonia exemplifies digital mapping where digital networks and Web 2.0 mapping affordances are closely intertwined. Technologically, InfoAmazonia is a Web platform that has affordances of scalability and packed software with lightweight pro-gramming models and software. The platform's technical standards also enable the sharing of information across networks because they are based on open access and open source technology. Hence, JEO, the platform that powers InfoAmazonia, is an open source program, and while the site is highly interactive, it uses the Jekyll site generator to avoid expensive dependencies on databases or dynamically server-side generated pages.

Since the platform launch in 2012, the InfoAmazonia team has built 17 different maps that together display 12 gigabytes of geographical data. All platform content is managed in Google spreadsheets, converted to GeoJSON (a format for encoding a vari-ety of geographic data structures) and built on the client side. All maps are constructed with a design tool TileMill and hosted on MapBox hosting. The data platform utilizes open data to embed stories in a contextual map by using data mining, geo-tagging, and visualizing trends and processes based on cross-referenced data. The platform is free to download, customize, embed maps, and hence it remains faithful to open source/access principles.

InfoAmazonia as a participatory platform harnesses collective intelligence, which is a common feature of the Web 2.0 mapping affordances. It has a participatory struc-ture as it crowdsources information from activists, journalists, indigenous communities, researchers, non-governmental organizations (NGOs), and citizens within the area expanding over nine countries within the Amazon delta. Using organizations and local communities with satellites and remote sensing multiplies the actor-network centres of data gathering. For example, locations such as mapping agencies where observations are accumulated and analysed allow human perception to expand on satellite data in its immediate environmental context, linking remote and close-by ethnographic sens-ing. By the affordances of crowdsourcing information, the platform also has control over unique, hard-to-create data. The data sources tend to get richer as more people use them. Hence, the platform is serving as a provider of data and a tool instead of simply offering maps.

For instance, when the platform updates its map of deforestation, water access, or forest fires with up-to-date satellite data, communities in the risk regions can verify the new information, contextualize it, and help to explain it. According to Gustavo Faleiros:

> Satellites do see a lot of things, but they do not tell you the reasons why an area of forest has been cleared. Is it now being used for cattle ranching or mining? You can guess based on your experience, but the real story, the characters involved, the human dimension will emerge from the ground reporting. (IJNet 2014)

This type of architecture of participation where the local community and other environmental organizations collaborate, acts as a filter for politicized information coming from economic stakeholders, such as the regional governments and international corporations. To enable this, the platform exhibits an ethical and affective bonding by showing trust towards users as co-developers and co-creators (including rich user experiences that would not otherwise be accessible). Produ(s)ers with their crowdsourcing skills and engagement aim to spread the "glocal" visibility and information on the Amazonia.

The platform's inbuilt technological affordances ensure that the data are grounded on *crowdsourcing* (intelligence, sourcing, mining, and funding). The crowdsourcing initiative is supported by the Avina and Skoll foundations, as well as by partnering NGOs within the Amazon rainforest region. Together, they donate funds to InfoAmazonia to build applications that enable citizen reporting, data sharing, and fact-checking. The ((o))Ecolab, one of InfoAmazonia's parent organizations, builds the crowdsourcing functions.

Part of the crowdsourcing ethos is to empower the network actors through education. During InfoAmazonia's launch, environmental journalists participated in a workshop where they were introduced to the data, photos, and maps on the platform. As part of this introductory session, the journalists learned about geo-tagging stories, how to use spreadsheets, such as Google Fusion Tables, and were introduced to data applications, such as Google Earth and MapBox, for storytelling.

The digital platform architecture is above the level of the single device, with a seamless connection to devices and other platforms. Its actor-networks include technical artifacts that record and translate information (such as tables of coordinates or satellite imaginary). They are both human (with ethnographic accounts and observations) and non-human (satellites and remote-sensing technologies). This merges with analyses provided with journalistic narratives and is distributed with the help of media partners, bloggers, and other users. For corrective action, the platform aggregates databases with historical series to find correlations with the environmental and socio-cultural phenomena and to help cross-check data-sets from different data sources.

Sites in a network that potentially exert control and influence, such as government departments, are few. Hence, the platform has, in principle, embraced openness, distributed unique data, and widened critical environmental knowledge via journalism by *creating tools* for extended citizenship for the "glocal" communities. Moreover, the actor-network's feature trials by strength (how competing visions and processes within a network compete for superiority) are measured by the spreadability and environmental impact of journalistic production.

Knowledge production on the platform consists of open source environmental data, maps, and local journalism on global issues based on the platform data. As such,

it is leveraging the long tail through consumer niches, via user networks and organizations such as Environmental News Lab. The network's programmes of action are based on volunteering, co-producing, and engaging for the environmental cause.

InfoAmazonia's platform structure is concerned with the storage, participatory retrieval, and analysis of data with cartographic display *per se* as part of other, journalistic information, and as part of information mapping that enhances embodiment in the experience of information. Spatial and environmental data are surveyed, digitized, crowdsourced, organized, and journalistic information is selected for inclusion. On the platform, there are more than 30 layers of geo-referenced data storage to be used on interactive maps. This information is produced into data journalism by the journalist networks and media partners specializing in environmental issues.

As the platform consists of a widening collection of visuals, observations, digital nodes, artefacts, documents sites, discourses, and events, it is continuously re-assembling and expanding. It is a composition consisting of an arrangement of miscellaneous digital and material objects, as well as digital networks consisting of diverse types of spatialities. As such, it creates an expanding digital archive contributing to an emerging *post-human memory* of digital footprints. Here collected data produce an archaeological site, which is simultaneously establishing it as part of the digital, archived memory of networked communities.

So far, the site has aggregated close to 1500 stories, which are geo-tagged from many local communities within the Amazon region. As the site continues to pull in news stories, the crowdsourced reports will add even more context to the archived stories. Hence, participatory mapping is in a state of continuously widening its territory.

To summarize, InfoAmazonia creates a complex, techno-social assemblage consisting of multiple actor-networks, within which the circulation of people, discourses, objects, and resources take place. DeLanda (2006, 3) defines such assemblage as being a whole whose properties emerge from the interaction between parts. As a cultural entity it is also a product of historical processes, as an assemblage it cuts across the nature–culture divide, as well as human–non-human dichotomies.

The roles of InfoAmazonia as an assemblage include both human and non-human actors. The material role of the InfoAmazonia assemblage is played out in environmental journalism (the content that spreads through media partners), as well as in digital network spaces, through their concrete and digital nodes, servers, human and non-human devices (satellites and remote sensors), data clusters, and platforms. The expressive role is performed by multimodal sign systems, communicative codes, platform architecture, design, data, participatory activity, technological features, visuals, external communication, and the practices of engagement. The territorializing role is played by communication chains, platform sites, immediate socio-technical and cultural environments, and other elements, that maintain the technological and social components, their relationships, and thus the durability of the assemblage. The de-territorializing role is played by mutation within the participatory platform and its elements that recombine or replace various elements within its actor-network, leading to its constant reformulation. The linguistic/coding role is fulfilled by coding the function within discourses on environmentalism, preservation, biodiversity, and more-than-human geographies. Hence, the participatory map assemblage becomes a mix of contingency and organizations. The contingency relates to occurrences and happenstances around the environmental events, where organizations act as digital archives, dense nodes, and network

builders. In this assemblage, human and non-human actors connect with things, technologies, discourses, and networked flows of information (Deleuze and Guattari 1987).

## Conclusions: InfoAmazonia as Affective Assemblage

The natural environment of networked and participatory cartographies such as InfoAmazonia is within open, adaptive digital media ecosystems. These ecosystems include properties such as self-organization, scalability, and sustainability both on the local and global levels. Digital media ecosystems, like natural ecosystems, exhibit aspects related to competition and collaboration among diverse entities. They also nurture social assemblages that can be understood as "open-ended, mobile, networked, and actor-centred space or geography" (Jones 2009, 487).

Through ANT, InfoAmazonia is composed of heterogeneous relations and assembled within actor-networks. As such, participatory practices create social assemblages that carry the ethos of those that participate. According to Deleuze and Guattari (1987), these synergies become productive as they can gather things into a singular context: forging new (political) meanings and possibilities.

In this context, the distinction between humans and non-humans becomes inconsequential. Hence, the platform-hosted, environmental agency is distributed through a heterogeneous arrangement of mapping practices including both human and non-human actors (Foucault 1990; Law 1994). This diversity in terms of agency allows creative play, in forming multiple heterogeneous positions, to change the political dynamics and spread environmental information both locally and globally regardless of political boundaries.

Mapping practices within InfoAmazonia also become cultural practices involving engagement of diverse actors. Its ethnographic encounters grow from more continuous versions of reality. The map assemblage circulates researchers, citizens, journalists, and non-human agents (satellites, remote sensing equipment, water sensors, etc.). It views the world first from a cartographically assumed centre when a biotechnological knowledge bank lies inside the actor-network functionally scattered by divergent environmentalist and journalist communities, only to refocus with a decentring ethnographic lens. The ethnographic focus helps the participatory platform to embed the different worlds and realities actors may encounter. These more-than-human networks are also materialized within (human) ethical fabrics, as mapping evolves registers of environmental engagement.

Firstly, the systematic engagement of local people in the creation of information enhances the sense of embedded existence with(in) nature. Hence, the mobilization of engagement becomes an integral part of our cartographic understanding of the environment. Secondly, affective ethos becomes a reflexive loop on how nature is understood. As nature, animals and "other life" are expected to be outside the human sphere as more-than-human, and yet they also include humans. In this loop, the nature of inclusion and inclusions of nature create a symbiotic and mutually inclusive future where humans and more-than-humans cannot be separated. Maps also mediate between the pressures emanating from the larger society and the exigencies of the local ecosystem (Ellis and Waterton 2005). Their affective nature stems from the fact

the human power over environment has caused changes in ecosystems, resulting in alarmism regarding the consequences, and has activated thinking of more-than-human geographies.

Following Corner (1999, 288), maps can be understood as having the power to unfold potential. They can be seen as conduits of possibilities and spaces of imagination and action in the world. According to Corner (1999), the function of maps is not to depict, but to enable and actualize ideas that are inherent within the ethos of local communities and environmental knowledge delivery. Hence, how affect interacts to produce politics and knowledge is a process that cannot be simply explained by a neat conceptual ecology of environmental mapping and its ideological registers.

The power of environmental participatory mapping is hence based on their interventionist and multi-vocal nature. These environmental cartographies exhibit a processual dimension where maps are constantly remade, and become political, by nature, revealing an eco-social dimension and related power that incorporates inter-species inequalities. A focus on environmental mapping also raises key questions on Judith Butler's (1990) notion regarding performativity as part of mapping practices. In this case, digital mapping practices can be seen as active performances in relation to their socio-political impact and effect on human consciousness.

More-than-human approaches to mapping the environment can also be combined to provide a means for understanding the multifaceted meanings, values, and practices associated with nature, changing ideas for ordering nature, and tools for transforming ecological understandings, relationships with the non-human world, and historical and contemporary processes that have created the endangered areas, such as Amazon rainforests, as we now know (Foley et al. 2007).

However, though current cartographies are based on data, maps on nature will never be neutral. Hence, there is need to consider how environmental mapping is performed, particularly by map users and producers. From this perspective mapping has to be considered as historically contingent actor-networks, as timed, placed, cultured, and negotiated. The focus shifts from what the map represents to how it produces and how it works in the world (Kitchin, Martin, and Perkins 2009, 16).

Finally, as digitalized nature can be seen as a product of globalization produced through computerization, more-than-human assemblages are productive of their forms, gaining distributed, post-human agency and, as such, exhibit emergent features of digital globalism. They create moral geographies of action where affect and engagement create its dynamics.

At the same time, biological life, even when digitalized, is not merely a "terrain for the exercise of power" (Moore, Pandian, and Jake 2003, 1) but it is also an active agent that can never be fully integrated into social relations. Foucault (1990, 143) states that "it is not that life has been totally integrated into techniques that govern and administer it; it constantly escapes them". Life is, therefore, a source of resistance to dominant forms of power/knowledge. In this sense, Foucault's view of biological life as constantly escaping technologies of power is strikingly similar to the post-humanist emphasis on the agency of non-humans as part of journalistic, participatory map assemblages.

Perhaps the main function of environmental journalism as participatory practice is to remind societies and territorial centres of political power that development inevitably binds humans and non-humans more closely together within complex social

assemblages. As participatory geographies, they are never complete, but in the state of becoming, meanwhile human, non-human, and post-human actors continue to modify ecological parameters of participatory action, environmental communication, and our understanding on more-than-human environments.

## DISCLOSURE STATEMENT

No potential conflict of interest was reported by the author.

## REFERENCES

Bennett, Jane. 2010. *Vibrant Matter. A Political Ecology of Things*. Durham: Duke University Press.

Butler, Judith. 1990. *Gender Trouble: Feminism and Subversion of Identity*. London and New York: Routledge.

Corner, James. 1999. "The Agency of Mapping; Speculation, Critique and Invention." In *Mappings*, edited by D. Cosgrove, 213–244. London: Reaction Books.

Del Casino, Vincent and Stephen Hanna. 2005. "Beyond the Binaries: A Methodological Intervention for Interrogating Maps as Representational Practices." *ACME; an International E-Journal for Critical Geographies* 4 (1): 36–56.

DeLanda, Manuel. 2006. *A New Philosophy of Society. Assemblage Theory and Social Complexity*. London: Bloomsbury.

Deleuze, Gilles, and Felix Guattari. 1987. *A Thousand Plateaus: Capitalism and Schizophrenia*. Minneapolis, MN: University of Minnesota Press.

Dodge, Martin, Rob Kitchin, and Chris Perkins, eds. 2009. "Thinking about Maps." In *Rethinking Maps*, edited by Dodge Martin, Kitchin Rob, and Chris Perkins, 1–25. London and New York: New Frontiers in Cartographic Theory. Routledge.

Ellis, Rebecca, and Claire Waterton. 2005. "Caught between the Cartographic and the Ethnographic Imagination: The Whereabouts of Amateurs, Professionals, and Nature in Knowing Biodiversity." *Environment and Planning D: Society and Space* 23: 673–693.

Foley, Jonathan A., Gregory P. Asner, Marcos Heil Costa, Michael T. Coe, Ruth DeFries, Holly K. Gibbs, Erica A. Howard, et al. 2007. "Amazonia Revealed: Forest Degradation and Loss of Ecosystem Goods and Services in the Amazon Basin." *Frontiers in Ecology and the Environment* 5: 25–32.

Foucault, Michel. 1969. *The Archaeology of Knowledge*. Translated by A. M. Sheridan Smith. London and New York: Routledge.

Foucault, Michel. 1990. *The History of Sexuality*. vol. I. New York: Vintage Books.

Haraway, Donna. 1992. *Simians, Cyborgs, and Women: The Reinvention of Nature*. New York: Routledge.

Harley, John Brian. 1989. "Deconstructing The Map." *Cartographica* 26 (2): 1–20.

Harley, John Brian. 2001. *The New Nature of Maps: Essays in the History of Cartography*. Baltimore, MD: Johns Hopkins University Press.

Harley, John Brian, and David Woodward, eds. 1987. *The History of Cartography*. Chicago and London: University of Chicago Press.

Harris, Leila, and Helen Hazen. 2009. "Rethinking Maps from More -than-Human-Perspective: Nature-Society, Mapping and Conservatory Territories." *Rethinking Maps*, 50–67. London and New York: New Frontiers in Cartographic Theory. Routledge.

InfoAmazonia. 2015. "Geojournalism, Maps and Data". http://infoamazonia.org/about/ (accessed May 21, 2015).

IJNet. 2014. "Data Journalism Site InfoAmazonia Will Add Ground Reporting to its Environmental Coverage" http://ijnet.org/en/blog/data-journalism-site-infoamazonia-will-add-ground-reporting-its-environmental-coverage accessed May 21, 2015).

Jones, Martin. 2009. "Phase Space: Geography, Relational Thinking, and beyond." *Progress in Human Geography* 33 (4): 487–506.

Kitchin, Rob, Martin Dodge, and Chris Perkins. 2009. "Thinking about Maps." In *Rethinking Maps. New Frontiers in Cartographic Theory*, edited by Martin Dodge, Rob Kitchin, and Chris Perkins, 1–25. London and New York: Routledge.

Latour, Bruno. 1987. *Science in Action*. Cambridge, MA: Harvard University Press.

Latour, Bruno. 1993. *We Have Never Been Modern*. Hemel Hempstead: Harvester Wheatsheaf.

Latour, Bruno. 2004. *Politics of Nature*. Cambridge: Harvard University Press.

Latour, Bruno. 2005. *Reassembling the Social*. Oxford: Oxford University Press.

Law, John. 1994. *Organising Modernity*. Oxford: Blackwell.

Moore, Donald, Pandian Anand, and Kosek Jake. 2003. *Race, Nature, and the Politics of Difference*. Durham, NC: Duke University Press.

Murdoch, Jonathan. 2006. *Post-Structuralist Geography*. London: Sage.

Pickles, John. 2004. *History of Spaces: Cartographic Reason, Mapping and GeoCoded World*. London: Routledge

Robinson, A. H. 1982. *Early Thematic Mapping in the History of Cartography*. Chicago, IL: University of Chicago Press

Salovaara, Inka. 2014. "Spaces of Emotions: Technology, Media and Affective Activism." In *The Routledge Companion to Global Popular Culture*, edited by Toby Miller, 471–480. New York and London: Routledge.

Salovaara, Inka. 2015. "#Je Suis Charlie: Networks, Affects and Distributed Agency of Media Assemblage." *Conjunctions: Transdisciplinary Journal of Cultural Participation*. Special Issue 2015/2 "Mediatized Cultural Activism." http://www.conjunctions-tjcp.com/article/view/22272

Serres, Michel, and Bruno Latour. 1995. *Conversations on Science, Culture and Time*. Ann Arbor, MI: The University of Michigan Press.

Vieira, I., P. M. Toledo, J. Silva, and Higuchi. 2008. "Deforestation and Threats to the Biodiversity of Amazonia." *Brazilian Journal of Biology* 68 (4): 949–956. ISSN 1519-6984. http://dx.doi.org/10.1590/S1519-69842008000500004.

Williamson, Dominica, and Emmet Connolly. 2009. "Theirwork: The Development of Sustainable Mapping." In *Rethinking Maps. New Frontiers in Cartographic Theory*, edited by Martin Dodge, Rob Kitchin, and Chris Perkins, 97–112. London and New York: Routledge.

# GIVING COMPUTERS A NOSE FOR NEWS
## Exploring the limits of story detection and verification

**Neil Thurman, Steve Schifferes, Richard Fletcher, Nic Newman, Stephen Hunt** and **Aljosha Karim Schapals**

*The use of social media as a source of news is entering a new phase as computer algorithms are developed and deployed to detect, rank, and verify news. The efficacy and ethics of such technology is the subject of this article, which examines the SocialSensor application, a tool developed by a multidisciplinary European Union research project. The results suggest that computer software can be used successfully to identify trending news stories, allow journalists to search within a social media corpus, and help verify social media contributors and content. However, such software also raises questions about accountability as social media is algorithmically filtered for use by journalists and others. Our analysis of the inputs SocialSensor relies on shows biases towards those who are vocal and have an audience, many of whom are men in the media. We also reveal some of the technology's temporal and topic preferences. The conclusion discusses whether such biases are necessary for systems like SocialSensor to be effective. The article also suggests that academic research has failed to recognise fully the changes to journalists' sourcing practices brought about by social media, particularly Twitter, and provides some countervailing evidence and an explanation for this failure.*

## Introduction

The ubiquity of computing in contemporary culture has resulted in human decision-making being augmented, and even partially replaced, by computational processes or algorithms using artificial intelligence and information retrieval techniques. Such augmentation and substitution is already common and even predominates in some industries, such as financial trading and legal research. Frey and Osborne (2013) have attempted to predict the extent to which a wide spectrum of jobs is susceptible to computerisation. Although journalists were not included in their analysis, some of the activities undertaken by journalists—for example, those carried out by interviewers, proof readers, and copy markers—were, and had a greater than 50 per cent probability of being computerised. It is that potential for the automation of journalistic work that is explored in this article.

Frey and Osborne remind us of how automation can be aggressively resisted by workers, giving the example of William Lee who, they said, was driven out of Britain by the guild of hosiers for inventing a machine that knitted stockings. Such resistance also exists in the context of journalistic automation. For example, a spokesperson from the German Federation of Journalists has said that it does not "think it is … desirable that journalism is done with algorithms" (Konstantin Dörr, personal communication, 6 February 2015). There is, however, also appreciation of the benefits automation can bring in assisting journalists with the management of the huge volumes of information—particularly from social media—they currently deal with (see, e.g., Schifferes et al. 2014).

Such algorithms, embodied in the SocialSensor mobile[1] and Web applications, are the focus of this article. A multidisciplinary, international team developed SocialSensor, including some of this article's authors.[2] The project has been designing, building, and testing a single tool that aims to rapidly extract trustworthy material from social media, with context. Such tools are, however, not just of professional interest to journalists; they also raise important issues for those who study journalism, prompting reflection on:

- The social and professional contexts that have incubated the development of such tools.
- How they work.
- What biases might they have and should they be challenged?
- How could an increase in their use change what journalists produce?

This article explores these questions, drawing on what we have learnt from the SocialSensor project.

## Social and Professional Contexts

More and more news stories are becoming known for their social media provenance. Take, for example, the Hudson River plane crash, which was reported on Twitter about 15 minutes earlier than anywhere else (Beaumont 2009). Since then, journalists tell us, social media has grown in importance as a source. "It's an incredibly important source", says Jonathan Rugman of Channel 4 News in the United Kingdom (personal communication, 12 September 2014), a view echoed by Krishnan Guru-Murthy, also of Channel 4, who says "we use [social media] constantly in all stories … I don't think you can overstate its importance" (personal communication, 21 September 2014).

There is some contradiction, then, in the fact that research to date has suggested that a relatively small proportion of newspaper and broadcast stories uses social media as a primary source. Broersma and Graham's (2013) study found that there were fewer than four articles per newspaper per day that quoted Twitter. The numbers were even smaller in a study of US newspapers and television stations (Moon and Hadley 2014). One explanation for this contradiction is that both studies used data from 2011 and, since then, there appears to have been a step change in the way journalists use social media. Laura Roberts believes that "[2011] was a bit of a turning point in the way that the *Daily Telegraph* looked at using social media" (personal communication, 2 October 2014). Rugman concurs, saying "it's been a huge change, and it started in 2011".

Nevertheless, even research that uses data from after 2011 continues to show relatively infrequent mentions of social media as sources of information (Paulussen and Harder 2014; Wallsten 2015). One explanation for this mismatch between journalists' statements about their heavy reliance on social media and how infrequently those sources are actually cited is that it is often used as a tip-off mechanism, with journalists corroborating the information elsewhere. "[Twitter] can help inform you where things are kicking off", Guru-Murthy told us. BBC Middle East Correspondent Yolande Knell assessed Twitter's utility in a similar way: "[In the Egyptian revolution] Twitter would often guide you to where an event was taking place" (personal communication, 29 September 2014). In addition to social media's utility as a tip-off service it has the potential to offer much more, for example highlighting trending topics, delivering multimedia content on running stories, and as a searchable archive of contacts and information. These additional capacities have not yet been fully exploited.

There are, however, also challenges that come with an increasing reliance on social media as a news source. Perhaps the greatest of these is the veracity of the information it carries. Although Channel 4's Lindsey Hilsum says she follows the "normal system for verifying stuff" when she gets a tip-off from social media ("ringing people you trust, ringing the original source, going and seeing"), to do so can be problematic if the source is anonymous or the news event inaccessible. Furthermore, journalists are increasingly working under severe time pressures and having to deal with large volumes of information, some of which seeks to mislead. For example, Hilsum says the information is "frequently contradictory" (personal communication, 15 September 2014). Guru-Murthy believes "it can be very misleading, it can be manipulated". Rugman agrees that the use of social media as a source has "raised huge issues of verification". BBC News Online's Joe Boyle sums up the problems journalists face by saying that "there are just so many sources out there [on social media] that it's hard to judge what's true and what's not" (personal communication, 16 September 2014).

There are, then, both opportunities to be exploited and challenges to be faced for journalists seeking to make the most of the potential of social media. These are starting to be addressed through the development of technology that seeks to partially automate the identification and verification of news in social media. Although progress has been made, results have been mixed because of the inherent difficulties involved, for example the proportion of "noise" in social media output (i.e. unimportant or malicious content) and fragmentation (people discussing the same topic in different ways). Callison-Burch (n.d.) reports that applying one technique—first story detection—to the problem produces "a mass of false positives" with "less than 1 percent of events detected in Twitter" being "news related". In terms of verification, although some tools and technologies do exist, journalists believe that they have not been "sufficiently granular to help [them] make judgements on authenticity in a fast-moving news story" (Schifferes et al. 2014, 409).

## The SocialSensor Approach

The SocialSensor project has made a number of innovations in automating news detection and verification. For example, it monitors a limited number of what it calls "newshounds". These are people—such as journalists, politicians, and bloggers—inter-

ested in or expert on particular subjects who share that information with others. Finding and following these newshounds and monitoring what they say was one method with which it was hoped that newsworthy information could be gathered in a rapid, flexible, and trustworthy way. In SocialSensor, a newshounds database is "grown" from an initial "seed" list, for example a manually compiled list of journalists on Twitter.[3] The initial seed list is expanded by including social media accounts that the "seeds" follow. So, for example, a BBC journalist on one of SocialSensor's seed lists, Lyse Doucet, follows over 2000 people, so all her followers were added, and so on. As could be expected, any "fully grown" database ends up containing tens or hundreds of thousands of social media accounts (the putative newshounds). Other research has indicated that there is minimal advantage in monitoring such large numbers of newshounds. For this reason, and because of technical limitations, the number of accounts followed was reduced by applying a scoring mechanism (see Table 1), with the 5000 highest scoring accounts becoming active newshounds.[4]

Accounts that scored highly but were mostly irrelevant in news terms—such as Justin Bieber—were excluded from the database. Our own testing also confirmed that following more than 5000 newshounds did not improve significantly the effectiveness with which the software could detect news. By following 5000 newshounds, we were able to capture between 63 and 90 per cent of the most popular stories taken from a database of tens of thousands of online news publications over a given period (for more information, see Hunt et al. 2015). This indicates how the dispersion of news on social media is likely to be skewed to a log-normal distribution. In other words relatively few, well-informed and well-followed individuals play a key role in the dissemination of news.

## Who Has Influence?

But who are these active newshounds? If tools like SocialSensor become more widely used, such people will play an important role as gatekeepers. The SocialSensor tool gives users the option of selecting different newshound databases. The "UK Trends" newshounds database, for example, was seeded with UK journalists on Twitter, many from the BBC, while the "US Trends" database was seeded with US journalists on Twitter, many from the *New York Times*. For this article, the "UK Trends" database of 5000 newshounds was analysed. A file containing the newshounds' Twitter handles was ordered by the scoring system outlined in Table 1. Three clusters of newshounds,

**TABLE 1**

Scoring mechanism used to select active SocialSensor newshounds

| Criteria | Score |
| --- | --- |
| Present on our initial "seed" list | 150 |
| Sends at least 10 tweets per day | 50 |
| Present on at least 50 Twitter lists | 25 |
| Verified with Twitter's blue tick | 25 |
| Score for each account on the initial "seed" list that follows them | 5 |
| Score for each account on the initial "seed" list that they follow | 2 |

selected stratificationally, were analysed: the top 100, middle 100, and bottom 100. Each newshound's Twitter profile was examined and categorised by:

1. Type of account holder: e.g. "Female".
2. Location: e.g. "UK".
3. Affiliation: e.g. "Politician".

The results show there is a bias towards men (52 per cent of the accounts), with women and institutions (such as the UK Supreme Court) making up the rest with 23 and 24 per cent, respectively (see Figure 1b). There is also a heavy bias towards mainstream media channels and those who work for them—they make up 63 per cent of our sample. Indeed, if freelance journalists and bloggers are included, that figure goes up to 74 per cent. Politicians, government spokespeople, and government agencies make up 11 per cent. Experts/academics, celebrities, activists, and consultants make up 7 per cent. Lastly, corporations, non-governmental organisations (NGOs), and public relations firms make up 5 per cent (see Figure 1a). The fact that the "UK Trends" database we analysed was seeded with journalists made little difference to its final composition. When an alternative "balanced" seed list was used (that included non-journalists such as experts and academics), the resulting database had a similar proportion of journalists. Journalists scored highly due to their activity and popularity, earning inclusion in the final database of active newshounds. Our analysis of the location of the active newshounds showed that they were, overwhelmingly, UK-based (78 per cent), with a further 15 per cent from other developed countries and only 5 per cent from non-European developing countries (see Figure 1c).

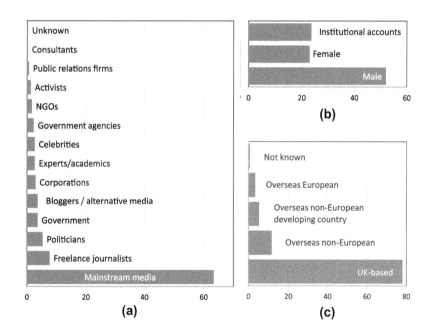

**FIGURE 1**

Type (a), affiliation (b), and location (c) of Twitter account holders in a sample (*N* = 300) of SocialSensor's "UK Trends" newshounds database

These results show how tools like SocialSensor rely on particular inputs and assumptions. Although the selection of newshounds was determined by a scoring system that was blind to gender and, for at least 90 per cent of the newshounds, blind to affiliation and location, we see that there is still a strong bias towards men, those in the mainstream media, and those in the United Kingdom and other developed countries. This raises interesting questions about whether such tools should be tuned to listen, as was the case here, to those being talked about most, to those who do the most talking, and to those with the largest audience, or whether such tools could be agents for change, tuned to also pick up the stories and experiences of those under-represented in the public sphere. We will return to this question in the conclusion.

## News Discovery and Clustering

Although there is no space to go into detail about how SocialSensor automatically identifies news stories, two of its techniques are of interest here. Broadly speaking, topics emerge because they are trending—that is, they are popular over a short period of time—or as a result of users' explicitly expressed (via search) or implicitly inferred (via analysis of their social media profile[5]) interests. Events that are trending (particularly over hours or a few days) are more likely to be detected (Aiello et al. 2013). It is interesting to consider whether the increasing use of tools that work, in part, by detecting such "bursty" events might reinforce relatively passive reporting of short-term events at the expense of longer-term issues like climate change and the economy. We should note here that social media is likely to become even more bursty with the launch of tools such as Thunderclap. Thunderclap deliberately concentrates particular social media messages into bursts so that users can, the company promises, "amplify your message with the power of the crowd" (Thunderclap, n.d.). This prefigures a potential arms race between journalists using algorithms to find news and, on the other side, those with messages they want to be found trying to trick the technology.

Another characteristic of SocialSensor's news detection algorithm is the boost it gives to stories containing proper nouns such as people, places, and organisations (Aiello et al. 2013, 1274). Are such methods necessary to make these tools work? Might they exacerbate the trend towards human-interest stories and the coverage of "elite" people and celebrities? On the other hand, could news detection software like SocialSensor be instructed to consider alternative news values, for example, focusing on "political, structural and natural root causes" and providing testimonies by "people concerned" and "positive images of women" (NGO–EC Liaison Committee, quoted in Harcup 2015, 41)?

## Verification

It is all very well for software to allow journalists to search or be alerted to clusters of social media posts representing news stories, but without context these clusters can be a trap as they are likely to contain a mixture of truth and lies. Twitter, for instance, carries significant amounts of misinformation, especially around breaking news events (see, e.g., Burgess, Vis, and Bruns 2012). As a result, journalists using social

media need to exercise care with the material they are sourcing. Of course, this is already happening. There are some good guidelines (e.g. Silverman 2014) and practice that focus on verification, often breaking the task down by looking at the content of the message, at the contributor, and the context around the message. For example, an analysis of a social media contributor purporting to be the Libyan prime minister showed he had previously tweeted that he would make all Libyans "tree hugging hippies". The account turned out to be fake, but not before it had been quoted by the media (Hermida 2015, 64). The rising volume of information on social media makes it difficult to do such checking manually. Computers can assess the veracity of contributors and content in a way that humans cannot. For example, they have the capacity to be trained using large volumes of historical material and once trained can work very quickly when a story breaks.

SocialSensor's experiments in the area of verification focused on both content and contributors and looked at both textual and visual material. The focus on visual content was a result of the high priority the project's stakeholders gave to being able to better find relevant multimedia and the serious consequences to news organisations of publishing fake images. The project started to develop techniques that could distinguish fake from real images that had been tweeted about actual news events by looking at both the images themselves and the textual content around them. This was done by training the software using a corpus of fake and real tweets from Hurricane Sandy and the Boston Marathon bombings. Once trained, the program was asked to assess a series of tweets it had not previously seen. It did a reasonably good job, achieving around a 75 per cent success rate, but only did so, however, in controlled conditions (Boididou et al. 2014). When more complexity was added (e.g. if the software was trained on one event and tested on another) its success rate was little better than random guesswork. With better training the success rate should improve; however, these early results go to show that there are considerable challenges in automatically giving credibility scores to individual pieces of content on social media.

This is part of the reason why, at the time of writing, the SocialSensor software only gives credibility scores to contributors and not to individual pieces of content. With contributors there is more data to work with, for example analyses of their social media history and their network. In the project's experiments with verification, contributors' initial credibility scores were first computed by looking at their history, their popularity, and their influence, based on these metrics:

- Number of tweets.
- Frequency of tweets.
- Number of Twitter followers.
- Number of follows.
- Number of retweets achieved (Fletcher, Schifferes, and Thurman 2015).

Generally the higher the value for each of these metrics, the higher the contributor's initial credibility score.[6]

In order to test this part of the software a different approach was taken than in the experiments with fake Twitter images. This is because contributors can post a mixture of trustworthy and less trustworthy information. It was decided to test the software by asking real—human—journalists to give a score to contributors and then comparing their scores with those given by the software. In the first round of testing

**TABLE 2**

Weighted metrics used by SocialSensor to give an initial credibility score to social media contributors

| Metric | Weight |
| --- | --- |
| Number of tweets | 1 |
| Frequency of tweets | 2 |
| Number of retweets | 2 |
| Ratio of followers to followings | 3 |
| Number of followers | 4 |
| Popularity* | 5 |
| Verified by Twitter | 5 |

*Defined as: "the number of days since the account was created divided by the number of followers since then" (Fletcher, Schifferes, and Thurman 2015).

the scoring came out pretty close, with mean scores of 5.67 (produced by journalists) and 5.71 (by the software). However, there were significant differences in some of the evaluations, indicated by the standard deviation of the scores produced by the software (2.45) against 2.10 by the journalists (Fletcher, Schifferes, and Thurman 2015). For example, there were some contributors who were relatively inactive on Twitter but who were—the human journalists thought—highly credible. In those cases, the journalists were ignoring some signals (like inactivity) and paying attention to others (like the high quality of their followers). So the metrics were calibrated—adding new ones and weighting them (see Table 2). This resulted in an improved set of scores, although the software remained reluctant to give any contributor 8 or 9 out of 10 on our scale.

## Conclusions

Journalists are drawing on increasing volumes of social media content in their sourcing practices, and, at the same time, we are seeing the emergence of the "digital nose for news". At least one of the tools that form part of this emergence, SocialSensor, relies on the input of journalists to power many of its processes, and it has been measuring its success by the "ground truth" of journalists' perceptions and their current output. In that sense, it is a tool that has been created in the media's own image. This is not surprising as SocialSensor was designed explicitly to mimic journalistic judgements on newsworthiness in its discovery of trending news topics. It should be noted, however, that SocialSensor also allows journalists to search across social media for topics that they are particularly interested in or that they are already following closely. Whether they will use this capacity to develop unconventional sources and move beyond established journalism norms remains to be seen.

This article has revealed some of the inputs and instructions SocialSensor relies on. It prioritises stories that show a spike of interest in the short term, and stories about people, places, and organisations; and it listens to those who are vocal and have an audience—many of whom are men in the media. For reasons we have already put forward, these characteristics are open to criticism. Is there, then, an alternative? Well, yes and no. Changes to these characteristics are possible, yes, but may result in

disadvantages that outweigh any benefits they bring. For example, the time window through which stories pass could be widened, but with the cost that the algorithm is compromised in its ability to detect breaking news events (SocialSensor 2013), something which is of great interest to news organisations. Stories mentioning people, places, and organisations could have their prioritisation rescinded, but to the detriment of the software's ability to detect effectively the stories being discussed on social media (Aiello et al. 2013). A different set of newshounds could be monitored. How though would they be chosen and by whom? The transparency and accountability of SocialSensor's selection mechanism—based on social media contributors' popularity, productivity, and ability to engage—has considerable merit. More importantly, we know that the current selection mechanism does actually work, because, as our experiments have confirmed, there appears to be a log-normal distribution of people who disseminate news (see also Hindman 2008; Lehmann et al. 2013). The results of the SocialSensor project confirm some of the "contradictions of convergence" (Murdock and Golding 2002, 111): specifically, how social media amplifies and concentrates existing trends in news as much as it enlarges the discourse. The increasing use of social media as news sources, whether automated or not, is no guarantee of a correction to the gender inequalities, or of the insularity of the mainstream media. Rather, we would emphasise the importance of changes to the demography of the journalism profession and to its practices.

In the SocialSensor project we found some of the greatest potential for computer software to be in the area of verification—to help combat the significant problem with fake social media content. When William Lee, the early pioneer of industrial automation, showed his mechanised knitting machine to Queen Elizabeth I, she refused him a patent, saying that "to enjoy the privilege of making stockings for everyone is too important to grant to any individual" (Calvertonvillage.com n.d.). Given the centrality of verification to what we expect of our news media, we might agree that no individual entity—computational or otherwise—should have a monopoly on determining fact from fiction. For now at least, it seems as though software is unlikely to be able to take into account all the nuances of media verification. People, whether we call them journalists or not, will continue to be required to make that final judgement on truth and trust.

## DISCLOSURE STATEMENT

No potential conflict of interest was reported by the authors.

## FUNDING

This work was supported by the European Union [grant number 287975], and partially supported by a VolkswagenStiftung Freigeist Fellowship.

## NOTES

1. See https://itunes.apple.com/gb/app/socialsensor/id906630117?mt=8.
2. See http://www.socialsensor.eu.

3.  Although Twitter was the first social media network mined by SocialSensor, subsequent iterations have incorporated Facebook, YouTube, and Flickr in order to accommodate journalists' desire for multimedia content from a wide range of platforms.
4.  The newshounds database is not static but allows for additions and relegations.
5.  Users of the software are able to link it to their Twitter account.
6.  In the current version of the software, contributors' initial credibility scores are dynamically adjusted up or down depending on whether their contributions appear in the stories detected by SocialSensor.

## REFERENCES

Aiello, Luca Maria, Georgios Petkos, Carlos Martin, David Corney, Symeon Papadopoulos, Ryan Skraba, Ayse Göker, Ioannis Kompatsiaris, and Alejandro Jaimes. 2013. "Sensing Trending Topics in Twitter." *IEEE Transactions on Multimedia* 15 (6): 1268–1282.

Beaumont, Claudine. 2009. "New York Plane Crash: Twitter Breaks the News, Again." *The Telegraph*. January 16. http://www.telegraph.co.uk/technology/twitter/4269765/New-York-plane-crash-Twitter-breaks-the-news-again.html

Boididou, Christina, Papadopoulos Symeon, Kompatsiaris Yiannis, Schifferes Steve, and Newman Nic. 2014. "Challenges of Computational Verification in Social Multimedia." In *Proceedings of the 23rd International Conference on World Wide Web (WWW '14 Companion)*, edited by Chin-Wan Chung, Andrei Broder, Kyuseok Shim, and Torsten Suel, 743–748. Geneva, Switzerland: International World Wide Web Conferences Steering Committee.

Broersma, Marcel, and Todd Graham. 2013. "Twitter as a News Source: How Dutch and British Newspapers Used Tweets in Their News Coverage, 2007–2011." *Journalism Practice* 7 (4): 446–464.

Burgess, Jean, Farida Vis, and Axel Bruns. 2012. "How Many Fake Sandy Pictures Were Really Shared on Social Media?" *The Guardian*, 6 November. http://www.theguardian.com/news/datablog/2012/nov/06/fake-sandy-pictures-social-media

Callison-Burch, Chris. N.d. "Distilling Collective Intelligence from Twitter." Crowdsourcing-Class.Org. Accessed August 6 2015. http://crowdsourcing-class.org/slides/twitter-first-story-detection.pdf

Calvertonvillage.com. N.d. "William Lee." Accessed August 22 2015. http://www.calvertonvillage.com/Willlee.html

Fletcher, Richard, Steve Schifferes, and Neil Thurman. 2015. "Evaluating the Truthmeter: Improving Automated Social Media Contributor Credibility Assessments within the Context of Journalism." Paper presented at the Artificial Intelligence, Robots and Media Conference, University of Dubrovnik, Dubrovnik, Croatia, 30–31 October.

Frey, Carl Benedikt, and Michael A. Osborne. 2013. "The Future of Employment: How Susceptible Are Jobs to Computerization?" Oxford Martin School, University of Oxford. http://www.oxfordmartin.ox.ac.uk/downloads/academic/The_Future_of_Employment.pdf

Harcup, Tony. 2015. *Journalism: Principles and Practice*. 3rd ed. London: Sage Publications.

Hermida, Alfred. 2015. "Filtering Fact from Fiction: A Verification Framework." In *Ethics for Digital Journalists: Emerging Best Practices*, edited by Lawrie Zion and David Craig, 59–73. New York: Routledge.

Hindman, Matthew. 2008. *The Myth of Digital Democracy*. Princeton: Princeton University Press.

Hunt, Stephen, Schifferes Steve, Thurman Neil, Newman Nic, Fletcher Richard, and Corney David. 2015. "Auto-Detection of News on Twitter: Tuning and Testing the SocialSensor App." Paper presented at the Artificial Intelligence, Robots and Media Conference, University of Dubrovnik, Dubrovnik, Croatia, 30–31 October.

Lehmann, Janette, Castillo Carlos, Lalmas Mounia, and Zuckerman Ethan. 2013. "Finding News Curators in Twitter." In *Companion Publication of the IW3C2 WWW 2013 Conference*, edited by Leslie Car, Alberto H. F. Laender, Bernadette F. Lóscio, Irwin King, Marcus Fontoura, Denny Vrandeèiæ, Lora Aroyo, José Palazzo M. de Oliveira, Fernanda Lima, Erik Wilde, 863–869. Rio de Janeiro: Companion Publication of the IW3C2 WWW 2013 Conference. ISBN 978-1-4503-2038-2.

Moon, Soo Jung, and Patrick Hadley. 2014. "Routinizing a New Technology in the Newsroom: Twitter as a News Source in Mainstream Media." *Journal of Broadcasting & Electronic Media* 58 (2): 289–305.

Murdock, Graham, and Peter Golding. 2002. "Digital Possibilities, Market Realities: The Contradictions of Communications Convergence." *Socialist Register* 38: 111–129.

Paulussen, Steve, and Raymond A. Harder. 2014. "Social Media References in Newspapers: Facebook, Twitter and YouTube as Sources in Newspaper Journalism." *Journalism Practice* 8 (5): 542–551.

Schifferes, Steve, Nic Newman, Neil Thurman, David Corney, Ayse Göker, and Carlos Martin. 2014. "Identifying and Verifying News through Social Media: Developing a User-Centred Tool for Professional Journalists." *Digital Journalism* 2 (3): 406–418.

Silverman, Craig, ed. 2014. *Verification Handbook*. Maastricht: European Journalism Centre.

SocialSensor. 2013. "DySCO." 23 August http://www.socialsensor.eu/project/dyscos

Thunderclap. N.d. "Homepage." https://www.thunderclap.it/?locale=en

Wallsten, Kevin. 2015. "Non-Elite Twitter Sources Rarely Cited in Coverage." *Newspaper Research Journal* 36 (1): 24–41.

# APPROPRIATING SOCIAL MEDIA
## The changing uses of social media among journalists across time

**Monika Djerf-Pierre** ⓘ , **Marina Ghersetti** and **Ulrika Hedman**

*The hype over social media and the rapid expansion of social networking and micro-blogging in recent years can easily lead us to believe that all journalists are online, chatting and tweeting, all the time. Previous research, however, indicates that the spread of social media differs between groups of journalists and that social media usage is related to the journalist's age, gender, type of work and workplace. This paper advances our understanding of how journalists appropriate social media in their professional lives by examining the changes in social media use across time. We examine if and how the perceived usefulness of social media for various professional purposes changes over time, and if different categories of journalists change their usage in different ways. The theoretical perspective draws from theories on the appropriation and adoption of technologies. The empirical material consists of Web survey data collected in 2012 and 2014, targeting representative samples of Swedish journalists. Our findings show that the use of social media increased slightly between the two surveys but the expansion was levelling off in 2014. Some early adopters were abandoning social media, and there was a noticeable decline in the journalists' valuation of social media affordances.*

## Introduction

Journalists' approach to and use of social media has been subjected to intense attention among media professionals and scholars over the past years. Increasing social networking and micro-blogging is understood to contribute to changing journalistic norms, ideals and practices. Nevertheless, the knowledge about how often and for what purposes journalists use social media, and how social media affect newsroom and professional cultures, is still limited.

A range of studies has been conducted in this area applying different methods, of which the majority are based on ethnographic newsrooms observations, expert interviews and content analysis. In comparison, studies building on survey data are few (Gulyas 2013; MacGregor et al. 2011; Spyridou et al. 2013) and statistically representative studies are rare. One exception is Hedman and Djerf-Pierre's (2013) analysis of professional attitudes and practices related to social media among Swedish journalists. Representative studies of changing social media usage among journalists across time

are missing altogether. In this paper, we present such a longitudinal analysis, examining changing attitudes and practices related to social media among Swedish journalists between 2012 and 2014, based on extensive survey data.

## Understanding the Apropriation of Social Media

Research on how new media technologies arise and are adopted is divided along familiar ontological and epistemological lines. A main dispute concerns how technology relates to the "social", i.e. the relationship between technological artefacts and social actions, actors and institutions (see Faraj and Azad 2012). This division is often conceptualized in terms of the technological determinism–constructivism dimension. Technological constructivism appears in radical and soft ("diluted") versions (Hutchby 2001a, 2001b). This paper draws mainly on the soft versions, which include the technology appropriation (Carroll et al. 2001, 2002; Orlikowski 2000) and the technology affordance approaches (Faraj and Azad 2012; Hutchby 2001a, 2001b) that emphasize the constitutive and constituting duality of technologies and the relational and recursive relationship between artefacts and the social.

## The Technology Affordances Approach

The technology affordances approach can be described as an attempt at reconciling the "opposing poles of realism and constructivism" (Hutchby 2001b, 444). Technologies have materiality that affords (allows/encourages) certain uses and restricts others but the use of technology is also a social practice where technologies have social values and norms attached to them. As such, affordance is *a* relational concept; a relation between technologies (artefacts) and socially situated users. Faraj and Azad conclude that:

> Technology affordances are action possibilities and opportunities that emerge from actors engaging with a focal technology. Affordances are rooted in a relational ontology that gives equal play to the material as well as the social. (Faraj and Azad 2012, 238)

A key point of departure in the affordances approach is that technologies have a materiality that is independent of the actual user. This materiality allows for certain uses but restricts others. You can do certain things with a mobile phone (make phone calls, send text messages, use social media, etc.) but not eat soup, make toast or mow the lawn. Similarly, social media have certain affordances that journalists largely but not wholly recognize. Affordances are thus not purely functional but also connected to the social values associated with using a technology. Different users recognize different possibilities and restrictions. Social media use is thus a practice that involves social norms that prescribe not only what a journalist can do with a certain technology, but also how a social group, such as a profession or organization, values different usages. If having a large network is essential to a journalist, the key social value of a micro-blog such as Twitter rests with the potential of assembling a large group of followers. In a previous study, we found that the perceived usefulness of social media among journalists was

high (Hedman and Djerf-Pierre 2013). Still, of the 14 suggested affordances, only a few were widely appreciated: 60 per cent of journalists use social media to "follow ongoing discussions", but only 26 per cent for "personal branding" (Hedman and Djerf-Pierre 2013).

Social media are technologies. As technological artefacts, they consist of "a bundle of material and symbol properties packaged in some socially recognizable form, e.g., hardware, software, techniques" (Orlikowski 2000, 408). Social media are, however, not one single entity. Although all social media share some social (interaction, networking) and technical features, different social media such as micro-blogs (e.g. Twitter), social networks (e.g. Facebook, LinkedIn) or media-sharing sites (YouTube, Instagram) have different affordances and consequently different meanings attached to them. Moreover, these meanings are continually renegotiated in social practice (cf. Orlikowski 2000). We must thus avoid static conceptions of both uses and technologies. A key aim for the study of journalists' appropriation of social media is thus to examine if and how journalists' assessments and valuations of different affordances change across time.

## The Technology Appropriation Approach

The technology appropriation approach specifically highlights the processual and temporal aspects, emphasizing that users' interaction with a technology is recursive— that users in their recurrent practices shape the technology structure that in turn shapes their use over time. The technology appropriation approach is closely related to the normalizing approach often referred to in research on social media in journalism (e.g. Hedman 2015; Lasorsa, Lewis, and Holton 2012; Singer 2005). Normalizing is understood as the process by which journalists normalize social media to fit traditional practices and professional ideals in journalism, or the other way around—normalize journalism to fit the evolving practices of social media.

Technology structures emerge from people's repeated and situated interaction with particular technologies. Orlikowski (2000, 407) terms "these enacted structures of technology use technologies-in-practice" and they consist of "sets of rules and resources that are (re)constituted in people's recurrent engagement with the technologies at hand". Carroll et al. (2001) make a distinction between "technologies-as-designed" and "technologies-in-use" and identify three possible outcomes of processes of technology appropriation: non-appropriation, appropriation and disappropriation. The first entails that users refrain from using the designed technology and avoid initiating a process of appropriation, the second that an actor engages with the technology and thus reshapes the technology in the process of use, the latter that usage is discontinued for various reasons.

In a previous study, we identified three categories of social media users among journalists: enthusiasts, pragmatics and sceptics (Hedman and Djerf-Pierre 2013). Across time, the group of enthusiasts who have fully embraced a life online, being connected and twittering or blogging continuously, should become larger. Sceptical social media avoiders may be gradually disappearing. We certainly also recognize the possibility for discontinuation: are there journalists who have stopped or decreased their use of social media?

A key aspect of technology appropriation is that it is a process. We need to examine which factors influence the rate of adoption among different groups of users as well as the qualitative aspects of usage. Personal factors are obviously important; in the classic study of the "diffusion of innovations" in social systems, Rogers ([1962] 1983) distinguishes specific adopter categories based on how quickly they come to adopt a new innovation: (1) innovators, (2) early adopters, (3) early majority, (4) late majority, and (5) laggards. We know from the research on the diffusion of innovations that technologies spread through social systems in certain patterns. The diffusion studies specifically point to the importance of personal motivations and competences. The early adopters of technology often have higher social status, greater social connections (networks) and a more cosmopolitan outlook (Rogers [1962] 1983). With regards to information and communications technology, we also know from extant research that age is a key factor for adoption.

Personal motivations and competences are important but organizational, professional and societal factors also influence how journalists adopt social media in their everyday lives. To appropriate social media is not just to start using the technology (such as starting a Twitter account); it is to learn a social practice. Social practices are connected to social norms, which are produced and negotiated among socially situated users. Journalists' appropriation of social media in their professional lives is thus influenced by personal, organizational, and professional identities and positions. Personal factors include age and gender which have been previously identified as important predictors of journalists' social media use (Hedman 2015). Journalists' use of social media is also connected to professional values and norms. We know from previous research that journalists who are positive to audience adaptation and who embrace the commodification of journalists through personal branding are keener to use social media. On the other hand, social media use is not related to the classic professional norms of objectivity and scrutiny (Hedman and Djerf-Pierre 2013).

Management and organization studies have shown that organizational factors such as work tasks, policies and leadership influence technology use (e.g. DeSanctis and Poole 1994) and based on previous studies we expect journalists' appropriation of social media to be related to their work tasks, beat and workplace (Hedman 2015; Hedman and Djerf-Pierre 2013). Social media use is particularly complex to handle from an organizational perspective because of the fluid boundaries between the private and professional that social media entail. Boundary blurring is a specific affordance of social media, which may attract or repel individual users. As we have shown in another study, not all journalists are equally keen to be on public display 24/7. Indeed, some journalists use social media only because of organizational requirements (Hedman and Djerf-Pierre 2013). Some media organizations are particularly keen to promote social media use among their staff (in Sweden the tabloid press and public service radio).

## Changes in Journalists' Use of Social Media Across Time

The relational and recursive approach to how social media as technologies are appropriated by journalists recognizes that: (1) social media as technologies have a materiality that allows and restricts specific usages; (2) the materiality of social media as technologies evolves and changes across time as a result of social actors' engagement

with them; (3) social media as technologies have different meanings for different categories of users; (4) individual journalists' interpretations and uses of social media technologies derive from personal, organizational, and professional identities and positions; (5) and meanings and uses are negotiated and transformed across time. The aim of this paper is to study changing attitudes and practices related to social media among Swedish journalists between 2012 and 2014. Accordingly, our research questions are:

**RQ1:** To what extent do journalists use social media, and how has the usage changed across time?

**RQ2:** How are the changing uses of social media related to journalists' personal (age, gender) and organizational (type of work, workplace location, workplace) identities and positions?

**RQ3:** Which social media affordances do journalists recognize and value, and how does the valuation change across time?

## Method

The study draws from a Web survey of a panel of Swedish journalists. The Journalist Panel was initiated by the Department of Journalism, Media and Communication, University of Gothenburg, and aims to examine changes in journalists' views, opinions and practices across time. The panel was initially set up in 2011/2012. With the purpose of constructing a strategic sample representing Swedish journalists, journalists' email addresses were collected in a systematic search. From the collection of 6635 journalists representing a broad range of media, incorporating about a third of all Swedish journalists, the recruitment process ended with 1971 panel participants. A comparison between the panel members and the members of the Swedish Union of Journalists, of which about 80 per cent of all Swedish journalists are members, shows that the Journalist Panel is largely representative on key variables such as age, gender, social background, education and journalism education.

The journalists in the panel were asked questions about their social media use and attitudes related to social media on two occasions. In June 2012, 1305 panel members answered the survey, providing a net response rate of 66 per cent. In June 2014, 957 panel members answered the survey with a net response rate of 49 per cent. One explanation for the lower response rate in 2014 is that between 2012 and 2014 many panel members may have retired, changed workplace, been on parental leave, become unemployed, etc., and hence no longer received the survey.

The construction of the Journalist Panel makes it possible to compare changes in social media use and attitudes not only across time but also at an individual level. The net sample of the 2012 and 2014 surveys is 1689, of which 573 individuals have answered questions on social media in both surveys, providing a net response rate in this respect of 34 per cent.

## Findings

Given the hype surrounding the influence of social media in journalism, it is easy to assume that all journalists use social media all the time and for a range of profes-

**TABLE 1**
The use of social media for professional purposes in 2012 and 2014 (%)

| Professional use | 2012 | 2014 | Difference |
|---|---|---|---|
| 24/7 | 17 | 20 | +3 |
| Daily | 40 | 45 | +5 |
| Weekly | 17 | 11 | −6 |
| Monthly | 7 | 7 | − |
| Never | 19 | 17 | −2 |
| Total | 100 | 100 | |
| N | 1305 | 957 | |

The respondents were asked: "How often do you use social media for professional purposes?" The response alternatives were: "Never", "Now and then each month", "Now and then each week", "Now and then every day" and "All of the time" (24/7).

sional purposes (cf. Hermida 2013, 2014). However, the Journalist Panel survey data show that this is not always the case, and that some Swedish journalists have decreased their use of social media across time or even discontinued using social media altogether.

## Slight Increase in Use but Stage Usage Patterns (RQ1)

We first examine to what extent journalists use social media for professional purposes. The total level of social media use among Swedish journalists was fairly high already in 2012—usage has increased only slightly across time. In 2012, 57 per cent of all journalists used social media at least daily and in 2014, the share had increased to 65 per cent (Table 1). Still, about one out of five journalists claim they never use social

**TABLE 2**
Individual changes in social media usage, 2012 and 2014 (number of respondents)

| Professional use 2012 | Professional use 2014 | | | | | N |
|---|---|---|---|---|---|---|
| | 24/7 | Daily | Weekly | Monthly | Never | |
| 24/7 | 55 | 28 | 3 | 0 | 11 | 97 |
| Daily | 52 | 144 | 17 | 3 | 20 | 236 |
| Weekly | 11 | 44 | 25 | 7 | 10 | 97 |
| Monthly | 2 | 9 | 3 | 15 | 6 | 35 |
| Never | 11 | 38 | 14 | 14 | 31 | 108 |
| N | 131 | 263 | 62 | 29 | 78 | 573 |

The number of respondents presenting the same level of use in 2012 and 2014 are shown in italics, and the largest changes (increased/decreased use) between 2012 and 2014 are displayed in bold numbers. Increasing use (in **bold**) = 35 per cent (N = 198); same level of use (in *italics*) = 47 per cent (N = 270); decreasing use = 18 per cent (N = 105). The respondents were asked: "How often do you use social media professionally?" The response alternatives were: "Never", "Now and then each month", "Now and then each week", "Now and then every day" and "All of the time" (24/7). The answers from the 2012 and 2014 surveys are compared with regard to differences in the level of use. Only those who have answered both surveys are included in the analysis (N = 573).
Measure of association chi-square value: 233.157*** ($p < 0.001$).

media, neither privately nor for work—just about as many as the share of journalists that use social media constantly (24/7).

An analysis of the individual changes in use over time (Table 2) shows that 35 per cent of the journalists increased their use of social media, 47 per cent remained at the same level of usage and 18 per cent did in fact decrease their use of social media from 2012 to 2014. The latter category is mostly found within the groups of previous daily and 24/7 users, and there are journalists in these groups giving up social media altogether.

When asked about the use of specific social media platforms, the usage levels remain quite stable across time. Only Twitter, LinkedIn and chat forums show an increase over time (Figure 1). The most popular social media platform among journalists in both 2012 and 2014 is Facebook, which almost two out of three journalists use on a

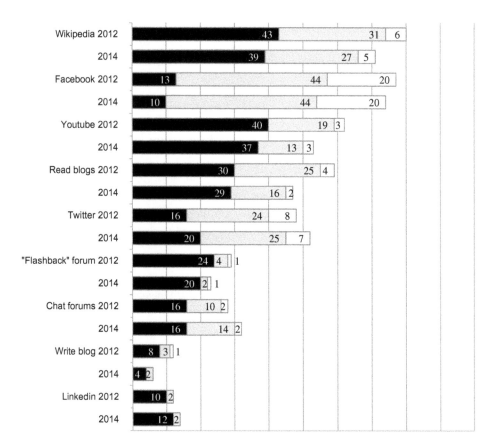

**FIGURE 1**

The use of different social media (%) in 2012 (N = 1305) and 2014 (N = 957). Black series: weekly use; grey series: daily use; white series: 24/7 use. The respondents were asked: "How often do you use...?" The response alternatives were: "Never", "Now and then each month", "Now and then each week", "Now and then every day", and "All of the time" (24/7). The "Flashback" forum is a Swedish forum targeting a broad range of topics, including "national politics" (often with a strong populist and anti-immigration sentiment), "(ongoing) crime news" (often speculative and sensationalist) and "entertainment gossip"

daily basis. Wikipedia is also popular, presumably for research purposes. Some social media platforms display a decrease in usage. Most noteworthy is the decline in reading and writing blogs.

## Across Time: Late Adopters Create a Levelling Effect (RQ2)

In 2012 we found significant gender differences in social media use with women as the most avid users (Table 3). In 2014, the gender difference had disappeared as more men showed an increased usage.

**TABLE 3**
Social media use among groups of journalists, 2012–2014 (%)

| | Frequent use | | | | Changes in use | | | | |
| | 2012 | | 2014 | | 2012–2014 | | | | |
| | % | Significance | % | Significance | – | = | + | Sum | N |
| --- | --- | --- | --- | --- | --- | --- | --- | --- | --- |
| All | 57 | | 65 | | 18 | 47 | 35 | 100 | 573 |
| Gender | | 0.10*** | | ns | | | | | |
| Women | 63 | | 63 | | 18 | 48 | 34 | 100 | 276 |
| Men | 53 | | 66 | | 19 | 46 | 35 | 100 | 295 |
| Age | | −0.24*** | | −0.10** | | | | | |
| 29 and younger | 65 | | 55 | | 29 | 57 | 14 | 100 | 7 |
| 30–39 | 74 | | 70 | | 29 | 45 | 26 | 100 | 87 |
| 40–49 | 62 | | 69 | | 16 | 46 | 38 | 100 | 143 |
| 50–59 | 54 | | 67 | | 18 | 47 | 35 | 100 | 190 |
| 60 and older | 41 | | 53 | | 14 | 49 | 37 | 100 | 141 |
| Workplace location | | 0.17*** | | ns | | | | | |
| Metropolitan | 58 | | 63 | | 19 | 47 | 34 | 100 | 244 |
| Other regions | 57 | | 66 | | 18 | 47 | 35 | 100 | 329 |
| Type of work | | | | | | | | | |
| Web/online | 67 | 0.10*** | 67 | ns | 12 | 48 | 40 | 100 | 12 |
| Radio | 65 | 0.15*** | 69 | ns | 26 | 43 | 31 | 100 | 88 |
| Multimedia | 69 | 0.05* | 86 | ns | 17 | 33 | 50 | 100 | 6 |
| Television | 58 | 0.08*** | 73 | ns | 21 | 39 | 40 | 100 | 52 |
| Newspaper (print) | 54 | 0.20*** | 62 | 0.08* | 17 | 48 | 35 | 100 | 387 |
| Workplace | | | | | | | | | |
| Radio | 67 | 0.16*** | 69 | ns | 23 | 45 | 32 | 100 | 83 |
| Television | 57 | 0.07** | 71 | ns | 21 | 39 | 40 | 100 | 52 |
| Tabloid | 58 | 0.05* | 69 | ns | 13 | 39 | 48 | 100 | 23 |
| Metropolitan news | 50 | ns | 57 | ns | 11 | 64 | 25 | 100 | 45 |
| Local/regional news | 58 | 0.17*** | 67 | ns | 15 | 47 | 38 | 100 | 100 |
| Freelance | 48 | ns | 52 | 0.10** | 21 | 41 | 38 | 100 | 73 |
| N | 1305 | | 957 | | | | | | |

The respondents were asked: "How often do you use social media professionally?" The response alternatives were: "Never", "Now and then each month", "Now and then each week", "Now and then every day" and "All of the time" (24/7). The column "Frequent use" shows the share of respondents that use social media professionally "Daily" or "All the time" (24/7) each year, respectively. The answers from the surveys of 2012 and 2014 are compared with regard to differences in level of use: decrease (–), same (=) or increase (+).
$*p < 0.05$; $**p < 0.01$; $***p < 0.001$, ns: not significant. The significance tests relate to two different measures of association: Cramer's $V$ for type of work, beat and workplace, each category tested separately (working at/as = 1, other = 0), and Tau-c for gender, age and workplace location.

As expected, age proves to be a significant predictor of social media use among journalists (Table 3). In 2012, the age effect was more or less linear, so that social media use was high among young and low among older journalists. In 2014, the age effect was still significant but now displays a curvilinear pattern, with the age groups 30–39, 40–49 and 50–59 as the most frequent users. Between 2012 and 2014, the proportion of frequent users even decreased among young journalists while the oldest (60 and older) journalists increased their use of social media quite significantly. Furthermore, there were significant differences in social media usage related to type of work and workplace in 2012 but not in 2014. The overall results thus indicate a levelling out effect as late adopters increase their professional use while some early adopters lose interest and discontinue or decrease their engagement with social media.

### Social Media Perceived as Less Valuable for Professional Tasks (RQ3)

One of the most interesting findings in this study is that the perceived usefulness of social media for different professional purposes is dropping dramatically (Table 4). For example, the usefulness of social media for finding sources/interviewees decreased from 59 per cent (somewhat or very important) in 2012 to 33 per cent in 2014. The decline in importance for audience feedback and crowdsourcing is equally dramatic—from 56 and 36 per cent in 2012 to 38 and 19 per cent in 2014, respectively.

**TABLE 4**
Valuation of the usefulness of social media for different purposes, 2012–2014 (%)

|  | "Important" [1] | | Changes in valuation of importance[2] | | | | |
|---|---|---|---|---|---|---|---|
|  | 2012 | 2014 | – | = | + | Sum | N |
| Finding sources/interviewees | 59 | 33 | 50 | 34 | 16 | 100 | 573 |
| The managers/editors want it | 36 | 44 | 33 | 37 | 30 | 100 | 573 |
| Getting feedback from colleagues | 35 | 23 | 41 | 37 | 22 | 100 | 573 |
| Getting feedback from the audiences | 56 | 38 | 42 | 37 | 21 | 100 | 573 |
| Personal branding | 43 | 27 | 44 | 37 | 19 | 100 | 573 |
| Crowdsourcing (getting help from others) | 36 | 19 | 45 | 37 | 18 | 100 | 573 |
| Promoting and distributing others' stories | 44 | 38 | 33 | 40 | 27 | 100 | 573 |
| Promoting and distributing own stories | 52 | 43 | 35 | 40 | 24 | 100 | 573 |
| Following ongoing news/events | 59 | 51 | 36 | 40 | 24 | 100 | 573 |
| Networking | 51 | 45 | 42 | 40 | 18 | 100 | 573 |
| Research | 57 | 44 | 38 | 41 | 21 | 100 | 573 |
| Finding ideas/angles | 58 | 44 | 38 | 41 | 21 | 100 | 573 |
| Trendspotting | 58 | 44 | 39 | 41 | 20 | 100 | 573 |
| Follow ongoing discussions | 69 | 56 | 37 | 42 | 21 | 100 | 573 |
| Organizational branding | 61 | 47 | 38 | 44 | 16 | 100 | 573 |

[1] N (2012) = 1305, N (2014) = 957. The respondents were asked: "How important are the following uses of social media for you?" The response alternatives were: "Not important at all", "Not so important", "Neither important/nor unimportant", "Somewhat important" and "Very important". The column "Important" shows the share of all respondents that value the affordance as "Somewhat important" and "Very important" each year.
[2] The 2012 and 2014 surveys are compared with regard to the differences in the level of importance: decrease (–), same (=) or increase (+). Only those who have answered both surveys are included in the analysis of the changes in valuation (N = 537).

The only category that clearly increases across time is the use of social media because "the managers/editors want it". This is indicative of the strong organizational pressures to be active in social media experienced by many journalists, a pressure that seems to have increased over time. In 2012, 36 per cent stated that this was a major reason to use social media; in 2014, the proportion had increased to 44 per cent.

When analysing the changes at the individual level, the overall results show that about 4 out of 10 journalists perceive social media as less important in 2014 than in 2012 (Table 4). A further analysis of the longitudinal data (not in the table) indicates, not surprisingly, a strong correlation between changes in the valuation of social media for different purposes and changes in the level of use. Decreasing use is thus connected to a diminishing appreciation of social media as a journalistic tool at the individual level, and *vice versa*.

## Conclusion: Normalization, Domestication and Disenchantment

Our findings suggest that the hype around social media in journalism might be coming to an end. Social media demonstrates the same pattern of dispersion among journalists as most new technologies (Rogers [1962] 1983): after first having been adopted by a small group of innovators and early adopters, social media is now used on a daily basis by the great majority of Swedish journalists. At present, we have reached the point where the journalists who are still in the process of appropriating social media belong to the group of late laggards. In parallel, we witness what Carroll et al. (2001) identify as disappropriation, that is, journalists who abandon social media after a period of trying out and incorporating them into their daily professional practices.

The findings support the notion of a relational and recursive technology appropriation (Carroll et al. 2001, 2002; Orlikowski 2000), demonstrating that journalists' appropriation of social media is an ongoing process during which the affordances, i.e. the advantages and limitations, of the new technology are tried out and reconsidered. The ending of the hype and the levelling out of usage and perceived affordances are, possibly, additional indications of the ultimate normalization of social media in journalism.

Furthermore, the analysis shows that the impacts of personal and organizational factors on social media use change over time. According to Hedman and Djerf-Pierre's (2013) earlier study, age, work place and type of work had significant effects on the use of social media. In the present study, the 2012 survey yielded similar results. In the 2014 survey, only the age factor remained as significant. In 2012, young journalists were the most frequent users of social media. In 2014, the highest levels of usage were found among journalists aged 40–59. The arrival of late adopters seems consequently to have had a domestication effect on social media usage as a whole, in the sense that the technology has been integrated into the everyday life of most journalists and adapted to their daily practices.

Finally, and rather unexpectedly, journalists' evaluation of the affordances of social media dropped considerably over the period 2012–2014. Decreasing valuations strongly correlate with declining use of social media at the individual level. The appeal of social media has apparently diminished for some journalists. The excessive optimism from 2012 seems to be gone. The 2012 answers to our survey were possibly not just

coloured by what journalists knew they could do with social media, but rather by what they thought and hoped to do.

The fact that the journalists who are abandoning social media tend to come from the group of former active users also indicates that there are journalists who "burn out" from being active social media users. Journalists who appear frequently in social media, the daily and 24/7 users, are more likely to be exposed to insults, net bullying and harassment online. Journalists also experience increasing organizational pressures to promote themselves and their work in social media, and not all journalists are positive about the commodification of journalists that takes place on social media. Altogether, the experience of social media seems to have engendered a more realistic conception of opportunities, constraints and complications, and, as a consequence, some journalists experience disenchantment with social media in their professional lives.

## DISCLOSURE STATEMENT

No potential conflict of interest was reported by the authors.

## FUNDING

This work was supported by Swedish Civil Contingencies Agency (MSB) [Project "Crisis Communication 2.0"]; FORTE The Swedish Council for Health, Working Life and Welfare [Project "The social journalist"].

## REFERENCES

Carroll, Jennie, Steve Howard, Frank Vetere, Jane Peck and John Murphy. 2001. *Identity, Power and Fragmentation in Cyberspace: Technology Appropriation by Young People.* ACIS 2001 Proceedings. Paper 6.

Carroll, Jennie, Steve Howard, Frank Vetere, Jane Peck, and John Murphy. 2002. *Just What Do the Youth of Today Want? Technology Appropriation by Young People.* Proceedings of the 35th Hawaii International Conference on System Sciences 2002.

DeSanctis, Gerardine, and Marshall Scott Poole. 1994. "Capturing the Complexity in Advanced Technology Use: Adaptive Structuration Theory." *Organization Science* 5 (2): 121–147.

Faraj, Samer, and Bijan Azad. 2012. "The Materiality of Technology: An Affordance Perspective." In *Materiality and Organizing: Social Interaction in a Technological World*, edited by Paul M. Leonardi, Bonnie A. Nardi and Jannis Kallinikos, 237–258. Oxford: Oxford University Press.

Gulyas, Agnes. 2013. "The Influence of Professional Variables on Journalists' Uses and Views of Social Media." *Digital Journalism* 1 (2): 270–285.

Hedman, Ulrika. 2015. "J-Tweeters." *Digital Journalism* 3 (2): 279–297.

Hedman, Ulrika, and Monika Djerf-Pierre. 2013. "The Social Journalist." *Digital Journalism* 1 (3): 1–18.

Hermida, Alfred. 2013. "#Journalism." *Digital Journalism* 1 (3): 295–313.

Hermida, Alfred. 2014. "Twitter as an Ambient News Network." In *Twitter and Society*, edited by Katrin Weller, Axel Bruns, Jean Burgess, Merja Mahrt and Cornelius Puschmann, 359–372. New York: Peter Lang.

Hutchby, Ian. 2001a. *Conversation and Technology: From the Telephone to the Internet*. Cambridge: Polity.

Hutchby, Ian. 2001b. "Technologies, Texts and Affordances." *Sociology* 35 (2): 441–456.

Lasorsa, Dominic L., Seth C. Lewis, and Avery E. Holton. 2012. "Normalizing Twitter." *Journalism Studies* 13 (1): 19–36.

MacGregor, Philip, Aukse Balcytiene, Leopoldina Fortunati, Vallo Nuust, John O'Sullivan, Nayia Roussou, Ramón Salaverría, and Mauro Sarrica. 2011. "A Cross-Regional Comparison of Selected European Newspaper Journalists and Their Evolving Attitudes towards the Internet—Including a Single-Country Focus on the UK." *Journalism* 12 (5): 627–646.

Orlikowski, Wanda J. 2000. "Using Technology and Constituting Structures: A Practice Lens for Studying Technology in Organizations." *Organization Science* 11 (4): 404–428.

Rogers, Everett M. 1962/1983. *The Diffusion of Innovations* (3rd ed.). New York: The Free Press.

Singer, Jane B. 2005. "The Political J-Blogger." *Journalism* 6 (2): 173–198.

Spyridou, Lia-Paschalia, Maria Matsiola, Andreas Veglis, George Kalliris, and Charalambos Dimoulas. 2013. "Journalism in a State of Flux: Journalists as Agents of Technology Innovation and Emerging News Practices." *The International Communication Gazette* 75 (1): 76–98.

## ORCID

**Monika Djerf–Pierre** ⓘ http://orcid.org/0000-0001-7754-0636

# SOURCING THE BBC'S LIVE ONLINE COVERAGE OF TERROR ATTACKS

## Daniel Bennett ⓘ

*The live blog or live page has emerged as a bespoke format for covering breaking news online and represents an important "site" to investigate the impact of social media on news sourcing. This article assesses whether the adoption of live online coverage has facilitated a more "multiperspectival" journalism through the inclusion of "non-official" sources. The article is based on comparative content analyses of the BBC's coverage of Anders Behring Breivik's killing spree in 2011 and the Mumbai terror attacks in 2008. The article is strengthened by "triangulating" data from interviews, access to BBC documents and observation work at the BBC. The comparison reveals that the incorporation of eyewitness accounts has driven an increase in the inclusion of "non-official" sources in the BBC's live online coverage, but it suggests that further significant increases are unlikely. In particular, the use of Twitter was becoming normalised by 2011 both in the range of actors who use the microblogging tool and the BBC's approach to sourcing content from Twitter. The article suggests that journalists' approach to sourcing continues to depend as much on conceptions of news values and editorial approach as it does on the live blogging platform through which the news is disseminated.*

## Introduction

On 22 July 2011, an explosion ripped through the Norwegian capital, Oslo. Far-right extremist Anders Behring Breivik had detonated a car bomb outside the head-quarters of the Norwegian government. Eight people died in the blast. Breivik then travelled to the island of Utøya where the Labour Party was holding a summer youth camp. He killed 69 political activists before being arrested by Norwegian police. When the World Editor of BBC News online Nathalie Malinarich first saw images of damaged buildings in Oslo she decided to start a live page for the BBC.

It was nearly three years since the assault on the Indian city of Mumbai in November 2008—one of the first times a major off-diary breaking news event was covered by the BBC using live updates (see Bennett 2013, 145–166). In this attack, 10 Pakistani gunmen conducted a campaign of killing in the city. Allegedly orchestrated by militant group Lashkar-e-Taiba (LeT), the attack continued for more than 60 hours while Indian security forces undertook room by room clearances of the city's Taj Mahal Hotel and other occupied buildings; 174 people died and hundreds were wounded (BBC 2009).

In many socio-political respects, the incidents in Mumbai and Norway are very different "terror" attacks. From the perspective of media coverage, however, both stories represent examples of "off diary" stories or "event-driven news" (Lawrence 2000). In both cases, journalists were reporting a major breaking news situation in which an armed attacker or attackers engaged in acts of violence against the civilian population for a significant period of time. The BBC also decided to start a live updates page on both occasions in order to cover the news online.

Live updates, live blogs or live pages have become established reporting tools as a means to convey breaking news to an online audience for a number of traditional news organisations (Newman 2009, 51). The format generates significant online traffic to the BBC News website and live pages have been regarded by senior BBC managers and editors as strategically important to digital news. According to Nic Newman (2009, 51), a live blog facilitates the inclusion of contributions from a digitally connected public into online news, enabling "journalists and audiences [to] report events together, as they unfold". For Charlie Beckett, the adoption of live blogging formats was an indicator of a more general shift towards a model of "networked journalism" (Beckett 2010, 3). In response to an identified gap in the literature (see Thurman and Newman 2014; Thurman and Walters 2013), this article tests whether this format for "networked journalism" does facilitate the incorporation of "eyewitnesses" and the "former audience" or "non-official" sources into coverage of major terror attacks.

## News Sourcing and the Impact of Digital and Online Communication Tools

Many academic studies have focused on the nature of the journalist's sources as they are a critical component of news coverage. A rich literature testifies to the power and influence of "official" or "elite" governmental and institutional sources over the news. These "official" sources and "authorized knowers" (Fishman 1980, 51) are able to deny and provide access to information (Herman and Chomsky 1988, 18; Sigal 1973). They share reciprocal professional and economic goals with "socially" and "geographically" proximate journalists (Herman and Chomsky 1988; Gans 2004) and they are able to fulfil journalists' understanding of professional "objectivity" and practice (Hall et al. 1978, 57–59; Hallin 1989, 73). This model has been refined and challenged by research into the journalist–source relationship which has also considered the question from the perspective of "official" sources. These studies have illuminated the nuances of a relationship which could be characterised more as a "bargaining interplay", a shifting "tug of war" or "a dance" (Gans 2004, 116; Schlesinger and Tumber 1994, 24; Schudson 2003, 54; Sigal 1973, 5). Although their access is usually irregular rather than "habitual" (Goldenberg 1975; Molotch and Lester 1974), it has also been shown that "non-official" sources can influence the news (Gitlin 1980; Goldenberg 1975; Manning 2001).

The technological development of the internet and more specifically the ability of the "former audience" to publish online (Gillmor 2006, xxv) was regarded as an opportunity for journalists to reflect a broader range of voices and perspectives on news stories and events (Pavlik 2001, 24). Journalists would not only mediate the statements, thoughts and ideas of society's "authorised knowers" and "official sources", they would also be able

to use digital and social media tools to incorporate the contributions of the "former audi-ence" and "non-official" voices into their journalism on a more regular basis. Academic studies looking at whether this potential has been realised are beginning to emerge. For example, Hermida, Lewis, and Zamith (2014) have demonstrated how journalist Andy Car-vin used his Twitter account to include more "non-official" sources in his coverage of the 2011 uprisings in the Middle East. In the context of European newspapers, a tentative con-sensus is forming that "social media" is more likely to be used as a means of incorporating non-official sources into news content (Broersma and Graham 2013; Paulussen and Harder 2014). In contrast to the "hard news" focus of this article, however, the use of social media in this manner was particularly significant in "soft news". Perhaps more relevantly here, then, in a study of the Virginia Tech shootings, Wigley and Fontenot (2009) discovered that 6.5 per cent of the sources cited were both "non-official" and mediated through "new" technology, while for coverage of the Tucson, Arizona shootings (Wigley and Fon-tenot 2011) the percentage had risen slightly to 9.5 per cent. These studies looked at tele-vision news websites and newspaper coverage, but there are very few studies on the sourcing of live blogs or live pages. Moreover, these "sites" are of particular interest as it has been contended that this bespoke online news format makes it easier to incorporate a range of sources (Thurman and Rodgers 2014). Studying *The Guardian*'s live blogs, Thur-man and Walters (2013) observed that primary sources were more likely to be cited than media sources in live blogs (although "primary sources" are not distinguished as "official" or "non-official", making comparisons problematic here) while Thurman and Rodgers (2014) expressed optimism that these "live" formats contributed to greater citizen partici-pation in the news. This article contributes to this strand of research by providing compar-ative empirical evidence of the BBC's approach to sourcing the news on their live pages.

## Methodology

A content analysis was conducted in order to ascertain which sources of informa-tion were used on the BBC's live pages to cover the events in Mumbai and Norway. The BBC's live pages for the Mumbai crisis on 27 and 28 November 2008 (BBC 2008a, 2008b) and for the attack in Norway on 22 and 23 July 2011 (BBC 2011a, 2011b) were accessed. Live updates for the Mumbai attacks continued until 29 November but this page was halted after only 17 updates and disregarded here in order to provide a com-parison over a two-day period. Every source of information cited on these pages was coded—"a source" was interpreted in its "journalistic sense" to mean the origins of a piece of information used by a journalist (Phillips 2010, 89).

The live pages were coded at two levels. First, the sources cited by the BBC were coded as individuals, organisations or groups of people. Twelve categories were identified:

1. BBC (own correspondents, staff, departments).
2. Domestic Media (Indian in 2008/Norwegian in 2011).
3. Foreign Media.
4. News Agencies.
5. Domestic Official Sources (Indian in 2008/Norwegian in 2011).
6. Foreign Official Sources.

7. Experts.
8. Eyewitnesses (individual who had seen or heard the attacks taking place or who was trapped in the Indian hotels or on the island of Utøya).
9. Directly Connected Commenters (individuals in Mumbai or Oslo/Utøya near the scene of the event or relatives or other individuals directly involved in the story who were not acting in an official capacity for a government or business).
10. Audience Commenters (an individual who apparently had no direct involvement in the news story beyond observing it; this included expatriates who may have been deeply affected by the story).
11. Gunman/Attackers.
12. Other.

**Mumbai 27-28 Nov 2008: Sources cited in BBC live updates**

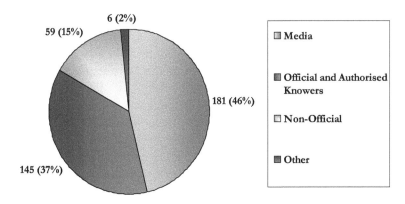

Total: 391 (100%)

**Norway 22-23 July 2011: Source types cited in BBC live updates**

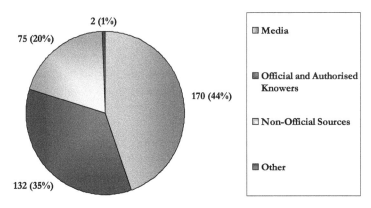

Total: 379 (100%)

**FIGURE 1**

Overview comparison of sources cited in BBC live updates. (Key reads clockwise from top of pie chart)

In Figure 1, categories 1–4 are grouped together as "media" sources, 5–7 as "official sources and authorised knowers" and 8–11 are collated as "non-official sources". Category 12—Other—was redistributed on a case by case basis into media, official, "non-official" or into a new "other" category.

Second, the sources cited were also coded separately for mentions of a digital or online source of communication (email, blog, Twitter, etc.). This two-level approach to coding avoids a weakness of previous research which has conflated the "individual or organisational source" and the "source of communication". For example, "Twitter users" have been coded as "alternative" or "non-official" sources regardless of whether the person updating the Twitter account could be considered an "alternative" or "non-official" source. This method also means the nature of the digital communication sources cited by the BBC can be assessed in relation to the first level of coding, revealing which actors were sourced through digital and online means.

The findings emerging from the content analysis were strengthened by "triangulating" the data with other methods of inquiry including interviews with BBC journalists, access to BBC documents and observations at the BBC. As part of an Arts and Humanities Research Council (AHRC)/BBC partnership, I acted as a "participant observer" at the BBC between 2007 and 2011. My access to the BBC meant I was able to analyse internal documents and also witness BBC journalists in the newsroom updating the Mumbai live pages in 2008. The latter provided a unique insight into the journalistic process of live blogging which is not always reflected in the content which is produced. In the aftermath of each attack, semi-structured interviews were conducted with journalists and editors, giving them an opportunity to reflect on their journalistic practice in relation to live blogging. Their evidence informs observations which move beyond *what* sources were included to *why* BBC journalists thought they were included—addressing a common weakness of many studies based solely on content analysis.

## Findings and Discussion

### Official and Non-official Sources

The BBC still relied on their own reporting, other media organisations, official sources and "authorised knowers" for most of their live page content in 2008 (83 per cent of sources cited) and 2011 (79 per cent). News agencies and media organisations accounted for 46 per cent of the sources cited in 2008 and 44 per cent in 2011. Official sources and "authorised knowers" for 37 per cent in 2008 and 35 per cent in 2011. A significant percentage of "non-official" sources were incorporated into the BBC's coverage of the events in Mumbai and Norway and there was an increase in the percentage of "non-official" sources cited from 15 per cent of sources cited in 2008 to 20 per cent by 2011 (Figure 1). The figures of 15 and 20 per cent for "non-official" sources, however, are not dissimilar to the 16.5 per cent of "non-official" sources cited in 2850 stories in *The New York Times* and *The Washington Post* between 1949 and 1969 (Sigal 1973, 124).

A more detailed breakdown of the sources cited is represented in Figure 2.

The 5 per cent increase in the citation of "non-official" sources in 2011 might be partially explained by the fact that the Norway live page was started much sooner after

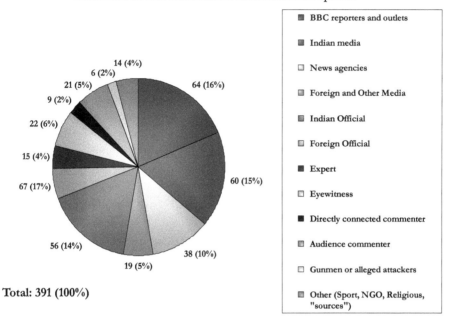

Mumbai 27-28 Nov 2008: Sources cited in BBC live updates

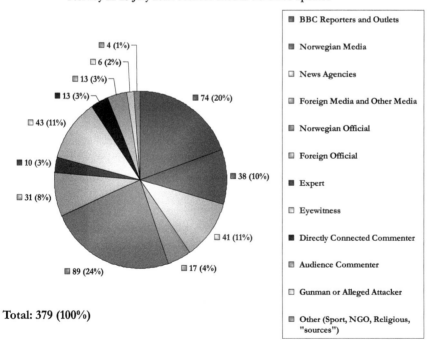

Norway 22-23 July 2011: Sources cited in BBC live updates

**FIGURE 2**

Breakdown comparison of sources cited in BBC live updates. (Key reads clockwise from top of pie chart)

the initial report of a major incident than in 2008. The BBC's Mumbai live page was started approximately 15 hours after the gunmen first entered the city, by which time the BBC's Mark Dummett was already at the scene of the incident near the Taj Mahal Hotel. In contrast, the Norway live page was started just over an hour after the bomb blast in Oslo. At this early stage, BBC journalists were not receiving information from a colleague at the scene and relied more on eyewitness accounts from "non-official" sources in the immediate aftermath. In the first hour of the live page on 22 July, the BBC cited 13 eyewitness accounts often sent in via email. Overall, there was an increase in the number of times eyewitnesses were cited as sources in the BBC's coverage between 2008 and 2011—from 6 to 11 per cent (Figure 2). If the BBC continues to start live pages quickly after a major incident or events occur where BBC journalists cannot quickly access the scene, then this level of content from digitally connected eyewitnesses is likely to be sustained or could possibly increase in the future.

## Audience Comment

Eyewitness accounts and "directly connected comment" were sourced by a variety of means including emails to the BBC, on Twitter, through BBC reporting, and in other media and news agency reporting. "Audience comment", however, was entirely facilitated through electronic communication from emails, on blogs or via Twitter. Instant digital communication allowed BBC journalists to incorporate these contributions from the "former audience" to reflect the public mood or general reactions on a story.

Nevertheless, the level of "audience comment" included by the BBC in the Norway live page (3 per cent) decreased slightly from the Mumbai story (5 per cent), perhaps reflecting a shift in editorial emphasis. Journalists covering the Mumbai attacks were encouraged by editors to include Twitter updates in the live page. In the aftermath, an internal document which collated advice on live blogging reveals that BBC journalists regarded "quoting tweets as general comment" as a valuable method of portraying "an all round picture" of an event and to "establish a public mood of events as they happen" (Smith 2008). One journalist working on the Mumbai live page, however, felt too much audience comment was included and believed future editors would specify what content they wanted from Twitter rather than just requiring that Twitter updates were included. It was notable, therefore, that in an interview in 2011, the World Editor of BBC News Online stressed the need for a balance of news and comment in live pages. In particular, she believed that "general users or readers don't like too much comment—certainly not too much uninformed comment" (Nathalie Malinarich, interview, 11 October 2011).

## Digital Sources

According to BBC journalist Matt Danzico, who was working on the Norway live page, email and Twitter messages are "extremely helpful in staying current on whatever story we are covering via a live page" (Matt Danzico, personal communication, 2 September 2011). There was a significant increase in the citation of digital sources in 2011 compared with 2008. For the Norway story, BBC journalists cited a digital source on 52 occasions—an increase from 33 occasions during the coverage of Mumbai when

slightly more sources were cited overall (Figure 3). It should be noted that one of the contributing factors for the increase was the online activity of the Norwegian gunman, Anders Behring Breivik. On 23 July, journalists discovered that Breivik had set up a Twitter account and a Facebook profile to announce his intentions. Breivik's online accounts were cited by the BBC on six occasions.

The content analysis also demonstrates the continued importance of "emails to the BBC" to report "crisis" events. When BBC journalists cite an "email to the BBC", this does include emails sent directly to journalists, but more often refers to people who have filled in a "post form" on BBC Web pages. These forms, usually posted at the bottom of a relevant Web page, encourage Web readers to contact the BBC if they

Total: 33 (100%)

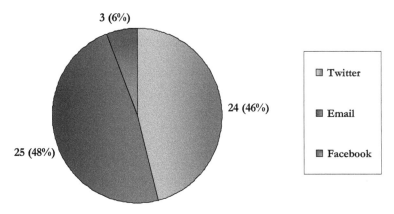

Total: 52 (100%)

**FIGURE 3**
Comparison of digital sources cited in BBC live updates. (Key reads clockwise from top of pie chart)

have information about a news story. The forms are delivered to BBC journalists in the form of an email, hence the BBC's terminology.

"Blogs"—which had accounted for 15 per cent of digital sources cited in 2008—were not cited as a source of information three years later. In 2008, Samanthi Dissanayake, who was primarily responsible for collecting blogs and Twitter updates in her role on the BBC's User Generated Content (UGC) hub, claimed that individuals who might previously have written blog posts were updating Twitter accounts instead (Samanthi Dissanayake, interview, 26 January 2010). She claimed they usually wrote blog posts after the crisis was over. This emerging shift towards the incorporation of Twitter updates rather than blogs is supported by the content analysis. For World Editor Nathalie Malinarich, the lack of blogs included in the live page coverage could be explained by the emergence of Twitter as journalist's first port of call: "I think ... people tend to go to blogs when it's linked off Twitter. I think the entry point is usually Twitter for everything now" (Malinarich, interview, 11 October 2011).

### The "Normalisation" of Twitter

The content analysis reveals a marked change in the nature of the sources cited via Twitter by BBC journalists. In 2008, BBC journalists cited two Twitter accounts from Indians who were in Mumbai (directly connected commenters). The rest of the Twitter updates cited were comments from other Indian cities or Twitter users based in other countries. In total, "audience comment" accounted for 88 per cent of the Twitter updates cited (Figure 4).

By 2011, "audience comment" only accounted for 19 per cent of all Twitter sources cited as BBC journalists more often cited Twitter accounts belonging to a range of journalists and news media organisations as a method of presenting the latest information on the breaking news situation to their audiences. Twitter updates from Norwegian and foreign media accounted for 47 per cent, emphasising the uptake of Twitter by journalists and news organisations by 2011 (Figure 4). An eyewitness, an expert, two foreign officials and Anders Behring Breivik's Twitter account were also cited, demonstrating that a variety of sources were using Twitter and being included by the BBC. The BBC could also have cited official Twitter accounts belonging to the Norwegian government—such as Prime Minister Jens Stoltenberg or the Prime Minister's Office—which were used to provide news updates on the situation. Although these "official" Twitter accounts were not included on this occasion, it is clear that journalists at the BBC were no longer using Twitter simply to include "alternative sources" or as a means of only including the voice of the "former audience" (Figure 4).

These findings point to a marked change in journalists' use of Twitter. In 2008, BBC journalists were grappling with Twitter as a new source of information. One of the BBC journalists covering the Mumbai attacks revealed he had little experience of the microblogging tool prior to November 2008. Another journalist working on the BBC's live page had never used Twitter before and had to learn how to use the social media site soon after arriving for his shift as his editors were keen to include Twitter updates in the BBC's coverage. By 2011, a number of the journalists working on the live page had their own accounts and were already experienced Twitter users: both Matt Danzico and Silvia Costeloe, for example, joined Twitter in 2007. More generally, the BBC had

**Mumbai 27-28 Nov 2008: Breakdown of Twitter users cited**

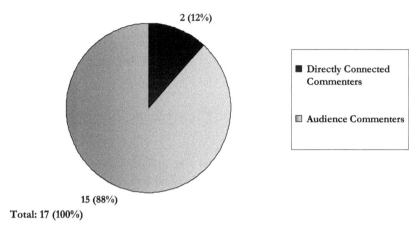

**Norway 22-23 July 2011: Breakdown of Twitter users cited**

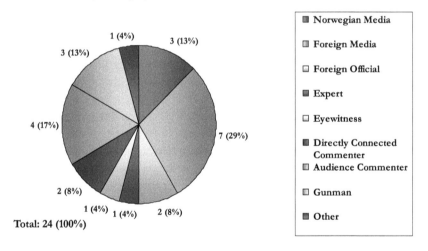

**FIGURE 4**
Comparison of sources cited via Twitter in BBC live updates. (Key reads clockwise from top of pie chart)

begun running a series of training workshops in social media tools in November 2009 and produced an internal reference document outlining "good practice" and "helpful hints" for Twitter in 2010.

Journalists' experience of using Twitter had evolved considerably in three years, but just as importantly so too had the nature of Twitter. In March 2008, technology website TechCrunch believed there were just over 1 million Twitter accounts and around 200,000 active users per week (Arrington 2008). Twitter claimed that around 300,000 tweets were being sent per day in 2008 (Twitter 2010). By the middle of 2011—just prior to the crisis in Norway—Mashable reported that Twitter had passed 200 million user accounts, while Twitter claimed that 200 million tweets were being sent every day (White 2011). Twitter had also been adopted by a wider range of actors,

including members of the public, journalists and media commentators, politicians, celebrities and "official" sources (Sambrook 2010, 33).

It appears that by 2011 then, the use of Twitter appeared to be "normalising" (see also Lasorsa, Lewis, and Holton 2012) both in the sense of the range of actors who were using the microblogging tool and the way in which BBC journalists were sourcing information from Twitter.

## Conclusion

The live blogging format does enable the BBC to present "multiperspectival" accounts of major terror attacks, but this article offers a nuanced picture of the opportunities and limitations of live pages for the incorporation of "non-official" sources. There was an increase in the number of "non-official" sources cited in BBC live page coverage between 2008 and 2011—from 15 to 20 per cent—but the findings caution against predicting any substantial further increase in the overall level of material included from "non-official" sources in future BBC live pages.

First, the volume of "directly connected comment" and "audience comment" from "non-official" sources decreased slightly from 7 per cent in 2008 to 6 per cent in 2011. Second, the BBC's citation of sources through Twitter changed significantly. Twitter can be used by journalists to include more "non-official" sources in their journalism (see Hermida, Lewis, and Zamith 2014) but the percentage of "directly connected comment" and "audience comment" cited through Twitter in the BBC's live coverage decreased from 100 per cent in 2008 to 25 per cent by 2011 (Figure 4). The widespread adoption of Twitter and other online tools as a method of public communication by a range of governmental, institutional and particularly media actors between 2008 and 2011 has meant that digital or social media sources are no longer used by journalists simply to access the voice of the "former audience". It suggests that the BBC's use of Twitter during the Mumbai attacks in 2008 should be judged as unusual in the context of the uncertain and uneven adoption of digital media tools by news organisations and official sources—a period of flux which was already ending by the Norway attack in 2011.

Ultimately, this article also emphasises that the live blogging format does not necessarily lead to an increased use of "non-official" over official sources by journalists despite the alleged ease with which it facilitates the inclusion of the "former audience". The BBC's approach to news traditionally relies more on "official sources" (Born 2004, 379; Hargreaves 2003, 27) and interviews with BBC journalists in this article, for example, revealed that they had an understanding of an "appropriate" level of "audience comment" which should be included in a live page. Editorial decisions such as these— which are informed by the organisation's news values—effectively limit the number of "unofficial" sources included in the coverage. The wider implication of this observation is that organisational news values, newsroom culture, editorial approach and the nature of the news story remain important indicators of how sources will be used regardless of the technological platforms used by news organisations to disseminate the news. Although the ways in which journalists are accessing and presenting the news have significantly evolved as a consequence of digital technologies and social media, their understanding of what "news" is and from whom it should be sourced appears to have

remained relatively unchanged—at least in the context of "hard" news stories such as terror attacks.

At most, then, live blogs updated by traditional news organisations have helped facilitate the inclusion of a *slightly widened* array of news sources which may increase further if news values, editorial approach and newsroom culture shift. However, Herbert Gans' (2004, 304–334) "multiperspectival" hope for "an *ever-widening* array of news sources" does not yet appear to be fulfilled within the context of live blogs updated by traditional news organisations. If traditional media live blogs, therefore, remain an important "site" where news of terror attacks are accessed, then it suggests that public understanding of such events will not be informed by any particularly greater diversity of ideological, political or cultural perspectives.

## DISCLOSURE STATEMENT

No potential conflict of interest was reported by the author.

## FUNDING

Article supported by the AHRC/BBC as part of a Collaborative Doctoral Award.

## REFERENCES

Arrington, Michael. 2008. "End of Speculation." *TechCrunch*, April 29. http://techcrunch.com/2008/04/29/end-of-speculation-the-real-twitter-usage-numbers/

BBC. 2008a. "As It Happened: Mumbai Attacks, 27 November." http://news.bbc.co.uk/1/hi/world/south_asia/7752003.stm

BBC. 2008b. "As It Happened: Mumbai Attacks, 28 November" http://news.bbc.co.uk/1/hi/world/south_asia/7753639.stm

BBC. 2009. "Mumbai Attacks: One year on, 25 November" http://news.bbc.co.uk/1/hi/world/south_asia/8379828.stm

BBC. 2011a. "As It Happened: Norway Attacks, 22 July" http://www.bbc.co.uk/news/world-europe-14254705

BBC. 2011b. "As It Happened: Norway Attacks Aftermath, 23 July" http://www.bbc.co.uk/news/world-europe-14260205

Beckett, Charlie. 2010. *The Value of Networked Journalism*. London: LSE POLIS

Bennett, Daniel. 2013. *Digital Media and Reporting Conflict: Blogging and the BBC's Coverage of War and Terrorism*. New York: Routledge.

Born, Georgina. 2004. *Uncertain Vision: Birt, Dyke and the Reinvention of the BBC*. London: Secker and Warburg.

Broersma, Marcel, and Todd Graham. 2013. "Twitter as a News Source: How Dutch and British Newspapers Used Tweets in Their News Coverage, 2007–2011." *Journalism Practice* 7 (4): 446–464.

Fishman, Mark. 1980. *Manufacturing the News*. Austin: University of Texas Press.

Gans, Herbert. 2004. *Deciding What's News*. 2nd ed. Evanston, IL: Northwestern University Press.

Gillmor, Dan. 2006. *We the Media: Grassroots Journalism by the People, for the People*. 2nd ed. Sebastopol, CA: O'Reilly Media.

Gitlin, Todd. 1980. *The Whole World is Watching: Mass Media in the Making and Unmaking of the New Left*. London: University of California Press.

Goldenberg, Edie. 1975. *Making the Papers: The Access of Resource-Poor Groups to the Metropolitan Press*. Lexington, MA: D.C. Heath & Co.

Hall, Stuart, Chas Critcher, Tony Jefferson, John Clarke, and Brian Roberts. 1978. *Policing the Crisis: Mugging, the State, and Law and Order*. London: MacMillan.

Hallin, Daniel. 1989. *The "Uncensored War": the Media and Vietnam*. London: University of California Press.

Hargreaves, Ian. 2003. *Journalism: Truth or Dare*. New York: Oxford University Press.

Herman, Edward, and Noam Chomsky. 1988. *Manufacturing Consent: The Political Economy of the Mass Media*. New York: Pantheon.

Hermida, Alfred, Seth Lewis, and Rodrigo Zamith. 2014. "Sourcing the Arab Spring: A Case Study of Andy Carvin's Sources on Twitter during the Tunisian and Egyptian Revolutions." *Journal of Computer-Mediated Communication* 19 (3): 479–499.

Lasorsa, Dominic, Seth Lewis, and Avery Holton. 2012. "Normalizing Twitter: Journalism Practice in an Emerging Communication Space." *Journalism Studies* 13 (1): 19–36.

Lawrence, Regina. 2000. *The Politics of Force: Media and the Construction of Police Brutality*. Berkeley: University of California Press.

Manning, Paul. 2001. *News and News Sources: A Critical Introduction*. London: Sage.

Molotch, Harvey, and Marilyn Lester. 1974. "News as Purposive Behaviour: On the Strategic Use of Routine Events, Accidents, and Scandals." *American Sociological Review* 39 (1): 101–112.

Newman, Nic. 2009. *"The Rise of Social Media and Its Impact on Mainstream Journalism."* Oxford: Reuters Institute for the Study of Journalism.

Paulussen, Steve, and Raymond Harder. 2014. "Social Media References in Newspapers: Facebook, Twitter and YouTube as Sources in Newspaper Journalism." *Journalism Practice* 8 (5): 542–551.

Pavlik, John. 2001. *Journalism and New Media, Journalism and New Media*. New York: Columbia University Press.

Phillips, Angela. 2010. "Old Sources: New Bottles." In *New Media, Old News: Journalism & Democracy in the Digital Age*, edited by Natalie Fenton, 87–101. London: Sage.

Sambrook, Richard. 2010. *"Are Foreign Correspondents Redundant?"* Oxford: Reuters Institute for the Study of Journalism.

Schlesinger, Paul, and Howard Tumber. 1994. *Reporting Crime: The Media Politics of Criminal Justice*. Oxford: Oxford University Press.

Schudson, Michael. 2003. *The Sociology of News*. New York: W.W. Norton & Co.

Sigal, Leon. 1973. *Reporters and Officials: The Organisation and Politics of Newsmaking*. Lexington, MA: D.C. Heath & Co.

Smith, Russell, ed. 2008. Livepage Guidelines, Full. Internal BBC Document.

Thurman, Neil, and Nic Newman. 2014. "The Future of Breaking News Online?" *Journalism Studies* 15 (5): 655–667.

Thurman, Neil, and James Rodgers. 2014. "Citizen Journalism in Real Time: Live Blogging and Crisis Events." In *Citizen Journalism: Global Perspectives Volume 2*, edited by Einar Thorsen and Stuart Allan, 81–95. New York: Peter Lang.

Thurman, Neil, and Anna Walters. 2013. "Live-Blogging: Digital Journalism's Pivotal Platform?" *Digital Journalism* 1 (1): 82–101.

Twitter. 2010. "Measuring Tweets", February 22. http://blog.twitter.com/2010/02/measuring-tweets.html

White, Charlie. 2011. "Twitter Reaches 200 Million Accounts." *Mashable.Com*, July 16. http://mashable.com/2011/07/16/twitter-accounts-200-million/

Wigley, Shelley, and Maria Fontenot. 2009. "Where Media Turn during Crises: A Look at Information Subsidies and the Virginia Tech Shootings." *Electronic News* 3 (2): 94–108.

Wigley, Shelley, and Maria Fontenot. 2011. "The Giffords Shootings in Tucson: Exploring Citizen-Generated versus News Media Content in Crisis Management." *Public Relations Review* 37 (4): 337–344.

## ORCID

**Daniel Bennett** ⓘ http://orcid.org/0000-0003-3200-3401

# TWITTER AS A FLEXIBLE TOOL
## How the job role of the journalist influences tweeting habits

Lily Canter and Daniel Brookes

*This study focuses on the tweeting habits of journalists with different job roles at a UK city newspaper. The Twitter profiles of 16 journalists working at* The Star *in Sheffield were captured in 2014 and a content analysis was conducted to examine the types of information each individual was reporting. The data revealed Twitter was being utilised as a versatile tool for gathering, reporting and disseminating news, and there was correlation between types of tweets and the job role of the profile account holder. Those in managerial positions tended to include more hyperlinks to their own news website and use Twitter as a promotional tool whereas sports journalists tended to use the social media platform as a live reporting tool. News reporters at the newspaper did not regularly link back to their legacy platform, preferring to use Twitter to build relationships and interactions with users. The authors conclude that these data together with similar comparative studies are useful for identifying patterns in changing journalistic roles within a local, national and international context. The emerging trends challenge the notion of the redefinition of the journalist as a universal role and instead point towards multiple redefinitions of the varying roles of journalists.*

## Introduction

City newspapers in the United Kingdom continue to experience a steady decline in circulation as a result of market fragmentation and a shift towards online and digital content via multiple platforms. Smartphone use for news has reached a third of the population in the United Kingdom and tablet use currently stands at 23 per cent and rising (Newman 2014). Meanwhile print newspapers such as the *Manchester Evening News* and *Birmingham Mail* have seen circulation drop year-on-year by 23 and 27 per cent, respectively, between 2014 and 2015 (Hold the Front Page 2015a), whilst their website audiences have seen exponential growth. Newspaper sales for the *Manchester Evening News* currently stand at around 56,000 yet their website audience has expanded by 200 per cent in the past year and now boasts 415,000 daily unique users (Hold the Front Page 2015b).

This change in news consumption has led city and regional newspapers to invest heavily in online technologies to further their readership and reach through their websites, Apps and social media profiles which are being accessed on desktops, laptops,

tablets and smartphones. With its wide-reaching capacity, simplicity and speed, Twitter has been adopted by news organisations as the number one social media tool due to its easy engagement with users and huge commercial potential. The platform is free to use but can raise brand profile significantly and, more importantly, link thousands of users to revenue-generating news websites. The Twitter explosion (Farhi 2009) of recent years has created an environment whereby the site is now considered a news platform as much as a social network (Hermida 2013), with 52 per cent of the user base getting their news from Twitter (Holcomb, Gottfried, and Mitchell 2013).

UK journalists readily acknowledge that Twitter is an essential part of their every-day reporting toolkit (Cision 2013; Hermida 2013; Oriella PR Network 2012) and is impacting on the way in which they operate within traditional journalistic practices and norms (Canter 2013, 2014; Dickinson 2011). Yet research to date has largely focused on global breaking news events (Bruno 2011; Newman 2009; Vis 2013) or the practices of journalists working for national news organisations (Ahmed 2010; Noguera Vivo 2013) or American publishers (Artwick 2013; Reed 2013). Studies in the field of non-national UK newspapers are limited and have only just begun to identity emerging trends in journalists' Twitter use.

This paper seeks to build upon the research of one of its authors (Canter 2012, 2013, 2014) to develop a greater understanding of the tweeting habits of regional UK journalists, particularly how different reporting roles can lead to different Twitter practices.

## Changing Practices

Twitter is changing the way in which journalists gather, produce and disseminate news (Dickinson 2011), which is increasingly broken by the public (Blasingame 2011) but amplified and contextualised to a mass audience via the media (Murphy 2015). The BBC's Director of Global News said as early as 2006 that "news organisations do not own the news any more" (Allen 2006, 169) and instead journalists gather information on social media platforms from breaking news situations and use it as a marketing tool to disseminate news and link back to their legacy platforms (Broersma and Graham 2011; Raimondo Anselmino and Bertone 2013). The dilemma for journalists is how to sift through, and verify, the "rapid and easily accessible flow of information" (Bruno 2011, 6), in effect acting as a "human algorithm" (Aviles and Carvajal 2008).

This clearly changes the role of the journalist which in the pre-internet era was heavily entrenched in the notion of the gatekeeping fourth estate, an industry which could be relied upon to report the news accurately on behalf of the public. Post-Web 2.0 scholars refer to the journalists as curators (Charman 2007), gatewatchers (Bruns 2005), conversationalists (Gillmor 2006) and verifiers (Bruno 2011) rather than traditional gate-keepers. Yet journalists still have a significant role to play in adding value and context to the streams of information online rather than simply acting as filters. They must have active knowledge of the area, an ability to understand the material being assessed and be able to communicate clearly why particular items are important (Charman 2007). Fur-thermore, they can use social media platforms—particularly Twitter due to its speed, reach and ease of use (Canter 2014)—to gather a wider range of voices and ideas and gain a new dimension in breaking news stories previously unavailable (Eltringham 2012).

These civic functions of engaging with, and providing, a platform for a plurality and diversity of voices are set within a commercial framework where news organisations are competing for increasingly fragmented audiences online. Twitter, along with other forms of social media, has therefore emerged as a method of building brand loyalty (Dickinson 2011) around legacy platforms such as newspapers. Canter (2013, 2014) argues that branding and promotion on regional newspaper Twitter profiles has split into two distinct approaches with "a traditional function for news organisations and a social function for journalists" (Canter 2013, 492). This is further supported by her 2014 research which illustrated how news organisation policy directs journalists to link to their legacy website. Yet this approach is only taken by news organisation accounts and editors, whilst individual journalists promote the brand at a much more nuanced level by "indirectly building a personal brand which is engaging for users to follow" (Canter 2014, 16), rather than by actively driving traffic to their news website.

These personal brands vary in scope from those who build a reputation for regular live tweeting, others who become celebrated for tweeting happy messages or engaging in sporting banter to a limited few who tweet family snapshots (Canter 2014). There is some evidence that journalists are breaking down traditional boundaries of objectivity and professionalisation by posting personal and sometimes subjective tweets commenting on the news or revealing their hobbies and interests (Hermida 2013; Lasorsa, Lewis, and Holton 2012), using personality to create a following (Marwick and boyd 2011; Palser 2009). However, there is still a swathe of journalists who set clear boundaries between their professional and personal persona when using Twitter as a reporting tool (Gulyas 2013; Reed 2013). In short, practice varies immensely amongst individuals but the dominating factor is that Twitter has become normalised into the working practices and routines of journalists albeit as a flexible tool which can be adapted to suit a journalist's specific job role and individual preferences in relation to interaction (Canter 2013). This is acknowledged in Twitter's own guidelines to journalists which state:

> Some reporters turn to Twitter as a virtual notebook using it to collect and provide real-time updates on breaking news events. Others use it as a way to point readers to their work or to share their perspective on a particular topic. (Twitter 2013)

This raises further questions about the role of the journalist and the notion that the occupation is moving towards a universal role where each individual is expected to act as a multimedia reporter who takes on convergent activities (Quinn 2005). This is particularly prevalent in the regional press due to financial constraints from the aforementioned drop in circulation and shift in advertising revenue to alternative online platforms. Traditional print reporters are now redefined as "multimedia" or "digital" journalists and are expected to produce written copy for the newspaper, website and social media platforms plus headlines, captions, hyperlinks, photo, video and audio content. Similarly, in traditional broadcast job roles journalists are expected to create content for multiple platforms including text, video and audio for websites and social media accounts together with their legacy platform. Employers are looking for all-rounder applicants who can "hit the ground running" and work as universal journalists with both written and digital skills (Canter 2015) no matter which sector of the industry they enter.

## Method

The research sample was selected from the UK city newspaper, *The Star*, referred to locally as "The Sheffield Star". The flagship newspaper and its associated website www.thestar.co.uk is owned by publisher Johnston Press which is the second largest regional newspaper company in the United Kingdom. *The Star* currently has a circulation of 21,437 (Hold the Front Page 2015c) in a city of 560,000 (Sheffield City Council 2015) and sales are currently down 12.7 per cent year-on-year. However, its website has seen rapid growth and now receives 51,524 daily unique users (Hold the Front Page 2015b), an increase of 37 per cent year-on-year. *The Star* has a dedicated Twitter account @SheffieldStar which at the time of the research in 2014 had 28,995 followers. Sixteen journalists had Twitter accounts that identified them as employees of *The Star*.

The coding was used to identify how each account holder was using Twitter and a categorisation system was developed using Canter's (2013) prior content analysis research as a benchmark. The aim of this research was to build upon previous findings at two different UK regional newspapers in order to identify emerging trends amongst individual journalists. As Krippendorff (2004, 13) argues, content analysis is an effective method for collecting data of "texts, images and expressions that are created to be seen, read and interpreted". In this research the individual tweets were the text, images and expressions that Krippendorff refers to and from these the researchers were able to provide a context and "reasonable interpretations" (Krippendorff 2004, 24) on the tweeting habits of different journalists.

The study involved a content analysis of all of the profiles of journalists who identified themselves as employed by *The Star* across a seven-day period from Monday 3 to Sunday 9 February 2014, midnight to midnight. To capture all of the tweets from the 16 accounts, free online software Snap Bird was used, which enables users to search through an individual Twitter profile from the present all the way back to the very first tweet they posted. This was a much more effective way of capturing tweets than the process used in the previous comparative research (Canter 2013) which captured tweets direct from Twitter by cutting and pasting them into a Word document which was "problematic due to the large volume of data" (Canter 2013, 476) and Twitter's inability to recall a large number of tweets from one profile's timeline. However, in the time between the two research projects Snap Bird had emerged as a more proficient data-gathering tool enabling large amounts of tweets to be captured quickly for coding.

Once the tweets had been collected they were coded one user at a time, taking reference from Canter (2013) and using a dominant coding system so each tweet was only coded into one category. Initially the coding process had the following categories: traditional story/link, external link (to a site outside *The Star*'s website), personal, interaction, reader participation (where the journalist specifically asked for the readers'/followers' participation) and live news. The coding system was tested with a second coder and this resulted in the combination of the personal and interaction categories as these interactive exchanges were personal in nature and involved conversing with either a fellow journalist, work colleague or reader/follower. The researcher then coded all of the tweets collected from 16 journalists (564 tweets in total). Two journalists, Mike Russell (@mikerussell2) and Richard Blackledge (@rblackedge), did not tweet during the one-week period and it was not identified whether they were on annual leave during this period or not.

## Tweeting Habits

A total of 564 tweets were posted in the data sample of one week across the 16 accounts. On average a total of 35 tweets were sent out per user, equating to an average of five a day per user. However, two accounts were inactive during the sample period meaning that a higher tweet rate of 40 tweets per user per week or 5.7 per user per day was recorded (Table 1).

Amongst *The Star* journalists, there were some who tweeted far more frequently than others. For example, Nik Brear (@nikbrear), whose Twitter biography describes her as a digital journalist and videographer, tweeted just once during the timeframe. By way of contrast, digital editor Graham Walker (@GW1962) tweeted 129 times during the same period. As Table 2 illustrates, the staff to tweet most frequently were all in senior roles including the digital editor, night editor and editor. These were followed by the sports reporters, but on average the news reporters tweeted the least during the sample period.

Nearly half of all of the tweets across all of the profiles were personal/interaction which involved sharing personal insights or opinions or responding to followers, revealing the informal nature of communication on Twitter. The second most frequent type

**TABLE 1**

Total number of tweet types

| Type of tweet | Quantity | Percentage |
| --- | --- | --- |
| Personal/interaction | 269 | 48 |
| Traditional story/link | 127 | 22 |
| Live news | 81 | 14 |
| External link | 67 | 12 |
| Reader participation | 20 | 4 |

**TABLE 2**

Total number of tweets per user

| Twitter handle | Job role | Number of tweets |
| --- | --- | --- |
| GW1962 | Digital editor | 129 |
| JayMitchinson | Editor | 80 |
| RichardFidler | Night editor | 68 |
| Westerdale10 | Sports reporter | 60 |
| E_Beardmore | Reporter | 41 |
| JamesShield1 | Sports reporter | 40 |
| DannyHall04 | Sports reporter | 36 |
| Starcourtrep | Reporter | 24 |
| MollyGraceLynch | Reporter | 24 |
| TommoOwls | Sports reporter | 19 |
| DomHowson | Sports reporter | 16 |
| NancyFielder | Readers' champion | 15 |
| Rmarsden_Star | Political reporter | 4 |
| NikBrear | Digital journalist | 1 |
| MikeRussell2 | Education reporter | 0 |
| Rblackledge | Reporter | 0 |

of tweet was a traditional story/link which made up almost a quarter of all posts and replicated the established way of formally and objectively presenting the news with a link to the news organisation website for the full story. Only 14 per cent of all tweets were about live news, and these mostly originated from the sports journalists reporting live from matches. Very few journalists linked to external websites, bar the digital editor, and only 4 per cent of tweets actively sought reader participation, which reinforces the view that Twitter is a tool for brand promotion rather than wider collaboration.

The variety of tweets sent out by individual journalists, summarised in Figure 1, demonstrates that there is a difference in tweeting habits depending on the job role of the individual. Secondly, there are a certain number of things that all of the journalists do, at least in some capacity.

### Traditional Versus Personal

The sample reveals that those in more senior positions, such as the digital editor, editor and readers' champion, are more likely to tweet a higher percentage of traditional tweets with links. This is likely to be due to their increased awareness of company commercial imperatives and social media policy, which focuses on promoting the brand and driving traffic to the website. Whereas individual journalists are more focused on journalistic practices such as breaking news and news gathering, and concentrate on building their own personal brand and following rather than promoting the company. Individual journalists rarely linked back to *The Star* website or their own individual stories, confirming findings by Canter (2014) that UK regional journalists use relatively few links in their tweets and it is not routine practice to link to the legacy website despite company guidance stating staff should do so.

Instead, the figures reveal that general news and sports reporters tend to tweet more personal and interactive posts than any other type. These could be comments on the news or responding to followers. In doing so they are developing a personal brand which is engaging for users to follow rather than simply overtly self-promoting their stories which in turn indirectly promotes their news organisation. As Canter (2014) also demonstrated, journalists on regional newspapers do not use Twitter to promote their

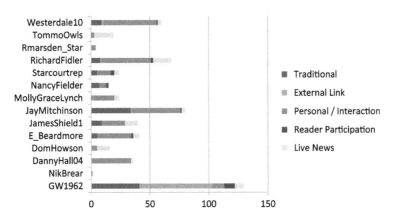

**FIGURE 1**
Types of tweets

own content and drive traffic but leave this to senior staff and the company official feeds which are often automated RSS feeds.

Furthermore, the data in this study show the editor of *The Star*, James Mitchinson (@JayMitchinson), took a mixed-method approach combining traditional and personal content. The editor was the second most prolific tweeter, posting an average of 11 tweets per day. He used a mixture of traditional tweets with links to promote his journalists' stories and drive traffic back to the company website with more personal interactive tweets often giving opinion on stories. In some cases a personal comment was integrated into the traditional link, for example:

> @JayMitchinson: TV Corrie's Bill Roache cleared of all charges: [link] So an innocent man has had his name dragged through the mud! #crazy

This approach blends the traditional function of reporting the news and promoting the legacy brand with a more personable approach which moves away from journalistic norms of objectivity. This enables the editor to demonstrate that his news organisation is quick and accurate with breaking the news whilst also setting the tone of the news organisation by coupling his informative tweets with personality and comment.

### Live Tweeting

The use of Twitter as a tool to report live from events was evident in this study particularly amongst the sports reporters. The majority of tweets by Dom Howson (@DomHowson) and Paul Thompson (@TommoOwls)—Sheffield United and Sheffield Wednesday correspondents, respectively—were live updates tweeting team news, press conference quotes and game updates using relevant hashtags. Many of these local football matches were not televised so the journalists were able to keep supporters up to date by live tweeting match reports.

The findings of Canter's (2014) similar research at the Bournemouth *Daily Echo* found contrary results, as sports reporters did not live tweet as much as news reporters. However, this was due to the *Daily Echo* website hosting its own live match blog and Twitter was used for match highlights rather than a rolling commentary. So in essence the practice of live coverage, albeit using different online tools, was the same in both studies. The night editor at *The Star* (@RichardFidler) also had a reasonable amount of live tweets (around a quarter). This may have been due to his role as the only staff member on duty at night and therefore tasked with breaking any live news on Twitter.

However, live tweeting amongst reporters was far less prevalent at *The Star* than at the *Daily Echo* where 57 per cent of reporters live tweeted regularly and this practice appeared to be a base requirement even if accounts were not active in any other way (Canter 2014). This illustrates the varying practices between regional newspapers and news organisations (*Daily Echo* is owned by Newsquest) in the United Kingdom.

### Combining Practices

The most prolific tweeter in the study was digital editor Graham Walker (@GW1962) who tweeted an average of 18 tweets a day and had the most varied range of tweet types. In his role as digital editor he spent time promoting the newspaper

website through traditional tweets and links but also shared content through external links, something absent from most other staff tweeting activity. These were often breaking news items concerning movies or concerts from around the world as well as topical information that was trending on Twitter and trade news. He also ran competitions for readers to win tickets to local concerts, events and film screenings, demonstrating that his role was partly a promotional and marketing one rather than focusing on hard news; for example:

GW1962: New editors appointed at Trinity Mirror titles: Move follows previous editor's promotion to MD: [link]

@GW1962: BREAKING: #Sheffield indie rock superstars @ArcticMonkeys to headline @OfficialRandL—full details @SheffieldStar [link]

In his role as digital editor Graham Walker operated as a disseminator of external news rather than simply a news breaker. He also had the largest amount of audience participation tweets as he tried to engage users in competitions and promotions.

### Common Practice

Moving away from specific job roles, the findings indicate that almost all of the journalists working for *The Star* use Twitter for a range of activities although some types are used more or less than others. News and sports reporters, as well as more senior staff, actively tweet as a part of their job role during their working week. Apart from a select few, all of the journalists were posting links to *The Star*'s website, albeit sporadically, as well as interacting with followers and live tweeting.

However, with the exception of the digital editor, encouraging reader participation, along with linking to external websites, were particularly weak amongst staff. This indicates that to a certain extent journalists are still operating in a traditional gatekeeper manner and are reluctant to engage their audiences in participation or share material from outside sources. Journalists may interact and respond to users in a reactive fashion but they are less likely to initiate conversations with users directly.

## Conclusion

This study further illustrates the versatile nature of Twitter as an adaptable tool for journalists which can operate as a flexible friend depending on the nature of a journalist's job role. The lack of protocol or formality around Twitter use has led to journalists creating their own tweeting style which crosses boundaries between personality and professionalism, and objectivity and comment, sometimes all within the same tweet.

For some, particularly those in more senior positions, it is a valuable tool for legacy brand promotion and driving website traffic, whilst for individual reporters it is a means to break news first and build personal relationships and interactions with readers. This supports prior research which emphasises the marketing value of Twitter for news organisations (Broersma and Graham 2011; Dickinson 2011; Raimondo Anselmino and Bertone 2013). This sits alongside its more personal, social function for individual

journalists who engage users through more informal tweets (Canter 2014), often breaking down traditional boundaries of objectivity in doing so (Hermida 2013; Lasorsa, Lewis, and Holton 2012), and using personality to create a loyal following (Marwick and boyd 2011; Palser 2009).

The mentioned parallels between this research and similar data gathered at national and international news organisations indicates that the findings are not limited to a snapshot of one UK city newspaper and have wider implications for the ways in which we understand the tweeting habits of journalists, whether they be local or global in status. Furthermore, the notion of the universal journalist is challenged in this fluid ecosystem as there are numerous adaptations of practice still emerging and journalists are constantly redefining themselves on Twitter as live news commentators, news disseminators, news responders, reader gauges, tone setters, brand ambassadors and more besides.

It is therefore pertinent for scholars and journalism educators to keep abreast of these changes within the digital landscape to enable them to educate and inform future generations of journalists wading into the increasingly murky and rapid waters of journalism online. The role of the traditional gatekeeper is awash with change and it is important for academics to understand the multiple contemporary roles of journalists in order to provide an accurate and pragmatic context for journalism students.

Research in this evolving field should continue to identify where established practices are settling and where they are simply momentarily trending. Currently, the emerging practices appear to be in legacy brand promotion and live reporting but the less clearly defined areas of user interactions (whether it be with readers, sources or other journalists), comment and personal disclosure warrant further exploration.

## DISCLOSURE STATEMENT

No potential conflict of interest was reported by the authors.

## REFERENCES

Ahmed, Ali Nobil. 2010. "Is Twitter a Useful Tool for Journalists?" *Journal of Media Practice* 11 (2): 145–155.

Allen, Stuart. 2006. *Online News: Journalism and the Internet*. New York, NY: Open University Press.

Artwick, Claudette. 2013. "Reporters on Twitter." *Digital Journalism* 1 (2): 212–228.

Aviles, Joe Alberto Garcia, and Carvajal, Miguel. 2008. "Integrated and Cross-Media Newsroom Convergence." *Convergence: The International Journal of Research into New Media Technologies* 14 (2): 221–239.

Blasingame, Dale. 2011. "Twitter First: Changing TV News 140 Characters at a Time." Paper presented at the 12th International Symposium on Online Journalism, Austin, November 21-24.

Broersma, Marcel, and Todd Graham. 2011. "Social Media as Beat: Tweets as News Source during the 2010 British and Dutch Elections." Paper presented at the Future of Journalism Conference, Cardiff, September 8-9.

Bruno, Nicola. 2011. "Tweet First, Verify Later. How Real Time Information is Changing the Coverage of Worldwide Crisis Events." Oxford: Reuters Institute for the Study of Journalism, University of Oxford. http://reutersinstitute.politics.ox.ac.uk/about/news/item/article/tweet-first-verify-later-new-fell.html

Bruns, Axel. 2005. *Gatewatching: Collaborative Online News Production*. New York, NY: Peter Lang Publishing.

Canter, Lily. 2012. "Web 2.0 and the Changing Relationship between Newspaper Journalists and Their Audiences." PhD diss., The University of Sheffield. http://etheses.whiterose.ac.uk

Canter, Lily. 2013. "The Interactive Spectrum: The Use of Social Media in UK Regional Newspapers." *Convergence: The International Journal of Research into New Media Technologies* 19 (4): 474–495.

Canter, Lily. 2014. "Personalised Tweeting: The Emerging Practices of Journalists on Twitter." *Digital Journalism*. http://www.tandfonline.com/eprint/USBS7KJtCPhRkbZKttQK/full#.VGn0uPmsV8E

Canter, Lily. 2015. "The Value of Journalism Accreditation." Paper presented at the Association of Journalism Education Annual Conference, Greenwich, June 25-26.

Charman, Suw. 2007. "The Changing Role of Journalists in a World Where Everyone Can Publish." *The Freedom of Expression Project*. http://www.freedomofexpression.org.uk/resources/the±changing±role±of±journalists±in±a±world±where±everyone±can±publish

Cision. 2013. "Social Journalism Study." http://www.cision.com/us/2013/12/how-journalists-view-pr-and-social-media/

Dickinson, Roger. (2011) "The Use of Social Media in the Work of Local Newspaper Journalists." Paper presented at the Future of Journalism Conference, Cardiff, September 8-9.

Eltringham, Matthew. 2012. "How Has Social Media Changed the Way Newsrooms Work?" *BBC College of Journalism*. http://www.bbc.co.uk/blogs/blogcollegeofjournalism/posts/How-has-social-media-changed-the-way-newsrooms-work

Farhi, Paul. 2009. "The Twitter Explosion." *American Journalism Review* 31 (3): 26–31.

Gillmor, Dan. 2006. *We the Media: Grassroots Journalism by the People for the People*. Farnham: O'Reilly.

Gulyas, Agnes. 2013. "The Influence of Professional Variables on Journalists' Uses and Views of Social Media." *Digital Journalism* 1 (2): 270–285.

Hermida, Alfred. 2013. "#Journalism." *Digital Journalism* 1 (3): 295–313.

Holcomb, Jess, Jeffrey Gottfried, and Amy Mitchell. 2013. "News Use across Social Media Platforms." *Pew Research Center*. http://www.journalism.org/2013/11/14/news-use-across-social-media-platforms/

Hold the Front Page. 2015a. "Sunday Titles See Monthly Circulation Boost." *Hold the Front Page*. http://www.holdthefrontpage.co.uk/2015/news/sunday-titles-see-monthly-circulation-boost/

Hold the Front Page. 2015b. "ABCs: MEN Trebles Audience to Top Regional Website Table." *Hold the Front Page*. http://www.holdthefrontpage.co.uk/2015/news/abcs-most-read-regional-newspaper-website-in-reader-boost-of-nearly-200pc/

Hold the Front Page. 2015c. "ABCs: All the Figures for Regional Dailies." *Hold the Front Page*. http://www.holdthefrontpage.co.uk/2015/news/abcs-all-the-figures-for-regional-dailies/

Krippendorff, Klaus. 2004. *Content Analysis: An Introduction to Its Methodology*. Thousand Oaks: Sage.

Lasorsa, Dominic, Seth Lewis, and Avery Holton. 2012. "Normalizing Twitter: Journalism Practice in an Emerging Communication Space." *Journalism Studies* 13 (1): 19–36.

Marwick, Alice, and boyd, Danah. 2011. "I Tweet Honestly, I Tweet Passionately: Twitter Users, Context Collapse, and the Imagined Audience." *New Media and Society* 13 (1): 114–133.

Murphy, John. 2015. "Twitter Monitoring." Paper presented at the Association of Journalism Education Annual Conference, Greenwich, June 25-26.

Newman, Nic. 2009. "The Rise of Social Media and Its Impact on Mainstream Journalism." Oxford: Reuters Institute for the Study of Journalism, University of Oxford. http://thom sonreuters.com/content/media/white_papers/487784

Newman, Nic. 2014. "Digital News Report." Reuters Institute for the Study of Journalism. http://www.digitalnewsreport.org/survey/2014/

Noguera Vivo, Jose Manuel. 2013. "How Open Are Journalists on Twitter? Trends towards the End-User Journalism." *Communication & Society* 26 (1): 93–114.

Oriella PR Network. 2012. "The Influence Game: How News is Sourced and Managed Today." The Oriella PR Network Global Digital Journalism Study. http://www.oriellaprnet work.com/sites/default/files/research/Oriella%20Digital%20Journalism%20Study% 202012%20Final%20US.pdf

Palser, Barb. 2009. *Hitting the Tweet Spot*. American Journalism Review, April/May

Quinn, Stephen. 2005. "What is convergence and how will it affect my life?" In *Convergent Journalism: An Introduction*, edited by Stephen Quinn and Vincent Filak, 3–19. London: Focal Print.

Raimondo Anselmino, Natalia, and Mauro Bertone. 2013. "Press and Social Networking Services in the Internet." *Brazilian Journalism Research* 9 (2): 88–109.

Reed, Sada. 2013. "American Sports Writers' Social Media Use and Its Influence on Profession-alism." *Journalism Practice* 7 (5): 555–571.

Sheffield City Council. 2015. "Sheffield Population Estimates." *Sheffield City Council*. https://www.sheffield.gov.uk/your-city-council/sheffield-profile/population-and-health/popula tion-estimates.html

Twitter. 2013. "Twitter for Newsrooms and Journalists". *Twitter*. https://media.twitter.com/best-practice/for-newsrooms-and-journalists

Vis, Farida. 2013. "Twitter as a Reporting Tool for Breaking News." *Digital Journalism* 1 (1): 27–47.

# THE ANATOMY OF LEAKING IN THE AGE OF MEGALEAKS
## New triggers, old news practices

Zvi **Reich** and Aviv **Barnoy**

*This paper examines the anatomy of leaking in the age of megaleaks based on a series of reconstruction interviews with 108 Israeli reporters, who recreated a sample of leaked versus non-leaked items (N = 845). Data show that leaking remains a journalistic routine, encompassing one in six items; however, they cease to be the sole game of senior sources, involving substantially more non-seniors. Despite new technologies and the mounting number of channels that enable their exposure, leaks remain an oral practice, exchanged mainly over the telephone. On the journalists' end, there is little change: leaks are the prerogative of more senior and experienced reporters in print and television news; they are still accompanied by more sources, more cross-checking and more consultation with editors than regular items. These findings concur with theories that perceive the relationship between megaleaks and traditional leaks as co-existing rather than disruptive.*

## Introduction

In the transforming news environment, the practice of leaking faces new social, political and technological challenges. While the rise of competition may push journalists to increase their reliance on leaks, they have at their disposal fewer resources to handle them carefully (Ryfe 2013) especially when journalism "amounts to little more than outsourced PR remixing" (Lovink and Riemens 2013, 247). New technologies, as seen in some new leaks such as the National Security Agency (NSA) leak (2013), Cablegate (2010) or an equivalent Israeli affair involving Anat Kamm, a soldier who leaked a CD containing thousands of classified military documents to *Ha'aretz* daily (2009), allow easier and safer access and delivery of information (McCurdy 2013; Pozen 2013), even by more junior sources. On the other hand, authorities wishing to trace and deter leakers have at their disposal a new arsenal of technologies. These enable easier tapping, voice recognition and call-log printouts, all of which make leaking more hazardous (Taylor 2015) with more investigations and prosecution of both leakers and journalists (Kitrosser 2015).

The question is how the new environment and new leaking platforms affect the traditional practice of ordinary leaking. This question is by no means trivial, since

ordinary leaks play a key political role in democratic regimes. They are seen as "safety valves" of democracy (Reston 1974), the "lifeblood of investigative journalism" (Sullivan 2013), an effective channel to "fight corruption" (Hess 1984), "checking executive power" and informing the public about "government's policies and programs" (Papandrea 2014, 464). While certain scholars highlight the disruptive power of WikiLeaks and its "clones and variations" (Beckett and Ball 2012, 155), suggesting that they "challenged and disrupted existing tenets of 'proper' journalism" (McCurdy 2013, 128), others have argued that the alternative platforms will co-exist with classic journalism (Dunn 2013), acting as merely another source (Handley and Ismail 2013; Wahl-Jorgensen 2014).

Despite involvement in only a few (albeit very well-known) leaks, the new platforms have caught the attention of numerous scholars who have tried to assess their role (e.g. Beckett and Ball 2012; Chadwick and Collister 2014; Conley 2010; Handley and Ismail 2013; Wahl-Jorgensen 2014). On the other hand, ordinary leaking, which was almost a day-to-day journalistic practice (Reich 2008), has been overlooked in recent scholarly literature, despite the potential changes in the anatomy of leaks, including the channels, sources and practices of exchanging unauthorized information.

This paper intends to close this lacuna, providing empirical evidence that enables a comparison of the anatomy of leaking before and after the rise of megaleaks in the Israeli media, covering the leakers, the journalists and the channels through which they communicate. Findings are based on a series of reconstruction interviews with 108 Israeli reporters, who recreated a sample of leaked versus non-leaked items ($N = 845$).

## Literature Review

The emergence of new platforms and the public resonance of famous megaleaks such as the NSA leaks (2013) or Cablegate (2010) yielded numerous papers and books published by journalists and news sources (e.g. Beckett and Ball 2012; Chadwick and Collister 2014; Handley and Ismail 2013; Wahl-Jorgensen 2014), trying to conceptualize the role of this species of leaks in society and journalism. Do they constitute yet another news source (Handley and Ismail 2013; Wahl-Jorgensen 2014), an alternative platform (Conley 2010) or markers of the "evolution of journalism in the mature internet age"? (Beckett and Ball 2012, 11). According to recent studies, these leaks have brought about a series of practical and normative changes (Chadwick and Collister 2014; Coddington 2014; Hindman and Thomas 2014; McCurdy 2013) that reshape the roles of the main actors involved in the exchange of leaks and in how they are obtained, handled and published.

Megaleaks are unauthorized "big package releases" (Greenberg 2012, 2) that are usually document-based. Mega-leakers exploit accessibility to large ICT system and use the digitalized formats of data for leaks (not necessarily to the mainstream media) that are not only massive in volume (between hundreds and hundreds of thousands of documents), but also pile up a conglomeration of events and topics. Ordinary leaks, on the other hand, are much more routine, focused on specific stories or series of stories. They usually involve a rapport between the leakers and journalists from mainstream media.

To lay the foundations for our hypotheses, we examine here some prior research about areas including the overall frequency of leaks, the profile of leakers and reporters

who publish them, the technologies through which they exchange information, and journalistic practices for dealing with unauthorized disclosures of information.

## The Frequency of Leaks

Though leaks were established to break the routine of exchanges between the state and the press (Boorstin 1972), they became a routine in their own right. According to one study and estimates of American news managers, leaks are routine and form the basis for one-fifth of all news items (Fisher 2005; Reich 2008). Leon V. Sigal (1973) suggested that the scope of leaks is much lower: only 2.3 per cent of the overall number of news cover stories in quality dailies in the United States were based on leaking. However, his numbers were based on content analysis that might have overlooked many leaked items that did not explicitly mention their reliance on unauthorized disclosure of information.

Should we expect a rise, a decline or no change in the overall frequency of leaks? If WikiLeaks marks the decline of investigative journalism, as claimed by Lovink and Riemens (2013), one might expect their migration from mainstream media to dedicated leaking platforms, following the broad layoffs of journalists, and the mounting pressures under which the remaining ones operate, which do not allow them the time and resources needed to cultivate the rapport required for trust-based practices such as leaks (Ryfe 2013). Less dramatic changes are expected according to scholars who see the relationship between the new platforms of leaking and mainstream media as one of co-existence rather than of substitution (Dunn 2013). The limitations of the new leaking platforms—which enter the public agenda only rarely and irregularly—correspond with the co-existence approach. Hence, it is doubtful whether alternative leaking platforms can play the "essential, yet imperfect, role in checking executive power and informing the American public about the government's policies and programs" (Papandrea 2014, 464). These platforms also have limited capacity to properly treat this highly sensitive exchange. While traditional leaks undergo a journalistic process of cross-checking, additional news gathering and contextualization, leaking platforms make do with posting raw materials without adding any context (Coddington 2014; Lovink and Riemens 2013).

## Who Leaks Information?

According to previous studies, leaks are mainly the domain of high-ranking officials (Papandrea 2014; Reich 2008), typically in politics (Pozen 2013; Sigal 1973). This was summarized in the famous aphorism of James Reston (1967, 66) that "government is the only known vessel that leaks from the top".

Senior sources have both the access to newsworthy information and the motivations to use leaks as "policy tools" and "trial balloons" for their experiments (Hess 1984). As a leak type, whistleblowing is more closely associated with junior sources, and frequently endangers those who try to expose corruption and moral misconduct (Kitrosser 2015; Taylor 2015).

While the motivations and risks may remain unchanged, junior sources and even ordinary citizens enjoy easier accessibility not only to information, as manifested in the cases of Private Bradley Manning and Edward Snowden, but also to journalists, thanks to the combination of new channels (Pozen 2013) and unprecedented openness to audience contribution (Hermida 2009; Singer 2014).

### Handling Leaks

According to Declan Walsh, the *New York Times* reporter known for his leaks that eventually led to expulsion from his beat country, Pakistan (Amnesty International 2014), "They [leaks] may come from difficult, even compromised sources, be ridden with impurities and require careful handling" (Sullivan 2013). Reich's study confirms Walsh's assertion, showing that leak-based items are systematically treated more meticulously compared with non-leaked stories, with extra cross-checking and more sources per item (Reich 2008). Hence, we expect these meticulous journalistic standards of treating leaks to continue, despite the mounting pressures brought by the deteriorating journalistic manpower and the shrinking reporting time and resources (Ryfe 2013).

### Who Publishes Leaks?

From the leaker's point of view, "the best sort of journalist to contact is one who has a good reputation and a track record of exposing problems" (Martin 2015, 15). Hence, one may expect that reporters who publish leaks will be the more senior and experienced ones. In addition to being a prime outlet for leaks, they have the knowhow, the resources and the editorial status to develop rapport with sources and treat their contribution with the required sensitivity (15).

In addition, one might expect to find leaks more in print and television news, not only due to the highest exposure of television news compared to any other medium (Reich 2011), and the traditionally high status of print and its ability to allocate greater space and prominence to leaked news, but also due to the tendency of news organizations to keep their best stories for the paper (Usher 2014), as well as the longer deadlines that daily media enjoys, compared to the immediacy of reporting on radio and the internet (Reich and Godler 2014).

### Communication Technologies

New technology has always been a double-edged sword with respect to leaking. Though some technologies allow easier access to information (Pozen 2013), others enable authorities to trace leakers more easily (Taylor 2015). One previous study suggests that leaks are exchanged mainly over the telephone (Reich 2008), since textual interactions leave more traces. However, there are two reasons to expect journalists and leakers to use other channels to communicate; first, since phone calls have become highly traceable through new technologies such as call-log printouts and voice recognition software; second, no oral channel can transfer massive amounts of information efficiently.

## Methodology

To explore the anatomy of leaking in the age of megaleaks, the study used a series of face-to-face reconstruction interviews, in which a sample of reporters recreated the production process of their recently published news items. For each item, reporters were asked to recreate in detail the sourcing and reporting processes behind individual news items, including the presence or absence of leaks. In addition, reporters were asked about their own demographics.

Reconstruction interviews enable systematic and quantitative study of leaks that are not only sensitive by nature, but also unobservable, exchanged inside and outside newsrooms through a variety of technologies. Reconstruction interviews, with their proven viability for exploring different aspects of news processes (e.g. Albaek 2011; Brüggemann 2012; McManus 1994) were conducted once to study leaks in 2001 (covering only print), before the era of megaleaks (Reich 2008). In 2006, another round of the study (which included print, online and radio news) yielded additional data on leaking, which has not been published to date.

Prior to the interviews, we selected the organizations, the news beats, the journalists and the items for the study. News organizations were chosen from all media according to their national outreach. Eleven reporters were selected from each news organization, covering political, business and domestic affairs, according to their proportion in the workforce. Then we identified all the publications of the selected reporters during a four-week period (November to December 2011), long enough to supply a rich mix of leaked and non-leaked stories, but not too long to tax participants' memories. Finally, we randomly sampled 8–11 news items per reporter (depending on the medium).

To address the sensitivity of leaks, the interviewers used special seating arrangements. Reporters and interviewers sat on opposite sides of a table with a low screen placed between them. The screen was high enough to hide the pile of sampled items the reporter was holding, but not too high to avoid eye contact between parties. Each time the reporter was asked to pick one of the sampled items supplied by the interviewer and recreate its reporting process. The presence of the screen and use of abstract categories (e.g. senior source, specialist, citizen, etc.) instead of specific identities, created a secure environment for reporters to discuss their work processes without inhibition.

### Measurements

To avoid ambiguous interpretations, interviewers were equipped with uniform definitions and predefined categories for each variable that might be perceived equivocally. These were defined as follows:

- *Leaks*: Unauthorized disclosures of substantial information (to avoid noises such as leaking minor details). Determined by a single question: did the item involve a leak? The single question was sufficient to retrace the footsteps of the leakers, the reporters and the process involved, since it enabled comparison between leaked and non-leaked items in many aspects.
- *Cross-checking*: Contacts with sources made with specific intention to corroborate or refute information supplied by another source.

- *Senior/non-senior sources*: Defined according to a uniform index of posits and ranks supplied by the interviewer. For example, CEOs, ministers and heads of political parties were categorized as seniors, as were army Colonels and Police Superintendents or higher ranks.
- *Triggering source*: Since we could not ask about the identity of the source that leaked the information, due to sensitivities of source confidentiality, we focused on the "triggering source"—who "triggered the process of news making" (Brüggemann 2012, 404). Although the triggering sources may not have been the leakers themselves, they—at the very least—paved the way for journalists' reliance on leaks, and are especially instructive if studied comparatively, i.e. comparing leaked and non-leaked items, as well as exploring leaks over time.

## Research Question and Hypotheses

The study uses a single research question, followed by five hypotheses:

**RQ1:** What are the patterns of leaking in national news? Does reliance on leaks still constitute a routine journalistic practice? Who are the sources that trigger the leaked stories? Who are the journalists that publish them? Over which channels of communication is the information exchanged? Are leaked items treated differently compared to non-leaked stories?

**H1:** Reliance on leaks remains a routine journalistic practice.

**H2:** A growing share of items triggered by non-senior sources will include a leak, while the dominance of senior sources might be diminishing.

**H3:** Leaks will be published mainly by experienced reporters in print and television news.

**H4:** Leaks are increasingly textual, exchanged over new media channels, and less orally/telephone mediated.

**H5:** Leaked items will involve more news sources, more cross-checking, consultations with editors and longer working time than regular items.

## Findings

Findings illuminate for the first time the anatomy of leaks in the age of mega-leaks; who leaks the information, to whom and how, and the extent to which leaks constitute a journalistic routine or a violation thereof. Findings are compared to those collected a decade earlier, before the emergence of the megaleaks.

### Leaking Frequency

Findings support H1: despite all changes in the news environment, leaks remain a routine part of journalistic work, with only a slight decrease in frequency. As can be seen in Table 1, one in six items (19 per cent) involved a leak ($\chi^2_2 = 22.626$; $p < 0.01$) compared to one in five 10 years earlier (Reich 2008).

**TABLE 1**

Items including a leak

| Year | % |
|------|---|
| 2001 | 21 |
| 2006 | 35 |
| 2011 | 19 |

Significance between years calculated using Chi-square.
$p < 0.001$.

## Leakers' Profile

At first glance, it may seem that the second hypothesis is not supported, and that senior sources still dominate leaking. Seniors and PR practitioners triggered 24–25 per cent of the leaks compared to 20 per cent for non-seniors, 8 per cent for professionals and 9 per cent for citizens (Table 2, fourth column). However, further analysis that focuses on the proportion of leaks out of all the items triggered by each source (second column) reveals a clear and significant decline in the dominance of senior sources alongside a rise in non-seniors, in tandem with the second hypothesis. Non-senior sources triggered the highest ratio of leak-based items (37 per cent), alongside professional sources (34 per cent), compared to only 27 per cent of the items among senior sources ($\chi^2_7 = 63.766$; $p < 0.01$).

As can be seen in Table 3, a comparison of senior and non-senior source share in triggering items across the studied decade reaffirms H2. While non-seniors' part in triggering leak-based news items increased significantly from 12 to 18 per cent over the decade ($\chi^2_5 = 31.877$; $p < 0.01$), the share of senior sources decreased significantly from 55 to 36 per cent[1] ($\chi^2_5 = 25.220$; $p < 0.01$).

The fluctuation of 2006 is probably a temporary deviation due to a major scandal that took place in 2006, when a well-known rapist escaped from prison. During the

**TABLE 2**

Leak-based items by type of triggering source

| Source | Total items triggered | Items including a leak (%) | Number of items including a leak | Share of the triggering source in all leaked items (%) |
|--------|----------------------|---------------------------|----------------------------------|--------------------------------------------------------|
| Senior source | 130 | 27 | 35 | 25 |
| Non-senior source | 76 | 37 | 28 | 20 |
| Public relations | 380 | 9 | 33 | 24 |
| Professional | 32 | 34 | 11 | 8 |
| Citizen | 53 | 23 | 12 | 9 |
| Other | 164 | 13 | 21 | 15 |
| All sources | 835 | – [a] | 140 | 100 |

Significance between source type calculated using Chi-square.
$p < 0.001$.
[a]The column does not sum up to 100 per cent covering only leaked items.

**TABLE 3**
Triggering leaks over time by source type (%)

| Year | Non-senior source* | Senior* |
|---|---|---|
| 2001 | 12 | 55 |
| 2006 | 38 | 26 |
| 2011 | 18 | 36 |

Significance between years calculated using Chi-square.
*$p < 0.001$.

**TABLE 4**
Reporters' medium, age and experience in leaked versus non-leaked items

| | Non-leaked items | Leaked items | Significance |
|---|---|---|---|
| Items in "daily media" (newspaper and television) (%) | 81 | 19 | *[a] |
| Items in "instant media" (radio and internet) (%) | 86 | 14 | |
| Reporters' average age | 39 | 35 | **[b] |
| Reporters' average years of experience | 15 | 12 | **[b] |

Significance tests:
[a]Chi-square;
[b]$t$-test.
*$p < 0.05$;
**$p < 0.01$.

national manhunt, which took place during three weeks of the sampling period, law-enforcement authorities were under such extreme stress that police authorities tightened instructions to avoid any contacts with the press, rendering any unauthorized exchange a leak.

## Who Publishes Leaks?

H3 was confirmed as well: as can be seen in Table 4, reporters who publish leaks tend to be older and more experienced, working for newspapers and television. Their age and years of experience are significantly higher—by four and three years, respectively ($t_{172} = 3.697$; $p < 0.01$; $t_{826} = 3.463$; $p < 0.01$). While in daily media (print and television) leaks constitute 19 per cent of the items, in the "instant media" (radio and online) they constitute only 14 per cent ($\chi^2_1 = 4.288$; $p = 0.038$).

## Technologies of Leaking

Surprisingly, H4 is not confirmed: the technology through which leaks are exchanged remains intact. As can be seen in Table 5, an overwhelming majority—74

**TABLE 5**

Technologies of leaking: how the triggering source was contacted (%)

|  | Including leak? | Face-to-face | Telephone mediated | Text | Other | Significance |
|---|---|---|---|---|---|---|
| 2001 | Yes | 16 | 74 | 8 | 2 | ** |
|  | No | 13 | 31 | 50 | 6 |  |
| 2006 | Yes | 10 | 68 | 17 | 5 | ** |
|  | No | 4 | 40 | 50 | 6 |  |
| 2011 | Yes | 9 | 74 | 12 | 5 | ** |
|  | No | 13 | 44 | 36 | 7 |  |

Significance of difference between technologies in leaked and non-leaked items was calculated for each year using Chi-square.
Difference between years were studied using Chi-square and found non-significant.
**$p < 0.01$.

**TABLE 6**

The journalistic treatment of leaks

| Practice | Non-leaked items | Leaked items | Significance |
|---|---|---|---|
| Cross-checking (%) | 52 | 78 | ** a |
| Editors' involvement in reporting (%) | 38 | 56 | **a |
| Number of sources per item | 3.36 | 4.81 | ** b |
| Reporting time in hours[c] | 12 | 25 | *b |

Significance tests between leaked and non-leaked items:
[a]Chi-square;
[b]$t$-test.
[c]Three cases in which working time exceeded two weeks were removed from the sample.
*$p < 0.05$;
**$p < 0.01$.

per cent of the contacts in leaked items—were kicked-off over the telephone, with only 12 per cent textually mediated and only 9 per cent obtained face-to-face ($\chi^2_3 = 13.338$; $p < 0.01$). The slight decline of face-to-face encounters and small rise of textual channels is insignificant. Telephone-mediated contact remain the most prominent channel as in 2006 ($\chi^2_3 = 25.091$; $p < 0.01$) and 2001 ($\chi^2_3 = 68.392$; $p < 0.01$).

### Handling Leaks

As can be seen in Table 6, H5 is confirmed. Despite their dwindling resources, reporters put more effort into leaked items, relying on significantly more sources per item ($t_5 = 31.877$; $p < 0.01$), more cross-checking ($\chi^2_1 = 31.489$; $p < 0.01$) and more frequent consultation with editors ($\chi^2_1 = 15.145$; $p < 0.01$)—practices that end up with longer reporting time ($t_{145} = 2.330$; $p = 0.021$).

### Discussion

Findings show that ordinary leaks continue to be a vital channel of news even in the age of megaleaks. Despite a minor decrease, a significant proportion of items

published in Israeli media (1:6, compared to 1:5 in 2001) involve unauthorized disclosure of substantial information, according to the testimony of reporters from all news media.

These findings suggest that ordinary leaks do not lose their role as a routine news channel, neither in their frequency, nor in their handling practices, despite the new platforms for the exchange and publication of leaks, the high profile of megaleaks, and the massive changes in journalism as an industry and a profession—in which fewer journalists with fewer resources face mounting workloads and pressures. These findings are in line with the co-existence approach, according to which "online whistle-blowing organizations" will not replace traditional journalism, since "without the structures and standards of professional journalism and the frameworks of self-regulation in mainstream media, online whistle-blowing organizations run the risk of compromising the security, lives, and reputations of countless people" (Dunn 2013, 97). In evolutionary terms suggested by Daniel Boorstin (2012), just as the deteriorating press conferences made room for the rise of leaks, the deterioration of leaks might give way to newer channels. However, according to our findings, there are still no signs of such a transformation. It seems doubtful whether megaleaks are a promising candidate.

A comparison with our data collected in 2001, about a decade before the rise of the megaleak, shows that ordinary leaks underwent substantial changes. These changes were mainly associated with the practices of leakers: though they were once almost the exclusive domain of senior sources, they are now increasingly triggered by non-seniors and professional sources.

On the journalist's end, things look like a gaze into a time capsule. Leaks continue to be published mainly by more experienced and older reporters, and are still handled with similarly meticulous news work practices compared to non-leaked items, just as in the past (Reich 2008). The treatment of leaks involves more cross-checking, more news sources per item, longer reporting time and greater supervision of editors. Surprisingly, leaks continue to be an oral practice, as they were at the beginning of the millennium, exchanged mostly over the telephone, despite their easier detection by government agencies, using tapping and call-log printouts. Why do journalists and their sources adhere to oral channels, despite the increased risks? Our suggestion is that except for some dedicated platforms for exchanging leaks, no technology is resilient against interception. A negotiation-enabling technology like the telephone fits the complex transaction of leaks more than any textual alternative, enabling not only the exchange of information, but also meta-information, such as the conditions for the exchange and the parts that will be published or omitted.

The fact that no changes were observed in the technology of leaking does not mean that technology plays no substantial role. Megaleaks based on massive documents, such as those carried out by Edward Snowden or Anat Kamm, indicate the growing access of junior sources to "big-data" and the unprecedented ease of copying them. The diffusion to a junior echelon of sources may change the role of leaks from a political device or a "professional prerogative" of managements, senior officials and politicians who send their "trial balloons" and "policy" leaks (Hess 1984; Papandrea 2014) to a new set of motives and agendas that characterize less senior people such as "heroic whistleblowers" (Hess 1984).

Though some say Israel is characterized by increased secrecy, which invites increased breaches and leaks (Negrine 1996), others claim it is difficult to determine

whether secrecy in Israel is more or less "pathological" than in other democracies (Galnoor 1975). Israel is considered "the region's only Free media environment" (Freedom House 2014). Though it maintains a pre-publication military censorship, in practice "the censor's role is quite limited and under strict judicial oversight" and "journalists often evade restrictions" (Freedom House 2014). Large-scale secrecy is not a uniquely Israeli practice. The United States, for example, went from 8.6 million classified documents in 2001 to 76.7 million in 2010 (Greenberg 2012).

Finally, though traditional media show their staying power as platforms for obtaining and treating leaks despite the emergence of new technology, new dedicated platforms and trends such as megaleaks, leaks might become an endangered species in these media in the case of further cutbacks in the ranks of the most experienced journalists, who according to our data, are *de facto* those who attract, handle and publish most of the leak-based stories.

## ACKNOWLEDGEMENTS

The authors are grateful to Yifat Naim, Yigal Godler and Inbal Avraham for their assistance in data collection and Tali Avishay-Arbel for her statistical advice.

## DISCLOSURE STATEMENT

No potential conflict of interest was reported by the authors.

## FUNDING

This research was supported by The Israel Science Foundation [grant number 1104/11].

## NOTE

1. Comparison across time focused on print newspapers—the only media studied in all three periods.

## REFERENCES

Albaek, Erik. 2011. "The Interaction between Experts and Journalists in News Journalism." *Journalism* 12 (3): 335–348.

Amnesty International. 2014. 'A Bullet Has Been Chosen for You' Attacks on Journalists in Pakistan. Accessed on April 11, 2015. https://www.amnesty.org/download/Documents/8000/asa330052014en.pdf

Beckett, Charlie, and James Ball. 2012. *Wikileaks: News in the Networked Era*. Cambridge, UK: Polity.

Boorstin, Daniel J. 2012. *The Image*. New York: Vintage.

Brevini, Benedetta, Arne Hintz, and Patrick McCurdy, eds. 2013. *Beyond WikiLeaks: Implications for the Future of Communications, Journalism and Society*. London: Palgrave Macmillan.

Brüggemann, Michael. 2012. "Transnational Trigger Constellations: Reconstructing the Story behind the Story." *Journalism* 14 (3): 401–418.

Chadwick, Andrew, and Simon Collister. 2014. "Boundary-Drawing Power and the Renewal of Professional News Organizations: The Case of the Guardian and the Edward Snowden NSA Leak." *International Journal of Communication* 8 (22): 2420–2441.

Coddington, Mark. 2014. "Defending Judgment and Context in 'original Reporting': Journalists' Construction of Newswork in a Networked Age." *Journalism* 15 (6): 678–695.

Conley, David. 2010. "Is Wikileaks Journalism." *The Australian* (Newspaper). Accessed on April 5, 2015. http://www.theaustralian.com.au/business/media/is-wikileaks-journalism/story-e6frg996-1225972790493

Dunn, Hopeton. 2013. "Something Old, Something New…" In *Beyond WikiLeaks: Implications for the Future of Communications, Journalism and Society*, edited by Benedetta, Brevini, Arne Hintz, and Patrick McCurdy, 85–100. London: Palgrave Macmillan.

Fisher, Louis. 2005. "National Security Whistleblowers." Library of Congress Washington DC Congressional Research Service. RL33125, 30 December 2005. Accessed on April 5, 2015. http://www.pogoarchives.org/m/gp/gp-crs-nsw-12302005.pdf

Freedom House. 2014. *Freedom in the World 2014: The Annual Survey of Political Rights and Civil Liberties*. Rowman and Littlefield. Accessed on April 5, 2015. https://freedomhouse.org/report/freedom-world/freedom-world-2014

Galnoor, Itzhak. 1975. "'Politics and Leaks: Balancing Secrecy and Publicity'." *Molad Z (L)*: 6–35. (in Hebrew).

Greenberg, Andy. 2012. *This Machine Kills Secrets*. New York: Penguin.

Handley, Robert L., and Amani Ismail. 2013. "A Watchdog to Reckon with: Delivering WikiLeaks in the Israeli and Australian Press." *Journalism* 14 (5): 643–660.

Hermida, Alfred. 2009. "The Blogging BBC." *Journalism Practice* 3 (3): 268–284.

Hess, Stephen. 1984. *The Government/Press Connection*. 2 Vols. Washington DC: Brookings Institution.

Hindman, Elizabeth Blanks, and Ryan J. Thomas. 2014. "When Old and New Media Collide: The Case of WikiLeaks." *New Media & Society* 16 (4): 541–558.

Kitrosser, Heidi. 2015. "Leak Prosecutions and the First Amendment: New Developments and a Closer Look at the Feasibility of Protecting Leakers." *Williamm and Mary Law Review* 56 (4): 1221–1987.

LeakDrectiry.org. 2015. Accessed on April 13, 2015. http://leakdirectory.org/index.php/Leak_Site_Directory

Lovink, Geert, and Patrice Riemens. 2013. "Twelve Theses on WikiLeaks1." In *Beyond WikiLeaks: Implications for the Future of Communications, Journalism and Society*, edited by Benedetta, Brevini, Arne Hintz, and Patrick McCurdy, 245–253. London: Palgrave Macmillan. 245.

Martin, Brian. 2015. "Leaking: Practicalities and Politics." *The Whistle* 81, 13–18.

McCurdy, Patrick. 2013. "From the Pentagon Papers to Cablegate: How the Network Society Has Changed Leaking." In *Beyond WikiLeaks: Implications for the Future of Communications, Journalism and Society*, edited by Benedetta Brevini, Arne Hintz and Patrick McCurdy, 123–145. London: Palgrave Macmillan.

McManus, John H. 1994. *Market Driven Journalism*. Thousand Oaks, CA: Sage.

Negrine, Ralph M. 1996. *The Communication of Politics*. London: Sage.

Papandrea, Mary-Rose. 2014. "Leaker Traitor Whistleblower Spy: National Security Leaks and the First Amendment." *Boston University Law Review* 94 (2): 449–544

Pozen, David E. 2013. "Leaky Leviathan: Why the Government Condemns and Condones Unlawful Disclosures of Information." *The Harvard Law Review* 127: 512–635.

Reich, Zvi. 2008. "The Anatomy of Leaks Tracing the Path of Unauthorized Disclosure in the Israeli Press." *Journalism* 9 (5): 555–581.

Reich, Zvi. 2011. "Comparing Reporters' Work across Print, Radio, and Online: Converged Origination, Diverged Packaging." *Journalism and Mass Communication Quarterly* 88 (2): 285–300.

Reich, Zvi., and Godler, Yigal. 2014. "A Time of Uncertainty: The Effects of Reporters' Time Schedule on Their Work." *Journalism Studies* 15 (5): 607–618.

Reston, James. 1967. *The Artillery of the Press*. New York: Harper and Row.

Reston, James. 1974. "In Defense of Leaks." *New York times*, 21 June: A38.

Ryfe, David M. 2013. *Can Journalism Survive*. Cambridge, MA: Polity.

Sigal, Leon V. 1973. *Reporters and Officials*. Lexington, MA: Heath.

Singer, Jane. 2014. "User-Generated Visibility: Secondary Gatekeeping in a Shared Media Space." *New Media and Society* 16 (1): 55–73.

Sullivan, Margaret. 2013, March 10. "The Danger of Suppressing the Leaks." Accessed on April 13, 2015. http://www.nytimes.com/2013/03/10/public-editor/the-danger-of-suppressing-the-leaks.html?_r=0

Taylor, Roland. 2015. "The Need for a Paradigm Shift toward Cybersecurity in Journalism." *National Cybersecurity Institute Journal* 1 (3): 45–65.

Usher, Nikki. 2014. *Making News at the New York times*. Ann Arbor: University of Michigan.

Wahl-Jorgensen, Karin. 2014. "WikiLeaks| is WikiLeaks Challenging the Paradigm of Journalism? Boundary Work and beyond." *International Journal of Communication* 8: 2581–2592.

# SOCIAL NEWS = JOURNALISM EVOLUTION?

## How the integration of UGC into newswork helps and hinders the role of the journalist

**Lisette Johnston**

*Social media and "citizen journalism" have arguably changed the face of traditional newsgathering. This paper examines how social media and user-generated content (UGC), specifically video, have been integrated by BBC World News into their coverage of conflicts, with Syria as the main case study. Drawing on interviews with BBC News staff, a newsroom ethnography and a content analysis of BBC World News TV reports, this research asks: What are the challenges for journalists wishing to use UGC? What are the skillsets needed? And is the role of the journalist itself changing, with news becoming more "social" as it is being gathered and disseminated on platforms such as Facebook and Twitter? This paper argues that journalists have been forced to react to issues pertaining to UGC newsgathering, verification and dissemination. The study contributes to literature examining how UGC is used by news outlets. It also considers the extent to which the role of the journalist itself is being redefined as new products are launched. The findings illustrate that UGC has, at times, been used extensively to cover events in Syria, but ideally complements journalists' own reportage. The research also highlights the crucial role played by journalists, harvesting and checking content found online.*

## Introduction

The changes in newsroom practices that have occurred with the advent of social media as a place for journalists to curate information as well as disseminate news have been well documented. Potential sources, once hard to pinpoint, are now located on social media platforms. Information gathered from social media is now often used by journalists in mainstream news organisations, helping them to tell stories across TV, radio, online and social platforms (Hermida 2012). Content from the audience, previously used to complement original reporting, is being harnessed to depict events in places journalists cannot get to (Allan and Thorsen 2014). The increased use of information from social media platforms and the ready availability of smartphones, which can be used to capture live events, means that audiences now have the power to generate content and disseminate it globally. They can become what Bruns called "produsers"

(Bruns 2005, 2013). This means journalists must learn how to navigate these platforms, and at times engage with these individuals in order to access this content. They also need to understand the importance of providing context if using eyewitness video to illustrate news events.

This paper investigates how eyewitness video, referred to as user-generated content (UGC) has been integrated by BBC World News TV into their coverage of conflicts, with Syria as the main case study. The study focuses on video rather than other types of UGC such as photographs and text, though these do fit under the "catch all" term UGC used in the academy (see Wardle and Williams 2008). The research examines how UGC has been used to depict events in Syria. It also explores the challenges for journalists using UGC, drawing on interviews with BBC News staff, a newsroom ethnography and content analysis of BBC World News TV reports. The paper argues that journalists' working practices are changing, as is their use of social media and UGC to cover news events. In turn, the role of the journalist itself is being redefined, as are the skills needed by newsroom staff. This paper contributes to refining scholarly understandings of the role of the journalist as we enter a period where news is more "social", i.e. it is found and disseminated on social media platforms. The study also expands on existing literature related to the use of UGC in news output, an issue which is important to news organisations, particularly in relation to breaking news.

## Examining Newsroom Roles

As more news organisations move towards becoming "digital first", the skills journalists are expected to possess have changed. They must become more "tech-savvy" (Belair-Gagnon 2015). Numerous newsroom studies have examined the practices of journalists who are now required to be curators of social media information (see Harrison 2010; Wardle and Williams 2008). Simultaneously, these same staff must also work as detective and "forensic" experts when using public video frequently found on sites such as Twitter, Facebook and YouTube (Barot 2013; Browne 2014; Murray 2011). The adoption of UGC into news coverage is now commonplace, but most frequently happens when there is no other way to tell the story, though there are risks associated with this editorial practice (Hermida 2010; Wardle, Dubberley, and Brown 2014). This paper examines how UGC has been used by BBC journalists and outlines how adopting this content and using social media platforms as places to engage in certain newsgathering activities has helped and hindered journalistic processes. It argues that evolving practices have in turn changed the responsibilities of some journalists working in twenty-first-century newsrooms.

## Method

This paper draws on findings from qualitative and quantitative data collection methods: interviews, newsroom ethnography and a content analysis. It is important to highlight that the study was carried out by a researcher who worked within BBC World News as a senior producer at the time of data collection. This meant that the researcher knew some of the interviewees personally, though the newsroom observations focused on other departments. There are well-documented ethical issues

regarding interviewing people with whom you have a pre-existing relationship (McConnell-Henry et al. 2010), but the view of the researcher was that any potential pitfalls were outweighed by the amount of rich data gathered as a result of unprecedented access to BBC journalists across the organisation. The aim was to be a "visible researcher" throughout (Hycner 1985). That involved adopting the stance of an interested and subjective actor rather than an impartial interviewer, as given their own industry experience it would not be entirely possible to detach themselves from the process (Plummer 1983).

Eighteen interviews were conducted with journalists including those working within BBC World News, BBC Arabic and the UGC Hub, the main division which processes UGC for use by the BBC. All interviewees had some experience working either with UGC or covering the conflict in Syria. The interviews were semi-structured which allowed questions to be tailored depending on the interviewees' experiences (McNamara 1999). The interviews all lasted between 40 and 60 minutes and were audio recorded, transcribed and then uploaded to NVivo for coding. The interviews were complemented by two periods of observation at the UGC Hub at their London offices for two weeks each in October 2013 and June 2014. This involved sitting with UGC staff on shift observing their work and writing notes, asking questions where appropriate. This enabled the researcher to pursue further lines of questioning related to journalistic practices and allowed for triangulation of these findings with those from the content analysis results.

The content analysis focused on new reports about Syria which broadcast on BBC World News TV during the first six months of the conflict, from March to September 2011. This was a period when Western journalists did not have a presence in the country. The sample took in reports, known as "packages", which contained the key word "Syria" in the clip description or title when searched in the main BBC News database system called Jupiter. There were 170 packages in total. Every fifth package was viewed and the data recorded using a previously devised codebook. Among other fields, the quantity of UGC used in each news report was counted and each separate UGC clip was coded.

## Results: Use of UGC in Coverage

Thirty-five news packages were analysed in total and 20 of them (57.14 per cent) opened with a UGC clip. However, the average overall percentage of UGC used when considering whole packages was considerably less at 35.18 per cent. The average percentage of UGC used in news packages was also calculated month by month (Figure 1).

From the beginning of the conflict in March, there was an increase in the average percentage of UGC used in BBC news packages, rising from 36.6 per cent in March 2011 to 42.95 per cent in April 2011 and 46.6 per cent in May 2011. The results, as illustrated in Figure 1, show the biggest spike in UGC used throughout the six-month period was in July 2011. During this month the average percentage of UGC used in news packages was 53.05 per cent. These figures tell us about how UGC has been used, and results suggest journalists were frequently reliant on this content. The peaks coincide with large-scale protests and more violence in Syria.

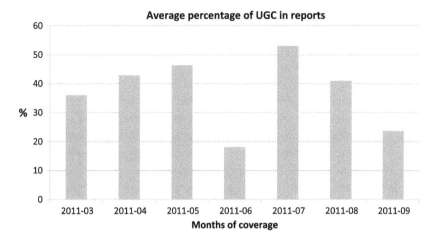

**FIGURE 1**
Average percentage of UGC in packages, broken down by month, March to September 2011

While BBC Arabic's Lina Sinjab was based in Syria in 2011, her movements were very restricted. Lyse Doucet was the first BBC journalist to be given a visa to enter Syria in September 2011. By this time, the monthly average percentage of UGC used in news packages was 23.7 per cent. Thereafter, BBC and western journalists sporadically entered Syria, but many reports were still filed by staff in London or in neighbouring countries such as Jordan and Beirut, so UGC remained an important element in newsgathering.

While the content analysis tells us how UGC was used by the BBC, it was the interviews and newsroom observations which shed most light on changing journalistic practices and challenges of using UGC to depict events. This next section uses the findings from the qualitative research to outline the obstacles related to processing UGC, and the skills and coping mechanisms adopted by journalists to overcome such difficulties.

## New "Social" News Skills

Journalists said they felt they had to harness a variety of new skills to enable them to "harvest" content uploaded to digital platforms. They found themselves actively engaging in "social media newsgathering" (Hughes 2011): searching across social media platforms for information on events in Syria. This extended to finding contributors and eyewitnesses, and meant staff had to be capable of navigating digital spaces effectively to locate relevant uploaded information. Staff said that adopting social media as a newsgathering tool was encouraged by editors, and they used platforms such as Twitter and Facebook to find new content which could be used on air. It was also a way to find information and triangulate it with other sources (Hermida, Lewis, and Zamith 2014). Journalists covering Syria tracked Local Co-ordinating Committees set up across the country who regularly posted regional updates on Facebook.

These updates often included Arabic and English descriptions of video with embedded links to the footage on YouTube.

All interviewees said they developed new coping mechanisms and strategies when dealing with UGC, particularly from Syria. This enabled them to work more effectively, but it took time to become "social news" savvy, particularly if these were not skills individuals already possessed or actively used. Journalists also learned about processes related to verification; that is, checking content as much as possible to establish its accuracy and validity before allowing it to be passed on for inclusion in news output, most often with a disclaimer of "this content cannot be fully verified". Even if they were not directly involved in the verification process, respondents said they still felt they needed to learn how to use UGC appropriately in terms of attribution, crediting and labelling, as well as warnings and caveats. With previous stories, staff processed UGC to be used alongside BBC material. In the Syria scenario, adopting UGC has helped news coverage and enhanced social news literacy, but it also resulted in more work as UGC was frequently the only footage available and this in some ways shaped working practices around UGC.

> In my personal opinion the Arab Spring shaped UGC, it made UGC a force to be reckoned with and it made the rest of the newsroom realise how incredible it can be and what a great tool it is, rather than an occasional added extra. And I think people realised how useful social media was because we couldn't get anyone in there [into Syria]. When it is going off in three or four cities in three or four countries you cannot send people in and you have people there using social media and they knew the power of it, probably before their own governments did, and certainly before the BBC did. (Former UGC producer and researcher, December 2013)

## Verification Skills

Integrating UGC into journalistic workflows was challenging for two reasons. Firstly, the volume of UGC, particularly coming from Syria, could be overwhelming. This meant it was difficult to select which items to attempt to verify. Secondly, the actual verification processes would not be the same for any two pieces of video and could be very lengthy as there is no magic tool to check all aspects of UGC (Schifferes and Newman 2013). Journalists spoke about becoming "more forensic" in their newswork (Murray 2011). Devising a "UGC checklist" was a measure that enabled UGC Hub producers in particular to implement a systematic checking process for UGC before details about clips and their veracity were forwarded to the wider newsroom. In this respect the role of the journalist also evolved. For example, journalists had to become "detective-like" when verifying UGC found online. Traditionally, the first port of call would be the uploader of footage, but with content from Syria this was near impossible, interviewees said, and it could also potentially put sources at risk if the BBC was found to have contacted them inside Syria. Therefore, interviewees said they were forced to become savvy about how to "verify" footage. This insight was in part based on experiences during the Arab Spring, when the need for journalists to have social media skills to seek out information and content was also realised. Most verification was done by the UGC

Hub, though BBC Arabic went through their own procedures, and correspondents in the field might use their own contacts to harvest content and check it.

These findings are congruent with the hypothesis of this paper that journalists' roles and processes are evolving as a result of the challenges posed by integrating UGC into newswork. This included applying basic common sense as well as technical know how, highlighting that while technology can assist in verification processes, journalistic "sensemaking" and logical questioning remain crucial to news staff doing their jobs. Common-sense approaches included trying to track down the uploader by doing searches for the name/user name or checking how often someone had tweeted; a recently opened account with few contributions would be suspect (Barot 2014). Technical approaches could be as simple as a YouTube search by upload date to check for duplicate posts, to checking metadata using Photoshop and corroborating that with what was known about events on the ground. The UGC Hub also trialled different types of software and gave feedback as to how useful it was in aiding the verification process.

> Now there are more social media tools, things such as Geofeedia which is like an interactive map. It picks up if people are tweeting, using Instagram or Facebook and have their location switched on, it picks up what they are saying, what they are producing. So we can make a map of it—and we probably get better content, we get more instant and better quality by going out and finding stuff and seeking out content. (Former producer and researcher within UGC, December 2013)

However, journalists have had to review certain processes due to high-profile mistakes such as publishing pictures of the Houla massacre which then turned out to be based on images that were actually from Iraq (Hamilton 2012). This further highlights the varied challenges faced by journalists when working with UGC. Staff have been aware of the issues around UGC and verification through their own experiences but also through the use of BBC blogs (Barot 2013; Hughes 2011; Murray 2011). The blogs also detail verification case studies.

## Role of the Journalist

In terms of addressing the research question about whether integration of UGC helped or hindered the role of the journalist, the research findings indicated that verifying UGC in itself could be problematic. For many journalists, learning to process UGC was something they did "on the job", and there was an acknowledgement from some respondents that they were unsure about what needed to be done in relation to using and verifying UGC from Syria in particular. Indeed, while certain "checklists" were introduced, these were initially somewhat *ad hoc*; a formal process was not in place. However, as verification relied mainly on individuals' expertise and ability to spot "real" content from Syria, BBC staff were able to take advantage of the close proximity of colleagues with in-country knowledge such as journalists from BBC Arabic and BBC Monitoring. These individuals were called upon to help translate content as well as give context, and analyse buildings, maps and accents to piece together where content might be from. In this respect, as more UGC became available across social platforms, journalists' jobs became more exploratory and investigative, and stronger links and relationships with other departments developed. This could be perceived as a benefit of

integrating UGC into newswork. Other new strategies were also introduced within the UGC Hub, which interviewees said were aimed at streamlining the workflow, helping staff to process UGC from Syria more efficiently.

## Learning to Understand Content—and New Coping Mechanisms

The BBC introduced new social media guidelines in 2011 and has updated them periodically (BBC 2015). The guidelines were aimed at helping staff understand their roles in the "journalistic machine" as well as the processes both content and potential contributors should be put through before going "on air". While there have been some pan-BBC changes, the research findings document extensive organisational changes within the UGC Hub itself. One of the first staffing decisions made in response to events in Syria was the creation of a dedicated "Syria desk". Again drawing on the knowledge of other BBC journalists, UGC staff sat alongside BBC Arabic journalists, staff and newsgathering specialists in the first few weeks of the Syria uprising. This allowed for the free-flowing exchange of information and meant expertise could be shared, helping journalists to understand the verification role. This was something that would arguably not have happened so quickly had UGC not been such a crucial part of editorial content. This is evident given the high proportion of UGC used in BBC news reports in the first weeks and months, as shown in the quantitative content analysis. UGC staff were gradually trained in verification and gained some understanding of sourcing voices and contributors.

In addition, a new role which involved one UGC producer working each day with the main newsgathering team in New Broadcasting House was created. The "Live and Social" producer role involved scouting social media for potential stories, working with newsgathering if there was breaking news by searching for UGC and social media content relevant to the story. They also acted as a liaison between newsgathering and the UGC Hub, helping teams keep abreast of what other journalists were doing. Interviewees said they believed the role ensured a constant point of contact between departments throughout the day, but it also meant that BBC journalists developed a greater understanding of the role of the UGC Hub, and the risks and responsibilities associated with using UGC.

Since mid-2015 other members of staff from the UGC Hub have been embedded with BBC World News TV and the BBC News Channel. By integrating staff in this way best practice can be shared and non-UGC staff can understand the importance of this content and the social media platforms on which it frequently appears. Ensuring journalists understand the risks associated with using UGC and how to use it effectively is a reflection both of the changing media landscape and news consumption patterns. In this respect, being capable of processing UGC and being able to navigate social media platforms which audiences inhabit are becoming core skills which journalists need to possess and maintain.

## Limitations and Further Research

This study aimed to give a comprehensive outline of the changes within BBC News in relation to journalistic roles as UGC has become more of a feature within

newsgathering. This research contributes to a greater scholarly understanding of journalistic practices through mixed methods, including newsroom ethnography. This article adds to existing literature by focusing on UGC and social media usage in relation to crisis events in the Middle East, particularly in Syria. The findings complement studies carried out by Harkin et al. (2012), Wardle, Dubberley, and Brown (2014) and Belair-Gagnon (2015) on verification practices and the changing role of the journalist. These are important considerations for both industry and for academia, and this work helps us understand more about journalistic norms and use of non-traditional content in the form of UGC. Risks related to eyewitness content from the perspective of the journalist is an important research topic (Dubberley, Griffin, and Bal 2015), and an issue which Wardle and Williams (2008) advised should be revisited. The findings indicate that for twenty-first-century journalists, an understanding of the most effective ways to use UGC in news production will continue to be highly significant. This is an age when producers are as likely to tweet contributors and eyewitnesses as ring them up. Use of UGC enables certain events to be depicted on air, but this does not mean the footage automatically ticks boxes for complete accuracy; and in some cases, as has been high-lighted in this case study, journalists have had to learn through trial and error how to manage this material.

While this study gives detailed insight relevant to scholars, the scope of the research in some respects is narrow. Therefore, it is appropriate to recognise some of the paper's limitations. The research field was restricted to journalists working within BBC News. In terms of looking at the wider journalistic framework, a comparative study focusing on how different outlets have used UGC, for example BBC World News and Al Jazeera English, might elicit interesting results. As Syria's conflict continues, this is an area of continued relevance for researchers.

The other point to outline is the role of the researcher herself. This research has been carried out by a researcher who also works at the BBC as a senior producer for BBC World News TV. As a "visible researcher" with a role within the company it is important to be clear about this position and how it could potentially relate to the research findings. Another researcher might interpret the data collected differently, which was one of the reasons to engage in a mixed-methods approach in which all content was not based on qualitative interpretation.

## Conclusions

> Our job is not to parrot sources and the material they provide, but to challenge them, triangulate what they provide with other credible sources and verify what is true, weeding from our work (before we publish, map or broadcast) what is false or not adequately verified. (Buttry 2014, 17)

This research investigated the ways in which the integration of UGC into newswork impacted on the role of the BBC journalist, both in positive and negative ways. It argues that changes in the ways journalists access sources and content, particularly via social media platforms, meant BBC staff encountered new challenges beyond traditional newsgathering. A number of examples of these challenges have been depicted here based on the research findings. The evidence indicates that journalists, particularly

those working with UGC, have been forced to develop new skills to ensure they remain relevant in a twenty-first-century newsroom. These vary from improving social media literacy to ensuring verification capabilities. As journalists and audiences alike are inhabiting social media spaces, it is no surprise that news is being disseminated on these platforms. In such situations, an understanding of how to access UGC and connect with individuals is important and could be considered a core skill.

Results suggest that BBC News' reporting of the Syria conflict altered as a result of inclusion of UGC footage, particularly in the first six months of the conflict, when it was heavily used in TV reports about events in the country. In this respect UGC has helped journalists. However, the inclusion of UGC and information made available via social media platforms has also led to an evolution in some journalistic roles and responsibilities. Findings suggest that BBC staff have encountered challenges which come alongside using UGC from Syria, including issues pertaining to newsgathering, verification and dissemination.

At the core, social media platforms have become "go to" newsgathering sources. They are also places to seek out eyewitnesses or footage. This means journalists have had to become more flexible and adaptable in digital spaces, perhaps having a greater presence on certain social media platforms as well as becoming more proficient in understanding technology which will help them track down uploaders, or content. With regard to UGC specifically, journalists have been challenged as they have had to adapt quickly and learn how to treat this content. They have had to refer to more learned colleagues from BBC Arabic and Monitoring when trying to find UGC and assess whether it can be used.

In conclusion, some journalistic roles have changed immeasurably as producers engage in social newsgathering and the delicate process of verification. Certain mechanisms and strategies have emerged as a result of this evolution amid concerns about content accuracy. For journalists now and in the future, digital tools have become more important for tracing information, forensic examination and disseminating UGC to the audience while depicting events on the ground. As technologies for checks and platforms used to showcase UGC evolve, journalists must continually develop their skills to keep apace. As news becomes more social, so too, it seems, must the journalists.

## DISCLOSURE STATEMENT

No potential conflict of interest was reported by the author.

## REFERENCES

Allan, Stuart, and Einar Thorsen, eds. 2014. *Citizen Journalism: Global Perspectives (Vol. 2)*. New York: Peter Lang.

Barot, Trushar. 2013. *UGC: Source, Check and Stay on Top of Technology*. BBC College of Journalism, 17 December 2013. Accessed 29 June 2015. http://www.bbc.co.uk/blogs/colle geofjournalism/entries/1fbd9b88-1b29-3008-aae6-1cab15e13179.

Barot, Trushar. 2014. "Verifying Images." In *Verification Handbook: A Definitive Guide to Verifying Digital Content for Emergency Coverage*, edited by Craig Silverman. Maastricht, the Netherlands: European Journalism Centre, 33–39.

BBC. 2015. *Editorial Guidelines. Section 1: The BBC's Editorial Values*. Accessed 21 April 2015. http://www.bbc.co.uk/editorialguidelines/page/guidelines-editorial-values-editorial-values/

Belair-Gagnon, Valerie. 2015. *Social Media at BBC News: The Re-Making of Crisis Reporting*. New York: Routledge.

Browne, Malachy. 2014. "Verifying Video." In *Verification Handbook: A Definitive Guide to Verifying Digital Content for Emergency Coverage*, edited by Craig Silverman, 45–51. Maastricht, the Netherlands: European Journalism Centre.

Bruns, Axel. 2005. *Gatewatching: Collaborative Online News Production* (Vol. 26). New York: Peter Lang.

Bruns, Axel. 2013. "From Prosumption to Produsage." In *Handbook on the Digital Creative Economy*, edited by Ruth Towse and Christian Handke, 67–78. Cheltenham: Edward Elgar.

Buttry, Steve. 2014. "Verification Fundamentals: Rules to Live By." In *Verification Handbook: A Definitive Guide to Verifying Digital Content for Emergency Coverage*, edited by Craig Silverman, 15–23. Maastricht, the Netherlands: European Journalism Centre.

Dubberley, Sam, Elizabeth Griffin and Haluk Mert Bal. 2015. *Making Secondary Trauma a Primary Issue: A Study of Eyewitness Media and Vicarious Trauma on the Digital Front Line*. Istanbul: Eyewitness Media Hub.

Hamilton, Chris. 2012. *Houla Massacre Picture Mistake*. BBC Blog, 29 May 2013. Accessed 04 November 2013. http://www.bbc.co.uk/blogs/theeditors/chris_hamilton/

Harkin, Juliette, Kevin Anderson, Libby Morgan, and Briar Smith. 2012. "Deciphering User Generated Content in Transitional Societies: A Syria Coverage Case Study." Center for Global Communication Studies. Annenberg School for Communication: University of Pennsylvania.

Harrison, Jackie. 2010. "User-Generated Content and Gatekeeping at the BBC Hub." *Journalism Studies* 11 (2): 243–256.

Hermida, Alfred. 2010. "Twittering the News." *Journalism Practice* 4 (3): 297–308.

Hermida, Alfred. 2012. "Tweets and Truth: Journalism as a Discipline of Collaborative Verification." *Journalism Practice* 6 (5-6): 659–668.

Hermida, Alfred, Seth Lewis, and Rodrigo Zamith. 2014. "Sourcing the Arab Spring: A Case Study of Andy Carvin's Sources on Twitter during the Tunisian and Egyptian Revolutions." *Journal of Computer-Mediated Communication* 19 (3): 479–499.

Hughes, Stuart. 2011. *Newsgathering for Social Media - a Case Study*. BBC Blogs. Accessed 25 June 2015. http://www.bbc.co.uk/blogs/collegeofjournalism/entries/fccd467f-5d65-3bbd-87ce-0a43c922c9b7

Hycner, Richard H. 1985. "Some Guidelines for the Phenomenological Analysis of Interview Data." *Human Studies* 8 (3): 279–303.

McConnell-Henry, Tracy Ainsley James, Ysanne Chapman, and Karen Francis. 2010. "Researching with People You Know: Issues in Interviewing." *Contemporary Nurse*, 34 (1), 2–9.

McNamara, Carter. 1999. *General Guidelines for Conducting Interviews*. Accessed 23 July 2014. http://managementhelp.org/evaluatn/intrview.htm

Murray, Alex. 2011. *BBC Processes for Verifying Social Media Content*. BBC Blog. Accessed 13 June 2013. http://www.bbc.co.uk/blogs/blogcollegeofjournalism/posts/bbcsms_bbc_procedures_for_veri

Plummer, Ken. 1983. *Documents of Life: An Introduction to the Problems and Literature of a Humanistic Method*. London: Unwin Hyman.

Schifferes, Steve and Nic Newman. 2013. "Verifying News on the Social Web: Challenges and Prospects." In Proceedings of the 22nd International Conference of World Wide Web Companion, 875–878. Geneva.

Wardle, Claire, and Andrew Williams. 2008. *UGC@Thebbc: Understanding Its Impact upon Contributors, Noncontributors and BBC News*. Cardiff: Cardiff School of Journalism. 11.

Wardle, Claire, Sam Dubberley, and Pete Brown. 2014. "Amateur Footage." *A Global Study of User-Generated Content in TV and Online-News Output.* Tow Center for Digital Journalism.

# "TWITTER JUST EXPLODED"
## Social media as alternative vox pop

**Kathleen Beckers** and **Raymond A. Harder**

*News media regularly include the voice of the "man or woman in the street" alongside that of the actors involved in a news story. Journalists use these vox pops to give an impression of public opinion. With the coming of social media, access to people's opinions has never been so easy. Little research exists about how social media (Twitter in particular) are used by journalists to describe public opinion. This is the question this research aims to answer by using a combination of a qualitative and a quantitative content analysis of Dutch and Flemish news websites. We found several patterns regarding the use of Twitter vox pops. First, we found Twitter to be regularly used as a representation of public opinion. Second, many items generalised these opinions to larger groups with strong—mostly negative—emotions. Third, when referring to Twitter, the articles used (abstract) quantifiers and hyperbolic terms (commotion, explosions) to imply an objective basis for these inferences about the "vox Twitterati".*

## Introduction

News media frequently include the voice of the "(wo)man in the street" along-side that of actors who are directly involved in a news story (Pantti and Husslage 2009) to provide an impression of what the public thinks. Surveying people to gather these "vox pops", especially for television, traditionally required physical effort by journalists, but this situation has changed. The vast increase of social media use in recent years (Pew Research Center 2015) enables journalists to tap into the opinions of laypeople by merely entering a search string. This is especially true for Twitter, which is easily searchable and has a public character by default (in contrast to Facebook). Since media representations are the primary source of information for audiences to get an idea of how other people think about an issue (Moy and Scheufele 2000), this begs the question of how these "social media opinions" are presented in the news. How do journalists include Twitter when describing attitudes current among the population? By combining qualitative and quantitative content analyses of Flemish and Dutch news websites, this paper investigates which specific formal and substantive patterns are adopted when including tweets as vox pop in news coverage, and examines the frequency with which these occur in online news items.

## Public Opinion, Vox Pops and Social Media

The very notion of "public opinion" has drawn a considerable amount of scholarly attention—from the question of whether it even exists to how it can be adequately measured (e.g. Lewis, Inthorn, and Wahl-Jorgensen 2005). Despite these difficulties, journalists regularly refer to what "the people" think. To do this, journalists include opinion polls, images of interactions between audiences and officials (i.e. protests), vox pops or their own inferences about public opinion in their coverage (Brookes, Lewis, and Wahl-Jorgensen 2004; Lewis, Inthorn, and Wahl-Jorgensen 2005). Vox pops, one of the most prevalent means to represent public opinion (Lewis, Inthorn, and Wahl-Jorgensen 2005), can be defined as apparently randomly chosen common persons with no affiliation, interviewed by media, making a statement about the news item (Bosch 2014; De Swert 2013; Lefevere, De Swert, and Walgrave 2011). Contrary to other news sources, vox pops are defined by the fact that they are interchangeable with any other person from the population they represent. This distinguishes them from other citizen sources such as eyewitnesses, who provide unique information about a news issue (De Swert 2013). Because of the replaceability of vox pops, journalists can be more selective in which voices (not) to include and thus have more control over the message that is eventually broadcast or published.

Vox pops can be a means to balance traditional elite sources and allow regular, non-elite people to express (political) opinions in the news (Lewis, Inthorn, and Wahl-Jorgensen 2005, 72). Daschmann (2000) found vox pops to have more influence than opinion polls on voter judgement, perceived public opinion and even own opinion. Moreover, vox pops are found to influence audiences' perceived public opinion and individual opinion more than statements from elite actors such as politicians and experts (e.g. Lefevere, De Swert, and Walgrave 2011). These effects might be attributed to the representativeness heuristic (Tversky and Kahneman 1971), which theorises that a small number of examples that seem randomly distributed would reinforce the belief that the whole population is represented and that these examples are an accurate rendition of public opinion. Research shows that audiences take vox pops seriously because they perceive them as representative of the public in general (Lefevere, De Swert, and Walgrave 2011).

To collect vox pops, journalists always had to go on to the streets and approach individuals. With the rise of social media, however, this changed. Selecting a number of opinions from the wide array of voices on social media is possible without much effort. This is especially true for Twitter, given its public and searchable nature. Having become "part of the everyday toolkit of journalists" (Hermida 2013, 296), Twitter is regularly used as a source of information or inspiration for a story. Studies across different European countries show that the voice of "common people", or "vox populi", accounts for a considerable share of the tweets that make it into newspaper coverage (Broersma and Graham 2013; Hladík and Štětka 2015; Paulussen and Harder 2014). Moreover, Twitter vox pops have been employed as a public opinion tool on television news and in newspapers during election times (Anstead and O'Loughlin 2015). While we know vox pops are influential and that Twitter vox pops are used in news media as a public opinion tool, so far no research has studied specifically *how* Twitter is used to represent ordinary citizens in the news. This study addresses this topic and elaborates on the

ways in which Twitter posts are used as vox pops and how these vox pops are contextualised, asking the following two research questions.

**RQ1:** Which formal and substantive patterns are present concerning the use of Twitter as vox pop in news coverage?

**RQ2:** How often do these patterns occur in a sample of online news items?

## Methodology

### Qualitative Analysis

Our research is divided into two parts. The first consists of a qualitative analysis of website news items. Since there was no previous research available on this subject, its purpose was to find specific patterns relating to the use of tweets as vox pop in news coverage.

We have two reasons to use online coverage as our sample. First, production deadlines disappear for news websites (Quandt 2008; Rosenberg and Feldman 2008). Instead of having one fixed deadline per edition (as with newspapers or television newscasts), articles have to be published around the clock with competition between different outlets, resulting in ever-faster reporting. Therefore, website journalists may have more incentives to use social media content than their peers who produce content for traditional media. In addition to these constant deadlines, online news media also provide the technology to easily include social media in their articles (e.g. the possibility to include tweets directly from Twitter).

Using Dutch and Flemish news websites, we constructed a data-set of news items that included Twitter vox pops from the year 2014. The items were found through Google News, website-specific search engines and by following websites' RSS feeds on a daily basis. This resulted in a sample of 33 Dutch and 29 Flemish news items ($N = 62$). We did not strive for representativeness in terms of sample size, but rather aimed at attaining a point of theoretical saturation, at which we did not encounter any new patterns. The items were imported into NVivo 10 software and coded manually. To code, we used the sensitising concepts "quantities", "emotions" and "groups". Problematic cases were discussed between the authors.

### Quantitative Analysis

The second part of the study consists of a quantitative content analysis of website news items. The purpose was to complement the findings of the qualitative study and determine how the patterns we found related to a sample of news items.

A sample of 800 news items from the first semester of 2015 was used, again retrieved from Dutch and Flemish news websites. The Google search engine was used to retrieve the website items. For each country, we selected four news websites with a different profile (see Table 1). For each website, we used the search query *"op Twitter"* *site:[website]* and specified the period between January 1, 2015 and July 1, 2015. The first 10 pages[1] of search results were saved, amounting to 100 news items in total per medium. We manually verified whether the article was *about* Twitter (the company or

**TABLE 1**

Overview of news websites and their profiles

| Profile of news website | Dutch | Flemish |
|---|---|---|
| Online only (popular) | Nu.nl | Newsmonkey.be |
| Website of public service broadcaster (elite) | NOS.nl | Deredactie.be |
| Website of popular newspaper | Ad.nl | Nieuwsblad.be |
| Website of elite newspaper | Volkskrant.nl | Standaard.be |

website in general) or featured information *from* Twitter. In some cases, the search query yielded results where Twitter was not mentioned in the article itself, but only in the header, footer or in a sidebar of the site. An overview of this assessment is presented in Table 2. In addition, we coded whether the article featured celebrity tweets ("Kanye West says something on Twitter") and/or whether it featured references to common persons on Twitter. The articles containing vox pops (27.6 per cent, $N = 221$) were used for further analysis.

*Variables.* Coding of the news items was conducted on two levels. First, on the level of the news item, we determined whether Twitter served as a *trigger* (something that happened on Twitter triggered the news story) or an *illustration* (activity on Twitter was used to support a news story). Also, we listed the *emotions* and *groups* that the news items mentioned. These emotions were coded as either "positive", "neutral" or "negative". Next, we coded whether or not the displayed opinions showed unanimity and if a (trending) *hashtag* was mentioned. *Hyperbolic markers* used in the articles were also coded. With this term, we refer to words that signal (1) a large impact or quantity, (2) have a negative valence and (3) carry an image of incontestability (e.g. "storm on Twitter", "Twitter explodes").

Second, variables were coded on the level of the individual Twitter message. For each tweet mentioned in the news items, we determined whether it was sent by a *known* (celebrity, politician) or *unknown* person ("(wo)man in the street") and checked whether the name of the Twitter user was mentioned. Next, we determined the *format* of every tweet (paraphrase, direct quote, embedded tweet). Last, we coded whether

**TABLE 2**

Overview and assessment of Twitter items (%)

| | About Twitter | Twitter as source | Twitter not mentioned |
|---|---|---|---|
| Dutch media | | | |
| Nu.nl (N = 100) | 28 | 37 | 35 |
| NOS.nl (N = 100) | 11 | 81 | 1 |
| Volkskrant.nl (N = 100) | 12 | 86 | 2 |
| Ad.nl (N = 100) | 14 | 84 | 2 |
| Flemish media | | | |
| Newsmonkey.be (N = 100) | 15 | 79 | 6 |
| Deredactie.be (N = 100) | 7 | 81 | 12 |
| Standaard.be (N = 100) | 3 | 74 | 23 |
| Nieuwsblad.be (N = 100) | 0 | 83 | 17 |

there was a hyperlink (pointing directly to the tweet) present. Inter-coder reliability was calculated on a sample of 10 per cent of the news items containing vox pops and reached Krippendorff's alpha scores between 0.70 and 1.

## Findings

Although this paper is comprised of two separate studies, we present the results together for reasons of clarity. They are structured according to the formal and substantive patterns derived from the qualitative analysis, which were also used for the interpretative assessment of the findings. The statistics provided refer to our quantitative analysis.

### *Prevalence of Twitter as Vox Pop*

In general, we found that when a news item included Twitter as a source, Twitter was used as a means to represent "common people" in 38.2 per cent of the cases (e.g. "the ordinary Twitter user", *Newsmonkey.be*, January 25, 2015). When comparing the news websites, we found that Flemish news websites used Twitter vox pops on average more often (mean = 0.42, SD = 0.49) than Dutch news websites (mean = 0.34, SD = 0.47); $t(597.98) = -2.07$, $p < 0.05$. We also found an association between the "type" of the news websites and their use of Twitter vox pops. Popular websites (mean = 0.48, SD = 0.50) used Twitter vox pops more often than websites with an elite character (mean = 0.31, SD = 0.46); $t(561.75) = 4.29$, $p < 0.001$. The 221 website articles that contained Twitter references to common people mentioned 1323 individual tweets. Of those, 1053 (79.2 per cent) were written by ordinary citizens, the remaining 270 (20.8 per cent) were posted by celebrities, companies or media outlets. We discard the latter group of tweets for the remainder of the paper and focus on the tweets written by ordinary citizens.

The vast majority (69.2 per cent) of the news items featured Twitter as the trigger of the news item. This means that the news item covers a situation that takes place entirely on Twitter and which would not have existed without the social medium. Examples include Twitter reactions ("#JeSuisCharlie: Twitter condemns attack on Charlie Hebdo with mass of support tweets", *Newsmonkey.be*, January 7, 2015) or when the news item focuses on someone's post on Twitter ("Bruno Tobback launches #ikwilwerk", *Standaard.be*, March 27, 2015). In only 30.8 per cent of the news items, Twitter serves as an illustration—a function that is comparable to that of traditional vox pops ("Also on Twitter calls for action appear", *Volkskrant.nl*, January 7, 2015).

### *Formal Characteristics: Attribution and Presentation*

There are several ways in which journalists can include Twitter posts in a news item. Tweets can be quoted directly, meaning that their text is copied without changes, or they can be paraphrased, meaning that the journalist phrases the content of a tweet in his or her own words. Table 3 shows that the latter is used least often by journalists,

while direct quotes are used more frequently. Notwithstanding the presence of traditional forms of source inclusion, we found that Twitter's specific "embed" option is used overwhelmingly (90.2 per cent). When embedding a tweet, its content is displayed in a frame that features the characteristic Twitter layout, including "follow", "retweet" and "favourite" buttons, as well as hyperlinks to both the Twitter user and the tweet itself. In terms of source attribution and tweet retrievability, it is clear that embedding tweets provides the most transparency and possibilities for interaction with the public. An embedded tweet ensures that readers are able to verify the exact source. In 53.4 per cent of the cases in which the tweet was paraphrased or quoted, it was virtually impossible to retrieve the original tweet, as it featured neither author nor hyperlink. Adding to this, some were translated, making it impossible to find the tweet using a search query.

### Emotions

When referring to Twitter, an inference of the emotions of Twitter users is often made by the journalist. In 29.4 per cent of the cases, the news item mentioned one or more emotions relating to Twitter users. Three aspects of these described emotions stand out. First, the emotions usually relate to a group of people, even though it is often unclear what this assessment of "group emotions" is based on (also see the next sections). Second, the emotions are mostly very intense, with news items talking about "shock" or even a "hate campaign" on Twitter. Third, the described emotions are predominantly negative in tone. There is "anger", "frustration", "outrage" and "disappointment" (e.g. "This statement infuriates Twitter users", *Newsmonkey.be*, April 22, 2015). On the other hand, we did find a minority of cases that described emotions such as "hilarity", "contentment" or "madness with joy" (e.g. "Immediately after the tweet was posted, twitterers went crazy with enthusiasm", *Standaard.be*, April 24, 2015). In total, 89 emotions linked to individuals or groups on Twitter were mentioned in the news items; 22.5 per cent of these emotions were positive, 76.4 per cent negative and 1.1 per cent neutral in tone.

### Twitter as a Group

As with traditional vox pops, it is physically impossible for journalists to survey more than a small subsection of the population. Yet, 148 (67 per cent) of the news

**TABLE 3**
Prevalence of different tweet formats ($N = 1053$)

| Format | $N$ | % |
| --- | --- | --- |
| Embedded | 949 | 90.2 |
| Direct quote | 57 | 5.4 |
| Paraphrase | 46 | 4.4 |

items referred to the common (wo)man in the street in collective terms. In total, 212 references were made about groups when talking about common people (see Table 4). The majority (60.4 per cent) of the news items referred to a group as if it were the reactions of an entire group transcending Twitter, although we notice that they display reactions and emotions as expressed on Twitter. These groups were specified in different ways, such as "people", "Belgians" or "fans". Other news items do refer to groups on Twitter (37.3 per cent), for example "Twitter users" or "Twitter enthusiasts". These Twitter group references make it easier for audiences to form an idea of the scale of the opinions and emotions displayed in the article, although it is still difficult to get an impression of the size of the group. Lastly, a small group of news articles (2.3 per cent) referred to a group in other terms, such as "the internet" or "internet users". These groups transcend Twitter, but are still located in the online realm. To conclude, most articles make very broad generalisations, ascribing reactions to an entire group. The impact therefore seems large, even though an unverifiable generalisation is made.

Next, we looked at the portrayed unanimity of these groups. In 18.2 per cent of all articles mentioning groups, we found an explicit mention of dissent among the described group (e.g. "The news was met with mixed reactions", *Standaard.be*, January 30, 2015). In the other news items, a certain group of people was either explicitly (2 per cent) or implicitly (79.8 per cent) presented as being unanimously in agreement (e.g. "Everybody in the Netherlands loves coach Radmilo", *Ad.nl*, May 18, 2015).

### Quantities

To describe the scope of a given phenomenon or to introduce an embedded or quoted tweet, quantitative markers were used. By this we mean terms such as "many", "some" and "a lot", which are used to quantify a certain group of people ("a lot of Belgians") or tweets ("many tweets"). Thereby, the reader is supposed to get an impression of the prevalence of a phenomenon on Twitter. While most articles (57.9 per cent) do not feature any quantifiers, 42.1 per cent features at least one, with a maximum of four.

The nature of these markers varies in concreteness, but they are usually abstract in nature. Only 16 of the 128 markers (12.5 per cent) referred to a specific number ("15,160 retweets", "2,000 followers"), which can be verified objectively, at least in theory. The remaining quantifiers, however, cannot. This is less problematic for terms such as "some", which are incontestable (yet vague), but all the more so with terms such as "many" and "en masse", which require a journalist's judgement. However, the readers

**TABLE 4**
Prevalence of references to groups (N = 212)

|  | N | % |
| --- | --- | --- |
| Group on Twitter | 79 | 37.3 |
| Group transcending Twitter | 128 | 60.4 |
| Other | 5 | 2.3 |

do not learn what this judgement is based on. Moreover, it remains unclear how the quantity marker relates to the full population that is described. An example of this is the sentence "Only a tiny proportion agrees with Shepherd" (*Nos.nl*, October 22, 2013). This statement may or may not be true, but cannot be verified based on information provided in the article.

Another way of giving a quantitative assessment of tweets is the statement that something was "trending", which we saw in 18.6 per cent of the news items. Again, this seems to be an incontestable indicator of impact, but we have very little knowledge of the underlying algorithms that govern the composition of the list of current trending topics. This is even more problematic as these "trends" differ between countries and cities.

## *Hyperbolic Markers*

The final pattern we found in our sample was the use of what we call "hyperbolic markers" in news coverage about Twitter. Examples include "commotion", "fuss" and "storm". There is no predetermined threshold to what a "fuss" or "storm" constitutes, both in terms of intensity and number of tweets. In 26.7 per cent of all items, we found at least one term of this type (e.g. "Yesterday, Twitter exploded during the RTL-show Obese" *Ad.nl*, May 15, 2015). We also found some recurring patterns in these hyperboles. First, we found that many of these terms refer to natural phenomena. Examples are "storm on Twitter", "a wave of outrage" and "reactions poured in". Furthermore, references were made to the explosive nature of the Twitter phenomenon, for example "the whole thing exploded" and "exploded like a bomb".

## Conclusion and Discussion

The goal of our research was to explore how journalists use Twitter to describe the sentiment or mood among the population. We found Twitter to be an important public opinion tool. Of the news items mentioning Twitter, 38.2 per cent used the medium to refer to common people and 69.2 per cent of the news in our sample was Twitter-initiated. The first pattern we found is that the tweets are generalised to larger groups stretching beyond Twitter and/or the digital realm and that these groups are linked to intense, negative emotions. In doing so, (abstract) quantifiers are used that imply an objective basis for these inferences. In 81.8 per cent of the articles mentioning groups we found (implicit) claims of unanimity. In 26.7 per cent of the news items hyperbolic markers were used when talking about public opinion (e.g. a Twitter storm, a fuss, commotion). These markers imply objectivity and seem very matter-of-fact.

This generalisation of singular opinions to larger, unanimous groups of people has been observed before in public opinion research (Lewis, Inthorn, and Wahl-Jorgensen 2005). Ignoring the complexity and diversity of opinions that exist in that group of people, these inferences "serve to create a vision of public opinion as unified and comprehensible" (Lewis, Inthorn, and Wahl-Jorgensen 2005, 97). However, questions can be raised about Twitter's suitability for measuring the "vox populi". First, Twitter has a specific user base, which makes it non-representative of the general public. Second,

when journalists gather opinions from Twitter, the users who do not speak out on a certain topic are by definition ignored. Journalists function as passive gatherers of opinions and do not actively seek new ones. This is understandable, as showing tweets of people who had no opinion would not be very interesting in an article. This issue applies to other public opinion tools also. Even more representative tools in which transparency is more common, such as opinion polls, often lack information about non-response and other statistics (Lewis, Inthorn, and Wahl-Jorgensen 2005). Third, when writing a tweet, people usually do not bear in mind that it might be used as a vox pop. People's reactions may be impulsive and more emotional than their actual opinion is. This is amplified by the 140-character limit, which restrains the possibility to be nuanced. In summary, Twitter is a poor measure of the "vox populi" in general, but even the "vox Twitterati" is virtually impossible to estimate.

When journalists use generalising terms and hyperbolic markers to refer to public opinion, the basis of the journalist's assessment, or his or her frame of reference when discussing a "fuss" or "Twitter storm" is not made clear, which makes it also impossible for readers to verify these claims. Consequently, we arrive at a "double layer" of uncertainty. First, journalists themselves, by definition, cannot tell how their interpretation relates to the "true" *vox populi*. Second, the reader is neither able to deduce nor verify the journalist's assessment. In contrast, while these general assessments cannot be verified, the content (or even existence) of the individually cited tweets oftentimes can. The vast majority (94.8 per cent) of these tweets were accompanied by a hyperlink to the tweet in question. Yet, although providing transparency of sources increases journalists' accountability, there is some tension between this and respecting the privacy of Twitter users.

While our study demonstrates the prevalence of Twitter vox pops and the ways in which they are presented, our empirical data do not allow us to infer why journalists employ this feature routinely. To reflect on this question, we suggest that future research builds on the typology of media logics that Brants and van Praag (2015) put forward. From the *public interest logic* point of view, we may hypothesise that journalists judge opinions from Twitter to be inherently valuable and as much a part of democratic deliberative discourse as organised protests or opinion polls. It should be noted, however, that the Twitter vox pops in our study were mostly found in "soft" news items such as celebrity and sports news. This contrasts with other forms of public opinion representation, which are also used to illustrate "hard" news (Lewis, Inthorn, and Wahl-Jorgensen 2005). The *media logic* perspective offers a more critical explanation, namely that the use of Twitter vox pops is driven by economic considerations. Creating news items on the basis of tweets requires few resources. Media workers may therefore conclude that this is an efficient way of dedicating their time in a news ecology characterised by virtually round-the-clock news demand (Rosenberg and Feldman 2008). At the same time, entertaining news items written in a certain forward-referencing style ("clickbait", see Blom and Hansen 2015) tend to generate high volumes of website traffic, thereby bringing in more advertisement revenue than other articles. Finally, the *logic of the public* suggests that journalists have altered their perceptions of what the public expects of them. With audiences now able to both inform and express themselves via the internet, "[l]arge segments of the public … are now used to speaking and being listened to" (Brants and van Praag 2015, 9). A view of journalists as having "the sole right to 'the' truth" (10) is no longer tenable. By consequence, journalists may

consider it arrogant, if not elitist, not to include these voices in their coverage. Indeed, we may even hypothesise that the public "force[s] [journalists] to listen and take their preferences into account" (Brants and van Praag 2015, 10).

As these logics are not contradictory, they reinforce one another to some extent. A complete explanation of why journalists choose to use Twitter vox pops in their coverage might therefore incorporate these motivations. Again, our study does not allow us to determine the extent to which these motivations lie behind the use of Twitter vox pops. It does, however, shed some light on the ways in which public opinion is represented in the contemporary news ecology. In doing so, we hope to have provided some pointers for further inquiry into this topic.

## DISCLOSURE STATEMENT

No potential conflict of interest was reported by the authors.

## NOTE

1. The results were ordered for relevance and not by date, since sorting by date resulted in an unworkable list of pages mentioning the text "op Twitter" anywhere but in the news item on the page. We are aware that how Google's algorithms determine what "relevance" entails is unclear, but we believe our relatively big sample mitigates the representativeness question.

## REFERENCES

Anstead, Nick, and Ben O'Loughlin. 2015. "Social Media Analysis and Public Opinion: The 2010 UK General Election." *Journal of Computer-Mediated Communication* 20 (2): 204–220. doi:10.1111/jcc4.12102.

Blom, Jonas Nygaard, and Kenneth Reinecke Hansen. 2015. "Click Bait: Forward-Reference as Lure in Online News Headlines." *Journal of Pragmatics* 76: 87–100. doi:10.1016/j.pragma.2014.11.010.

Bosch, Brandon. 2014. "Beyond Vox Pop: The Role of News Sourcing and Political Beliefs in Exemplification Effects." *Mass Communication and Society* 17 (2): 217–235. doi:10.1080/15205436.2013.779718.

Brants, Kees, and Philip van Praag. 2015. "Beyond Media Logic." *Journalism Studies*. doi:10.1080/1461670X.2015.1065200.

Broersma, Marcel, and Todd Graham. 2013. "Twitter as a News Source: How Dutch and British Newspapers Used Tweets in Their News Coverage, 2007–2011." *Journalism Practice* 7 (4): 446–464. doi:10.1080/17512786.2013.802481.

Brookes, Rod, Justin Lewis, and Karin Wahl-Jorgensen. 2004. "The Media Representation of Public Opinion: British Television News Coverage of the 2001 General Election." *Media, Culture & Society* 26 (1): 63–80. doi:10.1177/0163443704039493.

Daschmann, Gregor. 2000. "Vox Pop & Polls: The Impact of Poll Results and Voter Statements in the Media on the Perception of a Climate of Opinion." *International Journal of Public Opinion Research* 12 (2): 160–181. doi:10.1093/ijpor/12.2.160.

De Swert, Knut. 2013. "Explaining the Use of Vox Pops in Television News: An International Comparison." Paper Presented at the Annual Meeting of the International Communication Association, London, England, June 17–21.

Hermida, Alfred. 2013. "#Journalism. Reconfiguring Journalism Research about Twitter, One Tweet at a Time." *Digital Journalism* 1 (3): 295–313. doi:10.1080/21670811.2013.808456.

Hladík, Radim, and Václav Štětka. 2015. "The Powers That Tweet: Social Media as News Sources in the Czech Republic." *Journalism Studies* ahead-of-print: 1–21. doi:10.1080/1461670X.2015.1046995.

Lefevere, Jonas, Knut De Swert, and Stefaan Walgrave. 2011. "Effects of Popular Exemplars in Television News." *Communication Research* 39 (1): 103–119. doi:10.1177/0093650210387124.

Lewis, Justin, Sanna Inthorn, and Karin Wahl-Jorgensen. 2005. *Citizens or Consumers? What the Media Tell Us about Political Participation*. Maidenhead: Open University Press.

Moy, Patricia, and Dietram A. Scheufele. 2000. "Media Effects on Political and Social Trust." *Journalism & Mass Communication Quarterly* 77 (4): 744–759. doi:10.1177/107769900007700403.

Pantti, Mervi, and Karin Husslage. 2009. "Ordinary People and Emotional Expression in Dutch Public Service News." *Javnost-the Public* 16 (2): 77–94. doi:10.1080/13183222.2009.11009005.

Paulussen, Steve, and Raymond A. Harder. 2014. "Social Media References in Newspapers: Facebook, Twitter and YouTube as Sources in Newspaper Journalism." *Journalism Practice* 8 (5): 542–551. doi:10.1080/17512786.2014.894327.

Pew Research Center. 2015. "Social Networking Fact Sheet". http://www.pewinternet.org/fact-sheets/social-networking-fact-sheet/.

Quandt, Thorsten. 2008. "News Tuning and Content Management: An Observation Study of Old and New Routines in German Online Newsrooms." In *Making Online News: The Ethnography of New Media Production*, edited by A. Paterson Chris and Domingo David, 177–206. New York: Peter Lang.

Rosenberg, Howard, and Charles S. Feldman. 2008. *No Time to Think: The Menace of Media Speed and the 24-Hour News Cycle*. New York: A&C Black.

Tversky, Amos, and Daniel Kahneman. 1971. "Belief in the Law of Small Numbers." *Psychological Bulletin* 76 (2): 105–110. doi:10.1037/h0031322.

# WHO SHARES WHAT WITH WHOM AND WHY?

## News sharing profiles amongst Flemish news users

**Ike Picone, Ralf De Wolf** and **Sarie Robijt**

*Successful online publishers like BuzzFeed and the Huffington Post have mastered the art of making news go viral. In order for this to happen, it needs to be shared by a large number of online media users. Understanding what makes a piece of content worth sharing with others then becomes a key element in understanding current news flows. User-oriented studies about what incites people to share news are limited. Content characteristics, personal dispositions towards news and new media, and self-presentation have proved to be relevant indicators, but people might differ considerably in the way they share news. We hypothesize that different "sharing profiles" are discernible amongst online news users, based on their motivations to share, but also considering internet skills and news-sharing behaviour. In order to identify these profiles, we draw on a survey amongst Dutch-speaking Belgian online media users (N = 1237). The results illustrate how motivations to share are important predictors of online sharing activity; especially staying socially connected with others. Yet, self-confidence in internet skills was found to be a second, important predictor for online sharing behaviour. Drawing on these insights, we discuss whether viral news forms a threat or an opportunity to news reporting.*

## Introduction

After online news outlets disrupted the print industry, it is now their turn to be disrupted. Today, the major social network sites are becoming an increasingly important medium for distributing news content, where the users themselves decide which items become "viral" by sharing content among their social circles. The latest Ofcom report on adults' media use (Ofcom 2015, 89–90) reveals that in 2014 30 per cent of UK internet users shared links to websites or online articles at least weekly, rising to 45 per cent amongst those 16–24 years old. A study by the Pew Research Center (Anderson and Caumont 2014) shows that in 2013, 64 per cent of Americans used Facebook and just under half of these Facebook users, 30 per cent in total, received news from it. Overall, half of social network users have shared news content. When undertaking these

activities, media users constantly make decisions about whether to pass along media content, decisions that "are reshaping the media landscape itself" (Jenkins, Ford, and Green 2013, 1).

For news content providers, it is important to explore this growing trend of write-to-be-shared publishing in search of ever more and varied business cases for journalistic content. But understanding what drives people to publish content online also keeps academics occupied. People's motivations to share information have been investigated in relation to various digital platforms such as homepages (Papacharissi 2002), collaborative content platforms (Bruns 2005), social networks (Hargittai and Hsieh 2011) and news sites (Berger and Milkman 2012).

This paper seeks to contribute to the growing knowledge of media users' motivations to share content online in an effort to better understand the phenomenon of *content virality* or *spreadability* (Jenkins, Ford, and Green 2013). We build on our previous research on content-, individual- and social-related factors that influence online sharing (Picone 2011) to further expand our understanding of the virality of news content. The question central to our research is whether we can see distinct sharing profiles emerge amongst online media users.

## Study Rationale

### *Sharing Online Content from the Perspective of the Media User*

In their book *Going Viral*, Nahon and Hemsley (2013), 3) distinguish between a top-down and a bottom-up approach to studying virality. The former is concerned with how information flows through social media, how users-as-gatekeepers circumvent editorial selection. The latter focuses on users' ways of engaging in this process in terms of motivations and social connectedness. This article adheres to the bottom-up perspective and considers sharing content online to be an act of online self-presentation (Papacharissi 2002) or self-publication (Picone 2011; Picone, Willaert, and Donders 2013). This approach strongly echoes the dramaturgical metaphor of Erwin Goffman (1959).

In this perspective, media users do not consider content sharing merely an exchange of information; it is at the same time a publication (a making public) of an aspect of one's personality. By sharing content, people are always sharing something about themselves too, even if mostly implicit. This can be an opinion, a concern, an idea, etc. The reasons for doing so may vary, but media users seem to be aware that shared content will always reflect on their own image.

Considering sharing an act of self-publication implies that, in the same way as journalists take into consideration the preferences of their audience when publishing news, media users also reflect on their audiences when deciding whether and what to share. They make a "social" consideration based on the likelihood of people in their social network being interested in their "share". This complements an individual consideration based on their dispositions towards sharing (Picone 2011).

In the survey, we have operationalized these two elements as "social connection" and "self-presentation". As the results show, these have proven to be strong indicators of variation in the respondents' online sharing activity. Also, we have sought to probe

how the respondents view their potential public in general, ranging from a few close persons to their wide social network and the whole public.

### Indicators for Sharing Online Content

The question of which content is more likely to go viral has been addressed mainly from a psychological point of view, looking at people's emotional connection with a story. According to (Cappella, Kim, and Albarracín 2015, 400), the likeliness of a certain piece of content going viral depends on two things: whether the item is likely to be selected by readers (primary exposure) and whether people are likely to retransmit it to their potential audience (secondary exposure). Both processes have a similar causal base, constituted by individual, psychological factors and factors related to the message. These individual factors revolve around four main elements, i.e. impression formation and relationship management, in line with the notion of self-publication described above, and defence and accuracy. The latter refers to people being more likely to share content that is accurate and congenial with their attitude and that of the receiver (i.e. cognitive dissonance). Berger and Milkman (2012, 193) find that people are more likely to share stories that engender a state of activation or arousal rather than a state of relaxation. Their results suggest that positive content is more likely to be highly shared, but at the same time content that evokes high-activation emotions, like awe (positive) or anger (negative), is more likely to be shared than content that evokes a deactivating emotion, like sadness (10).

While these studies take a more psychological approach, placing the sender's reaction to a specific form of content at the centre, they hint at the importance of the audience in the process. Lee and Ma (2012) identify socializing as the second-most important gratification for sharing online news, after people's previous experience with social media, but much more important than information seeking or being entertained. They interpret socializing as interacting, keeping in touch and exchanging ideas with people. They suggest, "people derive social gratifications from sharing views and news with others" (337). In the same study, status seeking, in terms of credibility, self-confidence and self-esteem, is also identified as a strong motivating factor for sharing news in online media. Below, we give an overview of the questions used to probe respondents' motivations related to these aspects.

The work of Lee and Ma already considers socio-demographic indicators next to individual gratifications to explain variance in people's online sharing activity. In our own analysis, we therefore take age and gender into account. Still, the more mainstream digital media become, the less these traditional factors are likely to play a role in the way people consume both news and digital media. Nguyen (2008), for example, finds that orientation towards news, new media-mindedness and internet experience play a greater role than gender, class and education in directing people's news use. These factors also return in the work of Blank (2013), as applied to content creation. In a profile study for online news commenters, he uses six categories of variables related to content creation. Regarding internet experience, he differentiates between technical ability and negative experiences. Next to new media-mindedness (broad technology attitudes) and internet experience, he also incorporates comfort revealing personal data and confidence on the internet.

Therefore, in the survey, we have operationalized these indicators by means of a series of questions probing people's affinity with news (attitude and use) and past experiences online (self-confidence in performing online tasks), in addition to questions on people's motivations to share and basic socio-demographics.

## A Survey Study on Online Sharing Behaviours and Motivations

In the next section, we provide an overview of the questions and respondents' answers. First, we offer a concise outline of background information about the respondents. Second, the motivations for sharing information are described. Third, we determine the predictors of online sharing activity. Finally, we present a typology of online sharers based on motivations to share information and sharing behaviours.

### *Background Information of Respondents*

A total of 1237 respondents completed the survey (men = 52.6 per cent; women = 47.4 per cent). The average age is 32 (SD = 12.81). Overall, the respondents are highly educated (higher education = 33.4 per cent; university = 29.3 per cent) and are white-collar workers (39.7 per cent) or students (33.7 per cent). As regards their media and news repertoires, most respondents own a smartphone (85.9 per cent) and are active on Facebook (96 per cent). Those who have an account on Facebook, Twitter, Instagram and Snapchat make weekly or daily use of these platforms. Personal computers, Facebook, smartphones and tablets are particularly widely used to follow news online. The respondents indicate that they are mainly interested in societal issues, politics and cultural activities. Overall, the respondents can be considered active news searchers. In terms of ICT knowledge and experience, the respondents are rather cognizant and have elaborate internet skills. They are confident in their online skills (mean = 3.89; SD = 0.73). Further, 58.1 per cent indicate that they have been overwhelmed by information by others. Overall, the respondents have a positive view towards ICT.

### *Results for General Sharing Behaviours and Motivation*

In this section, we address the motivations for sharing information online. Four different sorts of questions were asked to ascertain respondents' sharing behaviours and motivations. First, the respondents were solicited to score five-point Likert items (1 = totally disagree, 5 = totally agree) of sharing motivations. Second, these motivations were further studied by asking the two main reasons for sharing online articles. The respondents were only allowed to choose two items maximum, to capture what they especially perceived as important. Third, we also asked the respondents about their motivations not to share information online. Finally, we explored further the underlying dimensions in online sharing motivations by means of a factor analysis.

The factor analysis of the motives to share information online yielded two interpretable factors: self-presentation and social connection. The first factor, labelled as *self-presentation*, accounted for 49.23 per cent of the variance and consists of three

items. The first factor showed a high internal consistency (Cronbach α = 0.84). The second factor, labelled as *social connection*, also consists of three items and explained 18.21 per cent of the variance with a lower but acceptable internal reliability (Cronbach α = 0.63). Self-presentation (mean = 2.51; SD = 0.98) was found to be less important for sharing information online in comparison to staying socially connected (mean = 3.65; SD = 0.71).

The motivations for sharing information were further studied by asking the two main reasons for sharing online articles. Table 1 presents the options that were provided and the scores for each item. For example, 24.01 per cent, or 279 of the 1237 respondents, indicated that that they share an online article because they find it useful for others. Overall, the data indicate how the social component is important when sharing information online. By contrast, the items that are solely motivated by self-presentation (i.e. "I am indignant"; "It corresponds with my expertise") were less likely to elicit agreement among respondents.

We also asked respondents about the reasons *not* to share information online. Respondents were instructed to offer just one or two responses. Table 2 gives an overview of the motivations not to share information online. The results especially show how many respondents do not consider themselves to be "sharers" and that the social component—yet again—is the important reason (e.g. "it won't interest anyone else"; "too long and complex").

### Predictors of Online Sharing Activity

Following authors like Lee and Ma (2012) and Blank (2013) who also take sociodemographic factors into consideration, we used a hierarchical regression method to analyse the effect of predictors of online sharing activity other than individual gratifications and account for the increment in variance. No significant relation was found between gender and online sharing activity after controlling for all the variables integrated in the model. The data indicate a positive relationship with age, where older individuals are more likely to share information, although the effect is small ($\beta = 0.007$, $p < 0.05$). The news searcher scale also shows a positive relationship ($\beta = 0.072$,

**TABLE 1**
Motivations for sharing online articles

| "I share an online article when..." | Absolute numbers (N = 1237) | Percentage |
| --- | --- | --- |
| I think the theme of the article is important | 507 | 40.99 |
| It can be useful for others | 297 | 24.01 |
| Others find will find it interesting | 275 | 22.23 |
| It corresponds with my hobbies or interests | 261 | 21.10 |
| It deserves much attention | 232 | 18.76 |
| Others have to read it | 186 | 15.04 |
| It concerns something fun | 150 | 12.13 |
| Others will like it too | 121 | 9.78 |
| I'm indignant | 114 | 9.22 |
| It corresponds with my expertise | 55 | 4.45 |

**TABLE 2**
Motivations for NOT sharing online articles

| "I do not share an online article because..." | Absolute numbers (N = 1237) | Percentage |
|---|---|---|
| I don't have a tendency to share much | 581 | 47.0 |
| I think it won't interest anyone else | 556 | 44.9 |
| It is too long/complex | 265 | 21.4 |
| I'm afraid of negative responses | 118 | 9.5 |
| I don't know how my friends will react | 89 | 7.2 |
| I'm afraid my friends will find it offensive | 86 | 7.0 |
| I don't know how to share easily | 16 | 1.3 |

$p < 0.01$). Self-confidence in online skills is the second-most important predictor included in the model ($\beta = 0.221$, $p < 0.001$). In total, the regression model accounts for about 31 per cent of the variance in online sharing activity. The motivations for sharing information were found to be particularly important. Social connection is the strongest predictor of online sharing activity ($\beta = 0.342$, $p < 0.001$). Self-presentation also has a positive relationship to online sharing ($\beta = 0.16$, $p < 0.001$).

To summarize, the respondents are motivated to share information online for social connection and self-presentation. These results are in line with the work of Lee and Ma (2012), clearly showing the importance of both personal and social gratifications, but in addition also reveal how the latter are considered more important. The regression analysis further reveals that traditional socio-demographics like gender and age are much less important indicators than self-confidence in internet skills through past experiences and, to a lesser extent, the degree to which one actively engages with news. Not surprisingly, the media partners in this project, like many others, still cater very much to the needs of traditional marketing target groups, like young women. There is no doubt that particular forms of information will be more attractive to specific user groups, but the underlying motivations and processes of online sharing are not really affected by gender and age. Rather, our findings suggest that media users' inclination to share content online increases as people grow into their role as savvy content seekers. This is, to a certain extent, also reflected in Lee and Ma's study, as previous experience with social media is identified as playing an important role in people's online sharing activity, over social gratifications. Interestingly, in our study, social gratifications are the main indicator for both sharing and not sharing information online. Either way, we can assume that sharing content online is principally a way to connect to others through the exchange of mutually relevant stories.

## Cluster Analysis for Online Sharing and Motivation

Based on their motivations to share and their sharing behaviour, can we now cluster the respondents according to distinct sharing profiles? K-means clustering was performed based on the general online activity scale and the two scales of motivations (self-presentation and social connection) with four clusters.

Cluster 1 (*N* = 330) consists of respondents who score average to high on online activity (mean = 3.66; SD = 045); low on self-presentation (mean = 2.03; SD = 049), but high on social connection (mean = 3.92; SD = 049). Cluster 1 is labelled as the *social sharers*. Cluster 2 (*N* = 353) consists of respondents who score average to high on online activity (mean = 3.60; SD = 051) and are motivated by both self-presentation (mean = 3.59; SD = 045) and social connection (mean = 4.06; SD = 047). Cluster 2 is labelled as the *reflective sharers*. Cluster 3 (*N* = 255) consists of respondents who score low on all three levels. Online activity (mean = 2.22; SD = 057), self-presentation (mean = 1.46; SD = 043) and social connection (mean = 2.75; SD = 066). Cluster 3 is labelled as the *uncaring sharers*. Finally, Cluster 4 (*N* = 299) consists of respondents who score average on all levels. Online activity (mean = 2.62; SD = 042), self-presentation (mean = 2.66; SD = 047) and social connection (mean = 3.63; SD = 046). Cluster 4 is labelled as the *moderate sharers*. Table 3 gives an overview of the four online sharing types.

*Social sharers* (*N* = 330) score high on online activity and are motivated to share to exchange ideas and stay in touch with others. Self-presentation is less important for this group. They are particularly likely to use Facebook to share online articles, and their intended audience primarily consists of family and friends. They are confident in their online activity (i.e. able to check the reliability of an internet source, participate in an online discussion, etc.) and have a positive view of ICT.

*Reflective sharers* (*N* = 353) are also active online and are motivated to share because of social connection *and* self-presentation. Hence, making a good impression and gaining status is as important to this group as staying in touch with others. Facebook is the most important platform to share online articles, but in comparison with the other three types, Twitter, LinkedIn and Blog are also important. The personal network is the primary intended audience, but sharing for a wide and professional network is significantly greater than in the other three types. Similar to social sharers, they also have a positive view of ICT.

*Uncaring sharers* (*N* = 255) rarely share information online and score low on self-presentation and social connection as motivators. They are less active on Facebook and Twitter in terms of sharing online articles, while e-mail is still the second-most important online platform (after Facebook). Their intended audience consists of family friends and one or two people with whom specifically they want to share. Although their ICT

**TABLE 3**
Sharing clusters

| Clusters | Social sharers (*N* = 330) | Reflective sharers (*N* = 353) | Uncaring sharers (*N* = 255) | Moderate sharers (*N* = 299) |
|---|---|---|---|---|
| Online sharing activity | 3.66 (0.45)** | 3.60 (0.51)** | 2.22 (0.57)* | 2.62 (0.42)*** |
| Self-presentation | 2.03 (0.49)* | 3.59 (0.45)** | 1.46 (0.43)* | 2.66 (0.47)*** |
| Social connection | 3.92 (0.49)** | 4.06 (0.47)** | 2.75 (0.66)* | 3.63 (0.46)*** |

Values are means with standard deviations in parentheses.
*Low; **high; ***average.

experience and vision of technology is not negative, they are less confident and more worried about privacy than the social and reflective sharers.

*Moderate sharers* ($N$ = 299) score average for online activity and self-presentation and average to high on social connection. They share many characteristics with the uncaring sharers: e-mail is the second-most important platform for sharing articles and their intended audience also consists of family and friends and those with whom they share specifically. Their view of technology is also similar to that of uncaring sharers, but less pronounced. On all levels they are moderate.

We went further, looking for significant relations between these clusters and gender, sharers' intended audience, their preferred online platforms, and their levels of ICT knowledge and experience. A total of 991 respondents reported their gender. A chi-square test of independence was performed to examine the relation between the type of sharer and gender. No significant relation was found ($\chi^2$(3, $N$ = 991) = 4.456, $p > 0.05$).

The respondents were asked who their intended audience was when sharing information online. In all four clusters the respondents indicated that their intended audience consists of family and friends. A chi-square test of independence showed a significant difference for wide audience ($\chi^2$(3, $N$ = 1131)= 37.103, $p < 0.001$), professional network ($\chi^2$(3, $N$ = 1131) = 10.807, $p < 0.05$) and personal network ($\chi^2$(3, $N$ =1131) = 20.768, $p < 0.001$).

As regards preferred sharing platforms for online articles, Facebook is by far the most popular. Still, when comparing the scores between the rare sharers and the other types, the data show that Facebook is significantly less popular among the rare sharers ($\chi^2$(3, $N$ = 1131) = 57.412, $p < 0.001$). The usage of e-mail seems to be more popular among average and rare sharers although not significantly ($\chi^2$(3, $N$ = 1131) = 7.183, $p > 0.05$). Also, a significant relation was found for Twitter ($\chi^2$(3, $N$ = 1131) = 78.284, $p < 0.001$), LinkedIn ($\chi^2$(3, $N$ = 1131) = 24.277, $p < 0.001$) and Blog sharing ($\chi^2$(3, $N$ = 1131) = 11.903, $p < 0.01$). The latter three platforms are more popular with the reflective sharers.

We then asked the respondents to score propositions concerning their self-confidence (e.g. I'm able to check the reliability of an internet source) on five-point Likert scales (1 = not confident, 5 = very confident). The data show how social sharers and reflective sharers score higher on the self-confidence scale. A Kruskal–Wallis $H$ test showed that there was a statistically significant difference $\chi^2$(3) = 98.249, $p < 0.001$. We did the same for their attitude towards new technology and the internet as a privacy threat (1 = totally disagree, 5 = totally agree). The uncaring sharers score higher on this variable in comparison with other groups. A Kruskal–Wallis test confirmed the difference between the four groups ($\chi^2$(3) = 30.741, $p < 0.001$. A set of Mann–Whitney $U$ tests further showed a significant difference between the uncaring sharers and the other groups ($p < 0.001$). No significant differences were found between the other groups ($p > 0.05$).

The respondents were asked if they consider it a good idea to test new technology (1 = totally disagree, 5 = totally agree). A Kruskal–Wallis test showed a significant difference between the groups ($\chi^2$(3) = 15.419, $p < 0.001$). A set of Mann–Whitney tests further showed a significant difference between social and reflective sharers on the one side and uncaring sharers ($p < 0.01$). No significant difference was found between uncaring and moderate sharers ($p > 0.05$). However, a significant difference was found

for the perception of technology (i.e. making life easier): $\chi^2(3) = 16.487$, $p < 0.01$. A further set of Mann–Whitney $U$ tests found only significant differences between rare sharers and the other three groups.

## Discussion: What Does Viral News Mean for Journalists?

In addition to being a societal media-related phenomenon, virality is also a strategy of content providers to maximize their audience. As such, the typical normative discussion between offering news people *need* to know versus news they *want* to know also applies to virality. Is it a threat to in-depth reporting or could it provide an opportunity to reach new audiences? Our study suggests that connecting with others is a far more powerful motivation to share than showing off one's knowledge or ambitions. It is not really a form of plain fun or distraction either, but mainly a way to connect with others by means of exchanging content that might appeal to, interest or entertain one's social circle. This motivation does not by definition exclude in-depth news stories from being shared, as many news outlets will have experienced the occasional "going viral" of posts that were not intended for that purpose. Hard news could in theory be as "shareable" as soft news, but in practice it seems fair to assume that people connect more easily with insightful, emotional or practically useful content than with technical, difficult content or issues that are not of direct interest.

Therefore, as is the case with journalistic output in general, we should avoid a dichotomous view based on quality versus popularity and avoid pointing the finger at the audience for the dumbing down of journalism. As Costera Meijer (2013) convincingly argues, discussions on the quality of journalistic texts should take into account both the media professionals' and the media users' perspectives. Also rather than assuming that the latter group prefers easily digestible, mindlessly entertaining content, one should ask the question what makes journalism valuable for news users.

Hence, as this research suggests, news stories that go viral appeal to a specific aspect of people's lives that make them very valuable: they appeal to our desire to connect to others. In this way, news becomes a means to connect rather than merely a container of information. In a sense, this is not new. News consumption has been found to be a way of experiencing social belonging ever since mass media first made it possible to feel connected to fellow citizens of the nation state. The difference is that in a media system characterized by connected media, where this kind of news can easily be shared, practices that facilitate social belonging transcend the domain of user experience and influence the actual distribution of news. Media professionals now experience the impact of what people value not merely in an indirect way through overall ratings or circulation or audience figures, but directly through the reach of a specific article; of a specific journalists' own work.

It is understandable, then, that editors and journalists seek to adopt "viral strategies" in order to reach a wider audience. In doing so, however, focusing on the outward characteristics that many viral news stories, share like listicles, suggestive titles and other clickbait, might be besides the point. Instead, they could seek to make in-depth or complex stories more "conversational". This would imply offering resources that sustain public conversations and invite news users to get involved through acts of curation and circulation (Jenkins, Ford, and Green 2013).

## Conclusion

Our study has sought to develop our understanding of what makes online news content go viral. We have found further support for the importance of social connection as a prime intrinsic motivator as well as previous online experience as a strong indicator of willingness to share. Furthermore, we identified four sharing profiles based on people's motivations to share and their online sharing activity.

Common to all profiles is that both self-presentation and social connection prove to be strong indicators for the respondents' online sharing behaviour, in line with previous research from, amongst others, Lee and Ma (2012) and (Cappella, Kim, and Albarracín 2015). Interestingly, however, the results suggest that people are more motivated to share information because of social connection than because of self-presentation. In general, over all identified clusters, staying in contact with others, exchanging ideas and interacting with others come forward as strong motivations for sharing information online. Even more, the social component seemed to be an important motivator also for not sharing content online, as thinking that the article you share will not interest anyone else or would be too complex point towards a lack of social connection as a threshold to share content.

It is interesting to see this social component feature so prominently as a part of online sharing practices. Especially because a similar need for social connection can be found in functionalist approaches to (news) media (McQuail 1994, 78–82), where news is seen as social glue: by offering people a shared window to what happens in the society they live in and to issues that concern us all. The ongoing fragmentation of the mass media threatens that function, as niche audiences lose their connection to the broader society they live in and which they get to know through news reporting (Deuze 2007, 7).

But building on the conversational approach instigated by our study's results, a more optimistic view can be envisioned. Even if the news audience as a material entity might more than ever be fragmented over various media moments, devices and offerings (Napoli 2011, 57), the news audience as an "imagined community" (Anderson 1983) might persevere. As connecting with others appears to be essential to sharing online content, online sharing practices might be a way for scattered audiences to re-imagine themselves as a community around the stories that are deemed of mutual interest.

Building on these insights, the rather perfect match between social media and news content should not come as a surprise. Social media might provide precisely the environment that allows for this kind of social connectedness by means of sharing content. Social media form an online environment where you come to connect per definition, where your social network is present by default. An environment where news can perfectly perform its role of social glue.

As it has been doing for decades, news needs to connect socially, also in our digitally connected world. If news does so, it does not really matter whether it is in-depth, high-brow, investigative or just fun, whether it is longform or listicle for it to be shareable. If journalists, however, would like their stories to go viral, they should implement this "conversational" vision in the stories they write and take into account media users' willingness to connect. In a connected media system, journalists and news users share and share alike.

## ACKNOWLEDGEMENTS

The research was supported by iMinds, a funding body of the Flemish Government, through the ICON granted project PROVIDENCE (Predicting Online VIrality anD EntertainmeNt ContEnt). The project's aim is to optimize online news publication strategies by investigating and proactively making use of virality factors of news on social media platforms. The research consortium comprises of Newsmonkey, VRT, iMinds-SMIT-VUB, Massive Media and IBCN-UGent. IMinds-SMIT and VRT O&I carried out the presented research. The data were collected through the VRT Proeftuin, VRT's living lab environment.

## DISCLOSURE STATEMENT

No potential conflict of interest was reported by the authors.

## FUNDING

This work was supported by the iMinds ICON funding program.

## REFERENCES

Anderson, Benedict. 1983. *Imagined Communities: Reflections on the Origin and Spread of Nationalism*. London: Verso.

Anderson, Monica, and Andrea Caumont. 2014. "How Social Media is Reshaping News." *Facttank (Pew Research Center)*. http://www.pewresearch.org/fact-tank/2014/09/24/how-social-media-is-reshaping-news/

Berger, Jonah A., and Katherine L. Milkman. 2012. "What Makes Online Content Viral?" *Journal of Marketing Research* 49 (2): 192–205.

Blank, Grant. 2013. "Who Creates Content?" *Information, Communication & Society* 16 (4): 590–612.

Bruns, Axel. 2005. *Gatewatching. Collaborative Online News Production*. New York: Peter Lang Publishing.

Cappella, Joseph N., Hyun Suk Kim, and Dolores Albarracín. 2015. "Selection and Transmission Processes for Information in the Emerging Media Environment: Psychological Motives and Message Characteristics." *Media Psychology* 18 (3): 396–424.

Costera Meijer, Irene. 2013. "Valuable Journalism: The Search for Quality from the Vantage Point of the User." *Journalism* 14 (6): 754–770.

Deuze, Mark. 2007. *Media Work*. Cambridge: Polity Press.

Goffman, Erving. 1959. *The Presentation of Self in Everyday Life*. New York: Anchor Books.

Hargittai, Eszter, and Yu-Li Patrick Hsieh. 2011. "From Dabblers to Omnivores." In *A Networked Self: Identity, Community and Culture on Social Network Sites*, edited by Z. Papacharissi, 146–168. New York: Routledge.

Jenkins, Henry, Sam Ford, and Joshua Green. 2013. *Spreadable Media: Creating Value and Meaning in a Networked Culture*. New York: NYU Press.

Karine, Nahon, and Jeff Hemsley. 2013. *Going Viral*. Cambridge: Polity Press.

Lee, Chei Sian, and Long Ma. 2012. "News Sharing in Social Media: The Effect of Gratifications and Prior Experience." *Computers in Human Behavior* 28 (2): 331–339.

McQuail, Dennis. 1994. *Mass Communication Theory: An Introduction*. London: Sage Publications.

Napoli, Philip. 2011. *Audience Evolution: New Technologies and the Transformation of Media Audiences*. New York: Columbia University Press.

Nguyen, An. 2008. *The Penetration of Online News. past, Present and Future*. Saarbrücken: Verlag Dr. Müller.

Ofcom. 2015. "Adults' Media Use and Attitudes." Research Document Report 2015. http://stakeholders.ofcom.org.uk/binaries/research/media-literacy/media-lit-10 years/2015_Adults_media_use_and_attitudes_report.pdf

Papacharissi, Zizi. 2002. "The Presentation of Self in Virtual Life: Characteristics of Personal Home Pages." *Journalism & Mass Communication Quarterly* 79 (September): 643–660.

Picone, Ike. 2011. "Produsage as a Form of Self-Publication. a Qualitative Study of Casual News Produsage." *New Review of Hypermedia and Multimedia* 17 (1): 99–120.

Picone, Ike, Koen Willaert, and Karen Donders. 2013. "The Public in Public Service Media: The Case of Villasquare." In *Public Service Media in the Digital Age. International Perspectives*, edited by Agnes Gulyas and Ferenc Hammer, 53–68. Newcastle upon Tyne: Cambridge Scholars Publishing.

# MAKING SENSE OF TWITTER BUZZ
## The cross-media construction of news stories in election time

**Raymond A. Harder, Steve Paulussen** and **Peter Van Aelst**

*As the use of social media becomes more common, it is often claimed that a media environment arises in which traditional distinctions between concepts like online and offline, producer and audience, citizen and journalist become blurred. This study's purpose is to identify and explore the implications for contemporary news stories. Using a content analysis of Belgian election campaign coverage in 2014, we study the role of five newspapers, two daily television newscasts, seven current affairs programmes, radio news bulletins, three news websites, and a selection of Twitter accounts in creating and shaping news stories. We find that the analytical distinction between platforms still matters, since they have different roles in creating and shaping news stories, suggesting that different platform-specific logics are at play. Twitter is an important factor in launching and shaping news stories, but it tends to be dominated by establishment actors (journalists and politicians), whereas citizens only play a modest role.*

## Introduction

Research on the role of Twitter in journalism and political communication is growing fast (Hermida 2013; Klinger and Svensson 2015). Several studies describe how Twitter is increasingly being adopted by journalists for professional purposes, not only as a news source (Broersma and Graham 2013; Paulussen and Harder 2014), but also as a networked "social awareness system" for monitoring the continuous streams of news and information (Hedman and Djerf-Pierre 2013; Hermida 2010). Other studies have focused on the ways in which both politicians and citizens are using Twitter to broadcast opinions and participate in direct, public conversations (Bruns and Highfield 2013; Enli and Skogerbø 2013; Graham et al. 2013).

While most studies on the use of Twitter among journalists, politicians and citizens have looked at the microblogging platform as an emerging networked "social space" or a new "arena of political communication" (Enli and Skogerbø 2013), our study explicitly aims to position Twitter within the broader cross-media environment. This means that we try to examine the "Twittersphere" not in isolation but in relation to the broader media ecology and public sphere of which it is an integral part. Following Chadwick (2013), we conceptualise today's cross-media news environment as a "hybrid

media system". Although we use the dichotomous categories "traditional news media" and "social media", it is not our intention to compare and stress the differences, but rather to explore their mutual interactions and to understand to what extent and how they have become interdependent. In this paper, we illustrate this point by describing how news stories emerge and spread in today's cross-media news environment.

## The Cross-media Construction of News Stories

Literature on new media has a tendency to emphasise change over continuity and difference over similarity. Hence, scholars studying social media are likely to argue that a new "public sphere" is emerging, one that is networked rather than centralised, user-centred rather than professionally controlled, participatory rather than elitist, and messy rather than overseeable (see e.g. Klinger and Svensson 2015; Papacharissi 2015; Singer et al. 2011).

In his book *The Hybrid Media System*, Chadwick (2013) stresses that the "newer" media logics do not simply replace "older" logics, but they mutually build upon and interact with each other. The result of these interactions is a hybrid media system where these newer and older logics can no longer be understood in isolation, but should be considered as interrelated and interdependent. The boundary between "networked" and "traditional mass" media spheres becomes very theoretical, for it is clear that mass media are an integral part of the networked media environment and networked communication patterns are (re)shaping the processes of news production and distribution of mass media. The hybridity concept provides an analytical framework to understand the mutual interactions between online and offline, networked and traditional media.

To understand the construction and flow of news within the hybrid media environment, Chadwick (2013, 62–63) argues that we should look beyond the "news cycles" of a single medium. In today's cross-media environment, news continuously travels between and across different media platforms, resulting in what Chadwick calls "political information cycles":

> Political information cycles possess certain features that distinguish them from "news cycles". They are complex assemblages in which the logics … of supposedly "new" online media are hybridized with those of supposedly "old" broadcast and newspaper media. This hybridization process shapes power relations among actors and ultimately affects the flow and meanings of news. (Chadwick 2013, 63)

The notion of hybridity does not only help to understand the cross-media flows of news, but also relates to the blurring lines between the producers and users of news. Social media are typically regarded as the focal example hereof. Particularly Twitter has attracted a considerable amount of scholarly attention. Several authors view it as a social space where news and opinions are collaboratively "prodused" by "networked publics" of both professionals and citizens (Papacharissi 2015). According to D'heer and Verdegem (2014, 731), who studied the conversations between political, media and citizen actors on Twitter, the public debate can be understood as "a combination of and overlap between three fields", thereby echoing its hybrid nature. Their analysis shows that despite the prominence of citizens in the debate, established political and media

agents still tend to hold central positions in these Twitter networks. Hence, Twitter does not only represent a "logic of the public" (Brants and van Praag 2015), but at the same time reflects the older political and media logics that we are likely to associate with traditional news media.

Highlighting individual aspects of hybridity in the current media ecology is one thing, but a holistic approach to examine the *extent* to which processes of hybridisation are visible in the news is another. In this study, we address this open issue by exploring the life cycles of news stories. We specifically look into two aspects of contemporary news cycles. First, one central aspect of the hybridity concept is the supposed cross-medial nature of news. To what extent is this realised in practice? Second, if older and newer practices become increasingly synthesised, what does this mean for the origins of news stories? Our research questions, then, are:

**RQ1:** How are news stories distributed across the hybrid cross-media news environment?

**RQ2:** How are news stories created within the hybrid cross-media news environment?

To specify the second question, we divide it into two sub-questions that address different aspects of the derivation of news. First, we study news stories' platform origins. Do platforms matter less in this respect, do we find that traditional media are leading, or has the balance shifted to social media? Second, we have to acknowledge the hybrid nature of Twitter itself. Different publics, including citizens, journalists and politicians, assemble in a networked sphere. Therefore, researching how often the platform breaks a news story does not suffice here—in contrast to traditional media, for which news is produced only by professionals. Instead, we should look more in-depth and ask *who* exactly is first. Are "older" logics, in which news is created by elite actors dominant, or do we witness the ascendance of "newer" logics, in which citizens and other publics are also able to influence the news agenda?

**RQ2a:** Where do news stories originate?

**RQ2b:** Which Twitter actors are the sources of news stories?

## Methodology

### Data Collection

Using the hybridity concept strongly implies using a holistic approach, a requirement that we try to meet by taking a wide range of media outlets into account. Data from these media were collected in the run-up to the 2014 national elections in Belgium. An election campaign provides a framework of reference for journalists, in which certain kinds of stories are favoured over others. This provided us with the opportunity to retrieve many interwoven news stories within a relatively short time-span. For three levels of government (regional, federal and European), elections were held on May 25. We started our data collection on 1 May (Labour Day, when left parties traditionally present their concerns for the coming period), and ended on 24 May (the last campaign day, we excluded election day itself to avoid biases).

We opted to include only Flemish (northern, Dutch-speaking part of Belgium with a population of around 6.2 million) media and Twitter accounts. Specifically, we included five newspapers (*De Standaard*, *De Morgen*, *De Tijd*, *Het Laatste Nieuws*, *Het Nieuwsblad*), three news websites (*destandaard.be*, *demorgen.be*, *deredactie.be*), the two daily 19:00 television newscasts (*Het Journaal* from the public broadcaster and its commercial *VTM Nieuws* counterpart), six daily radio newscasts (the 7:00, 8:00, 12:00, 13:00, 18:00 and 19:00 public Radio 1 bulletins), the regular current affairs television programmes (*De Zevende Dag*, *Reyers Laat*, *TerZake*), and election-specific shows (*Het Beloofde Land*, *Het Nationale Debat*, *Jambers Politiek*, *Zijn er Nog Vragen?*) in our sample. Since the news websites in this sample are directly associated with newspapers, radio and television outlets, we consider them part of traditional media.

For Twitter, we were inspired by Axel Bruns' Twitter News Index approach (mappingonlinepublics.net, also see Bruns and Burgess 2012; Bruns and Stieglitz 2014) and constructed a sample of relevant accounts, encompassing 678 professional Flemish journalists (virtually all retrievable journalists who had a Twitter account); 44 accounts affiliated with the principal traditional media; 467 politicians (the top-three candidates per constituency, plus a selection of lower-listed candidates); and 19 accounts of civil society organisations. In addition, we included a selection of 109 "influentials" (experts, business representatives, celebrities and active citizens), whom we identified using the "top Twitter influencer" list of *twitto.be*. This website provides a ranking of Belgium-based twitterers based on their *Klout*-score, an algorithm that estimates one's online influence. In sum, we had a sample of 1317 accounts of which we retrieved all (re)tweets. Furthermore, we saved the tweets in which any of these 1317 accounts was mentioned by people outside our sample. Also, tweets mentioning the election hashtags #vk14 or #vk2014 were retrieved.

With this sample, our aim was to provide an adequate overview of the discourse in the Flemish "Twittersphere". The rationale was that even when we did not follow a particular Twitter user, when his or her tweet had considerable impact, it would be retweeted by at least one user in our sample (and thereby be included in our data-set). To ensure that all tweets in the data-set have had at least *some* impact, a threshold of two favourites and two retweets per tweet was set. The underlying assumption is that "impact" can be regarded as having gained some traction in terms of diffusion and appraisal. We consider retweets and favourites, respectively, approximations hereof.

Respecting this threshold, 23,134 items were captured across all platforms. Of those, 9749 (42 per cent) could be categorised as politically relevant—meaning it featured a political topic, a domestic political actor and/or an election-specific term.

## Coding

These politically relevant items were then coded on the news story level (Thesen 2013). Here, "news story" refers to the collection of news items, across different media, that deal with something that happened at a given location and point in time. A general example of a news story could be the bankruptcy of a large enterprise. In this conceptualisation, all coverage, whether it be newspaper articles, television news or Twitter posts, about this bankruptcy is considered part of this news story.

We found that in the election campaign, the bulk of the news stories is less about what happened than about what was said (often by politicians). For example, one often-covered news story was about a top politician who claimed that everyone with a good résumé is able to find a job in Belgium. Another major story was about a politician who contradicted his own party's viewpoints regarding welfare benefits in an interview.

Not each and every utterance by a politician does fit the news story concept, however. Only the main statements, meaning those that were highlighted in the title or introduction of the article, or those that were mentioned in other articles (even those bits that appeared in other media after the initial publication of an interview) were coded as news stories.

In the inter-media agenda-setting tradition, a framework that is often used to analyse how content transfers between different media, studies have often relied on rather broad issue categories, like "foreign policy" or "public welfare" (McCombs and Shaw 1972). These are valuable for tracking issue attention over a longer period of time, making large-scale statistical analyses (correlations and time series) possible. However, this level of analysis does not enable one to track the origins and dissemination of chains of directly related news items—which is eventually our aim in the present paper. A news story-level approach (Thesen 2013), then, is more suitable for these purposes.

A codebook was constructed to provide guidelines for identifying and labelling news stories, which were applied to traditional news media items (i.e. items from newspapers, newspaper websites, radio bulletins and television newscasts) only. Items judged to belong to a previously identified news story were coded as such. The remaining items in the sample (e.g. tweets and current affairs television shows) were not used to identify any extra news stories, but only assigned to the ones we previously found in traditional media.

About a third of the 9749 items (3395, including 3145 tweets) were not found to be related to any news story. In the other 6354 items, we were able to identify 869 news stories. Since some news items were judged to belong to more than one news story, thus counted more than once, the news stories ultimately encompassed 6497 items. Table 1 shows, per media platform, how often news items were assigned. Here,

**TABLE 1**

Number of items assigned to single- or multiplatform news stories, by media platform

| Platform | All items, assigned to 869 news stories (N = 6497) | | Assigned to 413 single-platform news stories (N = 502) | | Assigned to 456 multiplatform news stories (N = 5995) | |
|---|---|---|---|---|---|---|
| | N | % | N | % | N | % |
| Newspapers | 1440 | 22.2 | 245 | 48.8 | 1195 | 19.9 |
| Television | 433 | 6.7 | 17 | 3.4 | 416 | 6.9 |
| Radio | 248 | 3.8 | 45 | 9.0 | 203 | 3.4 |
| News websites | 1015 | 15.6 | 195 | 38.8 | 820 | 13.7 |
| Twitter | 3361 | 51.7 | –* | –* | 3361 | 56.1 |

*Since tweets were not used to identify news stories, they only show up in the multiplatform column.

we distinguish between stories that did not spread beyond their initial platform of publication (single-platform news stories) and those that did (multiplatform news stories). Our analysis is focused on the latter group.

At first glance, only using the traditional news media to find news stories may seem to limit the inferences we can make. However, we consider this a more sensible approach than it would be to start from tweets as well. There were 3145 tweets (of the 6506) that could not be associated with an existing news story in the data-set, each of which we might have considered an additional news story on its own. Yet, an inspection of these Twitter messages suggests that they predominantly concerned meta-comments, jokes, general criticism of politics (pub talk, in other words) and self-promotional tweets. It can hardly be argued, then, that they genuinely merit the name "news", while using that label to classify *news*casts and *news*paper items is by definition correct. Ultimately, 3361 tweets were considered.

In a final coding step, the original authors of all tweets included in the analysis were coded in one of ten categories: politicians, political parties, citizens, journalists, media outlets, experts/professionals, business representatives, celebrities, civil society actors, and other.

## Findings

### The Distribution of News Stories

To answer the first research question, regarding the distribution of news stories across platforms, we analyse their size, lifespan and number of platforms reached. As discussed before, we distinguish between single- and multiplatform news stories. Of the total number of 869 news stories, 413, or less than half, did not spread beyond their initial platform of publication. The other 456 featured on at least two platforms. We ignore the single-platform stories for the remainder of this paper, as we are only interested in the stories that actually spread across platforms.

Therefore, the smallest news stories encompassed two individual items, while the largest story (about the death of former prime minister Jean-Luc Dehaene) consisted of 450 items. The median number of platforms that a news story reached (i.e. radio, television, newspaper, website, Twitter), was two, with a range of two to five. We also calculated the difference between a news story's first and last occurrence in the election campaign. By this measure, the lifespan of the shortest news story, concerning a liberal politician's statement that "Belgium is a good country to live in" was just 0.05 hours (or

**TABLE 2**
Median lifespan and size of multiplatform news stories, by number of platforms reached

| Platforms reached | N | Lifespan (in hours) | Size (items in story) |
| --- | --- | --- | --- |
| 2–5 | 456 | 28.7 | 5.0 |
| 3–5 | 201 | 60.8 | 10.0 |
| 4–5 | 77 | 123.6 | 23.5 |
| 5 | 22 | 183.5 | 44.0 |

3 minutes). The lifespan of the longest news story, which is about proposals to adapt the automatic inflation correction of wages, was 558.74 hours (or 23 days, 6 hours and 44 minutes). A median lifespan of 28.7 hours was calculated.

Table 2 shows the statistics regarding lifespan and size of stories, split up by the number of platforms reached. Here, too, we use the median as the central tendency.

Perhaps unsurprisingly, we find that the more platforms a news story reaches, the longer its lifespan is, and the more items that news story encompasses. It also becomes clear that the number of news stories that reaches all platforms is fairly limited, as only 22 did so.

Next, we analysed what proportion of the 456 news stories each media platform featured. In this respect, Twitter is leading, covering 80.9 percent of the news stories. That is, few stories were *not* covered here. News websites and newspapers cover 70 and 63.6 per cent, respectively. Numerically, television (33.3 per cent) and radio (17.8 per cent) are underperformers. Thus, we may say that Twitter is the most comprehensive of all media platforms, at least in touching upon news stories.

### The Origins of News Stories

Our second research question, on the creation of news stories, is divided into two sub-questions that will be addressed separately. Concerning sub-question 2a, about where news stories originate, Table 3 shows how often news stories appear first on that particular media platform, how long these stories last and how many items they encompass.

Starting 18 per cent of all news stories, newspapers are far from obsolete in setting the news agenda. Moreover, the comparatively long median lifespan (62.8 hours) indicates that these stories also tend to be the more important ones. Online news websites account for 28.9 per cent, which suggests that traditional media follow a digital-first strategy (as these three websites were associated with newspapers, radio and television). At the same time, editors seem to save some stories for their newspaper's print edition. The role of television and radio in bringing new news stories is modest, both accounting for 6 per cent each. Reporting stories that were already covered by other media, then, seems to be the predominant role of television and radio. A last and remarkable observation is that Twitter starts the biggest share, 41.7 per cent, of news stories, something which we explore further in the next sub-question.

**TABLE 3**

Median lifespan and size of multiplatform news stories, by platform on which the stories started

| Started on | N | % | Lifespan (hours) | Size (items in story) |
|---|---|---|---|---|
| Newspaper | 82 | 18.0 | 62.8 | 6.0 |
| Television | 26 | 5.7 | 84.0 | 7.0 |
| Radio | 26 | 5.7 | 7.0 | 7.0 |
| Website | 132 | 28.9 | 14.1 | 4.0 |
| Twitter | 190 | 41.7 | 34.4 | 8.0 |
| Total | 456 | 100 | 28.7 | 5.0 |

In the second sub-question, we asked about the exact origins of news stories on Twitter. To answer this last question, we analyse the original senders of all first tweets of the 190 news stories that were Twitter-instigated. Table 4 shows an overview of these actors. The "other" category includes experts/professionals, civil society actors, celebrities and business representatives.

What stands out is the dominance of institutional actors, particularly political parties and politicians, who account for almost half of the news stories that started on Twitter. This finding confirms the strategic use of Twitter by politicians and parties alike to influence the news agenda (Enli and Skogerbø 2013). More important for our present purposes is that over a third of these stories originate from either individual journalists or accounts associated with media outlets. By contrast, the contribution of citizens and other actors is relatively small. It should be conceded, nonetheless, that it may be less likely that citizens are the origin of a news story in traditional mass media. Yet, the main pattern that emerges from this quantitative analysis is a focus on elites, paired with a dominant presence of journalists and media outlets in the discourse on the platform.

This also shows when we look at the nature of the stories that started on Twitter. An exploration of these stories shows that even when not brought up by journalists or media-associated accounts, their topics are closely aligned to those initiated by mass media. Indeed, in some cases there is a direct link, as Twitter users are live-twittering about what they see in other media. For example, when viewing a television documentary, one citizen was first to note that two politicians did not wear their seat belts when driving their car. In other cases, we find that the *logic* of news reporting, particularly that of breaking or unfolding news, is incorporated on Twitter (cf. Marchetti and Ceccobelli 2015). The news that one candidate's campaign vehicle burnt down, for example, was announced first on Twitter. Also, people attending (political) conferences are sometimes first to mention these gatherings.

These findings suggest that Twitter's role in election campaign news should not be sought in providing alternative types of stories that are picked up later by traditional media. Indeed, Twitter is more likely to behave exactly like traditional media or discuss their news coverage (cf. D'heer and Verdegem 2014). We can point to only one instance, namely the grassroots campaign to tunnel the highway around Antwerp, in which an alternative story (driven by citizens, not urgent) spread from Twitter to traditional mass media. Yet even for this case, traditional news media mainly seemed interested when established actors commented on the issue.

**TABLE 4**

Actor-type frequencies in tweets

| | Frequency overall (*N* = 3361) | | Frequency of starting a news story (*N* = 190) | |
|---|---|---|---|---|
| | *N* | % | *N* | % |
| Politician or political party | 1334 | 39.7 | 88 | 46.3 |
| Journalist or media outlet | 1144 | 34.0 | 70 | 36.8 |
| Citizen | 421 | 12.5 | 15 | 7.9 |
| Other | 462 | 13.7 | 17 | 9.0 |

## Conclusion and Discussion

This paper has aimed to provide an insight in the distribution, as well as the origins, of news stories in the contemporary news ecology. These issues link back to Chadwick's (2013) hybridity concept.

Concerning the question of how news stories are distributed across and within the hybrid cross-media news environment, we can conclude that the majority indeed spread across media platforms. We also see that the more platforms a story reaches, the more items it encompasses, and the longer its lifespan is. Although Twitter and news websites cover the highest proportion of news stories, newspapers have not yet had their day, as nearly two-thirds of the stories can still be found there. By contrast, television and radio only cover one-third and less than one-fifth of all stories, respectively. We should be aware, however, that this does not say anything about the quality of the coverage. Obviously, a tweet of 140 characters is unlikely to challenge a newspaper article in terms of information value. Nor does this say much about the stories' importance—television and radio channels may deliberately dedicate their limited airtime to fewer, but more important news stories. From an electoral perspective, it may well be that following traditional media still provides the best information to make an informed political judgement, even though these media tap into fewer news stories. Presently, our data do not allow for making this assessment. Furthermore, we should bear in mind that our sampling method plays a role here as well. While we made an effort to capture the debate on Twitter comprehensively, it seems unpractical for individuals to attend to this wide array of voices while the election campaign unfolds.

Regarding the question on the origins of news stories, our conclusion is that Twitter is the fastest medium overall, being the first medium to feature over 40 per cent of the news stories. News websites are second, with about 29 per cent. Since these websites are associated with traditional media (radio, television and newspapers), the inference is that an online-first strategy prevails in today's news industry. Here, too, we find that newspapers are not at all obsolete, since nearly one-fifth of the stories appear here before spreading to other platforms. Television and radio, however, are far less important in this respect.

We find that there tends to be an establishment bias in the stories that appear first on Twitter, for the vast majority derive from accounts of political actors, journalists or media outlets. Citizens account for less than 8 per cent of the news stories that break on Twitter. Hence, we should not equate "social media" with "the public", but rather regard social media as a mediated social space where the "public of citizens" interacts and blends with the political and media fields (D'heer and Verdegem 2014).

Our research provides some first indicative figures on the scope and degree of hybridity in the contemporary news ecology. We have tried to give the hybridity concept more empirical ground. The blurring of categories, as well as the interaction between "newer" and "older" logics, are crucial to this concept (Chadwick 2013). Indeed, while we find that novel elements like Twitter firmly establish their position, this does not imply a complete overhaul of the pre-existing news ecology. Core elements are still key to understanding the news ecology, particularly platforms and actors.

First, our study shows that differences between media platforms remain relevant, as they clearly occupy different positions in the news ecology. Some platforms

(television, radio) are far less important in starting news stories, but are probably crucial for a news story to reach the public at large. Although most stories are multiplatform in nature, few reach all platforms. Further research is needed to explain to what extent the diffusion of news stories can be explained by differing criteria of newsworthiness per platform.

Second, though the theoretical difference between producer and audience can be questioned, we find that the interaction from which news stories arise is still centred around established actors. Journalists and political actors have a vastly more important role than ordinary citizens. This is partly due to our focus on the election campaign in which journalists and especially politicians are more active than usual in reaching out to the electorate (Walgrave and Van Aelst 2006). Potentially, in political "routine" periods, other actors have more opportunities to influence and initiate news stories. It would therefore be useful to replicate this study in other contexts to see whether social media and traditional media become more distinct platforms outside election time. We hope our study can be a helpful starting point for this.

## ACKNOWLEDGEMENTS

The Twitter data were collected in collaboration with Evelien D'heer and Pieter Verdegem of Ghent University. The authors would like to thank Tessy Cuyvers, Adriaan Delsaerdt, Julie De Smedt, Koen Pepermans, Anniek van Duijnhoven, Nick Van Hee and Patrick Verdrengh for their assistance with data collection and coding.

## DISCLOSURE STATEMENT

No potential conflict of interest was reported by the authors.

## FUNDING

This study is part of a PhD research project funded by the Research Fund of the University of Antwerp.

## REFERENCES

Brants, Kees, and Philip van Praag. 2015. "Beyond Media Logic." *Journalism Studies*. doi:10.1080/1461670X.2015.1065200.

Broersma, Marcel, and Todd Graham. 2013. "Twitter as a News Source." *Journalism Practice* 6 (3): 403–419.

Bruns, Axel, and Jean Burgess. 2012. "Researching News Discussion on Twitter." *Journalism Studies* 13 (5–6): 801–814.

Bruns, Axel, and Tim Highfield. 2013. "Political Networks on Twitter." *Information, Communication & Society* 16 (5): 667–691.

Bruns, Axel, and Stefan Stieglitz. 2014. "Twitter Data: What Do They Represent?" *It - Information Technology* 56 (5): 240–245.

Chadwick, Andrew. 2013. *The Hybrid Media System*. New York, NY: Oxford University Press.

D'heer, Evelien, and Pieter Verdegem. 2014. "Conversations about the Elections on Twitter: Towards a Structural Understanding of Twitter's Relation with the Political and Media Field." *European Journal of Communication* 29 (6): 720–734.

Enli, Gunn S., and Eli Skogerbø. 2013. "Personalized Campaigns in Party-Centred Politics." *Information, Communication & Society* 16 (5): 757–774.

Graham, Todd, Marcel Broersma, Karin Hazelhoff, and Guido van 't Haar. 2013. "Between Broadcasting Political Messages and Interacting with Voters: The Use of Twitter during the 2010 UK General Election campaign." *Information, Communication & Society* 16 (5): 692–716.

Hedman, Ulrika, and Monika Djerf-Pierre. 2013. "The Social Journalist." *Digital Journalism* 1 (3): 368–385.

Hermida, Alfred. 2010. "Twittering the News." *Journalism Practice* 4 (3): 297–308.

Hermida, Alfred. 2013. "#Journalism. Reconfiguring Journalism Research about Twitter, One Tweet at a Time." *Digital Journalism* 1 (3): 295–313.

Klinger, Ulrike, and Jacob Svensson. 2015. "The Emergence of Network Media Logic in Political Communication: A Theoretical Approach." *New Media & Society* 17 (8): 1241–1257.

Marchetti, Rita, and Diego Ceccobelli. 2015. "Twitter and Television in a Hybrid Media System. The 2013 Italian Election Campaign." *Journalism Practice*. doi:10.1080/17512786.2015.1040051.

McCombs, Maxwell E., and Donald L. Shaw. 1972. "The Agenda-Setting Function of Mass Media." *Public Opinion Quarterly* 36 (2): 176–187.

Papacharissi, Zizi. 2015. "Toward New Journalism(s)." *Journalism Studies* 16 (1): 27–40.

Paulussen, Steve, and Raymond A. Harder. 2014. "Social Media References in Newspapers." *Journalism Practice* 8 (5): 542–551.

Singer, Jane B., Alfred Hermida, David Domingo, Ari Heinonen, Steve Paulusse, Thorsten Quandt, Zvi Reich, and Marina Vujinovic. 2011. *Participatory Journalism: Guarding Open Gates at Online Newspapers*. Malden, MA: Wiley-Blackwell.

Thesen, Gunnar. 2013. "When Good News is Scarce and Bad News is Good: Government Responsibilities and Opposition Possibilities in Political Agenda-Setting." *European Journal of Political Research* 52: 364–389.

Walgrave, Stefaan, and Peter Van Aelst. 2006. "The Contingency of the Mass Media's Political Agenda-Setting Power: Toward a Preliminary Theory." *Journal of Communication* 56 (1): 88–109.

# LETTING THE DATA SPEAK
## Role perceptions of data journalists in fostering democratic conversation

Jan Lauren Boyles and Eric Meyer

*Journalists in democratic societies perceive their role as guardian of the public's trust. This ethic of social responsibility has been infused into all tasks related to news production—particularly the act of convening debate surrounding salient issues. The entry of data journalists into the newsroom has upended this shared occupational schema. In processing big data for a lay audience, data journalists place greatest emphasis upon their role as translators of abstract and technical knowledge. While these newsworkers still perceive their work as operating in the public good, data journalists are shifting their professional boundaries when promoting conversation around data products—particularly in the social space. This work, based on in-depth interviews with data journalists in America's top newspapers, illuminates how data journalists perceive their social responsibility role in fostering democratic conversation with the audience.*

## Introduction

Large-scale datasets, spanning in size from terabytes to petabytes, cannot be easily conveyed with traditional forms of storytelling or with computer-aided illustrations, such as simple charts and tables, long common in newsrooms. In the context of journalistic production, the complex nature of big data requires the complement of clear and concise narratives with interactive, visual elements. Journalists, who have long been socialized to operate in service of the public, are uniquely positioned to synthesize and simplify this emerging class of information for audiences. Adhering to the notion of socially responsible newswork, journalists can help citizens tame the information overload of the digital age.

While this explanatory role remains at the heart of newswork, the duties, routines, and professional orientation of data journalists appear to be concurrently shifting. As newsrooms push editorial employees toward deeper levels of audience engagement, data journalists are finding they must not only translate knowledge, they must also convene debates in the social space. Increasingly, practitioners of data journalism are approaching journalism-as-conversation, attempting to integrate enhanced dialogue into the process of news production. Consequently, data journalists are engaging in a

renewed round of boundary-work, in which newsworkers are demarcating their profes-
sional spheres of influence in the ever-evolving environment of digital media making.

Documenting this turn in journalistic boundary-work, this study features 31
in-depth interviews with data practitioners at America's top-circulation newspapers. The
exchanges evidence that journalists are reordering their patterns of audience engage-
ment and approach to newswork. Taken together, this research outlines the challenges
inherent in making data "conversational" from the viewpoint of practitioners.

## Establishing Boundaries: Journalism-as-conversation

In the social responsibility construct of producing news in Western democracies,
journalists serve the public and keep its trust (Christians 2009; Hallin and Mancini 2004;
Marchionni 2013; Nerone 2013). The output of journalistic labor acts to educate and
enlighten the audience, thereby creating an informed citizenry (Carey 1991). Citizen
engagement with the knowledge produced by journalists, in turn, stands essential to
the persistence of the republic (Carey 1991). Carey posited that journalists should act as
the catalyst for citizen conversations surrounding public policy and news events. In the
best case, journalism should provide dialogue rather than monologue, reinforcing the
two-way nature of conversation about the news (Kunelius 2001; Lewis, Holton, and
Coddington 2014; Marchionni 2013; Min 2015).

Carey's ideals found resonance in the public journalism movement of the 1990s.
Public journalism was intended to bolster democratic discussion, empowering
audiences to deliberate and discuss salient issues within their communities (Haas 2001;
Nip 2006; Rosen 1999). By design, citizens were to actively collaborate with journalists
through town hall meetings, focus groups, and public opinion polls. Through this
candid, interpersonal dialogue, citizens would identify substantive policy topics, thereby
directly influencing the news agenda (Nip 2006). Despite ambitions to shift the long-
standing gatekeeping paradigm, public journalism was largely branded as a failure
(Haas and Steiner 2006). In eulogizing the movement, Schudson highlights that not all
democratic talk in the public sphere advances the ambitions of democracy (Schudson
2008). Carey (1991, 219), in fact, conceded that journalistic involvement in democratic
conversation can be imperfect, as the back-and-forth exchanges may be "cacophonous"
and disjointed. Taken together, the movement's detractors asserted that public
journalism engaged reporters in a function for which they were not intended: direct
collaboration with the audience.

While public journalism largely failed, artifacts of the movement persist more than
two decades later. Extending Carey's ideals into the digital age, Marchionni (2013, 136)
defines the current momentum behind *journalism-as-conversation* as "the manner and/or
degree to which interpersonal, reciprocal exchanges between journalists and everyday
citizens, whether mediated or unmediated, enhance newswork on matters of public
import for the common good." Newswork within the digital environment today more
closely approaches conversation, mainly because interactivity permits deeper engage-
ment with the audience than could be achieved with pre-digital formats, such as static let-
ters to the editor (Marchionni 2013). Recent energy within digital newsrooms has
resurrected the notion that newsworkers possess a democratic duty to facilitate citizen
conversation (Lewis, Holton, and Coddington 2014). In today's parlance, newsrooms are

increasingly oriented toward *audience engagement*—a twenty-first-century stand-in for journalism-as-conversation (Lewis, Holton, and Coddington 2014; Min 2015).

The integration of journalism-as-conversation into everyday newswork requires a complementary recalibration of a journalist's duty to the public—particularly for news-workers heavily engaged in digital spaces. In conducting such *boundary-work*, journalists are actively redefining their respective spheres of professional authority and autonomy by attributing "selected characteristics to the institution"—thereby more clearly defining relationships between insiders and outsiders (Carlson 2015; Gieryn 1983, 782; Lewis 2012). Boundary-work may require re-approaching practitioner routines and reassessing internal values (Gieryn 1983). Prior cycles of boundary work within journalistic practice have addressed the emergent challenges of participatory media platforms (Robinson 2010; Wahl-Jorgensen 2015), source relations (Revers 2014), and verification (Hermida 2015). In these instances, journalists have debated how best to demarcate the profession's porous boundaries.

In the digital space today, data journalists are revisiting—via boundary-work—their professional spheres of influence. The manufacture of data blends the technical domain of coding with the artistic domain of visual expression, incorporating interdisciplinary knowledge from the fields of visual art and graphic design, as well as from statistics, mathematics, Geographic Information Systems (GIS), psychology, and computer engineering. Statisticians, for instance, have suggested that the entry of non-specialists into the production of data visualization has diminished the methodological rigor of the field (Gelman and Unwin 2013). In short, disciplinary boundaries are further blurring as data journalism reaches critical mass.

In negotiating boundary-work surrounding data journalism, practitioners are also recalibrating their role as a conversational convener. To audiences, the power of data storytelling rests in its ability to translate technical, granular data that is typically the province of data scientists into visual, broad data that can be easily comprehended (Telea 2015). Central to the definition of journalism-as-conversation, such acts of newswork "may provide foundation for public dialogue" (Beckett and Mansell 2008, 92; Lewis and Usher 2013). The promotion of dialogue around data products, in short, requires new boundaries to be set between working practitioners and their audiences.

## The Challenges of Making Data "Conversational"

Following the tradition of socially responsible newswork, data journalism products should stimulate critique and criticism stemming from the large-scale dataset (Cairo 2012; Telea 2015; Yau 2011). Cognitively, journalistic interpretations of datasets can rationally organize and shape the audience member's perception of the news event or issue under examination (Cairo 2012). Concurrently, data visualization design taps into the audience member's emotional capacities of visual engagement by emphasizing aesthetics and beauty (McCosker and Wilken 2014). When fusing the cognitive with the aesthetic, conversation can be achieved when journalists engage audience members in back-and-forth dialogue about the dataset, rather than merely leaving the data product to stand on its own in digital space (Min 2015). Beyond quickly glancing at a data journalism product and interpreting the results, audiences are often invited to actively manipulate the data product itself. Through data interactives, users can explore and

gain insights by engaging with the dataset, becoming more actively involved with the process of interpretation (Yau 2011). The applied use of data visualization, in particular, can promote conversation by helping inform the process of decision making through active discovery (Parasie and Dagiral 2012; Yau 2011).

In the process of making data "conversational" for the audience, prior scholarship has illustrated that journalists diverge in their adoption of, and adherence to, emergent forms of storytelling (Dick 2014; Karlsen and Stavelin 2014). Within the field of data journalism, one set of practitioners ascribes to the notion that the journalist should perform the primary data analysis and interpretation, highlighting the story inherent in the dataset (Cairo 2012; Parasie and Dagiral 2012). Other journalists suggest that "news in itself should be viewed as computer-processable data, and not only as a story hidden in the data" (Lewis and Usher 2013; Parasie and Dagiral 2012, 862). To deepen audience engagement, these practitioners believe that the journalistic output should feature "drillable" interfaces that "frame and empower the reader to become the investigator or journalist" (Karlsen and Stavelin 2014, 40). As newsroom analytics grow in sophistication, data journalists will continue to know more about their audience and how best to manage journalism-as-conversation (Cherubini and Nielsen 2016). Devolving authority to the audience significantly restructures the sovereignty that journalists once possessed to frame narratives—an act of boundary-work that needs further examination.

While prior studies have established a preliminary foundation for the shifting professional boundaries of data-driven newswork (Coddington 2014; Fink and Anderson 2014; Gynnild 2014; Karlsen and Stavelin 2014; Parasie and Dagiral 2012; van Dalen 2012), these works have not fully considered that the restructuring of journalism-as-conversation requires a more nuanced understanding of the data journalist's connection to the data audience itself. To better understand the landscape of data production, this research outlines the role perceptions of data newsworkers and their relationship to the audience in convening conversation.

## Methods

To more clearly articulate how practitioners of data journalism see their role as conversational conveners and to further define emerging boundaries of the profession, this research encompassed in-depth interviews with 31 data newsworkers—a method employed in several prior studies of the emerging data news landscape (Fink and Anderson 2014; Karlsen and Stavelin 2014; Parasie and Dagiral 2012). Interview subjects were selected using a combination of two sampling frames: the top 100 newspapers in the United States by circulation (as measured by the Alliance for Audited Media's 2013 figures) and newspapers from each of the country's 50 state capitals. When the two frames were fused together, researchers eliminated newspapers that were initially in both datasets, resulting in a final sample of 120 daily newspapers.

Researchers sought to locate any staffer working at these publications with the following job titles: data journalist/reporter/writer/editor or data visualization designer/editor. Interview subjects were identified through a combination of snowball sampling industry contacts, Web searches of publication staff directories and Twitter profiles, public listings on muckrack.com, as well as correspondence with individual publications. Of the 120 newspapers sampled, 51 publications (nearly 43 percent) had a data

newsworker on staff (as of January 2016). In the final pool of interview subjects, 19 respondents worked as data journalists/reporters/writers or editors, and 12 worked as data visualization designers or editors. On average, interviewees had 13 years of newsroom experience. While all interviewees had prior experience in computational newswork prior to assuming their current posts—particularly backgrounds in Computer Assisted Reporting—data journalists with less than five years of newsroom experience were more likely to have formal training and/or academic degrees in computer science, statistics, or GIS. The interviewees consisted of 27 men and four women. The in-depth interviews were conducted by phone between April 2015 and February 2016, and averaged 36 minutes in length.

The conversations centered on data newsworkers' role perceptions, production routines, audience engagement efforts, understanding of audience, and approaches to convening conversation. Because the journalists were talking about proprietary approaches to data newswork and the competitive pressures of their news organizations, all interviewees were granted anonymity. Guided by a grounded theory approach, researchers initially examined the set of interview data for patterns of action related to audience engagement and democratic conversation (Corbin and Strauss 2008; Creswell 2007; Soss 2006). The study's objective rests in articulating how data practitioners perceive their role as conveners of debate, while also articulating the degree to which data newswork currently approaches journalism-as-conversation.

## Self-perceptions of Data Newswork

Data journalists place greatest emphasis on their role as explainer of societal knowledge. "To someone who is not in the field [of data newswork], I would say that my job is to look at the data, to look at the mass of the dataset, and to reveal the patterns and see if there is a story behind it," said one data newsworker. "And if there is a story behind it, I want to design a way of telling that story." Several journalists expressed the desire to spotlight narrow, niche subjects that may not otherwise receive attention. While much of the data published online by newspapers is already freely available from state and federal agencies, data journalists—in their explanatory role—worked to make the information "less clunky" than governmental interfaces. "I sort of lean on the public good argument," a data journalist said. "It may take more time [for data journalists] to figure out the dataset for the audience, but if that information isn't easily accessible, and we don't do it—maybe no one else will." In this explanatory function, nearly all practitioners noted the centrality and primacy of data. "My starting point is that all stories are based on data—all of life is quantifiable," said one practitioner. "You quickly start to think along the lines of 'How can I count that—How can I extract meaning from that?'" Too often, data journalists say, practitioners can get distracted by the design elements of newswork, however, losing sight of the story at hand. "A lot of designers or programmers can be carried away by the computational or design aspect," a data designer shared. "They are missing the point; the role of data is to make it easier for your readers to understand the subject."

Despite their expertise as explainers of societal knowledge, the overall confidence level of practitioners in producing data products for audiences was routinely self-described as "low." In relating day-to-day routines, data journalists expressed significant

feelings of professional inadequacy. Namely data reporters said they struggle to achieve competency with the evolving assortment of programming languages, software tools, and visualization packages central to data production. As the field has yet to coalesce around industry-standard approaches to data newswork, the constant culture of experimentation equates to continuous on-the-job learning. All interviewees reported a piecemeal approach to building their knowledge of new data platforms and tools. According to interviewees, the time spent on traditional reporting tasks—interviews, document analysis, writing—pales in comparison to the labor-intensive nature of learning new skills from the ground up, particularly the arduous process of cleaning data. Many journalists had a vision of what they would like to create, but said they lacked the technical skills or software to make that vision a reality. Nearly all interview subjects related that newsroom management understood this challenge, however, giving data newsworkers more time to tinker than other editorial employees.

In many cases, data journalists were also relied upon to retrain other newsroom staff in new approaches to newsgathering—particularly database tools and code literacy. While these training sessions were reported as hit-and-miss in their effectiveness, data journalists say they are viewed as the technical experts in the newsroom—a mentorship duty that stretches their talents beyond those assigned in their job description. Together, the community of data journalists is working toward better routinizing not only the process of production, but also the act of convening conversation with the audience.

## Convening Conversation

Within newsrooms, all editorial employees are increasingly charged to engage their audiences. In designing data products for public conversation, data practitioners similarly place the audience at the center of the production process. "I'm always thinking of my audience," said one data reporter. "Who is reading this? And what are they reading it on?" Complex datasets are rarely self-explanatory and require differing levels of audience engagement than other types of journalistic production, however. Because data stories and visualizations often revolve around highly technical and interdisciplinary knowledge, newsworkers say they feel a strong responsibility to promote discussions around the data so that audiences can fully comprehend the final product. Activating audiences in conversation around data journalism has been most successful when focusing on highly personalized, local-level, policy-driven news products—such as visualizations that illustrate the location of water main breaks or the pattern of crime in their neighborhoods. Compared with traditional news audiences, data journalists generally find that consumers of data products are more deeply invested in their communities and are "highly engaged in civic life."

Data journalists diverged, however, in how best to tap into the audience's innate curiosity by making data conversational. Data newsworkers within investigative reporting units tended to favor data products that emphasized simplicity. By creating "glanceable information," readers could quickly and intuitively navigate the data story or visualization, acting as a catalyst for conversation. To data journalists whose function was more closely tied to reporting, the objective was to provide information in the fewest number of clicks. "Someone's got to understand what this [the data product] is

about very quickly," shared one data journalist. "If you put too many bells and whistles and things—the reader will say, 'I don't get this.'" And that frustration with the data product will stymie any attempts at conversation, interviewees say. In this capacity, journalists are needed to ease any levels of irritation that audiences may encounter with navigating the dataset. On the other hand, data designers with expertise in data visualization stressed that conversation arises from making the data product interactive, which in turn, increases digital engagement time. As a whole, engagement time (a preferred metric over the once-standard page view) for data products is routinely measured in minutes rather than seconds, interviewees said. At several publications, internal newsroom research revealed that access to datasets was one of the few editorial products for which audiences were willing to pay premium subscription rates, thereby building "brand prestige" for the publication, interviewees say. Designers believed that visualizations created conversation in these spaces, in that audiences could "drill down" into the data and interrogate the story from multiple angles. "I want to give readers every little piece of information so they can fine tune the data in any way that they want," said one data visualization practitioner. "I like going deep and granular."

To strike a balance between the two perspectives in making data conversational, several journalists advocated publicly sharing the datasets used to build interactives and fuel reporting. Audience members can then decide the degree and depth to which they would like to engage in conversation. A disconnect existed, however, between aspiration and practice. Only a handful of publications routinely released datasets publicly. Practitioners working in publications favoring open sourcing data reported that they routinely interacted with "data gurus"—audience members who often downloaded spreadsheets of data released by the newspaper, and conducted their own quantitative analyses. Citizen newsworkers also uncovered additional stories that were "missed" by the data journalists, providing more information for those "geeked out" by the topic. But even when datasets are not released publicly, audience members regularly report minor inaccuracies to journalists, such as name misspellings or transposed numbers in published narratives or visualizations.

Given the push in newsrooms for deeper levels of audience engagement, data journalists have experimented with various digital forums to best promote conversation. Several journalists reported checking on the performance of their own data stories, and changing their approach to digital promotion depending on the traffic numbers. Traditional spaces of digital engagement—particularly publication homepages—do not yield robust conversation around data products, data journalists say; and as for "landing pages" for data, the comment sections were "virtual ghost towns," with little constructive feedback provided by readers, data reporters said.

The most hopeful conduit for promoting conversation, however, rests in social media platforms. Across news organizations, Facebook and Twitter were the most significant referrers of online traffic for data products. Seven publications had created social accounts that exclusively showcased the work of the newspaper's data team. Specialized reporters in these publications were explicitly assigned to monitor the social flow, quickly replying to inquiries while also posing questions to audiences. Two advanced data-driven newsrooms had crowdsourced data directly from readers in social spaces and collaborated with readers on the source code behind data stories via GitHub, an online software-building repository. In most newsrooms, however, audience

exchanges were integrated into the work of the publication's existing Web and social media editors, who would drive traffic to the data product. Data reporters would then amplify the efforts of their colleagues responsible for the social feeds, handling more specialized and technical conversation with the audience. Despite competing on-the-job tasks that stretch data newsworkers quite thin, all interviewees said interacting with the audience, particularly in the social space, remained a central, day-to-day priority— passed down from newsroom managers.

Despite the shift toward deeper levels of audience engagement, data journalists did not report feeling explicitly pressured by managers to draft narratives for the sole purpose of pushing traffic online. On the contrary, data journalists said they found greatest value and validation in producing stories that promoted civic engagement. "The feedback from the readership has been really positive," one data journalist said. "It reaffirmed people's belief that we're still doing investigative and enterprise reporting in their communities."

## Reshaping Professional Boundaries: Data-as-conversation

In forging conversation with audiences, data practitioners subscribe to the long-held belief that journalists should operate in service of the public. More specifically, data journalists emphasized the socially responsible nature of their work, suggesting that practitioners should aspire to translate technical knowledge for a non-specialist audience. The complex, interdisciplinary nature of data production and presentation requires a different approach to audience engagement than other forms of storytelling. Compared to traditional news narratives, emergent forms of data presentation—particularly interactive visualizations—are unfamiliar to general audiences. Data products, which often require more explanation than traditional news narratives, require that practitioners spend more time in conversation—particularly within the social spaces in which audiences congregate.

As conversational conveners, data journalists are echoing tenets of the public journalism movement. Data narratives built around community-based, policy-driven issues generated the deepest levels of audience engagement, journalists say. For practitioners, journalism-as-conversation may be easier to achieve around data products because current audiences are inclined toward civic engagement. To this end, the capacity for conversation appears strongest around highly personalized, neighborhood-level data—products that align the interests of both socially responsible journalists and civic-minded audiences.

To foster conversation around civic issues, data journalists are interfacing more routinely with external stakeholders. While the levels of experimentation with conversation are currently uneven across news organizations, practitioners concur that audiences are talking more about data narratives, particularly in the social space. This boundary-work conducted by data journalists is reshaping the professional autonomy that practitioners once possessed in producing content for audiences who are increasingly engaged in newswork. Within sophisticated, well-staffed data operations, data journalists report that their audiences have actively participated in content production. In the long term, such audience partnerships may advance the public journalism movement into the digital age. In the meantime, while data journalists may struggle to

balance their at-work demands, the return on investment from audience interaction yields longer digital engagement times—a key reward in today's competitive news marketplace.

While data journalists engaged in boundary-work are reformulating their relationship with the audience, practitioners still lack a full understanding of their readers' needs and desires as they connect to data journalism. To this end, further research is needed to understand precisely how data practitioners engage with readers in social spaces. Content analysis work to examine these messages would provide vital insights into the level of interactivity inherent in these conversations. Ethnographic work within newsrooms (particularly smaller-circulation publications) would also illustrate how data journalists are redefining their roles in day-to-day practice. Such research will more holistically illustrate the extent to which data newswork adheres to the notion of journalism-as-conversation and how practitioners are consequently reshaping their roles through acts of boundary-work.

Data newsworkers are now increasingly oriented toward collaboration and are approaching journalism-as-conversation—a contrast to the failed public journalism movement of the 1990s. As practitioners continue to redefine their professional identity around audience engagement, the boundaries of the profession will continue to shift. While the explanatory role of newswork appears constant, as data journalism advances, newsworkers will continue to foster enhanced conversation with audiences, particularly in the social space.

## DISCLOSURE STATEMENT

No potential conflict of interest was reported by the authors.

## REFERENCES

Beckett, Charlie, and Robin Mansell. 2008. "Crossing Boundaries: New Media and Networked Journalism." *Communication, Culture and Critique* 1 (1): 92–104.

Cairo, Alberto. 2012. *The Functional Art: An Introduction to Information Graphics and Visualization*. Berkeley: New Riders.

Carey, James W. 1991. "'A Republic, If You Can Keep It': Liberty and Public Life in the Age of Glasnost." In *James Carey: A Critical Reader*, edited by Eve Stryker Munson, and Catherine A. Warren, 207–227. Minneapolis, MN: University of Minnesota Press.

Carlson, Matt. 2015. "The Many Boundaries of Journalism." In *Boundaries of Journalism: Professionalism, Practices and Participation*, edited by Matt Carlson, and Seth C. Lewis, 1–18. London: Routledge.

Cherubini, Federica, and Rasmus Kleis Nielsen. 2016. *Editorial Analytics: How News Media Are Developing and Using Audience Data and Metrics*. Oxford: University of Oxford Reuters Institute for the Study of Journalism.

Christians, Clifford G. 2009. *Normative Theories of the Media: Journalism in Democratic Societies*. Urbana: University of Illinois Press.

Coddington, Mark. 2014. "Clarifying Journalism's Quantitative Turn: A Typology for Evaluating Data Journalism, Computational Journalism, and Computer-Assisted Reporting." *Digital Journalism* 3 (3): 1–18.

Corbin, Juliet, and Anselm Strauss. 2008. *Basics of Qualitative Research: Techniques and Procedures for Developing Grounded Theory*. Thousand Oaks: Sage.

Creswell, John W. 2012. *Qualitative Inquiry and Research Design: Choosing among Five Approaches*. Thousand Oaks: Sage.

Dick, Murray. 2014. "Interactive Infographics and News Values." *Digital Journalism* 2 (4): 490–506.

Fink, Katherine, and C. W. Anderson. 2014. "Data Journalism in the United States: Beyond the 'Usual Suspects'." *Journalism Studies* 16 (4): 467–481.

Gelman, Andrew, and Anthony Unwin. 2013. "Infovis and Statistical Graphics: Different Goals, Different Looks." *Journal of Computational and Graphical Statistics* 22 (1): 2–28.

Gieryn, Thomas F. 1983. "Boundary-Work and the Demarcation of Science from Non-Science: Strains and Interests in Professional Ideologies of Scientists." *American Sociological Review* 48 (6): 781–795.

Gynnild, Astrid. 2014. "Journalism Innovation Leads to Innovation Journalism: The Impact of Computational Exploration on Changing Mindsets." *Journalism* 15 (6): 713–730.

Haas, Tanni. 2001. "Public Journalism Project Falls Short of Stated Goals." *Newspaper Research Journal* 22 (3): 58–70.

Haas, Tanni, and Linda Steiner. 2006. "Public Journalism a Reply to Critics." *Journalism* 7 (2): 238–254.

Hallin, Daniel C., and Paolo Mancini. 2004. *Comparing Media Systems: Three Models of Media and Politics*. Cambridge: Cambridge University Press.

Hermida, Alfred. 2015. "Nothing but the Truth: Redrafting the Journalism Boundary of Verification." In *Boundaries of Journalism: Professionalism, Practices and Participation*, edited by Matt Carlson, and Seth C. Lewis, 37–50. London: Routledge.

Karlsen, Joakim, and Eirik Stavelin. 2014. "Computational Journalism in Norwegian Newsrooms." *Journalism Practice* 8 (1): 34–48.

Kunelius, Risto. 2001. "Conversation: A Metaphor and a Method for Better Journalism?" *Journalism Studies* 2 (1): 31–54.

Lewis, Seth C. 2012. "The Tension between Professional Control and Open Participation: Journalism and Its Boundaries." *Information, Communication & Society* 15 (6): 836–866.

Lewis, Seth C., and Nikki Usher. 2013. "Open Source and Journalism: Toward New Frameworks for Imagining News Innovation." *Media, Culture & Society* 35 (5): 602–619.

Lewis, Seth C., Avery Holton, and Mark Coddington. 2014. "Reciprocal Journalism: A Concept of Mutual Exchange between Journalists and Audiences." *Journalism Practice* 8 (2): 229–241.

Marchionni, Doreen M. 2013. "Journalism-as-a-Conversation: A Concept Explication." *Communication Theory* 23 (2): 131–147.

McCosker, Anthony, and Rowan Wilken. 2014. "Rethinking Big Data as Visual Knowledge: The Sublime and the Diagrammatic in Data Visualization." *Visual Studies* 29 (2): 155–164.

Min, Seong-Jae. 2015. "Conversation through Journalism: Searching for Organizing Principles of Public and Citizen Journalism." *Journalism* (ahead-of-print).

Nerone, John. 2013. "The Historical Roots of the Normative Model of Journalism." *Journalism* 14 (4): 446–458.

Nip, Joyce Y. M. 2006. "Exploring the Second Phase of Public Journalism." *Journalism Studies* 7 (2): 212–236.

Parasie, Sylvain, and Eric Dagiral. 2012. "Data-Driven Journalism and the Public Good: 'Computer-Assisted-Reporters' and 'Programmer-Journalists' in Chicago." *New Media & Society* 15 (6): 853–871.

Revers, Matthias. 2014. "Journalistic Professionalism as Performance and Boundary Work: Source Relations at the State House." *Journalism* 15 (1): 37–52.

Robinson, Sue. 2010. "Traditionalists Vs. Convergers Textual Privilege, Boundary Work, and the Journalist—Audience Relationship in the Commenting Policies of Online News Sites." *Convergence* 16 (1): 125–143.

Rosen, Jay. 1999. *What Are Journalists for?*. New Haven, CT: Yale University Press.

Schudson, Michael. 2008. *Why Democracies Need an Unlovable Press*. Maiden, Mass: Polity.

Soss, Joe. 2006. "Talking Our Way to Meaningful Explanations: A Practice-centered View of Interviewing for Interpretative Research." In *Interpretation and Method: Empirical Research Methods and the Interpretative Turn*, edited by Dvora Yanow and Peregrine Schwartz-Shea, 161–182. North Castle: M.E. Sharpe.

Telea, Alexandru. 2015. *Data Visualization: Principles and Practice*. Boca Raton: Taylor & Francis.

van Dalen, Arjen. 2012. "The Algorithms behind the Headlines: How Machine-Written News Redefines the Core Skills of Human Journalists." *Journalism Practice* 6 (5-6): 648–658.

Wahl-Jorgensen, Karin. 2015. "Resisting Epistemologies of User-Generated Content? Cooptation, Segregation and the Boundaries of Journalism." In *Boundaries of Journalism: Professionalism, Practices and Participation*, edited by Matt Carlson, and Seth C. Lewis, 169–185. London: Routledge.

Yau, Nathan. 2011. *Visualize This: The Flowing Data Guide to Design, Visualization and Statistics*. Indianapolis, IN: John Wiley & Sons.

# TOWARDS A NEW MODEL FOR JOURNALISM EDUCATION

## Dan Gillmor

Accepting an award from Arizona State University's Walter Cronkite School for Journalism & Mass Communication in 2008, former *PBS NewsHour* host Robert MacNeil called journalism education probably "the best general education that an American citizen can get" today.[1] Perhaps he was playing to his audience, at least to some extent. Many other kinds of undergraduate degree programs could lay claim to a similar value—a strong liberal arts degree, no matter what the field of focus, has great merit.

Still, there's no doubt that a journalism degree, done right, is an excellent foundation for a student's future in any field, not just media. And even if MacNeil overstated the case, his words should inspire journalism educators to ponder their role in a world where these programs' traditional reason for being is increasingly murky.

Our *raison d'être* is open to question largely because the employment pipeline of the past, a progression leading from school to jobs in media and related industries, is (at best) in jeopardy.[2] We're still turning out young graduates who go off to work in entry-level media jobs, particularly in broadcasting—but where is their career path from there? It's not clear in an era when traditional journalism jobs are disappearing at a rapid rate, even if non-traditional ones are growing.

Traditional media have adapted fitfully to the collision of technology and media. Journalism schools as a group may have been even slower to react to the huge shifts in the craft and its business practices. Only recently have they embraced digital technologies in their work with students who plan to enter traditional media. Too few are helping students understand that they may well have to invent their own jobs, much less helping them do so.

Yet journalism education could and should have a long and even prosperous future—if educators make some fundamental shifts, recognizing the realities of the twenty-first century.

No one has asked me to run a journalism school. That is no doubt wise. If I did find myself in that position, however, I would ask teaching colleagues to think about some fairly major shifts in the way we did our jobs. Since my background is in practice for the most part, not research, I will focus first on undergraduate journalism education. Then I'll make some suggestions about how we might approach graduate-level research, a vital part of many of our institutions and also, one hopes, open to some digital-era tweaks.

## Undergraduate Program

We would start with some basic principles of honorable, high-quality journalism—such as thoroughness, accuracy, curiosity, independence, and transparency—and embed

them at the core of everything else. If our students didn't understand and appreciate those principles, nothing else we did would matter very much.

We would emphasize undergraduate journalism degrees as great liberal arts programs. This would start in the admissions phase, where we would suggest to prospective students (and their parents who are likely to be paying the bills) that a journalism degree is a nearly ideal foundation for many kinds of careers, one of which is journalism. For example, journalism majors who go on to law school bring with them the ability to write clearly, a valued skill in legal circles. However, journalism would remain the focus of our program, as the best way to create the kinds of skills that have that wider application.

With few exceptions, journalists and other professionals work in teams of people who have dissimilar skills and knowledge. It is never too early to foster cross-disciplinary teamwork. So we would encourage, and in some cases require, cross-disciplinary learning and doing. We would foster partnerships around the university, working with business, engineering/computer science, film, political science, law, design and other programs. The goals would be both to develop our own projects and to be an essential community-wide resource for the future of local media; more on the latter below.

Journalists of the future will—not might—work with computer programmers. It is not necessary for journalists to become programmers, though I strongly believe everyone should take at least a short course in JavaScript.[3] But it is vital for journalists to know how to communicate with programmers. (We'd also encourage computer science undergraduates to become journalism graduate students, so they can help create tomorrow's media.) Moreover, understanding basic principles of computer code provides a window into a way of thinking that everyone needs to grasp in the modern world. Famed venture capitalist Marc Andreessen, who helped invent the first commercial Web browser, has said "Software is eating the world,"[4] a reference to the reality that computer code increasingly is part of everything we touch and the services we use. Journalists need to know what that means.

Along those lines, we desperately need journalists who understand basic statistics, especially as it applies to survey research, and fundamental scientific methodology. A modern journalism school can help supply them, and we've never needed them more. Put bluntly, journalists are terrible at math,[5] and it shows in embarrassing ways. For example, media coverage of risk is grossly skewed toward things that are, statistically, exceedingly rare in our society—terrorism is a prime example—while coverage of much more risky things is rare or ho-hum. We mislead our audiences, and do society a disservice.

One of the absurdities of the past half-century in media organizations has been journalists' ignorance—often encouraged by their bosses—of how their businesses operated. The "church–state" separation had well-meaning foundations, but it was paternalistic and, as we've now seen, counterproductive. Journalism schools should require all students to understand business concepts, especially those relating to media.[6] This is not just to cure the longstanding ignorance of business issues in the craft, but also to recognize that today's students will be among the people who develop tomorrow's journalism business models. A program I ran would help students learn about for-profit and not-for-profit business models, and would help teach them about advertising, marketing, social networking, and search engine optimization, among many other elements.

In a related move, we would embed entrepreneurship into our program. We should not expect all or even many students to start their own companies, but we should help them understand and appreciate the startup culture—because even traditional businesses

are having to adopt entrepreneurial practices internally. Arizona State University, where I work, is among several schools working on this, and the early experiments are gratifying.[7] At City University of New York (CUNY), Jeff Jarvis has been collecting (and creating) some best practices concerning how to bring the startup culture into the curriculum; CUNY's Tow-Knight Center for Entrepreneurial Journalism is the most advanced, and best-funded, of these efforts.[8] When I say "entrepreneurship" I do not only mean the Silicon Valley style of business development, where the objective is usually hyper-growth in a hyper-scalable way. I also mean what technology investors deride as "lifestyle businesses," the kind of enterprise that can support a few people, or a few dozen, in a sustainable way. A few years ago I thought that we would save journalism with 50 new big companies. That was absurd, I now realize. Today I hope we can save journalism with 500,000 small enterprises and a few big ones. We'll need people with entrepreneurial spirit for all of them.

Part of the journalism environment, at big and small companies alike, is data. We may wish otherwise, and we should be deeply worried about Big Data's privacy implications, but we have no choice but to teach students about how data are generated, collected, massaged, and otherwise used to make decisions in a modern media organization.

Journalism schools should not be outposts inside university islands, separated from their communities, especially when traditional media organizations are fading and failing. Our students do actual journalism, their work should be widely available in the community, particularly when it fills in gaps left by the shrinking traditional media. At Arizona State, the Cronkite News Service provides all kinds of coverage of topics the local news organizations rarely cover, making our students' work available to those organizations. We practice the "teaching hospital" model[9]—a hands-on approach—and recommend it for any school with the appropriate facilities.

We would partner with local media organizations where possible, and compete with them where necessary. Simultaneously, we would advise and train citizen journalists to understand and apply sound principles and best practices. They are going to be an essential part of the local journalism ecosystem and, like Cardiff University's Centre for Community Journalism,[10] we should reach out to show them how we can help.

Journalism skills are core to media literacy, and media literacy would be part of our mission. We would work to persuade the university that every student on the campus should learn media literacy principles and skills before graduating, preferably during freshman year. At State University of New York's Stony Brook campus, the journalism school has been given a special mandate of exactly this kind.[11] (I teach two online media literacy courses at Arizona State, and led a massive open online course (MOOC) on the topic; the MOOC attracted thousands of people from around the world.[12])

We would create a program of the same kind for people in the community, starting with teachers. Our goal would be to help schools across our geographical area bring media literacy to every level of education—not just college, but also elementary, middle, and high school. We would offer workshops, conferences, and online training. Beyond the education community, we would offer this to concerned parents who feel overwhelmed by the media deluge themselves, to help turn them into better media consumers and to give them ways to help their children.

Those are some of the initiatives I would encourage in modern undergraduate journalism education. They raise an obvious question: If we add this or that to our program, what should we drop? In some cases, such as data skills, the answer might be to offer

elective courses. Others, such as entrepreneurship, might be better embedded in core courses. But I won't pretend this is a trivial issue; the one limited quantity is time.

## Graduate Programs

In the United States, graduate journalism programs break down into two major areas. The first, normally undertaken at the Master's level, is practice. The other, typically in PhD programs, is research. We need both, but we probably need research more.

Arizona State University offers a Master's degree program[13] aimed at training people to become journalists operating at a high level. A few are mid-career journalists, but most are arriving either directly from undergraduate schools or from other areas of the workforce. They get deep training in skills and in developing a core expertise. Other graduate programs of this sort are fairly common, but some are carving out more narrow, but much-needed, areas such as entrepreneurship and social media.

Journalism schools should also offer combined Master's degrees with other university programs. An advanced degree in, say, journalism and medicine would give the student the background to become a medical journalist or communications specialists within the medical field. There are any number of topics where this approach might work well.

And it's important, as noted at the top, that journalism graduates have to look beyond journalism for the widest opportunities—and we can help. For example, non-governmental organizations and advocacy organizations are increasingly hiring journalists for their communications needs. A journalism school could offer a one-year Master's degree, giving people who plan to go in that direction the specific skills they need for this growing area. This is a significant potential market.[14]

The other vital area for graduate schools, of course, is research. I'm not arguing only for research into industry-specific areas. Pure research has led to vital breakthroughs in many fields (though rarely if ever in journalism, as far as I can tell), and we shouldn't abandon it. In our imagined school, we would encourage a research agenda with deep connections to key media issues of today. More than ever, we need solid data and rigorous analysis. Happily, unprecedented amounts of data are pouring out of the media field today. (I would also insist that faculty members translate their research into language that average people can understand, in addition to the dense, even impenetrable, prose that can only be understood, if at all, by readers of academic journals.)

The proposals above suggest a considerably broader mission for journalism schools and programs than the one they've had in the past—and big opportunities. The need for this kind of training has never been greater. We're not the only ones who can do it, but we may be among the best equipped.

## ACKNOWLEDGEMENT

This essay is adapted from Dan Gillmor's book, *Mediactive* (mediactive.com), which aims to help media audiences become active users, as consumers and creators.

## DISCLOSURE STATEMENT

No potential conflict of interest was reported by the author.

## NOTES

1. http://mediashift.org/idealab/2009/02/journalism-educations-broader-deeper-mission038/.
2. http://www.niemanlab.org/2015/07/newsonomics-the-halving-of-americas-daily-newsrooms/.
3. https://www.codecademy.com/ is the best of the free online courses.
4. http://www.wsj.com/articles/SB10001424053111903480904576512250915629460.
5. http://www.cjr.org/behind_the_news/sorry_wrong_number.php.
6. http://www.poynter.org/2012/why-journalists-should-explore-the-business-side-of-the-newsroom/196857/.
7. https://cronkite.asu.edu/real-world-experiences/professional-programs/media-innovation-and-entrepreneurship-lab.
8. http://www.journalism.cuny.edu/academics/entrepreneurial-journalism/.
9. http://www.usatoday.com/story/money/columnist/rieder/2014/06/25/major-teaching-hospital-for-journalism-at-arizona-state/11350267/.
10. http://www.cardiff.ac.uk/jomec/aboutus/communityjournalism/.
11. http://www.centerfornewsliteracy.org/.
12. https://www.edx.org/course/media-lit-overcoming-information-asux-mco425x (the course materials are available under a Creative Commons license).
13. https://cronkite.asu.edu/degree-programs/admissions/graduate.
14. http://mediashift.org/2014/04/journalism-schools-need-to-educate-non-journalists-and-almost-journalists-too/.

# THE FUTURE OF PROFESSIONAL PHOTOJOURNALISM
## Perceptions of risk

**Adrian Hadland, Paul Lambert**, and **David Campbell**

*The work practices of the professional photojournalist are currently undergoing rapid change in the digital era. New technologies, new platforms and new methods of visual storytelling are exerting a range of pressures and influences that require photojournalists to adapt and respond in different ways. The changes provoke a number of questions that are critical to the future of professional photojournalism: What are the new risks being faced by photojournalists? How are the transformations in the media economy affecting photojournalists' employment? What does this mean for image quality? How do photojournalists think about the manipulation of images or the staging of events? Given the rise of citizen journalism, digital technology and social media, will there even be professional photojournalists in the future? This paper presents some of the results and new analysis from the first international study into the current state and future of professional photojournalism, with a specific focus on risk and on perceptions of risk among photographers. The results indicate a high degree of risk is experienced among professional photographers with a very strong correlation to the country in which they are based.*

## Introduction

While the image is a central and vital component in modern communications, the place of the professional photographer has never been as potentially under threat as it is in the digital era.

Even relative to the falling number of journalists in full-time employment over the past two decades, photographers have lost their jobs in disproportionate numbers particularly in America (Anderson 2013; Mortensen 2014). On occasion, entire photographic departments have been shed or drastically reduced, most infamously at the *Chicago Sun Tribune* and at *Sports Illustrated*. US career surveys have even named photojournalism among the 10 worst jobs (Romenesko 2015).

The challenge to professional news photography, however, goes far beyond job security, and is both multi-faceted and complex. The digital revolution has witnessed the transformation of the audience into producers and with technology growing in power and shrinking in cost, a new generation of amateur and citizen image-makers has emerged. Every contemporary disaster, natural or self-inflicted, has been captured by people on the scene with cameras or mobile phones. Nor are these new content creators satisfied only to take images. They transmit them, edit them, mash them, mix them with other media and take enjoyment out of the boundless creativity and appeal the technology now offers.

But it is not only the emergence of visual media as a mass phenomenon that impacts on the future of the professional news photographer, nor is it changing work patterns or even ethical challenges. Professional photography, as this article confirms, is also an extremely risky occupation and is getting riskier.

This research clearly demonstrates that risk of physical harm or death is felt deeply across the genders and across age groups, with most photographers believing that it will increase over time. Less than 1 in 10 photographers surveyed say they are "never" exposed to risk at work, while a very substantial 92 per cent say they are exposed to physical risk at some point. This is one of the digital era's more alarming trends, with important implications for the sustainability of photojournalism[1] as a profession.

Drawing on data from the first major international study into the current state and future of professional photojournalism,[2] this paper focuses specifically on the risks faced by professional news photographers in this digital twenty-first century.

## Literature Review

News photographers are an understudied group of creative practitioners. Some would claim this replicates the systemic under-valuing of photographers and their work in traditional print organisations through, for instance, the common omission of bylines. Even in fairly recent work on the media industry and on the creative industries, it is rare that photographers are the principal concern. In Tunstall's (2001, 16), *Media Occupations and Professions*, photography merits only passing mention in the introduction's discussion of media occupation "fragments". This absence is replicated in many other important works analysing the sector, including Deuze (2007), Hartley (2005) and Hesmondhalgh (2013).

As a relatively small group with not much economic clout, photographers tend to be added in to research that looks at larger clusters of workers or sectors of which the media form a part, such as the creative industries. In this area, a large number of scholars (Florida 2002; Butler 2004; Neilson and Rossiter 2005; Gill and Pratt 2008; Randle and Culkin 2009; Ross 2009; Gill 2014) have noted not just more versatile work arrangements among creative producers such as casualisation and zero-hour contracts but also a rise in stress, insecurity, ill-health and what they call "precarity", or the precariousness of life in the digital age.

Alternatively, photographers are included in studies of journalists. Beyond work commissioned by the World Press Photo Foundation (see, especially, Campbell 2010, 2013, 2014), we could find only a handful of research studies specifically on professional news photojournalists as a group (Taylor 2010; Pantti and Bakker 2009; Papadopolous and Pantti 2011; Caple 2013; Mortensen 2014). Often this research looked at other groups too, such as amateur or citizen photographers (see, for instance, Allan 2015).

Mäenpää's (2014) is one of the few pieces of research dedicated specifically to photojournalists. It looks at the professional values guiding photojournalists and, in particular, examines the relationship between these values and the three activities of digital photo editing, the production of online news videos and amateur photography.

As useful as it is, Mäenpää's work is based on Finnish data obtained from 20 interviews and an online survey of 200 people associated with the photography industry, including graphic designers and art directors. More systematic but still country-specific is Vauclare and Debauvais (2015), a French-language study of French photographers conducted recently by the Ministry of Culture and Communication (for a summary and analysis, see Sutton 2015).

This paper applies new statistical analysis to what we believe to be the first, large-scale international survey that aims to track over time the circumstances of professional photojournalists and examine the impact of the digital era on their lives and livelihoods.

## Methodology

We gained access to a representative sample of photographers through collaboration with the World Press Photo Foundation, host of a leading international photography competition. In 2015, 5158 photographers from more than 100 countries sent in their work to be judged across a variety of categories. It is this group which was tapped for the data that underpin this article. All entrants to the 2015 contest were invited to participate anonymously and confidentially, and 1556 answered in excess of 60 questions, some with multiple options or with the opportunity to explain their answers in more detail.

The questionnaire was piloted with the assistance of the Reuters news agency in London in January 2015 and the final questionnaire was distributed on Monday 2 February by the World Press Photo Foundation. All potential respondents were informed that participating in the study did not have any bearing on their chances for an award. Entrants were approached by email and asked to link voluntarily to the online, anonymous questionnaire. The link and questionnaire were closed on Sunday 15 February 2015. A total of 1556 questionnaires were completed during this time, representing a high response rate (for online surveys) in excess of 25 per cent. About half of those who filled in the survey were living in Europe with about a quarter in Asia (including Oceania and the Middle East), 11 per cent in South and Central America and the Caribbean, and just under 10 per cent in North America.

### Analytical Methods

In our analysis we have used descriptive statistical techniques that are designed to summarise patterns of difference in one measured variable and how they are related to those in one or more other variables. Across the range of survey questions we used cross-tabulations and other similar bivariate techniques to review systematically the extent to which responses on each question varied by the gender, age, continent of residence and employment status of respondents. Additionally, we reviewed many other patterns of association in response to *ad hoc* evidence or specific research questions, such as in the relationship between employment arrangements and income from photography, and attitudes about the future of or risks related to photography. In many instances, we summarise the patterns of association in relevant cross-tabulations by quoting "association statistics" such as the "Cramer's *V*" and "Gamma" values for particular tables of data.

Some additional techniques of analysis, such as using regression models to explore the joint relative effects of several different "explanatory" variables upon a specific "outcome" variable of interest, were used and are elaborated upon at the relevant point. The statistical techniques of analysis used throughout follow common conventions and routinely used techniques of analysis. A popular methodological text that covers most techniques mentioned from the point of view of attitudinal survey research is Blaikie (2003).

It is worth noting that as detailed as the survey instrument was, some aspects of photographers' working lives, such as the diversity of their practices even within the broad ambit of news photography, were not distinguishable. This article is intended to present a broad overview. Much of the analysis explores the breakdown of influences on

reporting risks—the descriptive statistics and regression models try to summarise the relative influence of different sorts of differences between photographers upon answers to the questions on risks.

### Results and Analysis

Most of the 1556 photographers surveyed in this research face a number of significant risks in their daily work, often physical in nature but also risk to their financial stability and job security. These risks are expected to worsen in the years ahead, according to a majority of our respondents.

The things that worry photographers the most, according to our survey, are risk of injury or death, erratic income, failure to provide for families and a decreasing demand for work. These are illustrated, broken down by gender, in Figure 1.

Figure 1 indicates that financial risks faced by photojournalists are felt keenly by the group who participated in this study. This is reflective of the "precarity" of creative work in the digital era and the challenges of securing a reliable income over time. In addition to the financial (and other) risks of photojournalism in the twenty-first century, and indeed outranking the financial concerns as the most popular choice by this sample, however, is the issue of physical risk.

The questionnaire contained five questions directly related to risks experienced during photography. These ranged from questions concerning different kinds of risks experienced in the present to questions about risks in the future. Only 8.5 per cent of respondents said that they "never" faced physical risks at work, whilst 62.1 per cent reported that they "sometimes" faced risks, and 29.4 per cent of respondents said that they faced physical risks "about half the time", "often" or "always". Some 618 respondents

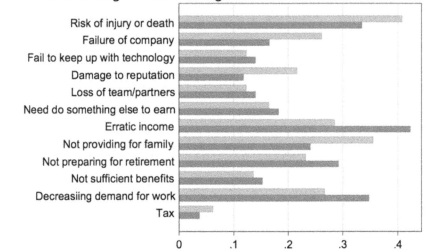

**FIGURE 1**
What worries photographers most

(40 per cent of all respondents), mentioned that the "risk of injury or death" was one of the three things that cause them the most worry in their work as a photographer.

Reports of risk were not restricted to only certain domains of photography. Photographers who mentioned commercial, portrait and "other" photography as their main activity were slightly more likely to report that they never faced risks, and those who mentioned doing sport, and particularly so news, were less likely to report never facing risks, but respondents from all categories of photography reported a range of answers to the questions on risk. The 132 respondents who said that they "never faced physical risks" in their photography were somewhat more likely to be working in Europe, and were somewhat more likely to be female, but they were spread across a wide range of locations and circumstances.

In Figure 2 the size of the markers is proportional to the number of respondents in each combination of categories. For example, those in the top left of the graph are those who do not anticipate worsening physical risks in the future and who do not report a high level of physical risk in their own work; those in the top right do not report a high level of physical risk, but are more concerned about risks increasing in the future; and those in the lower half of the graph represent respondents who report higher levels of risk, a great many of whom also think that risks will increase in the future. The bulk (but not all) of those respondents in the lower half of Figure 2 also mentioned that one of the things that most worried them was the "risk of injury or death". At the same time, a moderate number of people from the upper left and right quadrants of Figure 2 also reported that this risk was one of the things about which they were most worried (i.e. some respondents were worried about the risk of physical injury or death, but did not

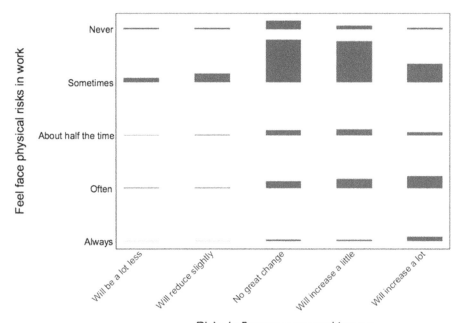

**FIGURE 2**
Relationship between physical risk faced at work and future expectations

actually report currently being exposed to this risk and/or did not anticipate these risks increasing over time).

Disregarding country-to-country variations, across the sample of respondents there was surprisingly little relationship between other measured individual characteristics, and self-reported attitudes to risk. Table 1 summarises the bivariate correlations between three indicator measures of risk (whether or not respondents say they face physical risks in their work "about half the time", "often" or "always"; whether or not respondents believe that risks will "increase a little" or "increase a lot"; and whether or not respondents mention "risk of physical injury or death" as one of the factors that most concerns them). The figures shown are the correlation statistic, and an indicator of whether the correlation value is estimated to be statistically significant.

None of the variables examined show what would be described as a "strong" correlation to attitudes to risk. There are weak associations between gender and age (the pattern, not shown in the table, is that younger photographers, and male photographers, report greater experience of or concern about risk). There is a slight pattern of association between self-employment and physical risk (the relationship is that those who are self-employed report relatively lower levels of physical risk and anxiety about risk). The strongest relationship in the data involves the area of photography that respondents mainly work in—there is a modest association whereby people who mainly work in news tend to report higher levels of risk, or concern about physical risks, than those who do not.

**TABLE 1**
Correlations between three measures of risk

| | Q53: Whether or not face physical risks | Q54: Whether physical risks will increase in the future | Q55–57: Whether mentions risk of physical injury or death as one of three biggest worries |
|---|---|---|---|
| Gender | 0.05* | 0.02 | 0.05* |
| Age (10-year bands) | 0.09* | 0.07 | 0.08 |
| Long-term job contract | 0.04 | 0.01 | 0.06* |
| Self-employed | 0.08** | 0.02 | 0.08** |
| University-level education | 0.01 | 0.04 | 0.04 |
| Studied photography at university | 0.01 | 0.05* | 0.01 |
| No photography training | 0.01 | 0.01 | 0.01 |
| Mainly works in news | 0.13** | 0.13** | 0.13** |
| Mainly works on personal projects | 0.03 | 0.06* | 0.04 |
| Mainly works in environment/ nature | 0.01 | 0.05* | 0.03 |

Analysis from 1556 respondents to the photography survey. Association statistics (Cramer's *V*) range from 0 to 1, with 0 indicating no association and 1 indicating perfect association. No symbol for statistical significance indicates less than 95 per cent threshold reached (i.e. it is plausible that this pattern of association may have arisen due to chance sampling variations).
*95–99 per cent threshold; **>99 per cent threshold.

However, an important statistical consideration concerns the extent to which variations from country to country are taken into account in such analysis. The survey features responses from photographers who are living or working in 116 different countries and/or territories and it is very plausible that experience of, and attitudes towards, physical risks may vary considerably from country to country. Figure 3 summarises risk responses by continent of usual residence. In fact, there is also evidence (see further below) that fine-grained country-to-country differences also explain considerable patterns of variation in risk patterns. Accordingly, it is less compelling to summarise the relationship between attitudes or experiences of risk and other individual-level characteristics (e.g. gender, age) without controlling for country-to-country variations. Equally, it is less compelling to summarise country-to-country variations in risk without in some way controlling for individual-level differences between photographers (e.g. of gender, educational level) that might be related to countries.

Therefore, to explore influences upon concerns about physical risk in a more nuanced way, statistical modelling was conducted in order to summarise how other measured features were, on average, related to concerns about physical risk. A logistic regression was conducted to assess influences on whether or not respondents tended to say that they faced physical risks "about half the time", "often" or "always" (i.e. the lower half of Figure 2). Additionally, a linear outcomes regression was run on a "risk score" variable. This measure was constructed by adding together metric scores based upon responses from different questions, such that a higher score indicates one or more answers being associated with greater concern and/or experience of risk.[3]

Table 2 summarises the results. Models 1 and 4 do not use data on the country of respondent's work, whilst the other models are examples of "multi-level" models, statistical models that use devices that are designed to allow us to assess simultaneously both macro-

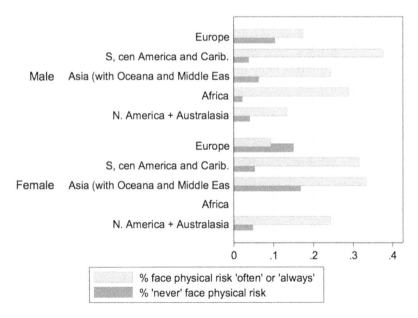

**FIGURE 3**
Perceptions of risk by continent of usual residence

**TABLE 2**

Six models of risk

| | Influences upon "risk score" (linear outcome) | | | Influences on probability of reporting being at physical risk "about half the time" or more (binary outcome) | | |
|---|---|---|---|---|---|---|
| | Model 1 Single level | Model 2 Fixed effects | Model 3 Random effects | Model 4 Single level | Model 5 Fixed effects | Model 6 Random effects |
| Gender = female | -0.08 | -0.08 | -0.07 | -0.25 | 0.26 | -0.25 |
| Age in years | -0.01 | 0.01 | -0.01 | -0.01* | -0.01 | -0.01 |
| Long-term job contract | -0.01 | 0.07 | 0.04 | -0.13 | 0.01 | -0.08 |
| Self-employed | -0.14 | -0.05 | -0.09 | -0.28 | -0.15 | -0.23 |
| Photography at university | 0.06 | 0.04 | 0.05 | -0.05 | -0.10 | -0.07 |
| No photography training | 0.03 | 0.05 | 0.05 | -0.03 | 0.05 | 0.01 |
| Mainly works in … | | | | | | |
| News | 0.41** | 0.34** | 0.36** | 0.61** | 0.53** | 0.56** |
| Personal projects | 0.19** | 0.13* | 0.15** | 0.21 | 0.09 | 0.16 |
| Environment/nature | -0.06 | -0.06 | -0.07 | -0.01 | -0.01 | -0.01 |
| Country-level $R$ | 0 | 0.389** | 0.384** | | 0.292** | 0.393** |
| $N$ | 1556 | 1556 | 1556 | 1556 | 1440 | 1556 |
| No. of countries | | 119 | 119 | | 76 | 119 |

Values are regression coefficients. Analysis uses the restricted maximum likelihood algorithm for linear random effects and numerical integration (seven integration points) for binary random effects. The binary outcomes fixed effects model (Model 5) is run only for countries with at least two respondents within them. "Country-level $R$" refers to the correlation between outcome patterns and countries net of other controls. It equals the "rho" statistic in the fixed effects linear model and the square root of the intra-cluster correlation in the random effects models. For the fixed effects binary model, it is the square root of the difference between the model pseudo-$R^2$ statistics with and without country fixed effects.

*95–99 per cent threshold; **>99 per cent threshold.

level variations (i.e. country-to-country differences) and micro-level variations (i.e. individual-level influences) as they are related to individual-level data on risk. Specifically, in Models 2 and 5, country-level "fixed effects" are used. This means that the coefficients summarised in the table represent the average influence of the explanatory factors completely net of country-to-country influences, i.e. they indicate the influence of, say, variations in gender, in terms of how it affects variations in risk "within" countries. In Models 3 and 6 by contrast, country-level "random effects" are used. This is a different modelling approach that means that control is built into the model for average differences from country to country in risk patterns, but that coefficients from the explanatory variables tell us about influences upon more or less risk in terms of a mixture of "within"- and "between"- country patterns.

The six models of interest in Table 2 show relatively little difference between those which analyse the "risk score" as an outcome (Models 1–3) and those that analyse whether or not a respondent reports being at physical risk about half the time or more often (Models 4–6). Perhaps of greater interest is the substantial effect of countries upon the risk outcomes. Country-to-country variation statistics suggest a correlation between countries and risk (after controlling for individual-level factors) of around 0.3–0.4. This is a considerable value and suggests that physical risks are considerably bigger in some countries compared to others, irrespective of personal characteristics.

Figure 4 also depicts the overall patterns of country to country variation in concerns about physical risks. The first plot excludes controls for other factors (i.e. it shows average country-to-country differences in risk scores) and the second focuses on country

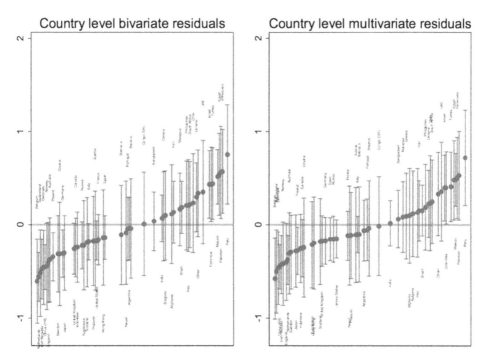

**FIGURE 4**
Country-to-country variations in perceptions of risk

differences that are net of individual-level factors, as in Model 6. The figure uses the format of what are usually known as "caterpillar" plots in multi-level statistical modelling. The values plotted represent the extent to which the particular country is estimated to deviate from the mean response outcome, taking account of patterns associated with that country and with the distribution of patterns across countries.[4] The mid-point of the line shows the estimated country deviation or "residual", and the lines around it show the range of plausible values based upon estimated "standard errors". Conventionally, if the range of plausible values does not overlap the overall mean of zero, we conclude that there is evidence that that country has higher or lower levels of risk than average. For convenience of presentation, the values for countries are only shown if there were six or more respondents to the survey from that country.

The plot shows two interesting patterns. Firstly, there is virtually no mediation in the country-to-country variation patterns before and after controlling for other individual-level differences (such as in employment area or field of work). That is, the country-level influences seem to be largely independent of individual-level circumstances. Second, there is a considerable range of deviation from the average risk profile, with a number of countries (mainly European) where photographers report lower risks than average, and a number of other countries (often in South America and/or the Middle East) where respondents report above-average levels of risk. There are various plausible reasons why country-to-country variations have such a powerful impact on the level of risk, though these are not isolated or quantified by our data. The patterns could reflect genuine differences between countries in the levels of risks within the working lives of photographers. However, it is also possible that photographers' living conditions vary from country to country and in some countries lives are just riskier for various reasons that are unrelated to photography (such as high crime levels or political instability). There may also be cultural variations in how readily respondents choose more extreme answers to the survey questions on risk, and it may be the case that in different countries, the sort of person answering the questionnaire could vary in a way that influences answers on risk (our model does control for individual variations, but may not do so comprehensively).

## Conclusion

The disruption of the digital era has produced many profound changes in photographers' work patterns, income sources, technology use and, perhaps, ethical principles. But few might have anticipated the growing threat of physical risk to which the overwhelming majority of photographers now feel they are increasingly vulnerable.

The first major international survey of professional photographers has presented the opportunity to record the attitudes, expectations and working environment of the people who provide much of the raw material that drives the digital age, the images, often without reward or acknowledgement.

From these data, we see that photographers as a whole feel they are vulnerable to physical risk, though this is not the only risk to which they are subject. The risk of physical injury or death is reported by men and women, across all forms of photography and all ages. But the strongest influence on this perception is the substantial effect of country of residence or work upon the risk outcomes. Physical risks are evidently considerably more significant in some countries compared to others, irrespective of personal characteristics.

For photographers, the digital age is indeed the age of risk.

## ACKNOWLEDGEMENTS

Our grateful thanks go to the following: Geert Linnebank, Katrin Voltmer, Reuters Institute Director David Levy, World Press Photo Foundation Managing Director Lars Boering, his predecessor Maarten Koets and World Press Photo Foundation head of communications Kari Lundelin, and to D. J. Clark and the photojournalists at Reuters in London who helped us with the pilot of the questionnaire. The research analyses data taken from 1500 professional photojournalists from more than 100 countries and is a partnership between the University of Oxford's Reuters Institute for the Study of Journalism, the University of Stirling's journalism department and the World Press Photo Foundation, one of the premier platforms for the recognition of global excellence in photo- and video-journalism.

## DISCLOSURE STATEMENT

No potential conflict of interest was reported by the authors.

## FUNDING

This research was part-funded by the Carnegie Trust for the Universities of Scotland [Small Grant Number 31917].

## NOTES

1. Photographers describe themselves in a range of different ways from photojournalists to visual storytellers and while there are many kinds of photographers and a wide range of photographic work, equipment and endeavour, our principle focus is on news photography and, in particular, on photojournalism and documentary photography.
2. See Hadland, Campbell, and Lambert (2015).
3. Scores were constructed by adding together the scores for the principal dimension (85.7 per cent of inertia) of a multiple correspondence analysis between three variables: responses to questions on levels of risk and future prospects of risk; and a dichotomous indicator of whether or not the risk of physical injury or death was mentioned as a main concern. The risk score has a mean of 1.5, a range from 0 (lowest levels of physical risk) to 4.2 (highest levels of physical risk) and a standard deviation of 1.
4. This property is known as "shrinkage" towards the overall pattern, and means that the estimated values are slightly different to those that would be obtained by simply calculating the mean patterns of responses within a country (which is problematic when many countries have low numbers of respondents).

## REFERENCES

Allan, Stuart. 2015. "Introduction." *Digital Journalism* 3 (4): 467–476.

Anderson, Monica. 2013. "At Newspapers, Photographers Feel the Brunt of Job Cuts." http://www.pewresearch.org/fact-tank/2013/11/11/at-newspapers-photographers-feel-the-brunt-of-job-cuts/.

Blaikie, Norman. 2003. *Analyzing Quantitative Data: From Description to Explanation*. London: Sage.

Butler, Judith. 2004. *Precarious Life: The Powers of Mourning and Violence*. London: Verso.

Campbell, David. 2010. "Dead or Alive? The State of Photojournalism." https://www.david-campbell.org/2010/10/05/dead-or-alive-the-state-of-photojournalism/.

Campbell, David. 2013. Visual Storytelling in the Age of Post-Industrialist Journalism, Research Project Published under the Auspices of the World Press Photo Academy. https://www.david-campbell.org/multimedia/world-press-photo-multimedia-research/.

Campbell, David. 2014. *The Integrity of the Image*: Current Standards and Practices Relating to the Manipulation of Still Images in Photojournalism and Documentary Photography, Published by the World Press Photo Academy, November. http://www.worldpressphoto.org/academy/integrity-of-the-image.

Caple, Helen. 2013. *Photojournalism: A Social-semiotic Approach*. Basingstoke: Palgrave MacMillan.

Deuze, Mark. 2007. *MediaWork*. Cambridge: Polity Press.

Florida, Richard L. 2002. *The Rise of the Creative Class: And How It's Transforming Work, Leisure, Community and Everyday Life*. New York: Basic Books.

Gill, Rosalind. 2014. "Academics, Cultural Workers and Critical Labour Studies." *Journal of Cultural Economy* 7 (1): 12–30.

Gill, Rosalind, and Andy C. Pratt. 2008. "In the Social Factory? Immaterial Labour, Precariousness and Cultural Work." *Theory, Culture & Society* 25 (7–8): 1–30.

Hadland, A., D. Campbell, and P. Lambert. 2015. *The State of News Photography: The Lives and Livelihoods of Photojournalists in the Digital Age*. Research Report. Oxford: Reuters Institute for the Study of Journalism. Acessed September 2015. http://reutersinstitute.politics.ox.ac.uk/page/publications.

Hartley, John, ed. 2005. *Creative Industries*. Oxford: Blackwell Publishers.

Hesmondhalgh, Desmond. 2013. *The Cultural Industries*. 3rd ed. London: Sage.

Mäenpää, Jenni. 2014. "Rethinking Photojournalism: The Changing Work Practices and Professionalism of Photojournalists in the Digital Age." *Nordicom Review* 35 (2): 91–104.

Mortensen, Tara M. 2014. "Blurry and Centred or Clear and Balanced?" *Journalism Practice*. doi:10.1080/17512786.2014.892703.

Neilson, Brett, and Ned Rossiter. 2005. "From Precarity to Precariousness and Back Again: Labour, Life and Unstable Networks." *Fibreculture Journal*, 5. http://journal.fibreculture.org/issue5/neilson_rossiter.html.

Pantti, Mervi, and Piet Bakker. 2009. "Misfortunes, Memories and Sunsets: Non-professional Images in Dutch News Media." *International Journal of Cultural Studies* 12: 471–489. doi:0.1177/1367877909337860.

Papadopolous, Kari Anden, and Mervi Pantti. 2011. *Amateur Images and Global News*. Bristol: Intellect.

Randle, Keith, and Nigel Culkin. 2009. "Getting in and Getting Out: Freelance Careers in an Uncertain Industry." In *Creative Labour: Working in the Creative Industries*, edited by A. McKinlay and C. Smith, 93–115. Basingstoke: Palgrave McMillan.

Romenesko, Jim. 2015. "Newspaper Reporter is 'The Worst Job of 2015'." http://jimromenesko.com/2015/04/14/newspaper-reporter-is-the-worst-job-of-2015/.

Ross, Andrew. 2009. *Nice Work if You Can Get It: Life and Labour in Precarious Times*. New York: New York University Press.

Sutton, Benjamin. 2015. "New French Report Zooms In on Field of Photography." http://hyperallergic.com/209257/new-french-report-zooms-in-on-field-of-photography/.

Taylor, John. 2010. "Problems in Photojournalism: Realism, the Nature of News and the Humanitarian Narrative." *Journalism Studies* 1 (1): 129–143. doi:10.1080/146167000361212.

Tunstall, Ian. 2001. *Media Occupations and Professions: A Reader*. Oxford: Oxford University Press.

Vauclare, Claude, and Remi Debauvais. 2015. Le Metier de Photographe. http://culturecommunication.gouv.fr/Politiques-ministerielles/Etudes-et-statistiques/Publications/Collections-de-synthese/Culture-etudes-2007–2015/Le-metier-de-photographe-CE-2015–3.

# UNRAVELLING DATA JOURNALISM
## A study of data journalism practice in British newsrooms

**Eddy Borges-Rey**

*The centrality of data in modern society has prompted a need to examine the increasingly powerful role of data brokers and their efforts to quantify the world. Practices and methods such as surveillance, biometrics, automation, data creeping, or profiling consumer behaviour, all offer opportunities and challenges to news reporting. Nonetheless, as most professional journalists display a degree of hesitancy towards numbers and computational literacy, there are only limited means to investigate the power dynamics underpinning data. This article discusses the extent to which current data journalism practices in the United Kingdom employ databases and algorithms as a means of holding data organisations accountable. Drawing on semi-structured interviews with data journalists, data editors, and news managers working for British mainstream media, the study looks at how data journalism operates within the news cycle of professional newsrooms in the United Kingdom. Additionally, it examines the innovations data journalism brings to storytelling, newsgathering, and the dissemination of news.*

## Introduction

Modern society has witnessed the advent of an age of data superabundance. The scale of the data we have accumulated until now, and the speed needed to process it, have prompted a pressing necessity to understand the intricacies and the impact of data-driven technologies and practices in ordinary life, driving contemporary institutions into a race to harness the potential of *big data*.

As algorithms use data to make vital decisions about our lives in a domain free of public scrutiny, practices such as surveillance, biometrics, automation, consumer profiling, algorithmic predictability, and machine learning tend to agitate public opinion. Simultaneously, in a dynamic indistinguishable to the public eye, mediated discourses of innovation extol big data's messianic virtues as the cure to all societal illnesses, framing it as the ultimate panacea. Whilst reports on the marvels and failures of big data populate the mainstream news agenda, journalists debate whether to engage with governments and corporations in the construction of a reality increasingly modelled by informational data. As numeracy tends to be rather limited in professional newsrooms (Curtin and Maier 2001), a growing demand for journalists able to investigate the power dynamics underpinning data is generally unfulfilled. Nonetheless, an emergent breed of data journalists, empowered by the methods and tools of data science, begins to display a remarkable understanding of the computing language and logics behind this datafication of the world,

making apparent a growing need to revise many of the traditional practices and philo-sophies of the news media establishment.

With all this in mind, this article discusses the extent to which current data journalism practices in the United Kingdom employ databases and algorithms to hold data organ-isations accountable. Additionally, through the prism of material, performative, and reflexive frameworks, this research seeks to: (1) explain how data journalists operate within the news cycle of professional newsrooms in the United Kingdom; and (2) examine the innovations data journalism brings to storytelling, newsgathering, and the dis-semination of news. Lastly, the article contributes to current debates on data power, and the materiality and professional practice of data journalism.

## Materiality, Performativity, Reflexivity, and Power as Explicative Frameworks

This theoretical section seeks to outline briefly the four frameworks I used to analyse the idiosyncrasies of British data journalism practice and its ability to hold data organ-isations to account. In this respect, the notions of materiality, performativity, and reflexivity serve as an explicative framework to understand how data as a material entity intermedi-ates the professional practice and mindsets of data journalists. The article also draws on Foucauldian approaches to power relations and strategies to help explain the ways in which a burgeoning group of data brokers interact with the rest of society's institutions to negotiate power.

Materiality is not an alien concept to journalism studies, particularly since a current enthusiasm about Latour's Actor-Network Theory has stimulated a line of inquiry concerned with the materiality of data journalism artefacts (see De Maeyer et al. 2015; Parasie 2015). Research in this field focuses on the binary complementarity between actors (journalists) and actants (journalism technologies) facilitating the emergence of cybernetic hybrids capable of restructuring news labour (Turner 2005). More recent "object-oriented" approaches to journalism studies (Anderson and De Maeyer 2015; Neff 2015) shift their analytical focus from the human–non-human nexus to the social, material, and cultural con-texts that shape a multiplicity of technology-driven spheres.

Here, I will employ Miller's (2005, 3) distinction between a "vulgar theory of mere things as artefacts" and "a theory that claims to entirely transcend the dualism of subjects and objects" to expand beyond a reductionist conceptualisation of data as *objective* evi-dence. By approaching data rather as a "body without organs" (Deleuze and Guattari 1987, 4), hence "something more than 'mere' matter: an excess, force, vitality, relationality, or difference that renders matter active, self-creative, productive, unpredictable" (Coole and Frost 2010, 9), I address a wealth of active automations powered by data which nowadays play a fundamental role in news production.

After determining how data are enacted by data journalists, I look at the norms and discursive practices which enable data journalists to impose their constructed truths on the public (Broersma 2013). Broersma (2010, 17–18) remarks that journalism functions as a per-formative discourse that endeavours to persuade the public of the truthfulness of its accounts, either by (re-)staging or retelling events and consequently attaching meaning to them, or by describing and producing phenomena at the same time. When it succeeds in persuading the public through the way it presents the news, journalism transforms an interpretation into a reality upon which citizens can act (17–18).

I argue that the constant interplay between the elements that shape data journalists' performativity and the materiality of the data with which they interact consequently mediates the reflexivity of these professionals. In this vein I define reflexivity "as a conscious and continuous attention to 'the way different kinds of linguistic, social, political and theoretical elements are woven together in the process of knowledge development, during which empirical material is constructed, interpreted and written'" (Alvesson and Sköldberg, cited in Guillaume 2002).

As data journalism finds its place within the vast spectrum of professional journalism practice, inevitably it has to interact with an emergent breed of power holders such as Facebook, Google, Wikimedia, IBM, and General Electric, amongst other data conglomerates. To understand better the complexities of this interaction and its subsequent negotiation of power, I resort to Foucault's ideas of power strategy as my conceptual point of departure. According to Foucault:

> Every power relationship implies, at least *in potentia*, a strategy of struggle, in which the two forces are not superimposed, do not lose their specific nature, or do not finally become confused. Each constitutes for the other a kind of permanent limit, a point of possible reversal. (Foucault 1982, 794)

Foucault (1982, 794) observes that "between a relationship of power and a strategy of struggle there is a reciprocal appeal, a perpetual linking and a perpetual reversal". This means that power relations can cause a confrontation between data journalists, who want to expose wrongdoing within data corporations, and data brokers, who want to preserve corporate secrets to maintain their competitive advantage. The interaction between both adversaries can prompt mechanisms of power triggered by the influence that both exert on each other. This instability, remarks Foucault, provides a dual interpretation of the same event, from the perspective of either the struggle or the power relationships, generating dissimilar elements of meaning and types of intelligibility (Foucault 1982, 795).

## Methodology

This qualitative research draws on 24 semi-structured interviews with key informants working for *The Guardian*, BBC, *Financial Times*, Channel 4, Trinity Mirror (ampp3d and regionals), *The Times*, CNN, Thomson Reuters, *Telegraph*, STV, *The Scotsman*, *The Herald*, thedetail, and the *News Letter*. Interviews were conducted face-to-face or via Skype/landline between January 2014 and August 2015. Conversations focused on different aspects of the data news production process: how data journalists operate within the news cycle of professional newsrooms in the United Kingdom; and what innovations data journalism brings to storytelling, newsgathering, and the dissemination of news. The empirical data gathered were then categorised into four thematic domains, namely (1) materials of the trade, (2) practices, (3) mind-sets, and (4) power dynamics.

The number of British news organisations with the financial infrastructure required to appoint data journalists or set up data units was relatively small. Informants were selected following the principle of enculturation, defined by Spradley (1979, 47) as "the natural process of learning a particular culture". In this respect, informants with a high level of enculturation were selected from organisations performing data journalism within the mainstream UK media. Interviews were conducted with 12 data journalists or journalists working with data (coded as DJ1–DJ12), eight data editors (coded as DE1–DE8), two

news managers (coded as NM1 and NM2), one programmer (coded as P1), and one graphic designer (coded as GD1). The geographic segmentation is as follows: 15 informants were based in London (five DJs, six DEs, two NMs, one P, and one GD), one informant was based in Manchester (a DE), four informants were based in Scotland (four DJs), two informants were based in Northern Ireland (a DJ and a DE), and two informants were based in Wales (two DJs).

## (De)constructing British Data Journalism

Epistemologically speaking, data journalism is defined by informants in terms of a constant interplay between two predominant paradigms. A portion of the informants suggested that data journalism refers to an ability to report through the articulation of quantifiable evidence (DE4, DE6) and its subsequent contextualisation through human testimony (DJ4, DJ7, DJ8, DJ9, DJ12). Another portion of the informants remarked that data journalism, by means of a combination of journalistic and computing logics, sees beyond the structures of computerised information to unearth novel insights that are then packaged as a multi-layered, database-driven, informational experience. Informants unanimously agreed that the end is journalism—or telling stories—and data are the means to that end. The phrase "it's not data for data's sake" was a phrase frequently used to illustrate the significance of remaining anchored within the confines of journalism, and avoiding drifting away to the realm of computing science without a practical reason.

This epistemological diversification of data journalism's ethos materialises in the UK context as three predominant forms of data journalism practice that I will delineate next through the examination of their material, performative, and reflexive dimensions.

### Figures Versus Databases: The Materiality of Data Entities

From the testimonies of the informants, it became clear that the use of data by data journalists in the United Kingdom largely adheres to the rigid ethos of the Freedom of Information Act (FOIA) scheme. In this respect, the materiality of data obtained through Freedom of Information (FOI) requests (1) is mediated by ideals of alleged openness and transparency; (2) is subject to the bureaucracy and politics of public institutions (DE1, DJ4, DJ5, DJ7, DJ8, DJ12); (3) covers themes circumscribed to public governance, health, education, or crime; and (4) is usable as long as it is provided in a machine-readable format (DJ7, DJ8). Despite being viewed by some of the informants as a powerful source for exclusives (DJ2, DJ4, DJ10, DJ12, DE1, DE4, DE5), the materiality of FOI-driven data provides a distinctive flavour to the reports of data journalists that generally restricts data-driven stories to the few topics outlined above, affecting not only the style of reporting but also the scope of the story (DJ4).

Notably, as Web-scrapers and similar automations become normative elements of British data journalism (DE3, DE4, DE5, DJ2, DJ3, DJ11), data gathered through these techniques is infused with the flexible philosophy of computerised methods, fostering, as a result, problem-solving and creative ways of finding, compiling, and understanding unstructured informational data (DE5, DJ4). The adoption of such methods also provides a wider range of alternative sources of data, which allows data journalists to cover more diverse topics, thus overcoming the topical saturation of open/FOI data. In addition, this wider range of sources can help journalists to expose corporate wrongdoings, placing

private institutions under similar degrees of scrutiny to those experienced by public power holders.

Within the rigidity and flexibility of both materialities, data mediated by FOI regimes is predominantly assumed to be a claimable material object (DJ2, DJ7) that functions as either an evidential input for stories (DE1, DE4, DE8, DJ3) or as a data-driven output, depending on the human agency of either journalists or experts to make the data under-standable through proper contextualisation (DJ7, DJ12). Beyond the boundaries of object-oriented materiality, a number of informants rendered data as embodied entities capable of mediating their practices—Web metrics informing editorial decision-making (DE5), for instance. Embodying embryonic forms of artificial intelligence, computerised algorithms are capable of agency, intentionality, and decision-making, and act as companions during the news production process. Automations can also take the form of made-to-measure scripts or algorithms to process vast amounts of data at great speed (DE7, DJ4), scrape unstructured data, generate visualisations that aid the analysis process (DJ2, DJ10, DJ11), or to create datafied outputs, which challenge the very conventions of what is news-worthy (NM2, DE3, P1). Within smaller news outlets, data journalists have to resort to generic, third-party solutions limited by the universality of their user-interface design. This distinction between large and small news companies is primarily driven by a lack of advanced computational skills and a technological infrastructure that creates a gap between data journalists with the competences to query data in its own terrain, and data journalists who have to spend more time finding ready-made tools to fit their lines of inquiry.

These idiosyncratic aspects of data materiality clearly pervade the performativity and reflexivity of data journalists, mediating how they perceive themselves and their working procedures. In this sense, a portion of informants felt comfortable performing more elementary forms of data analysis to produce FOI-driven stories. Another portion felt the need to utilise techniques employed in computer science to provide structure to data obtained through less conventional methods, such as Web-scraping, thus escaping the constraints of open data regimes and the limited thematic flavour that the FOIA scheme granted their stories.

## The Shifting Performativity of Data Journalism

Surfacing in a sphere where journalistic performativity is legitimised through the rig-orous adoption of axiomatic conventions institutionalised almost a century ago, data jour-nalism has had to adhere to these established norms in order to be acknowledged as a serious form of journalism by audiences and the news industry alike. Perhaps that is why informants referred to journalistic authority as a paramount principle shaping their perfor-mativity (NM1, DE6, DE7, DJ3, DJ5, DJ12). Concurrently, in an attempt to overcome the high levels of public mistrust that normative journalism suffers nowadays, data journalists have resorted to an additional set of discourses and conventions to legitimise their performativ-ity in the public eye and persuade audiences of the veracity of their accounts.

In this respect, informants agreed that data journalists resort to the principle of numeric infallibility in providing quantifiable evidence in their stories, which is then reinforced by the rigour of statistical methods used during the news production process (NM1, NM2, DE1, DJ2, DJ4, DJ5). Additionally, they adhere to the premise of computational neutrality by using technologies that arguably circumvent human bias and efficiently

perform automated gathering, analysis, and presentation of unstructured journalistic information.

Informants almost unanimously stressed the significance of data journalism's collaborative nature. The absence of certain advanced computational skills and/or the restricted access to certain information compelled some of the informants to embrace open-source ideals and seek internal or external collaboration in their efforts to, firstly, overcome these limitations, and secondly, to generate and explain phenomena simultaneously.

Data journalists tend to engage with audiences in collaborative crowdsourced projects by sharing data-sets as part of their news outputs. Furthermore, as data journalism ideals impregnate the news culture of professional newsrooms, specialised correspondents seek to collaborate with data journalism units to provide soundness and robustness to their stories through the use of numeric evidence and rigorous scientific methods. An informant observed that some of the best stories they have produced were those where data journalists collaborated with specialised correspondents (NM1). Collaborative projects where data journalists, developers, statisticians, and graphic designers interacted were deemed by informants as very effective; combining the expertise of various disciplines to produce ground-breaking news experiences (NM1, DE1, DE2, DE3, DE4, DE7, DJ1, DJ4, GD1, P1). Data journalists with rather limited technical competences and infrastructure tend to collaborate with external programmers, civic initiatives, third-sector organisations, and libraries, trusts, or universities to generate stories.

As data journalists try to fit within the rigidly established performativity of the professional newsrooms where they operate—simultaneously developing their own individual performativity—their practices diversify into different forms of data journalism. In this sense, informants distinguished between daily, quick turnaround, generally visualised, brief forms of data journalism (DE6, DJ3); extensive, thoroughly researched, investigative forms of data journalism (DE2, DE7, DJ1, DJ4); and light, editorialised, entertaining, often-humorous, gamified forms of data journalism (DE3, DE4). In terms of approaches to data, exclusive stories sometimes emerged from data (NM1, NM2), whilst at other times data were used to fact-check allegedly objective information that was already in the public domain (DE3, DE4, DJ5). As for the work flow, data units could generate content commissioned by data editors, act as datafied internal news wires (NM2, DE5, D11), or, as mentioned before, collaborate with other beats or specialist reporters in co-authored longer projects (NM1, DJ3, DE6).

This increasingly common collaboration between data units and beat/specialist correspondents in datafied affairs has resulted in data journalists investing much of their time in training sessions, assistance, or simply dealing with data-related issues that in many cases are outside their core remit (NM2, P1). In order to deal with their heavy workload, some data units have created basic automated tools for traditional journalists struggling with data that can assist them in the generation of simple data journalism outputs (NM1, DE1, P1), so that they can better allocate their time and efforts in more investigative, high-end projects.

## Nose for News Versus Computational Cognition

In spite of the increasing relevance of computerised dynamics and their disruptive effect on the performativity of data journalists, journalistic reflexivity prevailed as essential. In this respect, a couple of informants at editorial level claimed that within the constraints of the newsroom cycle it was more feasible to train traditional journalists to become

data-savvy and capable of writing scripts at a very basic level than to teach programmers a proficient level of journalism (DE4, DE7). Informants almost unanimously stressed that their primary goal was to tell journalistic stories and the varying degrees of technical experience they possessed served to achieve that goal (DJ1, DJ3, DE1, DE6, DE8).

Nonetheless, the testimonies of data journalists and editors with the highest proficiency in computing science inadvertently proved how heavily their reflexivity was pervaded by traces of computational thinking. These informants demonstrated a high degree of efficiency in overcoming the typical limitations of open/FOI data, displaying a remarkable capacity for problem-solving and an exceptional understanding of the functioning dynamics and the architecture of Web technologies (DJ1, DJ2, DJ6, DE5, DE7).

Often referring to the improvement of the user experience, these data journalists approached data as a means to generate innovative ways to offer users a compelling news experience (NM1, DE4, GD1, DJ2, P1), as opposed to linear news stories following more conventional norms. Their mindset and approach evoked many of the well-established principles of user-interface or human–computer interaction design of computer science, thus disrupting normative forms of journalistic storytelling.

Some of the informants regarded computing skills and thinking as essential for contemporary data journalism, explaining that data literacy and basic notions of computing were required to work within their data units (DE1, DE2, DE3, DE4, DE7, DJ3). One of the informants observed that computing knowledge enabled him to work individually, maintaining control over projects at every stage of the process, hence reducing the appearance of errors, misrepresentations, or misinterpretations (DJ2).

Although journalistic attitudes remain deeply ingrained within the reflexivity of data journalists, a clear merging with computational logics was noticeable. In fact, more than half of the informants declared that data literacy should be an essential skill for journalism in the near future (NM1, DE1, DE4, DE5, DE7, DJ4, DJ5, DJ7, DJ8, DJ10, DJ12).

## The Central–Regional Divide

Following the material, performative, and reflexive analysis of the current state of affairs in data journalism in the United Kingdom, a closer examination of the testimonies of the informants suggested a set of noticeable discrepancies between central and regional British data journalism.

Central news organisations such as *The Guardian*, *Financial Times*, BBC, or *The Times* are championing the development of cutting-edge data journalism as their executive boards recognise the added value of data journalism units (NM1, NM2, DE1, DE2, DE5, DE6, DE7, DE8). Meanwhile regional data journalism—with a few exceptions such as thedetail, Trinity Mirror, and BBC Scotland—tends to be strongly limited by internal organisational and editorial pressures and by the scarce human and material resources. Despite having a devolved data policy, Scotland displayed a higher degree of editorial hesitancy towards data journalism, which was interpreted by most of the Scottish informants as a barrier to the definitive consolidation of data journalism in Scotland.

Data journalists working centrally tend to seek collaboration within the confines of their news organisations, generally with specialist reporters, in order to preserve the brand identity of their stories (NM1, DJ2). News organisations following this dynamic normally possess the required infrastructure and know-how to develop ambitious journalistic projects in-house. Smaller news organisations, operating on the periphery of the regions,

equally pursue collaboration internally but tend to reach out for external collaboration in an effort to palliate the lack of technical skills or the scarcity of resources. Informants mentioned that they frequently collaborate with civic organisations and open-source initiatives (such as Hacks/Hackers or scraperwiki) that seek to establish partnerships with developers; or seek advice from communities of programmers (DJ6, DJ7). Collaborations with libraries, trusts, or foundations (DE5) were judged to be fruitful when the data-sets were collated, curated, and maintained by these organisations in a pristine manner. Occasionally, some projects engaged in a partnership with third-sector organisations (DE8) or private companies (DE5) that contributed to the project by opening up their databases for journalistic scrutiny.

Amid claims of journalistic authority over computational proficiency, at least half of the regional data journalists felt limited by their inability to write software code, regarding this skill as a powerful enabling agent in data journalism. On many occasions, these informants expressed a degree of frustration when the generic third-party solutions they used for data processing or visualisation were not compatible with the software infrastructure of their news outlets or were not fit for certain projects they pursued.

The data editor is solidly established in central data journalism as a figure that not only has editorial autonomy over the content produced within the unit, but more importantly is a mediator between the rest of the newsroom and the editorial staff (DE1, DE2). The role varies in each news organisation, but they are largely responsible for negotiating the workload of their journalists—making sure they are not overwhelmed by requests from other desks. Data editors also organise and deliver training sessions on data journalism for conventional journalists within their newsrooms (DE1, DE2, DE5, DE7).

## The Challenges of Holding Data Brokers Accountable

Despite an initial thesis that described data journalists and data brokers as opposing forces, results suggest that before engaging in this struggle—if that even happens—data journalists tend to struggle with two internal forces. These two forces consist of (1) a power relationship through which data journalism is acknowledged by fellow journalists as a serious form of journalism and not only a service or support unit (DE1, DE2, P1); and (2) a continuous power struggle with constantly evolving data technologies, philosophies, logics, and dynamics. Externally, they struggle against powerful corporations that are pioneers not only in the development of the technological platforms and architectures that data journalists are trying to understand or adapt to, but also in the establishment of the legal framework surrounding the business models developed by these datafied technologies and platforms.

Although data journalists are fully aware of the power dynamics driven by emergent data brokers (NM1, DE1), most of them feel that they can contribute to uncovering wrongdoing within these domains as long as they are collaborating with beat/specialist journalists traditionally commissioned to cover these areas: business, technology, and science. Beat reporters are perceived by the informants as the most suitable professionals to investigate the behaviour of news subjects, sources, and news events within the confines of data power arenas (NM1, DJ1, DJ4, DE2, DE6, DE7). As pointed out by an informant: "There is a difference between data being the story or the issue and data-driven journalism which can apply to whatever the subject matter" (DE6). Similarly, another informant observed

"You don't want to conflate the Big Data world and the data journalism world because they are doing very different things" (DJ3).

In this scenario, access to the corporate data held by data brokers does not depend on the advanced computational skills of data journalists, but on the will of insiders, whistleblowers, or leaks and similar traditional means (NM1, DJ2, DJ4, DJ5, DJ10, DE1, DE7).

In spite of the growing expansion of open data schemes regulated by FOIA regimes, many data journalists have recognised that open data is too overly politicised to be used effectively for journalistic purposes, deeming the data scraped from websites or obtained through informants or similar conventional methods to be more appropriate (DJ2). In this sense, data journalism seemingly works better as an alternative methodology or philosophy that adapts to journalistic themes or beats—be that sports, or investigative journalism—to provide both a robust backbone to stories, and tools to efficiently make use of Web-based knowledge infrastructures.

## Conclusions

This article has provided a panoptic overview of the current state of affairs in British data journalism. Through the examination of its material, performative, and reflexive dimensions, data journalism is defined in terms of a constant interplay between two predominant paradigms: (1) reporting through the articulation of quantifiable evidence and its subsequent contextualisation through human testimony; and (2) a combination of journalistic and computing logics to see beyond the structures of computerised information and unearth novel insight that is then packaged as a multi-layered, database-driven, informational experience.

As the practice becomes more popular in the United Kingdom, data journalism units have been established in most of the newsrooms that comprised the sample. In cases where a data unit was not in operation, a minimum of one data journalist was appointed—or worked informally—to write data-driven journalism or to collaborate with other specialist correspondents in co-authored pieces. In this respect, data journalism practice is fully ingrained within the news cycles of the majority of the mainstream organisations studied, and has been approached strategically as a means to create sound, robust, transparent, and collaborative news exclusives that offer a better and more interactive informational experience for the public. After a period of consolidation, data journalism practice in the United Kingdom has largely diversified into three forms of data journalism: (1) a daily, quick turnaround, generally visualised, brief form of data journalism; (2) an extensive, thoroughly researched, investigative form of data journalism; and (3) a light, editorialised, entertaining, often-humorous, gamified form of data journalism.

Despite generalised claims in favour of journalistic authority over computing skills, data journalism has potentially disrupted an otherwise quite normative practice by gradually infusing the performativity and reflexivity of traditional journalists with traces of computational thinking. The clearest indication of this is the progressive replacement of linear storytelling by more interactive and engaging forms of informational user experience that offer multi-layered, multiplatform, gamified, database-linked dynamic content. This informational experience appears to be heavily mediated by the ontologies of user-interface design, user-experience design and human–computer interaction, which signals the pervasiveness of computational thinking in data journalists' reflexivity. The news production process has also been considerably transformed following the increasing prevalence of

active embodiments of data, such as algorithms, metrics, Web-scrapers, and other forms of automation or artificial intelligence that nowadays are part of professional newsrooms.

Data journalists have also innovated by institutionalising a whole new range of norms and conventions to both legitimise their practice, and overcome generalised public mistrust of journalism. In this respect, data journalism uses methods reinforced by values such as numeric infallibility, scientific rigour, computational neutrality, crowdsourced collaboration, intra- and extra-newsroom co-operation, and hyperlocal empathy to generate exclusives that are generally perceived as more accurate and transparent. Notably, because of the collaborative nature of this type of news reporting, data journalists' authority is not affected when members of the public challenge their data or when alternative angles to their stories are suggested by audiences. In fact, they embrace this kind of public engagement as a natural part of their news reporting.

As for the power dynamics driven by emergent data brokers, informants declared that those were subjects commonly covered by beats such as technology, business, or even science. Data journalists did not see such topics as part of their core remit, and explained that they would collaborate in projects related to data power insofar as they included a database-related component they were responsible for, whilst the specialist correspondent reported on content-related issues. In spite of the informants' remarkable understanding and knowledge of issues related to the aforementioned power brokers, data journalists acknowledged their limitations as data experts when dealing with the inaccessibility of the data held by data corporations. In such instances, they preferred to uncover this type of data through traditional methods such as leaks or whistleblowers.

## ACKNOWLEDGEMENTS

The author would like to thank the informants for their generosity and invaluable contribution. Also thanks to Greg Singh, the editors, and the anonymous reviewers for their most helpful suggestions.

## DISCLOSURE STATEMENT

No potential conflict of interest was reported by the authors.

## REFERENCES

Anderson, Chris, and Juliette De Maeyer. 2015. "Introduction: Objects of Journalism and the News." *Journalism* 16 (1): 3–9. doi:10.1177/1464884914545728.

Broersma, Marcel. 2010. "Journalism as Performative Discourse. The Importance of Form and Style in Journalism." In *Journalism and Meaning-making: Reading the Newspaper*, edited by Verica Rupar, 15–35. Cresskill: Hampton Press.

Broersma, Marcel. 2013. "A Refractured Paradigm. Journalism, Hoaxes and the Challenge of Trusts." In *Rethinking Journalism. Trust and Participation in a Transformed News Landscape*, edited by Chris Peters and Marcel Broersma, 28–44. Hoboken: Taylor and Francis.

Coole, Diana H., and Samantha Frost. 2010. "Introducing the New Materialisms." In *New Materialisms: Ontology, Agency, and Politics*, edited by Diana H. Coole and Samantha Frost, 1–43. Durham: Duke University Press.

Curtin, Patricia A., and Scott R. Maier. 2001. "Numbers in the Newsroom: A Qualitative Examination of a Quantitative Challenge." *Journalism & Mass Communication Quarterly* 78 (4): 720–738.

De Maeyer, Juliette, Manon Libert, David Domingo, François Heinderyckx, and Florence Le Cam. 2015. "Waiting for Data Journalism." *Digital Journalism* 3 (3): 432–446.

Deleuze, Gilles, and Felix Guattari. 1987. *A Thousand Plateaus*. London: University of Minnesota Press.

Foucault, Michel. 1982. "The Subject and Power." *Critical Inquiry* 8 (4): 777–795.

Guillaume, Xavier. 2002. "Reflexivity and Subjectivity: A Dialogical Perspective for and on International Relations Theory." *Qualitative Social Research* 3 (3). http://www.qualitative-research.net/index.php/fqs/article/view/826/1795

Miller, Daniel. 2005. "Materiality: An Introduction." In *Materiality*, edited by Daniel Miller, 1–50. Durham: Duke University Press.

Neff, Gina. 2015. "Learning from Documents: Applying New Theories of Materiality to Journalism." *Journalism* 16 (1): 74–78.

Parasie, Sylvain. 2015. "Data-Driven Revelation?" *Digital Journalism* 3 (3): 364–380.

Spradley, James P. 1979. *The Ethnographic Interview*. Belmont: Wadsworth.

Turner, Fred. 2005. "Actor-networking the News." *Social Epistemology* 19 (4): 321–324.

# CHANGES IN U.S. JOURNALISM
## How do journalists think about social media?

David H. Weaver and Lars Willnat

*During the past decade, great changes have occurred in journalism, many of them due to the rapid rise of social media. What has happened to American journalists in the decade since the early 2000s, a time of tumultuous changes in society, economics, and technology? What impact have the many cutbacks and the dramatic growth of the internet had on US journalists' attitudes, and behaviors—and even on the definition of who is a journalist? To answer the questions raised above, in late 2013 we conducted a national online survey of 1080 US journalists. The survey is part of the American Journalist project, which conducted similar surveys of US journalists in 1982, 1992, and 2002. We found that US journalists use social media mainly to check on what other news organizations are doing and to look for breaking news events. A majority also use social media to find ideas for stories, keep in touch with their readers and viewers, and find additional information. Thus, journalists use social media predominantly as information-gathering tools and much less to interview sources or to validate information. Our findings also indicate that most journalists consider social media to have a positive impact on their work. Of particular value, it seems, was the fact that social media make journalism more accountable to the public. However, only about a third of the journalists also think that social media have a positive influence on the journalistic profession overall. One of the most common negative perceptions was that online journalism has sacrificed accuracy for speed. Overall, then, it appears that most journalists do see the benefits of social media, but fewer are convinced that these new forms of digital communication will benefit journalistic professionalism.*

## Introduction

During the past decade, great changes have occurred in journalism and in the larger society, many of them due to rapid advances in computer technology and the rise of new forms of media, especially social media such as various blogs, Facebook, and Twitter.

The three books produced by the Indiana team—*The American Journalist* (Weaver and Wilhoit 1986), *The American Journalist in the 1990s* (Weaver and Wilhoit 1996), and *The American Journalist in the 21st Century* (Weaver et al. 2007)—have documented major changes over time in US journalism, including the dramatic growth in the size of the journalism workforce in the 1970s and 1980s, substantial increases in the proportions of women and college graduates, increases in racial and ethnic minority journalists, declines in job satisfaction and perceived autonomy, more conservative ideas about the ethics of reporting practices, changes in working conditions and required tasks, and changes in ideas about the roles that journalists should perform in society.

What has happened to American journalists in the decade since the early 2000s, a time of tumultuous changes in society, economics, and technology? What impact have the many cutbacks and the dramatic growth of the internet had on US journalists' characteristics, attitudes, and behaviors—and even on the definition of who is a journalist?

This 2013 survey addresses these and other questions. It asks many of the same questions included in the 1982, 1992, and 2002 studies so that trends can be tracked over time. But it also includes a series of new questions about the impact of the internet and social media on the practice of modern journalism, and how journalists use these new forms of communication in their work. This paper focuses on these questions.

## Related Studies

In spite of all the growth in online news sources and in online news audiences, there has not been much research on those who produce online news (Deuze and Paulussen 2002; Hammond, Petersen, and Thomsen 2000; Neuberger 2002; Quandt et al. 2006). Johnstone, Slawski, and Bowman's 1971 study, reported in their book, *The News People* (Johnstone, Slawski, and Bowman 1976), provided a benchmark against which US journalists' backgrounds, demographics, attitudes, beliefs, and working conditions could be compared in 1982, 1992, and 2002. The three books by Weaver and Wilhoit and Indiana colleagues based on the later studies, *The American Journalist* (Weaver and Wilhoit 1986), *The American Journalist in the 1990s* (Weaver and Wilhoit 1996), and *The American Journalist in the 21st Century* (Weaver et al. 2007), have documented changes over time in US journalism, including dramatic growth and later shrinkage in the number of journalists; some increases in the proportions of women among younger journalists, college graduates, and minority journalists; changes in job satisfaction; declines in perceived autonomy; changes in income and ideas about the ethics of reporting practices; and changes in ideas about the roles that journalists should perform in society.

The overall picture from research on US journalists from the early 1970s to the early years of this new twenty-first century was one of "more stability than change" (Weaver et al. 2007, 239). But there were some changes worth noting.

In terms of demographics, the number of full-time US journalists decreased by nearly 5 percent, the average age increased from 36 to 41, there was slight growth in the percentage of racial and ethnic minorities from 8 percent to 9.5 percent, there was a decline in the percentage identifying with the Democratic political party and considering themselves left of center politically, and there was an increase in viewing cable television network news (Weaver et al. 2007, 28).

In terms of education and training, the high degree of educational diversity of US journalists found in the 1971 study of Johnstone, Slawski, and Bowman (1976 ) eroded in the 1990s. In 2002, more journalists had graduated from college, and more had majored in journalism or communications at the undergraduate level. In 31 years, the proportion with at least a bachelor's degree from a four-year college jumped from 58 to 89 percent, and the proportion majoring in journalism or communication increased from 41 to 50 percent (Weaver et al. 2007, 31). In addition to these increases, there was also an increase in those who had participated in a continuing education program. But there were few differences between those who had majored in journalism–communication and other subjects.

In terms of working conditions, there was a downward trend for measures of perceived autonomy from 1971 to 2002, especially for deciding story emphasis, which dropped from 76 percent of reporters saying they had almost complete freedom to decide in 1971 to 42 percent in 2002. Likewise, perceived freedom to select stories dropped from 60 percent in 1971 and 1982 to 40 percent in 2002, another significant decline (Weaver et al. 2007, 72). The largest drops in perceived freedom were among journalists working for daily newspapers, wire services, and television.

The amount of perceived freedom of US journalists was positively correlated with job satisfaction. Those who were very satisfied with their jobs had higher average scores on autonomy measures. Although levels of job satisfaction increased a bit from 1992 to 2002, the percentage of journalists saying that they were very satisfied declined from nearly half (49 percent) in 1971 to about one-third (33 percent) in 2002 (Weaver et al. 2007, 107).

In terms of professional roles, there was a decline in the perceived importance of investigating government claims, analyzing complex problems, and discussing national policies from the early 1970s to the early years of this new century. Even though there has been a decline in the perceived importance of this investigative role in the past 30+ years, it is also true that investigating government claims and getting information to the public quickly have remained dominant roles in the minds of US journalists over the years—and investigating government was on the upswing from the early 1990s to the early 2000s, whereas getting information out quickly was on the decline (Weaver et al. 2007, 140).

In terms of reporting methods, there have been conflicting findings in the American Journalist studies from 1982 to 2002. (These questions were not asked by Johnstone, Slawski, and Bowman in their 1971 study.) On the one hand, it could be argued that decreases in support of deceptive practices such as claiming to be someone else and getting employed to obtain inside information are an indication of increased professionalism or ethical standards; and decreases in support for paying for information and revealing the names of rape victims can also be seen as indicators of higher ethical standards and more sensitivity to the rights of others.

On the other hand, there have been increases in support of using confidential business, government, and personal documents without permission (especially business and government records), and a substantial majority (60 percent) of all journalists thought in 1992 and 2002 that using hidden microphones and cameras may be justified in the case of an important story (Weaver et al. 2007, 163).

Clearly, US journalists have made a distinction in the past between some deceptive practices, such as concealing one's identity and paying for information, and others such as using government and business documents, but the only substantial increases in support of these methods were for using confidential documents, both official and personal. But even in the case of documents, there were modest declines in support between 1992 and 2002, and no real increases in support for any of these questionable methods during that decade (Weaver et al. 2007, 163).

In terms of online journalists, the 2002 study of US journalists found that they were "more similar to, than different from, journalists working in more traditional print and broadcast news media, but there were some notable differences, mainly in work-related attitudes and behaviors" (Weaver et al. 2007, 224). Some of these differences included being more likely than traditional journalists to have had some graduate education and

to have earned a graduate degree, being more satisfied with their jobs, being less likely to perceive complete freedom to select stories to work on, being less likely to hear from news sources and much more likely to receive feedback regularly from audience members, being more likely to emphasize an interpretive role and slightly more likely to consider the adversarial or watchdog function extremely important, and being more likely to justify using controversial reporting methods than traditional journalists (Weaver et al. 2007, 223–224).

### Job Satisfaction and Perceived Autonomy

During the last two decades, the work environment of journalists around the world has been transformed dramatically. News media ownership became more consolidated when a severe recession led to staff reductions and layoffs. Potential threats to professional autonomy emerged as news organizations became more market-driven and "civic journalism" challenged the traditional relationship among journalists, sources, and audience members.

Many of these changes can be traced to the influence of the internet on journalistic work and news organizations that have embraced online media to reach additional audiences with more targeted and frequently updated news. However, the specific demands of online news have also changed the way modern journalists work. While the internet and social media made it easier for journalists to research and report their stories, many of them are now expected to write a story, shoot still pictures or video, and then edit their own work for multiple media platforms. These are new professional obligations that might increase the risk of burnout, exhaustion, and stress among journalists (Deprez and Raeymaeckers 2012).

## Research Questions

Given these dramatic changes in the working environment of US and other journalists, what do they think about the impact of social media on their work and how do they use it in their day-to-day reporting and editing?

## Methods

To answer the questions raised above, in the fall of 2013 we conducted a national online survey of 1080 full-time US journalists, similar to those conducted in 1971, 1982, 1992, and 2002. The survey asked many of the questions included in the previous studies so that trends could be tracked over time. However, it also included a series of new questions about the use and impact of the internet and social media in the practice of modern journalism. In addition to the regular closed-ended questions, the 2013 survey also included open-ended questions to allow journalists to explain some of the quantitative findings in their own words.

### Sampling

The 2013 study employs the same basic sampling methods used in the previous studies that include journalists from all the print and broadcast traditional news media. The sample of traditional US journalists is based on a multi-stage sampling

procedure, which first draws a representative sample of media organizations in the United States and then, in a second step, samples of journalists from within each of the selected organizations. The sample of online journalists was created by identifying online journalists within a representative selection of traditional media organizations and by obtaining lists of journalists from online-only media organizations and news websites.

The findings presented in this paper are based on 1080 completed interviews conducted from August 7 to December 20, 2013, with full-time journalists working for a wide variety of daily and weekly newspaper, radio and television stations, wire services, newsmagazines, and online news media throughout the United States. All 3500 journalists originally selected for our sample were invited via email to participate in our online survey. They also received four follow-up reminders via email and one personal "nudge" call by telephone. The response rate for the final sample of 1080 respondents was 32.6 percent, and the maximum sampling error at the 95 percent level of confidence is plus or minus 3 percentage points.

### Questionnaire

The survey questionnaire included a total of 86 questions and focused mostly on journalists' (1) job satisfaction, (2) perceived levels of freedom in their jobs, (3) role perceptions, (4) reporting practices, (5) use of social media in their work, (6) perceived impact of social media on their work, (7) additional training sought, and (8) demographics. The new questions regarding the use of social media and their perceived impact were partially adopted from recent studies by Gulyas (2013) and Hedman and Djerf-Pierre (2013), and these are the focus of this paper.

### Use of Social Media in Journalism

How journalists use social media in their jobs was assessed with a series of questions that measured the perceived importance of social media in journalists' work, the frequency of use of different types of social media, and the way social media were used. Perceived importance of social media was measured by asking journalists how important (1 = not important at all; 5 = extremely important) they thought social media are for reporting or producing their stories. The frequency of social media use in their work was assessed by asking journalists how often they use social media such as blogs written by private citizens or other journalists, social networking sites such as Twitter, or audio-visual sharing sites such as YouTube. Finally, in order to get a better understanding of how journalists use social media in their work, respondents were asked whether they regularly use social media to do things such as checking for breaking news, finding new ideas for stories, or keeping in touch with their audiences.[1]

### Perceived Impact of Social Media on Own Work and Profession

The survey also included a series of questions that probed how journalists thought about the impact of social media on their work and the profession overall. After asking journalists first how they would rate the impact of social media on their work (1 = very negative; 5 = very positive), they were then asked to indicate whether they agreed or disagreed

(1 = strongly disagree; 5 = strongly agree) with the following eight statements: (1) Using social media allows me to promote myself and my work much better; (2) Because of social media, I am more engaged with my audience; (3) Because of social media, I communicate better with people relevant to my work; (4) Social media have improved my productivity; (5) Social media have decreased my daily workload; (6) Using social media enhances my credibility as a journalist; (7) Social media allow me to be faster in reporting news stories; (8) Social media allow me to cover more news stories.[2]

Similarly, after being asked about how they would rate the impact of social media on the journalistic profession overall, respondents were asked to indicate whether they agreed or disagreed with the following five statements: (1) Social media are undermining traditional journalistic values; (2) Social media threaten the quality of journalism; (3) Social media make journalism more accountable to the public; (4) User-generated content threatens the integrity of journalism; (5) Online journalism has sacrificed accuracy for speed.[3]

*Demographics*

Gender, age, race, religion, political party affiliation, political leaning, income, and marital status were measured for both descriptive and statistical control purposes.[4]

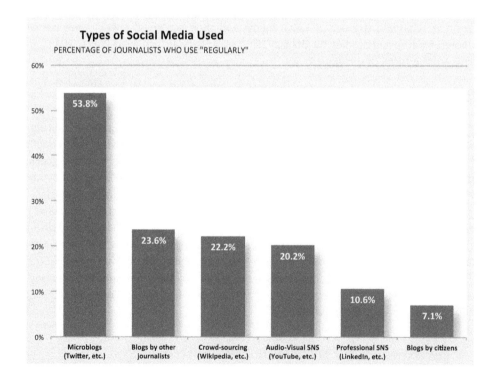

**FIGURE 1**
Types of social media used (percentage of journalists who use "regularly"). SNS, social networking sites

## Findings

### *Journalists' Use of Social Media*

Because social media have become an important part of daily journalism, we included a number of questions in the 2013 survey that probed journalists' use of social media in their work and their perceptions of how social media have affected their work and the profession overall. These questions were not asked in any of the previous surveys and therefore cannot be compared across time. However, we can analyze the use and perceived effects of social media by journalists working for different types of media (e.g., daily newspapers, television, and radio) and by different demographic backgrounds (e.g., male and female).

Because the internet has dramatically changed the way journalists do their work, it is not surprising that 40 percent of US journalists said that social media are very important to their work. Women were a bit more likely to say this (45 percent) than men (37 percent). Television journalists were most likely (59 percent) and magazine journalists least likely to say so (24 percent). About one-third of all journalists (35 percent) said they spent between 30 and 60 minutes every day on social networking sites in their work as a journalist, with no difference between men and women. Radio journalists were most likely to say this (43 percent) and television and online journalists least likely to say so (29 and 27.5 percent, respectively), mainly because these two types of journalists were more likely than others to use social media for two to three hours a day.

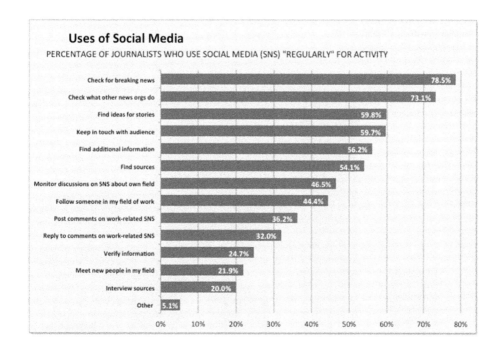

**FIGURE 2**
Uses of social media (percentage of journalists who use social media "regularly" for activity). SNS, social networking sites

More than half of all journalists (53.8 percent) said they regularly use microblogs such as Twitter for gathering information and reporting. As Figure 1 illustrates, other types of social media were used less frequently, including the blogs of other journalists (23.6 percent), crowd-sourced sites such as Wikipedia (22.2 percent), audio-visual sites such as YouTube (20.2 percent), and professional sites such as LinkedIn (10.6 percent). Least likely to be used were blogs by citizens (7.1 percent). There was not much difference between men and women on these measures, nor between the various types of journalists, except that television and online journalists were more likely to use audio-visual sharing sites such as YouTube more often than others, and magazine journalists were more likely to use crowd-sourcing sites such as Wikipedia.

As indicated in Figure 2, most journalists use social media to gather information for their news stories. About three-fourths of the journalists, for example, said they used social media to check what other news organizations do or whether there might be any breaking news. More than half of them also used social media to find new ideas for their stories, to gather additional information, and to find sources. Almost 6 in 10 journalists also said that they keep in touch with their audiences through social media. Other possible uses of social media, such as interviewing sources, verifying information, or posting comments on work-related social networking sites were much less common. Overall then, social media were used predominantly as information-gathering tools by journalists, and much less often as a tool to interview sources or to verify information.

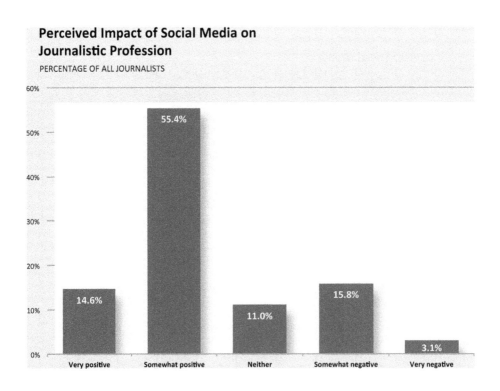

**FIGURE 3**
Perceived impact of social media on journalistic profession (percentage of all journalists)

### Perceived Effects of Social Media

Another goal of this study was to establish a baseline for how journalists see the effects of social media on their profession. Overall, our findings indicate that a clear majority (71.5 percent) of journalists thought that social media had a "very" or "somewhat" positive effect on their work, while only about 7.1 percent said that the effect was negative. Similarly, Figure 3 shows that about 70 percent of the journalists thought that social media had a somewhat or very positive effect on the journalistic profession overall, while only about one-fifth thought the effect of social media was somewhat or very negative.

When asked specifically what effects they thought social media might have on their work, Figure 4 shows that most journalists indicated that self-promotion, better engagement with their audiences, and faster reporting were the three most beneficial aspects. Significantly fewer thought that social media might enhance their credibility, allow them to cover more news, or improve their productivity. Almost no journalists said that social media had decreased their workload.

In spite of the overall positive perceived effect of social media on the journalistic profession, about three-quarters (75.5 percent) of the journalists thought that "online journalism has sacrificed accuracy for speed." Almost half also thought that social media "threatens the quality of journalism" (48.4 percent) and that "user-generated content threatens the integrity of journalism" (46.8 percent). On the other hand, a similar percentage of journalists

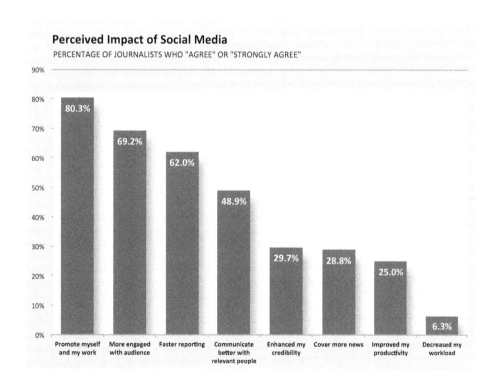

**FIGURE 4**

Perceived impact of social media (percentage of journalists who "agree" or "strongly agree")

also believed that social media "makes journalism more accountable to the public" (48.1 percent).

Thus, the use of social media as a networking and promotional tool in US journalism seems clear, although it might not always yield desired effects. Whereas a majority of US journalists (62 percent) agreed that social media allow them to produce faster reporting, speed of news coverage does not imply that journalists can cover more news (only 29 percent agreed) or that they are more productive (one-fourth agreed).

## Conclusions

US journalists use social media mainly to check on what other news organizations are doing and to look for breaking news events. A majority also use social media to find ideas for stories, keep in touch with their readers and viewers, and find additional information. Thus, journalists use social media predominantly as information-gathering tools and much less to interview sources or to validate information.

Finally, our findings indicate that most journalists consider social media to have a positive impact on their work. Of particular value, it seems, was the perception that social media make journalism more accountable to the public. However, one of the most common negative perceptions was that online journalism has sacrificed accuracy for speed. Overall then, it appears that most journalists do see the benefits of social media in their own work, but fewer are convinced that these new forms of digital communication benefit journalistic professionalism overall in the United States.

## DISCLOSURE STATEMENT

No potential conflict of interest was reported by the authors.

## FUNDING

This work was supported by the School of Journalism, Indiana University.

## NOTES

1. *Use of social media in job*: How important is social media for reporting or producing your stories? (coded as: 1 = not important at all; 2 = not very important; 3 = somewhat important; 4 = very important; 5 = extremely important). How often do you use the following types of social media in your work as a journalist? (1) Blogs authored by journalists or other professionals; (2) Blogs authored by regular citizens; (3) Microblogging sites, such as Twitter; (4) Professional social networking sites, such as LinkedIn; (5) Audio-visual sharing sites, such as YouTube, Flickr, or Tumblr; (6) Content communities and crowd-sourcing sites, such as Wikipedia (coded as: 1 = never; 2 = seldom; 3 = occasionally; 4 = regularly). How do you use social media in your daily work as a journalist? Please select all that apply. (1) Check for breaking news; (2) Check what other news organizations are reporting; (3) Monitor discussions on social media about my field of work; (4) Find new ideas for stories; (5) Interview sources; (6) Find sources I would otherwise not be aware of or have access to; (7) Verify information; (8) Find additional information; (9) Meet new people in my field of work; (10) Follow someone on social media I met in my field

of work; (11) Keep in touch with my audience; (12) Post comments on work-related social media; (13) Reply to comments on work-related social media; (14) Other.

2. *Perceived impact of social media on own work*: Overall, how would you rate the impact of social media on your work as a journalist? (coded as: 1 = very negative; 2 = somewhat negative; 3 = neither negative nor positive; 4 = somewhat positive; 5 = very positive). Please tell us how much you agree or disagree with the following statements about the impact of social media on your work as a journalist. (1) Using social media allows me to promote myself and my work much better; (2) Because of social media, I am more engaged with my audience; (3) Because of social media, I communicate better with people relevant to my work; (4) Social media has improved my productivity; (5) Social media has decreased my daily workload; (6) Using social media enhances my credibility as a journalist; (7) Social media allows me to be faster in reporting news stories; (8) Social media allows me to cover more news stories (coded as: 1 = strongly disagree; 2 = disagree; 3 = neither agree nor disagree; 4 = agree; 5 = strongly agree).

3. *Perceived impact of social media on profession*: Overall, how would you rate the impact of social media on the journalistic profession? (coded as: 1 = very negative; 2 = somewhat negative; 3 = neither negative nor positive; 4 = somewhat positive; 5 = very positive). Please tell us how much you agree or disagree with the following statements about the impact of social media on the journalistic profession in general. (1) Social media is undermining traditional journalistic values; (2) Social media threatens the quality of journalism; (3) Social media makes journalism more accountable to the public; (4) User-generated content threatens the integrity of journalism; (5) Online journalism has sacrificed accuracy for speed (coded as: 1 = strongly disagree; 2 = disagree; 3 = neither agree nor disagree; 4 = agree; 5 = strongly agree).

4. *Sex*: Are you: Male; Female. *Age*: In what year were you born? *Race*: Are you Spanish, Hispanic, or Latino? (yes; no). In which one of the following racial groups would you place yourself? White (Caucasian); Black or African-American; Asian or Asian-American; American Indian or Alaska Native; Pacific Islander; Other. *Religion*: In what religion, if any, were you brought up? Protestant/Lutheran; Evangelical Christian; Roman Catholic; Jewish; Muslim; Hindu; Buddhist; Other. *Marital status*: What is your marital status? Married; Widowed; Divorced; Separated; Unmarried, but living with partner; Single (never married); Other. *Political party affiliation*: In politics today, do you consider yourself a Republican, Democrat, or Independent? Republican; Independent closer to Republican; Independent; Independent closer to Democrat; Democrat; No preference; Other. *Political leaning*: In general, would you describe your political views as: Very conservative; Conservative; Moderate; Liberal; Very liberal. *Income*: Finally, we'd like to ask you some financial information. Would you please tell us what your total personal income was, before taxes, from your work in journalism during 2012? Less than $15,000; $15,000 to less than $20,000; $20,000 to less than $25,000 … $150,000 and over.

## REFERENCES

Deprez, Annalore, and Karin Raeymaeckers. 2012. "A Longitudinal Study of Job Satisfaction among Flemish Professional Journalists." *Journalism and Mass Communication* 2 (1): 1–15.

Deuze, Mark, and Steve Paulussen. 2002. "Research Note: Online Journalism in the Low Countries: Basic, Occupational and Professional Characteristics of Online Journalists in Flanders and the Netherlands." *European Journal of Communication* 17 (2): 237–245.

Gulyas, Agnes. 2013. "The Influence of Professional Variables on Journalists' Uses and Views of Social Media: A Comparative Study of Finland, Germany, Sweden and the United Kingdom." *Digital Journalism.* doi:10.1080/21670811.2012.744559.

Hammond, Scott C., D. Petersen, and S. Thomsen. 2000. "Print, Broadcast and Online Convergence in the Newsroom." *Journalism and Mass Communication Educator* 55: 16–26.

Hedman, Ulrika, and Monika Djerf-Pierre. 2013. "The Social Journalist: Embracing the Social Media Life or Creating a New Digital Divide?" *Digital Journalism.* doi:10.1080/21670811.2013.776804.

Johnstone, John W. C., Edward J. Slawski, and William W. Bowman. 1976. *The News People: A Sociological Portrait of American Journalists and Their Work.* Urbana: University of Illinois Press.

Neuberger, Christophe. 2002. "Online-Journalismus: Akteure, Redaktionelle Strukturen und Berufskontext [Online Journalism: Actors, Editorial Structures and Professional Context]." *Medien and Kommunikationswissenschaft* 50: 102–114.

Quandt, Thorsten, Martin Loeffelholz, David Weaver, Thomas Hanitzsch, and Klaus-Dieter Altmeppen. 2006. "American and German Online Journalists at the Beginning of the 21st Century: A Bi-national Survey." *Journalism Studies* 7 (2): 171–186.

Weaver, David H., Randolph A. Beam, Bonnie J. Brownlee, Paul S. Voakes, and G. Cleve Wilhoit. 2007. *The American Journalist in the 21st Century: U.S. News People at the Dawn of a New Millennium.* Mahwah, NJ: Lawrence Erlbaum.

Weaver, David H., and G. Cleve Wilhoit. 1986. *The American Journalist: A Portrait of U.S. News People and Their Work.* Bloomington: Indiana University Press.

Weaver, David H., and G. Cleve Wilhoit. 1996. *The American Journalist in the 1990s: U.S. News People at the End of an Era.* Mahwah, NJ: Erlbaum.

# ARE YOU TALKING TO ME?
# An analysis of journalism conversation on social media

**Martin Chorley** ⓘ and **Glyn Mottershead** ⓘ

*Social media has become a key medium for discussion and dissemination of news stories, fuelled by the low barrier to entry and the ease of interaction. News stories may be propagated through these networks either by official news organisation accounts, by individual journalists or by members of the public, through link sharing, endorsing or commenting. This preliminary research aims to show how computational analysis of large-scale data-sets allows us to investigate the means by which news stories are spread through social media, and how the conversation around them is shaped by journalists and news organisations. Through the capture of more than 11 million tweets relating to 2303 Twitter accounts connected to journalism and news organisations, we are able to analyse the conversation within and around journalism, examining who spreads information about news articles and who interacts in the discussion around them. Capturing the tweets of news organisations and journalists and the replies and retweets of these micro-blogs allows us to build a rich picture of interaction around news media.*

## Introduction

Twitter, and the use of Twitter within journalism and by journalists, has become an increasingly discussed topic in recent years (Hermida 2013; Hedman and Djerf-Pierre 2013), focusing not only on how journalists use Twitter, but also how the use of Twitter and other social media by wider society (Zhao and Rosson 2009) is influencing news gathering, creation and discussion (Bruns and Highfield 2012; Newman, Dutton, and Blank 2012; Nielsen and Schrøder 2014).

Many studies of the use of Twitter within journalism focus on small pools of subjects and limited manual monitoring of Twitter activity. These studies often look at a restricted set of tweets from users, collected over short time periods, or examine only small numbers of tweets per user per day. Such small samples may not be representative of the actual use of Twitter within journalism, and monitoring small time periods or limited portions of tweet activity may skew study results or weaken the applicability of findings to the general population. However, using computational methods it is possible to examine a large subject pool, monitoring all of the Twitter activity associated with these subjects, and using algorithmic analysis to draw conclusions about the Twitter activity that are consequently more applicable to the population as a whole.

In this research study, we examine the Twitter activity of 2303 journalists, news organisations and others working for such organisations, capturing the tweets and retweets made by these individuals over a period of several weeks. Analysis of these tweets allows us

to understand the Twitter behaviour of the users and organisations, and answer two research questions:

**RQ1:** Are there differences between the social media use and attitudes of news organisations and their journalists?

**RQ2:** Are journalists engaging with the public around the news stories they promote?

## Related Work

Several previous studies have examined the use of Twitter within news organisations and by journalists. Herrera-Damas and Hermida (2014) considered the use of Twitter by talk radio stations in Canada, examining the tweets of three radio stations over two weeks in 2010 and 2011, finding that the main use of Twitter by these organisations was to provide information, rather than to engage with their audience. The number of retweets and external mentions and links was also low. Similarly, Lasorsa, Lewis, and Holton (2012) investigated the use of Twitter by practising journalists in an effort to discover whether the use of microblogging had caused journalists to change the norms and practices of their industry. An analysis of 500 journalists (primarily based in the United States) in which for two weeks the first 10 tweets posted by each journalist were examined, found that the journalists frequently displayed behaviour online that deviated from their traditional roles, such as offering opinions rather than appearing non-partisan, while also retweeting and promoting external links and content, and offering insights into working practices. Cleary et al. (2014) look at the use of Twitter by CNN and three news anchors/reporters to examine the values put forward by the organisation, finding that the journalists tweeted with different priorities than the organisation, who use it more often for promotional purposes. This finding is often repeated throughout the literature (Rosenstiel and Mitchell 2011). It has also been noted (Vis 2013) that thanks to its real-time distributed nature, Twitter can effectively be used as a tool for reporting breaking news. Of further interest is the role of digital gatekeepers within social media (Bro and Wallberg 2014), those users whose actions of sharing, liking and commenting on the news disseminates news articles further. Examination of large-scale data-sets can allow these gatekeepers to be identified and examined.

What is common to all these studies is the limiting effect of requiring human coding in order to analyse Twitter use. Sample sizes must be kept small, or large pools of analysts must be used. Indeed, Lasorsa, Lewis, and Holton (2012) comment that while their study analysed 22,000 tweets, this sample did not cover *all* of the tweets by these journalists. Using automated algorithmic analysis it is possible to study a far larger sample of Twitter usage, in order to build a clearer picture of its use. Twitter has often been used in order to examine communities and the conversation within and between them (Burnap et al. 2013).

### Data Collection

Many tools exist for collecting Twitter data (Bruns and Liang 2012; Burnap et al. 2015), and research is available on methodologies for accessing large quantities of Twitter data (Bruns and Burgess 2012). However, given the relative simplicity and targeted nature of this research, it is easy to build custom Twitter-monitoring software to capture the required data.

Twitter data are made available through a publicly accessible application programming interface (API), which has two primary methods of access: the REST API and the Streaming API. When using the REST API, requests are made to the Twitter API servers and a limited set of data returned. When using the streaming API, an initial request to the Twitter API sets up a continuous connection, and data are returned from the Twitter API on an ongoing basis. This streaming method allows more data to be accessed than by using the REST API. For this study, data were collected from Twitter using both the Streaming API and the REST API.

The Streaming API was used to "follow" a set of user accounts. "Following" a user account using the Streaming API allows collection of all original tweets sent by that user account, any retweets of those original tweets, any retweets made by the account and replies to any tweet they send. It does not, however, include tweets that "mention" the original user other than those sent as direct replies. It also does not include manual retweets of a user's tweets or any tweets by protected users.[1]

The REST API was used to access the Twitter profile details of the followed user accounts at regular intervals, in order to monitor profile statistics, such as the number of followers, during the study period.

This research aims to examine the Twitter behaviour of both individual journalists as well as a selection of the news organisations for which they work. It is therefore necessary to classify or code users into distinct groupings. In this research we are interested in distinctions between three sets of users: (1) official accounts of news organisations, (2) journalists and others working for news organisations, and (3) everyone else. This is a fairly high-level grouping, with less granularity than some previously used encodings of Twitter users (Vis 2012), however, it has some advantages. Firstly, it is exactly fine-grained enough to allow us to answer our research questions and, secondly, by restricting the number of classes it should be relatively straightforward to separate users into classes automatically without requiring manual coding.

The main Twitter accounts of the news agencies and organisations given in Table 1 were followed during the study. These organisations represent a mix of media classes, covering both print and online news as well as television and agency reporting. While

**TABLE 1**

Organisations and Twitter accounts followed during study

| Organisation | Accounts followed |
| --- | --- |
| The Guardian | guardian, guardiannews |
| Daily Mail | MailOnline, DailyMail, DailyMailUK |
| BBC | BBCWorld, BBCNews, BBCBreaking |
| CNN | cnni |
| The New York Times | nytimes, nytimesworld |
| Reuters | Reuters, ReutersLive |
| Financial Times | FinancialTimes, ft |
| The Times | Thetimes |
| Sky News | SkyNews, SkyNewsBreak |
| The Mirror | DailyMirror, ampp3d |
| Channel 4 | Channel4News |
| The Sun | TheSunNewspaper |
| The Telegraph | Telegraph |
| The Independent | independent, thei100 |

predominantly UK-based, there are also a number of international accounts. These organisation accounts were supplemented with a list of active journalists on Twitter, identified through the list "Journalists on Twitter" from journalism.co.uk.

In total, a list of 2303 Twitter usernames was provided to the follow parameter of the API request, and tweet responses received were stored in full as they arrived. These 2303 "users of interest" (UoI) were followed from 10:24 am on 20 March 2015 to 9:53 am on 15 July 2015. During this time, a total of 11,638,197 tweets were received by the monitor.

In order to ensure that the list of accounts being examined contained only journalists or people connected to news media the profile descriptions of UoI were examined. Descriptions were algorithmically checked for the presence of either a main news source (e.g. a biography stating "Journalist for *Daily Mail*") or the presence of a job keyword from the list in Table 2. Of the 2303 users monitored, 2163 were algorithmically confirmed to self-describe in their Twitter biography as either having a role as in Table 2, or to associate themselves with one of the news outlets as given in Table 1. The remaining 140 users were inspected manually and confirmed to self-describe either as working for outlets not included in Table 1, or to use other names/slang or Twitter account names in order to identify their job role or employer. We can state that the user sample from this study consists of either official accounts from news organisations, or individuals who work for news organisations in some news-related capacity.

## Data Filtering

Of the 11,638,197 tweets gathered during the monitoring period, a large number were retweets as opposed to original content. These retweets fall into three categories:

1. Retweets of one of the accounts under study (UoI) by a third party.
2. Retweets of a third party by one of the accounts under study (UoI).
3. Retweets of one of the accounts under study by a second of the accounts under study.

When considering the content posted to Twitter by the users of interest, categories 2 and 3 add something material to the study, as they can be seen as content provided by the users. Category 1 is partially of interest as a measure of popularity of the users, but does not reveal anything new about the content created, promoted or discussed by the users. To begin with, we examine only the tweets created or retweeted by the users in the study (original content, plus those tweets in categories 2 and 3).

### Data Analysis

Extracting from the data-set of collected tweets, only those tweets created or retweeted by the UoI within the study gives a collection of 1,225,752 tweets. Of these, 1,039,106 tweets were made by individual users, while 186,646 came from an official

**TABLE 2**
News-related terms searched for in Twitter profile descriptions

**News-related terms**
"broadcaster", "journalists", "editor", "hack", "sub", "critic", "reporter", "journo", "commentator",
  "journalist", "columnist", "correspondent", "presenter", "producer", "features", "writing"

organisation account. Of the 1,039,106 tweets by individuals, 299,902 were retweets, while 739,204 were not. Of the 186,646 tweets from organisation accounts, 36,443 were retweets, while 150,203 were original tweets. As shown in Table 3, this reveals a difference of almost 10 per cent in the number of original tweets versus retweets between organisations and individual accounts, with original tweets making up a higher proportion of the total for organisation accounts. This could fit with earlier findings that organisations tend to use Twitter as a promotional tool, favouring their own content over that of others, but further analysis of the content of the original tweets versus retweets must be carried out in order to confirm that.

Looking at the breakdown of tweets per user (Table 4) shows a wide range of Twitter behaviour, as might be expected from such a large sample. Organisations are more active than individual users, which again is unsurprising given that the primary function of organisational Twitter accounts will be to participate in Twitter, whereas most individuals will be using Twitter only as a secondary function or distraction from their primary function within the workplace. Java et al. (2007) concluded that users may have four primary reasons for using Twitter: daily chatter, conversation, sharing information and reporting news).

Examining the timing of tweets, either by day (Figure 1) or by hour (Figure 2) does not show anything particularly surprising in the sample. The number of tweets recorded are highest during the week, with lower levels at the weekend, and are highest throughout working hours and into the evening, with comparatively low levels of Twitter activity seen during the overnight hours and early morning.

## Conversation Analysis

The simplest way to gain an understanding of the conversations happening between the users of interest and other individuals is to look at the number of mentions each user has made during the period of the study. Table 5 shows the average mentions made per user for both organisation and individual accounts. As can be seen, the average is significantly higher for organisational accounts, for both original tweets and retweets. There could be a number of reasons for this. Organisational accounts may be engaged in the conversation with their audience more than individual users, or perhaps they may be including names of their other organisation accounts within tweets in order to point the audience to other sources of content. Again, it is necessary to examine the content of the tweets and see exactly who it is that is being mentioned in order to draw any firm conclusions.

Examining the number of unique users mentioned on average (Table 6) shows that organisation and individual accounts are much closer in terms of the number of different people they mention on Twitter. Coupled with the information in Table 5, this indicates that

**TABLE 3**
Breakdown of tweets and retweets for organisations and individuals

|  | Original tweets | | Retweets | | Total |
|---|---|---|---|---|---|
|  | *N* | % of total | *N* | % of total |  |
| Organisations | 150,203 | 80.47 | 36,443 | 19.53 | 186,646 |
| Individuals | 739,204 | 71.14 | 299,902 | 28.86 | 1,039,106 |
| Total | 889,407 |  | 336,345 |  |  |

**TABLE 4**
Number of tweets and retweets per user

|  | Original tweets | | | Retweets | | |
|---|---|---|---|---|---|---|
|  | Mean | Min. | Max. | Mean | Min. | Max. |
| Organisations | 7153 | 63 | 31,218 | 1918 | 3 | 10,973 |
| Individuals | 333 | 1 | 36,376 | 141 | 1 | 20,276 |

Difference between organisations' and individuals' number of original tweets and between organisations' and individuals' number of retweets significant at $p < 0.001$.

while organisations mention other users in tweets more often, the pool of other users mentioned is not that much larger than the pool of users for the average individual account.

### Number of Unique Users Mentioned per User

In total, 157,172 user accounts were mentioned by either the individual accounts or the organisation accounts examined in the study. Of these, 155,097 were user accounts not belonging to the group under examination.

In order to determine whether the conversation between the users in this study and other Twitter users is an example of journalists and news organisations conversing within their own community, or engaging with users outside the community, it is necessary to attempt to classify the other users, in order to determine whether they belong to the "news" community or are external.

An initial attempt at this classification can be carried out by examining the profile descriptions of the users. Much as the presence of keywords or organisation names in profile descriptions was used previously to determine whether the accounts under examination belonged to journalism-related users, the same keyword analysis can provide an indication as to whether an external user is a journalist, or related to a news organisation in some way.

The profiles of these 155,097 user accounts were retrieved from the Twitter API. Of the 155,097 accounts, 3019 accounts no longer exist as of the analysis in this paper,

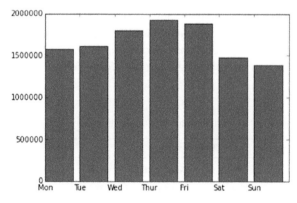

**FIGURE 1**
Number of tweets recorded per day

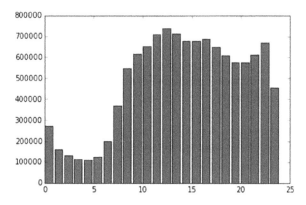

**FIGURE 2**
Number of tweets recorded per hour

**TABLE 5**
Mentions made per user

|  | Original tweets | | | Retweets | | |
|---|---|---|---|---|---|---|
|  | Mean | Min. | Max. | Mean | Min. | Max. |
| Organisations | 821 | 5 | 4969 | 2356 | 6 | 14,177 |
| Individuals | 269 | 1 | 9564 | 218 | 1 | 21,531 |

having either been banned by Twitter or deleted by the users themselves. The remaining 152,078 account profiles were accessed and examined for the presence of keywords and organisations as in Tables 1 and 2. Additionally, accounts that were not identified as belonging to journalists or news-related media were further assessed to check for the presence of words related to blogging ("blogging", "blogs", "blogger").

Of these users, 25,629 were confirmed to contain either a job description or reference to a media organisation, suggesting that these accounts also belong to users relevant to journalism; 1500 users contained a mention of blogging. The remaining account descriptions do not point to those users belonging to a media organisation or working in a field relating to journalism.

At a basic numerical level, this shows that, as would be expected, the communication of users is mixed. There is a level of communication between the users within the study, with users external to the study who belong to the journalistic and news community, and with users external to the study who have no formal relationship to the creation and delivery of news.

**TABLE 6**
Number of unique users mentioned per user

|  | Original tweets | | | Retweets | | |
|---|---|---|---|---|---|---|
|  | Mean | Min. | Max. | Mean | Min. | Max. |
| Organisations | 137 | 1 | 451 | 212 | 6 | 1191 |
| Individuals | 107 | 1 | 2683 | 110 | 1 | 3518 |

The next step is to quantify the communication between the different groupings in terms of the level of communication. In order to do this, we examine how many times the users of each different class have been mentioned by the users of interest in the study. It is also worth considering that the figures for external third-party "news" accounts can be combined with the figures for UoI, as it has already been confirmed that users in the study are of this class. However, the figures are presented separately. Organisation data are presented in Table 7. It is clear to see that in the overwhelming majority of cases, organisation accounts are mentioning other news accounts (either accounts already included in this study or otherwise) far more than they mention either self-described bloggers or non-news-related accounts. This suggests that either the promotional effort or the engagement of others in conversation is primarily focused within the news community for these organisations.

For both individual users and organisations, a per-user summary of mention classes is given in Table 8. For individual users, the average number of mentions between users of interest and news accounts versus non-news accounts is fairly equal, with non-news slightly higher (214.5 against 236.6). This indicates that unlike the news organisations, individuals are using Twitter to promote or engage with users beyond the news community.

These mentions include users with whom only one mention has been made. One mention may not be considered evidence of a significant interaction. Limiting the mentions to only those users with five or more mentions (showing that the users have interacted more than just once) gives the number of separate users conversed with in Table 9 and the total count of mentions in Table 10. It can be seen that even when only significant interactions are taken into account, there is a difference between the conversation between news users and non-news users. For individuals, the split remains fairly even in terms of the number of users mentioned (2.85 + 5.07 versus 7.94) for news and non-news accounts. However, looking at the total number of mentions reveals that individuals have contacted news-related accounts far more often than non-news accounts (averages of 46.6 + 77.2 versus 91.7). This indicates that the users are conversing more with users within their own industry than those outside. For organisations, it is clear that they are contacting news-related accounts more than non-news-related accounts, conversing with an average of 8.43 + 204 news accounts versus 16.6 non-news accounts, with a total number of messages of 228.29 + 1253.6 versus 801.6. Organisations are clearly mentioning those within the news industry more than those who cannot be easily identified as being related to a news organisation or news-related occupation.

Simple mentions are not proof of meaningful interaction or conversation. Raw counts of mentions are therefore not enough to be able to conclude that users or organisations are interacting in any way. However, each tweet contains data of the tweet it is written in reply to. It is therefore possible to follow threads of conversation between users by linking tweets together. Finding multiple threads of conversation from users provides a stronger argument for significant meaningful interaction between users than just a simple count of mentions.

## Content Sharing

The number of links shared by each user is given in Table 11. As can be seen, organisational accounts shared a far higher number of links to content in both original tweets and retweets. This fits previously observed behaviour where official accounts are used primarily as promotional tools in order to disseminate content.

**TABLE 7**
User mentions in each class for each organisation account

| Organisation | Mentions | | | |
|---|---|---|---|---|
| | **UoI** | **News** | **Blogging** | **Non-news** |
| *The Guardian* | | | | |
| guardian | 139 | 2426 | 12 | 505 |
| guardiannews | 11 | 534 | 0 | 12 |
| *Daily Mail* | | | | |
| MailOnline | 8 | 781 | 2 | 429 |
| DailyMail | 0 | 577 | 0 | 200 |
| DailyMailUK | 42 | 478 | 1 | 345 |
| BBC | | | | |
| BBCWorld | 818 | 4876 | 4 | 1592 |
| BBCNews | 3312 | 7023 | 9 | 3851 |
| BBCBreaking | 34 | 38 | 0 | 96 |
| CNN | | | | |
| cnni | 3 | 13 | 0 | 14 |
| *The New York Times* | | | | |
| nytimes | 0 | 67 | 0 | 35 |
| nytimesworld | 0 | 9 | 0 | 3 |
| *Financial Times* | | | | |
| FinancialTimes | 0 | 0 | 0 | 4969 |
| *The Times* | | | | |
| thetimes | 298 | 409 | 2 | 433 |
| Sky News | | | | |
| SkyNews | 56 | 1230 | 2 | 923 |
| SkyNewsBreak | 4 | 0 | 0 | 1 |
| *The Mirror* | | | | |
| DailyMirror | 77 | 3236 | 2 | 3274 |
| ampp3d | 47 | 95 | 2 | 221 |
| Channel 4 | | | | |
| Channel4News | 4 | 2484 | 2 | 1537 |
| *The Sun* | | | | |
| TheSunNewspaper | 120 | 1854 | 12 | 2102 |
| *The Telegraph* | | | | |
| Telegraph | 637 | 2089 | 7 | 765 |
| *The Independent* | | | | |
| thei100 | 4 | 8 | 0 | 34 |

**TABLE 8**
Total user mentions in each class

| | UoI | | | News | | | Blogging | | | Non-news | | |
|---|---|---|---|---|---|---|---|---|---|---|---|---|
| | **Mean** | **Min.** | **Max.** | **Mean** | **Min.** | **Max.** | **Mean** | **Min.** | **Max.** | **Mean** | **Min.** | **Max.** |
| Individuals | 72.2 | 0 | 3592 | 142.3 | 0 | 3592 | 3.3 | 0 | 255 | 236.6 | 0 | 12,187 |
| Organisations | 267.1 | 0 | 3312 | 1344.4 | 0 | 7023 | 2.7 | 0 | 12 | 1016.2 | 1 | 4969 |

**TABLE 9**
Per user mentions in each class (≥5)

| | UoI | | | News | | | Blogging | | | Non-news | | |
|---|---|---|---|---|---|---|---|---|---|---|---|---|
| | Mean | Min. | Max. | Mean | Min. | Max. | Mean | Min. | Max. | Mean | Min. | Max. |
| Individuals | 2.85 | 0 | 62 | 5.07 | 0 | 110 | 0.12 | 0 | 15 | 7.94 | 0 | 516 |
| Organisations | 8.43 | 0 | 62 | 20.4 | 0 | 76 | 0.14 | 0 | 1 | 16.6 | 0 | 68 |

**TABLE 10**
Total user mentions in each class (≥5)

| | UoI | | | News | | | Blogging | | | Non-news | | |
|---|---|---|---|---|---|---|---|---|---|---|---|---|
| | Mean | Min. | Max. | Mean | Min. | Max. | Mean | Min. | Max. | Mean | Min. | Max. |
| Individuals | 46.6 | 0 | 3569 | 77.2 | 0 | 13,618 | 1.42 | 0 | 147 | 91.7 | 0 | 7208 |
| Organisations | 228.29 | 0 | 3115 | 1253.6 | 0 | 6624 | 1 | 0 | 10 | 801.6 | 0 | 4969 |

**TABLE 11**
Number of links shared per user

| | Original tweets | | | Retweets | | |
|---|---|---|---|---|---|---|
| | Mean | Min. | Max. | Mean | Min. | Max. |
| Organisations | 7236 | 62 | 31,130 | 1571 | 2 | 7681 |
| Individuals | 117 | 1 | 36,417 | 73 | 1 | 20,066 |

## Conclusions and Future Work

This preliminary investigation into the data collected during a large-scale study of Twitter users connected to journalism and news organisations has revealed some interesting areas that require further examination. From examining the amount of original content created versus the retweeting of existing content, there are clear differences between the uses of Twitter by journalists and individuals and the uses of Twitter by the news organisations for which they work. Organisations favour original content, with 10 per cent more of their tweets being original compared to individual users.

The same is true of the conversational aspects of Twitter, with organisational accounts "mentioning" news-related accounts far more often than non-news accounts. While individuals are more even, "mentioning" accounts both inside and outside the news community, examining those with whom they have longer/more conversations reveals that they too are focused on conversing within the news community more than conversing outside the community.

There is much more analysis to undertake with these data. The collection of Twitter data can be broadened to include further organisations and their staff. Comparisons can be made between those organisations approaching Twitter from a place of "old" media (established newspapers, etc.) and those "new media" organisations, focused on the Web.

The identification of communities can be improved by including more detailed analysis of user profiles and by using machine-learning classification algorithms, backed up by human evaluation to classify the users more accurately.

This paper has not addressed the vast number of retweets of original content created by users within the study by external third parties. Analysis of these retweets, the accounts that carried them out, and the comments or additions made to the original tweet may reveal insights into the level of agreement with news reporting and analysis, shedding further light on the role of gatekeepers and the spread of news information through social media.

The full content of original tweets has also not been analysed. Examining this, along with data relating to profile growth, may reveal common trends and features in audience capture and retention, increasing the knowledge of what content succeeds within social media.

## DISCLOSURE STATEMENT

No potential conflict of interest was reported by the authors.

## NOTE

1.    See https://dev.twitter.com/streaming/overview/request-parameters#follow.

## REFERENCES

Bro, Peter, and Filip Wallberg. 2014. "Digital Gatekeeping." *Digital Journalism* 2 (3): 446–54. doi:10. 1080/21670811.2014.895507.

Burnap, Pete, Omer F. Rana, Nick Avis, Matthew Williams, William Housley, Adam Edwards, Jeffrey Morgan, and Luke Sloan. 2013, May. "Detecting Tension in Online Communities with Computational Twitter Analysis." Technological Forecasting and Social Change. Elsevier B.V. doi:10.1016/j.techfore.2013.04.013.

Burnap, Peter, Omer Rana, Matthew Williams, William Housley, Adam Edwards, Jeffrey Morgan, Luke Sloan, and Javier Conejero. 2015. "COSMOS: Towards an Integrated and Scalable Service for Analysing Social Media on Demand." *International Journal of Parallel, Emergent and Distributed Systems* 30 (2): 80–100. doi:10.1080/17445760.2014.902057.

Bruns, Axel, and Jean Burgess. 2012. "Researching News Discussion on Twitter." *Journalism Studies* 13 (5–6): 801–14. doi:10.1080/1461670X.2012.664428.

Bruns, Axel, and Tim Highfield. 2012. 'Blogs, Twitter, and Breaking News: The Produsage of Citizen Journalism.' In *Producing Theory in a Digital World: The Intersection of Audiences and Production in Contemporary Theory*, edited by Rebecca Ann Lind, 15–32. Digital Formations, v. 80. New York: Peter Lang.

Bruns, Axel, and Yuxian Eugene Liang. 2012. "Tools and Methods for Capturing Twitter Data during Natural Disasters." *First Monday* 17 (4–2), April. http://firstmonday.org/ojs/index.php/fm/article/view/3937/3193.

Cleary, Johanna, Eisa al Nashmi, Terry Bloom, and Michael North. 2014. "Valuing Twitter: Organizational and Individual Representations at CNN International." *Digital Journalism*, no. January 2015 (December): 1–17. doi:10.1080/21670811.2014.990255.

Hedman, Ulrika, and Monika Djerf-Pierre. 2013. "The Social Journalist." *Digital Journalism* 1 (3): 368–85. doi:10.1080/21670811.2013.776804.

Hermida, Alfred. 2013. "#Journalism - Reconfiguring Journalism Research about Twitter, One Tweet at a Time." *Digital Journalism* 1 (3): 295–313. doi:10.1080/21670811.2013.808456.

Herrera-Damas, Susana, and Alfred Hermida. 2014. "Tweeting but Not Talking: The Missing Element in Talk Radio's Institutional Use of Twitter." *Journal of Broadcasting & Electronic Media* 58 (4): 481–500. doi:10.1080/08838151.2014.966361.

Java, Akshay, Xiaodan Song, Tim Finin, and Belle Tseng. 2007. "Why We Twitter: Understanding Microblogging Usage and Communities." Proceedings of the 9th WebKDD and 1st SNA-KDD 2007 Workshop on Web Mining and Social Network Analysis - WebKDD/SNA-KDD '07, 56–65. New York, NY: ACM Press. doi:10.1145/1348549.1348556.

Lasorsa, Dominic L., Seth C. Lewis, and Avery E. Holton. 2012. "Normalizing Twitter." *Journalism Studies* 13 (1): 19–36. doi:10.1080/1461670X.2011.571825.

Newman, Nic, William H. Dutton, and Grant Blank. 2012. "Social Media in the Changing Ecology of News : The Fourth and Fifth Estates in Britain." *International Journal of Internet Science* 7 (August 2015): 6–22. doi:10.2139/ssrn.1826647.

Nielsen, Rasmus Kleis, and Kim Christian Schrøder. 2014. "The Relative Importance of Social Media for Accessing, Finding, and Engaging with News." *Digital Journalism* 2 (4): 472–89. doi:10.1080/21670811.2013.872420.

Rosenstiel, Tom, and Amy Mitchell. 2011. "How Mainstream Media Outlets Use Twitter." The Project for Excellence in Journalism. Pew Research Center, School of Media and Public Affairs, George Washington. University. http://www.journalism.org/files/legacy/How%20Mainstream%20Media%20Outlets%20Use%20Twitter.pdf.

Vis, Farida. 2012. "Reading the Riots on Twitter: Who Tweeted the Riots?" Researching Social MediaBlog, January 24. http://researchingsocialmedia.org/2012/01/24/reading-the-riots- on-twitter-who-tweeted-the-riots/.

Vis, Farida. 2013. "Twitter as a Reporting Tool for Breaking News." *Digital Journalism* 1 (1): 27–47. doi:10.1080/21670811.2012.741316.

Zhao, Dejin, and Mary Beth Rosson. 2009. "How and Why People Twitter." Proceedings of the ACM 2009 International Conference on Supporting Group Work - GROUP '09, 243. New York, NY: ACM Press. doi:10.1145/1531674.1531710.

## ORCID

**Martin Chorley** ⓘ  http://orcid.org/0000-0001-8744-260X

**Glyn Mottershead** ⓘ  http://orcid.org/0000-0001-7552-0420

# POLITICAL JOURNALISTS' INTERACTION NETWORKS
## The German Federal Press Conference on Twitter

Christian Nuernbergk

*This article examines with whom political journalists interact on Twitter and what information they share. These relations are explored by combining a content analysis and a network analysis of interaction patterns. The activities published on journalists' personal accounts are studied. Prior research has shown that elite journalists, in particular, mainly seek to remain gatekeepers and tend to normalize emerging communication spaces. Only one-quarter of the parliamentary correspondents in the German Federal Press Conference had an individual Twitter profile as of February 2014. The content analysis of all tweets published during a week in March 2014 (N = 2210) reveals that German political journalists clearly normalize Twitter to fit existing practices: the journalists mostly tweeted about publicly relevant communication and reported in an information-oriented style. Transparency was limited on their topics of interest, and they did not provide direct opportunities for the audience to become more active in the news-creation process. The network analysis shows that the correspondents especially incorporated politicians into their regular circle of contacts. Nevertheless, the interaction networks were clearly dominated by exchanges between journalists. In this way, journalists' tweets allow us to observe expert talks rather than encouraging users to participate in a discussion.*

## Introduction

The widespread use of social media is believed to affect newsgathering, reporting, and the dissemination and discussion of news (Chadwick 2013). Its impact on journalism is primarily challenging three issues: relationships with the audience and sources, journalistic practices, and professional norms and values. While Broersma and Graham (2016, 90) argued that "the relationship between politics, journalism, and the public changed into an actual ménage a trois," research on this relationship triangle has been contradictory, particularly when journalists' or politicians' interactions with citizens on Twitter have been studied. The empirical research literature suggests only a few attempts to allow multiway communication (Lasorsa, Lewis, and Holton 2012).

Generally, the extant research has focused on audience participation and sharing practices. So far, studies have not explored why and how journalists use social media accounts to follow and interact with one another and what kind of networks emerge through this. Yet, individualized social media accounts help journalists to directly

connect with their audiences. Furthermore, they could help to cultivate relationships with specific followers, especially other journalists and actors in their beat, and might put journalists in the role of "curators" (Molyneux 2014), still trustworthy guides in an ambient system of information streams (Hermida 2010). As a consequence, journalists are also likely to be targeted when political actors (or other sources) try to strategically distribute their messages via social media.

Against this background, this article analyzes what information journalists share on Twitter and what networks emerge through their tweeting behavior. By examining German political journalists' use of Twitter, this study attempts to complement previous research on interactions between journalists, politicians, and ordinary citizens (lay people) from a network perspective. Generally, political journalists have a comparably high status in Germany; senior and better-paid journalists more often belong to the political beat instead of to other editorial departments (Reinemann and Baugut 2014). By analyzing how the members of the Federal Press Conference (BPK)—the country's leading group of political journalists—use Twitter, this study also contributes to a better understanding of how a core part of journalism adapts to social media.

## Literature Review

A growing body of scholarly work on Twitter has been conducted in several areas (for an overview, see Weller et al. 2014). Consequently, the relationship between Twitter and journalism has also been emphasized (e.g., Hermida 2010). Social media has changed the way news is produced, disseminated, and discussed (Nielsen and Schrøder 2014). Hence, journalism studies related to Twitter have mainly focused on how media organizations and individual journalists adapt to social media.

### Journalists' Twitter Use and Professional Norms

Quite a few studies have been interested in how professional values shape the integration of social media in the news process, and how Twitter affordances may affect these practices and norms. According to the objectivity norm, journalists are expected not to deviate from their role as nonpartisan information-providers (Kovach and Rosenstiel 2007). Furthermore, the principles of accountability, transparency, and inclusivity are also taken into consideration. Transparency as a news account demands openness about how news materializes, and who contributes to it. Accountability, in this sense, means that journalists rely on knowledgeable sources and reference original source material where possible (Lasorsa, Lewis, and Holton 2012). As Revers (2014, 808) put it, tweeting journalists promote participatory transparency by enabling and thus implicitly inviting "others to interact with them and to get involved in the news process." Holding public discussions in social media, linking to source material and being open about methods and about one's job can all be interpreted as indicators of (participatory) transparency. Such openness presents an opportunity to be more accountable, and is likely to increase legitimacy with citizens (Karlsson 2010).

Lasorsa, Lewis, and Holton (2012) analyzed how journalists negotiated these professional norms on Twitter. In short, they found that journalists both adopt Twitter features and normalize this communicative space to suit existing routines. According to their findings, journalists indeed offer a substantial number of personal opinions in their tweets, and

may thus circumvent the objectivity norm. A specific analysis by Lawrence et al. (2014) of US political journalists around the 2012 party conventions also revealed a significant amount of tweets containing opinions.

Hedman (2014) demonstrated that journalists who embrace Twitter enthusiastically were especially more inclined to deviate from professional norms. Her representative Swedish survey found that journalists using Twitter on a daily basis were more likely to adjust to evolving social media practices compared to their less active colleagues. Furthermore, some studies found that the workplace is likely to affect the journalists' degree of sharing of opinions and personal information. Elite journalists who worked for major news outlets shared comparably fewer opinions than their counterparts at minor outlets (Lasorsa, Lewis, and Holton 2012). Cozma and Chen (2013), who studied US foreign correspondents, demonstrated that print correspondents were more likely to share opinions than broadcast journalists. In contrast, Hedman (2016) found that journalists working for television were tweeting almost twice as much personal information than their counterparts working at the tabloids.

Rogstad's (2014) survey study on Norwegian political journalists found that microblogging took place in an almost exclusively non-private manner. However, news commentators were particularly more inclined to challenge professional distance and neutrality when using social media. This group was also more likely to discuss politics, compared to political reporters.

In this particular context, Germany might also be an interesting object of study: a longitudinal analysis by Umbricht and Esser (2014) described the reporting patterns of German newspapers as remarkably stable, and identified only a moderate level of opinion-oriented news. Furthermore, survey data by Gulyas (2013) showed that German journalists are especially more reluctant to use and are more critical towards social media in comparison with their UK and Swedish colleagues.

Against this specific backdrop, this study seeks to explore whether German political journalists tend to normalize Twitter as a space by largely following professional norms and practices. To describe patterns of how these journalists use Twitter, different forms of reporting, investigation, and audience participation practices will also be illuminated.

**RQ1:** How do German political journalists use Twitter? Do they adapt to the objectivity norm by avoiding composing opinionated or personal messages?

## Journalists' Interaction Networks on Twitter

Generally, research to specifically determine journalists' interaction networks with politicians and other actor groups is scarce. This is surprising, given that the playing field for political reporting is likely to be extended by social media (Broersma and Graham 2016). A few studies have looked at this phenomenon by focusing on the politicians' side and their outgoing relations; for instance, D'Heer and Verdegem (2014) and Nuernbergk and Conrad (2016) found that journalists often appear as interaction partners in politicians' tweets. Verweij (2012) combined both actor perspectives in one study by exploring how 150 Dutch journalists and politicians follow one another. However, the underlying network was not based on actual use of Twitter's @mention and retweet features, and thus could not reveal how these follower and following relations manifest in public discussions.

The extant literature also found a strong tendency towards linking to and retweeting fellow reporters. The findings on interactions of Lawrence et al. (2014, 800) indicated that political journalists do not tend to "disrupt traditional one-way gatekeeping flows," which calls the inclusivity of these interactions into question. Unfortunately, the authors did not study interactions based on the @mention feature. Revers' (2014) study of correspondents' tweets at the New York State Capitol showed that a significant portion of these messages promoted the journalists' own news stories as well as their colleagues'. Journalists were also the main discussion partners, which may be explained through Broersma and Graham's (2016) argument that political journalists avoid public talks with politicians on Twitter because competitors watch them closely, and they do not want to share what they are working on.

I believe that further mapping of such discussions could provide insights into how source relationships evolve, and how inclusive they are in terms of participatory communication. According to a survey by Neuberger, Langenohl, and Nuernbergk (2014), Twitter was the most used social media platform for the continuous monitoring of prominent sources. Twitter has also been often used to find experts to cite, and for building expert networks. It is likely that these purposes are especially relevant for the political beat. Large proportions of Members of Parliament are now active on Twitter in several countries, particularly trying to influence legacy media (Broersma and Graham 2016).

The second research question specifically explores the networking behavior of political journalists within this context:

**RQ2:** To what extent do political journalists interact with politicians, journalists, and other users, and how do different Twitter features (@mentions, retweets) relate to these interactions?

## Research Focus and Methodology

### Cases, Population, and Sample

The empirical goals of this study require locating political journalists who use Twitter. I identified these journalists on the basis of a directory edited by the BPK and issued in February 2014. The directory comprises all BPK members; members must be German citizens and report on federal politics as their main occupation. As the nation's main press gallery, the BPK organizes the government press conference as well as conferences with leading representatives from politics, business, and culture. Currently, the directory lists more than 800 parliamentary correspondents.

By using Google and Twitter I examined whether each of the 839 BPK members had a Twitter account. All Google searches included the journalist's full name in combination with the search term "Twitter". Identified individual accounts were only considered when they exhibited a journalistic affiliation with their holder's newsroom as noted in the BPK directory (that is, within the account's public self-description field). Accounts that did not disclose a journalistic affiliation of their holder were additionally searched for tweets containing references to this. Accounts that did not include any such tweets were excluded from tracking. Overall, I located 218 BPK journalists with an accessible Twitter account (26 percent).

The data retrieval took place using Twitter's Streaming API (application programming interface). All tweets from the respective accounts were tracked during a month-long

period from March 8, 2014 to April 4, 2014. The monitoring of this timeframe allowed me to describe the Twitter habits on a comprehensive basis. The tracking located 9940 tweets composed by 170 journalists who were active on Twitter during that month (78 percent, $N = 218$). I also tracked all other tweets containing the respective @usernames. A total of 878 users directed 1570 tweets to the group of BPK accounts.

To conduct a meaningful combination of both content and network analysis, a continuous subset of tweets was needed. The tracking did not show significant differences of activity during the four weeks. Therefore, I selected the first week for a detailed analysis (March 8–14, 2014). During this particular week, the European Union decided on initial sanctions towards Russia because of the Crimea crisis, and in Germany, the president of FC Bayern Munich was convicted of tax evasion. For the content analysis I coded 2210 tweets published during the selected timeframe.

Almost one-quarter of these tweets were retweets (24 percent). One-third of all tweets did not @mention or retweet other Twitter accounts (33 percent). All remaining tweets could have been directed to more than one user. Thus, for the purpose of completely mapping interactions, all identified user–user pairings were listed separately according to their interaction type (retweet or @mention). The network analysis was conducted using UCINET 6.499 and Gephi 0.8.2.

## Coding Categories

To analyze how individual Twitter profiles are used for reporting practices, I first examined the context and topics of the tweets. The applied "context" variable refers to the relevance of the disclosed information from a societal viewpoint: "personal communication" in this analytical sense discloses solely information of personal relevance (e.g., tweeting about one's personal life, emotional state, a current location, or a holiday impression). Conversely, "public communication" is considered to relate to a (current) topic of social or public relevance. These tweets' "topics" were also classified according to typical news beats and genres (that is, politics, business, culture, sports).

In order to analyze RQ1, I examined whether journalists freely express their *opinions* on Twitter and thus deviate from their traditional role as a nonpartisan information provider (see Lasorsa, Lewis, and Holton 2012). Tweets were classified as containing major opinions, minor opinions, or information-only. Additionally, I separated tweets into three different "journalism styles" (information-oriented, entertainment-oriented, or service-oriented).

Different indicators were used to determine how journalists provide *transparency and accountability* in their Twitter messages: first, the variable "source" examined whether journalists provided additional information on a news source. Second, "observation" was coded if journalists stated that they were directly reporting from a scene or participated in an event. Third, "transparency" was coded if a journalist tried to explain their own reporting (such as by providing background information or justifications). Fourth, I checked whether the journalists' tweets contained feedback requests (to their followers) on their own reports.

Twitter opens avenues for *audience participation* in many ways. Besides retweeting non-journalists, journalists can let users participate in the news process in various forms. "Response bid" was coded when journalists requested their followers to respond to specific questions on current events. I also examined whether Twitter users were requested to send "pictures/videos" to the newsroom. Furthermore, messages were checked for hints at more

ambitious tasks like "crowdsourcing requests" (crowdsourcing allows specific tasks to be shared with active users, such as classifying documents, etc.) or "story editing". I also noted tweets containing requests for eyewitnesses or experts (on a specific topic or incident). Furthermore, all tweets directed to other users via @mentions were examined for responses or questions related to current news ("news conversation").

RQ2 considered with whom political journalists interact on Twitter and how this is related to different Twitter features. Thus, the appearance of different Twitter operators (@mentions, retweets, hashtags, and hyperlinks) was noted. Next, I coded all actor types, which appeared through @mentions or retweets directed to their accounts. Actors were only classified as "ordinary citizens" if I found no indication of them holding an office or being a representative. Conversely, members and representatives of indicated organizations/groups were classified according to the respective actor types [political actors, media actors, business actors (that is, companies/corporations), economic interest groups/unions, civil society groups and organizations, religious actors, judiciary actors, and science actors]. Following these classifications, I partitioned the actor networks of user–user pairings based on each actor's attributes.

## Reliability

Four undergraduate coders participated in the coding process. I tested the coding instrument's reliability in two steps (before coding started and during the process). Hidden test-tweets were included in all coders' final data sets. Each variable's reliability was estimated on the basis of up to 328 independent decisions in the final test. I used Krippendorf's α as conservative and percentage agreement (according to Holsti's method) as a more liberal reliability coefficient. The α-value reached 0.75 on average and percentage agreement 0.92. Krippendorf's α was below 0.66 for only one variable reported in this study ("source"; see above), but percentage agreement was sufficient (0.79).

## Findings

An overview of the journalists in our sample shows that 134 BPK members tweeted during the week analyzed. Two-fifths of these worked for daily newspapers (40 percent, $N$ = 51), roughly one-quarter for news magazines/weekly newspapers (27 percent, $N$ = 34), one-quarter for broadcast media (25 percent, $N$ = 32), and only a few members were associated with internet-only news providers (3 percent, $N$ = 4) or news agencies (6 percent, $N$ = 7). Most of the journalists were male; females represented just 24 percent. The majority of BPK journalists had non-leading functions, as most of them were correspondents (64 percent). Five account holders were chief editors, and 20 had managing roles for parts of the respective media according to their self-description.

### Topics and Reporting Styles

Most of the journalists' messages remain in a professional news context: 90 percent of tweets were related to publicly relevant communication ($N$ = 2005). In contrast, political journalists rarely composed messages of just personal relevance (5 percent). Unsurprisingly, political topics were the most popular among the BPK journalists' postings (56 percent, $N$ = 1778); interestingly, the second most important category referred to media and internet (14

percent). Business topics were also somewhat visible (4 percent). All other listed topics reached values below 2 percent.

The journalists studied mostly remained in a nonpartisan role: a clear majority of the messages contained only information without opinions (65 percent, $N = 1365$); one-fifth of the messages exhibited personal views (18 percent); and the remaining proportion contained a mixture of both forms. Major opinions were most visible in messages from journalists working for news magazines and weekly newspapers (29 percent, $N = 214$), but overall, the media sectors differed only in a minor way in this regard (Cramer-$V = 0.146$, $p < 0.001$).

The tweets were generally written in an information-oriented style (84 percent, $N = 1821$). BPK members rarely composed postings in an entertainment-oriented way (15 percent). Likewise, information related to service journalism was only occasionally provided (1 percent). However, the journalists sometimes posted recommendations or promoted interesting media content (9 percent, $N = 1877$). Such recommendations are of a navigational character and could help users to follow the news.

## Transparency and User Participation in the News Process

To a very limited extent, the BPK members' tweets help to explain the news process and offer insights on their own role in it: only five tweets provide background information on a story's genesis. Perhaps blogs are preferred for such information because they allow these issues to be discussed in a less instantaneous environment. In our case, the messages also rarely stated that their author reported directly from a scene or event (4 percent, $N = 1819$), with the journalists mainly using Twitter to quickly share news-related information. Only a few tweets contained further information on relevant sources (5 percent, $N = 1878$), and more than two-fifths of the messages provided links to news items (45 percent, $N = 1878$). However, most of these linked to the journalists' own reports and respective media websites. None of the tweets contained requests for feedback on own reports. Somewhat related to the dimension of transparency is "job talking" (see Lasorsa, Lewis, and Holton 2012); tweets in this category contained information about personal experiences that occurred at work. Such personal impressions were only provided in 2 percent of all tweets ($N = 2193$).

The BPK journalists did not broadly allow their Twitter audience to engage with them on the news as it happened. Only a few tweets contained questions on current events and requested the respective followers to respond (3 percent, $N = 1899$). However, I observed that *some* users successfully interacted with the journalists by becoming conversation partners through @mentions. Thus, I looked for news-related questions or responses only directed to these users. This particular exchange on news—using Twitter's @mentions feature—appeared in 8 percent of the cases ($N = 1883$).

Investigation efforts have been a rather uncommon part of political journalists' public activity on Twitter: the selected week's sample did not contain tweets that specifically searched for experts or eyewitnesses or any requests for photo or video material. Likewise, no efforts to participate in crowdsourcing projects were found in any of the tweets analyzed.

## Network Interaction Patterns and Use of Operators

To contribute to answering RQ2, this section explores the different actor types with whom the political journalists interacted using Twitter's features. Therefore, the analysis will

focus on @mentions and retweets. The operators were used to different degrees: on the aggregated account level, hyperlinks were the most popular feature among the BPK members (Table 1), followed by hashtags and @mentions. More than two-thirds of the BPK journalists also retweeted messages. The frequent use of hyperlinks indicates that information sharing is largely relevant to journalists' tweeting behavior. Unsurprisingly, media websites were clearly dominant with regard to external linking (67 percent, $N = 786$) in self-composed tweets. Websites related to political actors (4 percent) only played a minor role.

Overall, the analysis identified 1427 @mentions; one-fifth of these (21 percent) appeared within a retweet. Those @mentions within retweets were excluded from the following network in order to define with whom the journalists personally decided to interact. The majority of @mentioned accounts were user-owned (63 percent) rather than organization-owned (37 percent, $N = 1110$). Most often, @mentioned accounts belonged to journalistic actors, followed by political accounts (see Table 2). A smaller but substantial third proportion—every seventh @mention—was addressed to citizens. Contact with all other actor types remained an exception. Remarkably, major opinions were significantly more prevalent when citizens were @mentioned (53 percent, $N = 75$) than in the case of other actor types (15 percent, $N = 682$, Phi $= 0.294$, $p < 0.001$).

**TABLE 1**
Use of common Twitter operators

| | Tweets using … | | Accounts using … | |
|---|---|---|---|---|
| | % | N | % | N |
| Retweets (RT@) | 24.1 | 2210 | 70.9 | 134 |
| @mentions[a] | 49.6 | 1678 | 78.0 | 123 |
| Hashtags (#)[a] | 52.7 | 1678 | 80.5 | 123 |
| Hyperlinks (http://)[a] | 48.8 | 1678 | 86.2 | 123 |

[a]Operators within retweets not counted.

**TABLE 2**
Actor types of interaction partners by using retweets and @mentions

| Actor type | @mentions to … % (N = 1058) | BPK accounts with @mentions of … % (N = 96) | Retweets from … % (N = 517) | BPK accounts with retweets of … % (N = 94) |
|---|---|---|---|---|
| Media users/organizations | 54.8 | 85.4 | 73.7 | 94.7 |
| Political users/ organizations | 22.8 | 38.5 | 9.1 | 20.2 |
| Ordinary citizens/non-affiliated users | 14.3 | 45.8 | 11.4 | 30.9 |
| Business users/ organizations | 2.4 | –[a] | 1.4 | –[a] |

All other actor types with proportions below 2 percent not shown.
[a]Not calculated on account level.

The majority of retweets were previously sent by user-owned accounts (71 percent, *N* = 540), while organization-owned accounts accounted for 29 percent. Nearly three-quarters of retweets were associated with journalistic accounts. Political actors, in particular, were far less retweeted than @mentioned. Only one-fifth of the BPK accounts retweeted political actors. Retweets are often perceived as endorsements, which may be one reason for journalists to only retweet political actors in exceptional cases.

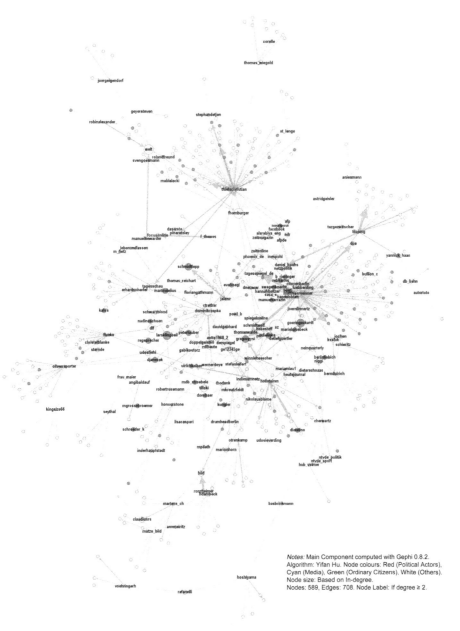

Notes: Main Component computed with Gephi 0.8.2. Algorithm: Yifan Hu. Node colours: Red (Political Actors), Cyan (Media), Green (Ordinary Citizens), White (Others). Node size: Based on In-degree. Nodes: 589, Edges: 708. Node Label: If degree ≥ 2.

**FIGURE 1**
The @mention network emerging from BPK journalists' tweets (main component-only)

The BPK @mention network deriving from the weekly sample consisted of 663 nodes and 761 edges. Most accounts showed no direct connection: the average in-degree was 1.15, and the average weighted in-degree was 1.71 (includes multiple connections). These numbers indicate that a typical conversation activity was mostly limited to two nodes, and rarely occurred more than twice during the given period. In particular, supra-regional media organizations, television journalists, and a news agency's chief editor were mentioned quite often. Some top politicians (Göring-Eckardt, Gysi) also appeared among the network's most visible accounts. These politicians also received comparably high weighted in-degrees. This means that they were mentioned more than once by specific users.

Because political actors were often connected to different BPK journalists, many were centrally located in the @mention network (see Figure 1). This indicates that interactions between journalists and politicians are not an isolated phenomenon caused by a small number of highly active journalists. Within the network's k-core (with $k = 2$), I found the chancellor's speaker and 24 politicians of different parties in the Bundestag and the European Parliament. The k-core contains all accounts connected to at least two other network members.

The retweet analysis shows that the network based on BPK journalists' retweet activity was also comprehensive: it contained 410 nodes and 450 edges. A total of 95 BPK members retweeted 315 different users. As explained above, a large majority of retweets went to other journalistic actors (Table 2). An additional k-core ($k = 2$) analysis showed that only three accounts managed by "ordinary citizens" received retweets by at least two BPK members. In contrast, the retweet k-core with 95 members contained nine political actors who were often located in the core's center.

## Conclusion

The detailed analysis of Berlin's political journalists' tweets revealed that this elite group of German media is still likely to "normalize" Twitter to fit existing norms and practices. Although this study showed that journalists freely expressed personal opinions in some of their tweets, the sharing of this opinionated journalism does not generally deviate from the findings reported for German newspapers (see Umbricht and Esser 2014). Unsurprisingly, most of the tweets covered news related to the political domain. Thus, by following BPK members, one can derive some insights into the particular topics to which the journalists were attracted. Admittedly, those who follow for "the purpose of understanding the news" may "get disappointed" (Hedman 2016, 10). While journalists often promoted (own) media content and acted in some ways as news curators, most of their tweets did not significantly increase transparency and accountability. Likewise, only in a few exceptions did the journalists provide opportunities for their Twitter audience to participate in the news.

Based on a network analysis, this study has contributed with evidence that journalists are likely to remain in a *journalism-centered bubble* and to mostly interact with one another on Twitter. This public networking fulfills purposes beyond political reporting. The journalists' tweeting behavior suggests that this particular networking has become also part of a strategy to profile their brands and for professional information exchange. Furthermore, political actors were also substantially visible—though to a lesser extent—in the core networks studied. This indicates that Twitter, even in a social media-reluctant country like

Germany (Nielsen and Schrøder 2014), has started to become indispensable for political reporting, and affects the dynamics between politicians and political journalists. Through social media, journalists can access a convenient channel for the monitoring of relevant sources and new means of relationship management. Nowadays, direct messages and @mentions allow reporters to quickly approach politicians and even to circumvent their spokespersons (Broersma and Graham 2016). While such exchanges may be considered part of a politician's (hybrid) news management, journalists seem to be primarily interested in quotable tweets (Nuernbergk and Conrad 2016; Broersma and Graham 2013). Such episodic micro-level interactions are indeed part of the emerging "hybrid ways in which politics is now mediated" (Chadwick 2013, 88), and journalists should keep in mind that these exchanges may often occur because of certain political aims.

As with any study, some limitations should be taken into account. My analysis of tweets and interactions is based on a weekly period. For the purpose of generalization, a longer period, ideally within a longitudinal or comparative framework, should be considered. Future studies could also examine interaction networks based on both political and media actors' interactions in order to completely describe these actors' interdependencies in social media. This would require a specific sample which uses journalists and politicians as relevant seeding points.

## DISCLOSURE STATEMENT

No potential conflict of interest was reported by the author.

## FUNDING

This work was supported by the Media Authority of North Rhine-Westphalia (LfM).

## REFERENCES

Broersma, Marcel, and Todd Graham. 2013. "Twitter as a News Source." *Journalism Practice* 7 (4): 446–464. doi:10.1080/17512786.2013.802481.

Broersma, Marcel, and Todd Graham. 2016. "Tipping the Balance of Power." In *The Routledge Companion to Social Media and Politics*, edited by Axel Bruns, Gunn Enli, Eli Skogerbø, Anders Olof Larsson, and Christian Christensen, 89–103. London: Routledge.

Chadwick, Andrew. 2013. *The Hybrid Media System. Politics and Power*. Oxford: Oxford University Press.

Cozma, Raluca, and Kuan-Ju Chen. 2013. "What's in a Tweet?" *Journalism Practice* 7 (1): 33–46. doi:10.1080/17512786.2012.683340.

D'Heer, Evelien, and Pieter Verdegem. 2014. "Conversations about the Elections on Twitter: Towards a Structural Understanding of Twitter's Relation with the Political and the Media Field." *European Journal of Communication* 29 (6): 720–734. doi:10.1177/0267323114544866.

Gulyas, Agnes. 2013. "The Influence of Professional Variables on Journalists' Uses and Views of Social Media." *Digital Journalism* 1 (2): 270–285. doi:10.1080/21670811.2012.744559.

Hedman, Ulrika. 2014. "J-Tweeters." *Digital Journalism* 3 (2): 279–297. doi:10.1080/21670811. 2014.897833.

Hedman, Ulrika. 2016. "When Journalists Tweet: Disclosure, Participatory, and Personal Transparency." *Social Media + Society* 2 (1): 1–13. doi:10.1177/2056305115624528.

Hermida, Alfred. 2010. "Twittering the News." *Journalism Practice* 4 (3): 297–308. doi:10.1080/17512781003640703.

Karlsson, Michael. 2010. "Rituals of Transparency." *Journalism Studies* 11 (4): 535–545. doi:10.1080/14616701003638400.

Kovach, Bill, and Tom Rosenstiel. 2007. *The Elements of Journalism: What Newspeople Should Know and the Public Should Expect.* New York: Three Rivers Press.

Lasorsa, Dominic L., Seth C. Lewis, and Avery Holton. 2012. "Normalizing Twitter." *Journalism Studies* 13 (1): 19–36. doi:10.1080/1461670x.2011.571825.

Lawrence, Regina G., Logan Molyneux, Mark Coddington, and Avery Holton. 2014. "Tweeting Conventions." *Journalism Studies* 15 (6): 789–806. doi:10.1080/1461670x.2013.836378.

Molyneux, Logan. 2014. "What Journalists Retweet: Opinion, Humor, and Brand Development on Twitter." *Journalism.* doi:10.1177/1464884914550135.

Neuberger, Christoph, Susanne Langenohl, and Christian Nuernbergk. 2014. *Social Media und Journalismus.* Düsseldorf: LfM NRW.

Nielsen, Rasmus K., and Kim C. Schrøder. 2014. "The Relative Importance of Social Media for Accessing, Finding, and Engaging with News." *Digital Journalism* 2 (4): 472–489. doi:10.1080/21670811.2013.872420.

Nuernbergk, Christian and Julia Conrad. 2016. "Conversations and Campaign Dynamics in a Hybrid Media Environment: Use of Twitter by Members of the German Bundestag." *Social Media + Society* 2 (1): 1–14. doi:10.1177/2056305116628888.

Reinemann, Carsten, and Philipp Baugut. 2014. "German Political Journalism between Change and Stability." In *Political Journalism in Transition*, edited by Raymond Kuhn and Rasmus Kleis Nielsen, 73–91. London: I.B.Tauris.

Revers, Matthias. 2014. "The Twitterization of News Making: Transparency and Journalistic Professionalism." *Journal of Communication* 64 (5): 806–826. doi:10.1111/jcom.12111.

Rogstad, Ingrid D. 2014. "Political News Journalists in Social Media." *Journalism Practice* 8 (6): 688–703. doi:10.1080/17512786.2013.865965.

Umbricht, Andrea, and Frank Esser. 2014. "Changing Political News? Long-Term Trends in American, British, French, Italian, German, and Swiss Print Media Reporting." In *Political Journalism in Transition*, edited by Raymond Kuhn, and Rasmus Kleis Nielsen, 195–217. London: I.B.Tauris.

Verweij, Peter. 2012. "Twitter Links between Politicians and Journalists." *Journalism Practice* 6 (5–6): 680–691. doi:10.1080/17512786.2012.667272.

Weller, Katrin, Axel Bruns, Jean Burgess, Merja Mahrt, and Cornelius Puschmann, eds. 2014. *Twitter and Society.* New York: Peter Lang.

# JOURNALISM UNDER THREAT
## Intimidation and harassment of Swedish journalists

**Monica Löfgren Nilsson** and **Henrik Örnebring**

*Previous studies of intimidation and harassment of journalists have (rightly) focused on non-democratic and authoritarian nations and/or transitional/emerging democracies. In this article, we examine the situation in Sweden, a country with strong de facto and de jure safeguards of journalistic freedom and autonomy. We report the findings from a representative survey of Swedish journalists where three themes are analysed: the extent of harassment, the forms of harassment, and the consequences of intimidation and harassment. The results show that a third of the respondents had experienced threats at work in the past year, and an overwhelming majority said they had received offensive and insulting comments. Intimidation and harassment also had consequences, both professionally and personally, such as fear and self-censorship. We therefore argue that it is time to add the dimension of external pressure and threats to the discussion of journalistic autonomy—including in countries like Sweden.*

## Introduction: Setting the Stage

Violence and overt harassment of journalists are tracked and documented by a number of international non-governmental organizations (NGOs; e.g. Committee to Protect Journalists 2015; Freedom House 2015a; Reporters Without Borders 2014). Attention is generally focused on overt violence toward journalists in authoritarian or semi-authoritarian societies. These are the most visible, the most extreme, and arguably the most urgent instances of harassment of journalists. There is likewise extensive scholarship on war reporting, which often touches upon issues of violence, safety, and the effects of violence and other trauma (e.g. Carlson 2006; Feinstein 2006; Greenberg et al. 2007; Tumber 2006). Because the perpetrators of violence against journalists are commonly states, insurgency groups, or organized crime (e.g. Freedom House 2015a, 1), such violence is rarer in democratic countries, where the state can guarantee the rule of law and has a monopoly on legitimate violence. Thus, research on violence and threats to journalists in (Western) democracies is very sparse, even though democracies also have, at various points, used violence against media professionals and institutions (e.g. Chalaby 2000; Nerone 1994).

There is reason to move beyond both the focus on authoritarian societies and on overt violence in the further study of threats and harassment against journalists. Recent studies of media and democracy in Central and Eastern Europe revealed many cases of threats and various forms of harassment (legal, economic, and personal) to journalists and media outlets in the studied countries—all European Union members and on paper

fairly stable parliamentary democracies. Perpetrators ranged from governments, political parties, corporations, and criminal groups (e.g. Bajomi-Làzàr 2011, 18–19; Örnebring 2012, 22–23; Štětka 2011, 16–17). Even if violent attacks are rare, various forms of harassment of journalists exist in democratic societies as well. Sweden, the country studied here, often is placed at the very top of the scale of media freedom and democratic development (e.g. Economist Intelligence Unit 2015, 3; Freedom House 2015b, 26) and thus, all things being equal, we would expect threats to and harassment of journalists to be at a very low level and violent attacks against journalists to be virtually non-existent. As we shall see, this is not quite true.

However, we may conversely expect certain conditions that may "encourage" harassment to be more applicable in democratic nations than in non-democratic ones. Journalism is a public profession, and journalistic work is performed in the public eye. The visibility of and public access to journalists have increased manifold in recent years due to the rise of audience interactivity as a core value in the contemporary media industry (Gillmor 2006; Hedman and Djerf-Pierre 2013; Usher 2014). In most democratic nations, journalists are more visible and accessible than ever, and audience members have unprecedented opportunity to (anonymously) express whatever sentiments they wish to journalists, in particular in the online context.

## Theoretical Framework

Regardless of our opinions of the social legitimacy of journalism as an agent of democracy, most of us would intuitively agree that violence, threats, and harassment of journalists constitute a democratic problem, particularly if such attacks are systematic and sustained. Furthermore, systematic violence toward and intimidation of journalists also commonly indicates more widespread democratic problems, for example, the inability of the state to maintain a monopoly on legitimate violence, weak police, and judiciary authorities who are unable to guarantee the rule of law, low status of freedom of expression in general, and so on (Waisbord 2002).

Physical attacks and other forms of intimidation and threats against journalists in most cases have the explicit purpose of silencing journalists or entire media outlets. As Nerone writes in his history of anti-press violence in the United States, "Acts of violence have rarely been just noise—senseless explosions of passion, bestial reactions from bestial people. On the contrary, most of the acts of violence discussed here were quite strategic" (Nerone 1994, 214). Harassment can therefore be considered political, even though it may come from individuals who are not organized in any conventional sense. "In most cases, violence against the press expresses some kind of judgment about the proprieties of public discourse. Anti-press violence is and has been political in the deepest sense: it has been about the definition of polity" (214). Although Nerone writes specifically about violence, his points hold true for other types of harassment as well. Violence and harassment of journalists are indeed generally successful in this purpose and have a strong chilling effect on critical reporting (Chalaby 2000; Waisbord 2002).

Harassment of journalists is thus a democratic problem because it affects journalistic *autonomy*, the ability of individual journalists to work and act independently of factors internal and external to the newsroom (cf. Reich and Hanitzsch 2013, 135), and is widely considered a necessary condition for journalism to fulfil its democratic functions (for an overview, see Waisbord 2013, 43–72). While phenomena like harassment and persecution

are generally seen as important autonomy-limiting external factors in authoritarian societies (e.g. Mellor 2009), studies of journalistic autonomy in (Western) democratic contexts rarely consider such things as constraining factors (e.g. the surveys in Weaver and Willnat [2012] lack questions on harassment as a constraint on autonomy). Following Nerone's historical study, we suggest that it may be high time to include harassment and threats as key external constraints on journalistic autonomy in the Western context as well.

Nerones' typology of anti-press violence in the United States can, with some small modification, be applied to harassment of journalists more generally. Nerone differentiates between violence among individuals, violence against ideas, violence against groups, and violence against an institution (Nerone 1994, 10–12). Violence among individuals refers to cases where personal rivalries were the basis of attacks (e.g. duels between editors and personal enemies). Violence against ideas refers to attacks directed against the media by particular ideological movements (e.g. anti-federalism, Catholicism, abolitionism, and labour unionism), a form of violence that was common in the socially turbulent 1830s and 1840s. Violence against groups, by contrast, refers to violence against groups whose bases are ethnic/racial rather than ideological. Finally, violence against an institution refers to violence directed toward the media as an independent societal institution and may be used by people who in different ways feel "excluded" from the common as a way to force the news to include them in its world (conspiratorial rants against mainstream media would be a non-violent manifestation of this). Nerone holds that the first three categories are generally on the decline in the United States (some categories are also strongly connected to specific historical eras and/or movements, e.g. the persistent violence against the anti-slavery press in the 1830s and 1840s; see Nerone 1994, 84–110) and that it is the latter, i.e. violence against the media as an institution, that is dominant (if still not widespread) in the contemporary era. We would suggest that absent evidence to the contrary, the trends in Sweden are probably similar. Furthermore, Nerone's categories of violence against ideas and against groups also highlight the fact that certain ideas and certain groups may, in a given historical context, trigger more violence and harassment than others. Thus, tracking which topics seem to incite harassment helps us discern how those who engage in such harassment view the "proprieties of public discourse" (i.e. what types and categories of journalistic expression are the harassers trying to silence?). Are the threats and harassments intended to prevent the expression of specific ideas or to minimize/maximize attention to specific groups? If violence (and by extension non-violent harassment as well) is strategic, as Nerone suggests, then what specific ideas or themes are those strategic goals related to? And—perhaps most importantly—are those who threaten and harass successful in their goals, i.e. do they manage to silence journalists?

## Methodology

The study draws from a Web survey of a sample of Swedish journalists, the Journalist Panel. The panel was initiated by the Department of Journalism, Media, and Communication (JMG), University of Gothenburg, in 2012, with the aim to investigate journalistic self-perceptions and experiences from different perspectives. For the purposes of the panel, a journalist is defined as someone who is either employed or a freelancer and whose work primarily consists of journalistic activities on behalf of a Swedish media organization or one that operates in Sweden. The definition of journalistic activities used in the

panel is consistent with the one used by the Swedish Union of Journalists: namely the inde-pendent production, selection, evaluation, or editorial reworking of material on behalf of media organizations.

In spring 2013, when the survey was carried out, the panel consisted of 1936 journal-ists working in local morning press (39 per cent), metropolitan press (10 per cent), tabloids (4 per cent), radio (13 per cent), television (8 per cent), freelance (11 per cent), magazines (13 per cent), and other media (3 per cent). A comparison, in which union membership (affiliation rate approximately 80 per cent) is used as a proxy for the population as a whole, shows that the panel is largely representative in terms of critical factors, such as gender, age, education, and type of workplace. However, some biases should be noted. Since the email addresses used in the panel are typically workplace emails, permanently employed journalists are overrepresented. Furthermore, journalists working within daily news (daily press and broadcast) are slightly overrepresented, while journalists working in the popular press and journals/magazines are slightly underrepresented.

In the survey, 16 questions were asked about the frequency of threats and harass-ment, the forms/content of the threats and harassment, the measures taken after receiving threats and harassments, and the perceived consequences. After two reminders, the final participation rate was 76 per cent.

## Findings

The following section presents the key findings of the 2013 survey, first presenting an overview of the frequency of threats and abusive comments, then going into more detail about the forms of threats and abuse received, how the threats are received (in person/face-to-face, or via some kind of medium), the subjects that trigger abuse/threats, the measures taken when faced with threats/abuse, and the perceived consequences of threats/abuse.

### Frequency of Threats/Abuse

Almost a third of the Swedish journalists have received at least one threat in the past 12 months. Abusive comments, i.e. abuse, name-calling, and similar comments directed at the journalist or his/her work, which are unpleasant but do not involve any direct threat, are much more common: 74 per cent have received such comments sometime in the last 12 months and around 10 per cent receive such comments every week (Table 1).

Around a quarter of the respondents have not received any threats or abusive com-ments in the past year, and 12 per cent have received two or more threats or abusive

**TABLE 1**

Frequency of threats and abusive comments received by Swedish journalists (%)

| | Never | One time in last 12 months | Every 6 months | Every 3 months | Once every month | Once a week | Several times a week | N (replies) |
|---|---|---|---|---|---|---|---|---|
| Threats | 69 | 18 | 4 | 4 | 4 | 1 | – | 1369 |
| Abusive comments | 24 | 30 | 10 | 12 | 13 | 6 | 5 | 1356 |

**TABLE 2**
Mediation of threats and abusive comments during the last 12 months (%)

| Threat/comment mediated via ... | Threats | Comments |
| --- | --- | --- |
| Face-to-face | 8 | 30 |
| Email | 19 | 61 |
| Phone | 14 | 43 |
| Letter | 8 | 23 |
| Comments on article | 13 | 49 |
| Social media | 10 | 34 |
| Internet forum | 10 | 27 |

comments in the last 12 months. In other words, there is a strong correlation between the frequency of receiving threats and the frequency of receiving abusive comments (Pearson's $r = 0.536**$—correlation is significant at the 0.01 level, two-tailed).

The frequency of harassment differs between different groups of journalists. Journalists working at tabloids and metropolitan morning dailies are more likely than others to receive threats, 71 per cent of the first category and 48 per cent of the second have received at least one threat in the past year. Freelancers and journalists working in different kinds of magazines are conversely less likely to be threatened; 20 per cent have received a threat in the past 12 months. The pattern is the same for abusive comments. In terms of categories of journalists, columnists and op-ed writers (closely followed by managers) are more likely than other categories to receive threats and abusive comments. The results indicate that the more high-profile and visible a journalist is (columnists and op-ed writers more frequently have photo bylines than other journalists, for example), the more likely the journalist is to elicit reactions in the form of threats and comments.

Given previous research on the endemic misogyny of many online environments (Jane 2014a, 2014b), we would expect women in the public sphere to be more exposed to various forms of harassment than men. However, the survey does not support this expectation. On the contrary, 80 per cent of the men have received abusive comments compared to 72 per cent of the women. For threats, there is no gender-based difference.

In Sweden, journalists are most likely more visible than in many other countries. In 2013, most journalists' emails were easily accessible (with the exception of those working for public service television and some magazines); therefore, it comes as no surprise that email is the most common way to convey threats and abusive comments. Online threats exist, but phoning in threats is more common than threatening via internet forums, and phoning is almost as common as reader comments when it comes to conveying abusive comments (Table 2).

## Forms of Threats and Abusive Comments

Forms of harassment can vary widely from name-calling and online trolling through persistent stalking and shaming to outright threats of sexual violence or death. Therefore, a question was asked about the forms of threats and abusive comments. Among the specified alternatives, threats about physical violence are the most common; threats concerning sexual violence are rarer; and 72 per cent receive other forms of threats. Although no specific question was asked about those threats, some clues can be found in the comments

**TABLE 3**

Forms of perceived threats (%)

| The threats are about … | Often | Sometimes | Occasionally | Never | Total | N (replies) |
|---|---|---|---|---|---|---|
| … sexual violence against yourself | 2 | 3 | 5 | 90 | 100 | 386 |
| … sexual violence against someone else | 1 | 1 | 1 | 97 | 100 | 383 |
| … other forms of physical violence against you personally | 4 | 8 | 30 | 58 | 100 | 402 |
| … other forms of physical violence against someone else | 1 | 2 | 7 | 90 | 100 | 382 |
| … damage or destruction of personal property | 1 | 5 | 13 | 81 | 100 | 382 |
| Other forms of threats | 7 | 15 | 50 | 28 | 100 | 403 |

**TABLE 4**

Forms of abusive comments (%)

| Nature/content of abusive comment | Often | Sometimes | Occasionally | Never | Total | N (replies) |
|---|---|---|---|---|---|---|
| Journalistic competence | 20 | 26 | 39 | 15 | 100 | 1022 |
| Intelligence/judgement | 18 | 26 | 33 | 23 | 100 | 1003 |
| Appearance | 2 | 6 | 6 | 86 | 100 | 957 |
| Sexism | 3 | 5 | 9 | 83 | 100 | 958 |
| Racism | 5 | 5 | 6 | 84 | 100 | 945 |
| Ideological* | 10 | 16 | 24 | 50 | 100 | 989 |
| Other | 6 | 17 | 31 | 46 | 100 | 948 |

*For example, "You fucking Marxist" or "You conservative bastard".

made by the respondents. It might be that the character of these other forms of perceived threats are of a more indirect and subtle form (Table 3).

A man called me every day for three month[s], at exactly the same time, when I was standing on the [subway] platform on my way home, commented on my appearance and told me to "watch out". It started because of an article I wrote about domestic violence, I'm pretty sure about that. (Comment from respondent)

"I know where you live" or "I know where your children go to school" are other statements that would be categorized as "Other forms of threat" (Table 4).

Abusive comments also come in different forms. The most common abusive comments are about journalistic competence and intelligence/judgement. They concern a range of matters, from news values to simple statements like "You're an idiot". They may be offensive but are still more or less harmless. However, such "milder" forms of harassment also have consequences.

These results point toward the existence of a misogynist discourse. A third of the female journalists have received sexist comments in which bitch, slut, and whore are common invectives and 15 per cent have been threatened with rape, the cutting of

genitals, or other forms of sexual violence (the equivalent numbers for male journalists are 3 and 5 per cent, respectively). It is also notable that op-ed writers and journalists working at tabloids receive both more threats and all types of abusive comments discussed here much more often than other journalists.

## Subjects that Trigger Harassment

The survey shows that crime reporters as a group receive the most threats. Around 70 per cent of them have received at least one threat in the past 12 months. Together with journalists covering foreign affairs and sports, they also receive the most abusive comments; 90 per cent have received such comments. Another question was about whether there were any specific topics that generated threats and abusive comments (Table 5).

Almost every subject can trigger threats and hatred: religion, hunting, international conflicts, and even diets (these are all topics suggested by journalists in the category of "Other subject"). However, the existence of a xenophobic discourse is obvious. Many respondents report that stories concerning immigration in some way often trigger harassment. The Swedish Democrats is a populist party with reduced immigration as their main political issue, and reporting about racism also elicits reactions. "Reporting about a crime and the readers are certain that it is committed by a foreigner", "An interview with a non-European person", and "Scrutinizing statements made by the Swedish Democrats about immigration or promote a multicultural society" are some of the many examples mentioned by the respondents (in an open comment section of the survey). Furthermore, the earlier mentioned misogynist discourse is also visible in terms of subjects, since 16 per cent of the journalists mention feminism/gender issues as triggers.

**TABLE 5**
Subjects that generate threats and abusive comments according to journalists (%)

| Stories about … | Threats | Abusive comments |
|---|---|---|
| Immigration/immigrants/refugees/integration | 38 | 44 |
| Gender issues/feminism | 16 | 16 |
| Crime | 16 | 4 |
| Racism | 11 | 9 |
| Swedish Democrats | 9 | 8 |
| Sport | 6 | 7 |
| Other subjects* | 40 | 36 |
| N (replies) | 228 | 404 |

*For example, other political topics, hunting, religion, international affairs, dieting advice.

## Measures Taken and Consequences of Threats

In the survey no definitions of threats or abusive comments were provided, which makes it hard to judge how serious they actually are. Therefore, two questions were asked about whether the journalists had taken any measures and whether the harassment had had any consequences for them (Table 6).

Around a third of those who have received threats have taken some kind of protective action. Among those, a third had contacted the police to file a report. The most common protective measure was to make it harder (in different ways) for people to find

**TABLE 6**
Measures taken by journalists who have been harassed (%)

| Measures taken | Threats | Abusive comments |
|---|---|---|
| None | 66 | 85 |
| Installing alarms at home | 10 | 0 |
| Reporting threat/abuse to police | 33 | 7 |
| Different forms of personal protection* | 14 | 0 |
| Restricting behaviour on social media | 13 | 13 |
| Hiding/erasing phone number and other personal data | 38 | 6 |
| Blocking email account | 0 | 7 |
| Closing down/sharply restricting the possibilities to comment on content | 0 | 44 |
| N (replies) | 450 | 1078 |

*For example, personal alarms with direct contact to the police, police protection, camera surveillance, bullet-proof vest.

the journalist's phone number or address. One strategy was to erase data from public records wherever possible, an action taken by 38 per cent of threatened journalists.

Concerning abusive comments, 15 per cent of the journalists have tried to avoid them in different ways. By far the most common way is to close down or moderate readers' comments. Another way is to obstruct contact by email or phone and to close down blogs, Twitter accounts, and other forms of social media accounts. Seven per cent found the abuse serious enough to contact the police.

Despite a lack of aggregated data and specific studies on the issue, it has often been claimed that the harassment of journalists, including threats of violence, has a serious psychological effect that may result in self-censorship (Waisbord 2002). The survey supports such claims since the threats received clearly have consequences for the daily practices of journalists; more than a quarter of the threatened journalists have avoided covering specific topics and groups because of the risk of threats/abuse. Furthermore, there are consequences on a more personal level in the sense that half of the threatened journalists regard the threats as serious and have become scared, and 1 out of 10 has considered leaving the profession. In this sense, it sadly seems like threats and abuse of journalists "work", i.e. it does scare journalists and prevent them from writing about particular topics, actors, or groups (Tables 7 and 8).

It would seem a reasonable assumption that the frequency of threats affects the consequences. Frequency of threats does have an effect on fear (Pearson's $r = 0.341**$) and on thoughts about leaving the profession (Pearson's $r = 0.338**$). The frequency of threats affects self-censorship as well, however, to a somewhat lesser degree: avoiding subjects (Pearson's $r = 0.125**$) and avoiding groups (Pearson's $r = 0.156**$).

The results also show that abusive comments do not have the same impact on self-censorship as threats. One-third of the respondents worry about the comments they receive, and two-thirds sometimes get offended/hurt. However, while the frequency of threats mainly had effects on a more personal level, the frequency of abusive comments, on the contrary, has effects on self-censorship; the more abusive comments, the more censorship: avoiding subjects (Pearson's $r = 0.289**$) and avoiding groups (Pearson's $r = 0.248**$).

**TABLE 7**

Consequences of being threatened (%)

| It happens that I … | Often | Sometimes | Occasionally | Never | Total | N (replies) |
|---|---|---|---|---|---|---|
| … avoid covering specific issues because of the risk | 1 | 5 | 20 | 74 | 100 | 453 |
| … avoid covering specific persons/groups because of the risk | 1 | 4 | 25 | 70 | 100 | 451 |
| … become afraid of the threats I receive | 4 | 11 | 34 | 51 | 100 | 446 |
| … consider quitting the profession because of the threats I receive | 1 | 2 | 6 | 91 | 100 | 446 |

**TABLE 8**

Consequences of receiving abusive comments (%)

| It happens that I … | Often | Sometimes | Occasionally | Never | Total | N (replies) |
|---|---|---|---|---|---|---|
| … avoid covering specific issues because of the comments | 1 | 4 | 12 | 83 | 100 | 1031 |
| … avoid covering specific persons/groups because of the comments | 1 | 3 | 13 | 84 | 101 | 1032 |
| … feel hurt because of the comments I receive | 8 | 18 | 42 | 32 | 100 | 1037 |
| … worry about the comments I receive | 2 | 9 | 25 | 63 | 100 | 1036 |
| … consider quitting the profession because of the comments I receive | 1 | 2 | 6 | 92 | 101 | 1031 |

## Conclusions

As one-third of the Swedish journalists have received threats and an overwhelming majority have received insulting comments, intimidation and harassment have for many journalists become a common element of their daily work. In terms of Nerone's (1994) typology of anti-press violence, in our case defined as threats and harassment, many of these threats and comments could be considered as violence against media as an institution, as journalists are often targeted in their capacity as professionals rather than as representatives of a particular ideology or ethnic group. However, this is only partly true. Violence against ideas could also be considered an important category, as such a large part of the "trigger subjects" are topics that relate to immigration in one way or other (and as feminism/women's issues are also a distinct "trigger topic"). The intention behind much of the harassment experienced by Swedish journalists does indeed seem to be to prevent the expression of ideas of a multicultural society and to some extent gender equality from being expressed in the public sphere. Nerone (1994) furthermore points out

violence against groups as a third form of anti-press violence and in the Swedish case media coverage about non-European immigrants as a group triggers more threats and harassment than others. The categories suggested by Nerone therefore appear to be interlinked to a higher degree than originally suggested.

The intimidation and harassment of journalists can also be categorized as exclusionary or inclusionary (Nerone 1994). Exclusionary violence is meant to prevent media attention toward certain groups and ideas, and we argue—based on the fact that around a quarter of Swedish journalists have avoided covering specific groups or topics as a consequence of being harassed—that the threats and harassments are exclusionary and political in the sense that they are strategic with the intention to silence journalists. Inclusionary violence, on the other hand, constitutes a way for some people to try to impose a different news agenda on the media. We argue that the far-reaching digitalization of journalism, combined with the increasing transparency of journalistic work, has opened up new possibilities to intimidate and harass journalists for those who are dissatisfied with the proprieties of public discourse. Readers' comments, social media, and email, in this sense, represent platforms where different forms of cyberbullying can be used as tactics to force the media to include what is perceived as excluded ideas and groups. Journalists' reluctance toward audience interactivity has often been explained by an increased workload or the fear of losing control, especially in the case of readers' comments (Mitchelstein 2011; Viscovi and Gustafsson 2013). Our research points toward an additional explanation: readers' comments, social media, and email have become effective ways for both exclusionary and inclusionary intimidation and harassment.

In summary, our results show that intimidation and harassment indeed constitute an effective way to silence journalists, even in the context of a stable democratic society like Sweden. We argue, therefore, that it is high time to add the dimension of external pressure and threats to discussions and studies of journalistic autonomy, including in countries like Sweden.

## DISCLOSURE STATEMENT

No potential conflict of interest was reported by the authors.

## REFERENCES

Bajomi-Làzàr, Petér. 2011. "Hungary." Accessed 20 August 2015. http://mde.politics.ox.ac.uk/images/stories/hungary_mdcee_2011.pdf.

Carlson, Matt. 2006. "War Journalism and the 'KIA Journalist': The Cases of David Bloom and Michael Kelly." *Critical Studies in Media Communication* 23 (2): 91–111.

Chalaby, Jean K. 2000. "New Media, New Freedoms, New Threats." *International Communication Gazette* 62 (1): 19–29.

Committee to Protect Journalists. 2015. *Attacks on the Press.* Accessed 17 August 2015. https://cpj.org/attacks/.

Economist Intelligence Unit. 2015. Democracy Index 2014. Accessed 20 August 2015. http://www.eiu.com/Handlers/WhitepaperHandler.ashx?fi = Democracy-index-2014.pdf&mode = wp&campaignid = Democracy0115.

Feinstein, Anthony. 2006. *Journalists Under Fire.* Baltimore, MD: Johns Hopkins University Press.

Freedom House. 2015a. "Freedom of the Press 2015." Accessed 17 August 2015. https://www.freedomhouse.org/sites/default/files/FreedomofthePress_2015_FINAL.pdf.

Freedom House. 2015b. "Freedom in the World 2015." Accessed 20 August 2015. https://www.freedomhouse.org/sites/default/files/01152015_FIW_2015_final.pdf.

Gillmor, Dan. 2006. *We the Media*. Sebastopol, CA: O'Reilly Media, Inc.

Greenberg, Neil, Samantha Thomas, Dominic Murphy, and Christopher Dandeker. 2007. "Occupational Stress and Job Satisfaction in Media Personnel Assigned to the Iraq War (2003): A Qualitative Study." *Journalism Practice* 1 (3): 356–371.

Hedman, Ulrika, and Monika Djerf-Pierre. 2013. "The Social Journalist: Embracing the Social Media Life or Creating A new Digital Divide?" *Digital Journalism* 1 (3): 368–385.

Jane, Emma A. 2014a. "'Your A Ugly, Whorish, Slut' Understanding E-Bile." *Feminist Media Studies* 14 (4): 531–546.

Jane, E. A. 2014b. "'Back to the Kitchen, Cunt': Speaking the Unspeakable About Online Misogyny." *Continuum* 28 (4): 558–570.

Mellor, Noha. 2009. "Strategies for Autonomy: Arab Journalists Reflecting on Their Roles." *Journalism Studies* 10 (3): 307–21.

Mitchelstein, Eugenia. 2011. "Catharsis and Community." *International Journal of Communication* 5: 2014–2034.

Nerone, John C. 1994. *Violence Against the Press*. New York: Oxford University Press.

Örnebring, Henrik. 2012. "Latvia." Accessed 20 August 2015. http://mde.politics.ox.ac.uk/images/stories/latvia_mdcee_2011.pdf.

Reich, Zvi, and Thomas Hanitzsch. 2013. "Determinants of Journalists' Professional Autonomy: Individual and National Level Factors Matter More Than Organizational Ones." *Mass Communication and Society* 16 (1): 133–156.

Reporters Without Borders. 2014. "2014 Round-up of Abuses Against Journalists." Published Dec 13, 2014. Accessed 17 August 2015. http://en.rsf.org/files/bilan-2014-EN.pdf#page = 1.

Štětka, Václav. 2011. "Bulgaria." Accessed 20 August 2015. http://mde.politics.ox.ac.uk/images/stories/bulgaria_mdcee_2011.pdf.

Tumber, Howard. 2006. "The Fear of Living Dangerously: Journalists who Report on Conflict." *International Relations* 20 (4): 439–451.

Usher, Nikki. 2014. *Making News at the New York Times*. Ann Arbor, MI: University of Michigan Press.

Viscovi, Dino, and Malin Gustafsson. 2013. "Dirty Work." In *Producing the Internet*, edited by T. Olsson, 85–102. Gothenburg: Nordicom, University of Gothenburg.

Waisbord, Silvio. 2002. "Antipress Violence and the Crisis of the State." *The Harvard International Journal of Press/Politics* 7 (3): 90–109.

Waisbord, Silvio. 2013. *Reinventing Professionalism: Journalism and News in Global Perspective*. Cambridge: Polity.

Weaver, David H., and Lars Willnat, eds. 2012. *The Global Journalist in the 21st Century*. New York: Routledge.

# FAKE NEWS
# The narrative battle over the Ukrainian conflict

**Irina Khaldarova** and **Mervi Pantti**

*The crisis in Ukraine has accentuated the position of Russian television as the government's strongest asset in its information warfare. The internet, however, allows other players to challenge the Kremlin's narrative by providing counter-narratives and debunking distorted information and fake images. Accounting for the new media ecology—through which strategic narratives are created and interpreted, this article scrutinizes the narratives of allegedly fake news on Channel One, perceiving the fabricated stories as extreme projections of Russia's strategic narratives, and the attempts of the Ukrainian fact-checking website Stopfake.org to counter the Russian narrative by refuting misinformation and exposing misleading images about Ukraine. Secondly, it analyses how Twitter users judged the veracity of these news stories and contributed to the perpetuation of strategic narratives.*

## Introduction

The Ukrainian crisis has triggered claims that Russia has raised information war to a new level. The claims arise because it has effectively managed national and international perceptions of the conflict through its use of mainstream media and by controlling internet discussions, using a large amount of resources to do so (Hoskins and O'Loughlin 2015). Russian mainstream television has taken a key position in advancing the strategic narratives of the government, presenting stories about the cause, nature and resolution of the conflict to domestic and international audiences. These narratives have centred, on the one hand, on the hostility and self-interest of Western states behind the regime change in Kiev and, on the other, on the idea of a fascist threat spreading in Ukraine (Cottiero et al. 2015; Hansen 2015). Much of the discussion about Russia's information war focuses on the government-led creation of confusion and disinformation in the media (e.g. Pomerantsev and Weiss 2014).

The aggressive media campaign has been effective in that approximately 70 per cent of Russian viewers believe that the events in Ukraine are covered by the government-owned channels truthfully and without bias (Levada Center 2015; VCIOM 2014). The number of Russians citing television as their main source of information is about 90 per cent, and the majority of them are also more likely to trust their source (Volkov and Goncharov 2014). Channel One (*Perviy kanal*), which is accessed by up to 98 per cent of the population in Russia (Russian Ministry of Telecom and Mass Communications 2012), has been the

leading news source since 2009 and a great majority of Russians (82 per cent) prefer this channel to any other media (Levada Center 2015).

The internet has turned modern information warfare into a global multimedia forum where rival voices struggle to be heard (Cottle 2006), making it increasingly difficult to impose hegemonic narratives or framings on a conflict (Hoskins and O'Loughlin 2015; Miskimmon, O'Loughlin, and Roselle 2014; Kaempf 2013). While the internet provides new opportunities for top-down strategic narrative work, it also nurtures the routine contestation of strategic narratives and the management of information by a new set of elite and citizen actors (Bolin, Jordan, and Ståhlberg forthcoming).

Accounting for the new media ecology through which strategic narratives are created, projected and interpreted (see Miskimmon, O'Loughlin, and Roselle 2014), we first look at the narratives of fake news on Channel One, perceiving the fabricated stories as projections of Russia's strategic narratives, and the attempts of the Ukrainian fact-checking website Stopfake.org to counter the Russian narrative by refuting misinformation and exposing misleading images about Ukraine. Secondly, we analyse the reception of both Channel One "fake news" about the Ukraine crisis and their debunkings by Stopfake among Twitter users.

## Crowdsourced Information Warfare

StopFake was launched in March 2014 in Kiev as a crowdsourced project to fight misinformation emanating mostly from Russian media and the internet. It started as an initiative of journalism students but was joined by other professionals and computer-savvy internet users from Ukraine and elsewhere. The community mobilizes ordinary internet users to engage in detecting and revealing fabricated stories and images on the Ukraine crisis through a "Report a Fake" button.

The volunteer contribution to the StopFake community is not unique in contemporary warfare. Part of the paradigmatic change in today's wars is that ordinary people have become complicit in creating and contesting war narratives (Hoskins and O'Loughlin 2015; Kaempf 2013). While Soviet propaganda was able to control information flows, in the new global media ecology Russia's strategic narratives are fragile as they are challenged by alternative domestic information sources, international news and other transnational actors (Oates 2014). Digital communication technologies have contributed to the "privatization of propaganda" (Bolin, Jordan, and Ståhlberg forthcoming) as well as nurtured general digital suspicion (Andrejevic 2013; Kuntsman and Stein 2011), emerging in the contexts of political conflicts and war, particularly in relation to photographic authenticity.

Some studies looking at the role of social media during periods of political turbulence in Russia question the impact of the internet on politics in Russia. They show that there is no distinctive difference between opinions shared by television viewers and internet users (Cottiero et al. 2015). Moreover, over 80 per cent of Russians share negative attitudes towards politically controversial content being available online (Nisbet 2015). Other studies, in contrast, propose that the internet provides new opportunities for civic discussion that is significantly different from that provided by the traditional mainstream media (Kelly et al. 2012; Etling, Roberts, and Faris 2014). Twitter has become integrated into the new media ecology as one of the information warfare battlefields. On Twitter any (dis)information from governments, militaries or other official sources is met with counter-propaganda campaigns (e.g. Zeitzoff 2014). In general, Twitter in Russia is widely recognized

as a crucial tool in creating an independent alternative to the more tightly controlled offline media and political space, as well as for use in social mobilization and civic action (Alexanyan et al. 2012).

## Methods

The study consists of two complementary strands. The first strand looks at allegedly fake news stories on Channel One as a proxy for Russian strategic narratives and the Stop-Fake debunkings of these stories as counter-narratives. The search through the StopFake website (its Russian- and English-language versions) returned 339 items in Russian and 260 items in English between 1 December 2013 and 1 February 2015. Channel One was identified as the source of fake news in 31 reports in Russian and 30 reports in English (the reports were identical in both languages). We selected the 10 most popular debunked news stories that were shared on social networks, i.e. the reports which the Channel One website displayed as having received the biggest numbers of shares, likes or recommendations.

The other strand consists of the content analysis of 6043 tweets produced by 5391 users. We used followthehashtag.com to collect the tweets published between 1 December 2013 and 1 February 2015, which contained the URLs (including shortened versions) to the 10 selected news reports on the Channel One website and the URLs to the reports debunking them on the StopFake website (in total 20 URLs).

The analysis considers how credible the Twitter users found the Channel One news reports and their discrediting by StopFake. The sentiments contained within all individual Russian-, Ukrainian- and English-language tweets were categorized as either explicitly trusting or distrusting the news story. Neutral tweets were classified as those which did not express an opinion either way.

## Fake News as Strategic Narratives

Strategic narratives are a tool for political actors to articulate a position on a specific issue and to shape perceptions and actions of domestic and international audiences (Miskimmon, O'Loughlin, and Roselle 2014). While often drawing on the past, a strategic narrative is future-oriented and constantly re-negotiated and challenged (Miskimmon, O'Loughlin, and Roselle 2014). We believe that false news stories may represent the distillation of the Russian state narrative, having the purpose of supporting already-constructed identity claims, rather than reporting on events. Fake news often takes the form of propaganda entertainment (*kompromat*), which is a combination of scandalous material, blame and denunciations, dramatic music and misleading images taken out of context (Oates 2014).

The importance of World War II as a symbolic resource of nation building has been noted by, for example, Malinova (2014). At the core of the narrative is the victory in the Great Patriotic War, which is seen as the most "sacred achievement" in Russia's history. Consequently, labelling somebody "fascist" is a powerful way of appealing to the values of Russians, who associate World War II with fascist horrors and crimes (Cottiero et al. 2015). In mainstream Russian media, the threat of fascism being spread in Ukraine was initially related to the ultra-nationalist movements in the EuroMaidan protests. However, after the Ukrainian presidential elections in 2014, the "fascist" label started being attached to

the Ukrainian government and Ukrainian soldiers. At the same time, the Ukrainian army was termed "executioners". This was the term used during World War II for the special Nazi units that became infamous for savage reprisals against civilians. Executioners often included locals who collaborated with Nazi Germans. Channel One explicitly exploited the notion of "executioners" in its reporting on the Ukrainian army's actions in eastern Ukraine and also did so implicitly while reporting on the Ukrainian government.

The most scandalous reportage of Channel One is often cited as an illustration of the Russian information war against Ukraine (12 July 2014). It introduces a young woman as a refugee from the eastern Ukrainian town of Slavyansk from where she has fled with her four children from a Ukrainian army "atrocity". According to the eyewitness, the Ukrainian soldiers gathered locals on Lenin Square and crucified a three-year-old boy on a bulletin board and left him to bleed out while his mother was forced to watch and then tied to a Ukrainian tank and dragged around the square until she died. Her story of the Ukrainian soldiers was filled with references to the Nazi past:

> When they entered the town, there was not a single rebel there, but they shot, marauded. Even fascists did not do that. They are the great grand-children of the SS-volunteers of "Galician" division. I am saying this because I am originally from Zakarpatye, and old people there say that fascists never did what those SS-volunteers from the "Galician" division did to people. They were local, they tortured other locals, raped women, killed children. Now these [Ukrainian soldiers] are their great grand-children. They returned, rose from the ashes.

The narrative referring to Ukrainian soldiers as executioners worse than fascists was also used in two more of the 10 reports analysed. One was published with the title: "Seventy Years Ago the Soviet Army Liberated Ukraine from Fascists" (2 November 2014). The story was built around the accounts of old people from Donbas. They were shown poorly dressed and crying, and with their destroyed houses in the background. They constantly repeated that the Ukrainian army was even worse than the fascists. All the imagery was combined with alarming music and alternated with documentary episodes from World War II. Based on the words of one of the elders, the reportage claimed that the Ukrainian soldiers were fighting in Donbas because they "were promised a parcel of land and two slaves".

"Banderovtsy" is another important trope in the strategic Russian narratives on the Ukrainian crisis. Banderovtsy are followers of Stepan Bandera, leader of the nationalist faction who strove to eliminate all ethnically non-Ukrainians from Ukraine and collaborated with Nazi Germany for this purpose. After EuroMaidan where some extremist movements did use Bandera's image as their symbol, the Russian media started developing a narrative that Ukrainian national unity could lead to human rights violations and the rebirth of fascism. Channel One published a news report (14 November 2014) about the public speech of Ukrainian President Petro Poroshenko in Odessa, saying that he called Odessa a "banderovtsy city" adding that "nothing could be a better compliment for the city". The compliment was ironic and meant to be a reference to the Russian media, where anything Ukrainian could be labelled as "banderovtsy". Meanwhile, the report continued with a fragment where the President spoke about the "severe economic pressure on Ukrainian citizens living in Donbas". This fragment with Channel One's interpretation was quickly spread around the internet with the title: "Poroshenko: Children from Donbas Will Be Sitting in Cellars".

Crimea became another symbol of the glorious history of Russia. Generally, it was included in the narratives related to Russia's revenge for the siege of Sevastopol in World War II and the annexation was often referred as "The Third Defense of Sevastopol" (The Defense of Sevastopol is a "sacred" World War II battle that resulted in considerable losses for the Soviet army). After the annexation, a news report (12 May 2014) pictured how Crimea became more prosperous after joining its historical motherland and was literally overwhelmed with tourists from different countries during the May holidays in 2014. Another report broadcast a few days earlier (7 May 2014) pictured Crimea as threatened by Ukraine allegedly building a dam to block the North Crimean water channel, thus trying to prevent Crimeans having access to fresh water.

The "West versus Russia" narrative in the Russian foreign policy and propaganda has received much scholarly attention (e.g. Cottiero et al. 2015; Malinova 2014). This is a narrative based largely on binary terms and a well-established set of stereotypes, according to which Russia is spiritual, moral and loyal to traditional values, while the West is immoral and acts only in its vested interests (Malinova 2014). Within this narrative, the West is not only the antithesis of Russia, but is also portrayed as a threat and an aggressive enemy. Four of the selected news stories were used to strengthen this strategic narrative. One report (1 March 2014) was based on the statements of Russian senators, who accused the United States and Europe of creating the crisis in Ukraine and presenting a threat to Russia's security. One senator is reported as having said: "I have heard in various media outlets that the President of the United States Obama threatens Russia and says Russia will pay a heavy price for its policy." The senator also reassured his audience that they were aware of the fact that "Ukrainian Maidan militants" were trained in Lithuania and Poland. The news piece was summed up with an image of people crying in a train, who were described as Serbians leaving their homes back in the 1990s.

Another accusation was connected to the shooting down of Malaysian Boeing MH17. Mikhail Leontiev, a famous television host and a Vice President of RosNeft, in his programme *Odnako*, which he co-owns with Channel One, presented a "sensational image" (14 November 2014): this was an aerial photo claiming to show a jet fighter firing a missile at MH17. According to Leontiev, this photo was supposed to refute the widely held view in the West that MH17 had been shot down by a BUK missile fired by Russian-backed separatists in eastern Ukraine. The report openly shifted the blame to Ukraine and other countries, which purportedly supported Ukraine in this crime.

A lighter version of "propaganda-entertainment" was a report that propagates the anti-Western narrative and hostility between Ukraine and Russia in the cultural field. The news story (20 November 2014) claimed that Ukraine would not continue with the Russian tradition of celebrating New Year's Eve with Father Frost and his granddaughter Snegurochka. Rather, Ukrainians wanted to join the Western world as soon as possible and welcomed Santa Claus to celebrate with them. The report was ironic and made Ukrainians look awkward in their desire to join a world they did not belong to.

## StopFake: Debunking the Russian Narrative

Amongst the deluge of information and disinformation, there is, as Andrejevic (2013) argues, a desire to get to the real truth. In the context of conflict reporting, this desire can stem from the journalistic ideal to seek the truth, or from ideological and political commitments (cf. Sienkiewicz 2015). StopFake makes use of novel digital means to question

potentially false narratives originating from the mainstream media or internet and advances their own version of the truth. The verification of news, in this way, becomes also a form of ideological voluntary assistance contributing towards the political goals of governments or other actors (see Bolin, Jordan, and Ståhlberg forthcoming; Sienkiewicz 2015).

StopFake's debunking methods vary from report to report. One of the basic methods is pointing out the baselessness of the evidence. For example, as a response to the claim about "a parcel of land and two slaves", StopFake declared that "a mosaic of fragments of soldiers' conversations" could not serve as proof of the claim. In the same way, they argued that the helmet with a Nazi symbol pictured in the same report cannot be proven as being worn by a Ukrainian soldier because of the lack of other identifications on the uniform or details about where and when the image was taken.

Another debunking practice is based on spotting inconsistencies in details. Thus, in the "crucified boy" story, StopFake points to the fact that there is no Lenin Square in Slavyansk, which is the square where the public execution supposedly took place. Another example is from the story about "a parcel of land and two slaves". StopFake claimed that at the time when the television report was made, the Donetsk separatist forces, not the Ukrainian army, had already destroyed the village.

One of the most powerful debunking methods is presenting a counter-narrative or their own evidence that Channel One's images are manipulated. While debunking the "crucified boy" story, StopFake presented a nine-minute video of the journalist from the opposition newspaper *Novaya Gazeta*. The journalist visited the scene of the purported incident in Slavyansk and interviewed residents. The video shows a number of people saying they have neither seen nor heard anything about the crime.

Image verification is at the core of today's digital suspicion and the community revealed that several images were not what they purported to be. For instance, a photo depicting a long shallow ditch full of dead bodies, reported on Channel One as civilians killed by the Ukrainian army, was discovered by StopFake to pre-date the current conflict by nearly two decades. To prove this, StopFake published the original image, showing a Russian soldier standing over the mass graves of civilians in Chechnya in 1995 during Russia's own battle with separatists in the contested North Caucasus republic. For the sake of Channel One's argument, the soldier was cropped out and the image was reframed as a result of a Ukrainian army attack.

Regarding the "sensational photo" presented as a proof of Ukraine's guilt for NH17's crash, StopFake put a great deal of effort into convincing its audience of its inauthenticity. They claim that the photo has been artificially constructed with photo manipulation software and present several explanations as why the image cannot be authentic. The fact-checkers argued that a background fragment in the satellite photo exactly matched a patchwork of Yandex and Google Map satellite images from 28 August 2012. Secondly, the image depicts MH17 with the Malaysian Airlines logo in the wrong place, while the shape of the plane itself is also incorrect. Thirdly, on the image neither the Boeing nor the jet fighter have vapour trails, as if their engines are turned off. Finally, the image was found to have been published a month earlier on internet forums.

## Tweeting Trust and Suspicion

Out of 6043 tweets that we have collected, the original tweets constitute about 26 per cent ($N = 1596$); the biggest percentage consists of retweets, 68.4 per cent

(N = 4132); and the smallest percentage of tweets are replies to the original tweets, which is 5.3 per cent (N = 321). The tweets that include Channel One URLs prevail over those which contain StopFake URLs (87.7 per cent versus 12.3 per cent). The tweets which contain the references to Channel One are mostly "distrust" comments (54.8 per cent) or neutral (31 per cent), while the tweets with a reference to StopFake are mostly neutral (81.8 per cent) or "distrust" for Channel One content (16.8 per cent).

Not all Twitter account holders make their personal information available, but according to the publicly available data, most of the analysed tweets were posted from Ukraine (34.6 per cent), Russia (27.8 per cent) and the United States (17.3 per cent). Contributors from Canada, the United Kingdom, Germany and Latvia constitute around 11 per cent in total (Figure 1).

It should be noted that all comments expressing trust were from users based in Russia, while users based in Ukraine (tweets in Ukrainian) expressed only distrust. There were also tweets that only repeated a title or a phrase reflecting the news storyline and then provided a link to the news piece (36.4 per cent); they were classified as neutral.

Our content analysis of the tweets shows 50.7 per cent of distrust to the Channel One news (Figure 2). Fake news encouraged sarcastic, ironic comment. The strongest emotions for comments expressing distrust were sarcasm (44.5 per cent) and disgust (38.7 per cent), often targeted at propaganda on Channel One in general or the specific content of a news story. Sarcastic remarks were made with the intention of making the bizarreness of the news conspicuous: "Russian soldiers: Why do Ukrainian soldiers get two slaves and we don't? That's not fair!" Disgust was expressed through exclamations such as "ugh" or expressing explicit contempt towards the content: "You think Russian propaganda is always the same crap? No! Before, Ukrainians were Nazis. Now they're worse. #ugh. http://t.co/ZW5NNZA5Mg" and "Disgusting propaganda. http://t.co/75qdQ08i15. #MH17".

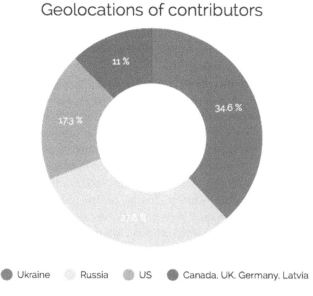

Geolocations of contributors

**FIGURE 1**
Geolocations of contributors

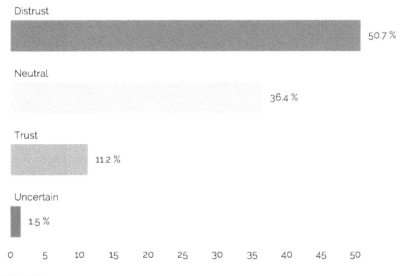

**FIGURE 2**
Users' attitude to selected news

The stories that received the highest level of distrust were about a parcel of land and two slaves promised to Ukrainian soldiers (95.6 per cent of "distrust" tweets), the crucified boy (86.1 per cent of "distrust" tweets) and Crimea being overwhelmed with tourists (48.1 per cent distrust compared with 0.3 per cent trust). Some comments, however, related to Channel One and its general policy of reporting on the events in Ukraine: "Who was doubting that Channel One never lied. Look here, this is proof: a link to the channel's website." Some Twitter users who expressed distrust also provided evidence about the baselessness of the news reports by referring to other internet users or verification sources, such as live Web cameras, YouTube videos, news media and the official Web pages of state organs and commercial organizations: "I was doggedly looking for tourists with the help of all the web cameras in Crimea. In vain. Channel One managed, it did find a whole 'wave of tourists'!"

The number of users who expressed trust in Channel One did not exceed 11.2 per cent. These posts were often emotionally neutral, i.e. expressed no emotions (43.4 per cent) or expressed aversion (36.9 per cent) towards the news story in general or particular characters in the report. Nevertheless, there were four news stories which were trusted more than distrusted according to the data. The news report about President Poroshenko threatening to keep Donbas children in cellars was among the most trusted, and also showed the minimum of suspicion about the truthfulness of the event (85.1 per cent of posts expressed trust). The other news items were about Ukraine building a dam to block fresh water to Crimea (showed 20.1 per cent trust against 0.5 per cent distrust); a supposed atrocity by the Ukrainian army that reused an image from the Chechen War (38.6 per cent trust against 30.7 per cent distrust); and MH17 being shot down by a Ukrainian jet fighter (30.5 per cent trust against 11.6 per cent distrust). The tweets reacting to these news stories were negative in their opinion of the Ukrainian government, displaying the users' indignation about events which they believed were true. The users used harsh language when referring to the official Kiev ("junta"), the United States ("americos") and the Ukrainian President. News presenting "new proof" of the responsibility of the Ukrainian

forces for shooting down the Malaysian Airlines flight MH17 generated both neutral and hostile comments: "#Russia's channel 1 obtained sat footage of a #Ukraine jet shooting down #MH17" and "One more proof that Boeing was shot down by ukrops [offensive word for Ukrainians] under the command of the US."

## Conclusions

In a diffuse media ecology, strategic narratives require continuous engagement to be able to cope with numerous opinions and rapidly changing news, and to keep their ability to shape the perception of emerging events for multiple audiences (Miskimmon, O'Loughlin, and Roselle 2014). In this light, fabricated and bizarre news reports circulating widely on the internet can be understood as agitation propaganda that is designed to provoke an affective response from the public. The set of symbolic resources and identity claims used by Channel One have been exploited to create legitimacy for the Kremlin's policy and to make a contrast between Russians and Ukrainians, who receive all the negative attitudes historically attributed to Nazi Germany. Channel One's narrative work also accentuates the contrast between the aggressive and immoral West representing a threat to Russia and Russia resisting the West's ambitions for world supremacy. The fact that television still enjoys extremely high popularity in Russia suggests that these narratives can be effectively integrated into public discourse in Russia.

However, strategic narratives do not always aim to make a rational point, and, in contrast to the claims of Miskimmon, O'Loughlin, and Roselle (2014), the power of strategic narratives does not solely rest on their credibility. Strategic narratives carried by Channel One's journalistically dubious stories can be seen aiming, in the first place, to appeal to emotions and to "blur" the border between what is real and what is not: in other words to form a context in which other messages can be communicated with greater ease (cf. Pomerantsev 2014; Oates 2014). At the same time, strategic communications are conditioned by the diffused media ecology in which narratives become evaluated and discussed by various political actors and the general public. Conflicts provide fertile territory for controversy and suspicion to appear and the internet provides ample opportunities for debunking falsehoods and producing counter-narratives. In this new media ecology, StopFake represents a hybrid agent (Chadwick 2013) that integrates different functions (journalistic and political), genres, tools and objectives.

Twitter users, on the whole, are rather sceptical about the accuracy of mainstream media narratives from Russia. Many tweets suggest that they are aware of the strategic narratives, and while they may adopt the terms offered by Channel One for describing events and actors, they make clear that they distrust Channel One, in general, and some of its content, in particular. Some users also demonstrate their own capability for contributing to the narrative work by pointing out the inconsistencies in the details of a report; by finding the images that have been used to create the allegedly fake news reports; by using verification sources available on the internet to counter Channel One news, such as Web cameras; or by making their own report from the scene of an alleged event. In future research on mediated strategic narratives, it is important to consider citizen contestation and their contributions to the perpetuation or disappearance of narratives.

## DISCLOSURE STATEMENT

No potential conflict of interest was reported by the authors.

## REFERENCES

Alexanyan, Karina, Vladimir Barash, Bruce Etling, Robert Faris, Urs Gasser, John Kelly, John Palfrey, and Hal Roberts. 2012. "Exploring Russian Cyberspace: Digitally-Mediated Collective Action and the Networked Public Sphere." *Berkman Center Research Publication* 2. http://ssrn.com/abstract = 2014998

Andrejevic, Mark. 2013. *Infoglut: How Too Much Information Is Changing the Way We Think and Know*. New York: Routledge.

Bolin, Göran, Paul Jordan, and Per Ståhlberg. Forthcoming. "From Nation Branding to Information Warfare: The Management of Information in the Ukraine-Russia Conflict." In *Media and the Ukraine crisis: Hybrid media practices and narratives of conflict,* edited by Mervi Pantti. New York: Peter Lang.

Chadwick, Andrew. 2013. *The Hybrid Media System: Politics and Power*. New York: Oxford University Press.

Cottiero, Christina, Katherine Kucharski, Evgenia Olimpieva, and Robert W. Orttung. 2015. "War of Words: The Impact of Russian State Television on the Russian Internet." *Nationalities Papers: The Journal of Nationalism and Ethnicity* 43 (4): 533–555. doi:10.1080/00905992.2015.1013527.

Cottle, Simon. 2006. *Mediatized Conflict: Understanding Media and Conflicts in the Contemporary World*. Berkshire: McGraw-Hill Education.

Etling, Bruce, Hal Roberts, and Robert Faris. 2014. "Blogs as an Alternative Public Sphere: The Role of Blogs, Mainstream Media, and TV in Russia's Media Ecology." *Berkman Center Research Publication* 8. http://dx.doi.org/10.2139/ssrn.2427932

Hansen, Flemming Splidsboel. 2015. "Framing Yourself into a Corner: Russia, Crimea, and the Minimal Action Space." *European Security* 24 (1): 141–158. doi:10.1080/09662839.2014.993974.

Hoskins, Andrew, and Ben O'Loughlin. 2015. "Arrested War: The Third Phase of Mediatization." *Information, Communication & Society* 18 (11): 1320–1338. doi:10.1080/1369118X.2015.1068350.

Kaempf, Sebastian. 2013. "The Mediatisation of War in a Transforming Global Media Landscape." *Australian Journal of International Affairs* 67 (5): 586–604. doi:10.1080/10357718.2013.817527.

Kelly, John, Vladimir Barash, Karina Alexanyan, Bruce Etling, Robert Faris, Urs Gasser, and John Palfrey. 2012. "Mapping Russian Twitter." Berkman Center for Internet and Society at Harvard University. https://cyber.law.harvard.edu/sites/cyber.law.harvard.edu/files/Mapping_Russian_Twitter_2012.pdf

Kuntsman, Adi, and Rebecca Stein. 2011. "Digital Suspicion, Politics, and the Middle East." Critical Inquiry. http://criticalinquiry.uchicago.edu/digital_suspicion_politics_and_the_middle_east/

Levada Center. 2015. "Developments in the Eastern Regions of Ukraine: Attention and Participation of Russia." Press Release. http://www.levada.ru/28-07-2015/sobytiya-na-vostoke-ukrainy-vnimanie-i-uchastie-rossii

Malinova, Olga. 2014. "'Spiritual Bonds' as State Ideology." *Russia in Global Affairs*. 18 December. http://eng.globalaffairs.ru/number/Spiritual-Bonds-as-State-Ideology-17223

Miskimmon, Alister, Ben O'Loughlin, and Laura Roselle. 2014. *Strategic Narratives: Communication Power and the New World Order*. New York: Routledge.

Nisbet, Erik. 2015. "Benchmarking Public Demand: Russia's Appetite for Internet Control." Center for Global Communication Studies and the Russian Public Opinion Research Center. http://www.global.asc.upenn.edu/app/uploads/2015/02/Russia-Public-Opinion.pdf

Oates, Sarah. 2014. "Russian State Narrative in the Digital Age: Rewired Propaganda in Russian Television News Framing of Malaysia Airlines Flight 17." Paper prepared for the American Political Science Association Annual Meeting (Political Communication Pre-Conference at George Washington University), Washington, DC. http://www.media-politics.com/presentationspublications.htm

Pomerantsev, Peter. 2014. "Russia and the Menace of Unreality." *The Atlantic*. http://www.theatlantic.com/international/archive/2014/09/russia-putin-revolutionizing-information-warfare/379880/

Pomerantsev, Peter, and Michael Weiss. 2014. "The Menace of Unreality: How the Kremlin Weaponizes Information, Culture and Money." *The Interpreter*. http://www.interpretermag.com/wp-content/uploads/2014/11/The_Menace_of_Unreality_Final.pdf

Russian Ministry of Telecom and Mass Communications. 2012. http://www.gks.ru/bgd/regl/b14_11/IssWWW.exe/Stg/d01/10-10.htm

Sienkiewicz, Matt. 2015. "Open BUK: Digital Labor, Media Investigation and the Ukrainian Civil War." *Critical Studies in Media Communication* 32 (3): 208–223. doi:10.1080/15295036.2015.1050427.

VCIOM. 2014. "Events in Ukraine: How Reliable the News in Mass Media?" Survey Data. http://wciom.ru/index.php?id = 459&uid = 114821

Volkov, Denis, and Stepan Goncharov. 2014. "Russian Media Landscape: Television, Press and Internet." Press release. http://www.levada.ru/17-06-2014/rossiiskii-media-landshaft-televidenie-pressa-internet.

Zeitzoff, Thomas. 2014. "The Way Forward or Just Another Tool in the Toolbox? Social Media and What It Means for Conflict Researchers." In *Routledge Handbook of Civil Wars*, edited by Edward Newman, and Karl DeRouen, Jr., 279–288. London: Routledge.

# GENDER, RISK AND JOURNALISM

Janet Harris, Nick Mosdell, and James Griffiths

*The central concern of this paper is to address the question, "Is it more dangerous to be a woman journalist when reporting conflict". Beck states "risk is the anticipation of the catastrophe—so it is existent and non-existent". Is the contention that female journalists are more at risk, knowledge, or a construction of knowledge? Are editors and journalists who decide that women are more at risk merely anticipating a catastrophe? There is no certainty, of course, that women are more at risk, but the fear that they might be can prevent them from being sent to cover conflict, or force them to decide not to go to dangerous places. Certainly, an improvised explosive device or rocket fire does not distinguish between sexes. In many situations being female actually helps women journalist in conflict zones. In this paper we present findings from a survey of journalists who work in conflict zones and ask whether it is the job or the gender which is the most dangerous?*

## Introduction

This paper poses and considers the question, "Is it more dangerous to be a woman journalist when reporting conflict?" The question raises a huge number of other issues and questions. Can journalism be gendered? What forms a journalist's identity? If qualifications to the role of a journalist are acknowledged, will they impact on decisions made about what stories a female journalist can cover, based on gender rather than experience or ability? The question of sexual harassment also arises as it is a risk faced predominantly by women, in the office and in the field.

There is no doubt that the number of targeted killings of journalists is rising, so research into the risks for all journalists becomes more pressing, and there is no doubt that a factor in this consideration of risk is gender. Adamczyk (2014, 78) writes, "It is beyond doubt that the phenomenon of active aggression towards women journalists, increasingly often resulting in their death, is an indivertible trend".

Active aggression towards journalists is an indisputable trend, but we wanted to find out whether respondents felt the aggression was specifically aimed at the woman or aimed at the journalist. Variations in the availability of training and safety equipment, and of job security, between freelance journalists and staff are also inextricable from these issues.[1]

The survey we conducted asks what role gender plays in the assessment of risk to journalists, but also asks what advantages being a female might bring to reporting.

## Journalism and Gender

The increasing danger to all journalists is a feature of similar surveys focused on journalistic work in the theatre of war. The recent report of the International News Safety Institute[2] (INSI 2015) states that 1480 journalists and media support workers have died doing their job in the past 10 years. Twenty-four out of the 79 respondents who answered the

INSI 2014 survey thought the increasing number of female journalists was an issue in the general rise in risk to all journalists. By 2012 female students outnumbered men by at least 2:1 in many of the most well-established journalism teaching and training programmes (Franks 2013, 3), yet as Franks writes, they disappear up the chain (3). This finding is echoed by studies from the Lebanon where, on average, four females for every male student enrol in journalism programmes (Melki 2009), yet, in the Lebanese news industry men outnumber women by a ratio of more than two to one (Byerly 2011). However, even where women have enjoyed a long history of involvement in journalism, men are still in authority and in control of newsrooms and organisations, and on the whole receive more pay (Byerly 2013; Franks 2013; Melki and Mallat 2014). There may be more women reporting, but many are still answerable to a male editor.

The International Women's Media Foundation (Byerly 2011) found that 73 per cent of the top management jobs are occupied by men compared to 27 per cent occupied by women. Among the ranks of reporters, men hold nearly two-thirds of the jobs, compared to 36 per cent held by women. However, among more experienced journalists, women are nearing parity with 41 per cent of the newsgathering, editing and writing jobs.

It is worth bearing the gender balance in mind when considering the differences of experiences of risk to freelance and staff journalists. The International Federation of Journalists (IFJ) (2009) report states that freelancers are particularly vulnerable to violence. Dwindling budgets and the closure of foreign bureaux often mean that freelancers and local journalists are excluded from training and the provision of safety equipment.

The problems of the newspaper industry, the new digital economy (Beck 1997), the changing nature of the job market and the drive to freelance work have forced many more journalists out of staff jobs. Franks (2013, 54) also writes of the drift from staff to freelance positions by many women in journalism, where freelancers tend to be paid less. Francesca Borri writes of the romantic image of the freelancer who has "exchanged the certainty of a regular salary to cover the stories she wants to is completely the opposite". She states: "The truth is that the only job opportunity I have today is staying in Syria, where nobody else wants to stay ... where you ask for $100 and somebody else is ready to do it for $70" (Borri 2015).

These are all issues which affect the decision both by the editor and by the journalist themselves when considering reporting from a conflict zone, and perhaps at the back of their minds will be the question of whether it is more dangerous to be a woman journalist than a man. Should gender make a difference, and does that give editors and organisations an excuse not to send women to conflict zones, or for women themselves to decide not to go to conflict zones?

It is not possible to say with certainty whether women journalists are targeted because they are *women* or because they are *journalists*. The Committee to Protect Journalists (CPJ) reports that 24 per cent of the journalists killed in 2015 have been killed by cross-fire or combat. However, there is a perception that reporting can be more dangerous for a woman. When Lara Logan was attacked in Tahir Square in Egypt in 2011, Reporters Sans Frontières urged news organisations not to send women to Egypt: "It is unfortunate that we have come to this but, given the violence of these assaults, there is no other solution." There was an immediate hostile reaction to this and the statement was amended to "It is more dangerous for a woman than a man to cover the demonstrations in Tahrir Square. That is the reality and the media must face it" (*The Guardian*, 25 November 2011).

It is increasingly dangerous to be a journalist, but a concern is that all aspects of danger are assigned to gender. Arguably, location, culture and assignment all contribute to risk. Caroline Wyatt (2012, 8) from the BBC, for example, states that the danger (in Afghanistan) was not to do with being female, "but with being foreign, and by local standards, rich". Likewise, Tina Susman, the *Los Angeles Times* bureau chief in Baghdad 2007–2009 states:

> Like our male colleagues our main concerns are staying alive and keeping our limbs and brains intact. But as long as most assigning Editors are male, rape will always be one of their big worries ... When a female is sexually assaulted the questions immediately arise as to why a woman was there in the first place, and whether it is wise to have a woman reporting from a dangerous place. (Susman 2012, 25)

If knowledge is a construction, and editors are merely anticipating a catastrophe, there is no certainty that women would definitely be attacked if they were sent to Egypt. In stating that it is more dangerous to assign a woman journalist rather than a male journalist, Lindsey Hilsum voices a concern felt by many women journalists:

> It's one step away from saying it's our fault, for Christ's sake ... Of course it's dangerous, and there are particular risks for women, but it's not more dangerous as a result. It would be a mistake to let that thinking dominate when preparing for what might happen. (Neilan 2012)

A feature of risk society highlighted by Beck is that culpability is passed off to individuals, and thus collectively denied (Elliott 2002), so not only does the blame become that of the individual journalist but, when she is female, that also becomes a factor in the blame.

Many of the recent studies have investigated dangers to women, but from looking at women journalists' experience over many years, there are also clearly advantages. If editors are considering gender when assigning reporters, the advantages as well as the disadvantages might also be taken into consideration. Maggie O'Kane notes that when she was in Bosnia, being a woman gave her good cover. She said:

> I am a woman. Nobody pays attention to me ... To the soldiers, I was just a pain in the ass; a funny red-haired creature; a dumb female. They didn't find me a threat ... If they think I'm a bimbo, that's just fine. They become less guarded and give me better quotes. (Ricchiardi 1994)

When covering events where you encounter male chauvinism, playing up the "only a woman" label can be a good strategy to get access and stories. Men can be seen to pose a threat or be an obvious intrusion. Alice Martins, a photojournalist who has reported from Syria, states that as a woman, she can cross checkpoints without being stopped. "These guys are scary," she says, "but they try to avoid women" (Traub 2014). However, even she has stopped reporting from Syria as the situation there is now so dangerous.

There might be advantages to being a woman, but a factor mentioned by many studies is that women are more vulnerable to sexual harassment, both as a danger to the female journalist in the field, but also in the office, so the risk came both from those being reported on and from colleagues and bosses. The IWMF 2010 report found that more than half of the regions' newsrooms surveyed have policies on sexual harassment, with the range fairly tight between 47 per cent in Western Europe to 67 per cent in both Sub-Saharan Africa and Asia and Oceania. They state "It is important to emphasize,

however, is that many nations' newsrooms in the study reported having no policies on sexual harassment while other nations' newsrooms had a 100% showing" (Byerly 2011, 36).

Melki and Mallat's (2014, 16) study shows that the majority of female journalists in the Lebanon believe that gender discrimination and sexual harassment are serious problems for female journalists. However, many women, especially those on contract or in freelance positions, fear to report being assaulted or harassed. Shahira Amin states (2012, 35), "I think a lot of female journalists would choose not to raise these issues because of the fear that they might not get sent out". Judith Matloff (2007) also argues that women often failed to report assault in case it stopped them getting future assignments or hindered gender equality.

It was also apparent from the many reports from women reporting from conflict zones that there were many occasions when being a woman reporter was actually advantageous. It was these opinions which led to the desire for a more nuanced investigation into the subject of gender and the risks of reporting. However, as in much research, there is no conclusive answer to the question about whether it is more dangerous to be a woman than a male journalist. Journalists' safety depends on many issues such as the type of conflict, its culture and location, and the journalists themselves. This study has also not addressed the debate about the inherent masculine practices in the media such as long working hours, a rigid separation of career and life, and a lack of workplace flexibility (O'Brien 2015) which also impact on issues of gender and risk.

## Methods

We sent out a total of 483 emails with a link to the survey. The majority were sent directly to journalists listed in the Frontline Freelance Register, to the female journalists listed in the Storm & Peters (2012) and to journalists in conflict zones through personal contacts. We also sent general emails to news agency bureaux and organisations concerned with the safety of journalists (National Union of Journalists, Reporters Without Borders, IFJ, INSI, IWMF, CPJ) asking them to forward emails to journalists in conflict zones. We therefore did not know the total number of individual journalists who received requests to complete the survey, but we had 142 replies using KwikSurvey, a response rate of 29.4 per cent.

In terms of socio-demographics and professional experience, 76 respondents identified themselves as female and 66 (46 per cent) male, 61 of the respondents were from Europe, 23 from North America, 34 from the Middle East and North Africa (MENA), 4 from the rest of Africa, 7 from Central America and 9 from Asia. The majority had the least journalistic experience, with 40 per cent having 0–5 years' experience, 31 per cent having 5–10 years' experience and 29 per cent over 10 years' experience.[3] Respondents were also predominantly freelance: 78 per cent and 22 per cent staff; 49 per cent were female freelancers with less than five years' experience (38 per cent males). More male freelancers (32 per cent) had been in the job longer than 10 years (16 per cent females).

## Results

### More Dangerous to Be a Female Journalist?

Many women who report on conflict are wary about assigning a gender-specific motive to attacks on female journalists. When asked, however, whether it was more

dangerous to be a female or a male journalist, respondents to this survey thought that women were more at risk than men.

In the INSI survey which looked at the main threats and challenges to journalists in 2014, 53 per cent of the respondents (82 out of 154) thought that women journalists and media workers were more at risk than 10 years ago (INSI 2015).

In the Cardiff survey 56 per cent (78 out of 140) of respondents said it is more dangerous to be a female; slightly more than the INSI survey (Figure 1). Less than half (42 per cent) agree that there are more advantages being a male journalist, while more men than women thought it was more dangerous to be a female journalist (50 per cent of women and 62 per cent of males).

Sixty-one per cent of the respondents, more men than women, said that being a journalist was the most dangerous aspect (65 per cent of females and 69 per cent of males) rather than gender (Figure 2). When the figures are broken down, 77 per cent of the most experienced journalists said being a journalist regardless of gender was the most dangers aspect; 56 per cent of those with under six years' experience also agreed; 69 per cent of freelancers say being a journalist is the most dangerous aspect, compared to 58 per cent staff.

The Cardiff survey did not specifically ask respondents' perceptions of the main threats to journalists, since this had been considered and explored in the INSI survey. However, it is worth noting the 37 per cent of respondents put "other" when asked to state whether it was more dangerous to be a female than a male journalist, and that more of the experienced journalists, as well as over half the freelancers, thought that the job was the most dangerous aspect of reporting conflict.

## Is it more dangerous to be a female journalist than a male?

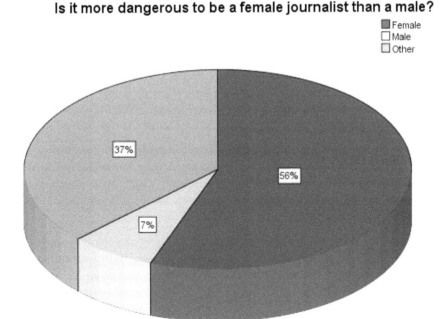

**FIGURE 1**
Is it more dangerous to be a female journalist than a male?

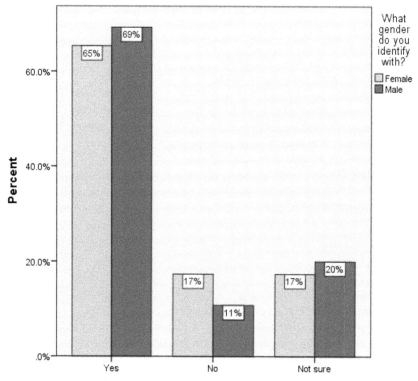

**Is being a journalist the most dangerous aspect,
regardless of gender?**

**FIGURE 2**

Is being a journalist the most dangerous aspect rather than gender?

A greater number of men than women thought it was more dangerous to be a woman journalist. If more men have senior positions in the media, this might impact on choices relating to who to assign to conflict zones. Many comments reflected that the danger was contingent on the location, the culture and the conflict. The individual's character was also important.

> There are advantages and disadvantages with either gender. But it's not just gender, it's also true with age, ethnic origins etc. Journalism is about interacting with people, so you will work better in certain cultures or environment or with certain people depending on who you are, your personality etc. (Freelance female journalist with 5–10 years' experience from East Africa)

> It all depends on the region you are in. But also, in most conflict zones, it depends more on the journalist's character. There are no advantages. A correspondent is a correspondent. (Staff male journalist with more than 10 years' experience from Libya)

### Advantages to Being a Female Journalist

A significant concern of the survey was to explore what, if any, advantages or disadvantages journalists thought there were in being a female journalist and asked respondents to

elaborate on why they thought it might be an advantage to be female, and why it might be an advantage to be a male. In this way some of the features of both gender and profession could be explored. A majority of female (63 per cent) recipients said being female had more advantages whereas 47 per cent of males said being female had no advantages (Figure 3).

Nearly half the recipients (48.4 per cent) and over half of the women (63 per cent) thought there were more advantages to being a female journalist. Over half the recipients (57 per cent) said there were no advantages to being a male journalist.

It would seem that the experience of the women journalists points to the perception that there are definitely advantages to being female, especially in cultures where women and men are segregated, and where it is unusual for a woman to be a reporter. The comments added to this section point to the complexity of the issue where location and culture impact on whether female journalists have an advantage in reporting. For example, 53 recipients mention a woman's ability to gain access to locations and events where a man might not be admitted. The Middle East, and Islamic countries where much of the global conflict to be reported is now situated, were frequently cited as places where women can access households and families barred to men.

In certain situations in strict Muslim countries for example, it is extremely difficult, if not impossible, for male reporters to talk to local women, particularly without a family

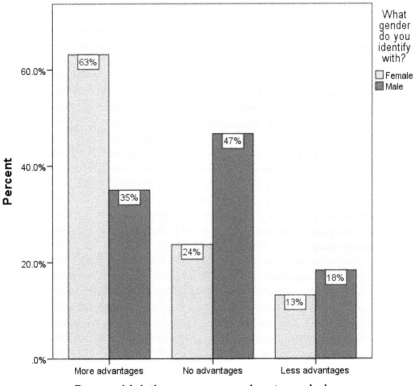

**Do you think there are more advantages being a female journalist?**

**FIGURE 3**
Do you think there are more advantages being a female journalist?

member present. Reporting conflict-related crimes such as rape or other forms of sexual violence are also problematic for male reporters. Women tend to open up to other women. Male reporters can often tell only half the story. (Male staff journalist with more than 10 years' experience from the United Kingdom)

Related to the issues of access was the perception that female journalists were seen to pose less of a threat than males, which could mitigate general risk and enable greater access. Nineteen journalists mentioned being seen as less of a threat as an advantage to women. A female journalist claimed it was:

Easier to access women in Islamic countries. Seen as less threatening so easier to ask hard questions of officials. (Female staff journalist with 5–10 years' experience from the United Kingdom)

While another suggested that:

Female reporters are generally perceived as "less threatening" and interested in humanitarian stories more than politics which can help defuse suspicions (of being spies, of being biased … ). (Female freelance journalist with 5–10 years' experience, from France working in MENA)

Allied to this and as the flip side of the coin to the disadvantage of male prejudice towards women, is the perception that male-dominated cultures can underestimate women, not only seeing them as being less threatening, but also of not being as professionally acute as men, so interviewees opened up more freely. Ten recipients mention this as being an advantage to women journalists:

it is totally dependent on the conflict. As a woman in Africa I've found that I can gain more access, mostly from being perceived as being stupid or more innocent and using their charm. (Female freelance journalist with 5–10 years' experience from the United Kingdom)

There are advantages in terms of access but those advantages derive from a large disadvantage which is that most people underestimate female journalists. This means that sometimes sources will trust you more because they underestimate your ability to do significant or meaningful reporting. (Female freelance journalist with 0–5 years' experience from the United States)

### Staff or Freelance

The dominance of journalists who class themselves as freelance (78 per cent of respondents) might be a reflection of the changing nature of journalism. A large number of personal emails were also sent to the Frontline Freelance Register. The higher proportion of female freelance journalists replying to the survey is at odds with INSI's statistics which show that from the 10 female casualties in 2015 only one was freelance. This variation might be an indication of Beck's (2009, 118) "anticipation of a catastrophe" as mentioned above, but is worth further investigation (Figure 4).

### Is Being a Journalist the Most Dangerous Aspect Regardless of Gender?

The INSI survey indicates that journalists think that freelancers are more at risk (121 out of 154) than staff members, even though only 13 per cent of the journalists killed in

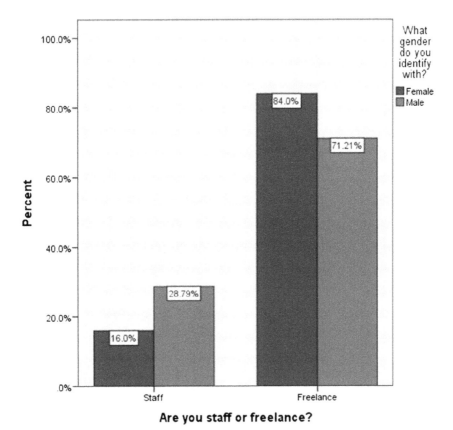

**FIGURE 4**
Male/female freelance/staff

2014 were freelance (INSI 2015). The prevalence of staff deaths is perhaps explicable because most of the deaths occurred in countries such as Iraq and Syria where local journalists are mainly staff reporters, but this does not explain the supposition that freelancers were thought to be more at risk. In the Cardiff survey, 77 per cent of journalists from Europe and North America were freelancers, while 52 per cent of journalists from MENA were freelancers.

Well over half of the recipients (67.4 per cent) thought that the job rather than gender was the most dangerous; 69 per cent of freelancers and 58 per cent of staff employees say that being a journalist is the most dangerous aspect, rather than gender (Figure 5).

This obviously indicates an area for further research on what people mean by "freelance", and the nature and responsibilities of organisations for employees. In their study of freelance women, Massey and Elmore (2011, 673) say "freelance" includes "self-employed freelance journalists, subcontractors who do outsourced news work, and temporary or short-term contract news workers". Some staff journalists also do freelance work. This has an impact on issues of safety as it is perceived that organisations are more willing to spend money on training and safety equipment for staff than for freelancers (IFJ 2009).

In the 2014 INSI report, 78 out of the 118 respondents said that they were more likely to use safety equipment, however, the results from the Cardiff survey found that a worrying

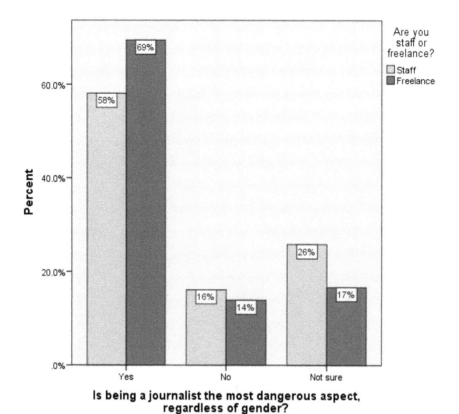

**FIGURE 5**
Is being a journalist the most dangerous aspect regardless of gender?

74 per cent of freelancers are not supplied with safety equipment. This might be a reflection of the greater number of staff journalists in the INSI survey, but does suggest that the desire for safety equipment among freelancers is not being met, despite some of the international media organisations such as Associated Press and Reuters making efforts to provide equipment and safety training to freelancers covering conflict (Mahoney 2015). It might also be that many freelancers are supplied with safety equipment, but that it is either inferior, or that the journalists have to pay for it themselves. Elia Baltazar, a journalist from Mexico, writes that a greater number of female journalists have to resort to training themselves, and this might also cover supplying their own equipment.

### Sexual Harassment

Sexual harassment is still a major risk to female journalists with almost half of the recipients (42 per cent) having experienced sexual harassment with 31 per cent responding that they had witnessed it.

More than half of the women respondents to the survey (68 per cent) had experienced sexual harassment; for male journalists the equivalent figure was 8 per cent (Figure 6).

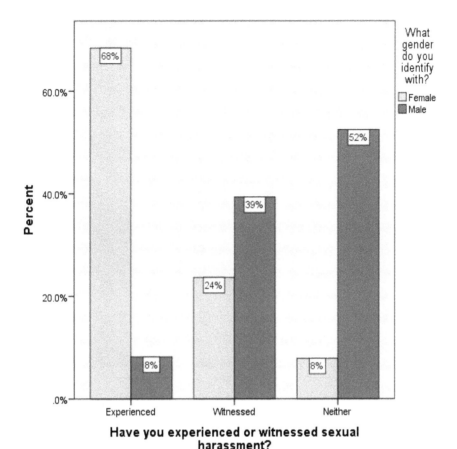

**FIGURE 6**
Have you experienced or witnessed sexual harassment?

Unlike the IWMF (2013) survey where more than half the perpetrators were colleagues and co-workers, only 15 per cent of the recipients in the Cardiff survey stated that the sexual harassment was committed by co-workers or bosses, whilst 51 per cent of those who had been harassed said it was committed by those they were reporting about. This might be because of increased commitment to anti-harassment policies in the workplace, but what is less positive is that 62 per cent of recipients would not report cases of sexual harassment and 23 per cent would hesitate to report them; 36 per cent of women and 7 per cent of men said they would hesitate to report cases for fear of losing assignments.

This might again reflect the more precarious employment security of women journalists in that they feel less secure in reporting incidents of sexual harassment. This is echoed by the findings that more freelancers (46 per cent) than staff (26 per cent) have been sexually harassed and more staff would report cases of harassment even if it meant not being assigned to similar jobs (70 per cent as opposed to 59 per cent of freelances) (Figures 7 and 8).

There were many angry comments about sexual harassment. A female journalist suggested that:

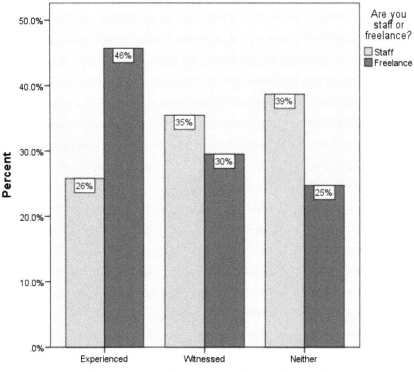

**FIGURE 7**
Have you experienced or witnessed sexual harassment?

Every single woman that has worked in Egypt, Bangladesh, India, myself included, has experienced sexual harassment and violence on a regular basis ... It's disappointing to me that the question you ask is whether or not we are disadvantaged in this regard, it's an obvious and exhaustive YES. (Freelance female journalist with 0–5 years' experience from Egypt)

Another female journalist with experience of working in a number of different countries claimed that:

Female correspondents are regularly harassed while in the field and the usual culprits are their co-workers or other journalists, and NOT the locals. There needs to be a structure within these organisations that makes it clear that rape and harassment is not tolerated. (Female freelance journalist with 5–10 years' experience from the United Kingdom, worked in Afghanistan and Russia)

Despite these comments, the majority of journalists who had experienced and witnessed sexual harassment came from Europe and North America; 47 per cent of the journalists who had witnessed and experienced sexual harassment were from Europe and North America and only 16 per cent of journalists who had witnessed or experienced sexual harassment were from Asia, South America and MENA countries. Whether this was because the

**FIGURE 8**
Do you or would you hesitate to report harassment in the field for fear of future assignment?

journalists from the West are more aware of the issue and more willing to talk about it, or that sexual harassment is more prevalent in Europe and North America, is a question which also needs more research.

## Conclusion

The findings to this survey on journalists' gender and safety are not conclusive. The location, culture, conflict and individual all impact on the safety of journalists. However, it is clear that most journalists think that in an increasingly dangerous world it is the profession not the gender which is the most dangerous aspect. For many women in conflict zones, being a woman can be an advantage. Anomalies with the fears and figures of the deaths of freelance journalists suggest that the definition of a freelance journalist and the responsibilities of media organisations to this group are areas in which more research is needed. Digital journalism and changing journalism practice might be opening new arenas for women to report about conflicts, but the freelance world also holds its risks. Many female freelance journalists are also experiencing sexual harassment, but many hesitate to report it for fear of reprisal. If this fear and the fear that it is more dangerous to be a woman journalist become the catastrophe intimated by Beck, the specific advantages that

women journalists bring to journalism will be lost, as well as a worrying depletion to the ranks of journalists as a whole.

## DISCLOSURE STATEMENT

No potential conflict of interest was reported by the authors.

## FUNDING

This work was supported by the Cardiff Undergraduate Research Opportunities Programme (CUROP).

## NOTES

1. Men were found to be significantly more likely than women to hold freelance jobs, as well as to have "other" terms of employment (Byerly 2011, 33).
2. The INSI conducts research and training on safety for journalists.
3. See the 2014 INSI survey: 71 per cent of the respondents had over 10 years' experience, 15.9 per cent had 5–10 years' experience and 12.8 per cent had 0–5 years' experience (INSI 2015).

## References

Adamczyk, Wojciech. 2014. "Killed in Action: Female Investigative Reporters, War Correspondents and Local Journalists, and the Risk of Death or Becoming a Victim of Violence." Accessed 9 August 2015. http://ssp.amu.edu.pl/wp-content/uploads/2014/12/ssp-2014-3-077-096.pdf.

Amin, Shahira. 2012. In Storm, Hannah & Williams H. Eds. *No Woman's Land: On the Frontlines with Female Reporters*, 29–31. International News Safety Institute.

Beck, Ulrich. 1997. *The Reinvention of Politics*. Cambridge: Polity.

Beck, Ulrich. 2009. *World at Risk*. Cambridge: Polity.

Borri, Francesca. 2015. "The Twisted Reality of an Italian Freelancer in Syria in The Columbia Journalism Review." Accessed 27 June 2015. http://www.cjr.org/feature/womans_work.php.

Byerly, Carolyn M., ed. 2011. *Global Report on the Status of Women in the New Media*. Washington: IWMF. http://iwmf.org/our-research/global-report.

Byerly, Carolyn M. 2013. Factors Affecting the Status of Women Journalists: A Structural Analysis in

Elliott, Anthony. 2002. "Becks Sociology of Risk: A Critical Assessment." *Sociology* 36 (2): 293–315.

Franks, Suzanne. 2013. *Women and Journalism*. London: IB Taurus.

INSI. 2015. "Killing the Messenger." http://www.newssafety.org/news/insi-news/insi-news/detail/killing-the-messenger-2015-1597/.

International Federation of Journalists. 2009. "Getting the Balance Right." http://portal.unesco.org/ci/en/files/28397/12435929903gender_booklet_en.pdf/gender_booklet_en.pdf.

International Women's Media Foundation. 2013. http://www.iwmf.org/global-research-project-investigates-violence-against-women-journalists/.

Mahoney, Robert. 2015. "Going it Alone: More Freelancers Means Less Support, Greater Danger." *Committee To Protest Journalists*. https://www.cpj.org/2015/04/attacks-on-the-press-more-freelancers-less-support-greater-danger.php.

Massey, Brian L., and Cindy J. Elmore. 2011. "Happy Working for Themselves." *Journalism Practice* 5 (6): 672–686.

Matloff, Judith. 2007. "Foreign Correspondents and Sexual Abuse: The Case for *Restraint*." *Columbia Journalism Review*, May/June. http://judithmatloff.com/correspondentsandsexualabuse.pdf.

Melki Jad. 2009. "Journalism and Media Studies in Lebanon." *Journalism Studies* 10 (5): 672–690.

Melki Jad, P., and Sarah E. Mallat. 2014. "Block Her Entry, Keep Her Down and Push Her Out." *Journalism Studies*. doi:10.1080/1461670x.2014.962919.

Neilan, Catherine. 2012. "Women in War Zones." *Broadcast*, March. Accessed 8 November 14. http://www.broadcastnow.co.uk/techfacils/production-feature/women-in-war-zones/5038972.article

O'Brien, Anne. 2015. "Producing Television and Reproducing Gender." *Television & New Media* 16 (3): 259–274.

Ricchiardi, Sherry. 1994. "Women on War." *American Journalism Review*. March. http://ajrarchive.org/Article.asp?id=1513.

Storm, H., and Peters H, eds. 2012. *No Woman's Land*. London: International News Safety Institute.

Susman, Tina. 2012. In Storm, H. and Williams H, Eds. *No Woman's Land: On the Frontlines with Female Reporters*, 25–27. International News Safety Institute.

Traub, James. 2014. The Disappeared' in Foreign Policy. Accessed 29 November 14. http://www.foreignpolicy.com/articles/2014/01/22/the_disappeared.

Wyatt, Caroline. 2012. In Storm, H & Peters H (eds) 'No Woman's Land' International News Safety Institute. 7–11.

# INTRAPRENEURIAL INFORMANTS
## An emergent role of freelance journalists

Avery E. Holton ⓘ

*As newspapers continue to wrestle with diminishing resources, they have, in part, turned to freelance journalists to help fill holes in content production. In light of this amplified reliance on freelancers, some media scholars have examined the ways in which they fit into the news process, arguing that they have the potential to override traditional journalistic norms in ways that can enhance news work and audience engagement while possibly breathing new life into news organization business models. Semi-structured interviews with 19 freelance journalists and nine newspaper editors in the United States help reveal that freelancers are harnessing social media to engage with and build audiences and individual brands. Freelancers frequently immerse themselves in social media experimentation that editors monitor and often incorporate into organizational strategies that may help inform newsroom practices and audience engagement. This hints at a shift for freelance journalists from the timeworn role of newsroom outsider to one of "intrapreneurial informant."*

## Introduction

Amidst a prolonged transition for news organizations from traditional modes of delivery to digital and mobile platforms—one that has resulted in the shrinkage of nearly 40 percent of editorial staffs at US newspapers (Edmonds 2015)—many organizations have relaxed their typical professional norms to include atypical resources as a means to keep up with audience demand and engagement. Freelance journalists, or those journalists who are not fully employed by news organizations but nonetheless supply published content in "piecemeal" fashion (Massey and Elmore 2011), represent an emerging slice of these atypical resources. They are fast becoming an integral part of the news process (Ladendorf and Edstrom 2012; Solomon 2015), helping to alleviate some of the burden placed on news organizations' reserves with nominal financial expectations (Bristol and Donnelly 2011; Kaufman 2010). In particular, they have been used with greater frequency in areas of specialty reporting that have been among the hardest hit by newsroom cutbacks, including science and health journalism.

This shift calls into question the historically staid boundaries of journalism professionalization, which have established and maintained distinctions between news producers and consumers as well as professional and amateur forms of news production (Domingo 2011; Lewis 2012a, 2012b). Freelancers have struggled to free themselves from the stigma of amateur or outsider, recently gaining ground through socialization with newspaper editors and newsroom managers while upholding the tenets of journalism including truth-telling, objectivity, and ethical storytelling (Gollmitzer 2014; Solomon 2015). They are increasingly present in digital spaces where newspapers have struggled to engage audiences, navigating new forms of immersive storytelling with the ambient dialogue between journalists and audiences created by social media (Hermida 2011, 2014; Lee 2015).

Drawing on semi-structured interviews with 19 freelance journalists and nine newspaper editors in the United States, this study focuses on the latter, asking freelancers how they perceive themselves in a profession that now demands the incorporation of audience engagement, particularly through social media. The findings indicate freelancers have incorporated social media to build and maintain audiences and individual brands and identities while constructing and repairing norms. The findings also suggest that editors have begun changing their views of freelancers, seeing them less as professional outsiders and more as exemplars of journalistic innovation. In particular, editors may be relying on freelancers for a certain level of intrapreneurial guidance, specifically in terms of social media engagement, suggesting freelancers may in fact be emerging as intrapreneurial informants.

## Evolving Journalistic Norms and Role Conceptions

The rise of digital storytelling and audience participation in the news process through digital channels and social network sites (SNSs) has challenged the professional norms of journalists and raised questions about how they see themselves and the work they undertake (Mellado and Van Dalen 2014; Tandoc, Hellmueller, and Vos 2013; Singer, 2015). Lasorsa, Lewis, and Holton (2012) noted that journalists' use of Twitter challenges the norm of objectivity by encouraging journalists to include opinion and humor alongside news content. Other studies have demonstrated increases in transparency related to professional work and sources, reliance on audiences for news and news-related information, partisan news coverage, speed of news content delivery over accuracy, and the inclusion of personal and professional branding in news work (Broersma and Graham 2013; Lasorsa, Lewis, and Holton 2012; Lee 2015; Molyneux 2015).

While they wrestle with evolving professional norms, journalists are undergoing an intense period of role conception reconsideration. Role conceptions, or how journalists and news organizations describe the work they do or ought to do (Mellado and Lagos 2014; Mellado and Van Dalen 2014), are sometimes explained through examinations of the professional norms and values of journalists and how those norms and values appear in professional practice. Weaver and Wilhoit (1996) determined four role types—disseminator, adversary, interpreter-investigator, and populist mobilizer. Hanitzsch (2011) added the roles of critical change agent and opportunist facilitator. Mellado and her colleagues (Mellado and Lagos, 2014; Mellado and Van Dalen, 2014) operationalized six distinct roles journalists perform: disseminator-interventionist, loyalist, watchdog, civic, service, and infotainment.

These and other studies tend to rely on individual levels of media psychology to operationalize and explain role conceptions (Shoemaker and Reese 2014), capturing how journalists believe they should be acting as professionals without considering the nuanced internal and external drivers of those beliefs (Tandoc, Hellmueller, and Vos 2013). Further, studies have focused almost exclusively on traditional definitions of professional journalists, leaving opportunities to explore role conceptions of other emergent journalistic contributors such as freelancers.

## The Role of the Freelancer

Once kept at arm's length by the very news organizations they served, freelancers are part of a rise in media entrepreneurship that is renewing "journalism's relevance and

reinvigorate[ing] stagnating business models" (Cohen 2015, 514). By balancing the professional norms of journalism with deviations necessary to sustain their autonomously entrepreneurial employment (Obermaier and Koch 2014; Solomon 2015), freelancers are positioning themselves as part of a profession that is undergoing paradigmatic changes that include an erosion of the boundary between news producers and users.

Historically, few media scholars have given them attention as key actors in the news process, though that began to change as increasing numbers of news organizations—newspapers in particular—turned to freelancers to fill voids in content left by a depletion of resources that began in the 1990s and has yet to see a reversal. This as they transition to digital and social media platforms, where audiences expect more opportunities for participation in the news process and socialization with news producers (Hermida 2014).

Despite these expectations, studies continue to show traditional journalists may not be all that interested in connecting with audiences (Broersma and Graham 2013; Lee 2015). While journalists working in newsrooms make use of social media for news work, they remain hesitant to exchanging information or building conversations with individuals outside of their professional circles (Lee 2015; Lee, Lewis, and Powers 2014). Freelancers, though, engage audiences and report seeing them as opportunities to spread build their professional brands though public conversations on SNSs (Molyneux and Holton 2015). They are also guided by autonomous privilege, allowing them more freedoms to develop individual approaches to audience interactions where other journalists may operate under organizational policies.

Such independence has largely kept freelancers out of newsrooms where they might be seen and heard, though recent studies indicate that freelancers and newsroom editors and managers are socializing more often and more frequently in person (Gollmitzer 2014; Obermaier and Koch 2014). This positions freelancers less as newsroom outsiders and more as professionals increasingly being included within considerations of news organizations.

This is perhaps best illustrated in areas of news coverage that have been hardest hit by financial cutbacks. These are often specialty beats that are considered expendable among local and regional news organizations, most notably topics related to science and health. Health journalists in particular are disappearing from newsrooms more rapidly than other journalistic specializations in part because of a prevailing belief among newsroom chieftains that health news is expendable and because health information is more readily available from a wider breadth of sources than ever before (Bristol and Donnelly 2011). As freelancers continue to help address content reductions, they may also bring with them informative practices that better suit the norms under which they operate.

## Problem Statement

Noting emerging scholarship that examines the evolving norms and role conceptions of traditional journalism professionals, as well as the rise in the reliance of newsrooms on nontraditional journalism professionals (i.e., freelancers), this study sought to elucidate how freelancers perceive themselves and their work, paying particular attention to their reliance on social media. This study also took up the call of Tandoc, Hellmueller, and Vos (2013), considering how key influentials such as editors might reinforce or negate certain role conceptions by asking them about the work of freelancers and where they fit into today's newsrooms.

## Method

This study began by seeking out a sample of freelance journalists and editors for semi-structured interviews. Given that the United States does not have a unionized labor force of freelance journalists, finding such a list can be cumbersome. By focusing in on an area of specialized reporting that makes use of freelancers such as those covering health and science, cultivation of a sample was achievable. With more than 1100 members, the Association of Healthcare Journalists (AHCJ) offers a rich sampling pool that includes journalists working for news organizations, freelance journalists, and editors. An e-mail invitation for interview participants was distributed through the AHCJ in March 2013, resulting in an initial pool of 58 newspaper journalists and 12 newspaper editors. For this study, only those journalists who had been active as freelancers for at least one year were included, as were editors who reported working with freelancers on a regular basis. These criteria narrowed the sample to 19 freelancers and nine editors.

Through a series of phone and digital interviews (i.e., Skype, Google Hangout), each of the 28 participants was asked a series of open-ended questions that followed a semi-structured format. Media scholars have suggested interviews that allow responses to guide questions rather than a strict set of queries can provide unique insider viewpoints and illuminate personal and professional norms and routines (Amend and Secko 2012; Humphreys, Von Pope, and Karnowski 2013). Thus, this study relied on open-ended questions and allowed conversations to develop somewhat organically. Freelancers were asked about their personal and professional routines and norms, their perceptions of themselves as professionals and as journalists, how they engaged with other journalists and their audiences, and how they made use of social and digital media in their work. Editors were asked about their perceptions of freelancers, how those perceptions were formed and how they have changed, if at all, and how they believed freelancers' routines and norms compared to those of journalists within their newsrooms.

Of those freelancers interviewed, most reported working for more than one news organization and across several platforms including newspapers, magazines, radio programs, websites, and blogs. Two had previously been employed full-time in newsrooms, though only one indicated a desire for a full-time newsroom position. Editors reported extensive journalistic backgrounds as reporters, copy editors, and section managers. Four were employed by metropolitan or national news outlets, two were with smaller or more local organizations, and three were working exclusively with online content.

## Results

Collectively, the freelancers and editors interviewed here indicated that news organizations should be more responsive to audiences who now demand a wide array of participatory roles in the news process ranging from conversations on social media to the production of news content. Freelancers overwhelmingly championed social media platforms such as Twitter, Facebook, and Instagram as ways to build audiences, create and maintain personal identities and professional brands, and to construct and repair journalistic norms. Editors focused more on freelancers' abilities to fill voids in news content, but noted that freelancers were significantly more attuned to social media. To this point, editors were monitoring freelancers' social media activities and leaning on insights from freelancers to help construct more meaningful forms of audience engagement in the

newsroom. These findings, which indicate freelancers may now be serving as intrapreneurial informants for newsroom editors, provide insights into the self-perceptions and role conceptions of freelancers at a time when they are being relied on more than ever.

## Freelancers, Social Media, and Authority/Credibility

### Freelancers Use Social Media to Build Audiences

All but one freelancer reported using social media daily to "catch up with the news," "dig up stories," "find sources," "gauge reactions to my work," and "see what everyone else was working on." Most frequently, though, freelancers said they turned to social media to help construct and maintain audiences. While some felt that newsrooms hamstrung journalists with restrictive or vaguely threatening guidelines for social media use, all said they paid little to no attention to those policies because, as one freelancer put it, "those aren't our individual policies."

In the absence of organizational rules, freelancers were guided by institutional and personal regulations. The majority said they followed the tenets of journalism on social media, providing truthful and informative content through an objective lens and in a timely manner. However, those precepts were tempered by individual choices about inclusions of opinion, job and life details, and direct engagement with audiences. More than half of the freelancers said they coupled news and information with "informed opinions" on social media posts, and all but two freelancers said they included information and photos about their professional and personal lives. This provided a "connection that helps people see we're journalists, and we're also human beings. We have faces, and we have dogs, and we have emotions, and we have lives that people can relate to."

One freelancer called such open connectivity an "absolute must for [freelancers] who want to stay employed," arguing that "whoever is looking for us to write a story or create a graphic or whatever is looking at who we are on social media." Most freelancers shared the perception that connecting with audiences publicly and personally could create more work opportunities. This deviation from social media as only a place for news work to one of news work paired with audience work represents the kind of role conception shifts some media scholars have argued is necessary for successful navigation of audience engagement (Holton et al. 2015; Lee 2015; Tandoc, Hellmueller, and Vos 2013). If journalists can be architects of networked communities built around news, as some scholars have suggested (Lewis, Holton, and Coddington 2014), then freelancers seem well positioned for the task.

No matter the platform, if there was an opportunity to participate with other users, freelancers said they did their best to incorporate interactions into their daily routines, even if it meant reducing the number of stories they wrote (and assumingly the profits those stories might bring). They saw long-term value in creating multi-layered networks (e.g., across different platforms) of individuals who could spread the word about their work while improving their own understanding of audience needs and knowledge. Above all else, they saw reciprocation with audiences in the form of information exchanges and public praise as a chance not only to improve their images, but also a means to deconstruct the complexities of information for and with audiences. They welcomed audiences as sources, but also as stakeholders in the production of news. They valued their input, answered their critiques, and worked hard to achieve a true measure of what Marchionni (2013) has called the process of "journalism as conversation," answering, at least in part,

Lewis's (2012a, 2012b) suggestion that journalists be more ethically bound to participation with audiences.

### Freelancers Use Social Media to Build Brand/Identity

By personalizing information and loosening their control on content, freelancers said they developed themselves as brands specific to their niche topic (i.e., health information), creating a network of potential brand ambassadors along the way. Though they never cast their connections as brand channels during interviews, they nonetheless reported the role of branding as part of their professional norms, emphasizing the importance of sustained engagement with audiences over time.

Freelancers seemed unabashed in the inclusion of branding into their norms, arguing that just as engagement with audiences served opened more work opportunities, so did branding empower them as individual entrepreneurs. While all said they lacked the funds, or even the need, to consistently promote themselves with traditional forms of advertising (i.e., banner ads, job-seeking announcements, etc.), most freelancers said they branded themselves by "more organic means." Branding developed through social media bios that displayed their areas of expertise through visuals, hashtags, or keywords. These, along with a consistent sharing of published works through links posted to social media, allowed freelancers to display their professional prowess.

Some media scholars have observed that journalists face a certain degree of anxiety when attempting to brand themselves through social media, often struggling with how to balance their personal identities with their professional ones (Molyneux and Holton 2015). However, that sentiment rarely came up in the interviews here. Instead, freelancers seemed to welcome such a challenge, with the vast majority arguing that minus a blend of their professional and personal lives, they would seem "just like every other journalist out there."

### Freelancers Use Social Media to Construct and Repair Norms

Not all journalists took such utopian approaches to social media. Several noted that by questioning or going against traditional journalism tenets, freelancers risked being seen as disrupters rather than innovators. "There's an authority in every newsroom," one freelancer argued,

> and whether that's a section editor, a managing editor, or a publisher, that person decides what flies and what doesn't. So if you're out there pushing boundaries and taking risks on social media, and if that authority thinks that doesn't reflect too well on such and such publication, well you're probably out of luck.

Yet, even that freelancer suggested a certain necessity to test such boundaries, saying, "every time journalism hits a wall, it takes a few lone wolves to pick up the pieces and challenge the old ways." That sentiment rang true for many of the freelancers here, who said that by listening to and engaging with audiences, they were able to put into practice more of what news consumers wanted. Time and again, they relied on transparency as a norm they were quicker to take up than news organizations. Freelancers said that while they believed most journalists, themselves included, sought truthful reporting through several means of verification, they were able to use social media to be more transparent than others.

Arguing that not all journalists practice transparency, and emphasizing the sheer lack of engagement in social media they perceived among news organizations, freelancers said that they have gravitated toward full transparency by including links to external information and original sources, providing names of contacts and pathways for reaching them, disclosing any conflicts of interest that might impact their reporting, and answering questions about the content of their stories truthfully, accurately, and quickly. To the latter action, several freelancers said they had more opportunities to confront their mistakes and correct them publicly ahead of traditional news outlets. Explained by one freelancer:

> I goofed up on this tiny little detail about a lawsuit against the makers of a pacemaker. I told my editor, who got to work on the correction, and hours before I heard back from him, I'd posted a correction on my blog and on my Twitter feed. No one really said much, but when I told some other freelancers about it, they said they'd done similar things.

## Using Freelancers as an Organizational Strategy

### Editors Use Freelancers to Fill Gaps

Editors interviewed here all agreed that freelancers had taken on more prominent roles in the news process, helping provide content that would have otherwise been lost to a reduction of resources. Most also agreed that while they initially turned to wire services for content, freelancers were better suited to explore the nuances of specialized areas of reporting such as health and science. As one editor explained:

> You can only squeeze so much out of [those] services before you start seeing the same content showing up across the board. That's where freelancers come into play. The cost isn't really the concern; it's how do we find unique, engrossing stuff.

This finding is certainly nothing new, and many media scholars have noted the significant role freelancers have in filling news holes (Ladendorf and Edstrom 2012; Massey and Elmore 2011). However, the assertion of confidence in freelancers—one enhanced by the consideration that most editors referred to freelancers more inclusively as "journalists"—hints as perceptional change among editors. While they have historically been perceived as atypical workers, freelancers may be experiencing what Gollmitzer (2014) observed as an institutional turn that positions freelancers and other entrepreneurially spirited news professionals as typical workers in the news process.

### Editors Use Freelancers Internally as Exemplars

Such a shift helps to explain why editors, or at least those interviewed here, are beginning to use the work of freelancers as standards for journalists working in their newsrooms. For example, editors, who pointed out that many journalists in their newsrooms laud the use of social media as a vehicle for audience engagement without necessarily putting such praise to action, saw the softening of social media anxiety among freelancers as an informative approach. By pointing to the work of freelancers, editors said they were able to encourage journalists in their newsrooms to follow suit. According to one editor,

even those traditionalists who say they don't have time or shouldn't be asked to take on more work with audiences don't put up reasonable arguments when shown [a freelancers] tweeting back and forth with a user who asked a question.

This signals a possible for solution for what Lee (2015) and others have observed as a disconnect between the understanding of social media's importance and its uses in practice. While journalists have taken up social media for news work, they have been slow to immerse themselves more fully with audiences—this despite encouragement from their news organizations (Lee 2015). Enter freelancers, who can operate in social media spaces and with audiences without fear of organizational repercussion. In this way, they serve as commercial risk assessment tools, providing editors with a means of exploring what does (and does not) work in terms of engagement with little or no cost to newsrooms.

### Editors Use Freelancers Externally to Build Audiences

With that in mind, editors said they valued freelancers' work with audience engagement. At a time when metrics and crowd-tracking tools have helped to attract and maintain larger digital audiences, editors said they continue to struggle with best practices in terms of engagement through SNSs. Here again, freelancers provided a low-cost approach to easing that concern. Not only did editors take note of how freelancers worked with audiences on SNSs, they also encouraged freelancers to link to work housed by their news organizations and, in some cases, to promote those organizations through tweets and Facebook posts. Some editors anticipated pushback by offering monetary incentives or the promise of future work, but others said freelancers required no extra enticements. "They see us a way to get their work out there," said one editor, "so they want to point to it, which points to us. They do great work, they link to us. They do bad work, they typically don't post it."

Editors also noted the importance of audiences to freelancers. Because freelancers have to answer to audiences who "can alienate them fast enough to cost them a career," as one editor said, they take time to engage those audiences. Editors reported seeing freelancers begin or respond to conversations and providing follow-up information or praise to their followers. Editors argued that these forms of engagement, combined with innovative efforts with content and storytelling, positioned freelancers as potential solutions to what may be a long-term crisis facing newsrooms. According to the editors, if there were gaps in coverage, and if those could be filled by freelancers who were willing to include layered levels of audience engagement in their work, then perhaps freelancers might fortify critical areas of journalism that have withered under a lack of resources in recent years. Further still, they might cultivate larger and more digitally networked audiences at a time when newsrooms are struggling to do so.

### Conclusion

This study took up questions about freelance journalists' norms and role conceptions, paying particular attention to their social media practices and giving voice to editors who monitor and financially back their work. The findings indicate that freelancers see themselves as social media engagers, using SNSs to build audiences and brands while reinforcing and repairing journalistic norms, including transparency. Editors see these role

conceptions and enactments as informative, taking lessons from freelancers and applying them as exemplars for newsroom journalists and as pathways to enhance engagement with audiences.

While the results here are notably limited in scope—they consider only the work of freelancers covering a particular specialty (i.e., health) and do not fully examine role enactments that are best illustrated through the content freelancers might produce and post to social media—they nonetheless uncover important findings about how freelancers see themselves and exhibit their work and indicate significant shifts in the perceptions of editors. Notably, the freelancers in this study were seen as potential innovators in a dramatically changing news process, helping to apprise editors, and in turn journalists, of appropriate ways to approach social media as a vehicle for news creation and audience participation. This situates freelancers more as *intrapreneurial informants*—as professionals who might be informing organizational work and policies.

Whether covering topics of health and science or other areas that have been impacted by diminishing resources, freelancers appear to be more receptive than other journalists when it comes to facing the challenges presented by social media. While other journalists and news organizations continue sluggish approaches to audience engagement (Lee 2015), freelancers are making use of audiences for traditional news work and more innovative extensions of brand reinforcement and proof of identity. Rather than rebuke audiences, they appear to be embracing them. This suggests freelancers may be catalysts for richer connections with audiences and may be more suited than other journalists to become architects of digital networks built around news.

Future studies should work to deepen these results, perhaps by considering how the role conceptions and enactments of freelance journalists are influencing change among other journalists and news producers. Such studies might give more attention to the tension freelance journalists face when balancing multiple professions and expectations of editors and news organizations that may be changing in light of more scrutiny. If freelancers truly are becoming intrapreneurial informants, then undoubtedly their roles as professional journalists will receive more attention from editors and other newsroom influentials. How they and those news producers around them respond remains to be seen.

## ACKNOWLEDGEMENTS

The author would like to thank Sue Robinson (University of Wisconsin-Madison) and Angela M. Lee (University of Texas-Dallas) for their valuable input during the development of this article.

## DISCLOSURE STATEMENT

No potential conflict of interest was reported by the author.

## REFERENCES

Amend, Elyse, and David M. Secko. 2012. "In the Face of Critique: A Metasynthesis of the Experiences of Journalists Covering Health and Science." *Science Communication* 34 (2): 241–282.

Bristol, Nellie, and John Donnelly. 2011. "Taking the Temperature: The Future of Global Health Journalism." *The Kaiser Family Foundation*, February 9. https://kaiserfamilyfoundation. files.wordpress.com/2013/01/8135.pdf.

Broersma, Marcel, and Todd Graham. 2013. "Twitter as a News Source." *Journalism Practice* 7 (4): 446–464.

Cohen, Nicole S. 2015. "Entrepreneurial Journalism and the Precarious State of Media Work." *South Atlantic Quarterly* 114 (3): 513–533.

Domingo, David. 2011. "Managing Audience Participation: Practices, Workflows, and Strategies." In *Participatory Journalism: Guarding Open Gates at Online Newspapers*, edited by Jane B. Singer, Alfred Hermida, David Domingo, Ari Heinonen, Steve Paulussen, Thorsten Quandt, Zvi Reich, and Marina Vujnovic, 76–95. Laden, MA: Wiley-Blackwell.

Edmonds, Rick. 2015. "Newspaper Industry Lost 3800 Full-Time Editorial Professionals in 2014." *Poynter*, November 8. http://www.poynter.org/tag/layoffsbuyoutsstaff-cuts/.

Gollmitzer, Mirjam. 2014. "Precariously Employed Watchdogs? Perceptions of Working Conditions Among Freelancers and Interns." *Journalism Practice* 8 (6): 826–841.

Hanitzsch, Thomas. 2011. "Populist Disseminators, Detached Watchdogs, Critical Change Agents and Opportunist Facilitators: Professional Milieus, the Journalistic Field and Autonomy in 18 Countries." *International Communication Gazette* 73 (6): 477–494..

Hermida, Alfred. 2011. "Fluid Spaces, Fluid Journalism: Lessons in Participatory Journalism." In *Participatory Journalism: Guarding Open Gates at Online Newspapers*, edited by Jane B. Singer, Alfred Hermida, David Domingo, Ari Heinonen, Steve Paulussen, Thorsten Quandt, Zvi Reich, and Marina Vujnovic, 177–191. Laden, MA: Wiley-Blackwell.

Hermida, Alfred. 2014. "Twitter as an Ambient News Network." In *Twitter and Society*, edited by Katrin Weller, Axel Bruns, Jean Burgess, Merja Mahrt, and Cornelius Puschmann, 359–372. New York: Peter Lang.

Holton, Avery E., Mark Coddington, Seth C. Lewis, and Homero Gil de Zuniga. 2015. "Reciprocation and the News: The Role of Personal and Social Media Reciprocity in News Creation and Consumption." *International Journal of Communication* 9: 2526–2547.

Humphreys, Lee, Thilo Von Pope, and Veronika Karnowski. 2013. "Evolving Mobile Media: Uses and Conceptualizations of the Mobile Internet." *Journal of Computer-Mediated Communication* 18 (4): 491–507.

Kaufman, Debra. 2010. "Health Care Journalism: The Quest for Coverage." *TV Week*. April 19. http://www.tvweek.com/in-depth/2010/04/by-debra-kaufmanits-impossible/.

Ladendorf, Martina, and Maria Edstrom. 2012. "Freelance Journalists as Flexible Workforce in Media Industries." *Journalism Practice* 6 (5–6): 711–721.

Lasorsa, Dominic, Seth C. Lewis, and Avery E. Holton. 2012. "'Normalizing' Twitter: Journalism Practice in an Emerging Communication Space." *Journalism Studies* 13 (1): 19–36.

Lee, Angela M. 2015. "Social Media and Speed-Driven Journalism: Expectations and Practices." *International Journal on Media Management* 17 (4): 217–239.

Lee, Angela M., Seth C. Lewis, and Matthew Powers. 2014. "Audience Clicks and News Placement: A Study of Time-Lagged Influence in Online Journalism." *Communication Research* 41 (4): 505–530.

Lewis, Seth C. 2012a. "The Tension Between Professional Control and Open Participation: Journalism and its Boundaries." *Information, Communication and Society* 15 (6): 836–866.

Lewis, Seth C. 2012b. "From Journalism to Information: The Transformation of the Knight Foundation and News Innovation." *Mass Communication and Society* 15 (3): 309–334.

Lewis, Seth C., Avery E. Holton, and Mark Coddington. 2014. "Reciprocal Journalism: A Concept of Mutual Exchange Between Journalists and Audiences." *Journalism Practice* 8 (2): 229–41.

Marchionni, Doreen. 2013. "Journalism-as-a-Conversation: A Concept Explication." *Communication Theory* 23 (2): 131–147.

Massey, Brian L., and Cindy J. Elmore. 2011. "Happier Working for Themselves? Job Satisfaction and Women Freelance Journalists." *Journalism Practice* 5 (6): 672–686.

Mellado, Claudia, and Claudia Lagos. 2014. "Professional Roles in News Content: Analyzing Journalistic Performance in the Chilean National Press." *International Journal of Communication* 8: 2090–2112.

Mellado, Claudia, and Arjen Van Dalen. 2014. "Between Rhetoric and Practice: Explaining the Gap Between Role Conception and Performance in Journalism." *Journalism Studies* 15 (6): 859–878.

Molyneux, Logan. 2015. "What Journalists Retweet: Opinion, Humor, and Brand Development on Twitter." *Journalism* 16 (7): 920–935.

Molyneux, Logan, and Avery E. Holton. 2015. "Branding (Health) Journalism." *Digital Journalism* 3 (2): 225–242.

Obermaier, Magdalena, and Thomas Koch. 2014. "Mind the Gap: Consequences of Inter-Role Conflicts of Freelance Journalists with Secondary Employment in the Field of Public Relations." *Journalism* 16 (5): 615–629.

Shoemaker, Pamela J. and Stephen D. Reese. 2014. *Mediating the Message in the 21st Century*. New York: Routledge.

Singer, Jane B. 2015. "Out of Bounds: Professional Norms as Boundary Markers." In *Boundaries of Journalism: Professionalism, Practices, and Participation*, edited by Matt Carlson and Seth C. Lewis, 21–36. Oxford: Routledge.

Solomon, Eileen F. 2015. "How Freelance Journalists can Help Shape Journalism Education." *Journalism and Mass Communication Educator*. Ahead of print. http://jmc.sagepub.com/content/early/2015/08/19/1077695815589444.full.pdf + html.

Tandoc, Edson C., Lea Hellmueller, and Tim P. Vos. 2013. "Mind the Gap: Between Journalistic Role Conception and Role Enactment." *Journalism Practice* 7 (5): 539–554

Weaver, David H., and Cleveland G. Wilhoit. 1996. *The American Journalist in the 1990s: U.S. News People at the End of an Era*. Mahwah, NJ: Lawrence Erlbaum Associates.

## ORCID

**Avery E. Holton** ⓘ http://orcid.org/0000-0003-1307-2890

# MAPPING CHANGES IN LOCAL NEWS

**Julie Firmstone**

*Local news media in the United Kingdom are undergoing a multitude of changes which have implications for our understanding of their value in local democracies. Despite the potential significance of these changes for those actors responsible for the provision of local news, very little research has investigated journalists' and political communicators' perceptions of the impact of these threats and opportunities. This article addresses this gap by presenting research which investigated the views of key stakeholders in the production of local news in a large city in the United Kingdom. The thematic analysis of 14 interviews evaluates how normative roles attributed to journalism, such as representing the public, acting as a watchdog, providing information, and running campaigns, are being fulfilled by different news providers in the current news ecology.*

## Introduction

Local news media in many Western democracies, including the United Kingdom, are undergoing a multitude of changes which have implications for our understanding of their contribution to the fulfilment of the normative roles associated with journalism. Fragmenting and declining audiences, resource cut-backs in television, radio, and most notably newspapers, increased competition, and the requirement to communicate news 24 hours a day via a multitude of platforms require the local news media to adapt to a news ecology that is undergoing transformation. This has led to a dominant narrative in industry commentaries and scholarship that journalism and, in particular local journalism, is in crisis (Barnett and Townend 2014; Currah 2009; Franklin 2006; National Union of Journalists 2014). Zelizer's (2015) thought-provoking interrogation of the notion of crisis to describe the current situation skilfully argues what many journalism scholars already suspected—that the broad brush label of crisis obscures rather than illuminates our understanding of the "diverse set of technological, political, economic, social, occupational, moral and legal circumstances" journalism operates within today (Zelizer 2015, 888). While it is widely acknowledged that the uncertainties brought about by changes in these circumstances are particularly acute in local news, we have relatively little empirical evidence of how the dynamics of local news ecologies are changing.

Without such an empirically based understanding it is difficult to move beyond the deceptive narrative of crisis. This article presents research designed to explore and unpack changes in local news ecologies in order to evaluate how and why these changes matter. A secondary aim is to use these insights to develop priorities for future research. I argue that it is important to place our understanding of local news in a theoretical context which recognises the potential democratic role of news in society. The role of local news in the public sphere is particularly significant because it is considered vital to the functioning of local communities and the engagement of citizens in local democracies (Fenton 2011; Kleis Nielsen 2015; Mcleod, Scheufele, and Moy 1999; Shaker 2014).

In order to explore the impact of changes in current local news production, the research design operationalised four normative functions commonly attributed to news in liberal democratic theory as a measure of its democratic value. These suggest that journalists should inform and educate citizens about local issues, represent the voice of citizens, hold governing bodies and organisations to account on behalf of citizens, and proactively campaign on matters of public interest (Barnett 2009; Barnett and Townend 2014; Gans 2010; McNair 2009; Williams, Harte, and Turner 2015). The research evaluates the way in which local news media fulfil these four roles—informational, representative, watchdog, and campaigning. Structuring the analysis of the value of local news around the concept of democratic value provides a clear evaluative framework. This allows us to consider the impact of changes relevant to wider debates about the future of journalism such as declining resources for investigative journalism, opportunities for citizen journalists, and changing audience demands. These and other issues which evoke concerns that "citizens will encounter difficulties in keeping themselves informed and that representative democracy will suffer as a result" (Gans 2010, 11) are explored through a main research question and two sub-questions:

**RQ1:** What implications do changes in the production of local news have for the democratic value of local news?

**RQ1a:** How do local journalists and council communicators perceive the local news media to be producing news of democratic value?

**RQ1b:** What contributions do local journalists and council communicators perceive "citizen journalism producers" make to news of democratic value?

## Research Design

The article presents findings from 14 interviews conducted in two stages of fieldwork in 2014 and 2015 in the United Kingdom's third largest city, Leeds. The research takes an innovative approach in four ways. Firstly, few studies consider local news provision comprehensively enough to provide a picture of the combined practices of local news providers. This research takes one city as a case study and considers the local news ecology of the city as a whole. Although the local media context of Leeds cannot be taken as representative of all UK cities, its relatively large population of over 750,000 supports a mix of news providers representing most types of local journalism found in the United Kingdom. Citizens can access local news through a long-established city-based newspaper, a public service (BBC) television channel and radio station, one commercial television channel, several commercial radio stations, one of the United Kingdom's recently launched local television stations, a diverse range of new hyperlocal news producers, and the predominantly digital products of citizen journalists. The city's news ecology features many of the challenges and opportunities characteristic of the state of flux in local journalism in Western democracies which were outlined above.

Secondly, while journalists and news producers are often interviewed by researchers to gain an understanding of news production practices, they are rarely consulted as experts in their field. Here, journalists (news producers) are interviewed as authoritative sources of

opinion on the impact of recent changes, threats, and opportunities faced by local news media. Thirdly, the research moves away from a media-centric approach and considers the perceptions of other actors interested in communicating with citizens for different reasons than journalists. Here communications professionals from the local authority (council communicators) are interviewed as actors who co-exist with and face similar challenges to local news providers in engaging with the public, and have a strong interest in maintaining a well-functioning local public sphere. These council communicators are able to draw on a different, more detached view of the local media landscape which provides a valuable alternative perspective in evaluating the current provision of local news. In the first stage of the fieldwork, three news producers and three council communicators were interviewed (see Table 1). Eight interviews were conducted in stage 2: six with news producers—journalists, producers, and editors from local television, radio, print, and online news outlets; and two with communications specialists from Leeds City Council's Press Office and Corporate Consultation team.

A set of open-ended questions guided the exploratory interviews in stage 1 and aimed to gather initial perceptions about the role of the local news media, the challenges facing local news media now and in the future, and the role of "citizen producers" in local democracy. In stage 2, a semi-structured interview schedule encouraged interviewees to reflect on local news in relation to key concepts developed to evaluate the concept of the democratic value of journalism. Interviewees were asked to explain their perceptions of how local news and journalism can serve the public interest, to comment on the performance of the local news media in fulfilling four normative expectations of local news, and to discuss changes in audiences for local news.

Finally, the news ecology approach attempts to move our understanding of local news closer to the experiences of the audience who remain neglected by much journalism

**TABLE 1**
Stakeholders interviewed

| | News producers | Council communicators (local council) |
|---|---|---|
| Stage 1. Exploratory interviews Total = 6 | 1. New local television station (Producer) 2. New local television station (Station Manager) 3. Hyperlocal news A (Freelance Journalist) | 1. Head of Communications 2. Senior Communications and Marketing Manager 3. Corporate Consultation Manager |
| Stage 2. Semi-structured interviews Total = 8 | 1. BBC local radio (Assistant Editor) 2. Local commercial radio (News Editor) 3. Local newspaper (Political Reporter) 4. Regional ITV news (Producer) 5. New local television station (News Editor) 6. Hyperlocal news B (Founder) | 1. Head of Press Office 2. Corporate Consultation Manager |
| Total = 14 | Total news producers = 9 | Total council communicators = 5 |

research (Harcup 2015). Considering the value of local news from the audience's perspective requires recognition that audiences draw local news from multiple outlets and platforms. Therefore, the questions in both stages were designed to encourage interviewees to discuss the entire landscape of local news provision in the city rather than just their own organisation or one type of news. All interviews were recorded and transcribed. The discussion of findings is based on a qualitative analysis which organised comments into thematic categories.

## Findings

Interviewee's responses to questions designed to explore their perceptions of the four normative roles of local news are analysed first to explore the question: how do local journalists and council communicators perceive the local news media to be producing news of democratic value?

### *Informational Role*

The majority of interviewees perceived the mainstream news media fulfilling less of an informational role than it has in the past due to changes in audience demands. All recognised that digital media creates competition with a greater quantity of sources of news than ever before. As a result, news providers have moved away from producing information-orientated news, with some seeing information as an "add on" and others only providing informational news when it can be produced in a way that is perceived to appeal to audiences. Radio news providers in particular described information-orientated news as an "add on" rather than a driver of their news bulletins, with additional information provided online for the audience to access separately. Additionally, several news providers talked about the importance of producing news that is distinctive (e.g. "a bit different", provides a "fresh view") in order to engage audiences:

> People aren't tuning in anymore to hear a list of things that are going on in Leeds today. They want to hear about what the issues of today are and what can I get angry about?, and what can I talk about over the water cooler? (Commercial radio)

On the face of it the provision of less informational news might seem like one of the least problematic ways in which news production has changed. Interviewees, however, commonly raised two concerns about the implications of these changes for the role of news in providing citizens with adequate information about local issues. First, it was acknowledged that news providers find themselves in a difficult position where it is hard to strike a balance between producing news that appeals to their audiences and covering issues that are in the public interest. Whilst it is hardly new to propose that audiences are not overly interested in civic news, there was a perception among some interviewees that local news has become increasingly sensational in order to retain the attention of fragmenting audiences. Secondly, although council communicators considered the local news media to be providing the public with good access to information, there was some concern about the extent to which news organisations were providing audiences with "enough" information for them to understand and engage with some of the issues that the city is dealing with. All local newspapers, not only the one in the locality, were perceived as

struggling to cover complex issues, with the result that newspapers are finding it difficult to "get underneath the skin of things".

## Campaigning

The move away from information provision appears to be driving a greater level of news which is campaign orientated in order to appeal to audiences, and there was a sense that major long-running campaigns on specific issues are less common. Instead, radio and newspaper journalists described pursuing a different kind of campaign role, producing more regular campaign-orientated news as a way to create a distinctive product. The pursuit of campaign-orientated news has both beneficial and detrimental implications for the democratic value of local news depending on the motivations driving the campaign. On the down side, some news organisations, particularly commercial radio, perceive news that takes a campaigning stance as a simple tool to attract audiences. As highlighted in the "water cooler" quote, this approach may see issues turned into campaigns simply to sensationalise and dramatise the issue, as a technique to "stand out from the noise". On the other hand, several news providers (BBC radio, newspaper) described a more public interest-orientated approach to campaign news which builds on their established and trusted relationship with their audiences. Campaign news driven by public-interest ideals is seen as providing the bonus of increasing audiences at the same time as facilitating greater audience engagement with specific civic issues which hold the potential to affect change in society. Indeed, the local newspaper described itself as a "campaign newspaper" and had recently launched a joint campaign with a local charity to tackle a range of issues identified by its readers as being of importance to the city. The ongoing campaign aims to re-connect with the audience, promote the role of the paper as acting in the interests of the community, and provide news content (Firmstone 2015).

## Representing

There was an overall perception that the combined efforts of the local news media in Leeds fulfil the role of representing the views of the public very well, with each catering for a different section of the population. In terms of recent changes, social media has significantly amplified journalists' capacity to connect with and represent the interests of their audience. It is used to gather public opinion (an alternative to vox pops), encourage audience participation, and measure the popularity of stories far more efficiently than was possible pre-Web 2.0. Council communicators raised concerns about the representativeness of such interactions. They suggested that unless news organisations take some editorial control over the audience's contributions through social media and commentary functions, they may only represent "the usual suspects" and/or people with extreme views. In addition to this risk, the concentration of representative practices on digital media limits the representative potential of local news by continuing the power of journalists as gatekeepers and the exclusions created by the digital divide and inequalities for engaging. Perhaps surprisingly, journalists did not mention any concerns about the potential exclusionary bias of these practices. Although there may be a greater level of engagement with the public than previously, the nature of the engagement raises age-old questions about empowerment and representativeness which point to local news facilitating "upscale democracy" (Gans 2010, 13) where not everyone is able to participate.

## Watchdogs

The reduced capacity of news providers to pursue investigative journalism and fulfil the role of watchdog was universally described as the most important and concerning change affecting the democratic value of local news. All interviewees talked about the impact of falling resources on the ability of mainstream news organisations, particularly newspapers, but also television, to hold those in power to account as often as in the past. Several of the most experienced news providers voiced concerns about whether large corruption cases unearthed by resource-intensive watchdog journalism would be exposed in today's pared back news industry. For example:

> It is a challenge for anybody in the journalism industry now to actually take the time out to do the proper full background on stuff. You just wonder whether the Poulson affair[1] would ever have been found out now. (ITV news)

Concerns about hard-hitting investigative journalism were matched by similar concerns about the day-to-day scrutiny afforded by current resources. Many interviewees painted a familiar picture of what Gans (2010) calls "everyday watchdogging" being restricted by an increase in desk-based journalists reliant on press releases and unable to invest time to attend council meetings, court hearings, or get out into the community. Several interviewees described how time constraints result in press releases being directly replicated in news coverage without journalists being able to take the time to scrutinise the "story" or put the "other side" across. Journalists' widespread regret that the capacity for watchdog journalism has decreased was nevertheless defended by the perception among journalists that "no one is doing it better than us", which leads us to the contribution of citizen producers.

## The Contribution of Citizen Journalists

One response to the perceived decline of local mainstream media has been to look at alternative ways that the news needs of local citizens may be served. The opportunities created by digital media have led to suggestions that citizen journalism can perform a "replacement" role to fill the gaps left by the shrinking mainstream media (Metzgar, Kurpius, and Rowley 2011; OFCOM 2012). A growing body of research has explored the potential for citizen journalists to produce news that meets the needs of local communities by analysing the content of hyperlocal news, and the motivations and business models of such sites (Williams, Harte, and Turner 2015). Less is known about how such new players are perceived by local mainstream news producers or other key stakeholders such as local authorities (Chen et al. 2015). Exploring one of the four ways that citizens can contribute to the production of local news suggested by Firmstone and Coleman's (2014, 2015) typology of citizen journalism, the research asked "What contributions do local journalists and council communicators perceive 'citizen journalism producers' make to news of democratic value?" Citizen journalism producers are citizens who contribute to the news ecology as individual or collectively organised producers of information and opinion, independent of mainstream media (Firmstone and Coleman 2014, 2015). At the time of the research, citizen producers in Leeds were typically operating as online hyperlocal news organisations or locally based magazines/lifestyle publications produced in digital formats and/or in print.

Citizen producers are perceived to add a valuable set of new voices to the news ecology, but the perceived democratic value of these voices is limited by their reach,

motivations, professional values, and sustainability. They are perceived as being good at providing news on very local events, but the relatively small size of their audiences raised questions about their ability to fulfil an informational role adequately. Interviewees thought that citizen producers can and do perform watchdog and campaign roles effectively but their potential to replace the contributions traditionally made by local newspapers in holding power to account and running campaigns is restricted. Concerns related to the differing motivations, professional values, and business models/resources of citizen producers in comparison to mainstream news organisations. Several interviewees' scepticism was based on the perception that watchdog and campaign news produced by citizen producers is motivated by interests other than the wider public interest commonly associated with mainstream journalism. Many also think the niche audiences and niche campaigns of such journalism make it unrepresentative. Even some citizen producers were sceptical of the democratic value of some citizen journalism and were concerned that such news is often produced according to an alternative set of motivations to those of professional journalists:

> Some blogs are just very, very opinionated whereas I at least try and be balanced and there is some journalism there. (Hyperlocal journalist A)

However, some new entrants aim to add something that is missing from the news ecology rather than replace the old functions of mainstream media. Defining output as "news features" not "news", and contributors as "storytellers" who do not identify as "journalists", this hyperlocal print publication said:

> What we're looking at is why did it happen and what happened afterwards and exclusive stuff, so if we do feel that there is something that we can explore that somebody else is not exploring that's where we'll go. (Hyperlocal news B)

While their additions to the local news ecology were broadly welcomed, the professional practices and values of citizen producers were of concern to council communicators who described difficulties in their interactions with some citizen producers. An example was given of a local blogger who did not act in accordance with the codes of professional journalism and published a story before an embargo had passed—such practices put the Council in a difficult position when it comes to engaging with citizen producers:

> And that then leaves us with that quandary of we'd like to treat you the same, because actually I'm all for openness, transparency, let xxx have it in the same way. However, if you expect to be treated the same you need to behave in the same way ... there's a set of behaviours that come along with that [acting in a journalistic role], a set of responsibilities, on our side but also on yours. (Head of Communications)

Coupled with concerns about the public-interest motivations of citizen producers, this points to a question at the very core of re-evaluations of the democratic role of journalism: what is a journalist? (Shapiro 2014).

## Perceptions of the Impact of Changes

Towards the end of the interview each interviewee was asked for their view of the suggestion that journalism is in crisis, and that local news is in a perilous situation. News providers commonly perceived this as an exaggeration of the current transformations in

local news provision where, in their view, any serious problems are confined to the news-paper industry.

> No, the crisis really is the papers. Nobody else is really facing an issue like that because we've all found ways to tap into what people are demanding now. And as I say, I think the crisis is as a result of people not demanding what they're [newspapers] trying to sell now. (Commercial radio)

Similarly, council communicators also felt that labelling the current situation as a crisis was too strong. However, based on a far broader view of the local news ecology, they expressed a significant degree of concern about the impact of changes in local news on the council's ability to communicate with citizens and the recent decline in the performance of the local news in engaging local citizens in local democracies.

## Discussion

The empirical evidence presented in this article confirms that the narrative of local news in crisis is unhelpful in two ways. Firstly, it is not a narrative that those with a vested interest in the future of local news identify with. Secondly, the label of crisis risks oversimplifying the complexity of the implications of ongoing changes in local news revealed by the thematic analysis of interviewees' perceptions. Yet the notion of crisis is helpful in lending a necessary sense of urgency to debates among academics and policy makers about the future of local news.

On balance, the analysis points to few changes that represent improvements in the democratic value of news and to more features of the shifting news ecology which cause concern for the quality of news available to the public. These include an inevitable yet potentially detrimental decline in the informational role of local news; a growing gap in the ability of local news media to fulfil the watchdog role due to an increase in desk-based journalism, over-reliance on public relations/pre-packaged news, and a lack of resources to investigate stories in depth; a perceived decline in the quantity of major news campaigns, a shift towards more frequent dramatised campaign-orientated news; and an improvement in the representative role of news brought about by social media but with the benefits largely restricted to the digitally active.

Amidst these changes, the stronger emphasis on running "public-interest" campaigns stands out as a beneficial implication, with the local newspaper's "Voice of Leeds" campaign fulfilling a potentially new role as a site of civic participation. By hosting monthly summits about key issues of public interest on "neutral territory" in partnership with a local charity, the newspaper has moved beyond the usual aim of campaigns to raise awareness or drum up support for an issue. Such campaigns are a direct reaction to the heightened need for local news organisations to maintain a trusted relationship with citizens to ensure their long-term legitimacy and economic success (Hermans, Schaap, and Bardoel 2014), and are a valued strategy to show readers that "we care, we are responsible and we are accoun-table" (Local newspaper).

The findings suggest three priorities for future research. Firstly an empirically based picture of how news content contributes to fulfilling the democratic value of news is required to establish how perceptions of changes in practices translate into changes in news content. Perceptions of local news that is increasingly dramatised, sensationalised, and campaign orien-tated in order to retain audiences suggest a continuing emphasis on entertainment, consumer,

and human-interest news found by Franklin a decade ago (Franklin 2006). Content analysis would reveal how local news content is shaped by the perceived proliferation of news unfiltered by the professional journalistic values of balance, fairness, and verification, and processes of "everyday watchdogging" (Gans 2010).

Secondly, the findings highlight the value of the news ecology approach in building a comprehensive understanding of local news. In considering multiple forms of news provision, the approach allows us to understand the wider implications of changes in the practices of one source of news. The comparison of emerging forms of local journalism with mainstream news media has shown that new news forms are not yet seen as fulfilling or replacing any of the democratic roles of news which are in decline in the mainstream media. Some citizen producers are, however, attempting to add value to local news ecologies in ways which may be innovative in providing democratic value. Seeing local news as a jigsaw puzzle, with each provider representing different pieces of an interlocking news ecology, allows us a more accurate insight into the consequences of removing a piece of the puzzle. Interviewees were particularly concerned about a decline in watchdog and campaigning news provided by newspapers. Such news is the most difficult for non-press news providers to fulfil due to either a lack of resources and expertise (in the case of hyperlocal news) or regulatory constraints for broadcasters to remain balanced and impartial. Indeed, the valuable position of newspapers as free to take sides in campaigns in a way that public service media cannot should not be forgotten in debates about the future remit of the BBC (Greenslade 2015), and local news industries generally. Shaker (2014) has highlighted the problematic consequences of the closure of local newspapers in the United States, where he found a correlation between the absence of local newspapers and falls in civic engagement.

Thirdly, whilst interviewees agreed that audiences for local news are larger than ever, the challenge of making content about civic issues interesting to them persists, highlighting the need for a fuller understanding of local news audiences. In short, it is necessary to establish "what needs saving and why" (Currah 2009, 27) to ensure that future policies and actions to bolster the democratic value of local news can be clearly justified.

## ACKNOWLEDGEMENTS

Thanks to the anonymous reviewers and John Corner for their comments on earlier versions. Thanks also to all the people interviewed for the study.

## DISCLOSURE STATEMENT

No potential conflict of interest was reported by the author.

## NOTE

1.    A 1970s corruption scandal about an architect in Northern England.

## REFERENCES

Barnett, Steven. 2009. "Journalism, Democracy and the Public Interest: Rethinking Media Pluralism for the Digital Age." *Reuters Institute for the Study of Journalism Working Paper*.

Barnett, Steven, and Townend, Judith. 2014. "Plurality, Policy and the Local: Can Hyperlocals Fill the Gap?" *Journalism Practice* 9 (3): 332–349.

Chen, Nien-Tsu Nancy, Katherine Ognyanova, Chi Zhang, Cynthia Wang, Sandra J. Ball-Rokeach, and Michael Parks. 2015. "Causing Ripples in Local Power Relations." *Journalism Studies.* doi:10.1080/1461670X.2015.1078738.

Currah, Andrew. 2009. "Navigating the Crisis in Local and Regional News: A Critical Review of Solutions." *Report for the Oxford Reuters Institute for the Study of Journalism.*

Fenton, Natalie. 2011. "Deregulation or Democracy? New Media, News, Neoliberalism and the Public Interest." *Continuum* 25 (1): 63–72.

Firmstone, Julie. 2015. "Journalistic Roles: Representing the Public and Encouraging Public Engagement in Civic Issues." Paper presented to the Political Studies Association, Media And Politics Group Annual Conference, "Mediating Democracy", University Of Chester, 5-6/11/2015.

Firmstone, Julie, and Stephen Coleman. 2014. "The Changing Role of the Local News Media in Enabling Citizens to Engage in Local Democracies." *Journalism Practice* 8 (5): 596–606.

Firmstone, Julie, and Stephen Coleman. 2015. "Rethinking Local Communicative Spaces: Reflecting on the Implications of Digital Media and Citizen Journalism for the Role of Local Journalism in Engaging Citizens." In *Local Journalism: The Decline of Newspapers and the Rise of Digital Media*, edited by Rasmus Kleis Nielsen, 117–140. London: I.B. Tauris.

Franklin, Bob. 2006. "Attacking The Devil? Local Journalism and Local Newspapers in the UK." In *Local Journalism and Local Media: Making the Local News*, edited by Bob Franklin, 3–5. London: Routledge.

Gans, Herbert. 2010. "News and the News Media in the Digital Age: Implications for Democracy." *Daedalus Spring 2010* 139 (2): 8–17.

Greenslade, Roy. 2015. "Why Local Papers Count." *The Guardian*, February 5.

Harcup, Tony. 2015. "Asking the Readers: audience research into alternative journalism." *Journalism Practice*. doi:10.1080/17512786.2015.1054416.

Hermans, Liesbeth, Gabi Schaap, and Jo Bardoel. 2014. "Re-establishing the Relationship with the Public: Regional Journalism and Citizens' Involvement in the News." *Journalism Studies* 15 (5): 642–654.

Kleis Nielsen, Rasmus. 2015. "Introduction: The Uncertain Future of Local Journalism." In *Local Journalism: The Decline of Newspapers and the Rise of Digital Media*, edited by R. Kleis Nielsen, 1–30. London: I.B. Tauris.

Mcleod, Jack, Dietram A. Scheufele, and Patricia Moy. 1999. "Community, Communication, and Participation: The Role of Mass Media and Interpersonal Discussion in Local Political Participation." *Political Communication* 16 (3): 315–36.

McNair, Brian. 2009. "Journalism and Democracy." In *The Handbook of Journalism Studies*, edited by Karin Wahl-Jorgensen and Thomas Hanitsch, 237–250. New York: Routledge.

Metzgar, Emily T., David D. Kurpius, and Karen M. Rowley. 2011. "Defining Hyperlocal Media: Proposing a Framework for Discussion." *New Media & Society* 13 (5): 772–87.

National Union of Journalists. 2014. https://www.nuj.org.uk/news/nuj-calls-for-short-sharp-inquiry-into-the-future-of-local/.

OFCOM. 2012. "Public Service Broadcasting Annual Report 2012." http://stakeholders.ofcom.org.uk/broadcasting/reviews-investigations/public-service-broadcasting/annrep/psb12/.

Shaker, Lee. 2014. "Dead Newspapers and Citizens' Civic Engagement." *Political Communication* 31 (1): 131–148.

Shapiro, Ivor. 2014. "Why Democracies Need a Functional Definition of Journalism Now more than Ever." *Journalism Studies* 15 (5): 555–565.

Williams, Andrew, Dave Harte, and Jerome Turner. 2015. "The Value of UK Hyperlocal Community News." *Digital Journalism* 3 (5): 680–703.

Zelizer, Barbie. 2015. "Terms of Choice: Uncertainty, Journalism, and Crisis." *Journal of Communication* 65: 888–908.

# MIXED MESSAGES
# An investigation into the discursive construction of journalism as a practice

## Sally Reardon

*Using the tools of discourse analysis, this research identifies the competing and sometimes contradictory public discourses around the requirements for the next generation of journalists—those of journalism educators, industry accreditation bodies, and of employers and journalists in the wider media landscape. Investigating and identifying the tensions in this debate may help all the parties to reflect on how the values and aims of the professional journalist are constructed and how this may impact on potential journalists entering education and the industry.*

## Introduction

Journalism in the United Kingdom has become the subject of the news as much as its purveyor. Scandals both in the press and in television reporting, such as phone-hacking scandals at the *News of the World* and more recently *The Mirror*, along with the reporting around Jimmy Saville, have brought to public attention some of the stresses and strains facing journalism in times of economic pressure and evolving technologies. However, these uncertain times do not seem to have dampened the enthusiasm to enter the profession, with journalism and related courses still growing in number (Ramsden 2012). Consequently, it is perhaps worth examining how journalistic values, knowledge and skills are represented to the public and to potential future journalists. With this in mind, this paper examines the competing public discourses around the requirements for the next generation of journalists by those involved in the education, training and practice of journalism—discourses of academic thought, journalism educators, industry accreditation bodies, and of employers and journalists in the wider media landscape. It aims to identify the various discursive constructions of journalism and to highlight any tensions between them.

## Journalism in the United Kingdom

The definition of the role and work of the "journalist" has variously been seen as an apprentice-based trade where workers are wage-earners engaged in white-collar work—the "hack"; or as a creative activity autonomously carried out—the "Hemingway"; or as a highly professionalised high-status occupation carried out by graduates—the "correspondent". In his overview of the job, Michael Bromley explains how journalism sits across a number of definitions: "While, strictly speaking, neither a profession nor a craft, it has displayed many of the characteristics of both" (Bromley 1997, 330).

The tenets of journalism ethical values and practice are also somewhat vague. Lewis remarks that "journalism as a profession is strangely elusive about its purpose" (Lewis 2006, 308) and, as Breed noted as long ago as the 1950s (Breed 1955) and others have concurred since, a journalist's ethics and knowledge are largely garnered from colleagues and managers. Practice and ethics are not explicitly spelt out but absorbed through socialisation. As such, journalism has been more accurately characterised as a "semi-profession" (Tunstall 1971; Tumber and Prentoulis 2005) where practitioners are expected to conduct themselves according to certain practices and ethics, even though the details of these practices and ethics are seldom agreed across the industry. As Örnebring points out, whilst some journalists may bear some "antipathy" towards the idea of journalism as a profession, "most journalists would probably consider themselves professionals, or at the very least aspire to a certain level of *professionalism*" (Örnebring 2013, 37, original italics).

What is apparent, though, is that journalism is increasingly exhibiting one characteristic of a profession in that the occupation has become a graduate one both in the United Kingdom and beyond (Deuze 2006). Journalists in the United Kingdom are increasingly likely to hold not only undergraduate degrees but also postgraduate masters degrees (National Council for the Training of Journalists 2013). Although many of the journalists working in the United Kingdom today will have been through some kind of training, the industry still has no entry requirements. However, efforts to set standards for a curriculum have been evolving over the last few decades. There are well-established initiatives for print journalists such as the National Council for the Training of Journalists qualifications and more recent industry initiatives for broadcast journalism in the form of the Broadcast Journalism Training Council (BJTC), which accredits broadcast journalism courses according to a largely skills-based set of criteria. These bodies aim to encourage higher education to produce industry-ready graduates and to enable employers to identify suitable candidates.

Yet, some have argued universities, under increasing pressure to engage in the "real world" and be "industry-facing" has led to an over-emphasis on practical skills. This attitude is succinctly put by Macdonald:

> In other words the purpose of media practice education must essentially be vocational … Anything, therefore, that does not fit within the codes and conventions operating within this market-orientated modality is going to be marginalized as alternative, experimental, unprofessional or in some way less valuable. (Macdonald 2006, 136)

These courses may also perpetuate myths and reinforce journalism practice rather than challenge it (Hanna and Sanders 2007). This is reflected in the journalism industry bodies which are focused on the practical, and largely ignore the critiques of practice. These kinds of vocational courses work to socialise students into the profession (Mensing 2011) and seem increasingly designed to please certain types of large industry employers.

However, media educators at higher education level expect students to learn more than shorthand and how to switch on a camera. If that was all that was expected a training college would be a more appropriate setting. Instead academics and "hackademics" have long argued against a programme which merely reproduces iterations of past practice but rather promotes learning that seeks to challenge and critique previous practice and ideas in order to produce a more engaged and thoughtful potential journalist. As Skinner, Gasher, and Compton argue:

the journalism curriculum must not only equip students with a particular skill set and broad social knowledge, but must also show students how journalism participates in the production and circulation of meaning. (Skinner, Gasher, and Compton 2001, 341)

De Burgh emphasises that journalism education's role is not to churn out employees but to educate citizens who will engage and contribute "to the intellectual and cultural life of society" (De Burgh 2003, 98).

Neither is it clear-cut that the move to a more industry-facing curriculum will make industry happy. Research shows some employers have expressed a desire to take on people who can "think" and be trained on the job, rather than be vocationally trained but lacking the breadth of knowledge and critical thinking which comes from academic learning (Thornham and O'Sullivan 2004). Employers have said they "do not care a fig" about skill and training, preferring to select people with the right "personal qualities" (De Burgh 2003, 109). Recent research by Lily Canter (2015) into the value of accreditation to employers shows a very mixed bag of skills and qualities which they see as important. Half of the employers interviewed said they would employ someone with no training whilst the other half said they would not.

The debate about what should be taught to journalism students is often carried out behind the closed doors of university departments and employers/accreditation boards. But it is also being played out in public, to the next generation of students (and their parents) as well as the wider public in both formal statements such as the university websites and in more informal pronouncements by practising journalists. This investigation will look at how these debates are discursively framed by industry and educators and what messages the next generation of would-be journalists are confronted with when choosing a career path. It also aims to identify the tensions between these discourses.

## Methodology

In order to investigate the types of discursive themes present in the public domain around the needs of the next generation of journalists, I have drawn on a number of sets of data. It is important to note at the outset that due to the small-scale nature of this research it was decided to concentrate on television journalism rather than print, online or radio journalism. That said, other types of journalism are touched upon in the course of this piece of work.

The data-sets are as follow:

1. *Education*: The BJTC website and the websites of 27 "Journalism" degree courses accredited by the BJTC were examined. The BJTC is an accreditation body supported by a number of industry employers such as the BBC, ITN, Sky, Channel 4, Associated Press and Thomson Reuters. It is funded through support from these employers and from running an accreditation service to universities and colleges. The home page of each course and the course outline were analysed as these are the first messages the students see and lays out the core message the university is trying to convey to potential students. The courses can be viewed on the BJTC website (BJTC 2015a).[1]

2. *Employers*: The websites of nine major broadcast journalism employers' trainee and graduate schemes websites were examined. These included the Press Association, BBC, Thomson Reuters, Associated Press, Sky News, ITV News, Channel 4, Bloomberg and Al Jazeera. Both written and visual texts were examined.

3. *Journalists in the media*: A Nexus search of national and trade press discussion of jour-
nalism education was carried out over a period of one year. This proved to yield little
in the way of data in the trade or national press, therefore a more anecdotal, impres-
sionistic analysis based on a number of cases the researcher came across in the wider
media were included in the following analysis. As discussed below, the results of this,
although not systematic, are reflected in other parts of the data examined.

## Methodology of Analysis

The data were examined using a framework of discourse analysis. The aim here was
not to identify the "truth" of the matter—that is, what you *actually* need to be a journalist or
which party espouses the "correct" answer about what is needed, but rather to discover
what has been termed the "interpretive repertoire" being played out in the various pro-
nouncements (Potter and Wetherell 1987).

Potter and Wetherell describe the "interpretive repertoire" as "a lexicon or register of
terms and metaphors drawn upon to characterise and evaluate actions and events" (Potter
and Wetherell 1987, 138). It looks at the body of discourse and uses a grounded method of
identifying patterns of language use rather than imposing the researcher's pre-existing
bias. As Taylor puts it, I approached the data with a "certain blind faith, with a confidence
that there is something there but no certainty about what" (Taylor 2003, 38).

This type of analysis has been taken up to look at the discourse of a range of issues
around employment from an employers' and employees' perspectives, ranging from career
choice (Moir 1993) to gender and employment opportunities (Wetherell, Stiven, and Potter
1987), and gender inequalities in media employment (Gill 1993). It has also been used in
looking at configurations of race and racism and other social issues (Wetherell and
Potter 1992; Foster 2009). As well as analysing the spoken word in research interviews, it
has been used to look at formal written texts (Edley 1993) and in formal spoken texts
such as television broadcasts (Potter 1996). Using a framework of interpretive repertoire
is useful in highlighting the constructions of "common-sense" notions, and the inconsisten-
cies between and within different accounts. By looking at these repertoires it is hoped to
gain a more nuanced understanding of the tensions between accounts and what this
may mean for would-be journalists and journalism educators.

A close and repeated reading of the data led to the identification of a number of
interpretive repertoires around the needs of journalists and journalism. The repertoires dis-
cussed are not exhaustive but perhaps the most relevant for those directly involved in the
teaching and employment of journalists. They also map on to previously identified dis-
courses around the job of the journalist.

## Findings

The various sources examined yielded a number of competing discursive construc-
tions of what is takes to be a journalist. The three main discursive repertoires identified
and discussed below consist of *training*, *vocation* and *critical thinking*.

## Training

The first construction of what is needed to become a journalist was centred round a
lexicon of training and skills for employability. This construction was evident, not

surprisingly, in the accreditation body and the university course material, but also in some of the employers' material.

This version of journalism is of an education delivered by professional current or former practitioners in state-of-the-art facilities. Within this repertoire the future is bright and "cutting-edge" for the twenty-first century. This literature emphasises that courses are endorsed by industry and are industry-facing. It took the form of an overwhelming emphasis on skills learnt from experts, as the following exemplify. The BJTC sets the tone:

> Our accreditation criteria reflect the rapidly changing world of journalism, in broadcast and digital multi media. We seek to ensure that the professional training provided is based on direct practical engagement … relevant to the operational demands of the industry, thus ensuring the highest levels of employability. (BJTC 2015b)

Various journalism courses take up the theme:

> As a student on one of the longest established journalism courses in the country, you'll learn the essential skills to make it in the challenging and rewarding world of the professional journalist—a career that can give you privileged access to some of the world's most incredible people, the best kept secrets, and awe inspiring tales of love, loss and heroism. Taught by working journalists and accredited by the Broadcast Journalism Training Council (BJTC), which represents employers such as the BBC, ITN and Sky, you'll have the opportunity to work across print, online, TV and radio in our fully equipped facilities.

The following course description is a typical example which includes a combination of themes which appear across the sample: a bright shiny future; industry-facing course; taught by professionals.

> A Broadcast Journalism Training Council (BJTC) accredited course that produced the Journalist of the Year and Best Documentary in its first year of membership. Our course has been described as "cutting edge" and one which could "revolutionise the way the next generation of journalists gather and distribute news". Taught by experts in their field, supported by numerous industry professionals, the course is designed with the future profession as its focus; giving you the knowledge and expertise to be a 21st Century journalist and media professional.

This repertoire of "professional" and cutting edge offers a narrative of learning from experienced past practitioners in order to "revolutionise" the future and foregrounds a repetition of past practice.

## Vocation

In contrast, the second construction characterises journalism as a vocation, something you are born to do rather than learn. This theme is strongly evoked by some of the employers' material, especially though use of trainee testimony, and can exist alongside the discourse of training. It is also evident in the wider public discourse of journalists. The discourse centres on inner emotional qualities such as righteous anger, determination, passion and raw talent, rather than externally learnt skills.

Some employers' material tends to discursively frame journalistic potentiality as something you *are* and this is rhetorically set in contrast to something you have *learnt*.

Formal learning is repeatedly set as secondary to the vocational bent of journalism candidates. For example, the BBC Journalism Trainee Scheme (JTS) Web page states:

> Serious contenders for the JTS are avid followers of news. They regularly read the local and national newspapers, watch television and listen to radio news. They have an excellent grasp of the role of social media in journalism. More than anything else, they are fascinated by story-telling—both the stories themselves and the processes that bring them to life.

Although the scheme is "not for complete beginners" there "are no academic entry criteria to apply for the JTS. We think talent, potential and determination count for more than an academic background" (BBC 2015).

The BBC website comes with a video about an open day event for people thinking of applying to the scheme. This again constructs the pathway as more open to people born with natural qualities to make them a journalist.

> We are looking for what we call vocational journalists. These are people who see themselves as journalists, have some evidence to show that's what they want to do, that's what they are. (BBC staff member featured in training video, 2015)

The emphasis throughout the video is that the scheme is "open to all" and that a candidate should "stay true to yourself". The video contains a quote from one attendee saying:

> I think it was the fact that it was truly open to everybody, you didn't have to be a degree student or have experience in the industry. As they call it, it was like a vocational journalist, you know? (BBC 2015)

Trainees' testimony is often used on the websites reiterating their "natural" talent and passion (cf. Oakes 2015). A trainee on the Channel 4 scheme is cited on the Channel 4 website, describing herself:

> I've been known to be gutsy, a perfectionist and not afraid to say what I think. I like pushing boundaries and it seems to come naturally; breaking the mould without actually realising there is one. (Baker 2015)

Reuters' graduate scheme outlines requirements as follows:

> Reuters is keen to have interns from varied backgrounds. While a strong academic record could be an advantage, it's not a must. A successful candidate will have insatiable curiosity and a demonstrable passion for news. (Reuters 2015)

Individual journalists and editors also exhibit this discourse of vocation. Alex Thomson of Channel 4 News (Thomson 2015) blogged in outrage when a fellow journalist suggested journalism was not an ideal choice of career as it does not pay well (Salmon 2015). Thomson responded with:

> People should become doctors because they want to cure sick other people. People should want to be journalists because of anger. And when I see anger I give real encouragement. And guess what—they actually do pay you a bit, enough, to go out and expose wrongdoing, and that feeling is a hell of a lot better than money or drugs or anything else for that matter. So that's why you should do journalism and that ain't going away no matter how the different platforms of media delivery are being invented ... That alone

should motivate journalists of any age—the anger to damn well try and do something about it. (Thomson 2015)

Roy Greenslade, the journalist and professor, championed Thomson's view, in a piece in *The Guardian* ending with, "Great stuff, Alex. That's the passion we need to instil into wannabe journalists. So I plan to read his uplifting piece to my City University MA students on Monday" (Greenslade 2015).

In some of the writing about the requirements for a would-be journalist *any* mention of prior education is specifically discouraged. For example, in a series of blogs, *The Spectator* editor Fraser Nelson (2014a, 2014b) repeatedly stated that those applying for jobs with *The Spectator* should not include educational information because "It's just not a factor in journalism" (Nelson 2014a). This echoes a long-standing discourse of industry professionals that you cannot teach journalism, exemplified by former *Sun* editor Kelvin MacKenzie in 2011 when he proclaimed: "No amount of academic debate is going to give you news sense, even if you have a PhD. It's a knack and you've either got it or you haven't" (MacKenzie 2011).

It is also worth noting that course descriptions are almost entirely devoid of any discussion about what kind of person you are. The rhetoric is very inclusive, emphasising that you can learn to be a journalist from other journalists, which contrasts sharply with the discourse of vocation discussed above where journalism is innate to some people.

## The Missing Link? Critical Thinking

A rather more muted discourse of reflection and critique is evident in the journalism course descriptors. In some cases the "academic" aspect of courses is defined and confined to law, regulation and ethics. In others this area is defined as skills. A wider contextualisation and reflection on practice issues is largely absent.

Some course descriptions avoid any mention of academic, reflective content, apart from mentioning there will be "some lectures". Others do embrace the academic or critical content in a wider context than law and ethics. At some point quite early in the course descriptors there is usually a nod towards the critical, as the following examples show:

[the course] combines practical training … with a solid academic base.

The course is academically challenging and is underpinned by a wide range of practical skills.

Details of how and what is meant by this is less clear. Much time is spent on explaining how students will gain skills in terms of the equipment and professional practice. Explanation of how you will become a "reflective practitioner" is less well defined. One course explains how "you will engage in intellectual debate about the communications industry during lectures and seminars as well as learning hands on broadcasting skills in the excellent facilities provided in our radio and TV studios, editing rooms and media suites".

The use of words such as intellectual is extremely rare. It is almost as if the courses are embarrassed to admit to this activity, glossing over this aspect in one sentence or a couple of words. More often this opening line is the only occasion when this aspect of the course is mentioned, with the discourse quickly shifting to an emphasis on practical skills, the work placements, the professional experience and details of up-to-date technical facilities. Descriptions of skills training is very specific and detailed compared to the rather vague statements about becoming a "reflective practitioner", if referred to at all. At other times

the academic activity is termed as "traditional" and separate from the main core of the course.

## Discussion

The three themes discussed above point to a wide range of discursive constructions of what is required to be successful in one's career in journalism, and highlight some tensions in discussions.

There is a tension between the first theme of "training" which stresses the facility to learn how to become a journalist in contrast to the second theme of "vocation" which implies a journalist is born rather than made. This second discourse constructs journalism as something you are "born" to do and that journalism itself is a product of common sense and of *natural* choices and practices. Therefore, the practice of journalism itself becomes constructed as immutable.

Further, the first construction of training is predicated on learning from past journalists who know how to *do* journalism. (There is also the seeming tension between the twin assertions of experienced *past* practitioners and cutting-edge revolutionising *future* practice which is glossed over and worthy of future examination.) This too, like the "vocation" discourse, frames journalism practice as an inevitability—in training you learn these processes from "natural" journalists and you will know how reiterate them and will become a journalist.

Both constructions contain knowledge and understanding of journalism within the realm of journalism itself, either as a natural activity born of natural talent or learnt from those with experience and natural talent. The persistence of this discourse of "natural" journalism has implications for journalism educators. If journalism is a natural, common-sense activity, how are journalism educators (who are not wedded to the industry) to challenge existing practice?

This brings in sharp focus the muted tones within the discourse of journalism practice —that of the critique. Students reading many of the course specifications would be forgiven for thinking that what they need to succeed is lots of training in skills. The discourse around intellectual reflection on the profession is implied as being of lesser importance compared to the acquisition of skills. There is a blurring of "professional education" and "training" (Deuze 2006, 19) whereby the training is foregrounded at the expense of critical thinking. In other words, the value of intellectual debate plays a poor second fiddle to the importance and value of being trained in skills. This perhaps maps on to the discourse of some employers interviewed by Lily Canter who could not see any added value to having a degree compared to non-university training courses, with little importance placed on critical thinking or research skills (Canter 2015).

This down-playing of critical engagement across the range of discourses around what it takes to be a journalist is intriguing. Although there has been a good deal of hand-wringing in the light of the Leveson Inquiry and other scandals, discursively all is goodness and light in the realm of journalism training and journalism employment. This is deeply worrying for all those concerned about the ethical and social aspects of journalism, and importantly, it is of concern to those directly teaching journalism. Journalism educators' discourse is one of striving to encourage critical thinking of journalism but this has to battle against a narrative of almost evangelical optimism about the profession.

Obviously university courses are in competition to attract students and the course websites are marketing tools. However, from an educationalist and perhaps employers' position it is worth considering what kind of message the potential student may take from this. Is it that skills are enough? And do we want the next generation of students to be the sort that are attracted to courses that do *not* emphasise the importance of thinking, reflecting and analysing? And for students looking out at the "real world", the discourse of employers and journalists is that the key requirement for a proto-journalist is not what you *know* but who you *are*, rendering education unnecessary.

Although extremely small scale, this investigation hopes to provide food for thought regarding the discursive portrayal of journalism's future. More work is needed to unpick the various strands of the competing interpretive repertoires of what it takes to be a journalist. As stated earlier, this investigation is not to identify the "true" or correct discourse to nurture future journalists. Neither is it to advocate that we all—educators, employers, practitioners—speak with one voice. Rather it is to understand the different emphasis placed on the needs of future journalist by the various interested parties and to consider if and how they may be aligned and what the consequences of these mixed messages might be in terms of understanding for new recruits to the industry and to the public at large.

## DISCLOSURE STATEMENT

No potential conflict of interest was reported by the author.

## NOTE

1.  Due to time and space restrictions analysis was limited to undergraduate courses only, specifically called Journalism, Broadcast Journalism and Multimedia Journalism. Masters courses and other undergraduate journalism courses such Sports Journalism were excluded.

## REFERENCES

Baker, Arazou. 2015. "Arazou Baker, Reporter." *Channel* 4. Accessed March 1, 2015. http://4talent. channel4.com/work-programmes/4crew/reporter.

BBC. 2015. "Journalism Training Scheme." Accessed February 28, 2015. http://www.bbc.co.uk/careers/trainee-schemes-and-apprenticeships/journalism/jts.

BJTC (Broadcast Journalism Training Council). 2015a. "Our Courses." Accessed February 18, 2015. http://www.bjtc.org.uk/#!repairs/cuy0.

BJTC (Broadcast Journalism Training Council). 2015b. "Careers in Journalism." Accessed February 28, 2015. http://www.bjtc.org.uk/#!careers/c1viv.

Breed, William. 1955. "Social Control in the Newsroom: A Functional Analysis." Reprinted 1999 in H. Tumber (ed.), *News: A Reader*. Oxford: Oxford University Press.

Bromley, Michael. 1997. "The End of Journalism? Changes in Workplace Practices in the Press and Broadcasting in the 1990's." In *A Journalism Reader*, edited by Michael Bromley and Tom O'Malley, 330–350. London: Routledge.

Canter, Lily. 2015. "Chasing the Accreditation Dream: Do Employers Value Accredited Journalism Courses." *Journalism Education* 4 (1): 40–52.

De Burgh, Hugo. 2003. "Skills are not Enough: The Case for Journalism as an Academic Discipline." *Journalism* 4 (1): 95–112.

Deuze, Michael. 2006. "Global Journalism Education: A Conceptual Approach." *Journalism Studies* 7 (1): 19–34.

Edley, Nigel. 1993. "Prince Charles – Our Flexible Friend: Accounting for Variations in Constructions of Identity." *Text* 13 (3): 397–422.

Foster, John D. 2009. "Defending Whiteness Indirectly: A Synthetic Approach to race Discourse Analysis." *Discourse and Society* 20 (6): 685–703.

Gill, Rosalind. 1993. "Justifying Injustice: Broadcasters' Accounts of Inequality in Radio." In *Discourse Analytic Research: Repertoires and Readings of Texts in Action*, edited by Erica Burman and Ian Parker, 75–93. London: Routledge.

Greenslade, Roy. 2015. "Why be a Journalist – Anger says Channel 4's Alex Thomson." *The Guardian*, February 16. Accessed March 1, 2015. http://www.theguardian.com/media/greenslade/2015/feb/11/why-be-a-journalist-anger-says-channel-4s-alex-thomson.

Hanna, Mark, and Karen Sanders. 2007. "Journalism Education in Britain: Who are the Students and What Do They Want?." *Journalism Practice* 1 (3): 404–420.

Lewis, Justin. 2006. "News and the Empowerment of Citizens." *European Journal of Cultural Studies* 9 (3): 303–319.

Macdonald, Ian W. 2006. "Mindset and Skillset: the persistence of division in media education." *Journal of Media Practice* 7 (2): 135–142. doi:10.1386/jmpr.7.2.135_3.

MacKenzie, Kelvin. 2011. I'd shut all the Journalism Colleges Down. [Online] Accessed July 3, 2015. http://www.independent.co.uk/news/media/press/kelvin-mackenzie-id-shut-all-the-jour-nalism-colleges-down-2264846.html.

Mensing, Donica. 2011. "Realigning Journalism Education." In *Journalism Education, Training and Employment*, edited by Bob Franklin and Donica Mensing, 15–32. Abingdon: Routledge.

Moir, Jan. 1993. "Occupational Career Choice: Accounts and Contradictions." In *Discourse Analytic Research: Repertoires and Readings of Texts in Action*, edited by E. Burman and Ian Parker, 17–34. London: Routledge.

National Council for the Training of Journalists. 2013. "Journalists at Work". http://www.nctj.com/downloadlibrary/jaw_final_higher_2.pdf.

Nelson, Fraser. 2014a. "Internships at The Spectator." June 24. Accessed February 27, 2015. http://blogs.spectator.co.uk/coffeehouse/2014/06/internships-at-the-spectator/.

Nelson, Fraser. 2014b. "Worried about Social Mobility? Here's a way to Change Things." August 28. Accessed February 27, 2015. http://blogs.spectator.co.uk/coffeehouse/2014/08/worried-about-social-mobility-heres-a-way-to-change-things/.

Oakes, Katie. 2015. "ITV Scheme: From Trainee to Journalist." Accessed March 6, 2015. http://journografs.com/2014/02/17/itv-scheme-from-trainee-to-journalist/.

Örnebring, Henrik. 2013. "Anything you can do, I can do Better? Professional Journalists on Citizen Journalism in six European Countries." *International Communication Gazette* 75 (1): 35–53.

Potter, Jonathan. 1996. *Representing Reality: Discourse, Rhetoric and Social Construction*. London: Sage.

Potter, Jonathan, and Margaret Wetherell. 1987. *Discourse and Social Psychology*. London: Sage.

Ramsden, Brian. 2012. "Institutional Diversity in UK Higher Education." A report for the Higher Education Policy Institute. Accessed March 29, 2013. http://www.hepi.ac.uk/466-2023/Institutional-Diversity-in-UK-Higher-ducation.html.

Reuters. 2015. "London European Journalism Internships". Accessed March 1, 2015. http://jobs.thomsonreuters.com/job/London-European-Journalism-Internship-Job/244025700/.

Salmon, Felix. 2015. "To All The Young Journalists Asking for Advice." Accessed March 6, 2015. http://fusion.net/story/45832/to-all-the-young-journalists-asking-for-advice/.

Skinner, David, Mike J. Gasher, and James Compton. 2001. "Putting Theory to Practice: A Critical Approach to Journalism Studies." *Journalism* 2 (3): 341–360.

Taylor, Stephanie. 2003. "Locating and Conducting Discourse Analytical Research." In *Discourse as Data*, edited by Margaret Wetherell, Stephanie Taylor, and Simeon J. Yates, 5–48. London: Sage.

Thomson, Alex. 2015. "I'm a Journalist Because I'm Angry – You Should be Too." *Channel 4 News blogs*. Accessed March 6, 2015. http://blogs.channel4.com/alex-thomsons-view/journalist-angry/8901.

Thornham, Sue, and Tim O'sullivan. 2004. "Chasing the Real: 'Employability' and the Media Studies Curriculum." *Media, Culture and Society* 26 (5): 717–736.

Tumber, Howard, and Marina Prentoulis. 2005. "Journalism and the Making of a Profession." In *Making Journalists: Diverse Models, Global Issues*, edited by Hugo de Burgh, 58–74. Abingdon: Routledge.

Tunstall, Jeremy. 1971. *Journalists at Work*. London: Constable.

Wetherell, Margaret, and Jonathan Potter. 1992. *Mapping the Language of Racism: Discourse and the legitimation of exploitation*. Harvester Wheatsheaf: Hemel Hempstead.

Wetherell, Margaret, Hilda Stiven, and Jonathan Potter. 1987. "Unequal Egalitarianism: A Preliminary Study of Discourses Concerning Gender and Employment Opportunities." *British Journal of Social Psychology* 26 (1): 59–71.

# THE NEW ARCHITECTURE OF COMMUNICATIONS

## Jean Seaton

*The new architecture of communications has two symbiotic features: an overwhelming abundance of information and communications and the emergence of narrow, 'silos' of information and opinion that have developed partly in response to the copious complexity available, partly because of the enhanced tools developed to navigate the variety. The weak 'bridging' links to many opinions that the media used to produce can be replaced by 'strong' personalised links to narrow views. In addition the democratic space of negotiated, re-distributive communicative space is dis-appearing. The article examines the practical working out of these tendencies in institutions by examining the new British Army doctrine which puts communications at the centre of action, and considers the ways in which silos emerge. It argues that we need new kinds of oversight. It argues that the UK tradition of extending the range of voices given platforms is a better response to the contemporary architecture of communications than the classic focus on individual freedoms of speech. It argues that the BBC, international and domestic, concerned with tone and feelings, is one of the few institutions we have constituted and built (albeit accidentally) to perfectly match this contemporary shape of communications.*

The new architecture of communications has two symbiotic features. On the one hand, there is an overwhelming abundance of information and communications that are multifaceted and shared multilaterally and multinationally. Political and social power, new interest groups and new problems have international and domestic dimensions: cyber crime and celebrity brands share the same communicative spaces. On the other hand, partly in response to the copious complexity available, partly because of the enhanced tools developed to navigate the variety, narrow "silos" of information and opinion may develop. The weak "bridging" links to many opinions that the media used to produce may be being replaced by "strong" personalised links to narrow views.

This article examines the practical working out of these tendencies in institutions by examining the new British Army doctrine which puts communications at the centre of action, and considers the ways in which silos are embedded in communications, the media and identity. It suggests that we need to be careful to ensure that we maintain the capacity of institutions to respond to these pressures. It argues that the British Broad-casting Corporation (BBC), international and domestic, concerned with tone and feelings, is one of the few institutions we have constituted and built (albeit accidentally) to match per-fectly this contemporary shape of communications. Indeed, these features are re-shaping

institutions and the relationships embedded within them—but we need to nurture institutions (and new kinds of oversight) to connect and bridge silos and common interests. We need to be especially careful of those few we have that advance journalism in the public interest.

## New Rules of Engagement

General Sir Nick Carter, the Head of the British Army, announced a new overarching doctrine for the future of the army in 2015. It is not about shooting (kinetics): perhaps surprisingly, it is all about communicating. Called "integrated action", it will make the army "smarter", "more bespoke". It was to play a "key part in enabling the UK to fight in the information age", consisting of "more than just traditional capabilities" (BBC News 2015). It is also a reminder that institutions, not just individuals, shape communications.

Carter, when he was in charge of British forces in Afghanistan, had proposed new rules of engagement—soldiers were required to exercise "courageous restraint" or "tactical patience", that is, hesitate before acting (for which he was promptly vilified by the British tabloid press, who claimed it risked soldier's lives). It was the first step towards this new doctrine, and was a response to the counter-insurgency conflicts the army found itself engaged in, from which it had previously been slow to learn. In Afghanistan Carter had observed a new kind of conflict. Complex actions were taking place amongst civilians with multiple allegiances (to local elders, the Taliban, local war-lords, drug cartels). Yet the rules of engagement the army was working within were out of date and inappropriate. The army was trying to fight a counter-insurgency within rules that had been framed for land-warfare on the European continent.[1]

Carter's rules built the calculation of how actions would be reported and understood into choosing what to do. In the new doctrine the principle is made a much larger idea. In any conflict, before soldiers act, having decided on an outcome they want, they need to:

> Go through a process of analysing the audiences that are relevant to the attainment of that objective, whether they're actors, allies or adversaries. You then take a view on what effect you need to achieve on those various actors. Then you look into your locker of methodologies, which will arrange all things from soft through to hard power, and you work out the best method of synchronizing and orchestrating those range of effects to impart effect onto audience, to achieve the outcome. (Carter 2015)

The new army doctrine demands that the entire chain of command considers the ways in which the meaning of any action will be interpreted by multiple audiences before they act. From soldiers on the ground, in the middle of a threatening incident, but also right at the top where long-term strategic decisions are made—all now have a specific responsibility to factor into choices how actions will be interpreted.

The new doctrine is an attempt to deal with the multifaceted challenge posed by contemporary communication technology and its particular patterns of human engagement. In it, enemies, potential enemies, non-combatants, civilians in the space where the action is taking place, allies (armies are increasingly international political coalitions), people at home, other people in other allies' home countries, other people in potentially hostile countries, neutral countries—everyone is seen primarily as an audience. The new information order means that they all have to be taken into account, because they are very likely to see the event and their perceptions will determine how it is assessed. How

an action is seen in all of these different communities, which then interact independently with each other, affects what it achieves. No wonder the army is rethinking communications.

While "enemies" have always sought to project messages (either intimidation or persuasion) into hostile territory, wars are now harder to define—winning, losing, beginning, ending are less clear. Indeed Carter says that "wars are permanent now" (General Sir Carter, interview, 2016). Their terrain has shifted too, and so have communications. While it is a truism to say that conflicts are won in people's minds, nevertheless this is taking a new form. Olivier Grouille says that Britain's enemies at the moment are "fighting her by using a franchise of ideas" (2011, 13).

Historians may criticise some of these claims. Power, and especially force, has always had a communicative aspect (though the latter is not one communication scholars have spent much time thinking about). So this preoccupation with messaging is perhaps less radical than it appears. Historians may also worry that the army is apparently assuming control of propaganda with no intervening institutions. In the past we have largely divided responsibility for those different aspects of messaging—propaganda, information, disinformation—even in total wars.

Indeed, during World War Two, there were many, often competing institutions (the much satirised Ministry of Information, the Foreign and Commonwealth Office, the Ministry of Economic Warfare, the Home Office, the "secret" Special Operations Executive, SO1 and SO2, and myriad committees) which "owned" different aspect of communicating to different audiences at home and abroad (Pimlott 1985). Yet the BBC's World Service (originally the Empire Service, later the Overseas Service), for example, set up to broadcast into occupied Europe, had a carefully constructed and resolutely defended editorial independence. This was triumphantly developed during the Cold War. While it took policy directives from government, as Alban Webb has pointed out, the BBC often created policy interrogatively *with* government—bringing its own special expertise in audiences and programmes to bear on policy (Webb 2014). The World Service's real but inevitably negotiated independence also relied on what John Tusa later called "the mothership" of wider (and larger) domestic BBC values (Sir John Tusa, interview, 2014). The BBC was unitary in ethic but diverse in delivery. Its size and authority at home protected its range and voice abroad.

The BBC's international service of news and entertainment and culture won audiences overseas during those wars because it was reliable, trustworthy and, although clearly broadcast from London with a British view, it nevertheless strained to understand the preoccupations, circumstances and needs of its foreign audiences.

In turn, the World Service was sensitised by the extraordinary institution of BBC Monitoring (Seaton, Hughes, and Webb 2015). This listened to, and later watched, what regimes all over the world broadcast, openly, to their own populations, informing the BBC's understanding of information and mood in all the places into which it broadcast. This was nuanced by a determination to understand audiences in threatening circumstances. All of these institutional arrangements, co-operative and competitive, developed into the management of information and opinion during the more extended Cold War. Yet the fundamental independence of the BBC's right to interpret policy in programmes and information remained.

Does Carter's innovative doctrine suggest we have lost the institutional oversight capacity we used to have because the situation both internationally and technically has shifted so fast? This is a policy issue that has been ignored in all of the loud noise about "leaks".

Yet the world is now multipolar—and international affairs far more complex than in the bipolar world of the Cold War (although it hardly felt simple at the time). Messaging and interpretations of events swirl around an interconnected world. This is easy to state but demanding to deal with in international affairs. Modern threats are not simple; they are multifaceted and waged at home as well as abroad. They come in unexpected ways and are hard to calibrate. International and national boundaries are porous, threats and opportunities spill from one realm to another. Domestic and international affairs are increasingly shaped by cross-national communities of interest which find expression in communications. Non-state actors—from terrorist groups, to multinational corporations, entertainment "brands" and personalities—are powerful in different ways. They have all been successful at exploiting this new fluidity. Then there is a leaky communication of action, a world in which it is harder for some players (but not others) to restrict or manage who interprets actions. It is said one alarmed diplomat liked playing "Eight-dimensional chess" (BBC Monitoring and History and Institutions Workshop 2010).

During the Cold War "we were clear about the capacity of our enemies, but unclear about their intentions", according to Chris Westcott (previously Director of BBC Monitoring) —which is why Monitoring was so important. We scrabbled to interpret what behaviour meant. Now this is reversed. "We are clear about our enemies' intentions, but are don't know their capacity" (Westcott 2016). Scrabbling around again for vital clues, we have sleepwalked into a more dangerous situation because for 30 years since the end of the Cold War we reorganised ourselves as if the end of history were settled. The new shape of world power and its links with our backyard are disrupting conventional spheres of responsibility—and perhaps oversight. We ought to be more concerned about this—but it is related to changes in communications.

"Extremists" have been swift to exploit media developments. It can be the simple appropriation of technology. The "GoPro" camera was invented to record the thrill of riding a wave from the surfer's point of view—by fixing a robust camera securely to clothing in extreme sports. The Kouachi brothers who murdered the staff of *Charlie Hebdo* had one in their car. Mohamed Merah, the gunman who killed three off-duty soldiers, a Rabbi and his two sons (the six-year-old finally killed as he crawled to his father) and an eight-year old girl, also used one attached to his cap. His film captures him pulling the little girl by her hair as she tried to flee and when his first gun failed, shows him getting another out and shooting her in the temple. He spent the last 36 hours of his life editing the footage from his GoPro into a 24-minute film (Burke 2015). The rhetoric of the editing was learnt from games, films, television and news, just as earlier "suicide videos", the last testament of bombers, replicated narratives from well-understood adventure films, and although produced in professional production houses, related to far older stories and symbols (Seaton 2005).

Yet if suicide bombers are "cheap" weapons, they are also the product of long-term investment in propaganda, messaging, contacting and support—as well as circumstances. The live streaming of an act of terrorism is the culmination of the interaction of the media and terrorism and the communications are implicated in any number of ways in the creation and response to these issues. As Jason Burke argues, the ways in which attacks are planned and their impact calculated: "is fundamentally, profoundly contemporary, the product of the same interaction of politics, economics, culture, technology and social organisation that affects us all. It is of its time, which is now, and created and shaped by its environment" (Burke 2015, 11–12). So if the media and communication systems are

used: what structural and individual part do they play (if any) in creating views? The new army doctrine is just one response to what Carter calls the "simultaneous explosion of communication opportunities and the narrowing of focus".

## Silos of Information and Opinion

In the new communications world, if shopping preferences are understood and enhanced technically so that consumers are offered more of what they want (or have wanted before) then so are their opinions and interests. Mumsnet, the influential website for parents, recently offered its interested and engaged users some helpful links to petitions they might like to sign—and then it signed them up to them. It was predicting their political preferences and helpfully pushing them to action (even if a minor relatively cost-free kind of action).

Amid the proliferation of communication, messages, information and images, and the breakneck pattern of integration and interconnectedness, reliable and important is not easy to distinguish from the insignificant or deliberately misleading. "Winning" attention (as newspapers have found) is hard, winning attention for the relatively trustworthy often harder. Winning consideration for the nuanced, the considered, the argued but open-minded, the grey world of uncertainty and "good enough" is peculiarly tough. The internet and social media are rarely deliberative, they are Manichean—most things are black or white. Social media have often taken on the mood of tabloid self-righteous denunciation (and blame) and personalised them.

This is in part because this overabundance has contributed to a new world of rigid "silos". These are sometimes called "ghettoes" or "buckets" but silos, "a system, process, department that works in isolation from others" as the *Oxford English Dictionary* defines them, also resonate with the sense that silos exist in structures but also in ideas, social groups and minds. It might be called the division of labour—specialisation after all permits complexity. However, "silos" can also be a threat because they exclude a wider view, they can be dangerous: the financial crisis of 2008 was at least in part created because almost no one understood aspects of the financial instruments that were being traded. Cass Sunstein (2007, 21) identified the "growing power of consumers to 'filter' what they see" as the "most profound influence on democracy and free speech" . He argued that the traditional regulatory concerns of the American system—restricted to minimising state power and enhancing individual choice—were inadequate to the new environment: "The phenomenon has conspicuous importance for the communications market, where groups with distinctive identities increasingly engage in within-group discussion … as the public becomes balkanised and groups design their own preferred communication packages … this is in part one adaption to the online plenty" (127).

In the United Kingdom there is an alternative tradition, which has always been concerned with interventions to extend the range of voices encountered. The BBC and other public service broadcasters are examples of such policy traditions. As Chris Westcott, recently the director of BBC Monitoring, said:

> Navigating this radically transformed landscape presents for example the BBC, with new challenges. The old broadcast model—"standing on a hill and shouting loudly"—is just one aspect. The "one to many" media is at best now co-existing with—and in some cases being usurped by—a new "many to many" model where the dominant mode is

conversation, or at least everyone having the same ability to stand shoulder to shoulder on the hill and shout loudly at each other. (Westcott 2016)

Distilling that cacophony—often ill informed, partisan and trivial—is a BBC challenge. Appropriating a term used by audio engineers, it is about improving the "signal to noise ratio" (Westcott, interview, June 2016)

This structural shift has been accompanied, and is also an expression of another trend, which sounds trite but whose impact is wide: personalisation. It is in part a sham —the much-vaunted "personalised" communication is often a patchwork of larger media brands and ideas. What has been less remarked is that this represents a decline in the space for the allocation and negotiation of resources and rights. Democratic space is not plebiscitary—it needs to allocate in collective interests, sometimes at the expense of particular interests. Many of the allocations are not easy to calculate exactly. But the grey area of compromise and trading is now inimical to the way in which communications work.

How do the "silos" of opinion emerge and work? Our capacity to roam over the prairies of the internet and then burrow down into topics and interests is an astonishing resource. Yet accidental, casual, curious choices can now dynamically lead in unexpected directions. If the news media traditionally enhanced unintended and weak links to outside organisations and ideas that users had not previously encountered (news surely by definition is a bridging mechanism in this way), now users make stronger, more personal and meaningful links to narrower groups (Granovetter 1973).

Consequently, one response to information excess has been the emergence of rigid "silos", the following of opinions and topics with like-minded people to the exclusion of others. Opinions and views are reinforced not challenged. Online plenty encourages tunnel vision: it can narrow encounters. Meeting different points of view is harder, not easier. How do these narrow places develop and how do they work?

One of the most resilient findings over nearly 70 years of research into the media has been that society trumps messages. It has been repeatedly shown that the community you are embedded in, the work you do, the family you belong to, the peer group tastes you admire or abhor, all locate you in a social structure that interacts with the media messages you consume and reply to. Comfortingly for democrats, it appeared that the reality of the web of social structures people live within determined their views more than mere images or messages.

However, the online world offers immediate, real-time, warm, personal, social support and a community. The social structure that used to be separate from the messages has decamped—at least for some—and become integral to the messaging. Some of these self-referencing spaces are very narrow and some are in addition *directional*: they have intentions and they have a tendency they wish to increase. Becoming a "member" of a community sounds warm and embracing—but not all supportive communities are benign. An apparently granular, social and political problem—with individual's self-imagination at the heart of it—can only be treated locally (swift intervention and alert institutions) but has a far wider communicative context.

## Fit-for-purpose Institutions

So there is a conundrum: what instruments do we have collectively to address these two entwined problems? There are complex international echo chambers of

communication and deep and worrying narrow spaces which may increasingly cordon off the vulnerable? As Nick Carter's new military doctrine shows, institutions have a role—but are having to re-invent themselves.

In the parochial, fussy, sour debate about the future of the BBC around the 2016 White Paper, these tough yet immediately important issues were hardly recognised. Yet the Corporation, invented in the 1920s, can address both the international multifaceted aspect of communications and has a potential role in enlarging the discussion of the most intimate, personal issues—like eating disorders. It can do both. The BBC's international presence combined with its national role, at the heart of the Corporation, makes the BBC one of the few institutions we have that is fit for purpose in the evolving, interconnected world.

So to the extent that we rely on journalism to be able to understand what is happening abroad and react to it, we need to understand the domestic consequences and manage those as well. In addition, there are the inter-connected problems where unilateral solutions are inadequate. Climate change, the control of epidemics, migration, cyber-crime, have thrown up international interest groups and sometimes—at least around epidemics— novel and remarkable forms of organisation. But all of them require complex cross-border, cross-lateral thinking and solutions. The BBC almost uniquely is the right shape for this new world. Dedicated to the national interest and public service, it has the right values for grappling with the problems.

But the challenge is larger and takes a different form from before: so the BBC also has to grow confidently into the new shape of communications. There are emerging movements—which make skilled use of the tools of communication—but for the first time also make their own communities. Online—whether you are a member of the radical social movement Occupy or a potential jihadi—you are both the receiver and producer of messages and, more significantly, part of that community (Bartlett 2016, 207). Online interaction (although still dependent on images and narratives often taken from the media) now wraps individuals in close communities of support. McLuhan ([1964] 1994) was wrong (about almost everything): it is not that the media are the message but that the media can be the society, the community, the network of apparently intimate social relationships that bind messages into identity. Powerful musical tastes and concern with fashion and "celebrities" are also increasingly important: indeed, "the culture tribes"—the demography of taste—may be more significant politically than political parties.

The BBC is already organically fitted to this new world—its institutional shape matches it. Indeed, it is ideally fitted to break down barriers (though it is a formidable task). It does many things that are linked: newsgathering and BBC Monitoring bring the world to the United Kingdom, where it is shaped for the national citizen. The World Service takes the United Kingdom to the world. It is a sinuous and strong system— based on the BBC's editorial independence and with the resources to deliver at every point in the chain. The Corporation is already a ringmaster for multilateral discussions, so that Afghans can hear what people in the Middle East are thinking and Poles what Africans are doing.

More widely, the corporation understands how music and political movements are related. It has the capacity to explore how people feel about things. In addition to public service journalism, it has drama and comedy, it has listening, discussion and argument— it is capable of sympathy. It deals—every day—in tone of voice, sentiment. These are incomparable advantages in the world of identity making.

Of course, the Corporation is just a tiny player in the new world of communications. Yet it is an institution we have that has the right shape and has the right—public—values at the core of everything it does (well if it fails, which it inevitably does, we can ask it to do better). The new structure of international, national and personal life is being shaped by communications, not borders—and the BBC is in the business of communicating.

## ACKNOWLEDGEMENTS

This paper was informed by the workshops conducted for the AHRC networking award on the history of BBC Monitoring for which Jean Seaton is principal investigator together with Dr Suzanne Bardgett. The award was a collaboration between the BBC, The Imperial War Museum, Westminster University, King's College London, and the Universities of Sussex, Reading and Cambridge; it was cross-disciplinary.

## DISCLOSURE STATEMENT

No potential conflict of interest was reported by the author.

## FUNDING

This work was supported by the Arts and Humanities Research Council [AH/M004007/1].

## NOTE

1.  Not that the possibility of land-war on the European continent has disappeared as it was expected to. That is the contemporary condition: old and novel forms of conflict co-exist.

## REFERENCES

Bartlett, Jamie. 2016. *The Dark Net*. London: Heineman.
BBC Monitoring History and Institutions Workshop, Imperial War Museum, London, June 10 2015.
BBC News. 2015. "Army Sets up New Brigade for 'Information Age'." January 31, http://Www.Bbc. Co.Uk/News/Uk-31070114.
Burke, Jason. 2015. *The New Threat*. London: The Bodley Head.
Carter, General Sir Nicholas, and Kcb Cbe Dso Acd Chief of the General Staff, British Army. 2015. "The Future Of The British Army: How The Army Must Change To Serve Britain In A Volatile World", 17th February, International Security Department, Chatham House Chair: James De Waal Senior Consulting Fellow.
Granovetter, Mark S. 1973. "The Strength of Weak Ties." *American Journal of Sociology* 78 (6): 1360–1380.
Grouille, Olivier. 2011. *Land Forces Fit for the Twentieth Century*. London: Chatham House.
McLuhan, Marshall. ([1964] 1994). *Understanding Media*. Cambridge, MA: MIT Press.
Pimlott, Ben. 1985. *Hugh Dalton*. London: Chapters Xix, Xx.
Seaton, Jean. 2005. Carnage and the Media, The Making and Breaking of News About Violence, Penguin, Chapter 7.

Seaton, Jean, Rosaleen Hughes, and Alban Webb. 2015. "Submission to the Defence and Security Review 2015." https://Www.Gov.Uk/Government/News/Strategic-Defence-And-Security-Review-Public-Engagement.

Sunstein, Cass. 2007. *Republic.Com.2.0*. Princeton: Princeton University Press.

Webb, Alban. 2014. *London Calling*. London: Bloomsbury.

Westcott, Chris. 2016. AHRC Workshop, "The History and Institutional Relationships of BBC Monitoring", University of Westminster, 10 June 2016.

INTERVIEWS

Jean Seaton. 2014. Interview with Sir John Tusa.

Jean Seaton. 2016. Interview with Chris Wescott. London, June 2016.

Jean Seaton. 2016. *Interview with General Sir Nick Carter*. London.

# NORMATIVE EXPECTATIONS
## Employing "communities of practice" models for assessing journalism's normative claims

**Scott Eldridge II** ⓘ and **John Steel** ⓘ

*Journalism's relationship with the public has historically rested on an assumption of its Fourth Estate roles and as fulfilling democratic imperatives. The normative dimensions of these ideals have also long been "taken as given" in journalism studies, serving as a starting point for discussions of journalism's public service, interest, and role. As contradictions to these normative ideals expose flaws in such assumptions, a reassessment of this normative basis for journalism is needed. This paper looks to challenge normative legacies of journalism's societal role. Drawing on uses and gratification theoretical frameworks and engaging with communities of practice, it explores how communities understand journalism from both top-down (journalism) and bottom-up (citizen) perspectives. This research considers citizen expectations of journalism and journalists, and evaluates perceptions of journalistic values from the ground up. By employing a community facilitation model, it offers an opportunity for participants from across the community to reassess their own conceptions of the role of journalism. This establishes a better basis to approach the journalism–public relationship that does not advantage historic, normative, or traditional legacies.*

## Introduction

The notion of the Fourth Estate has long been identified as journalism's *raison d'être* to safeguard democratic accountability and ensure the public has knowledge of what is being done on their behalf. This has been the essential moral basis for journalism's function in democratic societies since the mid-nineteenth century (Hampton 2004). The normative ideal of journalism acting as the Fourth Estate is one that rests upon shared journalistic claims about journalism's obligation to represent the interests of the democratic community (Hanitzsch 2011; Hanitzsch and Mellado 2011). Journalism's relationship with the public has historically rested on an assumption about *its* moral commitment to fulfilling *its* self-declared democratic obligations. This paper looks to stimulate new understandings of journalism's normative rationale by examining journalism from the perspective of those on whose behalf journalism purports to serve. We draw out arguments from a grassroots level for a more "ground-up" assessment of journalism. We use community groups and community news products as a locus of inquiry to understand what is expected of news media at community, local, regional, and national and international levels. This paper looks to advance research orientated towards "ground-up" normative criteria from those who consume journalism, around whom journalism's normative claims are framed. The

key interventions this paper seeks to make are therefore two-fold: firstly to challenge the normative basis of journalism as it has been understood by both journalist practitioners as well as critics of journalism; and secondly, to lay the foundations for re-evaluating normative criteria for journalism.

## Theoretical Context

Amongst the many roles that journalism purports to perform, the Fourth Estate is probably the most frequently cited, and for journalists describing what they do the democratic watchdog component is by far the most prominent (Hanitzsch 2011; Hanitzsch and Mellado 2011). Conversely, particularly within media and journalism studies, such an idealised conception of journalism has long been criticised. The notion that journalism actually nourishes democratic life is one that many have long had difficulty with (Lichtenberg 1983; Keane 1991) as these critics have argued that journalism's economic imperative tends to undermine its long-established democratic imperative. Yet it is important to note that those who criticise journalism's selective democratic credentials tend to do so from the same cherished and idealised notions of the Fourth Estate as held by those they criticise (Tuchman 1978; Lau 2004). Critics rightly argue that journalism is not engaged with its public, it does not represent its public, and it caters to market requirements and demands (Petley 2012). An idealised version of journalism's societal role is presented and journalism is assessed on the same normative criteria it purports to meet, and more often than not, journalism cannot live up to these expectations (Muhlmann 2010). Rather than assuming the public requires journalism to fulfil certain functions and therefore projecting on to the public an idealised and largely unquestioned set of normative claims, we suggest that it is the public themselves who might be better placed to formulate normative criteria to which journalism might aspire to achieve. In making this claim, we draw upon two related theoretical perspectives to locate a framework from which such normative criteria might emerge.

In the first instance, this is based on the idea that knowledge and practice can produce an understanding that is of most benefit to those involved in the process of its production. We argue that rather than journalism insisting on, via the weight of shaky historical foundations and self-proclaimed virtue (Hampton 2010), a deeply flawed conception of journalism's main function, it is the public itself and the communities that they inhabit that should prescribe the moral basis upon which journalism might function. This draws on Lave and Wenger's notion of situated learning (Lave and Wenger 1991; Lave and Chaiklin 1993), which argues learning and knowledge production occur via communities of participation, or communities of practice. This provides a useful model to analyse community conceptions of journalism's normative claims as it is the community itself that is the site of knowledge production. This idea of communities of practice explicitly relates to our commitment to develop a method through which a more grounded set of normative criteria for journalism might be developed. In this regard, we are drawing from a participatory research paradigm that is situated within those communities that have an interest in the outcomes of the research. For this we have also drawn on ideas from community-based participatory research "based on a commitment to sharing power and resources and working towards beneficial outcomes for all participants, especially communities" (Banks and Manners 2011, 6). To evaluate these questions we establish a standpoint from uses and gratification theory to understand how journalism is approached as a service (of use) to a public, as well

as how members of that public judge that performance (is there a match between use and gratification?). We argue, in line with Katz, Blumler, and Gurevitch (1974), that the role of the user should be assessed to consider the relationship between news media and audience, particularly as media selection (use) can be a goal-oriented process (towards gratification). Similarly, we approach news media as a set of options that people can turn to for various gratifications and with various motives (Papacharissi 2008). As such, their assessment of journalistic media may be based on considerations other than idealised roles.

In exploring these normative dimensions, aspects typically considered under use/gratification preferences (such as those underlining habitual consumption of a specific media or media type) cannot be considered "best" or presumed media need at any one time, and should therefore not be privileged. Westlund and Ghersetti (2015) argue this point in a study of media use in Sweden during times of crisis, and we look to extend that argument here to explore whether similar dynamics exist at civic and community levels. This gratification-centric approach shifts away from valuing news media as inherently ideal "gratifiers", and instead considers when members of the public and community might be disinterested as well—when they see media as not useful—thereby allowing dissatisfaction to be evaluated, either as a deterrent for media use or as a feature of the media system that is noted, and endured.

The prevailing view of media "as gratifying" public use (and demand) and fulfilling the ideals of the Fourth Estate rests on the idea that there is "a public", and that the media notion of this public is relatively stable, at least with regard to their needs and the demand for media content of a certain type (McQuail 2008, 410). This feeds back into the idealised notion of the Fourth Estate in a traditional communicative cycle (Hall [1977] 1993), where journalists perceive their role as knowing what a public "needs" for its participation in society and delivering what it determines as necessary. These assumptions are problematic when not paired with an inquiry into the motives of members of any public and community as they identify within use-and-gratification binaries. Employing a uses and gratifications framework allows us to take stock, first, of people's perceived needs as individuals as well as community members, and, second, how *they* perceive media as gratifying these needs, while, third, asking how, whether, and when they perceive motivation to communicate held by journalistic media (Rubin 2002). This paper offers an initial exploration of both how members of a community perceive their own motives and how they feel they are perceived, and documents the first phase of an on-going study into these dimensions.

Uses and gratification frameworks have been applied extensively in research focusing on contemporary media usage (Chen 2011; Westlund and Ghersetti 2015 ); we adapt this approach to expand, without prejudice, our analytical framework for community members' media usage, allowing the choice not to gratify certain media needs, even if they are viewed as important, and seek to approach the variety of media that members of communities can choose from to meet their needs. While traditionally the Fourth Estate treats information delivery as paramount, the use of news media for enjoyment must also be weighed (Bartsch and Viehoff 2010). Our approach to communities and hyperlocal outlets does not assess hyperlocal media as objects of inquiry, better addressed in the work of Forde (2011), Hess (2013), Paulussen and D'heer (2013), and Westlund and Ghersetti (2015). Rather, it allows us to identify community activists engaged with a range of media, including hyperlocal media, in order to evaluate the ways *they* might engage with concepts such as the Fourth Estate or locate gaps between idealised and experienced dimensions of

journalism. This has been the focus of a number of initiatives in the United States (Haeg and Hardman 2015), and within the academy has been explored as an area of opportunity for journalistic practice to serve communities (Hess and Waller 2014).

## Process

In developing our research it was first necessary to identify a small number of community-based groups and organisations that have an indirect interest in journalism's role and function. As the first phase of a multi-stage study, the preliminary findings here will be used to scope subsequent stages of research, while also using the views and activities of participants to shape subsequent aspects of the research. Two organisations in Sheffield were identified: Sheffield for Democracy, a group of non-partisan political activists who campaign for greater democratic accountability and better access to power for all citizens; and the Nether Edge Neighbourhood Group (NENG) who are active in the Nether Edge suburb of Sheffield. NENG campaigns to improve the environment for those living and working in the area and organises local events and activities for residents. NENG also publishes a monthly newsletter for local residents called *Edge*, and a co-produced edition of this publication is incorporated into Phase II of this research. Both of these are grass-roots organisations that share a commitment to specific yet different community values and goals. Sheffield has several printed hyperlocal news media, including *Edge* and publications like the *Burngreave Messenger*. These two community papers serve disparate socio-economic and geographic areas of Sheffield, and also present areas of study that avoid the pitfall Hess (2013) identifies, as the media produced for these communities is overwhelmingly read within the geographical boundaries of the communities of Burngreave and Nether Edge.

Following initial discussions with both groups, we invited members of the groups to participate in the study. We first distributed a questionnaire on individual uses of news and information via the groups' e-mail distribution lists (Denscombe 2014) to gain some baseline information about individuals' news consumption, the frequency and type of news they consume, the platforms they utilise, as well as the importance they place on local and national news. The questionnaires included closed and open responses, with the opportunity to add comments about news and journalism. Questionnaires have also been adopted in other media research projects which have sought to examine uses and gratification theory (Shin 2011; Kim et al. 2015). For our purposes, the questionnaires served as the only "steer" for participants in both the discussion (Research Intervention 1) and workshop (Research Intervention 2), as key to our research was seeing how people within communities spoke about news and journalism outside academic-led discussions. We were careful not to foreground the normative aspect of our work, to avoid priming discussions around those elements. Rather, we stated that our understanding of their uses of journalism will enable us to gain a "users' perspective" on journalism which might feed into how journalism is thought about in future. Phase I of our study is divided between a community facilitation (focus group) and a collaborative workshop. As will be discussed below, this has allowed us to tease out the expectations and perceptions of community members about the news media around them. Across the two research events in this first phase of study we had six active participants. Each of our active participants completed a 44-question questionnaire. A further 12 respondents answered open-ended questions distributed via email. Five respondents provided additional information via telephone or personal

correspondence. For the exploratory nature of our study, these data informed discussions of media use (e.g. the relevance of local news) and identified unanticipated trends (e.g. the role of interpersonal news). While small, this has allowed us to begin to revisit our own biases as an exploratory study, and has helped to develop the second stages of research with a wider range of participants, including journalism educators and practitioners.

## Initial Findings

From this first phase of research, our findings already point to some interesting preliminary results and provide a useful corrective to the expectations of the authors for considering the way we position normativity within journalism studies. As will be shown in this section, findings are being utilised to scope a broader study, and therefore should be approached as exploratory. Our data revealed the following key considerations:

- Participants have a somewhat blasé view of journalism's societal role and performance of any such role.
- There was a strong view of news and journalism as a form of entertainment—including the "jousting" of contrarian views, the practice of relaxing with a newspaper, and reading gossip or celebrity news—level with its informative dimensions.
- The commercial imperative of journalism (that newspapers need to sell and broadcast needs to be watched) was seen as an explanatory basis for why news content is positioned in the way it is.
- All of our research participants emphasised the importance of non-mediated news shared interpersonally and valued it highly, often over mediated content (even when that content might be personally relevant). The pub conversation, information shared by someone trusted, and the role of news from "friends and family" in particular were mentioned.
- Online media play a role for participants in their news habits, but were not considered stand-ins to fill gaps in local coverage. None of our research participants saw online media as avenues for more local coverage or higher quality.
- While participants would welcome better, higher-quality coverage, there is little expectation for this (there was also little appetite for investing, personally, in news seen as lesser quality) and little expectation for a different "idealised" journalism.

In general there was agreement among participants that local news receives inadequate coverage for them to stay informed of goings on in Sheffield, with some agreement that this meant there is a dearth of information relevant to their day-to-day lives (this was bemoaned as unfortunate, and a real gap in informing "the public"). However, contrary to our expectations, participants were not cynical or negative about this, mostly expressing resignation. Participants mentioned the lack of quality local news and community coverage in general, noting that the "precarious" nature of news media business models meant much of the content was more sensational: "they're produced in the same way as the popular national press—The Suns, The Mirrors, The Mail—and it just doesn't interest me", said one participant in the focus group, adding "for that reason I miss a lot of local news which is a shame".

We probed aspects of this resignation in the second of our research activities, a workshop-oriented event that allowed participants to consider why they read, navigated to, or otherwise selected news content in real time using think-aloud protocols (Costera Meijer

and Groot Kormelink 2014). None of our participants opted to evaluate the local papers (which were available), nor did any consider their online Web portals or other local plat-forms. When asked why participants opted for non-local news, we found that there was a general perception (expressed explicitly by two participants) that journalism at the local level was low quality, focused only on sensational content, and lacked journalists capable of producing strong content of interest to local audiences: "the quality of that sort of person would've moved on to a national newspaper by now ... there's probably a reason these people are at the local news". While this view was not universally held, it was reflected more broadly in the way that, across our study and despite being active in local affairs and community groups and producing hyperlocal content, none of our partici-pants cited the local news media as relevant to their day-to-day participation in society.

Local news was also not a part of their news habits—typical remarks from partici-pants noted the only time either of the two local Sheffield papers would be read were if they were ( 1) lying around somewhere, ( 2) if someone stumbled across one, or ( 3) if they were free. "I certainly don't read the local paper, but I am involved in a local neighbour-hood group, that's really so parochial it's to be within a mile and a half of my front door sort of thing, very, very local", said one participant. For this group, relevant news was likely to come from the people in that group getting agitated over an issue or involved in various activities, and then sharing information and news in a flurry of emails. There was also rec-ognition that geography was not a sufficient condition to be interested in local news (as opposed to hyperlocal). One participant who grew up in Liverpool said they felt more in tune with the local news in the *Liverpool Echo* than *the Sheffield Star*, despite living in Shef-field for more than 30 years, and this emotional connection played a role in how they sought out their news media.

Reflecting on the linkage between news in terms of quality and coverage (local, regional, and beyond), any performance of idealised roles was not a paramount consideration—"you don't think [about categories like local or national], or whether this is important or not important. You just watch it", said one participant. Another saw the value in the delivery of facts, but saw a lot of news as "a mixture of things to fill the time". For our considerations, evaluating the expectations of a Fourth Estate, these sorts of responses—resignation and lowered normative expectations—came as a surprise con-sidering our selection processes targeted active members of local communities. While, broadly speaking, publications like *Edge* and Sheffield community papers such as the *Burngreave Messenger* were identified as "more relevant" (in part because the people who produced them were known, and shared a commitment to their communities), partici-pants stopped short of seeing these on a par with the idealised normative dimensions of journalism, and were not seen as filling a local news void. Participants from the Nether Edge neighbourhood pointed out that the volunteers for *Edge* often debated whether they should even endeavour to take on a more traditional journalistic approach, also debat-ing the role of campaigning or "hard news" coverage in their publication. This offers an indi-cation of expectations and perceptions of journalistic role performance.

What people expect from their journalism and what they miss or bemoan in journal-ism are two different things. During the second research intervention, participants were asked to design their "ideal journalism". It was telling, said one participant, that their own "ideal" was not that different from the traditional news options they are familiar with, describing an ideal newspaper that "would make me aware first thing of what have happened overnight, indicate what might interest me in the day ahead and prepare me

for it, and stimulate and entertain me". In their ideal journalism constructions, our partici-pants noted that they would welcome a more tailored, local, journalism that reflected the varied neighbourhoods of Sheffield, but recognised this would result in a trade-off where "serendipity" and the chance of coming across news outside their personalised content would likely diminish, another pointing out that idealised journalism neglected the want for entertaining items like celebrity gossip they would still want "snuck in". There was a persistent view that even when given the scope to describe a "utopian" approach to news and journalism, the entertainment function was something participants wanted to remain, running alongside information: "where you're reading for enjoyment, you're enjoying disagreeing with [columnist] or enjoying agreeing with [them] … News merges into entertainment".

## Conclusion

This research prefaces its approach on an abandonment of authority over determin-ing the "ideal" normative dimensions of journalism. Not intended as a petulant rebuke of theoretical work or past inquiries (including our own, cf. Steel 2012, 2013; Eldridge 2013, 2014) that have also assumed "as given" the normative dimensions of the Fourth Estate, we look to instead draw attention to the locus of these normative foundations and the tra-ditional biases of either idealised self-perceptions or traditional perspectives in propagating its merits. In this, we are exploring journalism that finds itself in a state of flux (Conboy and Eldridge 2015), by asking whether the centre-point we evaluate journalism against is broadly recognised. In revisiting journalism's normative dimensions, we argue there is a need to assess the presence of gaps between the idealised and the expected. In particular, in trying to understand whether the absence of certain local coverage is identified as pro-blematic or rather as a feature of the current media reality, we find both community/hyper-local groups and their media provide useful prisms for exploration. In doing so we step away from a traditional focus of journalism studies which locates the Fourth Estate in national or international political journalism where these roles are structurally embedded. Therefore, we use the hyperlocal focus as a prism through which we can understand the perceptions and expectations of news media from the ground up. At this stage we are not focusing acutely on hyperlocal or community media as products, though in the next stage of this research co-production of a community newspaper is at the centre of research activity.

Extending beyond local or hyperlocal newspapers, it was surprising that news that was shared in person played a far greater role than our scoping of literature and previous work would have suggested. For our participants, the pub conversation and the neigh-bourly chat are considered highly important news avenues—not just for their local/hyper-local community news, but also for connecting the concerns of communities to the larger issues of the day. Interpersonal news was trusted to a greater degree, even used to validate (or challenge) mediated news, and was considered more likely to be factual and held stron-ger connections to the broader society, including key information sources for news on civic matters or council activities. Less useful was the sort of interpersonal news that parroted what had been printed in newspapers, when people are "being bad proxies for their respective newspapers". Where news online, on television, and in print was seen as "enter-tainment" and as a product that needed selling, interpersonal non-mediated news was con-sistently noted as trusted, relevant, and meaningful.

When it comes to journalism's idealised role perceptions and the normative expectations of a Fourth Estate, there were not very high expectations of journalism to perform these roles at all. This is not to say our study groups were disenchanted with journalism's performance or content *per se*, but rather that what they saw in their news content represented something else—something expected to be parochial at times, biased at others, sensational (when commercially viable), entertaining when possible, etc. For our research group, news serves a utilitarian role for connecting them to the world—"it makes me live less like a hermit"—but participants did not describe their expectations of journalism in terms of ideology, idealised roles, or expectations of performing as a Fourth Estate. Other responses noted the utilitarian service of journalism for staying informed about events in places one might travel to—"'a need to know what's going on in order to arrange your life"—of maintaining an "on-going narrative" about the wider world, of myth-busting, or as sating a human interest for information (these comments were made with reference to the crisis, celebrity news, and weather). In this regard, this initial study offers new threads of consideration for understanding and theorising journalism's normative claims. Our findings suggest, and further study will explore, that the normative ideals expressed by both journalism practitioners and their critics do not resonate with those members of the communities who they purportedly serve.

## DISCLOSURE STATEMENT

Neither author stands to benefit financially from the direct application of any of the research presented in this paper. This research was not grant-funded.

## REFERENCES

Banks, Sarah, and Paul Manners. 2011. *Community-based Participatory Research. A Guide to Ethical Principles and Practice.* Centre for Social Justice and Community. https://www.publicengagement.ac.uk/sites/default/files/publication/cbpr_ethics_guide_web_november_2012.pdf.

Bartsch, Anne, and Reinhold Viehoff. 2010. "The Use of Media Entertainment and Emotional Gratification." *Procedia - Social and Behavioral Sciences* 5: 2247–2255.

Conboy, Martin, and Scott Eldridge II. 2015. "Morbid Symptoms: Between a Dying and a Re-birth (Apologies to Gramsci)." *Journalism Studies* 15 (5): 566–575.

Costera Meijer, Irene, and Tim Groot Kormelink. 2014. "Checking, Sharing, Clicking and Linking: Changing Patterns of News use between 2004 and 2014." *Digital Journalism.* DOI: 10.1080/21670811.2014.937149.

Denscombe, Martyn. 2014. *The Good Research Guide: For Small-scale Social Research Projects.* Maidenhead: Open University Press.

Chen, Gina M. 2011. "Tweet this: A Uses and Gratifications Perspective on how active Twitter use Gratifies a Need to Connect with Others." *Computers in Human Behavior* 27: 755–762.

Eldridge II, Scott. 2013. "Perceiving Professional Threats: Journalism's Discursive Reaction to the Rise of New Media Entities." *Journal of Applied Journalism & Media Studies* 2 (2): 281–299.

Eldridge II, Scott. 2014. "Boundary Maintenance and Interloper Media Reaction: Differentiating between Journalism's Discursive Enforcement Processes." *Journalism Studies* 15 (1): 1–16.

Forde, Susan. 2011. *Challenging the News: The Journalism of Alternative and Community Media.* Basingstoke: Palgrave.

Hall, Stuart. [1977] 1993. "Encoding/Decoding." In *The Cultural Studies Reader*, edited by Simon During, 90–103. London: Routledge.

Hampton, Mark. 2004. *Visions of the Press in Britain, 1850–1950*. Urbana: University of Illinois.

Hampton, Mark. 2010. "The Fourth Estate Ideal in Journalism History." In *The Routledge Companion to News and Journalism*, edited by Stuart Allan, 3–12. Abingdon: Routledge.

Hanitzsch, Thomas. 2011. "Populist Disseminators, Detached Watchdogs, Critical Change Agents and Opportunist Facilitators: Professional Milieus, the Journalistic Field and Autonomy in 18 Countries." *International Communication Gazette* 73: 477–494.

Hanitzsch, Thomas, and Claudia Mellado. 2011. "What Shapes News Around the World? How Journalists in 18 Countries Perceive Influences on their Work." *International Journal of Press/Politics* 16: 404–426.

Haeg, Andrew, and Jesse Hardman. 2015. "A New Vision for Local that Starts with Listening." *KnightBlog*, August 10. http://www.knightfoundation.org/blogs/knightblog/2015/8/10/new-vision-local-starts-listening/.

Hess, Kristy. 2013. "Breaking Boundaries: Recasting the 'Local' Newspaper as 'Geo-social' News in a Digital Landscape." *Digital Journalism* 1 (1): 48–63.

Hess, Kristy, and Lisa Waller. 2014. "Geo-Social Journalism: Reorienting the Study of Small Commercial Newspapers in a Digital Environment." *Journalism Practice* 8 (2): 121–136.

Katz, Elihu, Jay Blumler, and Michael Gurevitch. 1974. "Utilization of Mass Communication by the Individual." In *The Uses of Mass Communications: Current Perspectives on Gratifications Research*, edited by Jay Blumler and Michael Gurevitch, 19–32. Beverly Hills & London: Sage Publications.

Keane, John. 1991. *The Media and Democracy*. Cambridge: Cambridge University Press.

Kim, Jooyoung, Jungwong Lee, Samsup Jo, Jaemin Jung, and Jaewon Kang. 2015. "Magazine Reading Experience and Advertising Engagement: A Uses and Gratifications Perspective." *Journalism and Mass Communication Quarterly* 92 (1): 179–198.

Lau, Raymond W. K. 2004. "Critical Realism and News Production." *Media, Culture & Society* 26 (5): 693–711.

Lave, Jean, and Seth Chaiklin. 1993. *Understanding Practice: Perspectives on Activity in Context*. Cambridge: Cambridge University Press.

Lave, Jean, and Etienne Wenger. 1991. *Situated Learning. Legitimate Peripheral Participation*. Cambridge: University of Cambridge Press.

Lichtenberg, Judith. 1983. "Foundations and Limits of Freedom of the Press." *Philosophy and Public Affairs* 16 (4): 329–355.

McQuail, Denis. 2008. *McQuail's Mass Communication Theory*. 5th ed. London: Sage.

Muhlmann, Géraldine. 2010. *Journalism for Democracy*. Cambridge: Polity.

Papacharissi, Zizi. 2008. "Uses and Gratifications." In *An Integrated Approach to Communication Theory and Research*, edited by Michael Salwen and Don Stacks, 137–152. Abingdon: Routledge.

Paulussen, Steve, and Evelien D'heer. 2013. "Using Citizens for Community Journalism: Findings from a Hyperlocal Media Project." *Journalism Practice* 7 (5): 588–603.

Petley, Julian. 2012. "The Leveson Inquiry: Journalism Ethics and Press Freedom." *Journalism* 13 (4): 529–538.

Rubin, Allan M. 2002. "Media Uses and Effects: Uses and Gratifications Perspective." In *Media Effects: Advances in Theory and Research*, edited by Jennings Bryant and Dolf Zillmann, 525–544. Hillsdale: Lawrence Erlbaum.

Shin, Dong-Hee. 2011. "Understanding e-book Users: Uses and Gratification Expectancy Model." *New Media and Society* 13 (2): 260–278.

Steel, John. 2012. *Journalism and Free Speech*. London: Routledge.

Steel, John. 2013. "Leveson: Solution or Symptom? Class, Crisis and the Degradation of Civil Life." *Ethical Space* 10 (1): 8–14.

Tuchman, Gaye. 1978. "Professionalism as an Agent of Legitimation." *Journal of Communication* 28 (2): 106–113.

Westlund, Oscar, and Marina Ghersetti. 2015. "Modelling News Media Use. Positioning and Applying the GC.MC Model to the Analysis of Media use in Everyday Life and Crisis Situations." *Journalism Studies* 16 (2): 133–151.

## ORCID

**Scott Eldridge II** ⓘ http://orcid.org/0000-0002-2184-1509

**John Steel** ⓘ http://orcid.org/0000-0001-5967-0699.

# VALUABLE JOURNALISM
# Measuring news quality from a user's perspective

**Irene Costera Meijer** and **Hildebrand P. Bijleveld**

*This paper aims at building a conceptual bridge called Valuable Journalism between quality journalism and users' experience of quality. To that end a questionnaire was designed, built on previous data and triangulated with the results of three simultaneously organized qualitative audience studies. The distinct dimensions of valuable journalism, as well as their interrelatedness and internal consistency, were then tested with explorative and confirmative factor analyses. The findings suggest how the resulting four dimensions—urgency, public connection, understanding the region and audience responsiveness—and 13 news subjects may provide a good starting point for journalists and news organizations who want to focus more on what users and audiences actually experience as valuable journalism.*

## Introduction

The popular news the public supposedly wants, and the quality news it supposedly needs, are usually considered incompatible regarding what counts as important information in a democratic society (Barger and Barney 2004; Tandoc and Thomas 2015). We will respond to this assumption by developing a *users'* standard for quality called Valuable Journalism (cf. Costera Meijer 2013a). To that end previous data were used to set up a questionnaire. Next, we tested the distinct dimensions of valuable journalism addressed, as well as their interrelatedness and internal consistency, with explorative and confirmative factor analyses. We will argue how the resulting four quality dimensions—urgency, public connection, understanding the region and audience responsiveness—may provide a good starting point for journalists and news organizations who want to focus more on what users or audiences actually experience as valuable journalism.

## Literature Review

The fundamental role of journalism for maintaining a vital democracy (Allan 2010; Dahlgren 1995; Schudson 2008) explains why the quality of news is such an important research topic. The vitality of our democracy depends on the presence of excellent journalism. Usually scholars concentrate on content and production routines as yardsticks for quality (Hansen, Neuzil, and Ward 1998; Koch 2008; Merrill 1968). But being present is insufficient; excellent journalism should also be read, watched or listened to in order to impact on democracy. Prompted by the crisis in the newspaper industry and the emergence of new digital platforms and devices, interest in audience studies has been growing. Web

metrics even make it possible for journalists to follow in real-time people's interest in their work, enabling a new yardstick for journalists' professional competence. On the flip side, as Tandoc and Thomas (2015) and Welbers et al. (2015) suggest, Web metrics show a disproportionate interest of users in soft news (entertainment, sports, crime, etc.). Editors' and journalists' increasing audience responsiveness could then just as easily lead to a trivialization of news, which in turn may endanger our democratic society.

Groot Kormelink and Costera Meijer (2016) argue that Web metrics are limited instruments to measure users' interests. Clicks may refer to interest, but also to other motives, while, vice versa, absence of clicks may indicate lack of interest, but it may also mean that users get enough information out of the lead. Also, by scrolling over, browsing or scanning the news, people may be updated about important events, without clicking on the news.

To make sense of people's own considerations regarding news use, journalism scholars often employ (a version of) the so-called Uses and Gratifications approach (U&G). This theory explains why individuals choose to use a particular medium or genre by looking at the gratifications they expect and gain from them (for an overview, see Ruggiero 2000). U&G research has identified many gratifications over the past 60 years by employing the classic two-step methodological approach of focus groups followed by surveys. In our research we took issue with Sundar and Limperos' (2013) observation that U&G researchers recently tend to dispense with the focus groups in addition to relying heavily on standardized questionnaires and broad categories (Kaye and Johnson 2002). We returned to the two-step approach and combined the strengths of survey data with the richness of in-depth interviews. Additionally, instead of equaling the main gratification factor of news —the need for information/surveillance—with keeping up with important events and incidents occurring in one's immediate surroundings (Eveland, Shah, and Kwak 2003; Vincent and Basil 1997), we asked news users *what* counts as important for them and *which* developments need surveillance. This open approach was also taken with regard to the factor of social utility; the usefulness of information in interpersonal communication and social and political orientation. We asked users *which* information they experienced as useful for interpersonal or public connection. Subsequently, we discussed the implications of these user needs for journalists and journalistic organizations.

The need for more insight into the audiences' use, needs and desires regarding news —and thus for a revised and updated U&G survey instrument—is felt most urgently among scholars and producers of regional and local news. In Western Europe, regional and local broadcasters and newspapers are losing a larger share of viewers and readers and at a faster rate than national newspapers and broadcasters (Barnett 2011; Franklin and Murphy 2005; Kik and Landman 2013). Dutch regional newspapers' quality is increasingly suffering from budget cuts (Buijs 2014), while regional public broadcasters' budgets more or less remained constant. Dutch regional public broadcasters, however, suffered from changes in broadcast channels. Unlike the BBC regional news, their Dutch counterparts operate more autonomously on a separate channel. To suggest how to improve both commercial and public news organizations' performance without extra budget, we focused our research in particular on users of regional news. In this paper we focus on two broadcasters situated in Zuid-Holland, serving the most densely populated and most industrialized region of the Netherlands with 1271 residents per km$^2$ (CBS 2014). They supply daily news on various platforms—television, radio, news sites, news apps and

various social media accounts—and we wondered whether they met the needs and desires of their audience, potentially consisting of over 3.5 million residents.

## What Counts as Valuable Journalism from a User Perspective?

Previous research suggests that audiences appreciate a wider selection of news topics, a more engaging presentation, a constructive approach and tone of voice, in particular, but not exclusively, in relation to regional news (Aldridge 2007; Costera Meijer 2010, 2013b; Costera Meijer et al. 2010; Heider, McCombs, and Poindexter 2005; Poindexter, Heider, and McCombs 2006; Rosenstiel et al. 2007). In addition to general benchmarks that apply to all good journalism—trustworthiness, credibility and good storytelling— seven criteria were identified which should be met in particular (again, not exclusively) by regional journalism if it aims to provide news that citizens deem valuable and important.

Compared to most content-analysis, the measures for "Valuable Journalism" were neither derived from an *a priori* concept of informed citizenship which emphasizes news about public affairs, nor from citizens' *opinions* about quality journalism. Rather, they pertain to when and how people *experience* journalism as valuable. These experiences were captured in previous research by asking people to supply concrete examples of when they felt regional journalism was valuable to them (Costera Meijer 2010; Costera Meijer, Kreemers, and Ilievski 2013; Costera Meijer et al. 2010). This happened, for instance, when they were truly captivated by what they saw, read or heard, or when a news item increased their understanding of a complex issue or when it gave rise to conversations. Also, users suggest some topics should be provided more often if news organizations wanted them to watch, listen or read the news more frequently. The following criteria proved especially relevant in a regional context. What people defined as regional was not fixed, however. When we asked people in 132 intercept street interviews to draw a circle on a map of what they felt belonged to their region, these circles varied, depending on their feelings of connection to a particular space, for some a neighborhood for others a province.

1)  Local and regional news media should devote sustained attention to *long-term regional themes* and preferably in a *constructive* manner (cf. Rosenstiel et al. 2007). Stories which show new perspectives or solutions on regional issues are especially welcome.
2)  Residents value items that facilitate regional orientation by visualizing everyday geographical, social and personal *landmarks*: central squares, prominent bridges, highways, public gardens, nature reserves, regional and local celebrities.
3)  Citizens want to know how individual stories are related to other or previous stories (*links and context*). This enables them to experience coherence, not only in the news, but in (the reported) reality as well.
4)  What citizens want is for news organizations to tell news *stories "from within"*—from the angle of the "locals" and their concerns (Costera Meijer 2010). This often applies in particular to background stories about a region or city that make it more understandable and familiar for those who work and live there. This information should not be confused with city branding or region marketing. Telling stories from within also contributes to a sense of *collective memory*, a "time line", allowing residents to position their life and that of others within the region (Assmann and Czaplicka 1995).

5) Providing insight into the regional *customs* or local *manners* is relevant for under-standing how things work. Schudson (1995, 31) argued in this context that journalists do not so much produce information, but "public knowledge". They contribute to "what is recognized or accepted … given certain political structures and traditions".

6) A side-effect of biased, sensationalized regional news for the people who actually work or live in the region is sometimes experienced as losing one's grip on everyday reality; a reason why residents want to be given a *layered* and *"realist" representation* of their region, leaving room for the complexities, ambivalences and contradictions of everyday lived reality. It is important to note that even residents from so-called urban problem areas are univocal in emphasizing that supplying only positive news may just as well lead to a sense of losing contact with reality (Costera Meijer 2013b).

7) Most people love so-called *talker news* items which often focus on relatively bizarre or human-interest news topics. Such "news" proves valuable because it facilitates (brief) conversations between relative strangers, thus strengthening people's feeling of belonging and connection.

## Design of the Study

These seven criteria served as a starting point for putting together our survey ques-tionnaire aimed at measuring valuable journalism as a category of analysis. Specifically, we wanted to establish how these criteria are interrelated in the experience of news consu-mers. Given this concern, our first research question is:

**RQ1:** Which dimensions contribute to Valuable Journalism?

Previous research suggests that paying attention to the desires of citizens pays off (Costera Meijer, Kreemers, and Ilievski 2013; Rosenstiel et al. 2007). This pertains to both preferences in form and in selection of news. So far it has not been sufficiently established which regional news topics deserve more attention in the eyes of the public and what would prompt them to watch, read or listen more often.

**RQ2:** Which topics deserve more attention by regional news media according to regional news consumers?

## Methodology

In the fall of 2014 we performed six different studies in this region. In this paper we focus on the results of the audience survey. In previous audience studies we were regularly confronted with harsh judgements about regional and local journalism, such as "I never watch the regional news; it's all about rescuing cats from trees or about neighbors arguing about the height of their fence". Such statements usually came from higher-edu-cated people with limited or no experience of it. They might reflect a point of Bourdieu (1984), that the culturally privileged feel they have "the right to speak" and pass judgement even without personal knowledge of a genre, while those with less cultural capital tend to reserve their opinions for genres they have actually used (cf. Friedman and Kuipers 2013). Because we were interested in peoples' experience of value instead of their *opinions* about value, we purposely selected *actual users* of regional journalism. Consequently, these users are not a representative sample of the population. The validity of the survey and the

generalizability of the results are enhanced because our survey respondents turned out to be a representative sample of the actual users of regional news (CBS 2015).

Although our survey propositions are strongly grounded in qualitative research, we agree with Lowrey, Brozana, and Mackay (2008) that what counts as "region" is not only a question of geography but also one of negotiating shared symbolic meanings. The studied region has a multicultural urban character which invites further calibration of the instrument when used to measure the value of national journalism or more rural areas.

Of the two (almost identical) surveys announced on the news websites of the broadcasters, their Twitter accounts as well as on their Facebook pages, 539 filled-out surveys resulted. We removed 169 from our sample because respondents had addressed fewer than six questions, implying that we analyzed the remaining 370 surveys for this study.

Our sample (see Table 1) consisted of a fairly large proportion of men, people over 50 and people with higher education. This is consistent with previous results (Van Cauwenberge et al. 2010; Dutta-Bergman 2004; Elvestad and Blekesaune 2008; Lauf 2001; Van Rees and Van Eijck 2003). On average, people in these groups consume more regional and local news.

On the basis of the criteria for valuable journalism, outlined above, we formulated 20 propositions. We asked respondents to evaluate them on a five-point Likert scale. To establish whether Valuable Journalism as a separate concept constitutes a single dimension in the experience of people, we started out with a Confirmatory Factor Analysis (CFA) in R with Lavaan (Rosseel 2012), whereby one factor explained the response patterns for all 20 items. This model did not meet the required model fit measures,[1] after which we deployed Exploratory Factor Analysis (EFA), interpreted after Oblimin rotation, to establish which items formed specific dimensions together.[2] Based on this we generated a new CFA model, from which in a step-by-step progression items were removed based on their beta coefficients and the modification index, until this model had an acceptable fit (see Table 2). Next, the model was modified to include a latent higher-order variable representing the overall experience of Valuable Journalism.

**TABLE 1**
Sample demographics

|  | N | % |
| --- | --- | --- |
| Gender |  |  |
| Male | 157 | 65.4 |
| Female | 83 | 34.6 |
| Age |  |  |
| 0–30 | 25 | 10 |
| 31–50 | 82 | 32.8 |
| 51+ | 143 | 57.2 |
| Level of education* |  |  |
| Low | 142 | 57 |
| High | 107 | 43 |

*Respondents with a General Certificate of Secondary Education or higher degree were considered highly educated; all others were considered lower educated.

**TABLE 2**
Goodness-of-fit statistics from Confirmatory Factor Analysis

|  | *p* | $\chi^2$/df | CFI | RMSEA | SRMR |
|---|---|---|---|---|---|
| One factor, 20 items | 0.000 | 2.84 | 0.816 | 0.087 | 0.059 |
| Five factors, 20 items | 0.000 | 1.95 | 0.912 | 0.062 | 0.046 |
| Four factors, 18 items | 0.000 | 2.06 | 0.917 | 0.066 | 0.045 |
| Four factors, 14 items | 0.000 | 1.48 | 0.970 | 0.044 | 0.036 |
| Four factors, one higher-order factor, 14 items | 0.000 | 1.46 | 0.970 | 0.043 | 0.037 |

CFA was conducted using Satorra–Bentler scaled chi-squared test for goodness-of-fit statistics.

## Reliability and Validity of the Instrument

The EFAs and CFAs combined the random samples of the two broadcasters. Both analyses were repeated for the data of the separate broadcasters. The final model with the latent higher-order variable resulted in acceptable goodness-of-fit statistics[3] for both broadcasters. The response patterns affirmed the same four dimensions amongst users of different broadcasters and from different regions, indicating reliability. Validity of the instrument was demonstrated because our respondents evaluated the performance of one broadcaster higher on the dimensions Public Connection and Audience Responsiveness. We also found different scores depending on gender and education.

## Results

EFAs and CFAs made it possible to answer RQ1: Which dimensions contribute to valuable journalism? It turned out that valuable journalism is best measured with 14 propositions which together constitute four dimensions—Urgency, Public Connection, Understanding the Region and Audience Responsiveness—and one superordinate dimension: the overall experience of Valuable Journalism (see Figure 1).

### Urgency

Not surprisingly, the main function of regional media, according to users, is to inform them about the most *urgent news*. The bonus of our results compared to previous U&G research is that the respondents also revealed what comprises "urgency". There appears to be a strong internal correlation between seemingly divergent needs (Cronbach's alpha = 0.840). Users do not only expect media to supply the news right after it happens; they also like to be able to easily find news once something of importance occurs. Second, urgency, to users, does not only apply to important *news*, but also to major public *events* in the region. Events like the annual flower parade and international *concours hippique* might not be new in the sense of unexpected, but they are important as common reference points. Moreover, broadcasters need to indicate clearly *where*, exactly, events take place. These matters go together in the experience of urgency.

### Public Connection

Couldry, Livingstone, and Markham (2007, 405) explain "public connection" as a shared "orientation to a public world where matters of common concern are, or at least

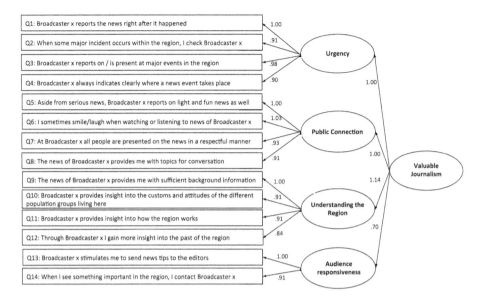

**FIGURE 1**

All coefficients are statistically significant at $p < 0.001$. The Satorra–Bentler scaled chi-squared test is used for goodness-of-fit statistics of the model: $\chi^2 = 106.37$; $df = 73$; $\chi^2/df = 1.46$; CFI $= 0.97$; RMSEA $= 0.043$; SRMR $= 0.037$

should be, addressed". The strong link we found between appreciation of serious news, presenting light and cheerful news, approaching people respectfully and supplying topics for conversation—affirms the relevance of Schrøder's extensive concept of *public connection* (Cronbach's alpha = 0.812). Schrøder (2015, 63) broadened the concept to include "democratic worthwhileness" (catering to the identity of people as citizens) and "everyday worthwhileness" ("content that links you to personal networks"). The link also confirms that "talker news"—human-interest stories or stories that have a light or humorous touch—may be used to facilitate conversations with a civic or public-interest dimension.

### Understanding the Region

The third public function of regional media appreciated by the audience is *background information* on the news, as a way to *provide insight into how the region works* (Cronbach's alpha = 0.875). In U&G approaches background is usually incorporated in the surveillance construct. Our study reveals that *background* is a distinct construct, measured by "providing insight into the customs and attitudes of the different population groups living in the region", "providing insight into how the region works" as well as "into the past of the region". The results confirm Lowrey, Brozana, and Mackay's (2008, 275) argument for community media as facilitators of negotiating and making meaning about community and its structure.

### Audience Responsiveness

Our study established an appreciation and a strong correlation between two items, namely "Broadcaster x stimulates me to send news tips to the editors" and "When I see

something, I contact Broadcaster x". This points to a fourth function of regional journalism —one that so far has not been addressed in U&G studies: actively offering *a listening ear* (Cronbach's alpha = 0.778). Broadcasters should be as responsive as possible to their (potential) audience and users. This is in line with the recommendation by O'Donnell (2009) to enable "everyday people" to speak, listen and be heard in the media.

### *The Overall Experience of Valuable Journalism*

We included in our model a higher-order latent variable representing the overall experience of Valuable Journalism. As Brown (2015) suggests, the use of a latent higher-order variable allows us to evaluate the relations of first-order dimensions. From the path coefficients between the latent higher-order variable and the first-order dimensions, we derive that the dimension Understanding the Region has the strongest explanatory power for Valuable Journalism.

## Which Topics Deserve More Attention?

To establish which news topics the regional media public feels should be addressed more often, we asked respondents to react to the proposition: "Broadcaster X may provide more information about certain topics"; 96.2 percent of the respondents subscribed to this proposition (3–5 on a five-point Likert scale). These respondents auto-matically received a second task: assigning a total of 100 points to 13 different news topics in reply to the proposition: "I would watch or listen to Broadcaster x more often if it pays more attention to … " As explained, we derived these 13 news topics from our qualitative research on regional media use. "Politics" as a separate topic was not included because in previous interviews people emphasized they were only interested in politics in connection with other themes. Respondents could add their own topics to the list, however.

Regarding RQ2, our analysis revealed that according to regional news consumers, media should devote sustained attention to 13 *long-term regional themes*.

Yet, as Figure 2 reveals, some topics were considered more important by more respondents: nature and people's immediate surroundings, history, safety and quality of care. More attention for these topics would encourage people to seek out regional media more often. These results were corroborated in 132 street intercept interviews, 10 focus interviews and 22 in-depth expert interviews.

Fifteen percent of the respondents took the opportunity to add their own topic to the list. Eight of them believed that news on "art and culture from the region" should be more salient in the reporting of the broadcasters. Only four respondents would appreciate extra news about local or regional politics, affirming what Rosenstiel et al. (2007) conclude about political news: successful stories cover issues instead of horse race and explain their relevance.

## Conclusion

Valuable Journalism is meant to conceptually fill the gap between marketing criteria (popularity) and journalistic dimensions (societal importance). We suggest that its four dimensions—urgency, public connection, understanding the region and audience

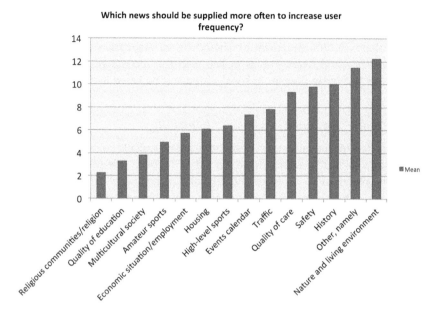

**FIGURE 2**
Mean score (out of 170 respondents) with respect to topics that deserve more attention

responsiveness—illustrate how users' news selection practices are more inclusive than journalists often assume and less trivial than Web metrics suggest.

First, *urgency* means that most people still want to keep up with important events and incidents close by. Urgency also refers to findability in connection to the platform as well as to the location of the event. This may reflect the importance of media's ease of use. Second, *public connection* stands out as the linking concept between respectfulness, a constructive approach and supplying serious as well as light conversation topics. This might illustrate the importance of regional journalism for keeping up personal networks as well as people's identity as citizens.

Our third suggestion is that the centrality of *understanding the region* within Valuable Journalism mirrors people's awareness of news as second-order reality; they know about others and others know about them in as far as and how they appear through news stories. Although Coleman et al. (2009) suggest people having direct personal experience with an issue usually do not need more information from the media, our respondents explicitly refer to a need for news about familiar topics, often not because they lack information, but because it enables them to compare their own experience of events with that of others. This comparison accommodates a need for a common frame of reference. Fourth, *audience responsiveness* is likely to mirror the growing assertiveness of the public. News media are expected to take into account and to listen carefully to the experiences of people of all walks of life, in interpersonal communication as well as in their stories.

Fifth, our respondents indicate they would increase their news use when journalism covered more thoroughly and extensively the seven news themes and, in particular, nature, living environment and history. Remarkably, these three subject areas are usually absent as conventional newsbeats, even in research on local journalism (cf. Rosenstiel et al. 2007, 2014). Finally, Valuable Journalism as a layered concept may lend itself as a framework

for evaluating the performance of news organizations from the public's perspective, in particular for news organizations operating in densely populated, urban areas with a continuously changing population.

## ACKNOWLEDGEMENTS

This article could not have been written without the research activities of Marrit van den Akker, Ferdy Hazeleger, Chris Pruissen and Steven Wiltjer. We are also grateful to Bernadette van Dijck for her professional reflections and to Meike Morren and Martijn Kleppe (VU University) who contributed to the methodology underlying this paper. Additional funding was received by two Dutch regional public broadcasters, RTV Rijnmond and Omroep West.

## DISCLOSURE STATEMENT

No potential conflict of interest was reported by the authors.

## NOTES

1. Based on Schreiber et al. (2006), we considered models with an $\chi^2$/df ratio lower than 3.0, Root Mean Square Error of Approximation (RMSEA) value lower than 0.06, Standardized Root Mean Square Residual (SRMR) value lower than 0.08 and a Comparative Fit Index (CFI) above 0.95 all as "good".
2. The Kaiser–Meyer–Olkin Measure of Sampling Adequacy was larger than 0.60 and the Bartlett's test of sphericity was significant. The Doornik–Hansen test revealed that our data have no multivariate normality ($\chi^2(36) = 206.87$, $p \leq 0.001$). For this reason the CFA was done with the Satorra–Bentler scaled chi-squared test for goodness-of-fit statistics.
3. Broadcaster A: ($\chi^2 = 92.897$, df = 73, $\chi^2$/df = 1.27, CFI = 0.964, RMSEA = 0.044, SRMR = 0.046). Broadcaster B: ($\chi^2 = 91.935$, df = 73, $\chi^2$/df = 1.25, CFI = 0.962, RMSEA = 0.049, SRMR = 0.055).

## REFERENCES

Aldridge, Meryl. 2007. *Understanding the Local Media*. Maidenhead: Open University Press, McGraw-Hill Education.

Allan, Stuart, ed. 2010. *The Routledge Companion to News and Journalism*. London: Routledge.

Assmann, Jan, and John Czaplicka. 1995. "Collective Memory and Cultural Identity." *New German Critique* 65: 125–133.

Barger, Wendy, and Ralph D. Barney. 2004. "Media-citizen Reciprocity as a Moral Mandate." *Journal of Mass Media Ethics* 19 (3–4): 191–206.

Barnett, Steven. 2011. *The Rise and Fall of Television Journalism: Just Wires and Lights in a Box?* London: A&C Black.

Brown, Timothy A. 2015. *Confirmatory Factor Analysis for Applied Research*. New York: Guilford Publications.

Bourdieu, Pierre. 1984. *Distinction: A Social Critique of the Judgement of Taste*. Cambridge, MA: Harvard University Press.

Buijs, Kees. 2014. *Regiojournalistiek in spagaat. De kwaliteit van het redactieproces in de regionale journalistiek; eencase-studie*. Meppel: Boom.

CBS. 2014. "Bevolkingsomvang en Aantal Huishoudens, 1980–2014." http://www.compendium voordeleefomgeving.nl/indicatoren/nl0001-Bevolkingsomvang-en-huishoudens.html?i = 15–12.

CBS. 2015. "Regionale kerncijfers Nederland." http://statline.cbs.nl/StatWeb/publication/?VW = T&DM = SLNL&PA = 70072NED&D1 = 1-2,15-20,2427,42-45,51-55,79-80,85-87,97,114-117, 123-145,162-182,184,187196,226,228,240,248,252,255&D2 = 13,68-71&D3 = 15-19&HD = 1409230008&HDR = T&STB = G1,G2.

Coleman, R., M. McCombs, D. Shaw, and D Weaver. 2009. "Agenda setting." In *The Handbook of Journalism Studies*, edited by Karin Wahl-Jorgensen and Thomas Hanitzsch, 147–160. London: Routledge.

Costera Meijer, Irene. 2010. "Democratizing Journalism?" *Journalism Studies* 11 (3): 327–342.

Costera Meijer, Irene. 2013a. "Valuable Journalism: The Search for Quality from the Vantage Point of the User." *Journalism* 14 (6): 754–770.

Costera Meijer, Irene. 2013b. "When News Hurts." *Journalism Studies* 14 (1): 13–28.

Costera Meijer, Irene, Merel Borger, Diana Kreemers, and Eva Mossevelde. 2010. *RTV Utrecht is van ONS. Een Onderzoek naar de Mogelijkheden en Belemmeringen tot het Vormen van een Nieuwsgemeenschap.* Amsterdam: VU University Amsterdam.

Costera Meijer, Irene, Diana Kreemers, and Devid Ilievski. 2013. *Waardevolle Journalistiek Voor de Regio. Onderzoek naar Nieuwsbereik, Nieuwswaardering en Kwaliteit van Regionale en Lokale journalistiek (Valuable Journalism for the Region).* Den Haag: Stimuleringsfonds voor de Journalistiek.

Couldry, Nick, Sonia Livingstone, and Tim Markham. 2007. *Media Consumption and Public Engagement: Beyond the Presumption of Attention.* Basingstoke: Palgrave Macmillan.

Dahlgren, Peter. 1995. *Television and the Public Sphere: Citizenship, Democracy and the Media.* London: SAGE.

Dutta-Bergman, Mohan J. 2004. "Complementarity in Consumption of News Types across Traditional and New Media." *Journal of Broadcasting & Electronic Media* 48 (1): 41–60. doi:10.1207/s15506878jobem4801_3.

Elvestad, Eiri, and Arild Blekesaune. 2008. "Newspaper Readers in Europe: A Multilevel Study of Individual and National Differences." *European Journal of Communication* 23 (4): 425–447. doi:10.1177/0267323108096993.

Eveland, William P., Dhavan V. Shah, and Nojin Kwak. 2003. "Assessing Causality in the Cognitive Mediation Model: A Panel Study of Motivations, Information Processing, and Learning During Campaign 2000." *Communication Research* 30 (4): 359–386. doi:10.1177/0093650203253369.

Franklin, Bob, and David Murphy. 2005. *What News? The Market, Politics and the Local Press.* London: Routledge.

Friedman, Sam, and Giselinde Kuipers. 2013. "The Divisive Power of Humour: Comedy, Taste and Symbolic Boundaries." *Cultural Sociology* 7(2): 179–195.

Groot Kormelink, Tim, and Irene Costera Meijer. 2016. "What Clicks Actually Mean: Exploring Digital News User Practices." Paper presented at ICA Fukuoka conference.

Hansen, Kathleen A., Mark Neuzil, and Jean Ward. 1998. "Newsroom Topic Teams: Journalists' Assessments of Effects on News Routines and Newspaper Quality." *Journalism & Mass Communication Quarterly* 75 (4): 803–821.

Heider, Don, Maxwell McCombs, and Paula M. Poindexter. 2005. "What the Public Expects of Local News: Views on Public and Traditional Journalism." *Journalism & Mass Communication Quarterly* 82 (4): 952–967.

Kaye, Barbara K., and Thomas J. Johnson. 2002. "Online and in the Know: Uses and Gratifications of the Web for Political Information." *Journal of Broadcasting & Electronic Media* 46 (1): 54–71.

Kik, Quint, and Lammert Landman, eds. 2013. *Nieuwsvoorziening in de regio*. Diemen: AMB.

Koch, Jochen. 2008. "Strategic Paths and Media Management – a Path Dependency Analysis of the German Newspaper Branch of High Quality Journalism." *Schmalenbach Business Review* 60 (1): 50–73.

Lauf, Edmund. 2001. "Research Note: The Vanishing Young Reader: Sociodemographic Determinants of Newspaper Use as a Source of Political Information in Europe, 1980–98." *European Journal of Communication* 16 (2): 233–243.

Lowrey, Wilson, Amanda Brozana, and Jenn B. Mackay. 2008. "Toward a Measure of Community Journalism." *Mass Communication and Society* 11 (3): 275–299.

Merrill, John Calhoun. 1968. *The Elite Press: Great Newspapers of the World*. New York: Pitman.

O'Donnell, Penny. 2009. "Journalism, Change and Listening Practices." *Continuum* 23 (4): 503–517.

Poindexter, Paula M., Don Heider, and Maxwell McCombs. 2006. "Watchdog or Good Neighbor? The Public's Expectations of Local News." *The Harvard International Journal of Press/Politics* 11 (1): 77–88.

Rosseel, Yves. (2012). "lavaan: An R package for structural equation modeling." *Journal of Statistical Software* 48(2): 1–36.

Rosenstiel, Tom, Marion Just, Todd Belt, Atiba Pertilla, Walter Dean, and Dante Chinni. 2007. *We Interrupt this Newscast: How to Improve Local News and Win Ratings, Too*. Cambridge: Cambridge University Press.

Rosenstiel, Tom, Jeff Sonderman, Kevin Loker, Millie Tran, Trevor Tompson, Jennifer Benz, Nicole Willcoxon, et al. 2014. "The Personal News Cycle." http://www.mediainsight.org.

Ruggiero, Thomas E. 2000. "Uses and Gratifications Theory in the 21st Century." *Mass Communication and Society* 3 (1): 3–37.

Schreiber, James B., Amaury Nora, Frances K. Stage, Elizabeth A. Barlow, and Jamie King. 2006. "Reporting Structural Equation Modeling and Confirmatory Factor Analysis Results: A Review." *The Journal of Educational Research* 99 (6): 323–338.

Schrøder, Kim Christian. 2015. "News Media Old and New." *Journalism Studies* 16 (1): 60–78.

Schudson, Michael. 1995. *The Power of News*. Cambridge: Harvard University Press.

Schudson, Michael. 2008. *Why Democracies Need an Unlovable Press*. Cambridge: Polity Press.

Sundar, S. Shyam, and Anthony M. Limperos. 2013. "Uses and Grats 2.0: New Gratifications for New Media." *Journal of Broadcasting & Electronic Media* 57 (4): 504–525.

Tandoc Jr., Edson C., and Ryan J. Thomas. 2015. "The Ethics of Web Analytics: Implications of Using Audience Metrics in News Construction." *Digital Journalism* 3 (2): 243–258.

Van Cauwenberge, Anna, Leen d'Haenens, and Hans Beentjes. 2010. "Emerging Consumption Patterns Among Young People of Traditional and Internet News Platforms in the Low Countries." *Observatorio* 4 (3): 335–352. doi:urn:nbn:nl:ui:22-2066/90293.

Van Rees, Kees, and Koen Van Eijck. 2003. "Media Repertoires of Selective Audiences: The Impact of Status, Gender, and Age on Media Use." *Poetics* 31 (5–6): 465–490.

Vincent, Richard C., and Michael D. Basil. 1997. "College Students' News Gratifications, Media Use, and Current Events Knowledge." *Journal of Broadcasting & Electronic Media* 41 (3): 380–392.

Welbers, Kasper, Wouter van Atteveldt, Jan Kleinnijenhuis, Nel Ruigrok, and Joep Schaper. 2015. "News Selection Criteria in the Digital Age: Professional Norms versus Online Audience Metrics." *Journalism:* 1–17. doi:10.1177/1464884915595474.

# FOLK THEORIES OF JOURNALISM
## The many faces of a local newspaper

Rasmus Kleis Nielsen

*To understand journalism, we need to understand how people understand journalism. We need to examine what I define as "folk theories of journalism", actually existing popular beliefs about what journalism is, what it does, and what it ought to do that people use to make sense of journalism across sources of news, means of accessing news, and ways of engaging with news. In this paper, I use data from interviews and focus groups to identify different and sometimes contradictory views of the role played by a local newspaper in Denmark to develop the notion of folk theories of journalism. I reconstruct three different folk theories in the case community around conceptions of relevance and place, one defining the local newspaper as relevant and local ("our newspaper"), a second defining it as relevant, but geographically or politically biased ("their newspaper"), and a third defining it as neither relevant nor local ("what newspaper?"). I show that the nominally "same" newspaper means different things to people depending on which folk theory they see it through and argue that journalism studies need to pay more attention to the different ways in which people interpret journalism to understand it.*

## Introduction

To understand journalism, we need to understand how people understand journalism. We need to examine what I define as "folk theories of journalism", actually existing popular beliefs about what journalism is, what it does, and what it ought to do. In this paper, I draw on work in science and technology studies and on the sociologist Ann Swidler's idea of culture as a "toolkit" (Swidler 1986, 2001) to develop the concept of folk theories of journalism. I define folk theories of journalism as the culturally available symbolic resources that people use to make sense of journalism across different sources of news, ways of accessing news, and means of engaging with news.

The main purpose of the paper is to develop the notion of folk theories. To show how it can be deployed, I use data from interviews and focus groups to identify different and sometimes contradictory views of the role played by a local newspaper in a community in Denmark held by people of different backgrounds who all draw on a broadly speaking shared culture. I reconstruct three different folk theories in the case community—the many faces of the local newspaper—structured around notions of relevance and place (lay conceptions of what Kristy Hess [2013] has called "geo-social news"). The first folk theory defines the local newspaper as relevant and local ("our newspaper"), the second defines it as relevant, but not geographically or politically aligned with the locale ("their newspaper"), and the third defines it as neither relevant nor local ("what newspaper?"). I show that the nominally "same" newspaper, and one that is demonstrably by far the most

important provider of news locally (Nielsen 2015) means different things to people depending on which folk theory they see it through, and argue that journalism studies need to pay more attention to the different ways in which people interpret, perceive, and understand journalism.

In the first part of the paper, I develop the notion of folk theories of journalism. In the second part of the paper, I outline the research design and data I draw on. In the third part, I present the three different folk theories that people in the case community use to make sense of the local newspaper. In the final part, I discuss the wider implications and possible applications of the notion of folk theories of journalism.

## Folk Theories of Journalism

I take the notion of "folk theories" from research in science and technology studies on various kinds of "folk sciences", for example, commonly accepted taxonomies of ecological systems ("folk biology"), taken-for-granted understandings of the physical world ("folk physics"), or widespread assumptions about how the human brain operates ("folk theories of the mind"; see e.g. Carruthers and Smith 1996; Medin and Atran 1999; Heintz and Taraborelli 2010). Such theories are implicit parts of everyday life, and provide ways of thinking about and guides for acting upon the world around us. They can be more or less explicit, they can be shared or contentious, and they can be purely speculative, based on personal experience, and/or second-hand sources (Rip 2006).

Folk theories are in some respects *theories* in the same sense as scientific theories. They are generalized views of how the world works and conceptions of what it contains that are distinct from fact and practice, purport to capture patterns in what is happening, that are normally reflected upon when they encounter recurrent anomalies, but that are also often durable enough that no one individual experience or piece of evidence will decisively falsify them. They are different in that they are *folk* theories, and thus not subject to the institutionalized forms of contention and communal evaluation that scientific theories are subject to, and in that they tend more towards enabling action than towards the accumulation of knowledge.

The distinction between folk theories and scientific theories is not tied to who holds a particular theory. Scientists are lay people too, and we all have folk theories (Rip 2006). As with scientific theories, some folk theories are, for lack of a better word, wrong. It can be difficult to judge in some cases, but not in others. Maybe I think the earth is flat. This is not true if I mean by "earth" and "flat" what we generally mean by those terms. Maybe I think that journalists are simply told by governments what to do. This is demonstrably not so in most countries.

Like scientific theories, folk theories—even folk theories held by the same individual on the same issue—need not form coherent wholes. Also as with scientific theories, folk theories need not cover everything, and not everyone will have a generalized view of any given issue or topic that can meaningfully be conceptualized as a folk theory. (Much of the world simply is, with no theoretical articulation, whether scientific or folk. Some of our individual views are idiosyncratic and not theories shared with others.)

Folk theories specifically concerning *journalism* (and by extension folk theories of other highly expressive and performative practices like mass entertainment, politics, and professional sports) are different from folk theories of science because in a recursive fashion they draw in part on journalists' professional self-presentation and meta-journalistic

self-reflection (Carlson 2012). This is different from folk theories of biology or physics. In these areas, people may draw in part on scientific theories in formulating their folk theories, but what we call ecosystems or gravity do not articulate theories about themselves the way journalists continuously and publicly represent journalism itself.

We should see folk theories of journalism as rooted in wider cultures. What we mean by "culture" is, to say the least, a contentious conceptual issue in the humanities and social sciences (Patterson 2014). The strand of cultural theorizing that I draw on is the idea of culture as a "toolkit", developed by Ann Swidler (1986, 2001). In her work, she highlights how the idea of culture as one unified whole (as in the cultural anthropology of Clifford Geertz, e.g. Geertz 1973) or society as defined by a few epochal discursive regimes (as in Michel Foucault's cultural analysis, e.g. Foucault 2002) is hard to reconcile with the wide variety of actual practices we can observe every day, even by people who in every conventional sense of the word have a shared cultural background. To overcome this problem, Swidler suggests we focus less on what culture does to us and more on what we do with culture. In her view, culture should not be seen as one or more grand schemes that define our everyday life, but as a more or less shared "bag of tricks", a relatively wide repertoire or "toolkit" from which people put together a narrower range of "strategies for action" that they then actively deploy to navigate everyday life.

Like cultural anthropologists such as Geertz and cultural analysts like Foucault, Swidler sees culture primarily as symbolic, and as connected to action. She defines culture as "symbolic vehicles of meaning, including beliefs, ritual practices, art forms, and ceremonies, as well as informal cultural practices such as language, gossip, stories, and rituals of daily life" (Swidler 1986, 273). But unlike Geertz's and Foucault's more structural approaches, she emphasizes the varying configurations people themselves create out of cultural resources to be able to handle and make sense of everyday life. All social scientific approaches to culture insist on both a structural component (culture as constituted) and a pragmatic component (culture in action) (Patterson 2014). The approach I draw on here emphasizes the particular importance of the pragmatic component and of investigating cultural configurations that are more specific than larger structures broadly shared by everyone in a particular setting. You and I can have the same cultural background in terms of, say, nationality and social class, but draw on these shared resources in ways that help us construct quite different views of the world, and informs different actual practices (Swidler 1986, 2001). Some of us have put together strategies of action drawing on available cultural tools ("journalism is superficial and silly" versus "journalism is superficial but also integral to democracy"). These strategies of action in turn are likely to lead to different forms of practical engagement with journalism. This is a crucial point I take from Swidler: cultures' explanatory power lies not in defining the *ends* of actions, but in providing toolkits of symbolic resource from which we can construct strategies *for* action—folk theories of journalism are thus *understandings* of journalism that in turn shape *engagement* with journalism.

The notion of folk theories of journalism is meant to be a generative concept, a way of asking new questions that help us understand journalism. The idea of different folk theories of journalism, furnished in different contexts from culturally available symbolic resources, and in turn put into use by people in different ways in their everyday life can be operationalized in a number of ways. Like scientific theories, we can imagine folk theories articulated around a number of different questions: ontological ("what is journalism?"), procedural ("what do journalists do?"), epistemological ("what do journalists know and

how do they know it?"), and of course ethical questions ("what is good journalism?"). Similarly, empirical analysis of folk theories can be designed around different overlapping issues. The questions include inductive questions ("which folk theories are there?"), explanatory questions ("why do people hold the folk theories that they hold?"), and questions about the consequences ("what do the folk theories that they hold mean for how they see and act in the world?").

In this paper, I analyse different folk theories on the basis of Kristy Hess' (scientific) theoretical concept of "geo-social news" (Hess 2013) to illustrate how the concept can be put to use. On the basis of an analysis of small "local" newspapers in an increasingly digitized media environment where the kinds of territorial distinctions and geographic boundaries that used to be taken-for-granted parts of what made a local newspaper "local" are less self-evident, Hess argues that instead of assuming the connection between space and place implicit in categorizing a paper as "local", scholars should see these types of newspapers as engaged in the active construction of a certain sense of place as a "locale" by virtue of its definition of what is relevant and an area for which it is relevant. My specific argument here is simple—the actualization of geo-social news in Hess' sense is dependent upon how people understand the content (and news organization) in question. It is one of the many phenomena in journalism studies we can only understand if we also pay attention to how people understand journalism—to their folk theories of journalism. Many aspects of journalism and its role in society are contingent upon people's perception of journalism. To analyse these, we need to break with both our own and the people we study's "discourse of familiarity" (Bourdieu 1977) which so often leaves unexamined precisely the cultural and symbolic taken-for-granteds that are so important.

The basic empirical question in the rest of the paper is how people in the case community, drawing on a broadly speaking shared cultural repertoire, see the connections between a newspaper that very much sees itself and presents itself as the "local" newspaper, the news it publishes, the place it demarcates, and their own everyday life.

## Research Design

The data I draw on comes from a research project on local communities and political communication in a new media environment. Together with Nina Blom Andersen and Pernille Almlund from Roskilde University, I conducted a large-scale mixed-methods community study in a strategically selected case community in Denmark in 2013 to understand how people experience and engage with local politics today. Inspired by the community studies tradition associated with the Chicago School of Sociology and Robert Park, as well as the early work of Paul Lazarsfeld and his colleagues in the Columbia School, we combined a survey with content analysis of local and regional media, monitoring of local social media accounts, three weeks of fieldwork in the community, as well as both elite interviews with local politicians, civil servants, and journalists, plus individual interviews and focus groups with a sample of ordinary citizens. The case community Næstved is a provincial municipality with a population of 81,000 centred around a mid-sized eponymous town of about 42,000 surrounded by smaller villages. The local daily newspaper, *Sjællandske*, has been published in Næstved since 1866. Originally associated with a centre-right political party (Venstre) and competing with several other papers associated with other parties, it has since 1971 been the only local paper and has both editorially and commercially aimed to serve the whole community. In 2013, the daily print circulation was around 8000 copies

(down from 15,500 in 2003). In our survey, 32 per cent of local citizens name the paper (in print or online) as an important or very important source of information about local politics (Nielsen 2015).

The data I use comes specifically from 10 individual semi-structured interviews and five focus groups conducted with ordinary citizens in the municipality. Interviewees were recruited from four groups defined in terms of (1) their level of educational attainment (without or with a college degree) and (2) their level of local civic engagement (activity in local associations, political groups, etc.). Education was used for sampling as an indicator of socio-economic status, engagement in local civic life as an indicator of social capital. We thus recruited interviewees and focus group participants from four groups defined as (1) low formal education and low civic engagement, (2) high formal education and low civic engagement, (3) low formal education and high civic engagement, and (4) high formal education and high civic engagement. The interviews were semi-structured and conducted over the phone, typically lasting about 20 minutes. For the five focus groups, we recruited in part on the basis of the groups defined above, in part on the basis of geography, conducting three groups in smaller villages in rural areas and two focus groups in the urban centre of Næstved itself. A total of 27 individuals took part in the focus groups.

## The Many Faces of a Local Newspaper

This part of the article outlines the three main views identified in the interviews and focus groups. In each sub-section, I indicate which of Swidler's "symbolic vehicles of meaning" (beliefs, ritual practices, art forms, ceremonies, informal cultural practices, etc.) are used to make sense of the local paper. Throughout, beliefs about what the newspaper does or ought to do, as well as ritual and informal cultural practices embedded in daily life (routines of reading) are central parts of how people construct their relationship with the local paper.

The first view identified sees the paper as "our paper". This view is centrally associated with the perceived fit between the news it provides and local community life. Typically, this view is articulated around two cultural elements. First, a *belief* in the importance of being informed about local politics: "I subscribe to [the paper] … That's the way in which you can follow the local politicians and understand the local political process" (College-educated man, Interview). Second, an informal *ritual* of reading: "I read [the paper]". Moderator: "You read the paper?", "Yes, I always read it on my iPad, first thing in the morning" (Focus group). But the view also comes with a much broader conception of the paper as playing a wider role as a civic institution, a belief in the collective, almost ceremonial function of the news as a way of tying together a community—as one college-educated woman in her forties puts it in a focus group discussion:

> Then there is [the paper], which we have all mentioned here. I mean, this is when you realize how much it actually ties together the community. Whether you like it or not, there has to be someone who gives voice to the community, someone who serves to bring together things happening in our area. If you lived in a town like this, and there was no local newspaper … (pauses) I mean, that would mean a lot, really, I think we would be even more alienated from the political processes. I think the newspaper is really, really important, the fact that it exists, even though I think a lot of young people don't read it.

Most of the focus group participants and interviewees who articulate the view of the paper as "our paper" have higher levels of education, are older, and have lived in the community longer. They are predominantly people who are active in local associations. The view is not confined to them, however. Again interpreting the paper through the belief that it is important to be informed about politics and aware of wider community events, a younger woman with a vocational degree who has only recently moved to the town says:

> We get [the paper] where I work … I mean, they were really important, all the way up to the election. They were actually really good, it wasn't that there wasn't anything else, there were a lot of good stories, but they also made space for the election and really covered all sorts of things about it. In a way, I guess that is sort of necessary.

It is important to underline that though this view valorizes the newspaper as an important part of the local community, it need not be an uncritical celebration of the paper. Praise is often tempered with qualifications. "I mean, it I'm sure there are better newspapers out there" (Focus group) and the like. "Our paper" is not necessarily a perfect paper.

The second view identified sees the paper as "their paper". This view is typically articulated around a belief that the content produced either (1) is not geographically proximate enough or (2) is politically biased. The perception that the newspaper and its content is geographically distant is especially prevalent in the smaller villages around Næstved itself, that, while routinely covered by the paper both in print and online, is subject to less coverage than the larger town.

> The so-called "big paper", the daily, it isn't really worth much, because it covers a larger area including [names a couple of other towns] and the devil knows what else. I mean, they do have a couple of pages about us, but they don't cover everything happening here. (College-educated man, Interview)

As noted, the perception that the paper is for someone else, "their paper", is not only tied to geography. It is also articulated around a perceived political bias, a perception that can be found also amongst people who live in the main town of Næstved that most of the paper's coverage is focused on. Here, even people who care about politics distance themselves from the paper as a source of political information if they think it biased.

> No, I'm sorry. I used to read the [local Social Democratic paper, closed decades ago]. I watch television and also read a lot on the internet. But [the local paper], that's a right-wing newspaper, I won't read it. (Man in his seventies with vocational training, Interview)

> It [the paper] is a right-wing paper, so they don't want to hear any critical voices (laughs). Oh, I didn't just say that, did I? (laughs again). I won't read it. (College-educated man, Interview)

The perception of *Sjællandske* as "their paper" is particularly interesting in that it directly engages with the paper's presentation of self as providing (geo-social) local and impartial news and rejects this by pointing to perceived geographic or political biases. While often critical of the paper, this view need not be a wholesale dismissal. Many of the villagers who see the paper as "their paper" also acknowledge that its coverage of Næstved town "is pretty good" (as one put it) (Focus group). "Their paper" may be good, but it is not our paper, it is not good for us, here, because of its geographical focus or political bias.

Given the dearth of alternative sources of local news in the community, this folk theory becomes a strategy for inaction rather than a strategy of action—the same people who distanced themselves from the local paper in interviews and focus groups would also often more generally highlight that they felt little genuinely local and relevant news was available for people like them and more often relied on a combination of national news (with no local coverage) and in some cases informal networks of social communication.

The third view identified is more the absence of a view, usually implicit. When explicit, it is a view that asks "what paper?" This can be associated with an absence of interest in local affairs and/or politics, but also in some cases simply the fact that people do not know of the existence of a paper that has covered the community for almost 150 years.

| | |
|---|---|
| **Man:** | I read the papers, you know, mostly online, but I don't really feel they cover [local politics] very much. |
| **Interviewer:** | What papers do you read? |
| **Man:** | I read all of them, you know the big ones, also the little one you get through the mail [a free community weekly]. But it is hard, they don't really tell you anything. |
| **Interviewer:** | Do you read [the paper]? |
| **Man:** | What paper? (Man with vocational training, Interview) |

I have never seen that newspaper before. (Man, Focus group 5)

It is always hard to interpret absence, but it is noteworthy that of the total of 27 people who participated in the focus groups, a small number did not express any explicit views of the paper, its content, or its role in the local community. In some cases, the absence of views is no doubt rooted in a wider lack of interest in news and current affairs coverage, but as in the first example above, the "what paper?" view sometimes goes hand-in-hand with interest in and engagement with national and international news, suggesting a particular problem at the local level. The interviewees and focus group participants who either explicitly articulated the "what paper?" view or who expressed no view at all were generally younger, had lower levels of formal educational attainment, and were rarely active in local civic life.

## Conclusion

In this paper, I have argued that to understand journalism, we need to understand how people understand journalism. Drawing on recent work in science and technology studies, I have developed the concept of folk theories of journalism as actually existing popular beliefs about what journalism is, what it does, and what it ought to do that people use to make sense of news in their everyday life. Inspired by the cultural sociologist Ann Swidler (1986, 2001), I have suggested that people develop folk theories of journalism as strategies for action on the basis of broadly shared symbolic resources including the publicly available beliefs, rituals, and informal practices that surround news, and that a feature that sets folk theories of specifically journalism apart from folk theories of, for example, science is that people in a recursive way can draw on journalism's presentation of self when they interpret, perceive, and understand it.

To illustrate how the concept of folk theories of journalism can be used, I have ana-lysed how people in a homogenous community in Denmark talk about a local newspaper that is demonstrably by far the most important provider of local news (Nielsen 2015) and very explicitly presents itself as the pre-eminent provider of what Kristy Hess (2013) has called "geo-social news". Drawing on data from interviews and focus groups with a wide range of individuals with different backgrounds, I have identified three different views of the local newspaper, "our paper", "their paper", and "what paper?" With such different views identified in a relatively homogenous community covered by a newspaper that aims to provide news for the whole area, folk theories are likely to be even more diverse in more heterogeneous communities (especially with strong social cleavages) and in more unevenly covered communities where local media more explicitly target specific geo-graphies (affluent suburbs, urban centres, etc.) or where multiple media position them-selves in different ways (popular versus upmarket).

The present analysis is not focused on the consequences of each view, but it is likely that those who articulate the first view are more likely to read the paper routinely and, as previous research suggests, therefore likely to be more informed about local affairs, more active in local politics, and more engaged in civic life (e.g. Tichenor, Donohue, and Olien 1980). Those who hold the second and third view seem less likely to engage with local news. Similarly, my aim here has not been to explain the origins of the views identified, though the overall findings suggest the importance of a more general social economy of cultural goods as well as the importance of associational involvement and spatial location in shaping how people see local news. Overall, and broadly in line with Pierre Bourdieu's (1984) idea that taste is deeply formed by social hierarchies, individuals with higher cultural and social capital accumulated through education and active engagement in local associ-ations tended more towards the "our paper" view, while those with lower levels of overall cultural and social capital tended more towards the "what paper" view. Importantly, however, the "their paper" view generally seemed less associated with education and engagement, and more with where people lived and with their politics. Generational differ-ences as well as how long someone has lived in the community seemed to matter too.

The concept of folk theories of journalism is meant to be generative and part of a wider attempt to connect journalism studies with work in audience research and media ethnography and complement cultural analysis of *journalists* (Schudson 2003; Zelizer 2004) with cultural analysis of *people's relation to journalism* (Bird 2003; Costera Meijer 2013; Palmer 2013). The concept opens up a wide range of research questions, including what folk theories there are, why, and what their consequences are, just as the concept can be centred on folk theories of many different aspects of journalism, including what people think journalism is, what people think journalists do, what people think journalism means (for them, for society), and so on. Finally, in a time where the profession of journalism and the institutions that have sustained and constrained it are changing very rapidly (Newman, Levy, and Nielsen 2015), there is an open empirical question as to how actually existing popular beliefs about journalism relate to the structural transformation under way, how folk theories of journalism relate to the professional and institutional realities of journalism.

## ACKNOWLEDGEMENTS

I am grateful to Nina Blom Andersen and Pernille Almlund for many interesting conversations while engaged in this research. Laurids Hovgaard was an invaluable research assistant on the project.

## DISCLOSURE STATEMENT

No potential conflict of interest was reported by the authors.

## REFERENCES

Bird, S. Elizabeth. 2003. *The Audience in Everyday Life*. New York: Routledge.

Bourdieu, Pierre. 1977. *Outline of a Theory of Practice*. Cambridge: Cambridge University Press.

Bourdieu, Pierre. 1984. *Distinction*. Cambridge, MA: Harvard University Press.

Carlson, Matt. 2012. "Where Once Stood Titans": Second-Order Paradigm Repair and the Vanishing US Newspaper." *Journalism* 13 (3): 267–83.

Carruthers, Peter, and Peter K. Smith, eds. 1996. *Theories of Theories of Mind*. Cambridge: Cambridge University Press.

Costera Meijer, Irene. 2013. "Valuable Journalism: A Search for Quality from the Vantage Point of the User." *Journalism* 14 (6): 754–70.

Foucault, Michel. 2002. *The Order of Things*. London: Routledge.

Geertz, Clifford. 1973. *The Interpretation of Cultures*. New York: Basic Books.

Heintz, Christophe, and Dario Taraborelli. 2010. "Folk Epistemology. The Cognitive Bases of Epistemic Evaluation." *Review of Philosophy and Psychology* 1 (4): 477–82.

Hess, Kristy. 2013. "Breaking Boundaries." *Digital Journalism* 1 (1): 48–63.

Medin, Douglas L., and Scott Atran, eds. 1999. *Folkbiology*. Cambridge, Mass: MIT Press.

Newman, Nic, David A. L. Levy, and Rasmus Kleis Nielsen. 2015. *Reuters Institute Digital News Report 2015*. Oxford: Reuters Institute for the Study of Journalism. http://www.digitalnewsreport.org/.

Nielsen, Rasmus Kleis. 2015. "Local Newspapers as Keystone Media: The Increased Importance of Diminished Newspapers for Local Political Information Environments." In *Local Journalism*, edited by Rasmus Kleis Nielsen, 51–72. London: I.B.Tauris.

Palmer, Ruth A. 2013. "In the Funhouse Mirror." Doctoral dissertation, Columbia University.

Patterson, Orlando. 2014. "Making Sense of Culture." *Annual Review of Sociology* 40 (1): 1–30.

Rip, Arie. 2006. "Folk Theories of Nanotechnologists." *Science as Culture* 15 (4): 349–65.

Schudson, Michael. 2003. *The Sociology of News*. New York: Norton.

Swidler, Ann. 1986. "Culture in Action." *American Sociological Review* 51 (2): 273–86.

Swidler, Ann. 2001. *Talk of Love : How Culture Matters*. Chicago: University of Chicago Press.

Tichenor, Phillip J., George A. Donohue, and Clarice N. Olien. 1980. *Community Conflict and the Press*. Beverly Hills, Calif: Sage Publications.

Zelizer, Barbie. 2004. *Taking Journalism Seriously*. Thousand Oaks, Calif; London: SAGE.

# INTERACTING WITH AUDIENCES
## Journalistic role conceptions, reciprocity, and perceptions about participation

**Avery E. Holton** ⓘ, **Seth C. Lewis** ⓘ, and **Mark Coddington** ⓘ

*Drawing on open-ended responses to a representative survey of US journalists, this article examines how journalists' role conceptions may be associated with distinct perceptions of and practices toward audiences, whether online or offline. In particular, this research considers the potential for more reciprocal, or mutually beneficial, interactions between journalists and audiences. Using exploratory factor analysis and normalized index scores, journalists are characterized within four role conceptions. Results show that Populist Mobilizer and Entertainment roles are more associated with digital audience engagement, while Loyal Support and Public Service roles better characterize offline interactions. Findings point to a need for better explanations of how journalists' role conceptions connect with their engaging (or not) in more purposeful, persistent and reciprocal interactions with audiences.*

## Introduction

In perhaps the most comprehensive cross-national study of audience participation in journalism, Singer et al. (2011) sum up their analysis of journalists affiliated with leading newspaper websites in 10 Western democracies by concluding: "What emerged in our study is a view of news organizations that are seeking to provide more avenues for audience involvement but simultaneously to protect the professional status of the journalist" (189). In effect, journalists recognized that people formerly known as passive readers had something to contribute as "users," whether that meant providing tips and eyewitness material on the front end of the journalistic process or in reacting via online comments on the back end. The upshot was that journalists tended to perceive the user as a potentially useful resource but nevertheless "an active recipient of the news rather than as an active participant in the news" (189)—comfortably at arm's length from journalists and their work. Since that research was conducted in 2007–2008, the potential for journalists to engage and interact with audience members, individually and collectively, has escalated dramatically. The rapid diffusion of smartphones and social media, among other technological advances in peer-to-peer networked communication across many countries (Graham and Dutton 2014; Rainie and Wellman 2012), has facilitated easy information creation and sharing among users. This contributes to media dynamics, characterized by a greater mixing of mass and interpersonal messaging, that are increasingly "hybrid" (Chadwick 2013), "affective" (Papacharissi 2014), and "spreadable" (Jenkins, Ford, and Green 2013) in nature.

Given such conditions, it is worth reconsidering the role(s) of the journalist in the light of such social, cultural, and technological conditions. More than ever, it would seem, journalists must confront the matter of what to do with their audiences. What kind of relationship should they negotiate with them, and with what implications for the professional purview that journalists have long maintained as gatekeepers? In 2007–2008, such questions primarily had to do with what journalists allowed users to do on their homepages (e.g., in writing blogs, uploading photos, or making comments). Today, those options have expanded to include seemingly the whole of the internet—all of the potential connections that might be forged with and among users on Twitter, Facebook, Instagram, and the like, setting aside the growth in messaging apps such as WhatsApp and other mobile-focused opportunities. How do journalists negotiate this proliferation of digital directions in addition to community-centric functions that may be as much about offline interactions as online ones?

Against that backdrop, and drawing on open-ended responses to a representative survey of newspaper reporters and editors in the United States, this article examines distinct approaches that journalists might take in relation to audiences, depending on their personal perceptions about their professional roles. The purpose of such research is twofold: first, to develop a richer picture of how journalists think about and act toward the audience—a key approach to updating the foundational research of Singer et al. (2011)—and, second, to frame those findings in light of conceptual heuristics that can aid in analyzing the various interpretations of audiences that emerge from journalists' self-reports. Such heuristics include the professional role conceptions approach to studying journalists, a longstanding line of research that emphasizes the importance of understanding how journalists perceive their normative role in society (e.g., see Hanitzsch 2011; Mellado 2015; Weaver and Wilhoit 1996). Additionally, given the dialogical character of emerging social media, this research considers the particular potential for *reciprocal* kinds of interactions between journalists and audiences—exchanges of more mutual beneficence that are considered essential to community formation and perpetuation (Molm 2010). Because reciprocity may be evident in ways that are direct and indirect, fleeting and sustained over time, this article considers the extent to which journalists envision engagement with audiences (Lewis, Holton, and Coddington 2014).

Ultimately, this study aims to clarify, at least within the American context, how different types of journalists may possess different self-conceptions about their roles, and, in turn, different perceptions of and practices toward audiences during this moment of heightened (potential) interaction through social media spaces.

## Journalistic Role Conceptions

How journalists perceive their professional roles in society is a central area of journalism studies. Since Cohen (1963) distinguished between "neutral" and "participant" roles, scholars have offered various conceptualizations of journalistic roles, or the predominant self-image that journalists report regarding their social functions. Such research includes Weaver and Wilhoit's (1996) four role types—disseminator, adversary, interpreter-investigator, and populist mobilizer—as well as Hanitzsch's (2011) finding of four global "professional milieus": populist disseminator, detached watchdog, critical change agent, and opportunist facilitator. These and other studies often develop role conceptions at the

individual level of media psychology (Shoemaker and Reese 2014), using surveys of journalists to understand how individuals express certain normative goals.

Recent reviews of the role conceptions literature have noted that while roles reveal *how* journalists believe they ought to do their work, they do not entirely capture *what* they do—a gap between role conception and role performance that may be exacerbated by economic, political, and institutional circumstances (Mellado 2015; Mellado and van Dalen 2014; Tandoc, Hellmueller, and Vos 2013). As Tandoc, Hellmueller, and Vos (2013) noted, journalistic role conceptions may be the result of what journalists expect of themselves, but those expectations may be overridden by a number of factors, including organizational influence, changes in routines, and the emergence of new technology. As such, role conceptions and their related enactments should be considered through multiple lenses that do not preclude other influences on journalistic work.

This emphasis on connecting journalistic ideals to journalistic practice points to a void addressed in this article: in the broad literature on roles, little attention is given to the particular contexts of audience interaction, engagement, and participation. How certain journalistic role perceptions translate to various types of journalist–audience relationships has yet to be explored fully (cf. Hellmueller and Mellado 2015). Thus, insofar as role conceptions outline how journalists may perceive and presumably act upon distinct political and societal functions, it matters to understand how such roles relate to different elements of journalist–audience interaction.

### Reciprocity and Journalism

The relationship between journalists and their audiences has long been a source of both dependence and disdain. An audience may be required for news to work, but journalists have not been particularly interested in listening to, let alone collaborating with, audience members, in part because of the threat such interaction poses to professional autonomy (Gans 1979). While Singer et al. (2011) and others have found journalists in the twenty-first century to be far more open to interacting with and even learning from audiences (e.g., Hedman 2015; Revers 2014), there is an enduring tension between maintaining professional control of the news information environment, as a key aspect of journalists' occupational role, and developing more dialogical relationships with users via digital media (Lewis 2012).

Amid this tension, the concept of reciprocity may pose a fresh possibility for rethinking this fractured relationship. Reciprocity, the practice of exchange with others for mutual benefit, is among the most universal of social norms. In its positive form, it is considered a fundamental starting point for establishing and maintaining personal relationships (Gouldner 1960), contributing to the formation and perpetuation of trust, social capital, and community dynamics both in online (Pelaprat and Brown 2012) and offline (Putnam 2000) settings. In more fully explicating the role of reciprocity as a set of social exchanges, Molm (2010) developed a model for understanding direct forms of reciprocity (e.g., A gives to B, and B gives to A) as well as indirect ones (A gives to B who gives to C who gives to D, and so on), illustrating how both personalized and generalized exchanges contribute to strengthening social ties, when positive.

Drawing on this perspective, we previously suggested that journalists and audiences alike may benefit from more reciprocally oriented exchanges (Lewis, Holton, and Coddington 2014). "Reciprocal journalism" proposes that journalists may develop more mutually

beneficial relationships with audiences across three forms of exchange: direct (exchanges between journalists and audiences in a one-to-one fashion), indirect (exchanges that are witnessed by others and intended for community benefit, in a one-to-many fashion), and sustained (exchanges that occur repeatedly over time, pointing to future interactions and benefits). The value of reciprocal journalism is underscored by research finding that, in participatory news projects, users expected reciprocity from journalists—something in return for their contributions—and that projects succeeded or failed according to reciprocal relationship-building (Borger, van Hoof, and Sanders 2014). While certainly no cure-all by itself, reciprocity nevertheless offers a perspective for envisioning how journalists and audiences might find mutually responsive patterns of social exchange, directly, indirectly, and repeatedly over time (see also Lewis 2015).

Bringing together the above insights on role conceptions and reciprocity, this research explores the nature of journalistic perceptions of and practices toward audience interaction by studying a representative sample of US journalists: their self-conceptions in connection with self-reported activities that seek to build improved relationships with audiences, reciprocally or otherwise. How journalists characterize such relationships, and how those characterizations compare across different role types and circumstantial dimensions, is the focus of this work.

## Method

This study employed a national survey of US newspaper journalists and editors (referred to hereafter as "journalists"), conducted in February 2014. The sample was drawn from Cision, a media contact service whose database contains at least 1.5 million media professionals worldwide. The authors drew a list of US newspaper journalists in that database with searches for job descriptions containing the words "writer," "reporter" "columnist," "contributor," and "editor." The search generated approximately 39,000 contacts, a similar number to the 37,983 full-time newspaper newsroom employees in the census of the American Society of Newspaper Editors (2013).

The sample was stratified according to the American Society of Newspaper Editors's 2013 ratio of editors to non-editors of 1.92:1, and then selected randomly within those two categories. Of the 5197 journalists who were e-mailed the survey, 546 completed it. Applying the American Association of Public Opinion Research's RR4 calculation, the response rate was 19.6 percent. This is similar to that of other research on journalists using Web-based surveys (Gil de Zúñiga and Hinsley 2013).

Journalists' professional role conceptions were measured through an index of 20 items drawn from the Worlds of Journalism Study,[1] each using a 10-point Likert-type scale (1 = not important, 10 = extremely important). The authors used an exploratory factor analysis with Varimax rotation to determine the underlying dimensions in the index, extracting dimensions with Eigenvalues greater than 1. Cronbach's alpha was then used to refine those dimensions into distinct cohesive roles. That process left four roles using a total of 16 items, after items were eliminated for their lack of fit into the structure of roles.

The first was *Public Service* (mean = 51.39, SD = 11.53), which included seven items (Cronbach's $\alpha$ = 0.80; monitor and scrutinize political leaders; provide information people need to make political decisions; monitor and scrutinize business; let people express their views; report things as they are; provide analysis of current affairs; be an adversary of the government). The second was *Populist Mobilization* (mean = 14.79, SD = 7.20),

which included three items ($\alpha = 0.82$; influence public opinion; set the political agenda; advocate for social change). The third was *Loyal Support* (mean = 9.01, SD = 5.51), which included three items ($\alpha = 0.81$; support government policy; convey a positive image of political leadership; support national development). The fourth was *Entertainment* (mean = 17.63, SD = 6.10), which included three items ($\alpha = 0.65$; provide the kind of news that attracts the largest audience; provide entertainment and relaxation; provide advice, orientation, and direction for daily life).

To organize participants into roles for qualitative analysis, role conception scores were normalized relative to the indexes' scale and to the scores of other journalists. Each role score was split into quartiles, and each respondent was assigned to a quartile for each role. Those quartile scores were then compared across roles, and respondents were assigned to the role for which they scored in the highest quartile. Respondents who had two roles sharing their top quartile score (e.g., scoring in the top quartile in both Public Service and Entertainment) were assigned to both roles. However, respondents who had three or more roles sharing their top quartile score were assigned to a "Three or More Roles" category ($N = 82$) and excluded from this analysis. If respondents were in the bottom two quartiles (i.e., below the median) in all four roles, they were assigned a "No Roles" category ($N = 68$) and also excluded from this analysis. There were also 15 respondents outside these groups who did not answer the survey's qualitative questions, leaving a total $N$ of 397 non-duplicated responses in the analysis. The resulting frequency of role conceptions, including overlapping assignments for those who strongly identified with more than one role, was Public Service ($N = 148$), Loyal Support ($N = 144$), Entertainment ($N = 138$), and Populist Mobilizer ($N = 132$).

The number of respondents assigned to each role conception was generally even across roles because they were normalized by overall professional scores; that is, they were categorized by role based on their scores relative to other journalists. For the Loyal Support role, then, though the overall scores for this role were much lower than those for other roles, respondents were assigned to this role if they scored particularly high in this role *relative to other journalists*. This method of categorization allowed for direct comparison across the varying numbers of items in the indices for the four roles and helped to isolate differences among journalists regarding their identification with roles that tended to be largely revered (Public Service) or reviled (Loyal Support).

In order to understand how these role conceptions might be associated with journalists' participatory beliefs and behaviors, especially those that have been linked to a richer, more reciprocal form of engagement, the journalists were asked two open-ended questions aimed at examining direct, indirect, and sustained reciprocal interaction: "Can you describe how you typically interact with readers/followers directly (one-on-one) and indirectly (one-to-many)?" and "Thinking about your interactions over time, how do you ensure a good relationship with your readers?" Through close readings, responses were categorized into patterns as suggested by scholars (Birks and Mills 2011; Strauss and Corbin 1998), with attention given to recurrent and dominant responses within each of the four role conceptions.

## Results

The journalists participating in the study were 54 percent male and 46 percent female and had a mean age of 49 (SD = 13.16), with a mean of 23 years working in the news

business (SD = 12.84). Nearly half (45.6 percent) had leadership positions as editors or publishers, not including copy editors. They worked in newsrooms with an average of 62 employees (SD = 134.40), but a median of just 15; that is, most of them worked in small newsrooms, but a few worked in very large ones. Close to half of the respondents (46.3 percent) described their newspapers as being in urban settings, with 22.2 percent in suburban settings and 31.5 percent in rural areas.

While the journalists broadly noted the routinization of social media into their professional lives as a vehicle for creating and conveying news, a clear break emerged in the way social media was approached as a participatory tool. In their open-ended responses, Populist Mobilizers and Entertainers favored social media channels such as Twitter, Facebook, and Instagram, not only as tools for sharing news and information but also as pathways to improved reporting, personal branding, responsive engagement, and reciprocal exchanges at direct and indirect levels. Populist Mobilizers said they used sharing news across digital devices and social media channels, and in some cases promoted their individual or organizational work, to open or extend conversations with their audience —all part of being perceived as being "more available as listeners." Those in the Entertainment role assumed a slightly more deliberate attitude, saying they often took on fewer or shorter stories in lieu of increasing social media interactions. They were receptive to audiences as sources of information, as critics of their work (e.g., in critiquing their opinion columns and reviews), and as "always-on respondents." Entertainers reported elevated levels of debate and banter with audiences on digital platforms, ranging from one journalist who said, "Sometimes I ask questions that are reflected back on blog items for the many, like where can people watch the US Olympic hockey team at 7:30 a.m. and get breakfast?" to another who said he engaged readers who sought advice and purposely tried to open larger debates with other social media users both directly and indirectly.

Alternatively, journalists who align more with the roles of Loyal Support and Public Service were less receptive to social media as instruments for participatory engagement, noting that while they did incorporate such media into their reporting and frequently experimented with ways to enhance their journalistic approaches, traditional forms of communication remained most important for them. In some cases, journalists within these roles indicated that they rarely if ever initiated contact with their readers through digital or social media channels, instead choosing to engage only when users engaged them first. They argued that direct participation with their audiences, including direct reciprocation, fell more along the lines of face-to-face contact, e-mails, and telephone exchanges. These journalists, a large number of whom worked for suburban or rural newspapers, said they made a point of positioning themselves in busy coffee shops, restaurants, town hall meetings, and other forms of public presence to remind the community they were available and to enhance the potential for direct levels of participation through means of conversation. These journalists viewed social media as more of an outlet to push news and far less a place to build community or engage in meaningful conversations. These exchanges helped journalists avoid online conversations that were "ugly, hateful, and engage personal insults," as one Loyal Support journalist put it, and instead have "actual conversations with people [that produce] much more constructive discussion than trying to engage people online." In other words, face-to-face dialogue was viewed at a premium in terms of participating and reciprocating with audiences.

Finding an online/offline balance for engagement was nearly impossible according to some Public Service journalists, including one who noted that comment boards, Facebook,

and Twitter indeed provided "room for interaction," but that face-to-face interactions remained the primary mode for opening direct dialogue. This approach frequently resulted in journalists listening at length to readers' arguments, disagreements, complaints, and opinions, according to several respondents. Such listening was largely cast as a positive form of direct reciprocation with potentially powerful indirect results. By taking the time to listen to their readers one-on-one, and at times to seek solutions for them, journalists said they were ensuring more sustained audiences. Further, because such actions occurred in public forums (i.e., coffee shops, town hall meetings, etc.) where intentions could not be veiled behind digital screens and emotional responses were readily ascertained, other potential and current readers were likely to develop and share positive perceptions of the journalists and their organizations.

Notably, this sentiment emerged digitally among Public Service journalists, many of whom reported taking on the role of arbiter in social media exchanges among their readers. By liking others' posts and providing information when requested, they said they helped keep online conversations civil. If the dialogue between readers turned sour, they worked to resolve the issue. In cases where hostility escalated, they attempted to cool the situation before taking extreme measures such as blocking readers from comment sections, blog forums, or Twitter discussions. Yet they remained distinctly cautious in terms of routine engagement with social media users, suggesting much like the Loyal Support journalists that participation and reciprocation with audiences was best practiced offline.

Many of these journalists saw themselves as indirectly engaged with audiences in other ways, such as "creating hashtags that might catch on" or "retweeting thoughtful responses." They saw their journalistic content as a means of indirectly engaging audiences without investing too much online time. As one Loyal Support journalist put it, "I communicate with my readers through my stories and columns published in our three editions a week and with breaking news stories posted on our website and email blasted to online subscribers." Those in the Public Service role seemed to agree, saying that indirect communication occurred most beneficially through content such as editorials or columns, which provided insights into their personal opinions and allowed readers to respond either through e-mail, telephone conversations, comment boards, or Twitter in rare cases. Many of these journalists argued for the virtue of content as a means of kick-starting reciprocation more broadly, offering audiences a service that has increasingly become free or inexpensive to access.

Relatively few journalists surveyed here spoke in temporal terms when discussing how they sustained participation or reciprocation with audiences. Instead, a sweeping majority said they relied on a combination of traditional tenets of good journalism (i.e., balance, objectivity, truthfulness, transparency, etc.) and what could be described as a certain level of "politeness" toward their audiences. Across all roles, journalists used phrases such as "being friendly," "being nice," "highlighting the good," "being approachable," and "being polite," to describe how they sustained audience. Such descriptors, despite their breadth, are indicative of sustained forms of reciprocity that many respondents said were necessary to build, strengthen, and maintain audiences.

Such "politeness" emerged in varying forms across roles. Loyal Support journalists, who again emphasized face-to-face interactions over time, said they frequently relied on the legacy or brand of their media and used positive engagements with readers to uphold that brand as well as the loyalty of their readers. Such engagements were described as participation with audiences less in terms of inviting engagement in the news process

and more in terms of being "fair and polite" at all costs. Public Service journalists extended that thought, saying that their audiences deserved a level of courtesy that included owning up to mistakes. Populist Mobilizers saw such civility as responsiveness, including a "willingness to immediately do what I can to provide information that [my readers] may seek." Others said simply allowing for limited forms of engagement was sufficient reciprocation to create lasting audiences: "I don't really think about having a relationship with readers. I think about providing good journalism and doing what it takes to make our newspaper more relevant, which involves allowing readers to have some input or getting input from the general public."

Of all responses collected that engaged the question of sustained participation and reciprocation with audiences, none explicitly indicated that certain actions repeated over periods of time were a cornerstone of building more engaged or meaningful relationships with their audiences.

## Discussion and Conclusion

This study has examined how journalists possessing different role conceptions may perceive their relationship with audiences, focusing on their self-reported attitudes and interactions regarding participation and reciprocation with such audiences. The results reveal that while some journalists are indeed using digital and social media to connect with audiences, others remain steadfastly traditional in their approaches. Much like Singer and her colleagues found (Singer et al. 2011 ), some journalists—especially those identifying with the Loyal Support and Public Service roles—continue to protect the more traditional tenets of their profession by limiting interactions with audiences and relying on more established forms of communication, such as face-to-face and email interactions. With regard to reciprocation, these journalists appear to put higher value on engagement and reciprocity in offline settings, and continue to see more benefit in customary interactions rather than those that may occur—directly or indirectly—through digital and social media channels. Additionally, whereas we previously hypothesized that journalists would seek to develop reciprocally oriented relationships over time (Lewis, Holton, and Coddington 2014), there was little evidence of "sustained reciprocity." On the whole, journalists were open to building relationships with audiences, but mostly on their own terms and not necessarily for the long term.

The primary differences appear to emerge between Populist Mobilizers and Entertainers, on the one hand, and Loyal Support and Public Service journalists, on the other. Broadly speaking, the former appear more willing to embrace digital platforms not only as routinized parts of their work but also as emergent spaces for interactions with audiences—in essence, welcoming the generative possibilities that might exist in connecting with and even responding to readers and followers online. More skeptical of digital forms of engagement were Loyal Support and Public Service journalists, who on balance preferred traditional channels, face-to-face encounters, and limited uses of social media for exchange with audiences. For these latter journalists, it seemed, simply doing "good journalism" was its own expression of courtesy and goodwill to audiences; to ask for more personal, ongoing, dialogical, and digitally oriented forms on top of that fell outside the scope of their role.

These differences appear to fit these role conceptions. Populist Mobilizers and Entertainers, by definition, have a greater audience orientation toward motivating and amusing

readers and followers while also covering issues that drive engagement. Loyal Support and Public Service—which may seem contradictory with regard to how they would monitor public officials, for example—both conjure up a certain paternalistic function of journalism, one concerned with looking after communities as journalists see fit, in accordance with their professional purpose. Loyal Support, in particular, is often associated with community journalism in rural settings, where face-to-face encounters are more likely to occur and be valued by journalists and audiences alike. Indeed, a limitation of this study is that it does not differentiate among journalists at metropolitan, suburban, and rural newspaper settings—a factor that may explain some of the differences that exist both within and across the roles identified here. Future research should examine how structural factors, such as community setting, may be connected with particular role conceptions and, in turn, distinct attitudes toward audience, participation, and reciprocation. Additionally, given the comparative aspect of studying role conceptions (Hanitzsch 2011), researchers should consider how roles relate to different forms of audience interaction across countries and media systems (Hellmueller and Mellado 2015).

Over time, the role conceptions literature has suggested that, among other factors that influence content, certain roles are associated with certain broadly shared approaches to *producing for* audiences, as in the case of an infotainment orientation being associated with market-driven tabloidization (Mellado 2015). However, the literature has yet to fully address the matter of how certain roles are connected with *interacting with* audiences, particularly at this moment of social, mobile, digital media. Going forward, better explanations are needed for how and why particular self-images are associated with journalists engaging (or not) in more purposeful and persistent interactions with audiences—and the results of such interactions for reciprocity in communities that journalists serve.

## ACKNOWLEDGEMENTS

The authors would like to thank Lea Hellmueller (Texas Tech University), Logan Molyneux (Temple University), and Shannon McGregor (The University of Texas-Austin) for their valuable input during the development of this article.

## DISCLOSURE STATEMENT

No potential conflict of interest was reported by the authors.

## NOTE

1.  The Worlds of Journalism Study, begun in 2007, is a cross-national effort to assess the state of journalism in dozens of countries (see http://www.worldsofjournalism.org/ for details and a list of publications resulting from previous surveys).

## REFERENCES

American Society of Newspaper Editors. 2013. *ASNE Newsroom Census*. Washington, DC. http://asne.org/content.asp?pl=121andsl=284andcontentid=284

Birks, Melanie, and Jane Mills. 2011. *Grounded Theory: A Practical Approach*. Los Angeles, CA: Sage.

Borger, Merel, Anita van Hoof, and Jose Sanders. 2014. "Expecting Reciprocity: Towards a Model of the Participants' Perspective on Participatory Journalism." *New Media & Society*. doi:10. 1177/1461444814545842.

Chadwick, Andrew. 2013. *The Hybrid Media System: Politics and Power*. Oxford: Oxford University Press.

Cohen, Bernard C. 1963. *The Press and Foreign Policy*. Princeton, NJ: Princeton University Press.

Gans, Herbert. J. 1979. *Deciding What's News: A Study of CBS Evening News, NBC Nightly News, Newsweek, and TIME*. New York: Pantheon Books.

Gil de Zúñiga, Homero, and Amber Hinsley. 2013. "The Press Versus the Public: What is 'Good Journalism'?" *Journalism Studies* 14 (6): 926–942. doi:10.1080/1461670X.2012.744551.

Gouldner, Alvin W. 1960. "The Norm of Reciprocity: A Preliminary Statement." *American Sociological Review* 25: 161–178.

Graham, Mark, and William H. Dutton, eds. 2014. *Society and the Internet: How Networks of Information and Communication are Changing Our Lives*. New York, NY: Oxford University Press.

Hanitzsch, Thomas. 2011. "Populist Disseminators, Detached Watchdogs, Critical Change Agents and Opportunist Facilitators." *International Communication Gazette* 73 (6): 477–494. doi:10. 1177/1748048511412279.

Hedman, Ulrika. 2015. "J-Tweeters: Pointing Towards a New Set of Professional Practices and Norms in Journalism." *Digital Journalism* 3 (2): 279–297. doi:10.1080/21670811.2014.897833.

Hellmueller, Lea, and Claudia Mellado. 2015. "Professional Roles and News Construction: A Media Sociology Conceptualization of Journalists' Role Conception and Performance." *Communication and Society* 28 (3): 1–11.

Jenkins, Henry, Sam Ford, and Joshua Green. 2013. *Spreadable Media: Creating Value and Meaning in a Networked Culture*. New York: NYU Press.

Lewis, Seth C. 2012. "The Tension Between Professional Control and Open Participation: Journalism and Its Boundaries." *Information, Communication and Society* 15 (6): 836–866. doi:10. 1080/1369118X.2012.674150.

Lewis, Seth C. 2015. Reciprocity as a Key Concept for Social Media and Society. *Social Media +Society* 1 (1). doi:10.1177/2056305115580339.

Lewis, Seth C., Avery E. Holton, and Mark Coddington. 2014. "Reciprocal Journalism: A Concept of Mutual Exchange Between Journalists and Audiences." *Journalism Practice* 8 (2): 229–241. doi:10.1080/17512786.2013.859840.

Mellado, Claudia. 2015. "Professional Roles in News Content: Six Dimensions of Journalistic Role Performance." *Journalism Studies* 16 (4): 596–614. doi:10.1080/1461670X.2014.922276.

Mellado, Claudia, and Arjen van Dalen. 2014. "Between Rhetoric and Practice: Explaining the Gap Between Role Conception and Performance in Journalism." *Journalism Studies* 15 (6): 859–878. doi:10.1080/1461670X.2013.838046.

Molm, Linda D. 2010. "The Structure of Reciprocity." *Social Psychology Quarterly* 73: 119–131.

Papacharissi, Zizi. 2014. *Affective Publics: Sentiment, Technology, and Politics*. Oxford: Oxford University Press.

Pelaprat, Etienne, and Barry Brown. 2012. "Reciprocity: Understanding Online Social Relations." *First Monday* 17 (10). http://firstmonday.org/ojs/index.php/fm/article/view/3324

Putnam, Robert D. 2000. *Bowling Alone: The Collapse and Revival of American Community*. New York: Simon and Schuster.

Rainie, Lee, and Barry Wellman. 2012. *Networked: The New Social Operating System*. Cambridge, MA: The MIT Press.

Revers, Matthias. 2014. "The Twitterization of News Making: Transparency and Journalistic Profes-sionalism." *Journal of Communication* 64 (5): 806–826.

Shoemaker, Pam J., and Steve D. Reese. 2014. *Mediating the Message in the Twenty-First Century: A Media Sociology Perspective*. New York: Routledge.

Singer, Jane B., David Domingo, Ari Heinonen, Alfred Hermida, Steve Paulussen, Thorsten Quandt, Zvi Reich, and Marina Vujnovic. 2011. *Participatory Journalism: Guarding Open Gates at Online Newspapers*. Malden, MA: Wiley-Blackwell.

Strauss, Anselm C., and Juliet M. Corbin. 1998. *Basics of Qualitative Research: Techniques and Pro-cedures for Developing Grounded Theory*. 2nd ed. Thousand Oaks, CA: Sage.

Tandoc, Edson C., Lea Hellmueller, and Tim P. Vos. 2013. "Mind the Gap: Between Journalistic Role Conception and Role Enactment." *Journalism Practice* 7 (5): 539–554.

Weaver, David H., and G. Cleve Wilhoit. 1996. *The American Journalist in the 1990s: U.S. News People at the End of an Era*. Mahwah, NJ: Erlbaum.

## ORCID

**Avery E. Holton** ⓘ http://orcid.org/0000-0003-1307-2890

**Seth C. Lewis** ⓘ http://orcid.org/0000-0001-7498-0599

**Mark Coddington** ⓘ http://orcid.org/0000-0001-6664-6152

# COSMOPOLITAN JOURNALISTS?
## Global journalism in the work and visions of journalists

**Johan Lindell** ⓘ and **Michael Karlsson** ⓘ

*It has been argued that the future of journalism resides within a global media ethics. Accordingly, journalism must renew itself by becoming less parochial and connect "citizens of the world" to a "global public sphere". In drawing upon a panel study with Swedish journalists, this paper shows that journalists do not define their everyday work according to the principles of global journalism. Most of them do, however, agree with such principles in normative visions of their profession. The paper furthermore illustrates the importance of taking into account various positions in the journalistic field when trying to identify global journalism. A small minority producing "hard news" for media organizations with national or international reach comes somewhat close to embodying the ideals of global journalism. For most journalists, however, everyday work consists of covering domestic issues for domestic audiences. As such, the study pinpoints a domestically biased doxa in the field of journalism that is unlikely to be overthrown in the near future.*

### Global Journalism—Assumptions, Visions, Evidence

Journalists are often given a central role in contemporary discussions on the rise of a cosmopolitan civil society. They have been understood as "workers of the imagination"—as capable of turning their audiences into "citizens of the world" through the narratives they construct about the world we inhabit together (Hannerz 2007; Robertson 2010). Such an impetus seems to, if not presuppose, expect that journalists spend a significant portion of their workload reporting on global issues, and strive to create in their audiences a sense of belonging to the world as a whole. The purpose here is to disclose the extent to which this is the case within the Swedish journalistic field.

In relation to such concerns, Beck (2006, 2) begins his argument that the human condition itself has become cosmopolitan by invoking the notion of how "the whole of humanity" is "participating simultaneously through the mass media" in global domestic politics. Likewise, Silverstone (2007) initiates his discussion on a civic, moral space that traverses national boundaries by discussing the capacity of a BBC Radio 4 programme to promote a sense of proximity to those who are distant to us. For Chouliaraki (2013, 138), in turn, the news "fully participates in the humanitarian imaginary" because it provides the stage upon which we encounter global injustices and suffering. In these accounts, journalists are not studied empirically, but are nonetheless assumed to play key roles in the transformative process in which people become entangled in "glocal" affairs—what Beck refers to as "cosmopolitanization" (Beck 2006).

Alongside a lack of empirical insight, normative calls for a journalistic professional ethics constituted with the purpose of promoting global openness and reflexivity have gained in appeal (Berglez 2008; Ward 2010, 2011a). During the last decade, media theorists have been drawing the contours of a cosmopolitan vision for contemporary journalism. A global journalism, it is argued, is "the journalism needed in times of globalization" (Berglez 2008, 855). Accordingly, journalism should make routine the need to investigate how "different parts of the world are interrelated" (847). Journalism should frame events not from a nationalist, but from a "global outlook" (847). Ward (2011b, 741) takes a similar point of departure when he argues that the professional ethics guiding the conduct of journalism have been too parochial. In times of global interconnection, when the news media and the practice of journalism increasingly traverse national boundaries, journalism should become "global-minded" (Ward 2005, 4; see also Ward and Wasserman 2014). A global media ethics proposes, therefore, that journalists should

a.  Act as global agents (in seeing themselves as agents of a global public sphere, creating a well-informed and diverse global "info-sphere");
b.  Serve citizens of the world rather than local audiences; and
c.  Promote non-parochial understandings (Ward 2010, 162; see also Ward 2005).

Ward's (2010, 237) call is a normative one with hopes that a constellation of academics, journalists and citizens can be "sowing the seeds" for a global journalism. Hafez (2009, 2011) has critiqued such notions by emphasizing the tendency of local or national journalistic frameworks to prevail in practice. The question regarding the extent to which global journalism is gaining ground in the practices of journalists remains, however, an empirical one.

Empirical research in the area has largely kept to the study of the content of various news outputs. Van Leuven and Berglez (2015, 2–3) reveal that there are studies suggesting that news content increasingly has a global outlook on events, and others which imply that domestic framing remains paradigmatic. The study of news outputs is also the analytical focus underpinning the notion of the journalist as a "worker of the imagination" that might enforce a mediated cosmopolitanism (Robertson 2010; see also Chouliaraki 2013). While it is important to study the end product of journalistic work, we endorse another approach. A closer look at journalists' views on their workday and their normative visions on their profession, which is the focus here, provides the possibility to explain not only how widespread the practice of global journalism might be, but also its prospects to gain ground within different loci in the "journalistic field" (Bourdieu 2005). We look thus to provide the "less media-centric perspective" on global journalism that Reese (2010, 348) has argued for.

The number of studies that have turned to journalists themselves in order to understand the extent to which they embody the ideal of the "worker of the imagination" is rather scarce. They include Dencik's (2013) study of BBC World. Her conclusion is that the "global" television channel is steeped in a domestic order "dictated by political elites within certain nation-states" (2013, 132). Clausen's (2004) interview study with Japanese television journalists and Baysha and Calabrese's (2014) study of Ukrainian journalists reveals a resistance both to identifying with a global community, and to framing events according to a global outlook. Both studies point to how news tends to be "domesticated"—a point originally emphasized by Gurevitch, Levy, and Roe (1991). This implies that even when the

events covered are global in scope they are shaped "in ways that make them comprehensible and palatable for domestic audiences" (214).

As for global journalism, the gap between normative visions of media scholars and the actual practices and outlooks of journalists seems rather wide. Heikkilä and Kunelius (2009) illuminates the picture further by illustrating that when something that resembles a global journalism exists, it is located in particular positions within the journalistic field (cf. Bourdieu 2005). Journalists who frame events in a transnational perspective, and work to connect audiences with a European public sphere, are those who specialize in European Union affairs and work for quality newspapers, particularly those in strong member states such as France and Germany (Heikkilä and Kunelius 2009). This not only shows that global journalistic practice is rare but highlights the importance of taking into account the structural and organizational factors when seeking to identify such practices. The foreign correspondent might come closest in representing a global journalism (Hannerz 2007). For most journalists, however, the idea of covering global events from a transnational point of view while having "citizens of the world" rather than local audiences in mind might, at best, seem a bit aloof. In what follows, we seek to build upon the lines of research that have sought to understand the extent to which cosmopolitan or global elements come to be part of everyday journalistic practices, and how such practices are dispersed across the journalistic field. Additionally, we seek to uncover the extent to which journalists agree with the principles of global journalism on a normative level.

The arguments surrounding a cosmopolitan or global journalism have been normative rather than descriptive. We believe, however, that any proposed media ethics that "would require a redefinition of the ultimate aims of journalism" (Ward 2011a, 223)—that is, expected to emerge "organically" in journalistic practice (Ward 2010)—deserves to be raised as an empirical question. Such an inquiry should take into account the perspectives and practices of practitioners—the journalistic *doxa* (Bourdieu 2005). Relatedly, there is also the question of under which conditions and constraints journalism exists. An abundance of previous research illustrates that ownership, workplace hierarchies and organization, peer pressure, information subsidies, audience and advertising considerations, amongst many other things, influence what stories are told and how (Shoemaker and Reese 1996; Schudson 2003). Hence, there might exist a gap between journalists' normative (global) outlook and their practice since they are neither fully autonomous nor completely isolated individuals.

For those reasons, the following two research questions are posed:

**RQ1:** To what extent do Swedish journalists identify their work as global journalism?

**RQ2:** To what extent do Swedish journalists agree with the normative principles of global journalism?

The first two research questions will establish whether there is a gap between normative outlook and everyday practice. The final and third research question will inform the extent to which global journalistic ideals and practices depend on position in the journalistic field:

**RQ3:** Where in the journalistic field are global journalistic ideals and practices situated?

## Method and Material

This study uses data from the Journalist Panel organized by Gothenburg University in co-operation with the Laboratory of Opinion Research (LORE). It is a Web panel consisting of 1757 journalists, with the aim of understanding how Swedish journalists view themselves, society, their profession and the media sector. The panel defines a journalist as someone who has a permanent position or work as a freelancer, working with the production, selection, evaluation or editorial reworking of media material within a Swedish media organization, or one that operates in Sweden. Tests of representativeness show satisfactory correspondence with the Swedish Union of Journalists. The sample is, however, slightly skewed towards permanently employed journalists and journalists working within the daily press and broadcast (whereas the popular press and other magazines are somewhat underrepresented) and the results have to be read with this in mind.

Small surveys with the panel are carried out two or three times per year. This study draws upon one such survey (JP8) that was in the field between 28 May and 16 June 2015. The answering rate was 32 per cent ($N = 571$).

In order to understand the extent to which Swedish journalists define their work according to the principles of a global journalism, and the extent to which they commend to these principles on a normative level, we constructed two variable batteries. The attempt is thus to translate the "philosophical foundations for a global media ethics" and "global" or "cosmopolitan" journalism (Ward 2005, 2010; Berglez 2008) into questions and statements for the journalists to respond to. As discussed in the previous section, global journalism involves working with global or transnational issues, connecting audiences to a global public sphere and promoting non-parochial understandings. In order to capture such practices we pose the following question: "some suggest that journalism has become more internationally oriented. Others suggest the opposite. What about your case? To what extent is your workday characterized by ... ". The question is followed by 13 different items measuring local, regional, national and global journalistic work (e.g. " ... contact with citizens in other countries?"). In order to capture the journalists' normative orientations we ask: "Below you will find a number of statements regarding journalism in Sweden. To what extent do you agree with them? 'Swedish journalism should ... '". This question is followed by 15 items (e.g. " ... connect its audience to the world as a whole").

Lastly, in order to locate global journalism practice and visions in the journalistic field we used the following variables: gender, age (years), journalist education, work experience (number of years working as journalist), class (upbringing), position in organization (e.g. "reporter" and "no executive responsibilities"), type of media organization (e.g. "local newspaper"), type of employment (e.g. "freelancer"), geographical location (e.g. Stockholm/Gothenburg/Malmö, which we henceforth refer to as "big city"), type of work (the kind of topics one covers, and the media with which one primarily works), geographical reach of the media organization (e.g. "national"), ownership and political orientation (favourite political party). We draw upon Bourdieu's (2005) notion of "the journalistic field" in order to account for the various "objective" positions that a journalist might occupy, and the potential differences these may generate in terms of "subjective" orientations and practices (in this case journalists' views of global journalism).

## Results

In this section, we attend to the question of the extent to which Swedish journalists claim to be working according to the principles of global journalism (RQ1). Additionally, we turn to the extent they support global journalism as a normative vision (RQ2). Finally, we address the question of where global journalistic practices and visions exist in the Swedish journalistic field (RQ3).

Turning to the first research question, the self-reported workday of a Swedish journalist does not fit with what scholars have described as "global" or "cosmopolitan" journalism (Berglez 2008; Ward 2010, 2011a). The mean values in all items measuring the extent to which journalists work according to the principles of a global journalism indicate that they do so to a "low extent" (Table 1).

It is possible, however, that journalists share the normative presuppositions of media scholars (Berglez 2008; Ward 2010) and do believe that journalism *should* be more globally oriented. Table 2 shows that this is the case. The relatively high mean values suggest that the journalists share the vision that their profession should become better attuned to what is going on in the world, and that it should be better at connecting its audience to that world.

While they indeed believe that their professional field should be better accustomed to the rest of the world in a number of ways (as seen above), their domestic bias seems to prevail in at least three ways. Firstly, when it comes to the geographical areas (ranging from the Swedish countryside to the world) they think journalism should be better updated about, we see that local community is favoured. According to the journalists themselves, Swedish journalism should first and foremost become better updated about events in Sweden (and its countryside) (Figure 1). Secondly, and expanding upon this, journalists believe that they should primarily connect its audience to a local, and national, social body rather than the European Union and the world as a whole (Figure 2). This should be read in contrast to Ward's (2011a, 223) "cosmopolitan journalist" who sees herself as an agent of a "global public sphere" rather than a "local agent". Swedish journalists indicate that they are at the same time local and cosmopolitan in their normative visions. Turning, thirdly, to the geographical areas covered during an actual workday, we see that European and global issues are much less favoured than local and national issues (Figure 3).

**TABLE 1**
Global journalism in everyday practice

| "Some suggest that journalism has become more internationally oriented. Others suggest the opposite. What about your case? To what extent is your workday characterized by …" | Mean[a] |
| --- | --- |
| … contact with journalists in other countries? | 1.42 |
| … contact with politicians in other countries? | 1.25 |
| … contact with citizens of other countries? | 1.52 |
| … efforts to endorse cultural diversity? | 2.40 |
| … efforts to provide empathic perspectives of people in other countries? | 2.18 |
| … consuming news from other countries? | 2.83 |
| … work with European Union issues? | 2.32 |
| … work with global issues? | 2.15 |
| Summarized index (Cronbach's alpha = 0.83) | 2.00 |

[a]1 = "to a very low extent"; 2 = "to a low extent"; 3 = "neither low or high"; 4 = "to a high extent"; 5 = "to a very high extent".

**TABLE 2**
Global journalism as a normative vision

| "Below you will find a number of statements regarding journalism in Sweden. To what extent do you agree with them? 'Swedish journalism should … '" | Mean[a] |
| --- | --- |
| … connect its audience to the European Union | 3.28 |
| … connect its audience to the world as a whole | 3.40 |
| … be better updated on European Union issues | 4.11 |
| … be better updated on issues in the rest of the world | 4.14 |
| … become better at giving priority to events from outside Sweden | 3.35 |
| … provide emphatic perspectives of people in other countries | 3.84 |
| … report on foreign affairs with the same depth as domestic affairs | 3.19 |
| … promote cultural diversity | 4.00 |
| Summarized index (Cronbach's alpha = 0.85) | 3.75 |

[a]1 = "do not agree at all" to 5 = "fully agree".

So far, we have identified a norm/practice gap when it comes to global journalism. A domestic focus dominates everyday journalistic practice; and while journalists would like to see their profession "globalized", they are even more inclined to wish for it to become better at reporting on local issues. We turn now to our third research question, regarding the position of global journalistic practices and ideals in the journalistic field.

To begin with, a cluster analysis of "global journalistic practice" and "global journalistic norm" explored in Tables 1 and 2 reveals three main groups within this sample of Swedish journalists. The first and largest group (making up 71 per cent of the sample) does not define itself as working according to the principles of a global journalism but they do support them at a normative level. Throughout their workday they do not have much contact with stakeholders in other countries, nor do they feel that they provide in-depth perspectives of events in other countries. On top of this, they work primarily with local issues. Yet they believe journalism should be reversing this, and work towards connecting audiences to the wider world. They are thus *visionaries*.

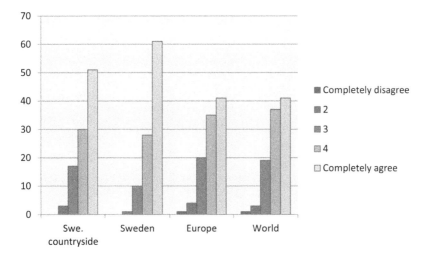

**FIGURE 1**
The geographical areas that the journalists perceive Swedish journalism should be better updated about

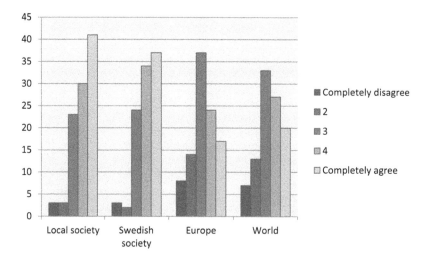

**FIGURE 2**
The geographical areas that the journalists perceive Swedish journalism should connect its public to

The second group consists of the *non-globals*. Similar to the majority of *visionaries*, the *non-globals* do not work according to the principles of a global journalism. The *non-globals*, however, are indifferent in their normative support for the same. This group makes up 22 per cent of the sample. Lastly, we have the *semi-globals* who, like the *visionaries*, share the normative ideals of a global journalism. While not working "globally" on any excessive levels, they do perceive their everyday professional practices to be located somewhere in between the local and the global. This group is small, making up only 8 per cent of the sample (nine individuals).

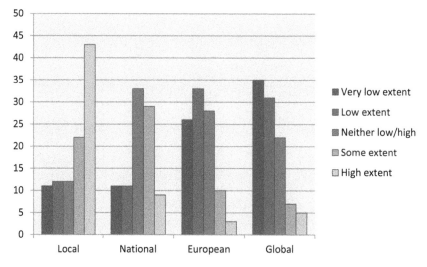

**FIGURE 3**
The geographical areas covered by the journalists on a workday

Table 3 shows the typical position of these three groups in the Swedish journalistic field. The groups have much in common. Like a majority of journalists in Sweden (shown in the column "full sample"), they have university degrees in journalism, and work as permanent employees without executive responsibilities in a privately owned newspaper company. Some things stand out as different. The *semi-globals* are found in the biggest cities, whereas the others are typically located in other cities across the country. Furthermore, in line with the results of previous research (Heikkilä and Kunelius 2009), the *semi-globals* produce "hard news" for media companies with national (or in some cases international) geographical reach. The other groups do not have any defined type of coverage assigned to their desk, and they tend to work towards local, regional or national audiences

**TABLE 3**
The clusters' position in the Swedish journalistic field (two-step cluster analysis and statistical dispersions within clusters; modes, means)

|  | "Visionaries" | "Non-globals" | "Semi-globals" | Full sample |
|---|---|---|---|---|
| Gender | Woman | Man | Woman | Man |
| Age | 50 | 51 | 52 | 52 |
| Education | Formal journalist education | Formal journalist education | Formal journalist education | Formal journalist education |
| Years as journalist | 21 | 22 | 23 | 23 |
| Upbringing (subjective) | White-collar home | Working-class home | Working-class home | White-collar home |
| Position in organization | Reporter | Reporter | Other | Reporter |
| Type of organization | Local newspaper | Local newspaper | Trade press/ freelance | Local newspaper |
| Employment | Permanent employment | Permanent employment | Permanent employment | Permanent employment |
| Geographical location | Town or city | Town or city | Big city | Town or city |
| Working media | Newspaper | Newspaper | Newspaper | Newspaper |
| Coverage | No specified type of coverage | General | – | No specified type of coverage |
| Type of news production | General | General | Hard news/other | General |
| Position | No executive responsibilities | No executive responsibilities | No executive responsibilities | No executive responsibilities |
| Geographical reach | Local | Regional/national | National | National |
| Ownership | Private | Private/mixed | Private | Private |
| Favourite political party | The left party | The left party/The greens/Sweden democrats | The left party/The social democrats/ The greens | The left party |
| Cluster size[a] | 71% (85) | 22% (26) | 8% (9) | 100% (571) |

[a]The percentages of the clusters refer to the *N* of respondents included in the cluster analysis, and not the full sample. The low internal response rate on these summarized indexes is due to the exclusion of respondents who have answered "don't know" on any of the items included. A two-step cluster analysis was conducted with indexes derived from the variable-batteries measuring "global journalistic practice" (alpha = 0.83) and "global journalistic norm" (alpha = 0.85) (see Tables 1 and 2). For this purpose the indexes were re-coded into categorical variables (1 = negative, 2 = neutral, 3 = positive).

—as most journalists tend to do. While the *visionaries* and the *semi-globals* tend to be women, the *non-globals* are men. Additionally, the *non-globals* are the only ones who are not exclusively oriented to the political left (the Sweden democrats [a nationalist/populist party] appear as one of three favourite political parties in this group).

The cluster analysis provides two key findings. First and foremost, the "cosmopolitan journalist" (that is, a journalist who is connected with stakeholders in other countries and works to connect her audience to a global public sphere and who shares the normative presuppositions of a global media ethics) does not exist in any clear embodiment in the present sample. The biggest group—the *visionaries* (71 per cent)—do have cosmopolitan aspirations in their vision of what journalism ought to be, but they are far from realizing this ideal in their everyday work. Secondly, the analysis reveals that one's position in the journalistic field does matter (cf. Heikkilä and Kunelius 2009). Indeed, how can one be a global journalist when one is working for a local daily, writing for an audience about events that take place in their immediate surrounding—a position in which most journalists find themselves?

In effect, a trifling minority producing "hard news" with a relatively wide geographical reach is the only group that can realistically close in on the expectations put forth in discussions on global media ethics. Still, almost 80 per cent of the journalists tend to agree with the ideas of global journalism in principle. Following Ward (2010), one might argue that the rather widespread normative support for global journalism may be "sowing the seeds" for change towards global journalism. However, we must note the divisions within the journalistic field. As we have seen, the field is not a monolith as far as its relation to global journalism goes.

In sum, Swedish journalists tend not to work according to the principles of a global journalism (RQ1) but many of them agree with its normative principles (RQ2). However, the domestic bias, in terms of the direction that journalism should take, tends to be stronger than the global one. Finally, a global journalism demands a certain position in the journalistic field, namely being located in a bigger city and working for a quality newspaper with a national or international reach (RQ3).

## Domestic *Doxa* in the Journalistic Field

Media scholars have argued that we live in a globalized world, and that this world requires journalism to renew itself. It is argued that it should adopt a "global outlook" on events, and to connect audiences to a global public sphere and promote non-parochial understandings (Ward 2005, 2010; Berglez 2008; Ward and Wasserman 2014). This implies a "redefinition of the ultimate aims of journalism" (Ward 2011a, 223). We have here argued that these principles—the principles of a global media ethics—deserve empirical illumination.

The results provide an ambivalent picture. When asking journalists to characterize the work they conduct on an average day it turns out that they are quite far from turning global journalism into more than a set of normative beliefs. Most of them do, however, agree with the idea of global journalism on the normative level. How come most journalists would like to see a "global turn" in their profession yet fail to practise what they preach (or rather, what they wish for their profession)? The answer is to a great extent provided by a social contextualization (here done via the notion of the "journalistic field"; Bourdieu 2005). As long as a majority of journalists work in local/regional/national media organizations with local/

regional/national audiences as their main audience, and as target group for advertisiing, along with other prevalent constraints (Shoemaker and Reese 1996; Schudson 2003), it is difficult to imagine journalists to "refuse to define themselves as attached to factions, regions, or even countries" (Ward 2010, 162). Thus, the findings in this study suggest that most (Swedish) journalists already are global journalists—on the attitudinal level. Indeed, a large majority of journalists do envision a journalism for a globalizing world—a world in which the democratic function of journalism would extend beyond the nation-state. If it was solely up to journalists, journalism would already be connecting local citizens to a transnational political community. Yet, this set of beliefs does not seem to guide their practice. Consequently, explanatory weight regarding the (non-)existence of a global journalism should not be put on individual journalists and their normative outlooks. A global turn in journalistic practice is, as indicated by the findings in this study, not likely to emerge from individual attitudes of journalists, but rather in interplay between journalists, media organizations and their stakeholders—including the public. While one may be optimistic in the face of the widespread professional support for global journalism, one should keep in mind that journalistic practice is embedded in a number of relatively stable social structures that may prevent change.

Admittedly, this study has its limitations. Firstly, it focuses only on journalists working within the traditional, national mass media. It should be noted, however, that previous research has failed to identify a global outlook even in the global newsrooms (Gurevitch, Levy, and Roe 1991; Clausen 2004; Dencik 2013). A focus on global journalism in new media could prove interesting for future studies. Secondly, the survey used has a low answer frequency (32 per cent) and the subsequent analyses of summarized indexes are limited by low internal response rates. We can, nonetheless, take the results to be indicative of the structural constraints that in practice constitute real obstacles for anything like a global journalism to prevail in the contemporary media landscape. The taken-for-granted presuppositions of what one as a journalist can do professionally are still confined within the imaginative horizon of "the domestic". In expanding upon Bourdieu's (2005) vocabulary, we have pinpointed a *domestically biased doxa* in the field of journalism that is not overthrown in the near future.

## DISCLOSURE STATEMENT

No potential conflict of interest was reported by the authors.

## REFERENCES

Baysha, Olga, and Andrew Calabrese. 2014. "Cosmopolitan Vision, Global Responsibility and Local Reporting in Ukraine." In *Media and Cosmopolitanism*, edited by Aybige Yilmaz, Ruxandra Trandafoiu, & Aris Mousoutzanis, 207–226. Oxford, Bern, Berlin, Bruxelles, Frankfurt am Main, New York, Wien: Peter Lang.

Beck, Ulrich. 2006. *Cosmopolitan Vision*. Cambridge: Polity.

Berglez, Peter. 2008. "What is Global Journalism?" *Journalism Studies* 9 (6): 845–858.

Bourdieu, Pierre. 2005. "The Political Field, the Social Field, and the Journalistic Field." In *Bourdieu and the Journalistic Field*, edited by Rodney Benson & Eric Neveu, 29–47. Cambridge: Polity.

Chouliaraki, Lilie. 2013. *The Ironic Spectator: Solidarity in the Age of Post-Humanitarianism*. Cambridge: Polity.

Clausen, Lisbeth. 2004. "Localizing the Global: 'Domestication' Processes in International News Production." *Media, Culture & Society* 26(1):25–44.

Dencik, Lina. 2013. "What Global Citizens and Whose Global Moral Order? Defining the Global at BBC World." *Global Media and Communication* 9 (2): 119–134.

Gurevitch, Michael, Mark R. Levy, and Itzhak Roe. 1991. "The Global Newsroom: Convergences and Diversities in the Globalization of Television News". In *Communication and Citizenship: Journalism and the Public Sphere in the New Media Age*, edited by Peter Dahlgren & Colin Sparks, 195–216. London, New York: Routledge.

Hafez, Kai. 2009. "Let's Improve Global Journalism!" *Journalism* 10 (3): 329–331.

Hafez, Kai. 2011. "Global Journalism for Global Governance: Theoretical Visions, Practical Constraints." *Journalism* 12 (4): 483–496.

Hannerz, Ulf. 2007. "Foreign Correspondents and the Varieties of Cosmopolitanism." *Journal of Ethnic and Migration Studies* 33 (2): 299–311.

Heikkilä, Heikki, and Risto Kunelius. 2009. "Journalists Imagining the European Public Sphere: Professional Discourses about the EU News Practices in Ten Countries." *Javnost–-The Public: Journal of the European Institute for Communication and Culture* 13 (4): 63–79.

Reese, Stephen D. 2010. "Journalism and Globalization." *Sociology Compass* 4 (6): 344–353.

Robertson, Alexa. 2010. *Mediated Cosmopolitanism: The World of Television News*. Cambridge: Polity.

Schudson, Michael. 2003. *The Sociology of News*. New York: Norton.

Shoemaker, Pamela J., and Stephen D. Reese. 1996. *Mediating the Message: Theories of Influences on Mass Media Content*. White Plains: Longman.

Silverstone, Roger. 2007. *Media and Morality: On the Rise of the Mediapolis*. Cambridge: Polity.

Van Leuven, Sarah, & Peter Berglez. 2015. "Global Journalism: Between Dream and Reality". *Journalism Studies*, 1–17. doi:10.1080/1461670X.2015.1017596.

Ward, Stephen. 2005. ""The Philosophical Foundations for Global Journalism Ethics"." *Journal of Mass Media Ethics: Exploring Questions of Media Morality* 20 (1): 3–21.

Ward, Stephen. 2010. *Global Journalism Ethics*. Montreal & Kingston, London, Ithaca: McGill-Queen's University Press.

Ward, Stephen. 2011a. "Multidimensional Objectivity for Global Journalism." In *The Handbook of Global Communication and Media Ethics*, edited by Robert S. Fortner & P. Mark Fackler, 215–233. Chichester: Blackwell Publishing Ltd.

Ward, Stephen. 2011b. ""Ethical Flourishing as Aim of Global Media Ethics"." *Journalism Studies* 12 (6): 738–746.

Ward, Stephen, and Herman Wasserman. 2014. "Open Ethics: Toward a Global Media Ethics of Listening." *Journalism Studies* 16: 834–849. doi:10.1080/1461670X.2014.950882.

## ORCID

**Johan Lindell** http://orcid.org/0000-0001-6689-0710
**Michael Karlsson** http://orcid.org/0000-0003-4286-7764

# PARTICIPATION AND THE BLURRING VALUES OF JOURNALISM

Jaana Hujanen

*This paper examines journalism's values and ethical principles by analysing how participation is becoming a part of the journalism culture in Finnish news media. The focus is on journalists' perceptions of the roles and practices of professional journalists and the audience in journalism practice. Of special interest is how the modern ideals of journalism affect its reinvention. The conceptual framework relies on theorizing journalistic ideals and critical discourse analysis. The data consist of in-depth interviews with journalists conducted from 2010 to 2011 and 2013 to 2015 in Finnish media. The data are approached using analysis of the discourses as a method. The discourses of professional news production, citizen debate and interactive news "produsing" are analysed. In the first discourse, professional skill is valued highly and connected to the experience of pursuing journalism, which follows the modern ideal of "good" journalism. A demarcation is constructed between professionals and amateurs, and between journalism and "non-journalism". In the second discourse, the participation of the audience is associated with discussion forums and is represented as a needed but problematic conversational recourse. Within the third discourse, journalism's ideals are reinvented. Emerging news media is portrayed as semi-social media with changing ethical principles. News making is portrayed as a collaborative practice between the newsroom and a community of local reporters and volunteers. Discursive boundaries between "user comment" and "editorial material" are fading. The evolution of the discourses indicates a nascent re-articulation of journalism's values, including the logic of control, in Finnish journalism practice.*

## Introduction

News media rely increasingly on citizen journalism and have become dependent on user-generated visibility. These processes mix the relationships between professional journalists and the former audience. The blurring of the practices of producing and using journalism also enhance the reinvention of the occupational ethos of journalism: the values defining journalism and constructing boundaries between journalism and non-journalism. Participatory communication culture makes changes in the values of journalism likely. The journalistic norms and practices connected to the ideal participation are, in many ways, opposite to those of modern journalism. They challenge the socio-cultural rationale for professional control over content creation, filtering and distribution (Deuze 2007, 142–170; Ryfe 2009; Witschge 2012).

The objectivity norm has claimed that journalists are impartial, neutral, fair and credible providers of information (Deuze 2005, 446–447). Journalists are truth-seeking professionals, aiming at factual, accurate, balanced and fair reporting (Tuchman 1978). Ethics refers to the idea of journalists having a specific sense of ethics, validity and legitimacy.

The high modern ideal of autonomy refers to a dispassionate and impersonal journalist with an outsider and matter-of-fact perspective. Autonomy presupposes that journalism is independent of economic, political or other efforts of influence. In contrast, participation refers to news as a shared and collaborative practice, and to journalists who listen to and reflect a variety of voices, avoid monology, and stimulate discussion and engagement (Soffer 2009, 474, 487–488).

The research so far has revealed an unresolved interplay between professional control and open participation. While journalists have perceived contact with the audience as being good, they have found participatory culture to be unsettling to the professional paradigm of journalism (Singer 2007; Heinonen 2011). Professional journalists' gatekeeping position vis-à-vis citizen journalists has been reinforced (Singer 2007, 2010; Domingo et al. 2008; Thurman 2008; Soffer 2009; Lewis, Kaufhold, and Lasorsa 2010). The majority of journalists have not regarded citizens' contributions as "proper" journalism, and newsrooms have co-opted participatory practices to suit traditional routines (Wardle and Williams 2010; Örnebring 2013).

However, journalism's ideological commitment to control may be giving way to the hybrid logic of adaptability and openness: a willingness to see audiences on a peer level, to appreciate their contributions, and to find the normative purpose for journalism in transparency and participation (Andén-Papadopoulos and Pantti 2013; Hujanen 2013; Singer 2014). Lewis (2012, 852) challenges researchers to track the contours of the nascent boundary work: how, where and why does the professional logic of control become rearticulated in relation to the participatory logic?

This article examines the evolution of journalism's values and ethical principles, and analyses how participation is becoming a journalism culture in Finnish news media. The focus is on newspaper journalists' perceptions of the roles and practices of professional journalists and audience/users in journalism. The article examines the blurring of the values of journalism and journalists' ethos against the high modern ideals of journalism (Deuze 2005). Of special interest is how objectivity, autonomy and ethics of journalism are made sense of and reinvented.

## The Study in Context

Newspapers face challenges that call for a re-evaluation of the professional ethos and culture of journalism. Since the beginning of the 1990s, Finnish newspapers have underlined audience-oriented policy. News criteria have veered from social importance and public interest to human interest (Hujanen 2008, 2009; Pantti 2009). Dailies have also had projects inspired by public journalism to perceive their audiences as citizens who compose *publics* and possess legitimacy to participate in the political processes (Ahva 2010). Kantola (2013) describes the change as a development from high modern journalism towards liquid journalism. A liquid modern journalist is flexible, producing content that appeals both to common sense and to emotions, combining the tasks of information transmission, telling stories, raising discussion and entertaining. In media companies' strategy, the notion of "audience participation" has become a key ingredient.

I have conducted 26 in-depth interviews with journalists from *Etelä-Suomen Sanomat, Helsingin Sanomat, Metro* and *Savon Sanomat*. Besides the printed paper, their content can be read on the internet and on mobile platforms. *Etelä-Suomen Sanomat* and *Savon Sanomat* are regional dailies with circulations of between 49,558 and 52,934

(Levikintarkastus 2014). *Helsingin Sanomat* has a circulation of 331,551 and is the leading paper in Finland. Even though it has lost subscribers, it has active development work going on. The business of the dailies has been profitable in past years but has sunken rapidly due to lower income from subscriptions and advertising, and problems in achieving gains in digital revenue. *Metro* is a free paper published five times a week in Helsinki, with a print run of 140,000.

The first set of interviews was gathered from 2010 to 2011. The second interview data were gathered from 2013 to 2015 in the situation of accelerating technological change, economic pressures, changes in people's media uses and media houses' development of journalism. The data-set includes interviews with (1) personnel dealing with innovation and development work; (2) news management; (3) producers; and (4) journalists. Managerial and development levels shed light on the objectives of change projects while journalists shed light on the everyday work. Only one interview was conducted by telephone; the rest were conducted face-to-face.

A written questionnaire structured the interviews. The themes covered interaction between journalists and readers, and journalists' perceptions about their own role and that of the "audience" in news production. The interviews, lasting about one hour each, were taped and transcribed. Participants were requested to give their informed consent and were accorded all due respect, including their anonymity.

Critical discourse analysis (CDA) deals with the social conditions and consequences of language use (Fairclough and Wodak 1997; Wodak 2001). Discourse is defined as language use as social practice and is considered to be a part of the construction of professionalism (Fairclough 1992, 62–65; Fairclough and Wodak 1997, 258–259). CDA emphasizes the need to study language use as an inherently social phenomenon within specific historical, cultural and interactional contexts. This means that the reinvention of the ideal and practice of journalism is seen as a local, historical and discursive process.

Journalistic values and practices, from the perspective of CDA, are constructed by drawing on discourses that have prior significations and that are socially available and possible in a particular context. I assume that journalists resort to powerful discourses about "good" journalism; journalists are constrained by these discourses but they also have options in creating, choosing and modifying them. I assume the modern ideals of journalism are present when Finnish journalists imagine new tasks and roles for themselves and for readers.

Within the context of this article, "discourse" refers to the different perspectives representing journalism, its values and its practices. Thus, the discourses occurring in the interviews are regarded as means of representing journalistic values and practices from particular perspectives, and it is assumed that they offer particular roles and tasks for journalists and readers. I have named these: (1) the discourse of professional news production, (2) the discourse of citizen debate; and (3) the discourse of interactive news "produsing".

## The Discourse of Professional News Production

For the data gathered in 2010, the discourse of professional news production occupies a hegemonic position. This perspective can be called the discourse of professional news production, because within it, a strong demand for professionally produced journalism is constructed. It suggests that professional skill is a part of "proper" journalism, and that a professional journalist is able to do a better job than the reader. Professional skill is

defined as knowledge and experience of the values and ethical principles of journalism. The command of principles of journalism is thus represented as a qualification required of the journalism profession even though journalism in Finland lacks many trappings of a classical profession (each quote shown is from the interview answers given in response to the questionnaire):

> If the newspaper thinks that this is the cheap way to produce content and that we take [content] for free from random writers and we replace the professional journalists with them, then it's clearly a threat; it threatens all general principles of journalism and professional production. I have always compared this to the doctor's occupation. If we need a doctor then we, of course, go to see a professional, not to any uneducated quack doctor. This shows well the difference between a professional journalist and whoever. Now the prevalent illusion is that "whoever" could sit down and write, but good journalism isn't done with fantasy or from one's own head, sitting and writing whatever comes to mind.

In the discourse, readers are called "audience", "readers", "citizens" or "anyone". Journalism produced by "non-professionals" is thought to threaten the quality of the journalism:

> Well, yes, if it [readers' participation] goes too far it is a [threat]. Especially if the same principles [that] journalists follow, aren't followed. At worst, this could take away the credibility, which is the most important for the existence of the newspaper.

An emerging representation questions a reader's skill, experience, knowledge and expertise: a reader is "an average reader", "an unexperienced person", "a random writer" who lacks the capability to produce journalism. Within the discourse, readers write their "own stuff", often on an impulse and out of imagination. There is hardly any reference to competent readership but there is to incompetent, indefinite and loud readership. Moreover, personal experience and local content lack general interest and social significance:

> Of course it [reader participation] can be [a threat] because there is always the risk that it leads to that … journalism will become even more superficial and that only inapplicabilities and quasi problems will come to the top. Then we forget the real problems that might be developing in Finnish society as well … I think it's wrong, if we think about the most basic task of journalism, as I see it myself, as the watchdog of the power, and as defender of democracy and as protector of fair access to information.

Within this discourse, a reader must be able to separate the content produced by the newsroom. Reader participation is limited to specific sections like letters-to-the-editor and youth pages. In this way, the discourse illustrates the boundary work between "journalism" and "non-journalism":

> I think it is quite arguable that journalists are professionals and the readers are readers, that they still have an active letters-to-the-editor section. Readers' articles are maybe not needed on other pages or sections, except for these young people's articles that are quite good … I think the reader should be able to distinguish what is journalistic content produced by the editorial staff and what is something else.

"Proper" journalism relies in the discourse on the "basic principles of journalism", which are connected to the high modern ideals of actuality, objectivity, public service, autonomy and ethics (Deuze 2005). There emerges a newspaper institution that thinks

through the code of journalism's ethics. As perceived in the discourse, "occasional writers" are not aware of their ethical and judicial responsibility. The interviewees used the term "objectivity" only seldom, but made suggestions about it. The audience's right to fair information and the journalist's obligation to diverse and independent points of view refer to the value of balanced journalism. In the discourse, "good" and professional journalism is thus defined as non-subjective.

Autonomy is also represented as a cornerstone of professional journalism. Professionalism is portrayed as autonomy from outside forces. Professional journalist's identity as an independent actor is stressed in relation to readers: "Exchanging ideas [with readers] does not harm, but a professional journalist should realize her/his own identity ... to stay an independent author". A restricted role is constructed for the participating readers as professional journalists are portrayed as gatekeepers, and readers are assigned an assisting role under the profession's control: "[As a] last resort, the journalistic right of decision and the fulfilment of stories is up to the editors; it can't be left to the citizens. And it can neither be left to any other quarter". In this discourse, journalism is not made with but for the readers. The authorship of journalism belongs to journalists:

> That the readers would start doing our newspaper ... that I find strange. I think it would be better if we did the paper for the readers ... If the content produced by readers increases, then the content produced by journalists decreases. Whose paper is it then, if we now talk about a newspaper?

## The Discourse of Citizen Debate

With regard to the evolution of journalism from the viewpoint of reader participation, the discourse of citizen debate indicates how journalistic values have been undergoing reinvention, with new practices negotiated for audiences and citizens. I have named this perspective the discourse of citizen debate in order to illustrate that within it, readers are seen as playing a role in the making of newspapers.

However, as the name of the discourse indicates, content produced by other than professional journalists is not perceived as journalism or even as public/civic journalism but as "citizens' debate", "public discussion" and "communality". The discourse thus contributes to the emerging boundary between journalism and non-journalism and can be seen as a sub-discourse to professional news making: "It isn't journalism any more if we go on to accepting that readers can churn out whatever they like, just like Facebook things, more connected to communities; it's not journalism, it's another thing".

Citizens' debates are portrayed as richness of democracy and multivoicing public discussion: they bring people's voices and faces into the public sphere, and strengthen freedom of expression. However, citizens' debate cannot proceed without journalistic control. Here, the discourse of professional news making intertwines with that of citizen debate: journalists' ethical code of practice is represented as a requirement for debate. Citizens' debate thus has the potential for democracy, but journalists voice reservations regarding its representativeness: "Damned elite, those of who were in the local paper, *Aamulehti*, that wasn't any democratic voice. It was a particular voice of an activist group that you could hear in fact ... " The need to follow journalists' code of practice also stems from the problems that people's voices are thought to generate. In the discourse, the use of raunchy language and pseudonyms, populism and extreme opinions make the debate

dynamite. The assumed problems generate a need for moderation, and participation becomes a time-consuming and expensive practice.

## The Discourse of Interactive News "Produsing"

Within the discourse of interactive news "produsing", journalism is perceived as a collaborative practice involving both professional journalists and readers. It is seen as a process in which the input and practices of both partners intertwine. Because within this perspective on journalism the practices of *producing* and *using* mix, it is called the discourse of interactive news "produsing". As a result, some of the old assumptions about divisions between user material and editorial material are fading.

The discourse started to emerge in 2013 and illustrates a change in journalists' occupational ethos. Interactive practices are represented as a focus of innovation. Digitalization, social media and mobile platforms explain the strengthening of the discourse. The notion of journalism's authorship is represented broadly and the practice of gatekeeping is renegotiated: readers are allowed to participate in the making and distributing of journalism, by providing material, ideas and contacts, comments and sharing journalism produced by professional journalists with other readers:

> Traditionally in the editorial office we have been thinking that the journalist is a gatekeeper who guards what is good or what is bad, what is interesting and what is less interesting. I would say that, of course, you have to face new challenges; that we maybe change the former gatekeeper role in a direction that accepts that there is material coming from other places and partners as well, from the readers.

Participating readers were called "helpers", "volunteers" and "a community of local reporters" who provided an additional workforce to pursue better journalism. A community of reporters is allowed to share practices that used to belong to professional journalists only. Some news media studied had developed an application to give journalistic tasks to local reporters. Newsrooms also had a practice of inviting readers to join a Facebook conversation, moderated by the news media.

However, discursive demarcation between the logic and practice of professional journalism and social media is still being reconstructed. What separates the two sides is the ethical code of journalism. It requires professional journalists to separate facts and opinions and strive for non-biased presentation. Because of this, the difference between "professionally produced journalism" and "citizen journalism" is reconstructed and ideas from readers are perceived as stimuli, which are developed further, or as material that is verified and complemented.

Unlike in the previously mentioned discourses, reader engagement is represented as professional news media's answer to change in communication culture: people expect that they can have an active role in the making of media. Despite the economic reasons behind reader engagement, which are portrayed as less important, the material produced by the readers has news value especially for a free paper like *Metro*, which has a small staff and is oriented towards local events.

> *Metro* has done reader engagement in a great way. There is a community of reporters, 150 people, to whom you can give various tasks. They even have an application with which you can send a request if you want ... "Hi, we would like to get pictures of coltsfoots".

> You get hundreds of pictures from there. They [reader-reporters] are really enthusiastic. We have 30 volunteers in Vantaa. If we send them a message that there is a big local factory building on fire and could someone go and take a picture with a mobile phone, there is always a couple of those who leave right away.

Reader engagement is also represented in the discourse as a tool for collaborative information gathering and crowdsourcing. *Helsingin Sanomat* has experienced crowdsourcing, and has asked readers to contribute to investigative journalism. Engagement is also connected to customer relationships. Reader participation was seen as important to *Metro* because readers normally do not commit themselves to free papers. For a leading newspaper, reader engagement represents a tool to bind people to the paper as subscribers and fight against becoming a newspaper of the elite only.

> When making the paper we have to listen to citizens and pay attention to them. I think it [participation] enhances readers' loyalty to the paper … People are more committed to our brand and they feel that *Helsigin Sanomat* is maybe not that elitist but more human and down to earth. The fear is that [if] the number of paying customers diminishes, *Helsingin Sanomat* becomes elitist in the end—a paper of a small group—and this is one of the biggest fears we want to avoid.

When readers have a role in the making of journalism, the demarcation between news media and social media becomes blurred. Journalists from *Metro* described their paper as a semi-social form of media, which has characteristics of both social media and traditional news media:

> Well, *Metro* has been called as semi-social media, it has characteristics of social media, the group of reader-reporters is like a community, they remember our phone number or that *Metro* publishes their pictures, but still there is the professional newsroom, on the other side.

Being a semi-social form of media means that professional journalists see their task as being available to readers, to listen to them and to communicate with them. In the emerging discourse, journalists position themselves within and among the audience. The new roles and practices of the audience also affect how the ideals of public service and autonomy are renegotiated. Relevance for the readers and popularity among them have become criteria in the evaluation of quality. The newsrooms have developed an index to measure which stories are clicked, how much time is spent reading them and if they are shared, illustrating how quality is redefined by the value the stories have in an online context.

Moreover, within this discourse, professional journalism is seen as being dependent on how it is consumed and promoted in social media. Whether the stories produced by professional journalists are clicked, liked, linked and shared is seen as vital for professional news media. Instead of being the target group and users, readers act as secondary gatekeepers and thus produce journalism. This is a profound change to the logic of autonomy; it becomes shared.

## Conclusion

I have examined the evolution of journalism's values and ethical principles, analysing how participation is becoming a part of the professional journalism culture in Finland. I

have analysed the discourses of (1) professional news production; (2) citizen debate; and (3) interactive news "produsing". The partially competing and contradictory discourses show that the values of journalism are evolving.

The first two discourses construct a clear boundary between journalism and non-journalism; between journalism and citizens' debate; and between professionals and amateurs. In this perspective, authorship of journalism belongs to the professionals. Even though there is no formal education requirement for the journalism profession in Finland, expertise and knowledge of the principles of journalism is represented as a qualification to participate in the making of journalism. Following this, content produced in line with the high modern practices is perceived as trustworthy and unbiased, and content produced outside the newsroom in principle is problematic.

In the first two discourses, journalists see it as their task to control the supposed high quality of content (Singer 2005, 2007, 2010; Domingo et al. 2008, 339–340; Thurman 2008; Heinonen 2011). This indicates that the way journalists renegotiate journalistic values reflects the high modern perception of autonomous journalism: a journalist follows the professional code of practice, and is just and independent from outside efforts of influence. A journalist is thus represented as a gatekeeper towards economic and political spheres of influence and citizens.

Soffer (2009, 473–474) argues that objectivity and participation or dialogue belong to distinct journalistic cultures on the basis that it is "hard to believe that they would be integrated on a regular basis". Participation and objectivity, with their distinctive world views, do differ. This study, however, reveals a pattern of integration in the complex relationship of high modern values and the idea of participation. The discourse of professional news making affects how the new roles of the journalists and the public is imagined, but the discourse of professional news making is also challenged by the discourse of interactive news "produsing".

The merging of those values can be seen in the discourse of the citizen debate, which constructs an ideal of moderated conversation or controlled polyphony in journalism (Soffer 2009). To ensure "quality" fact checking, distinguishing between professional and "amateurish" efforts, as well as moderating the discussions, were perceived as central. In the discourse of interactive news "produsing", the values of journalism evolve towards openness and transparency. Journalism is perceived as a collaborative practice between professional journalists and readers; it is a process in which the input of both partners intertwine. Readers are negotiated an assisting role based on the terms of the profession's principles. Even though the logic of control changes, discursive demarcation between the values and practice of professional journalism and social media are reconstructed. What separates the two sides are the values and the ethical code of professional journalists.

The value of objectivity is important for journalists because it helps them to protect themselves against criticism and allegations of manipulation (Schudson 2001, 165). The discursively constructed need for gatekeeping can also be interpreted as a means to maintain their exclusive power of control. Therefore, the requirement of control illustrates how professional power and authority operate (Hermida and Thurman 2008; Schudson and Anderson 2009).

The values of objectivity, actuality and autonomy are also updated to the context of participatory media. Within the third discourse, journalists allow readers a role as local reporters to provide topical information on local events or as experts in assisting with crowdsourcing and investigative journalism. Professional journalism is seen as being

dependent on how it is consumed and shared in social media. As readers get a role as secondary gatekeepers (Singer 2014), autonomy is being reinvented as a shared practice.

## DISCLOSURE STATEMENT

No potential conflict of interest was reported by the author.

## REFERENCES

Ahva, Laura. 2010. *Making News with Citizens. Public Journalism and Professional Reflexivity in Finnish Newspapers*. Tampere: Tampere University Press.

Andén-Papadopoulos, Kari, and Mervi Pantti. 2013. "Re-imagining Crisis Reporting: Professional Ideology of Journalists and Citizen Eyewitness Images." *Journalism* 14 (7): 960–977.

Deuze, Mark. 2005. "What is Journalism? Professional Identity and Ideology of Journalists Reconsidered." *Journalism. Theory, Practice & Criticism* 6 (4): 442–464.

Deuze, Mark. 2007. *Media Work*. Cambridge: Polity.

Domingo, David, Thorsten Quandt, Ari Heinonen, Steve Paulussen, Jane B. Singer, and Marina Vujnovic. 2008. "Participatory Journalism Practices in the Media and Beyond." *Journalism Practice* 2 (3): 326–342.

Fairclough, Norman. 1992. *Discourse and Social Change*. Cambridge: Polity Press.

Fairclough, Norman, and Ruth Wodak. 1997. "Critical Discourse Analysis. An overview." In *Discourse Analysis: A Multidisciplinary Introduction*, edited by Teun A. van Dijk, 258–284. London: Sage.

Heinonen, Ari. 2011. "The Journalist's Relationship with Users: New Dimensions to Conventional Roles." In *Participatory Journalism. Guarding Open Gates at Online Newspapers*, edited by Jane Singer, Alfred Hermida, David Domingo, Ari Heinonen, Steve Paulussen, Thorsten Quandt, Zvi Reich, and Marina Vujnovic, 34–55. Chichester: Wiley–Blackwell.

Hermida, Alfred, and Neil Thurman. 2008. "A Clash of Cultures. The Integration of User-generated Content within Professional Journalistic Frameworks at British Newspaper Websites." *Journalism Practice* 2 (3): 343–356.

Hujanen, Jaana. 2008. "RISC Monitor Audience Rating and its Implication for Journalistic Practice." *Journalism. Theory, Practice, Criticism* 9 (2): 182–199.

Hujanen, Jaana. 2009. "Informing, Entertaining, Empowering. Finnish Press Journalists' (Re)negotiation of their Tasks." *Journalism Practice* 3 (1): 30–45.

Hujanen, Jaana. 2013. "At the Crossroads of Participation and Objectivity. Reinventing Citizen Engagement in the SBS Newsroom." *New Media and Society* 15 (6): 947–962.

Kantola, Anu. 2013. "From Gardeners to Revolutionaries: The Rise of Liquid Ethos in Journalism." *Journalism* 14 (5): 606–626.

Lewis, Seth C. 2012. "The Tension between Professional Control and Open Participation: Journalism and its Boundaries." *Information, Communication & Society* 13 (1): 836–866.

Lewis, Seth C., Kelly Kaufhold, and Dominic L. Lasorsa. 2010. "Thinking about Citizen Journalism." *Journalism Practice* 4 (2): 163–179.

Levikintarkastus 2014. *Kansallinen Mediatutkimus, Levikintarkastus* [National Newspaper Circulation Audit]. Helsinki: MediaAuditFinland Oy.

Örnebring, Henrik. 2013. "Anything You Can Do, I Can Do Better? Professional Journalists on Citizen Journalism in Six European Countries." *The International Communication Gazette* 75 (1): 35–53.

Pantti, Mervi. 2009. "Tunteellisempaa journalismia [More emotional journalism]." In *Journalismi murroksessa* [Changing Journalism], edited by Esa Väliverronen, 193–206. Helsinki: Gaudeamus.

Ryfe, David. 2009. "Structure, Agency and Change in an American Newsroom." *Journalism* 10 (5): 665–683.

Schudson, Michael. 2001. "The Objectivity Norm in American Journalism." *Journalism. Theory, Practice & Criticism* 2 (2): 149–170.

Schudson, Michael, and Chris Anderson. 2009. "Objectivity, Professionalism, and Truth Seeking in Journalism." In *The Handbook of Journalism Studies*, edited by Karin Wahl-Jorgensen and Thomas Hanitzsch, 88–101. New York: Routledge.

Singer, Jane B. 2005. "The Political J-blogger. Normalizing' a New Media Form to Fit Old Norms and Practices." *Journalism. Theory, Practice & Criticism* 6 (2): 173–198.

Singer, Jane B. 2007. "Contested Autonomy: Professional and Popular Claims on Journalistic Norms." *Journalism Studies* 7 (1): 2–18.

Singer, Jane B. 2010. "Quality Control: Perceived Effects of User-generated Content on Newsroom Norms, Values and Routines." *Journalism Practice* 4 (2): 127–142.

Singer, Jane B. 2014. "User-generated Visibility: Secondary Gatekeeping in a Shared Media Space." *New Media and Society* 16 (1): 55–73.

Soffer, Oren. 2009. "The Competing Ideals of Objectivity and Dialogue in American Journalism." *Journalism. Theory, Practice & Criticism* 10 (4): 473–491.

Thurman, Neil. 2008. "Forums for Citizen Journalists? Adoption of User Generated Content Initiatives by Online News Media." *New Media and Society* 10 (1): 139–157.

Tuchman, Gay. 1978. *Making News – A Study in the Construction of Reality*. New York: The Free Press.

Wardle, Claire, and Andrew Williams. 2010. "Beyond User-Generated Content: A Production Study Examining the Ways in which UGC is Used at the BBC." *Media, Culture & Society* 32 (5): 781–799.

Witschge, Tamara. 2012. "Changing Audiences, Changing Journalism." In *Changing Journalism*, edited by Peter Lee-Wright, Angela Phillips, and Tamara Witschge, 117–134. London: Routledge.

Wodak, Ruth. 2001. "What CDA is about – A Summary of its History, Important Concepts and its Developments." In *Methods of Critical Discourse Analysis*, edited by Ruth Wodak and Michael Meyer, 1–13. London: Sage.

# CORE BLIGHTY? HOW JOURNALISTS DEFINE THEMSELVES THROUGH METAPHOR
## *British Journalism Review* 2011–2014

**Martin Conboy** and **Minyao Tang**

*Journalism has long relied on certain core metaphors in order to express its claims to social and political usefulness. The deployment of metaphors to describe a practice that in contrast asserts its truth-telling and plain prose style is in itself interesting. Since metaphor acts as a powerful indicator of presuppositions it can be used to reify complex public discourses, reducing them to common-sense thinking. This paper explores what metaphors have been used in association with journalism in the pages of the* British Journalism Review *since the closure of the* News of the World. *Do metaphorical articulations of the current role and image of journalism demonstrate an awareness among journalists of changes in its values or do they rather tend to reinforce more traditional attitudes to a practice under threat? Post-Leveson what can the patterning of such figurative language across articles by a wide range of prominent journalists in the United Kingdom tell us about the values and aspirations of journalists in a time when journalism is under intense scrutiny?*

## Introduction

Ambivalence of journalists towards their field of employment is nothing new and can be read, laced within many contemporary accounts (Aldridge and Evetts 2003; Eldridge II 2014). For a recent, striking example we can read Robert Peston, (then) BBC's economics editor, an impressively influential figure within British television and certainly not a social outsider—the son of a life peer, a former stockbroker and graduate of Balliol College, Oxford—as he differentiates himself from genuine expertise in his field:

A bit of history has been made with the disclosure that prices fell 0.1% in April—because the consumer price index has never before dropped since official records began in 1996 ...

So my natural impulse is to say that deflation has arrived in Britain—because there is no other word in the English language than "deflation" to describe this phenomenon.

However many of those who define themselves as "serious economists" (that's not me, by the way—I'm a hack) are desperately anxious that I and you don't use the "d" word. (Peston 2015 )

This piece explores contemporary journalism's values as expressed through metaphors deployed by journalists themselves when reflecting upon their own practices

during a time of widespread debate on the central aims and ambitions of journalism in the wake of the 2012 Leveson Report; the judicial public inquiry into the culture, practices and ethics of the British press following the News International phone-hacking scandal, chaired by Lord Justice Leveson. Exploring these metaphors allows us to consider the language with which journalists' ethical principles and moral standards are being debated in a particular national context (Deuze 2002).

## Enter the *British Journalism Review*

1989 was not a good year for British newspaper journalism. The longer-term consequences of the Wapping Revolution were becoming clear. The invasion of privacy scandals that were to lead to the convening of the Calcutt Enquiry were in full swing. The *Sunday Correspondent* was already showing the signs of flagging that would cause it to fold a little over 12 months after its 1989 launch. The accumulating problems prompted a group of concerned journalists to approach Sage Publications with an idea for a serious journalism quarterly. The *British Journalism Review* was launched. The title echoed the prestigious American publication, the *Columbia Journalism Review*, in publication since 1961. Unlike the *Columbia Journalism Review*, the *British Journalism Review* was not embedded within a particular university in the United Kingdom but rather developed its editorial coherence around a group comprised of academics, publishers and senior journalists. It is certainly not a peer-reviewed journal but nevertheless it is different from the run-of-the-mill trade press. It has combined topicality, brevity and seasoned assessments of a range of issues affecting journalism over almost three decades. Most importantly, and perhaps on account of these very reasons, it provides a relatively spontaneous commentary outside the bounds of normal editorial loyalties from writers who are authoritative within their field and acutely aware of journalism's challenges. The title of its first editorial articulates something of the ambiguity of the journal's role: "Why We Are Here". This refers to the function of the journal but it could, on reflection, equally be posing an existential question about journalism.

In his opening editorial, Goodman as editor expresses the view that: "Our primary aim is to help journalists themselves reflect on the changing character and problems of their job" (Goodman 1989, 2).

That was in 1989.

## Metaphors and Definitions of Journalism

Over a quarter of a century later, this paper will explore the ways in which the journal continues to articulate the role of journalism, focusing specifically on metaphor. Journalism has long depended on certain core metaphors in order to express its claims to social and political usefulness. These include the "Fourth Estate", "watchdog", "muckraker". As if to reinforce this, newspapers themselves have often been given titles that are rich in metaphorical assertion of the same functions such as "Argus", "herald", "leader", "recorder", "sentinel" (Larson 1937) while in the British newspaper world the same pattern has been identified by Jones (1996, 28–46). Embedded within these metaphors, as if to underscore the fact that metaphor is an important aspect of how we structure reality, are commonly shared understandings of what journalists do and what they believe the values of journalism are. At a time of crisis in British journalism post-Leveson, it is salutary to consider what

metaphorical range is being deployed and the extent to which it draws upon or challenges common perceptions of journalistic identity. Perhaps they might also show how new identifications are being created. Unlike Vos (2011), who has focused on one metaphor, that of the mirror in American journalism, this study will explore a wide but interrelating set of metaphors in the contemporary British context. The deployment of metaphors to describe a practice that highlights its truth-telling and plain prose style is in itself interesting and, beyond this, metaphor is a powerful indicator of presuppositions and can be used to reify complex public discourses, supplying them with all the potency of common-sense thinking.

We will argue that the contemporary crisis of journalism is perhaps a definitional crisis even before it is a crisis pertaining to the ethics of journalism or of technology's encroachment on the practices of journalism. We will not go looking for explicit definitions of journalism as some sort of journalistic "credo" but rather seek out subtler patterns expressed through metaphorical associations used by journalists when describing their work.

## Metaphor as Audience Design

Metaphor can be used to explore contemporary British journalists' own sense of identity as it provides a set of tacit assumptions about how journalism functions as well as their own definitions of their practice. To a large extent, the very nature of the *British Journalism Review* lends itself to a relatively spontaneous set of discussions, providing an everyday approach to contemporary issues in journalism. This everyday approach draws unselfconsciously on metaphors in expressing the views of journalists on journalism. Beyond the analytical, in probing the internal discussions among British journalists, we hope to open up a space where these expressions of contemporary journalistic identity might be discussed further with journalists themselves at a later date, enabling the *British Journalism Review* to claim a continuing status as a most productive forum for reflections on the state of journalism in the United Kingdom.

Much analysis of journalists' writing is either analytical of their product (Bell 1991; Fairclough 1995; Van Dijk 1998; Conboy 2007; Richardson 2007) or of the production process and their attendant linguistic patterning (Cotter 2010; Perrin 2013). Despite the fact that journalists often refer to themselves and their professional activities in metaphorical terms—e.g. watchdogs, mirrors, marketplace, cornerstone of democracy, crusaders, window on the world, Fourth Estate (Weaver and Wilhoit 1996; Christians et al. 2009)— little attention has been paid to broader metaphorical representation, apart from Gravengaard (2011) and Vos (2011), and none to our knowledge in a specifically British context. Our approach may not align micro-linguistic analysis directly with news production processes (Catenaccio et al. 2011) but it offers a looser, more spontaneous and even more off-guard set of observations on the relationships expressed between journalists and their practice. Such an approach insists that professional identities are created through discourse.

Our analysis draws upon research inspired by the cognitive linguistic approach introduced by Lakoff and Johnson (1980) which suggests that metaphors, beyond a merely decorative, poetic function, provide a level of shared cultural and social associations which take on the full force of a psychological reality. In terms of professionals talking about their own practice, metaphor therefore gives us an insight into deep but often unspoken assumptions of people associating as a group. As Gravengaard points out for our purposes:

Metaphors are conventionalized, hardly noticed and effortlessly used in the routinized linguistic practice ... In other words, metaphors are not just expressions of how journalists perceive reality, metaphors also play an important role in creating the reality in which they are used—and they affect the actors' perceptions of this reality and the way they act in it. (Gravengaard 2011, 1068)

Such an observation implies that in deploying metaphors that are already part and parcel of a highly conceptualized set of frameworks, the journalists are to a large extent constructing and disseminating their professional identity and their relationship with the social and political world in which their work takes place. This aspect of metaphor makes it all the more important when we consider the historical roots of some of the commonplace assumptions within journalistic identity.

On account of the fact that metaphors are always deeply embedded in longer cognitive patternings (Gibbs and Steen, 1999), metaphorical analysis contributes to the cultural history of journalism. It enables us to reflect upon how sedimentations of commonplace understandings of journalism's roles and the associated self-perceptions of journalists relating to these roles impact upon contemporary discussion. Vos (2011) has provided an exemplary account of how the mirror metaphor was used as an explanation of the journalistic norm of objectivity in nineteenth-century America and perhaps the much messier range of metaphorical associations in contemporary British discussions of journalism are an indicator of its current "crisis". Vos (2011, 576) is correct in pointing out that words and indeed metaphorical associations change over time but this makes it all the more interesting why metaphors which emerged in the eighteenth and nineteenth centuries specifically relating to British journalism should continue to hold such central positions in journalists' discourse (e.g. "Fourth Estate" and "hack").

The metaphorical process is conventionally divided between source domain (the fields from which the images are drawn) and the target domain (the literal topic of discussion). Beyond this approach, referred to as conceptual metaphor theory (Lakoff and Johnson revised 2003, 5), Fauconnier and Turner (2002, 45) have argued that metaphor blends source and target domains with readers' (or in our case journalists/writers) background knowledge to create a new "emergent structure". What is interesting in the sample selected is that it is not strictly speaking "journalism", it is more a metadiscourse on journalism being examined. This means that the usual expectations for metaphor in journalism are suspended; expectations such as helping readers conceptualize an abstract event or something alien to their everyday experience or enhancing the news value of a particular story including by sensationalizing it (Burnes 2011, 2162).

Bell (1991) explores the audience design of media language but in our particular corpus we are looking at the audience design of an insider community. Journalists are being created and reinforced in their common and sometimes changing assumptions through their underlying use of metaphorical commonplaces which is all the more important given that metaphor is a highly value-laden discourse and carries a high level of preferred reading within its associations. In enumerating the spread and quantity of metaphors, we are exploring how this particular journal identifies its ideal audience (journalists) in much the same way as newspapers identify their commercial and advertising-driven readerships (Fairclough 1995, 40).

## Searching the Corpus

We took four years of the *British Journalism Review*, comprising 16 editions with approximately 35,000 words in each volume of the journal, which totals a corpus of approximately 560,000 words. This is a significant body of language about journalism by journalists from which to draw our deductions. All 16 volumes of the journal were read by both researchers and metaphors were coded manually. The coding was then cross-referenced between the researchers.

We went through our material and performed an inductive categorization of the metaphors used by journalists directly relating to either journalism or journalists. Other metaphors were ignored as irrelevant to our research. The 28 source domains we identified were: natural disaster; the masses; brightness; mechanical; catastrophe; fishing; industrial; disreputable behaviour; darkness; machismo; treasure; optical; toxicity; theatre; nautical; meteorological; media management; religion; dirt; violence; sport; diet; physical world; corporeal; hack; bestial; and military. The range of metaphors even on first viewing indicates a set of conceptual frames which are sometimes complementary and at other times quite contradictory, especially when dealing with some of the core claims that journalism in the British context constitutes a public good, a Fourth Estate or a component of democratic society (Table 1; Figure 1).

**TABLE 1**

Use of metaphors in *British Journalism Review*

|  | *N* | % |
| --- | --- | --- |
| Natural disaster | 4 | 0.48 |
| The masses | 8 | 0.96 |
| Brightness | 8 | 0.96 |
| Mechanical | 11 | 1.32 |
| Catastrophe | 11 | 1.32 |
| Fishing | 12 | 1.44 |
| Industrial | 12 | 1.44 |
| Disreputable behaviour | 13 | 1.56 |
| Darkness | 13 | 1.56 |
| Machismo | 13 | 1.56 |
| Treasure | 13 | 1.56 |
| Optical | 16 | 1.92 |
| Toxicity | 17 | 2.04 |
| Theatre | 17 | 2.04 |
| Nautical | 17 | 2.04 |
| Meteorological | 18 | 2.16 |
| Media management | 19 | 2.28 |
| Religious | 24 | 2.88 |
| Dirt | 38 | 4.56 |
| Violence | 41 | 4.92 |
| Sport | 45 | 5.40 |
| Diet | 49 | 5.88 |
| Physical world | 67 | 8.03 |
| Corporeal | 71 | 8.51 |
| Hack | 79 | 9.47 |
| Bestial | 94 | 11.27 |
| Military | 104 | 12.47 |
| Total | 834 | |

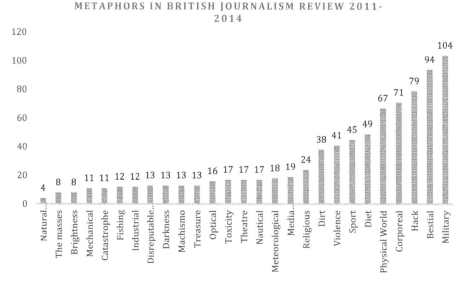

**FIGURE 1**

Metaphors in *British Journalism Review* 2011–2014

The total of metaphors associated with journalists or journalism was 834. We grouped metaphors in conceptual clusters in order to map sets of associations which pragmatically act in order to create new and challenge old values and identifications of journalists. Our approach in a relatively small corpus allowed for a manual and more sophisticated identification of metaphorical range than a more mechanistic and pre-determined inventory approach. Frequency of metaphors concerning journalism/journalists was one in 670 words, indicating that while relatively uncommon in absolute terms, there was a regularity of metaphorical use around one single topic—journalism—which draws attention to itself. These were then divided up into categories as they emerged. The top four categories in numerical terms and in term of the percentage of the total were: corporeal, 71 (8.51 per cent); hack, 79 (9.47 per cent); bestial, 94 (11.27 per cent); and military, 104 (12.47 per cent).

## Bestial

Bestial is a key source domain for metaphors which play down any noble or politically liberating set of associations. The use of the source domain of bestial behaviour is extremely prevalent in the data and most of these references are negative in implication. The routines of journalism for example are presented in a series of bestial metaphors that highlight an unthinking, mechanical set of utterances much in contrast to any notion of the journalist as an intelligent interpreter of events: "parroting of official truths", "parrot cry of press freedom", "journalists came to parrot a phrase". Likewise, in contradiction of traditional assertions of the journalist as rugged individualist, there are references to the defining feature of journalists being an ability to conform and sometimes depart from what is characterized as a predominantly group ethic identified most strongly as the "press pack". Those who depart from this behaviour are "separate from the herd" or "departing

from an insistent bleat". Neither of the associations implied here as representative of journalism's norms of behaviour are flattering. Journalists are commonly referred to pejoratively such as in one resonant phrase which identifies their group behaviour as: "feral press", while their activities often draw upon source domains of highly unflattering association: "Reporters who can worm their way into a place", "he ferrets away", the "freelance who dwells at the bottom of the food chain".

References to "rats" are rather more ambivalent since although the rat is not a positive bestial image, it is turned variously to the advantage of the journalists and their outsider status, held up as an exemplar of behaviour appropriate for a successful journalist: "rat-like cunning", "the rat of Fleet Street", while also being available as a feature of journalistic investigation. Journalists can, for example, "smell a rat" and can be described as "like ratcatchers" and are advised "not to rat on him" or behave like a "a rat deserting a sinking ship". A less ambivalent image, drawing upon and extending a powerful and pejorative cartoon image of journalists in popular culture (*Spitting Image*), one article depicts journalists simply as: "pigs in raincoats".

As a striking contrast to such deprecatory associations, we can perhaps consider reference to an idealization from a previous era when journalists could be referred to in more heroic terms, very distinctive from bestial metaphors of the present, as in Lord Beaverbrook's "Young Eagles".

It is interesting to see how one of the core metaphors of journalism, its watchdog status, is explicitly drawn upon to cast the contemporary varieties of journalism in a negative light: "the one-time watchdog has become a particularly ferocious, not to say rabid, attack dog". The contemporary negativity is nowhere more powerfully expressed than in the observation: "journalism is to politician as dog is to lamppost" which adds, savagely, that it is uncertain which refers to which. Contradictorily, while one writer can assert that journalism is a "dog-eat-dog profession", another in a separate piece can state that there exists: "the written journalistic code that 'dog does not eat dog'". Journalists can claim dog-like behaviour as a virtue when it matches their claims to tenacity, "dogged persistence", and one of journalism's chief claims to public service is also expressed in canine terms as representing "the underdog". However, we can revert to the combination of group behaviour and the canine metaphor as a specific sub-set of the bestial when considering one of the distinguishing core metaphors of British journalism: the "hack pack".

## Hack

Hack is interesting as a category but also in its relatively limited range of extension. It is used and repeated throughout our sample as a noticeably consistent anchor to definitions. This brings an aspect of very British anti-heroism into play and tells us much about the historical self-perception of the British journalist; a celebration of the unsavoury aspect of the British journalist even at a time when the unsavoury aspect of some of the activities associated with British journalism are in the spotlight.

According to the *Oxford English Dictionary*, the word "hack" emerges as a metaphor, associating from 1700 with horses for hire with the poor East London borough of Hackney. It soon became associated with poor women for hire (1730), prostitutes and, at the same time (1734), a writer hired for a short-term employment or writing speculatively for payment.

The extended subtitle of Pinkus's (1968 ) book provides an insight into the emergence of the reputation of such independent professional newswriters at the cusp of the eighteenth century:

> The scandalous lives and pornographic works of the original Grub St. writers, together with the bottle songs which led to their drunkenness, the shameless pamphleteering which led them to Newgate Prison, and the continual pandering to public taste which put them among the first to almost earn a fitful living from their writing alone.

A comment by Pinkus is worth holding in mind for its pertinence to the modern-day mythologizing of journalism; he writes:

> To the blue-nosed tradesman, the hacks were a drinking, whoring lot, abandoned to every vice—worse, they were a blasphemy against the sacred principles of thrift, industry and cash payment. The gentleman class found them rather useful in its political wars, at times entertaining, but always contemptible, because they wrote for bread.
>
> It is part of the myth that the Grub Street writers created for themselves, and, of course, it is only partly true. Many of the hacks lived austere, colourless lives … Yet a sufficient number believed in the dream and aspired to it so that it became associated with the contemporary image of Grub Street. It is part of what Grub Street came to mean. (Pinkus 1968, 14)

One of the legacies of this self-mythologizing is the resonance of the term "hack" which survives in descriptions of journalists to the present day in the United Kingdom. It is one of the distinguishing features which underlines the point made by Weaver and Wu's extensive research that each national variant of journalism has its own historical and cultural contours (Weaver and Wu 1998). For Grub Street we can substitute another now-defunct street of disreputable writers which continues to act as the symbolic heart of British journalism—Fleet Street—the once centre of the metropolitan British newspaper trade. The mythological red-line connecting Grub Street to the contemporary is the figure of the "hack". Driven by the need to earn a living, often by digging up dirty details which might embarrass someone in a position of power, the "hack's" reputation and reward were contingent upon frequenting a social milieu and indulging a lifestyle which were always likely to compromise any more straightforward concept of a "professional" (Conboy 2013, 22–23).

This brings us back to the opening discussions of the nature of the centrality of self-deprecating, anti-heroic self-perceptions of journalists as "hacks". We see the term related to dissolute behaviour, as in "hacks hang around", as well as seeing a whole host of varieties of new context for an ancient usage: "wannabe hacks", "a Daily Mirror hack", "retired hacks", "lady hack", "the seasoned hack", "former tabloid hack". Furthermore, the word is used to extend and shift its range of meaning: "Hackademic", "Hackgate", "the hackiest", "hack-ettes". The group behaviour mentioned above can also be expressed in terms of the "hack": "a posse of hackettes".

Ironically, despite the low level of regard for the work of the journalist expressed in this semantic strain, there is also a series of collocations which imply that these same "hacks" require some degree of formal training: "trainee hacks", "trained hacks", even "a proper professional hack".

Finally, we need to consider the very specific national context to this metaphorical domain. There does seem to be evidence that the "hack" is a peculiarly British, even English, phenomenon not to be found anywhere else in the world of journalism: "being an English hack", "Those British hacks"; and all the more pertinent as an area for exploration on account of this.

## Military

Military metaphors abound and yet paradoxically they highlight conflict within the context of news organizations, the economic environment and the work of ordinary journalists, while rarely touching upon the people or the democratic processes on whose behalf journalism often assumes it is acting. Organizationally, journalism can be presented "as the military wing of the TV business", "marshall their big guns", "clear chain of command", "from the media side of the barbed wire", "the corporate fortresses", and senior personnel are fitted within this domain: "news editors are the generals", "The bullying warrant officers", "The media baron". Gendered debate within the organizational hierarchy is also militarized: "there is also a gender pay gap that must be fought", "as a battle between a feisty woman and a male establishment".

The fierce contemporary competition within the news media is also included within the military source domain: "battled for commuters' attention", "A barrage of free print", "had to wipe out the opposition first", "newspaper sales have nosedived".

Within these processes of production, ordinary journalists are often categorized in contrast to the metaphorical senior military staff within the organization flow as the honourable but exploited infantry: "disciplined frontline troops", "foot-soldier journalists", "talented foot soldiers", and investigative journalism can be cast as "a crusade". There are, however, occasional expressions of the public in whose name such activities are taking place although these expressions do tend towards the abstract: "the battle could be won and lost in the trenches of public opinion".

Military metaphor indicates quite clearly that British journalists see their activities as in conflict with authority and yet there is little to suggest on whose behalf these battles are being fought. The military excursions seem to be in defence of journalism itself as a particularly solipsistic activity from which the broader beneficiaries have been erased. Jansen and Sabo (1994, 10) point out that "the language of sport/war represents the values of hegemonic masculinity (i.e. aggression, competition, dominance, territoriality, instrumental violence) as desirable and essential to the social order". When transferred metaphorically into the discourse of journalists, we can see that much of this insider identification of the work and identity of the journalist is threaded within such a machismo especially when it self-referentially portrays itself in terms of military engagement. The military source domain remains highly culture-specific within the British context.

## Corporeal

Journalism is regularly categorized in terms of it having a body that can be damaged, that requires sustenance and has physical attributes of sensory perception.

This allows journalism to be framed in terms which are at once more emotive than if describing a communicative process and also distanced from any explicit political function.

This range of metaphorical associations allows journalists to express emotional attachment to their practice.

Journalism can be described as being a "wounded industry" but, most often, the current predicament of journalism, in particular print journalism, is described in terms of dying: "newspapers as they were in their death throes", "print journalism was dying", "newspapers are dying", "the death of traditional journalism", "the Scottish press appears to be dying on its feet". The death of journalism as a physical entity is emphasized by frequent references to bones: "Newspapers have been pared to the bone", "skeleton staff". In contrast, claims for the vitality of journalism are often encapsulated through references to heart beat and blood: "through the veins of journalism", "BBC's values running through his veins", "The media, which should be the lifeblood of the debate", "cultural heartbeat of the organization".

Journalists, developing the cliché of having a "nose for news", can "sniff a coming political storm", "sniff an injustice" and this olfactory association is complemented with one of appetite even addiction: "a constant hunger for fresh stories", "embrace the print habit", "The heroin users of the news junkie world". Journalism's power is corporalized: "the sinews of broadcasting", "the paper regaining the editorial muscle of its illustrious past", "statutory muscle", "toothless", "broadcasting council with teeth". As with militarized metaphors, it is rare to read of the press acting as a body function on behalf of its readers: "The press is at once the eye and the ear and the tongue of the people".

## Conclusion

In this piece, we have explored in some depth four of the metaphorical domains which journalists use in the *British Journalism Review* to quantify their feelings about their own work and professional identities. The presence of repetitions of older tropes of journalist such as "hack" clearly remain central to these contemporary patternings of self-understanding. Across corporeal, bestial and military associations, journalism and journalists are routinely constructed within a range of discourse which highlights negative parameters as a form of mock-heroic self-identification. The most common metaphors indicate that journalists in the United Kingdom continue to express their identity in terms which isolate themselves and their practice from their audience.

The fact that these representations are featured in a publication which assumes that the majority of readers are "insiders" adds more weight to the presumption that these are core aspects of British journalists' self-identification today. In an era when the value and distinctiveness of the figure of the journalist is more than ever under threat, such a consistent set of metaphorical articulations of British journalists as outsiders to the society whose interests they purport they serve is surely a cause for concern.

## DISCLOSURE STATEMENT

No potential conflict of interest was reported by the authors.

## REFERENCES

Aldridge, Meryl, and Julia Evetts. 2003. "Rethinking the Concept of Professionalism: The Case of Journalism." *British Journal of Sociology* 54 (4): 547–564.

Bell, Allan. 1991. *The Language of the News Media*. Oxford: Blackwell.

Burnes, Susan. 2011. "Metaphors in Press Reports of Elections: Obama Walked on Water, but Musharaff was Beaten by a Knockout." *Journal of Pragmatics* 43 (8): 2160–2175.

Catenaccio, Paola, Colleen Cotter, Mark De Smedt, Giuliana Garzone, Geert Jacobs, Felicitas Macgilchrist, Lutgard Lams 2011. "Towards a Linguistics of News Production." *Journal of Pragmatics* 43 (7): 1843–1852.

Christians, Clifford G., Theodore L. Glasser, Dennis McQuail, Kaarle Nordenstreng, and Robert A. White. 2009. *Normative Theories of the Media: Journalism in Democratic Societies*. Urbana, IL: University of Illinois Press.

Conboy, Martin. 2007. *The Language of the News*. Abingdon, Oxon: Routledge.

Conboy, Martin. 2013. *Journalism Studies: The Basics*. Abingdon, Oxon: Routledge.

Cotter, Colleen. 2010. *News Talk. Shaping the Language of News*. Cambridge: Cambridge University Press.

Deuze, Mark. 2002. "National News Cultures: A Comparison of Dutch, German, British, Australian, and US Journalists." *Journalism and Mass Communication Quarterly* 79 (1): 134–149.

Eldridge II, Scott. 2014. "Boundary Maintenance and Interloper Media Reaction: Differentiating between Journalism's Discursive Enforcement Processes." *Journalism Studies* 15 (1): 1–16.

Fairclough, Norman. 1995. *Media Discourse*. London: Routledge.

Fauconnier, Gilles, and Mark Turner. 2002. *The Way We Think*. Basic Books: New York.

Gibbs, Raymond W., and Gerard Steen, eds. 1999. *Metaphor in Cognitive Linguistics*. Amsterdam: John Benjamins.

Goodman, Geoffrey. 1989. "Why We Are Here." *The British Journalism Review* 1 (1): 2–6.

Gravengaard, Gitte. 2011. "The Metaphors Journalists Live By: Journalists' Conceptualization of Newswork." *Journalism: Theory, Practice and Criticism* 13 (8): 1064–1082.

Jansen, Sue Curry, and Don Sabo. 1994. "The Sport/War Metaphor: Hegemonic Masculinity, the Persian Gulf War, and the New World Order." *Sociology of Sport Journal* 11: 1–17.

Jones, Aled. 1996. *Powers of the Press: Newspapers, Power and the Public in Nineteenth Century England*. Aldershot: Ashgate.

Lakoff, George, and Mark Johnson. 2003. *Metaphors We Live By*. Revised ed. Chicago, IL: University of Chicago Press.

Lakoff, George, and Mark Johnson. 1980. *Metaphors We Live By*. Chicago, IL: University of Chicago Press.

Larson, Cedric. 1937. "American Newspaper Titles." *American Speech* 12: 10–18.

Perrin, Daniel. 2013. *The Linguistics of Newswriting*. Amsterdam: John Benjamins.

Peston, Robert. 2015. "Don't Be Afraid of Deflation, Yet." *BBC News*, May 19. Accessed July 14, 2014. http://www.bbc.co.uk/news/business-32796307.

Pinkus, Philip. 1968. *Grub Street Stripped Bare*. London: Constable.

Richardson, John E. 2007. *Analyzing Newspapers: An Approach from Critical Discourse Analysis*. Basingstoke: Palgrave Macmillan.

Van, Dijk, Teun, A. 1998. "Opinions and Ideologies in the Press." In *Approaches to Media Discourse*, edited by Allan Bell and Peter Garrett, 21–63. Oxford: Blackwell.

Vos, Tim. 2011. "'A MIRROR OF THE TIMES': A History of the Mirror Metaphor in Journalism." *Journalism Studies* 12 (5): 575–589.

Weaver, David H., and G. Cleveland Wilhoit. 1996. *The American Journalist in the 1960s. US News People at the End of an Era*. Mahwah, NJ: Lawrence Erlbaum.

Weaver, David H., and Wei Wu. 1998. *The Global Journalist: News People around the World*. Cresskill, NJ: Hampton Press.

# WHAT MAKES A GOOD JOURNALIST?
Empathy as a central resource in journalistic work practice

**Antje Glück**

*Empathy performs a central role in regulating social relations. This applies equally to journalistic work routines. To explore the concept of empathy in the understanding of journalists, 46 interviews were conducted using a cross-cultural approach between the United Kingdom and India. It became clear that empathy occupies a central place in news production, fulfilling multiple roles. It serves to achieve a comprehensive access to information and to news protagonists at the interpersonal level. Without this "invisible" mode of communication, qualitative and ethical news journalism cannot be achieved; and the authenticity and emotionality of news packages would be diminished. Empathy varies on the individual level, but especially in sensitive journalistic work fields it represents a "naturally present" core skill for journalists. A final empathic dimension is found in the imaginary empathy towards the audience which provides essential guidance for journalistic news products. Cultural differences between India and the United Kingdom are apparent in this study, but results also indicate considerable similarities in the role of empathy in different journalism cultures.*

## Introduction

At the 2015 Future of Journalism conference in Cardiff, BBC historian Jean Seaton reminded the audience in her keynote speech that academic journalism research seems to display a reserved anxiety towards any subjects related to feelings. This statement found its reflection in the titles and abstracts of the numerous conference contributions —only one contained the terms "emotion", "feelings", "sensations", "sentiment", "affects" or the closely linked term "empathy".

The discussion of empathy in journalism is necessary to understand the ways in which it contributes to comprehensive and engaging news coverage. Empathy provides the ground for dealing with the emotions of news protagonists, using it as a means in reporting, and also affecting the emotional regulation of journalists during news production.

This gains momentum in an age when "serious" news journalism in the Anglo-American world and beyond remains ideologically tied to the normative guiding principles of factuality, impartiality, and objectivity[1] (Schudson 2001). But striving for the ideal of a detached objectivity appears to increasingly contradict the general social trend of emotionalization (McQuail 2010, 357), described in Furedi's (2004) "therapeutic culture" or Richards' "emotional public sphere", where emotions are seen as part of the political realm in debates and opinion formation (Richards 2009). Others note that journalistic

output has experienced an increasing visibility of emotions (e.g. Pantti 2005; Pantti and Wahl-Jorgensen 2011).

With emotions in news coverage leading to fears of a downgrading of news quality via "infotainment" or "tabloidization", this makes a look at journalistic competencies in dealing with emotions absolutely necessary. Here, empathy assumes a core role. Empathy is related to perceiving the emotions of others, but also to the deployment of emotions in news and in engaging audiences.

Empathy can be a mediator between the prevalent self-understanding of journalism practitioners as "messenger of reality" (Pantti 2010) and journalists reflecting about emotions (Schiller 2012); between the ideal of detached passionless reporting and a "strategic ritual of emotionality" in which journalists "outsource" emotional expressions into storytelling or emotional statements of news protagonists to keep personal subjectivity out of a story (Wahl-Jorgensen 2013). Journalists in "serious" news journalism acknowledge the existence and function of emotions, but try to deal sensitively with them in order to uphold professional values of objectivity and impartiality.

This paper focuses on empathy as a central element of journalism practice. So far, empathy has been a neglected concept. It has been neither addressed in journalistic work practice nor in relation to the debate about emotions in journalism. In the following, I explore and theorize the role which empathy plays in journalistic work practices. A two-country comparison between British and Indian television journalists examines empathy in a cross-cultural context. It seeks to identify how cultural differences are potentially reflected in journalism cultures of the "West" and Asia, with different underlying philosophies of emotions and social relations. Is empathy maybe after all not such a different thing, but rather a universal requirement for "good journalism"?

## Theorizing Empathy and Emotional Labour in Journalism

Empathy appears to be central to journalistic work routines. A journalist *without* a well-developed empathy might excel in more analytical fields like stock market analysis or data journalism, but would presumably face difficulties in more "human" scenarios. The central position of empathy is reflected in the example of a bereaved woman who just lost a close person, being interviewed by a television team. Narrating her story, she suddenly breaks down and bursts into tears. This scenario raises ethical questions over the correct response required of a professional journalist. A credo like "tears are good for business" and professional role understandings may be in opposition to the journalist's own subjective (empathic) emotions. Empathy is present in telling the story, in creating authenticity, and in relating to the news source as a human being. This scenario shows one of several dimensions where journalism requires empathetic understanding alongside ethical and pragmatic considerations.

Empathy is considered one of the fundamental resources of emotional and social intelligence (Goleman 1995), celebrated as a "communicative capability" (Köppen 2016) and as "universal solvent" of interpersonal problems (Baron-Cohen 2012). Relations are central to all forms of life, and empathy acts in this regard as adaptation for managing complex social relations. It allows fitting in.

Empathy is generally seen not as an emotion *per se*, but closely tied to emotions. It contributes essentially to the perception of emotions in others while not necessarily leading to a sharing of those emotional states (Köppen 2016). The original term *"Einfühlung"*

was coined by Lipps (1903), to refer to projecting oneself into the situation of another person or their aesthetic art work. Today, there exist at least eight competing definitions of empathy (Batson 2009).

Empathy is usually seen as a multidimensional and complex concept, roughly consisting of a cognitive component (recognizing feeling states and thoughts) and an emotional component (empathic participation or response, see Baron-Cohen 2012). De Waal's (2009) useful approach differentiates it further into affective (autonomic) elements, cognitive (reflective) elements, and perspective-taking.[2] De Waal understands the non-cognitive or affective element of empathy as a pre-linguistic form of inter-individual linkage, which enables emotional contagion. It is related to the mirror neuron system which allows people to non-cognitively adapt their emotions and actions to each other by sheer observation (Rizzolatti and Sinigaglia 2008). Differences in empathic understanding can be explained by biology and socialization (Baron-Cohen 2012).

Empathy can and needs to be distinguished from related concepts like sympathy, pity, compassion, and primitive empathy. Sympathy (in today's sense) can emerge based on empathy and focuses mostly on distressed situations of others, making the emotional state of the other one's own (Morrell 2010). Pity is understood by Nussbaum (2001) as a prerequisite of compassion. Compassion is regarded as thought about the well-being of others, where one is affected by the sorrow of another person, and one feels passionate about social justice, leading one to show compassion (Garber 2004). Finally, primitive empathy refers to one's own emotional arousal instead of others' which leads to either personal distress and/or emotional contagion.

Dealing with personal distress or any kind of necessary emotional regulation as a consequence of empathy leads us to another relevant theoretical concept which informs this paper—Hochschild's "emotional labour". Emotional labour can be understood as the difference between a subjectively felt emotion and a professionally required emotional adaptation and display (Hochschild 1979, 2003). It can lead to feelings of alienation from one's own (authentic) emotions, and therefore to emotional dissonance. Hence, the necessary management of emotions is influenced by social and cultural norms. Hochschild's concept helps to describe and contextualize the emotional requirements emerging during journalistic work practice and to think about its further implications for the health of the individual journalist.

I argue that both phenomena—empathy but also emotions within the journalistic work practice of individuals and groups—can be understood in the tradition of emotional labour. Whether to secure and enhance access to information, to performative elements for a news package, or imagining the audience—in each of these cases empathy is required by the journalist to achieve a situation of co-operation or appropriate journalistic adaptation. Empathy cannot be left out in sensitive journalistic interviews where people face varying degrees of distress. In case it does not arise "naturally", it needs to be performed to accomplish a work task. This can lead to the risk of draining out emotionally, as both cognitive and emotional processes and labour are involved in establishing an empathic mode. While empathy appears as a method of basic social bonding, at the same time it can lead to distressing emotional "performances" for journalists (Richards and Rees 2011).

In my paper, I focus on two core research questions:

**RQ1:** Is empathy perceived as an essential part of journalistic work, and what types of empathy emerge?

**RQ2:** Does empathy across the sample appear as a universal concept, or do the statements of the journalists reflect socio-cultural differences?

In the following sections, I outline journalistic understandings about empathy and relate them to further theoretical ideas, while the background for this is provided by a cross-cultural comparison.

## Method

In order to explore empathy in journalistic work practices, I investigated the reflexivity of journalists about the subject. This primarily concerned the discourses of journalists concerning empathy, but also touched the field of required emotional regulation. Journalistic perspectives are then combined with theoretical approaches towards empathy.

Qualitative semi-structured interviews were conducted with television news journalists of different professional positions, work experience, and age. Television, with its centrality of the audio-visual and of immediacy, represents a medium in which emotions play a more important role than in other text-based journalistic output and was therefore selected for analysing empathy.

In total, 46 interviews were conducted. In the United Kingdom, 21 journalists from the BBC, ITV and Sky News were interviewed between April and August 2015. The interviews in India took place from December 2014 to January 2015, with 25 journalists from several national news channels such as NDTV and Doordarshan, among others. The age range in the sample varies between 26 and 61 years. While the Indian sample contained an equal relation of male and female journalists, the British side is marked by a slight dominance of male journalists. The professional positions range from junior reporters, managing mid-level editors to the top level of the respective broadcasting organizations. The participants and their statements were anonymized and numbered; British journalists start with B, Indian with I.

This study draws upon the comparative research tradition in order to explore the ways in which a seemingly universal resource, such as empathy, differs locally, revealing socio-cultural constructions that vary within the complex media ecologies of British and Indian television news cultures. As Markus and Kitayama (1994) suggest, distinctive core cultural ideas shape customs, norms, practices and institutions, thereby determining the reflections and decision-making processes of journalists.

Cultural psychology points to a key cultural difference between the United Kingdom and India. British and Indian journalist cultures could be viewed as operating within societies that are characterized by different types of social relations. Markus and Kitayama (1994) have proposed a model of independence versus interdependence in the human conception of the self. The independent, autonomous self is viewed as bounded, stable, and separated from its social context, and this view emphasizes self-expression and the promotion of one's own goals. On the other hand, the interdependent self is viewed as connected to its social context, flexible, and variable; this interdependent view emphasizes external indicators (e.g. status, roles, relationships) and aims to integrate with a social group, where it often promotes the goals of others.

According to Markus and Kitayama's (1994) view, independent social relations would dominate within the Anglophone context, while Southern Asia would be marked by concerns of the socio-centric interdependent self and social relationships. Furthermore,

several studies reveal that social contexts influence emotional experiences more within interdependent than independent cultures (see Misra 2010). Subsequently, the issue of whether this translates for empathy in different cultural contexts is discussed.

## Findings and Discussion

### Views on Empathy in British and Indian News Contexts

A first area of research interest comprises the relevance of empathy in journalistic work from the perspective of television news producers. All journalists considered empathy as a central quality of their work. Journalists in both the United Kingdom and India agreed unanimously that empathy in general forms a "very crucial part of it … a trait that you need to be able to be a journalist" (I14, chief executive officer). It is therefore a basic skill and requirement for journalists in general and has even been institutionalized in the case of public service broadcasting in the United Kingdom, as "in the BBC, it has been used on a quite humanitarian basis; to empathize with famine victims or civilians, refugees as victims of conflict" (B02, director general).

At times, it is seen as an indispensable marker for a successful professional career as a journalist, as "the difference between a good journalist and a great journalist will be that level of empathy" (I18, editorial director). It is the way one deploys empathy as a resource which leads to exceptional journalism, narrates this former BBC journalist:

> I remember in [a conflicted Eastern European country], when me and [another journalist of the same channel] were up all night, talking to people, trying to sort of tell their story in a very sympathetic way. And another reporter came in the room—"Look it is 11 o'clock, I want to get my 8 hours of sleep, can you guys stop interviewing people?" So, I think you got to be, got to go the extra mile. (B15 editor in international news/world affairs)

Can empathy be learned on the job or is it a naturally given resource? Journalists agreed here also largely in understanding empathy as something which is "universally" given—or not. A British senior journalist described it as a "natural empathy, natural talent; to be a reporter or a journalist, they need to have those central sort of human skill where—empathy is absolutely essential! And I have seen many times reporters— you know they are not going to make it, because they just haven't got the human skills to ever get [there]" (B15, editor in international news). Amongst Indian journalists, a similar view prevails which moreover emphasizes the medium and a strong audience orientation:

> You can be an ok journalist, and you can probably get a job as a journalist, but I don't think that you find them among who are the stars—the stars will always be the ones who go a bit more, work beyond … I think television is an emotional medium … [Empathy] is a layer you have to have. I mean if you don't have it … A journalist should want to tell stories because he or she cares. Otherwise what is the point for that? (I18, editorial director)

Not all journalists believed empathy to be necessary in every field of journalism—it is rather partially applicable, as certain professional subfields are characterized by a higher sensitivity while others suffice with schematic journalistic scripts without having to draw on the resource of empathy. This differentiated view is represented also across the UK sample, with a British deputy editor recounting that "I have known both. And both had

their qualities. And you can survive. And you can be a great journalist without empathy. At some point it will catch you out, because you will misjudge a situation" (B05). "Most journalists need to understand people, and get on with people" in areas which require an understanding of the impact on the audience, like in human-interest news, foreign, or health reporting. But "if you are doing a purely analytical role, then it is less important", and "you could be a sort of financial markets journalist without being particularly empathetic" (all by B02, director general). The Indian journalists did not mention this division at all, instead seeing empathy as a general element of any journalistic work, with the aim of engaging the audience as

> You can't be seen as the same with your reporting on murder, a child's death, and the stock markets. There has to be a level of emotional involvement which is different according to each news story. (I18, editorial director)

It can be concluded that journalists in the United Kingdom and India see empathy as an essential part of immediate journalistic work routines in news journalism, having an impact on the quality of news coverage and even the career prospects of individuals. Differences are marginal; journalists from both countries only disagree when they relate empathy to journalistic fields. While British journalists accept that financial news, for example, is partially "unempathetic" journalism, this does not apply for Indian journalists who view the required empathy in more general terms.

This finding of a higher status of empathy can potentially be explained in two ways from a journalistic perspective. First, Indian journalists consider empathy to be an essential resource with which to engage the audience, regardless of the topic, reflecting the pressures of a highly competitive media market. Here, the journalist acts as a mediator between the news event and the audience. Second, I suggested that Indian journalists face a higher level of conflict and violence within their home territory, where empathy becomes central for the practice of a sensitive journalism.

### Dimensions of Empathy

From the interviews it also emerged that empathy is a multidimensional work routine in journalism practice. Empathy can be deployed with varying focus—towards the news story protagonists, the audience, and also within the production context. By combining theoretical approaches and qualitative interviews, it was possible to identify four main dimensions of empathy within journalistic work practice: epistemological, instrumental-strategic, performative, and imaginary.

*Epistemological dimension.* The journalistic commitment to the professional norms of objectivity and accuracy, or—a search for "truth"—translates in practice into establishing an intersubjective reality. "You need to be able to get into the shoes of who is there. Otherwise, why would we care about them" (B13). Journalists seem to follow most closely Lipps' original notion of empathy as a "feeling into" with retaining a sense of self, where identity and alterity go together, or, what Honneth (2003) named "functional empathy" as it refers to taking a reflective intersubjective perspective:

> It is fundamentally about human stories … if you can't understand why this matters to people, and why the actors involved, the characters involved would have been upset or

affected or angry of something. If you can't understand that then you can't understand the story. 'Cause it always should come back to the people involved. (B07, reporter VJ)

Empathy is a tool for the mediation of subjective individual experiences and wider context to an audience:

If a person is trying to tell their story to the world, it is I who should be able to understand what the person is going through, so that I can relate that story, I can give that story to the viewers. Unless I do that, I don't think a viewer can understand the emotions of what the person is going through. (I20, producer, anchor)

To approach a holistic understanding of reality, a journalist first engages with the story of the subject and then establishes an intersubjective perspective by stepping back to reflect about the subjective cognitive and emotional experience that the subject's narration does to him or her, while retaining the "protective" illusion of neutrality (Willis 2003). This resembles the mode of interaction between a therapist and patient (Jaenicke 2006).

*Instrumental-strategic function.* As we have seen, empathy shapes journalistic interactions with news protagonists. This has an impact also on information gathering, aiming for accuracy, and an intersubjective reality. But only by creating a situation of cooperation with the news source can information be acquired. How cautious a journalist has to act is especially important in conflict or trauma scenarios, in several ways:

What if that person is a complete third-grade scum? How you are being empathetic with them … Somebody is sitting in front of you and saying the most outrageous things—how do you nod your head. That took some training actually, frankly. That is what I learned with the Ayodhya movement, with these guys sitting and saying … "You know I think we should murder all of them" … Your natural reaction is to say—are you out of your mind. But if you are trying to get the guy to talk … then the only way you can investigate is by actually functioning like a secret agent, right? (I14, chief executive officer)

The necessary trust-building between journalist and interviewee can sometimes lead to personal distress for the journalist. This can be seen as emotional labour, as journalists need to regulate their emotional reactions according to their professional role. However, they are not detached observers with a low-empathy condition (Edge 2015), as they might claim to be, rather, they display high empathy. Emotional labour also occurs when journalists face situations being close to their own living world, such as female journalists being more empathic to rape incidents in India (I15).

Building up a relationship of trust with a news protagonist is "up against the deadline", so journalists are aware that "it sometimes takes a while to settle them down, to persuade them, to console them" (B03). This pressure to establish a necessary trustful and equal climate of conversation within a short time requires a high degree of skill and sensitivity:

It helps. There had been interviewees including last week [about 7/7] that said if they didn't feel that I was relating to what they had gone through in terms of the trauma, they would never have agreed to speak to me. So, and this has happened time again and again. (B18, senior correspondent)

If they don't believe that you CARE, you won't get the best interview … Truly cares. Isn't just doing their job, but actually cares. You get a better interview. Your reputation will

be better; you have more chance of getting other stories in the future … Empathy really comes across. So I think it is vital. (B19, producer)

Here, empathy helps in contributing to the recognition of the other as human subject and as "equal" in a social relation (Edge 2015). This serves deeply the democratic function of journalism. However, this mode of interaction also benefits the interviewed individual, as it allows him or her to be understood in their own frame of reference, of being comforted, and finally, allowing a reduction of stress in traumatic moments (Howe 2013).

*Performative dimension.* How engaging a television news package or interview is appears not only dependent on the type of story, but relies heavily on news protagonists, image selection, and sound bites. This shapes the performative value of empathy. As "television is a visual-emotional medium; it appeals to the visual sense", journalist I18 (editorial director) sees empathy as core in this process of news production. Only a trust-containing interview situation between journalist and news protagonist led by empathy can provide the required engaging news features which lend a story authenticity, such as a strong sound bite or emotional display (Wahl-Jorgensen 2013). Ideally, here empathy facilitates creating an adequate (emotionally authentic) situation.

You don't get the same result. I have done hundreds of door knocks where people have died … If you actually are sensitive and behave like a fellow human being instead of a robot who wants a picture, then you are more likely to get a picture. (B03, head of news)

However, there is also a "dark side" to it. Empathy with news sources can be deployed not only in an authentic sense, but overlap with manipulative or deceptive objectives. This "functional" or "tactical empathy" (Ciaramicoli 2001; Terpe and Köppen 2011) raises strong ethical questions.

*Imaginary empathy.* This mode of empathy focuses solely on the audience. Audience ratings matter essentially to any television station, not only in a highly competitive market like India with several hundred news channels, but also in the United Kingdom. Therefore, engaging the audience is a primary task of news coverage especially. Surprisingly, a number of European journalists tend to rather ignore the impact on their audience (Pantti 2010; Richards and Rees 2011).

Audience reactions remain still time-delayed and fragmentary, commonly shared via Twitter, email, or personal feedback. As news teams during the production process rarely encounter a chance to share synchronous time and space with the audience, they tend to deploy an imaginary working construct. This is what I call "imaginary empathy", a mode of relating to the audience with no material existence as it remains virtual in editorial rooms and mobile editing suits. The type of empathy which is dominant here is Batson's (2009) description of how another is thinking and feeling (perspective taking), with strong cognitive-reflexive, but less affective components ("re-enactive empathy" with Hollan 2012).

Journalists use imaginative techniques from different realms. These two British and Indian journalists draw strongly from their personal sphere:

I am thinking through what clips I would use, what pictures I would use—I have got my mom and another friend. And my other friend says, "Ah, sometimes I can't watch [your

channel] because—they seem to make you want to just feel everything!" And I kind of use my friend and my mom as my barometers. (B19, senior reporter)

You also have to go home and talk to your family … And when you talk to the family, then they view emotions. That does not necessarily mean that we have to build our opinion based on the people who WE are close to talk to us, but it gives us some idea, from the people who we trust; what is going on in THEIR minds. (I21, senior executive editor)

## Conclusion

As empathy is fundamentally embodied in human social relations, this paper takes a first step in applying the concept of empathy to journalistic work practice, exploring it from two different journalism cultures. I suggest that empathy forms an indispensable though "invisible" part of journalistic work. In the journalistic discourses presented here, empathy is not considered to be in conflict with the ideal of a largely detached passionless reporter in serious news journalism. Instead, its central qualities for journalistic storytelling as well as a successful journalistic career are consciously emphasized.

Therefore, empathy in journalism can excel as "emotional capital", as art of diplomacy and co-operation. To guarantee a qualitative and ethically sensitive news coverage, television journalists by and large require skills of empathic perception and understanding in their daily work. Although "empathic interest" can be trained to a certain extent (Köppen 2016, 290), this did not reveal itself in the discourses, where empathy is either "there"—or not.

Empathy is required in multiple work processes during news production. One is the strategic-pragmatic establishment of relationships of trust with news protagonists. This serves information gathering and news package performance, but also the epistemological realm of knowledge generation where journalists aim to establish a holistic intersubjective perspective, incorporating empathy as another means of access to figuring out what "actually happened" during an event. The other main dimension of empathy can be found in the "imaginary empathy" towards a largely invisible audience in order to generate a cognitively and emotionally engaging news coverage.

The comparative approach between the United Kingdom and India has demonstrated a large transnational agreement about the normative-ethical value and relevance of empathy in journalistic work practices. This unity among journalists from two different media ecologies, with Indian television displaying clearly more sensationalist and emotional features, allows us to reflect on the question of to what extent journalism cultures may have converged here. This can be left for further analysis.

With culture as an influential factor on human behaviour, minor differences appeared in the way empathy was cross-culturally highlighted. News journalists in India tended to regard empathy as deeply anchored in all areas of news production, with a clear link to the audience. This higher stance of empathy in the Indian context might be explained by the emphasis of socio-centric self and emotions in Asian societies.

## DISCLOSURE STATEMENT

No potential conflict of interest was reported by the author.

## NOTES

1.  Stemming from a nineteenth-century US tradition of "scientified" journalism based on scientific rationalism, objectivity diffused in different shapes into European as well as Indian journalism cultures, where objectivity is associated with neutrality, balance, and reporting the facts (see Yadav 2011, 6). In the British context, it is deeply anchored within the BBC but less with the press (Hampton 2008).
2.  A similar approach is followed by Morrell's (2010, 64) process model of empathy in which he distinguishes between non-cognitive, simple, and advanced cognitive processes.

## REFERENCES

Baron-Cohen, Simon. 2012. *Zero Degrees of Empathy*. London: Penguin.

Batson, C. Daniel. 2009. "These Things Called Empathy. Eight Related Phenomena." In *The Social Neuroscience of Empathy*, edited by Jean Decety and William Ickes, 3–16. Cambridge & London: MIT Press.

Ciaramicoli, Arthur. 2001. *Der Empathie-Faktor: Mitgefühl, Toleranz, Verständnis*. Munich: Deutscher Taschenbuch Verlag.

De Waal, Frans. 2009. *The Age of Empathy. Nature's Lessons for A Kinder Society*. New York: Three Rivers Press.

Edge, Matt. 2015. *Political Philosophy, Empathy and Political Justice*. New York: Routledge.

Furedi, Frank. 2004. *Therapy Culture: Cultivating Vulnerability in an Uncertain Age*. London: Routledge Chapman & Hall.

Garber, Marjorie. 2004. "Compassion." In *The Culture and Politics of an Emotion*, edited by Lauren Berlant, 15–28. New York & London: Routledge.

Goleman, Daniel. 1995. *Emotional Intelligence*. New York: Bantam Books.

Hampton, Mark. 2008. "The "Objectivity" Ideal and Its Limitations in 20th-Century British Journalism." *Journalism Studies* 9 (4): 477–93.

Hochschild, Arlie R. 1979. "Emotion Work, Feeling Rules and Social Structure." *American Journal of Sociology* 85: 551–75.

Hochschild, Arlie Russell. 2003. *The Managed Heart: Commercialization of Human Feeling*, Twentieth Anniversary Edition, with a New Afterword. Berkeley: University of California Press.

Hollan, Douglas. 2012. "Emerging Issues in the Cross-Cultural Study of Empathy." *Emotion Review* 4 (1): 70–78.

Honneth, Axel. 2003. *Unsichtbarkeit: Stationen einer Theorie der Intersubjektivität*. Frankfurt/Main: Suhrkamp.

Howe, David. 2013. *Empathy. What It Is and Why It Matters*. Houndsmills, Basingstoke: Palgrave Macmillan.

Jaenicke, Chris. 2006. *Das Risiko der Verbundenheit - Intersubjektivitätstheorie in der Praxis*. Stuttgart: Klett-Cotta.

Köppen, Eva. 2016. *Empathy by Design. Untersuchung einer empathie-geleiteten Reorganisation der Arbeitsweise*. Konstanz: UVK.

Lipps, Theodor. 1903. "Einfühlung, Innere Nachahmung, und Organempfindungen." *Archiv für die gesamte Psychologie* 3 (2–3): 185–204.

Markus, Hazel Rose, and Shinobu Kitayama. 1994. "The Cultural Shaping of Emotion: A Conceptual Framework." In *Emotion and Culture. Empirical Studies of Mutual Influence*, edited by

Hazel Rose Markus and Shinobu Kitayama, 339–51. Washington, DC: American Psychological Association.

McQuail, Denis. 2010. *Mcquail's Mass Communication Theory*. 6 ed. Los Angeles & London: Sage.

Misra, Girishwar. 2010. "The Cultural Construction of Self and Emotion: Implications for Well-Being." In *Personality, Human Development, and Culture: International Perspectives on Psychological Science*, edited by Ralf Schwarzer and Peter A Frensch, 95–112. New York: Psychology Press.

Morrell, Michael E. 2010. *Empathy and Democracy. Feeling, Thinking, and Deliberation*. University Park, Pennsylvania: Pennsylvania State University Press.

Nussbaum, Martha. 2001. *Upheavals of Thought: The Intelligence of Emotions*. Cambridge & New York: Cambridge University Press.

Pantti, Mervi. 2005. "Masculine Tears, Feminine Tears – and Crocodile Tears: Mourning Olof Palme and Anna Lindh in Finnish Newspapers." *Journalism* 6 (3): 357–77.

Pantti, Mervi. 2010. "The Value of Emotion: An Examination of Television Journalists' Notions on Emotionality." *European Journal of Communication* 25 (2): 168–81.

Pantti, Mervi Katriina, and Karin Wahl-Jorgensen. 2011. "'Not an Act of God': Anger and Citizenship in Press Coverage of British Man-Made Disasters." *Media, Culture & Society* 33 (1): 105–22.

Richards, Barry. 2009. "News and the Emotional Public Sphere." In *The Routledge Companion to News and Journalism*, edited by Stuart Allan, 301–11. London: Routledge.

Richards, Barry, and Gavin Rees. 2011. "The Management of Emotion in British Journalism." *Media, Culture & Society* 33 (6): 851–67.

Rizzolatti, Giacomo, and Corrado Sinigaglia. 2008. *Mirrors in the Brain: How Our Minds Share Actions and Emotions*. Oxford: Oxford University Press.

Schiller, Jakob. 2012. "When Tragedy Hits, Photojournalists Balance Reporting and Emotion." http://www.wired.com/rawfile/2012/07/on-the-ground-when-tragedy-hits/

Schudson, Michael. 2001. "The Objectivity Norm in American Journalism." *Journalism* 2 (2): 149–70.

Terpe, Sylvia, and Eva Köppen. 2011. "Empathie in der Arbeitswelt." *Berliner Debatte Initial* 22 (3): 66–75.

Wahl-Jorgensen, Karin. 2013. "The Strategic Ritual of Emotionality: A Case Study of Pulitzer Prize-Winning Articles." *Journalism* 14: 129–145.

Willis, Jim. 2003. *The Human Journalist: Reporters, Perspectives, and Emotions*. Westport, CN: Praeger.

Yadav, Y. Prabhanjan Kumar. 2011. "Is Social Responsibility A Sham for Media?" *Global Media Journal: Indian Edition* June: 1–10.

# CAMOUFLAGING CHURCH AS STATE
## An exploratory study of journalism's native advertising

Raul Ferrer Conill ⓘⅅ

*This paper explores the increasing trend of adopting native advertising in the digital editions of traditional news media outlets. Native advertising is defined here as a form of paid media where the commercial content is delivered within the design and form of editorial content, as an attempt to recreate the user experience of reading news instead of advertising content. Methodologically, this study examines 12 news websites of legacy newspapers from Sweden, Spain, the United Kingdom, and the United States, and analyzes the adoption of native advertising during the span of January 2015. Subsequently, these advertisements are analyzed in terms of type, form, function, integration, measurement, disclosure, and authorship. The results show that while the degree of implementation is still modest, the way in which it is implemented is uneven across countries.*

## Introduction

The grand narratives of democracy associated with journalism during the last century have slowly been contested both by scholarly work and by industry scandals (Peters and Witschge 2015). Similarly, the ideal values of journalism identified by Kovach and Rosenstiel (2001)—public service, objectivity, autonomy, immediacy, and ethics—offer a tainted glimpse on how journalism is practiced in western democracies (Deuze 2005). Traditionally, journalistic ideals have aimed at keeping editorial lines independent of commercial influences. This has been historically known as the separation of church and state. However, the introduction of native advertising within legacy news media has sparked a new rhetoric toward the church–state divide.

The notion of journalistic autonomy, in particular, has always been subjected to both external and internal factors that try to restrict or enable it; as well as structural contexts that reshape its dynamics (Sjøvaag 2013). Thus, the decline of sales and advertising revenues have spurred news organizations to find alternative sources of income, often deriving in commercial pressures that challenge how the sense of autonomy is experienced by journalists (Shoemaker and Reese 2014).

The increasing blurring of boundaries between the commercial and professional logics of journalism could have serious implications for the normative and performative role of journalists. This is one of the core principles that drive the industry's debate on native advertising. And yet, very few studies focus on the actual introduction of native advertising in journalistic contexts. The aim of this exploratory study is threefold: first, to explore and analyze if and how the digital editions of traditional news media have

introduced native advertising in their websites; second, to compare the trend and modes of implementation of this practice in four different countries; and third, to help address the current research gap on native advertising by exploring a methodology that is suited to effectively research native advertisements (ads) within journalistic practice. The focus remains on the anatomy of native campaigns, their format, and how they are being deployed.

## Native Advertising in Journalistic Contexts

Native advertising is not a term with an established definition. As a phenomenon that has traction within marketing and transmedia branding (Matteo and Zotto 2015), most of its interpretations come from consultant and advertising agencies that aim to demarcate it as a monetizing strategy, a marketable product, or as revenue model for the publishing business. The agency Sharethrough defines native advertising as "a form of paid media where the ad experience follows the natural form and function of the user experience in which it is placed" (Sharethrough, n.d.). Outbrain, another online advertiser, defines native advertising in a native ad placed in *The Guardian* as a "sub-set of the catch-all content marketing, meaning the practice of using content to build trust and engagement with would-be customers" (Hallet, n.d.). This situates native advertising within the all-encompassing notion of content marketing, accompanied by terms like branded content, sponsored content, advertorial, etc.

Turning to scholarly work, Couldry and Turow (2014, 1716) define native ads as "textual, pictorial, and/or audiovisual material that supports the aims of an advertiser (and is paid for by the advertiser) while it mimics the format and editorial style of the publisher that carries it".

Combining these three definitions, this paper proposes and uses the following working definition of native advertising within the context of news media: *a form of paid content marketing, where the commercial content is delivered adopting the form and function of editorial content with the attempt to recreate the user experience of reading news instead of advertising content.*

Thus, even though the content is inherently commercial, it is expected to behave, look, and feel like editorial content. The objective is twofold: first, to increase ad consumption by readers; second, to link the advertiser's brand to the publisher's qualities and authority by adopting the format of the latter.

Studies on native advertising in journalistic contexts are often divided between theoretical approaches and empirical research. Theoretically, the debate is centered on the blur between editorial and commercial content and its normative implications (see Carlson 2014; Coddington 2015). Empirically, researchers mostly study the effects and attitudes of journalists and readers towards native advertising. Burns and Lutz (2006) see a larger acceptance among consumers of ad formats that are less graphically dissonant with content, that are less distracting, and yet more entertaining. Howe and Teufel (2014) conclude that native advertising has no effect on the credibility of a news website, and that while younger audiences are more likely to recognize native ads as actual advertising, they seem unaffected by it. This is challenged by Austin and Newman's (2015) Reuters Report in which UK (33 percent) and US (43 percent) readers feel disappointed or deceived by sponsored content, a practice that damages news

organizations' image in larger proportion than marketers'. Actual content and format of native advertising is mostly overlooked.

## The Rhetoric of Church and State, a Shifting Discourse

As newspaper circulation decreased and advertising avoidance in the digital editions became the norm (Johnson 2013), the industry started looking for new forms of revenue. Legacy news media predominantly opted for online subscriptions, firewalls, and paid-for-content models. Newer digital news outlets, often mixing news and entertainment—such as *BuzzFeed* and *The Huffington Post*—adopted native advertising, which became economically successful, and eventually encouraged established actors—like *The New York Times* or *The Guardian*—to also adopt native ads (Chittum 2014).

Historically, transgressions from business influences into editorial decisions have had an effect on newspeople's working practices and how the public understands news media (Bantz 1997). The key principle of maintaining a certain degree of independence from those who are covered in the press (Kovach and Rosenstiel 2001, 118) is in place to give citizens a sense of autonomy while establishing the legitimacy of journalism's democratic professional values (Soloski 1989). The discourse of commercial independence became a fundamental cornerstone of journalism, shaping newsroom dynamics, and leading news organizations to materialize and institutionalize the divide between editorial and business decisions (Schudson 1978). The separation of church and state—also referred as the *Chinese Wall* or the *Iron Curtain*—became a boundary marker that allowed journalism's values and integrity to be differentiated from the influences of market-driven information (Coddington 2015). Newspeople were expected to overlook the wishes of advertisers and ignore the economic concerns of their employers (Croteau and Hoynes 2001). In reality, however, the economic pressures of advertisers continued influencing editorial decisions (Bagdikian 2004; McChesney 2004).

In the current digital media landscape, the change of discourse becomes evident when analyzing how some leading figures within news organizations respond to the success of new competitors. When discussing how business decisions have started to permeate legacy news media practices, Time Inc. CEO, Joe Ripp, openly defends that "[editors] are more excited about it [native advertising] because no longer are we asking ourselves the question are we violating church and state, whatever that was" (Bloomgarden-Smoke 2014). This new direction delegitimizes and questions the dynamics in which contemporary journalism has operated, and attempts to set new rules that dispute the need for a commercial–professional divide. The traditional news values discourse anchored in the logic of the church–state divide is further challenged by Meredith Levien, executive vice president for advertising at *The New York Times*, who attempts to refute "the notion that native advertising has to erode consumer trust or compromise the wall that exists between editorial and advertising. Good native advertising is not meant to be trickery" (Ferenstein 2014). Similarly, Carter Brokaw, executive VP-commercial at *Guardian U.S.* refers to the redesign of theguardian.com as "trying to bring elegance back into marketing. People come to us for content and we want to create a platform where marketers can share their content" (Sebastian 2014).

Signs that this new rhetoric has started to impregnate the discourse of the church–state divide can also be found in Carlson's (2014) case study of the *Atlantic*'s controversial use of native advertising, promoting the Church of Scientology. As the study shows, the outcry and critique on the ad focused on different aspects, not solely on bridging the

church–state divide. This suggests that the cause of controversy is not native advertising in itself, but its failure to conform to readers' expectations of to what extent and how openly editorial content can be exploited for commercial purposes.

In order to understand how native advertising is being adopted by the digital editions of legacy news media actors, this paper proposes the following research questions:

**RQ1:** How are the digital editions of legacy news media incorporating native advertising?

**RQ2:** Are there any differences in implementation between different countries? If so, what are these differences?

These research questions empirically address the physical characteristics of native advertising once adopted by legacy news media. The second question specifically allows for opening a comparative discussion on different nationalities and professional traditions.

## Methodology

This study is informed by a qualitative content analysis of the digital editions of 12 legacy newspapers located in four different countries.

Since the influence on journalistic practice from actors outside the newsroom is largely dependent on the media system they pertain to (Hallin and Mancini 2004), it is to be expected that the introduction of native advertising will be achieved in uneven patterns that emerge differently depending on the national context. The four countries and their corresponding digital newspapers chosen for this study respond to convenience and purposive sampling. First, the countries—the United States, the United Kingdom, Sweden, and Spain—are chosen because they represent each of the models of media systems proposed by Hallin and Mancini (2004). Sweden is a representative of the *Democratic Corporatist Model*, Spain is confined within the *Mediterranean Pluralist Model*, and the United States and United Kingdom are part of the *Liberal Model*. The publications chosen respond to an attempt to investigate the digital editions of daily newspapers, as legacy media carry a set of journalistic values that are often in conflict with native advertising. The sample is formed by *The New York Times*, *USA Today*, and *The Washington Post* from the United States; *The Guardian*, *The Telegraph*, and *The Times* from the United Kingdom; *El País*, *El Periódico*, and *La Vanguardia* from Spain; and *Dagens Nyheter*, *Nya Wermlands Tidningen*, and *Göteborgs Posten* from Sweden.

The goal of this pilot study is to provide a general overview on how native advertising is permeating digital legacy news media, quantifying its practice and characteristics. Considering the lack of similar empirical studies, the methodology used here follows an exploratory approach built upon traditional qualitative content analysis that invites further refinements in the future. During the span of a month—January 2015—every website in the sample was scanned daily in the search for native advertising. The demarcations and labeling of native advertising are not always clear and follow different nomenclatures on each publication. Visual, textual, and HTML coding searches for sponsored content in the front page of each digital edition, as well as covering the sponsored content hubs within each publication, were performed daily. The queries searched were: *sponsored, sponsor, brought, paid, support, supported, brand, branded, association*, and *collaboration*. The equivalent words in Spanish and Swedish were used on the respective sites. Since not all sponsored content is native advertising, once a piece of content was

flagged it was analyzed and then classified as native ad or not. Once all publications were scanned, a total of 29 native ads were located and subsequently analyzed. These articles are the unit of analysis. While most websites analyzed in the United States and the United Kingdom offer hubs containing all native advertising articles, the rest do not, which means that there is a possibility that some native advertising units were unable to be identified during the analysis. This is a limitation of the study.

There is a lack of an established research framework to analyze the format and specifications of native ads. Since developing a new framework is beyond the scope of this pilot study, the framework adopted—and adapted—here as measurement to conduct the analysis is largely informed by the specifications presented by the Interactive Advertising Bureau (IAB 2013). The IAB, while having a vested interest in the development and deployment of native advertising, remains the only entity that has an established typology and analytical tool for native ads. Their typology offers six types of commonly deployed ad units that aim to achieve native objectives: (1) *in-feed units*, ads that are placed in the regular flow of the items of the website. This means that in between a feed of news, there are sporadic units that are native ads; (2) *paid search units* are ads placed on top of a list of results deriving from a usual search; (3) *recommendation widgets* are placed on secondary sections of the layout and display native ads. These widgets usually are replicated in several pages across a website; (4) *promoted listings* are complete strings of native ads displayed as a feed of editorial content; (5) *in-ad native element units* take an appearance of a regular commercial, however, the content is aimed to appear editorial; and (6) *custom units* are native ads departing from these configurations and are not necessarily contained within the format of a single article. They still follow the main traits of design of the host website and keep the editorial tone of the ad.

Additionally, the framework for native advertising analysis is based on six characteristics borrowed from IAB's analytical framework with an added variable that incorporates the ad's authorship. These characteristics are operationalized in the following variables: (1) the *form* of a native ad relates to its capacity to fit with the overall page design. The demarcation of form is done inside a continuum between *in-stream* and *out of stream*; (2) *function* concerns itself with the degree in which the ad functions like other elements on the page in which it is placed; (3) *integration* refers to the content behavior. In this case, the two ends of the continuum are "mirroring page content behavior" and "introduced new behaviors"; (4) *measurement* is regarded as the aim behind the ad—whether it is brand engagement or political messages, it attempts to gauge the campaign's goal; (5) *disclosure* is probably the most important characteristic and certainly the most controversial—the ability of the reader to discern whether content is advertising or editorial content has concentrated the debate; (6) disclosing the *author* of a news item has become one of the landmarks for transparency in western journalism (Karlsson 2010), and thus it is important when addressing the blur between commercial and editorial barriers.

The analysis is performed at two levels: first, the type of ad unit in terms of how it is embedded in the website; and second, the main characteristics of the ad article itself.

## Findings

The analysis of the 12 websites offers both converging and diverging results. The provisional nature of these findings shows a first glimpse of a growing trend in journalism, and should not be understood as an attempt to generalize its practice, but rather as a

preliminary empirical study of native advertising within journalism. The results will be discussed according to the analytical framework: *type, form, function, integration, measurement, disclosure*, and *authorship*. Table 1 offers a summary of these results.

Locating 29 native ads becomes a finding in itself. Digital outlets of legacy news media have started to adopt native advertising, yet there are no studies empirically quantifying this practice. This is one of the contributions of this paper.

It is worth mentioning that once the data collection process was completed, no native advertising was found in any of the Swedish publications. However, tabloids in Sweden have started to adopt native advertising, and some of the legacy newspapers analyzed here have assembled teams to start experimenting with it (Edström 2015). Similarly, *The Times* in the United Kingdom offers paywall articles, and did not incorporate native advertising. This is an important finding and thus these news websites remain in the study.

## Type

Among the 29 articles analyzed, four different ad-types are represented. *The New York Times* and *The Washington Post* regularly use *custom* approaches in which their dedicated native ad departments create client-specific campaigns, generally distributed through social media. *The USA Today*, as well as *The Guardian* and *The Telegraph*, predominantly use *promoted listings*, which are distributed in specific sections of the homepage, often reserved for secondary content. *La Vanguardia* uses *recommendation widgets*, which are displayed in different sections of the website offering sponsored content. Finally, *El País* and *El Periódico* use *in-feed units*, which are the most controversial. *In-feed units* are embedded in the main flow of news, and thus are placed where the user is expecting editorial content.

## Form

The way a native ad aims to look like the overall design of the website is operationalized by the variable *form*. The two categories for this variable are *In-stream* and *out of stream*, in which the former follows the design of the host website, and the latter takes on different layout and design. While there are differences between all the articles analyzed, and the degree of fitting varies, there is a clear tendency to lean towards the *in-stream* form. In this regard, the Spanish publications mimic regular articles. *The New York Times* and *The Washington Post* offer a less *in-stream* approach with some designs being tailor-made to fit the story.

## Function

The *function* of a native ad refers to the user experience of the ad. If the ad functions and behaves like the regular elements of the rest of the website, then the ad is categorized as having a *matching* function. The analysis shows an overall trend converging towards the matching function. Certain parts of the ads behave differently in *The Washington Post* and *The New York Times*, like the top menu, as they are branded with their own in-house native advertising design studio—WP Brand Connect and T Brand Studio, respectively.

## Integration

The *integration* of native ads with the rest of the website depends on the capacity of the ad to mirror the editorial content behavior. The categorization of this variable can thus

**TABLE 1**

Native advertising adoption by publisher (January 2015)

| | Total | Type | Form | Function | Integration | Measurment | Disclosure | Authorship |
|---|---|---|---|---|---|---|---|---|
| *The Washington Post* | 5 | Custom | In-stream | Matching | Mild mirroring | Brand building | Clear | No |
| *USA Today* | 2 | Promoted listings | In-stream | Matching | Mirroring | Brand building | Clear | Yes |
| *The New York Times* | 7 | Custom | In-stream | Matching | New behaviors | Brand building | Clear | No |
| *El País* | 3 | In-feed units | In-stream | Matching | Mirroring | Political message | Not clear | Yes |
| *El Periódico* | 4 | In-feed units | In-stream | Matching | Mirroring | Political message | Covert | Yes |
| *La Vanguardia* | 1 | Recommendation widgets | In-stream | Matching | Mirroring | Brand building | Not clear | Yes |
| *The Telegraph* | 4 | Promoted listings | In-stream | Matching | Mild mirroring | Brand building | Clear | Yes |
| *The Guardian* | 3 | Promoted listings | In-stream | Matching | Mild mirroring | Brand building | Clear | Yes |
| *The Times* | 0 | | | | | | | |
| *Dagens Nyheter* | 0 | | | | | | | |
| *Göteborgs Posten* | 0 | | | | | | | |
| *Nya Wermlands Tidningen* | 0 | | | | | | | |
| | 29 | | | | | | | |

be either "mirroring page content behavior" or "introduced new behaviors". Practically all the native ads analyzed use a mirroring strategy, even though *The Washington Post*, *The Telegraph*, and *The Guardian* are marked as mild mirroring because they introduce some slight nuances to content behavior. *The New York Times* is the only publication to partially introduce new behaviors in native ads, unpacking diverging degrees of interactivity.

### Measurement

One of the main characteristics of native advertising is that it does not attempt to openly sell a product, but to provide editorial-like content that is informative while fulfilling marketers' objectives. This is operationalized with the variable *measurement*, which is the main aim of the ad. The newspapers within the Liberal Model—United States and United Kingdom—are clearly aimed at brand building. Their native ads are openly attached to corporate brands, portraying advertisers in a good light, or at least highlighting the importance of their existence.

In Spain, *El País* and *El Periódico* published articles sponsored by political actors, aiming to spread a political message or public relations campaign.

### Disclosure

The critical characteristic of native advertising is the way in which content is disclosed as actual advertising. The celebratory discourse proposes that if readers can tell that what they are reading is a commercial, native advertising would be a legitimate innocuous practice. The general practice in the United States and United Kingdom is to clearly disclose the condition of advertising. "Sponsored content", "in association with", "paid post" or "brought to you" are the most common approaches. *The New York Times* and *The Washington Post* brand their campaigns with their own in-house native ad departments' labels. Additionally, *The New York Times* offers a disclaimer at the bottom of the item, stating that news and editorial staff had no involvement in the piece. Conversely, *The Guardian* is the only publisher offering a clarification of the labels used in commercially related articles: "sponsored by", "brought to you by", and "supported by" identify different degrees of involvement between the marketer and the publication (*The Guardian* 2014).

The Spanish publications did not disclose their native ads clearly. Controversially, *El Periódico* produced four articles for Area Metropolitana de Barcelona (AMB), a local political entity, within the framework of more than a half a million euro contract in which AMB bought an unknown number of articles (Belmonte 2014). The contract was disclosed in the governmental official journal, but was not disclosed on the newspaper's website.

### Authorship

It is considered a sign of transparency to display the journalist authoring the news (Karlsson 2010). However, native advertising is not always written by journalists, or even someone working for that particular publisher. In the ads analyzed for this study, most publishers opt to provide an author of the piece and sometimes even their role. The exception once again is *The New York Times* and *The Washington Post*, who often only mentioned the advertiser as the creator of the content.

## Conclusions

These preliminary empirical findings offer a first glimpse of the ways in which native advertising is incorporated into digital editions of legacy news media. RQ1 (How are the digital editions of legacy news media incorporating native advertising?) can be answered by discussing the analysis of the findings. The number of native ads identified in a single month period ($N = 29$) is still low and thus the implementation is not extensive. The strongest actors in the field have started to incorporate native advertising and are currently developing new campaigns through their own in-house studios, as the WP Brand Connect and T Brand Studio departments clearly show. The general trend is to use custom and promoted listings types of ad, following an in-stream form, a matching function, and a predominantly mirroring integration. Disclosure is mostly used, even though not always very clearly. The measurement or aim of the ad is, in most cases, brand building with the exception of Spanish ads.

The answer to RQ2 (Are there any differences in implementation between different countries? If so, what are these differences?) offers a clear disparity in implementation between countries. The differences are consistent with Hallin and Mancini's (2004) comparative guidelines based on different media systems. According to the three models that they proposed, the Mediterranean Pluralist Model—represented here by the Spanish newspapers—is a model that has stronger political influence and strong state intervention. This is exemplified by the *measurement* of the native ads displayed in Spain, which were majorly aimed at conveying political messages that were not properly disclosed. The Liberal Model —represented here by the British and American newspapers—has a strong professionalism but it is mostly market-dominated. While still preliminary, the results show that these newspapers have adopted more native ads and have a stronger brand-oriented content. Finally, the Democratic Corporatist Model—represented here by the Swedish publications—aims for a strong public service, institutionalized self-regulation, and autonomy. This can also be seen in the data, as this study did not find native advertising in Swedish newspapers which opted for traditional banner-based advertising separate from the editorial content.

The long-standing divide between editorial and commercial content has started to be questioned by powerful actors within the industry. The adopting of native advertising could signal the end of the separation of church and state and the appearance of a new model of openly commercial journalistic ventures. Of course, advertising-supported, commercial-driven journalism has long operated within the confines of commercial influence. However, in the past it was considered a "bad way to survive", a necessary evil which journalists energetically frowned upon in the open. However, the adoption of native advertising is slowly showing signs that the discourse on journalistic independence and autonomy is changing from within. It seems plausible that as this discourse is put into question and the use of native advertising is normalized, public conformance could rise and journalistic autonomy could decrease. Just as autonomy is contested through technological, professional, and commercial fronts, native advertising is also based upon these pillars to further its expansion. Furthermore, if native advertising proves to be a viable business model, it could help sustain a struggling industry by offering informing and entertaining advertising, extending journalistic practice. If this is true, the industry should expect an increase in the use of native advertising.

Future research efforts should pursue longitudinal approaches that study the evolution of implementation of native advertising. Additionally, studies that propose analytical

tools for studying native advertising in journalistic contexts could be helpful, especially to map the uses of paid content in journalism.

## DISCLOSURE STATEMENT

No potential conflict of interest was reported by the author.

## REFERENCES

Austin, Shawn, and Nic Newman. 2015. "Attitudes to Sponsored and Branded Content (Native Advertising)." Digital news report 2015. Reuters Institute for the Study of Journalism.

Bagdikian, Ben H. 2004. *The new Media Monopoly: A Completely Revised and Updated Edition with Seven new Chapters*. Boston, MA: Beacon Press.

Bantz, Charles R. 1997. "News Organizations. Conflict as A Crafted Cultural Norm." In *Social Meanings of News: A Text-Reader*, edited by Daniel A. Berkowitz, 123–137. Thousand Oaks, CA: Sage.

Belmonte, Eva. 2014. "El Área Metropolitana de Barcelona gasta más de 600.000 euros para comprar una sección en El Periódico de Catalunya." Accessed August 5. http:// elboenuestrodecadadia.com/2014/06/05/el-area-metropolitana-de-barcelona-gasta-mas-de-600-000-euros-para-comprar-una-seccion-en-el-periodico-de-catalunya/.

Bloomgarden-Smoke, Kara. 2014. "Time Inc. Editors Happier Without Wall Between Church and State, Says Time Inc CEO." Accessed August 5. http://observer.com/2014/06/time-inc-editors-happier-without-wall-between-church-and-state-says-time-inc-ceo/.

Burns, Kelli S., and Richard J. Lutz. 2006. "The Function of Format: Consumer Response to six on-Line Advertising Formats." *Journal of Advertising* 35 (1): 53–63.

Carlson, Matt. 2014. "When News Sites go Native: Redefining the Advertising–Editorial Divide in Response to Native Advertising." *Journalism*. doi:1464884914545441.

Chittum, Ryan. 2014. "Native Ads Grow Up. The New York Times Gets the Controversial Format Right." Accessed July 5. http://www.cjr.org/the_audit/native_ads_grow_up.php.

Coddington, Mark. 2015. "The Wall Becomes A Curtain: Revisiting Journalism's News–Business Boundary." In *Boundaries of Journalism: Professionalism, Practices, and Participation*, edited by Matt Carlson and Seth C. Lewis, 67–82. New York: Routledge.

Couldry, Nick, and Joseph Turow. 2014. "Advertising, big Data and the Clearance of the Public Realm: Marketers' new Approaches to the Content Subsidy." *International Journal of Communication* 8: 1710–1726.

Croteau, David, and William Hoynes. 2001. *The Business of Media. Corporate Media and the Public Interest*. Thousand Oaks, CA: Pine Forge Press.

Deuze, Mark. 2005. "What is Journalism? Professional Identity and Ideology of Journalists Considered." *Journalism* 6 (4): 442–464.

Edström, Maria. 2015. "Blurring the Lines. Ethical Dilemmas for Journalists with Native Advertising and Other Look-alike Editorial Content." Paper presented at the Normedia conference, 13–15 August, Copenhagen, Denmark.

Ferenstein, Gregory. 2014. "Watch John Oliver Take on the News Industry's New Addiction: Native Ads." Accessed August 4. http://venturebeat.com/2014/08/04/watch-john-oliver-take-on-the-news-industrys-new-addiction-native-ads/.

Hallet, Tony. n.d. "What is Native Advertising Anyway?" Accessed August 1. http://www.theguardian.com/media-network-outbrain-partner-zone/native-advertising-quality-scalability.

Hallin, Daniel C., and Paolo Mancini. 2004. *Comparing Media Systems: Three Models of Media and Politics*. Cambridge: Cambridge University Press.

Howe, Patrick, and Brady Teufel. 2014. "Native Advertising and Digital Natives: The Effects of age and Advertisement Format on News Website Credibility Judgments." *International Symposium on Online Journalism #ISOJ* 4 (1): 78–90.

IAB (Interactive Advertising Bureau). 2013. *The Native Advertising Playbook*.

Johnson, Justin P. 2013. "Targeted Advertising and Advertising Avoidance." *The RAND Journal of Economics* 44 (1): 128–144.

Karlsson, Michael. 2010. "Rituals of Transparency: Evaluating Online News Outlets' Uses of Transparency Rituals in the United States, United Kingdom and Sweden." *Journalism Studies* 11 (4): 535–545.

Kovach, Bill, and Tom Rosenstiel. 2001. *The Elements of Journalism. What Newspeople Should Know and the Public Should Expect*. New York: Crown Publishers.

Matteo, Stéphane, and Cinzia Dal Zotto. 2015. "Native Advertising or how to Stretch Editorial to Sponsored Content Within A Transmedia Branding Era." In *Handbook of Media Branding*, 169–185. Zurich: Springer International Publishing.

McChesney, Robert W. 2004. *The Problem of the Media: US Communication Politics in the Twenty-First Century*. New York, NY: NYU Press.

Peters, Chris, and Tamara Witschge. 2015. "From Grand Narratives of Democracy to Small Expectations of Participation: Audiences, Citizenship, and Interactive Tools in Digital Journalism." *Journalism Practice* 9 (1): 19–34.

Schudson, Michael. 1978. *Discovering the News*. New York: Bacis Books.

Sebastian, Michael. 2014. "Guardian Rolls out U.S. Redesign with Eye Toward Native Ads." Accessed August 6. http://adage.com/article/media/guardian-rolls-u-s-redesign-eye-native-ads/295624/.

Sharethrough. n.d. "Native Advertising. The Official Definition." Accessed July 26. https://www.sharethrough.com/nativeadvertising/.

Shoemaker, Pamela J., and Stephen D. Reese. 2014. *Mediating the Message in the 21st Century: A Media Sociology Perspective*. New York, NY: Routledge.

Sjøvaag, Helle. 2013. "Journalistic Autonomy. Between Structure, Agency and Institution." *Nordicom Review* 34: 155–166.

Soloski, John. 1989. "News Reporting and Professionalism: Some Constraints on the Reporting of the News." *Media, Culture & Society* 11 (2): 207–228.

The Guardian. 2014. "Sponsored content, advertisement features and content supported by foundations". Accessed August 3. https://www.theguardian.com/info/2014/sep/23/paid-for-content.

## ORCID

**Raul Ferrer Conill** ⓘ http://orcid.org/0000-0002-0501-2217

# EMBEDDED LINKS, EMBEDDED MEANINGS
## Social media commentary and news sharing as mundane media criticism

**Matt Carlson**

*Social media transform the consumption environment of news by allowing users to separate individual stories from their original context within a bounded news product and recirculate them in new contexts. If, as this essay argues, the meaning of a news story stems from the interplay of textual and contextual elements, then this shift has interpretive consequences that require further conceptualization. An initial foray is made by developing a concept of mundane media criticism to account for the prevalence of social media commentary that accompanies the circulation of news stories through social media, including directly through news sharing. In this environment, to consume a news story is to simultaneously consume criticism of that story.*

## Introduction

Social media inhabit a central place in thinking about journalism in the digital age. This preoccupation is not difficult to understand. Social media provide a nebulous public space comprised of actors ranging from established institutions with pre-existing social status (news organizations among them) to individuals communicating with a few friends or followers. This is hardly a flat space—the reach of an average user is not comparable to Justin Beiber—yet its promotional mechanisms enable virality. Social media facilitate myriad conversations, flows of information, a lot of humor, and, of course, news.

Social media are often remarked upon for creating new spaces in which journalists and news consumers come together. This dynamic has generated a great deal of research interest, as even a cursory glance at journalism studies journals indicates. Much of the research on journalism and social media has tended to focus on how journalists use new media tools to gather, promote, and disseminate news in these spaces. Key questions include whether journalists pursue social media as merely another channel for mass communication, a collaborative space in which news practices become more transparent, or some combination. Another strand has examined how social media allow citizen journalists to provide their own mediated accounts, particularly in crisis situations, in ways that blur journalism's boundaries. Social media become spaces for mediated witnessing, citizen fact checking, and, of course, commentary. This essay adds another dimension by conceptualizing how social media users shape the meaning of news texts through their response to and recirculation of news stories. Social media provide a metadiscursive mediated space in which conversations about news stories occur alongside links to these stories.

Commenting on and sharing news are two well-known uses of social media. News consumers easily spread links to and comments about news stories with their networks, taking on a gatekeeping role once reserved for journalists (Bruns 2005; Coddington and Holton 2014; Singer 2014; Vos 2015). This essay goes further to argue these practices need to be understood as interpretive actions that shift the context of news consumption away from the original site of its production to re-embed news stories in new webs of meaning. Commentary provides extra-textual meanings that situate news stories in particular ways for other readers. These actions may seem trivial at first glance, but close scrutiny reveals how the circulation of news through social media affects the establishment of meaning around news texts.

Understanding how social media commentary and news sharing practices shape meanings surrounding the circulation of news stories contributes to the journalism studies literature by moving beyond the treatment of a news story as a discrete, self-contained text to attend to the wider interpretive context in which news consumption occurs. This essay homes in on commentary and news sharing taking the form of "mundane media criticism" through which users articulate public judgments about journalism that, in turn, shape how others consume news stories. In this scenario, the consumption of a shared news story is inseparable from the consumption of an interpretation of the story; news discourse is joined with metajournalistic discourse.

## Establishing Journalistic Meaning: Text and Context

How do news texts create meaning? This is a fundamental question, but also a difficult one. From a mass communication perspective, news texts utilize formal and epistemological conventions to provide mediated accounts of happenings. News is a discourse understood by numerous stakeholders: journalists, sources, and audiences. The routinization of forms allows for tacit recognition of a text as a news story and not some other discursive form. Yet meaning is more complicated than this schematic. When Robert Park (1940) examined news as a form of knowledge, he had to wrest the idea of knowledge away from its association with technical or professional knowledge to associate the term with the unending, always fleeting, terrain of news. News stories communicate an account of an event, utilizing different channels of information—text, images, audio, etc. However, the analysis of textual components alone cannot explain the establishment of meaning. Instead, textual characteristics join contextual factors to create journalistic meaning.

Scholars of anthropology and nonverbal communication know well the importance of context to interpretation. A wink, for example, is a subtle physical gesture that can have enormous semantic consequences (Geertz 1973). Yet journalism research has tended to downplay context by extracting news texts from their social location. Studies emphasizing framing choices or thematic narrative elements across a corpus of texts do so by isolating these texts from their original placement in the news (a methodological choice this author has employed). This scholarship should not be denigrated, but instead recognized as trading thoroughness across a body of work for entrenched understandings of individual story contexts. Mirroring the charge levied at experimental social science research, the study of news circulation too rarely occurs *in situ*.

The importance of examining any news story in the context of its appearance emerges from two elements developed in an earlier study (Carlson 2007). First, the

meaning of any news texts is informed by its placement alongside other news items. The inclusion of a news story as news is already pregnant with meaning as a marker of importance. The existence of any news story is "a call on public attention" (Schudson 1995, 19). By contrast, excluded events are deemed not to be newsworthy, or at least to be comparatively less newsworthy. This inclusion/exclusion dynamic speaks to the authority of journalists to act as professional arbiters of social importance. Journalists act as gatekeepers charged with deciding what is made public (Shoemaker and Vos 2009). The effects of this role have been alternately conceived of as the setting of the news agenda (McCombs and Shaw 1972) or the dictating of social reality (Hall et al. 1978).

Beyond the binary of inclusion/exclusion lies the more complex positioning of news stories. Barnhurst and Nerone (2001) track the evolution of newspaper design from a cacophony of nineteenth-century papers to the orderly front pages of twentieth-century news. This is not merely a stylistic evolution, but also an ideological shift in which news judgment meant curating events into a hierarchical system in which the meaning of any news item *vis-à-vis* other items can be realized from its relative placement. With broadcasting, the linear flow of stories requires careful ordering. As positioning becomes a source of meaning, a whole array of devices have sprung up across different media to communicate relative importance to the news audience. Certain stories become "front-page news" or a "top story" while other events are relegated to the back of the newspaper, the end of the news broadcast, or the background of news sites. This is not haphazard, but a deliberate arrangement that confers relative importance on topics and actors. Positioning and its accompanying cues tell the audience how to interpret a story—as important or inconsequential, as serious or humorous, as of general import or only for an audience fragment, etc. This is not an argument that all audience members must mirror the interpretive arguments journalists make through story placement, but a recognition that these widely understood conventions are learned by news audiences.

The contextual dynamics of story inclusion and story placement have become more complicated in the digital news environment. Although news sites have their own conventions for signaling importance, news search engines and personalization tools disintermediate news texts and remove contextual meaning established by the news organization (Carlson 2007). Meanwhile, through republication, aggregators rearrange meanings (Anderson 2013). To this list, we must add the transformation of news consumption through social media.

## News Sharing

News consumption has always been a communal activity. Print culture is often associated with individualization, or detribalization (McLuhan 1962), but news print products are also texts that can be read aloud and material artifacts that can be sent through space. These two actions get to a definition of news sharing as the practice of non-journalist news consumers relaying news to others. From this broad perspective, news sharing has a long history. Early newspapers were rare, expensive items before they became ubiquitous disposable products casually discarded or repurposed as birdcage liners. Uneven literacy also meant the necessity of reading news out loud. News sharing also meant such material practices as copying and circulating news clippings and the creation of personal archives of stories to be preserved. These news sharing actions became easier with the rise of digital news and email.

News sharing is a deeply ingrained facet of news consumption that can be found in the seminal literature of news audiences, from Berelson's (1948) study of New Yorkers coping with a newspaper strike to Katz and Lazarsfeld's (1955) influential two-step flow of human agents as both receivers and disseminators of news. Yet despite the prevalence of news sharing as a cultural practice, an emphasis on neoliberal individualist norms often obscures this role. Over time, notions of citizenship have shifted from communal forms of identity to individualistic ones in which news consumers act as rational citizens (Schudson 1998). Journalism's normative defenses developed in concordance with this vision by stressing the provision of objective news to individuals who are then expected to formulate independent political positions (Kovach and Rosenstiel 2001). News sharing points to an alternative consumption of the news consumer as embedded in social networks through which news circulates. An audience member is not an endpoint, but a node in a network.

Social media reinvigorate the idea of news sharing by making it a mediated activity carried out in public through social media platforms. In this context, news sharing is used here to pertain to a range of practices, from the mere re-transmission of a news story link, to re-transmission with commentary, to commentary about news stories. What unites these practices is the transformation of the context of news consumption away from its original placement. In doing so, news sharers present individualized calls to attention. Digital publishers have responded by creating an infrastructure of prominently featured news sharing tools in the hopes of extending the reach of any given story in order to attract attention that is then convertible to revenue. News is being integrated into social media with the express purpose of further facilitating news sharing. News audiences become disseminators of news through such simple actions as sending a tweet or posting on Facebook. Singer refers to this burgeoning function as "secondary gatekeeping" that empowers users to control news flows:

> Users' active participation in assessing the value—and in doing so, determining the visibility—of what is published on a media website goes well beyond previous journalistic conceptions of what audience members can or should do. Users now have the capability to make and implement what essentially are editorial judgments about what is worthy and what is less so, about what others should read and what they might as well ignore. (Singer 2014, 56)

News sharing involves an evaluative component in which users must interpret the value of any story and its potential desirability to others. For this sharing to take place, there is also a network component enjoining users. News sharing then moves away from the sender–receiver dynamic of mass communication to encourage sensitivity to the complex networks in which news travels (Domingo, Masip, and Meijer 2015).

The disintermediation of individual news texts from the larger context of the finished news product is a radical shift for journalism that has not received sufficient attention. The bounded news product acted as a statement of importance and an attempt to develop a shared culture. In Carey's (1992) sense, the ritual of news consumption aided the formation of communal ties and shared commitments. By contrast, generations of news scholars have quite deservedly decried both the overemphasis on certain actors and topics and the omission of others in these news texts. The shift to atomized news stories untethered to placement among other news items has its own perils and promises. It both expands the universe of available news stories and allows individual users to consume a narrower diet of topics or perspectives (Pariser 2011). The cultural consequences of this news

environment will continue to occupy much scholarly attention, but the focus here is on news sharing as an interpretive discursive practice.

Much of the existing literature on news sharing has largely been driven by media effects paradigms using quantitative methods or a uses and gratification model (see Lee and Ma 2012). These are important efforts to chart a new practice, but they rarely consider what news sharing means for news. This essay treats news sharing as a cultural practice— that is, as contextualized, patterned action with interpretive consequences. News sharing should be recognized as a distinct discursive practice marked by being in-between an idealized model of the citizen journalist as a creative actor and the audience as a collection of atomized passive individuals. News sharing comprises not only the transmission of comments and links, but a whole set of accompanying contextual meanings providing the receiver of the sharing with suggestions for how to interpret and consume the shared news story (or perhaps reasons to avoid it). The presence of textual cues underscores the argument that news sharing is not a neutral activity, but one that shapes the context of news consumption. This claim can be made clearer through focusing on the ways in which news sharing acts as a form of media criticism.

## The Rise of Mundane Media Criticism

As a discourse of representation, the news can never escape criticism. Journalism's core assertion of providing accurate accounts of events in the world invites perpetual critique. Such criticism is motivated by self-interested actors trying to affect media coverage (Carlson 2009, 2015) as well as by others who point to the gap between journalistic norms and news products (Dahlgren 1992). Although media criticism encompasses a wide array of discourses (including scholarly work), it is used in this essay to refer to "popular media criticism" or the production of public-facing criticism. Such criticism is defined by its mediated quality and arises from many sources, including media watch groups, politicians, media critics, and regular news consumers. It also is a staple of digital media, including blogs (Vos, Craft, and Ashley 2012).

Situating media criticism within the greater news ecology requires a theory of metajournalistic discourse that connects discourse about journalism to news production and consumption (Carlson, forthcoming b). From this perspective, talk about news is not an isolated discourse, but one inextricably linked to news discourse and the practices that create it. Metajournalistic discourse defines and demarcates the possibilities for journalism as a cultural practice. It gives rise to the creation of both shared identities (Zelizer 1993), competition over competing forms (Lewis 2012), and the negotiation of new material forms (De Maeyer and Le Cam 2015). By providing a public arena for the propagation and contestation of shared conceptions of legitimate news, metajournalistic discourse occupies a central role in the social construction of journalistic authority (Zelizer 1992).

Much of the research on popular media criticism examines the work of media critics (Haas 2006; Carlson 2007; Handley 2012), responses to critical events like scandals (Reese 1990) and economic crises (Chyi, Lewis, and Zheng 2012), or the remembrances of prominent journalists (Carlson and Berkowitz 2014). This research coalesces around substantial texts, often authored by established social actors, with a strong focus on case studies of a particular incident, news organization, or person. Although this research offers useful findings, it tends to overlook what might be called "mundane media criticism"—the terrain of casual mediated utterances evaluating the performance of news media. It is mundane in

that its prevalence escapes notices in its micro-iterations. An individual comment may not receive recognition as metajournalistic discourse defining the boundaries of legitimate journalism, but, in the aggregate, mundane criticism has become a staple of public expression about the news. A much remarked upon aspect of social media is the extension of access to mediated communication, which should include an interest in mundane media criticism.

Mundane media criticism consists of short utterances accompanying the sharing of a news story or as a response to a news story. On social media, these utterances constitute a particular contextual element that circulates alongside a news story. The audience simultaneously encounters the story with this commentary, and often the commentary precedes the story. In this latter scenario, this commentary provides an interpretive lens for the consumption of the story. This is not to argue that the recipient must accept the criticism being offered—such statements do not determine meaning for others. Nonetheless, when the recipient consumes criticism prior to encountering the story, it plants an expectation that becomes part of how the reader confronts a story.

As a form of micro-criticism, mundane media criticism is notable for short, direct attacks rather than sustained argument. However, this conciseness should not be dismissed as insubstantial. Any media criticism text has its antecedents, and long-running narratives can be easily activated. For example, in the United States perhaps the most persistent narrative within metajournalistic discourse is the accusation of entrenched leftist bias among journalists (Carlson 2009). This discourse can be succinctly activated through mundane media criticism. Conversely, mundane media criticism reinforces these narratives as they are perpetuated through social media.

Taken as a whole, mundane media criticism becomes part of the consumption environment of social media. The circulation of news involves the simultaneous circulation of meanings about the news. Theorizing about the significance of mundane media criticism begins with longstanding understandings of the news audience popularized by cultural studies. A key tenet of this literature is the movement away from a fixed meaning of a text to instead locate meaning-making in the interaction between texts and audiences—Hall's (1993) famous moment of "decoding." The interpretation of any news story depends (although is not wholly determined by) the social position of the audience member. Adapting these perspectives to social media requires moving beyond modes of audience reception bound up in the mass communication model to account for the productive abilities of social media as sites for expression. Mundane media criticism is one form of this expression. It allows news audiences to re-interpret the meanings of any news story in the act of passing it along to others. Cumulatively, these actions signal the power of the news audience to generate meaning about news stories outside the news text itself.

Mundane media criticism involves methodological challenges concerning how best to examine this diffuse phenomenon. Conceptually, the effects of such criticisms are held to occur in the aggregate, which creates difficulties around creating a meaningful sample. With an individual bit of criticism—a tweet or a Facebook post—judging impact based on audience exposure is difficult. Certain tweets or posts "go viral" by attracting users who then re-disseminate them to others. This provides an index of popularity, but assigning a threshold between "viral" and "not viral" is not simple. Some potential strategies include examining a bounded case study around an individual story to track how messages flow. In this pursuit, the tools of actor network theory (Latour 2005) are useful for looking at

connections between actors—including nonhuman ones. The in-depth interpretive tools of reception studies can also be used to examine news-sharing interactions.

A short example can help clarify the shape of mundane media criticism occurring through social media. At the time of the 2015 Wimbledon final, the *New York Times* ran an article titled "Tennis's Top Women Balance Body Image with Ambition" (July 10, 2015) focused on how female tennis players confront expectations of femininity with athleticism. It provoked a wave of criticism on social media accusing the article of reinforcing gender and racial stereotypes of beauty through its exclusive focus on female athletes. This response consisted of many social media texts responding to the original story, some of which were gathered together in another set of texts. *Vibe* (Hillyer 2015) provided an example of this meta-metadiscourse through a collection of such tweets as [Twitter user-names removed]:

- @nytimes Stupid article!!!! Can they win?? Can they beat her?? If not then they NOT good enuf!!! Let them "emulate" her excellence!!
- This is the most racist and sexist article I have seen in my adult life. Congrats? @nytimes
- This black people as "beast" thing needs to go down like the #ConfederateFlag ... starting with you @nytimes. Seriously. Apologize to #Serena
- @nytimes the only good thing about this tweet is seeing all the tweets in response calling out this bullshit.

The outcry prompted Margaret Sullivan, the *New York Times*'s Public Editor, to address the article on her blog, which included an embedded tweet blasting the story as racist. After reviewing the social media criticism and the response from the author and his editors, Sullivan (2015) echoed this criticism by concluding, "it's unfortunate that this piece didn't find a way to challenge the views expressed, instead of simply mirroring them."

The backlash to the *New York Times* story and the defense of Serena Williams provides a thumbnail example of what mundane media criticism looks like. Plenty of *New York Times* readers likely encountered the story in print or on the newspaper's site, but others came across the story through this online criticism. This latter audience became aware of the story within this critical context. As a body of texts, these responses challenged the journalistic representation of nonwhite female athletes. It demonstrates how mundane media criticism can coalesce in certain moments and even prompt a critical internal response from a news outlet. Yet the example also makes clear the conceptual and methodological difficulties of analyzing mundane media criticism. How much does any single tweet matter? How do they form a network? What is the context of their consumption? These issues will need to be worked out in future empirical investigations.

## Conclusion

At the heart of this essay is a caution to be wary of what is taken for granted in the new media environment. Social media have quickly evolved from a peripheral activity to become hubs of media activity, transforming legacy media by providing a platform that intermeshes modes of interpersonal and mass communication. Social media news commentary and news sharing have become common, in part spurred on by content producers looking to extend their reach. News organizations' efforts to partner with Facebook (Stelter 2015) demonstrate the continuing institutionalization of this approach to content distribution. Beyond affecting how news is produced, consumed, and circulated, its meaning

for journalistic authority also needs to be assessed. The act of sharing news on social media is itself a meaningful practice in which the sharer makes a claim on others' attention.

Disintermediation from traditional news products and the remediation of news texts by sharers presents a novel news consumption environment. This is an alternative context from the traditional spaces of news, where inclusion and positioning are used to create meaning for any story. One aspect of this is a new terrain of widespread media criticism occurring through the same social media channels through which stories travel. The concept of mundane media criticism helps bring into relief the close connections between news transference and interpretative framing. In commenting on or passing along news stories, sharers add meaning that shapes the conditions of consumption for others. While the impact of any individual bit of mundane media criticism may appear miniscule, in aggregate a whole new consumption environment presents a radical departure from mass communication news flows. What is needed is a broader framework to accommodate how these flows may make news meaningful and how persistent micro-critiques affect the journalist–audience relations underpinning journalistic authority (Carlson, forthcoming a).

This is a cursory attempt to examine the consequences of social media commentary and news sharing on the cultural authority of journalism, which will hopefully spur further conceptual and methodological innovation. However difficult, empirical research is needed to trace the flows of news stories and criticism about these stories through social networks. Doing so will shed light on the twin circulation of news and interpretations of news through social media. An assessment of how the presence of mundane media criticism on social media feeds back into the newsroom to influence news work is also needed. Finally, as news sharing evolves, more attention will be needed to understand how these form the interpretive context of news consumption. Although challenging, the need for this research will only grow as news circulation—and the circulation of discourse about news—becomes more complicated.

## DISCLOSURE STATEMENT

No potential conflict of interest was reported by the author.

## REFERENCES

Anderson, C. W. 2013. "What Aggregators Do: Towards a Networked Concept of Journalistic Expertise in the Digital Age." *Journalism* 14 (8): 1008–1023.

Barnhurst, Kevin G., and John C. Nerone. 2001. *The Form of News: A History*. New York, NY: Guilford Press.

Berelson, Bernard. 1948. "What Missing the Newspaper Means." In *Communications Research 1948–1949*, edited by Paul F. Lazarsfeld and Frank N. Stanton, 111–129. New York, NY: Harper.

Bruns, Axel. 2005. *Gatewatching: Collaborative Online News Production*. New York, NY: Peter Lang.

Carey, James W. 1992. *Communication as Culture*. London: Routledge.

Carlson, Matt. 2007. "Order versus Access: News Search Engines and the Challenge to Traditional Journalistic Roles." *Media, Culture and Society* 29 (6): 1014–1030.

Carlson, Matt. 2009. "Media Criticism as Competitive Discourse Defining Reportage of the Abu Ghraib Scandal." *Journal of Communication Inquiry* 33 (3): 258–277.

Carlson, Matt. 2015. "Keeping Watch on the Gates: Media Criticism as Advocatory Pressure." In *Gatekeeping in Transition*, edited by Tim Vos and François Heinderyckx, 163–179. New York, NY: Routledge.

Carlson, Matt. Forthcoming a. *Journalistic Authority*. New York, NY: Columbia University Press.

Carlson, Matt. Forthcoming b. "Metajournalistic Discourse and the Meanings of Journalism: Definitional Control, Boundary Work, and Legitimation." *Communication Theory*. doi:10.1111/comt.12088

Carlson, Matt, and Dan Berkowitz. 2014. "The Late News: Memory Work as Boundary Work in Commemoration of Television Journalists." In *Journalism and Memory*, edited by Barbie Zelizer and Keren Tenenboim-Wienblatt, 95–110. London: Palgrave Macmillan.

Chyi, Hsiang Iris, Seth C. Lewis, and Nan Zheng. 2012. "A Matter of Life and Death? Examining How Newspapers Covered the Newspaper 'Crisis'." *Journalism Studies* 13 (3): 305–324.

Coddington, Mark, and Avery E. Holton. 2014. "When the Gates Swing Open: Examining Network Gatekeeping in a Social Media Setting." *Mass Communication and Society* 17 (2): 236–257.

Dahlgren, Peter. 1992. "Introduction." In *Journalism and Popular Culture*, edited by Peter Dahlgren and Colin Sparks, 1–23. London: Sage.

De Maeyer, Juliette, and Florence Le Cam. 2015. "The Material Traces of Journalism: A Socio-Historical Approach to Online Journalism." *Digital Journalism* 3 (1): 85–100.

Domingo, David, Pere Masip, and Irene Costera Meijer. 2015. "Tracing Digital News Networks: Towards an Integrated Framework of the Dynamics of News Production, Circulation and Use." *Digital Journalism* 3 (1): 53–67.

Geertz, Clifford. 1973. *The Interpretation of Cultures*. New York, NY: Basic Books.

Haas, Tanni. 2006. "Mainstream News Media Self-Criticism: A Proposal For Future Research." *Critical Studies in Media Communication* 23 (4): 350–355.

Hall, Stuart. 1993. "Encoding, Decoding." In *The Cultural Studies Reader*, edited by Simon During, 90–103. London: Routledge.

Hall, Stuart, Chas Critcher, Tony Jefferson, John Clarke, and Brian Roberts. 1978. *Policing the Crisis: Mugging, the State and Law and Order*. London: Macmillan.

Handley, Robert L. 2012. "What Media Critics Reveal About Journalism: Palestine Media Watch and US News Media." *Journal of Communication Inquiry* 36 (2): 131–148.

Hillyer, Diamond. 2015. "Twitter Was Not Here For This Serena Williams Body Image Article By 'The New York Times.'" *Vibe*. Accessed July 12, 2015. http://www.vibe.com/2015/07/serena-williams-body-image-ny-times/.

Katz, Elihu, and Paul F. Lazarsfeld. 1955. *Personal Influence*. Glencoe, IL: Free Press.

Kovach, Bill, and Tom Rosenstiel. 2001. *The Elements of Journalism*. New York, NY: Three Rivers Press.

Latour, Bruno. 2005. *Reassembling the Social*. Oxford: Oxford University Press.

Lee, Chei Sian, and Long Ma. 2012. "News Sharing in Social Media: The Effect of Gratifications and Prior Experience." *Computers in Human Behavior* 28 (2): 331–339.

Lewis, Seth C. 2012. "The Tension Between Professional Control and Open Participation: Journalism and its Boundaries." *Information, Communication & Society* 15 (6): 836–866.

McCombs, Maxwell E., and Donald L. Shaw. 1972. "The Agenda-Setting Function of Mass Media." *Public Opinion Quarterly* 36 (2): 176–187.

McLuhan, Marshall. 1962. *The Gutenberg Galaxy*. Toronto: University of Toronto Press.

Pariser, Eli. 2011. *The Filter Bubble*. New York, NY: Penguin.

Park, Robert E. 1940. "News as a Form of Knowledge: A Chapter in the Sociology of Knowledge." *American Journal of Sociology* 45 (5): 669–686.

Reese, Stephen D. 1990. "The News Paradigm and the Ideology of Objectivity: A Socialist at the Wall Street Journal." *Critical Studies in Media Communication* 7 (4): 390–409.

Schudson, Michael. 1995. *The Power of News*. Cambridge, MA: Harvard University Press.

Schudson, Michael. 1998. *The Good Citizen*. New York, NY: Free Press.

Shoemaker, Pamela, and Tim P. Vos. 2009. *Gatekeeping Theory*. New York, NY: Routledge.

Singer, Jane B. 2014. "User-Generated Visibility: Secondary Gatekeeping in a Shared Media Space." *New Media & Society* 16 (1): 55–73.

Stelter, Brian. 2015. "Why Facebook is Starting a New Partnership with 9 News Publishers." *CNN*. accessed May 13, 2015. http://cnnmon.ie/1KI5ll7.

Sullivan, Margaret. 2015. "Double Fault in Article on Serena Williams and Body Image?" *New York Times*. Accessed July 13, 2015. http://nyti.ms/1UVhEBB.

Vos, Tim P. 2015. "Revisiting Gatekeeping Theory During a Time of Transition." In *Gatekeeping in Transition*, edited by Tim P. Vos and François Heinderyckx, 3–24. New York, NY: Routledge.

Vos, Tim. P., Stephanie Craft, and Seth Ashley. 2012. "New Media, Old Criticism: Bloggers' Press Criticism and the Journalistic Field." *Journalism* 13 (7): 850–868.

Zelizer, Barbie. 1992. *Covering the Body*. Chicago, IL: University of Chicago Press.

Zelizer, Barbie. 1993. "Journalists as Interpretive Communities." *Critical Studies in Media Communication* 10 (3): 219–237.

# POWER TO THE VIRTUOUS?
## Civic culture in the changing digital terrain

**Kristy Hess**

*Much scholarship laments a decline in civic participation and community social capital in a changing media world. But the concept of "civicness" remains important to functioning societies across the globe. This research borrows from the cultural turn in studies of media, communication and citizenship to examine civic as culture, anchored in the practices and symbolic milieu of everyday life. As its theoretical entry point, this research paper positions civic as virtue. Drawing on scholars from Aristotle to Pierre Bourdieu, civic virtue may be understood as a perceived moral obligation to serve the common good, especially the interests of a "community" in which individuals and/or groups are connected. In particular, the research extends Bourdieu's ideas to consider news media as a powerful institution alongside the state that may claim monopoly over the manipulation of civic virtue under certain social conditions. Civic virtue offers much in discussions about media power in the digital age and its relationship to the future viability and legitimacy of news media. The research draws on exemplars from a study into digitally mediated civic participation in a rural/regional Australian context to position certain local media as "keepers" and "conferrers" of civic virtue in the social settings they serve.*

## Introduction

At a time when the future of traditional news media faces uncertainty, there is also concern that civic participation—so vital to lubricating the wheels of democratic societies—is waning (see e.g. Putnam 2000; Kinney 2012). There is much scholarship that celebrates news media as providing the information essential to civic life, but in the digital world there is now a plethora of platforms available in which people can communicate with one another. This research examines the relationship between the civic and issues of media power and legitimacy in the changing digital landscape. To do this, the paper engages with the philosophical concept of civic *virtue*—the ethical/moral obligation to serve the common good—especially the interests of a "community" in which individuals and/or groups are socially connected (Burtt 1990; Hurka 2001; Audi 2000). Specifically, it extends the work of Pierre Bourdieu to argue there is great power to media institutions that are seen as central to upholding and perpetuating civic *virtue* in the communities they serve (see Hess 2016). In doing so, it resists a functionalist account that positions news media as putting the interests of the common good ahead of all else (see the communitarian view, especially Christians 1999; Borden 2010) or as a neutral conduit in which information flows. Rather, it highlights the advantages that come to media considered the legitimate platform to perpetuate and reinforce civic life, exemplified at the local level.

Media scholars who engage with the concept of *virtue* tend to provide an overview of the meta-ethical and normative positions that frame discussions, surveying deontology, forms of utilitarianism and virtue ethics (see e.g. Gordon et al. 1999; Borden 2010; Ward 2010; Couldry, Madianou, and Pinchevski 2013). This essay sidesteps such discussions by viewing civic virtue as the way people come to think about "community" and "collectivity" and the media's central relationship to this. The paper positions certain news media—especially at the local level—as "keepers and conferrers" of civic virtue. This is because of their symbolic power to construct reality (Bourdieu and Thompson 1991) and their centrality to the civic is consecrated by both the state and the actions of everyday people in the social spaces they serve. The essay illuminates key contentions by drawing on extracts from a series of interviews and a focus group that examined the relationship between media and civic life in rural/regional Australia in 2015. A burgeoning local government area covering 600 square miles with a population of 25,870 (that swells to more than 100,000 in summer months with tourism) was selected for study. In comparison to some local areas that receive little news and information, especially in the United Kingdom (see e.g. Fenton et al. 2010), the municipality has several active news providers. There are two weekly newspapers which have print and online presence (print is distributed free to letterboxes). There is a radio station covering the municipality along with several other local government areas in the district and designated Facebook pages have been set up for specific groups such as a local "buy, sell and swap" and political activist groups. Television services are located in a nearby capital city and do not provide designated, regular news for the municipality.[1]

## Defining the Civic

Civic life is widely considered synonymous with political life. The Oxford Dictionary, for example, defines civic as "relating to a city or town, especially its administration, municipal" (www.oxforddictionaries.com/definition/english/civic). There is not scope here to wade into the extensive definitional work across democratic, political community, governance and social theory on civic engagement, but it is widely linked to political participation (see e.g. Delli Carpini 2004; for an excellent summary of definitions of civic participation, see Adler and Goggin 2005). It is important, however, to acknowledge the growing body of scholarship that recognizes the social and apolitical dimensions of civic life. Political scholar Robert Putnam (2000) argued civic participation extends beyond the walls of politics to include informal social activities (visits with friends, card games) as well as formal activities (committee service, community and political participation). The cultural shift in media studies, meanwhile, also adopts the "hunch" (Bakardjieva 2009) that studying people's conversations and practices at the everyday level of society can tell us much about civic participation. This cultural turn has led to the introduction of notions such as civic culture (Dahlgren 2003, 2009), cultural citizenship (Hermes 2006), public connection (Couldry, Livingstone, and Markham 2007) and subactivism (Bakardjieva 2009). Dahlgren (2003 , 153) argues that while the boundaries between the civic and political are blurred and difficult to distinguish it is important that we do in order to understand civic culture. Dahlgren views the civic more like a social storehouse that can be drawn upon to enact political participation. He suggests the "civic" should be understood as the prerequisite for the political, "a reservoir of the pre- or non-political potentiality that becomes actualized at particular moments when politics arises" (154).

*Civic Virtue*

This research positions the civic in terms of the broader philosophical notion of civic *virtue*. This helps to shift understandings of the civic from a resource or reservoir for political action (Dahlgren 2003) to an embodied disposition among individuals to act and feel in a certain way, often without reflection or conscious thought (see Dagger 1997; Hurka 2001). Civic *virtue* is understood as the "blueprint" for an individual that outlines what to do in a given situation—to further the common good and determine the way a good citizen should behave in a given "community" (Blanken 2012; see Dagger 1997). I have argued elsewhere that the common good serves as a richer foundational concept for journalism than the politically oriented idea of serving the public good, because the former is associated with ideas of community, morality, meaning-making, notions of good and evil (Hess 2016). It helps to separate politics from culture and illuminates issues of power. For example, when asked to describe or define the "civic", participants in the Australian study all defined the concept as being synonymous with the idea of "community" and "collectivity", beyond the political sphere alone to incorporate social and moral dimensions. Consider these comments from an elected municipal councillor:

> Civic means you are part of a collective and involving yourself in the collective, beyond politics. It is your duty to being a good citizen ... I think it acknowledges that we are all in it together (Interview with researcher, 1 July 2015)

A part-time resident who had a long-term holiday home in the district offered this perspective:

> it is something bigger than politics, that we can all do the right thing by each other when it matters. (Interview with author, 3 May 2015)

Scholars such as Audi highlight there is good reason for civic virtue to be considered moral as it requires people to respect others and is incompatible with immorality in the social arena such as cheating, pillaging, etc. (Audi 2000, 151)—as demonstrated by the comments above. Theologist Patrick Riordan (2008, 2015) positions the common good and its subsidiary of civic virtue as a heuristic concept—naming something not already known in detail but to be discovered during ongoing deliberation (see e.g. Riordan 2008). Riordan (2015) contends the concept of the common good furnishes postmodern humanity with a valuable tool of analysis and persuasion. He argues that while shared meaning can be taken for granted, there are times it becomes a goal for action when there is a crisis and a need to repair, sustain or regenerate the meaning (Riordan 2015). There are both advantages and inequalities that arise from the role of "meaning makers" in society whom can also serve (and are expected to serve) as a moral compass in certain social contexts. I have argued the work of Pierre Bourdieu helps to illuminate how certain institutions are central to upholding and perpetuating civic virtue to retain their own power and legitimacy (Hess 2016).

## Bourdieu and Pillars of Virtue

In Bourdieu's scholarly work, he outlined three universes (political, religious and scientific fields) (Wacquant 2004). Each are based on a division between the profane and the specialists who claim monopoly over the manipulation of three essential goods—

scientific truth, spiritual salvation and civic virtue (Wacquant 2004, 13). He argues under certain conditions actors have a personal interest in being seen as virtuous, but he pays little attention to the media here. Such actors can draw symbolic gains, probably good reputation and social integration, and eventually material ones, from disinterested behaviour and being seen as central to upholding such ideas (Bourdieu 1998, 89, 142).

A key aspect of Bourdieu's work is that certain institutions and individuals in society, over time, are seen to "stand in" for the civic without conscious effort or challenge and hence perpetuating the importance of civic virtue is necessary to retain symbolic power[2] (Bourdieu 1998). The political field (see Bourdieu 1984), for example, is positioned as the "natural" centre of civic life. Participants in the Australian study perceived local government authorities as the primary custodian of the "civic"—in the localities where people lived, worked or had a "sense of place" (see Hess 2013).

An active volunteer, aged in his 70s, offered this view:

> When you live in a community, local government is just a civic body that's the authority. It's unquestioned. I don't put community organizations under the umbrella of civic institutions because they have no power. You can't do anything without power. (Interview with researcher, 17 July 2015)

The reference to local government authorities as the "unquestioned" authority speaks to Bourdieu's concept of misrecognition (Bourdieu 1977)—an unspoken, unquestioned power to influence facets of society—in this instance the idea of "civic" life. The intention of this paper is to conceptualize certain news media as a type of specialist, like the state, that Bourdieu argues can manipulate civic virtue to their own advantage (Bourdieu 1998). To unpack this further, I suggest that certain news media can be understood as "keepers" and "conferrers" of civic virtue in the "communities" they serve—exemplified most strongly at the local level. As a framework, this may serve to help the elite grow stronger in strategizing ways to maintain advantage in a digital world. It may also be useful to help others challenge media power. Either way, the intention here is to unmask it.

## News Media as "Keepers" of Civic Virtue

Bourdieu asks what are the social conditions and possible sites in which virtue pays—where expressions of the common good mask a direct self-interest to an individual or group but benefit society all the same (Bourdieu 1998). The term keeper is synonymous with custodian, warden, protector, minder. It implies a degree of power or control. The keeper is also a term given to a position on a sporting field where players competing to gain an advantage over others aligns with Bourdieu's theory of social space and associated concepts of field, habitus and capital (Bourdieu 1984). Those that are seen as keepers of civic life, I suggest, stand to gain, symbolically and economically.

### "Imagined Communities"

As keepers of civic virtue, certain news media wield symbolic power—the power to construct reality (see Bourdieu 1990; Couldry 2012). There is extensive literature that links local media as a powerful institution in generating feelings of community and collectivity (Anderson 1983; Moores 2000; Buchanan 2009; Mersey 2009; Hess and Waller 2015). The majority of participants in the Australian study outlined the important role of two local

newspapers serving the municipality—both distributed free to homes each week in print and also available online—as being central to generating "civicness". This was ahead of radio, television and social media such as Twitter, Facebook and Instagram. For many participants, one particular newspaper was aligned more closely to the civic than the other as it published only "local" information and the journalists were known to live and work in the municipality. This was in contrast to the other newspaper operating from a nearby regional city which devoted only small sections of its content to news in the municipality examined in the study. As a participant in the focus group, a father of young children aged in his 40s, said:

> The newspaper generates civicness because it is called the *Surf Coast Times* and it is specific to the area, you instantly know that if you can support it or get involved in it you are really supporting your local community. It's where you are. (Extract from focus group transcript, 1 August 2015)

This comment resonates with previous work that highlights the importance of geography and the "local" to news in the digital world, where local news outlets serve as a beacon to gaining an understanding of happenings in specific territories in global information flows and movements (Hess 2013). Hess and Waller (2015) have argued that perceived localness is important to news providers in the digital age and they must invest in both a physical presence and detailed understanding of the localities they serve to stay competitive in the digital world. The comment above also highlights the act of regularly reading the newspaper as being seen as part of people's civic engagement. Other participants in the focus group highlighted how their own media-related practices consecrated certain media over others as being associated with "civicness". The owner of a holiday home in the municipality made this remark:

> I always read the newspaper just to find out what is going on and get my bearings a bit … it's quite grounding. (Interview with author, 3 May 2015)

The editor of the more popular local paper based in the municipality said being perceived as central to the civic was important in shaping the news agenda and enhancing the outlet's reputation.

> It's crucial, especially if you are trying to establish a connection with your readers through your stories. If I were to put it another way, as an editorial compass or radar, my attention is certainly grabbed by a story that has a civic element to it. Like a fundraiser, it's a local group—it's an event we support. It's something no one would put on the front page but it connects a whole heap of different community groups together to participate in the event. So it all coalesces around the idea of community participation. (Interview with researcher, 26 June 2015)

### Consecrating Media as Central to the Civic

In a digital world, the role of certain media outlets as "keepers" of civic virtue is often reinforced and sanctified by the political elite in several ways. Journalists hold a privileged position in society to report on civic and civil life. They continue, for example, to be allocated a designated physical space to report in parliament, local government chambers and the courts, ahead of the "ordinary" person or amateur blogger (see Waller and Hess 2013). An especially powerful way of demonstrating how the state consecrates certain

media outlets as being central to the civic is the role of government legislation regarding the advertisement of public notices. In Australia for example, legislation (see e.g. www. legislation.vic.gov.au) requires local government authorities to publish such information in a newspaper. This is an unspoken assumption that remains unchallenged even in the digital age. In the United Kingdom, however, there have been calls for an urgent review of legislation that currently commits local planning authorities to publish notices in newspapers in the digital environment (Dale 2012). The Killian Pretty Review (2008), for example, recommended that local planning authorities should no longer be required to publish in newspapers to improve effectiveness of discussion and involvement of local community and give authorities flexibility to spend money in the way they see fit to best engage their local communities (see also Radcliffe 2015). Local government representatives interviewed in this study agreed that such legislation posed direct economic advantage to newspapers. It also highlights the potential inequalities to other news providers serving communities vying for legitimacy and viability in the digital world.

Another aspect of news—births, deaths and marriage columns—helps to demonstrate how certain news outlets are consecrated as central to the civic through people's everyday media practices. I have argued elsewhere that such notices (often the staple of local newspapers) provide a powerful way of reinforcing rites of passage and determining those individuals who see themselves "in" or "outside" a particular community (see Hess 2015). Such power emerges only through adopting a critical cultural lens and examining the role media plays in people's everyday lives (see Couldry 2012).

## Media as Conferrers of Virtuous Practices

Talpin (2011) argues particular attention should be paid to the public status of the groups that Bourdieu argues benefit most from upholding notions of civic virtue. As we have established, there are few institutions—aside from the state—that imbue or have the ability to bestow symbolic power on others like the news media (see e.g. Couldry 2012). In Australia, annual Australia Day and Queens Birthday honour celebrations are testament to this, where media and government link together to celebrate and sanctify exemplars of civic virtuosity in their municipalities. Local news also plays a role independently of the state in bestowing symbolic capital—individual's reputation and prestige (Bourdieu 1986)—upon those who are seen to be particularly civic minded. The editor of one of the local newspapers said this was integral to the newspaper's economic and social value:

> People like reading stories about somebody that plays a role in their community. Volunteers, especially, who put in the extra effort, unrewarded or unthanked, those stories are really popular. Those are important stories but you wouldn't fill the entire paper with them, at the risk of boring the readers. We always are on the look-out for that because we are a community newspaper. So it's good to be seen to be doing the right thing by the community. (Interview with researcher, 22 June 2015)

Serving as central to the civic is much more than reporting and recognizing the efforts of the civic-minded, it is as much about drawing boundaries; determining who belongs "in" community or "out" of community; who should be recognized or supported in fundraising initiatives or exposed for wrongdoings as well as setting moral expectations and values. A fear of corruption sits at the heart of the republican idea of civic virtue. Bourdieu highlights that journalists play a role in uncovering the self-interest of others because the logics of the

journalistic field reward such behaviour (Bourdieu 1998, 145). As conferrers of civic virtue, news media play a well-documented role in patrolling boundaries and serving as watchdog over the actions of elites (i.e. corrupt politicians) as aligned with the valued Fourth Estate function of the press. This involves covering council meetings and those who appear before the courts. There is also the lesser-examined practice of media shaming, where traditional local news outlets play a powerful role in exposing the actions of "everyday" people who undertake unacceptable or immoral activity in the communities they serve (see especially Waller and Hess 2013). In a digital world, the news media continues to be a powerful platform among everyday people to expose the wrongdoings of others. The managing editor of one of the newspapers said the publication's regular "Buckets and Bouquets" column was "probably our best-read thing" (interview with researcher, 22 June 2015). The column celebrates selfless behaviour important to upholding notions of the common good and ridicules selfish inconsiderate behaviour. Audiences are invited to submit their buckets and bouquets in the hope they will be published by the newspaper. Take this extract from a recent column:

> BOUQUETS to a couple who stopped their car when they saw my sister's cat on the road. The woman went to the cat and the man knocked on my door to alert me to the situation. The cat lost an eye but is recovering well.—Judy, Norlane

> BOUQUETS to lollipop lady Julia at South Geelong Primary School's crossing for helping us cross the road safely, always being happy and knowing our names. You are the best lollipop lady ever.—My Two Brothers And I, East Geelong

> BUCKETS to a cruel, uninformed woman at Corio Shopping Centre on Sunday for telling my husband: "I bet you wish you hadn't smoked". He has idiopathic pulmonary fibrosis and is awaiting a lung transplant. He has never smoked and neither have I. Wake up, you stupid person.—ED, Lara

A Bourdieusian framework points to the inequalities at play in discussions about civic virtue. Gutsche (2015), for example, argues the practice of boosterism—where media construct consensus narratives about a locality—often tend to exclude the voices of the underrepresented (Gutsche 2015). Further, it is important to note that news stories highlighting displays of civic virtue are often determined by a set of cultural codes referred to as news values that professional journalists rely on to construct the news (see Galtung and Ruge 1981; Noelle-Neumann 1993). Journalists have the power to decide what content will be published in columns and news stories. Not all virtuous behaviour is or can be rewarded and so the media's role in conferring such practices is unequally distributed. The teen who rescues a fellow swimmer from the surf will be celebrated and lauded for their bravery, for putting others' interests ahead of their own, but the elderly woman who helps at the soup kitchen every week may avoid public attention because her work is considered of a banal nature rather than newsworthy.

## Discussion

As the future of news media faces a period of uncertainty, this paper has unravelled the ways in which civic virtue can be reinforced and perpetuated by certain elites in given social contexts—primarily for their own gain but which stands to benefit society all the

same (Bourdieu 1998). News outlets that are seen as central to bringing people together, to generate conversations, to construct communities and be seen as pivotal to civic life, wield power; and with power comes advantage, inequality and responsibility. This paper has sought to highlight that media as keepers and conferrers of civic virtue not only feature content that celebrates and glorifies moral and altruistic practices—the idea of the civic is much more complex than that. It goes to understanding media's role in defining who and what exists "in" and "out" of community, constructing meaning around "good from evil", moral and immoral (see also Gutsche 2015), and providing information that connect others socially. A Bourdieusian framework illuminates how being seen as central to the civic is fundamental to media legitimacy and ultimately viability. Scholars should examine how people's practices—at the everyday level and elite levels of society—lead to certain media being positioned as "keepers and conferrers" of civic virtue. The role and place of "public notice" advertising, for example, is a starting point when exploring how the state underpins the legitimacy and viability of newspapers in Australia as central to civic information. Bourdieu's framework reminds us of the symbolic power that comes with being virtuous. In the digital age where anyone can communicate any-where, any time, positioning local news media as keepers and conferrers of civic virtue suggests a powerful point of distinction in this changing media world.

## ACKNOWLEDGEMENTS

The author would like to thank research assistant Angela Blakston for helping gather data for this study.

## DISCLOSURE STATEMENT

No potential conflict of interest was reported by the author.

## NOTES

1.  Twelve interviews were conducted with key stakeholders from local government officials, elected representatives, active volunteers and media professionals, and a focus group of "everyday" people who either lived in the shire or had a connection to it (i.e. holiday home, tourist). The study adopted a geo-social framework, meaning it drew its sample from within geographic boundaries whilst acknowledging the wider social space of which civic life and media are a part (see Hess 2013).
2.  Bourdieu's views differ from the classical republican idea of civic virtue—where citizens could be socially organized in such a way as to channel their self-interest and private vices towards a common good (Goldberg 2013).

## REFERENCES

Adler, Richard, and Judy Goggin. 2005. "What Do We Mean By "Civic Engagement"?" *Journal of Transformative Education* 3 (3): 236–253.

Anderson, Benedict. 1983. *Imagined Communities: Reflections on the Origin and Spread of Nationalism*. London: Verso.

Audi, Robert. 2000. *Religious Commitment and Secular Reason*. Cambridge: Cambridge University Press.

Bakardjieva, Maria. 2009. "Subactivism: Lifeworld and Politics in the Age of the Internet." *The Information Society* 25 (2): 91–104.

Blanken, Bas. 2012. "The Good Liberal Citizen: Why Citizens can be both Free and Vivirtous." PhD thesis, Leiden University. https://openaccess.leidenuniv.nl/bitstream/handle/1887/19286/MSc%20Thesis%20BDB%20Blanken.pdf?sequence=1.

Borden, Sandra. 2010. "The Moral Justification for Journalism." In *A Philosophical Approach to Journalism Ethics*, edited by Christopher Meyers, 53–68. New York: Oxford University Press.

Bourdieu, Pierre. 1977. *Outline of a Theory of Practice*. Cambridge: Cambridge University Press.

Bourdieu, Pierre. 1984. *Distinction: A Social Critique of the Judgement of Taste*. Cambridge: Harvard University Press.

Bourdieu, Pierre. 1986. "The Forms of Capital." In *Handbook of Theory and Research for the Sociology of Education*, edited by John G Richardson, 241–258. New York: Greenwood Press.

Bourdieu, Pierre. 1990. *The Logic of Practice*. Cambridge: Polity Press.

Bourdieu, Pierre. 1998. *Practical Reason: On the Theory of Action*. Cambridge: Polity Press.

Bourdieu, Pierre and John Thompson. 1991. *Language and Symbolic Power*. Cambridge: Polity Press in association with Basil Blackwell.

Buchanan, Carrie. 2009. "Sense of Place in the Daily Newspaper." *The journal of media geography* Spring: 62–82.

Burtt, Shelley. 1990. "The Good Citizen's Psyche: On the Psychology of Civic Virtue." *Polity* 23 (1): 23–38.

Christians, Clifford. 1999. "The Common Good as First Principle." In *The Idea of Public Journalism*, edited by Theodore Glasser, 67–84. New York: The Guilford Press.

Couldry, Nick. 2012. *Media, Society World: Social Theory and Digital Media Practice*. Cambridge: Polity Press.

Couldry, Nick, Sonia Livingstone, and Tim Markham. 2007. *Media Consumption and Public Engagement: Beyond the Presumption of Attention, Consumption and Public Life*. New York: Palgrave Macmillan.

Couldry, Nick, Mirca Madianou, and Amit Pinchevski. 2013. *Ethics of Media*. Basinstoke: Palgrave MacMillan.

Dagger, Richard. 1997. *Civic Virtues: Rights Citizenship and Republican Liberalism*. New York: Oxford University Press.

Dahlgren, Peter. 2003. "Reconfiguring Civic Culture in a New Media Milieu." In *Media and Restyling of Politics: Consumerism, Celebrity and Cynicism*, edited by John Corner and Dick Pels, 151–170. London: Sage.

Dahlgren, Peter. 2009. *Media and Political Engagement: Citizens, Communication and Democracy*. Cambridge: Cambridge University Press.

Dale, Rob. 2012. "Should Public Notice Legislation be Updated?" *The Guardian*, September 13. http://www.theguardian.com/local-government-network/2012/sep/13/public-notices-legislation-lgiu-report.

Delli Carpini, Michael. 2004. "Mediating Democratic Engagement: The Impact of Communications on Citizens' Involvement in Political and Civic Life." In *Handbook of Political Communication Research*, edited by Linda Lee Kaid, 395–434. New York: Lawrence Erlbaum Associates.

Fenton, Natalie, Monika Metykova, Justin Schloseberg, and Des Freedman. 2010. *Meeting the Needs of Local Communities*. Media Trust: London.

Galtung, Johan, and Mari Ruge. 1981. "Structuring and Selecting News." In *The Manufacture of News: Social Problems, Deviance and the Mass Media*. rev ed., edited by Stanley Cohen and Jock Young, 52–63. Beverly Hills, CA: Sage.

Goldberg, Chad. 2013. "Struggle and Solidarity: Civic Republican Elements in Pierre Bourdieu's Political Sociology." *Theory and Society* 42: 369–394.

Gordon, David, John Kittross, John Merrill, William Babcock, and Michael Dorscher. 1999. *Controversies in Media Ethics*. New York: Routledge.

Gutsche, Robert. 2015. "Boosterism as Banishment: Identifying the Power Function of News and Coverage of City Spaces." *Journalism Studies* 16 (4): 497–512.

Hermes, Joke. 2006. "Hidden Debates: Rethinking the Relationship Between Popular Culture and the Public Sphere." *Javnost - The Public* 13 (4): 27–44.

Hess, Kristy. 2013. "Breaking Boundaries: Recasting the Small Newspaper as Geo-social News." *Digital Journalism* 1 (1): 45–60.

Hess, Kristy. 2015. "Ritual Power: Illuminating the Blindspot of Births, Deaths and Marriages in News Media Research." *Journalism: Theory, Practice Criticism*. doi: 10.1177/1464884915570419.

Hess, Kristy. 2016. "Shifting Foundations: Journalism and the Power of the Common Good." *Journalism: Theory Practice Criticism* (in press).

Hess, Kristy, and Lisa Waller. 2015. "River Flows and Profit Flows: The Powerful Logic Driving Local News." *Journalism Studies*. DOI: 10.1080/1461670X.2014.981099.

Hurka, Thomas. 2001. *Virtue, Vice and Value*. New York: Oxford University Press.

Killan Pretty Review. 2008. Department for Communities and Local Government, United Kingdom. http://webarchive.nationalarchives.gov.uk/20120919132719/http://www.planningportal.gov.uk/uploads/kpr/kpr_final-report.pdf.

Kinney, Bo. 2012. "Deliberation's Contribution to Community Capacity Building." In *Democracy in Motion: Evaluating the Practice and Impact of Deliberative Civic Engagement*, edited by Tina Nabatchi, John Gastil, G. Michael Weiksner, and Michael Leighninger, 163–180. New York: Oxford University Press.

Mersey, Rachel. 2009. "Online News Users Sense of Community." *Journalism Practice* 3: 347–360.

Moores, Shaun. 2000. *Media and Everyday Life in Modern Society*. Edinburgh: Edinburgh University Press.

Noelle-Neumann, Elisabeth. 1993. *The Spiral of Silence*. 2nd ed. Chicago: University of Chicago Press.

Putnam, Robert. 2000. *Bowling Alone: The Collapse and Revival of American Community*. New York: Simon & Schuster.

Radcliffe, Damian. 2015. *Where are we Now? UK Hyperlocal Media and Community Journalism in 2015*. Cardiff: Centre for Community Journalism and Nesta.

Riordan, Patrick. 2008. *A Grammar of the Common Good*. London: Continuum International Publishing Group.

Riordan, Patrick. 2015. *Global Ethics and Global Common Goods*. London: Bloomsbury.

Talpin, Julien. 2011. *Schools of Democracy: How Ordinary Citizens (Sometimes) become Competent in Participatory Budgeting Institutions*. Cochester: ECPR Press.

Wacquant, Loic. 2004. "Pierre Bourdieu and Democratic Politics." *Constellations* 11 (1). http://loicwacquant.net/assets/Papers/PB-POINTERSPBDEMOPOL.pdf.

Waller, Lisa, and Kristy Hess. 2013. "News Judgements: An Examination of Reporting Non Convictions for Minor Crimes." *Australian Journalism Review* 35 (1): 59–70.

Ward, Stephen. 2010. *Global Journalism Ethics*. Montreal: McGill Queen's University Press.

# Index

# INDEX

For Product Safety Concerns and Information please contact our EU
representative GPSR@taylorandfrancis.com
Taylor & Francis Verlag GmbH, Kaufingerstraße 24, 80331 München, Germany